The Century of Sex

The Century

of Sex

PLAYBOY'S HISTORY OF

THE SEXUAL REVOLUTION:

1900–1999

by James R. Petersen

Edited and with a Foreword by

Hugh M. Hefner

 Grove Press New York

To Sierra and Conor

Published simultaneously in Canada
Printed in the United States of America

FIRST EDITION

Library of Congress Cataloging-in-Publication Data
Petersen, James R.
 The century of sex : playboy's history of the sexual revolution,
 1900–1999 / by James R. Petersen ; edited and with a foreword by
 Hugh M. Hefner.
 p. cm.
 ISBN 0-8021-1652-3
 1. Sex customs—United States—History—20th century. 2. Sex—
 United States—History—20th century. I. Title.
 HQ18.U5P444 1999
 306.7'0973'0904—dc21 99-23668

DESIGN BY LAURA HAMMOND HOUGH

Grove Press
841 Broadway
New York, NY 10003

99 00 01 02 10 9 8 7 6 5 4 3 2 1

SEX: The sum of the morphological, physiological and behavior peculiarities of living beings . . . that is typically manifested as maleness and femaleness.

SEX: The sphere of interpersonal behavior especially between male and female most directly associated with, leading up to, substituting for or resulting from genital union.

SEX: The phenomenon of sexual instincts and their manifestations. specif: sexual intercourse.

(Webster's Third International Dictionary)

"There is nothing new in the world except the history you do not know."

—Harry S. Truman

"Battles are won in the daytime but history is made at night."

—from *Pin-up Girl*

CONTENTS

FOREWORD

In 1995, I asked the editors of *Playboy* to undertake a history of the sexual revolution. But not the one that I am sometimes credited with (or, conversely, blamed for) starting.

Most Americans today think the sexual revolution happened in the sixties and seventies. As they recall, it only lasted a short time and gave us the Swedish Bikini Team, *Debbie Does Dallas,* unwed teenage mothers, date rape, and AIDS.

The story I envisioned was a far grander event, one that was inextricably connected with the history of the twentieth century. If viewed over a one-hundred-year span the sexual revolution would be seen for what it was: a great struggle involving ideas, champions, and villains. We would chart the liberation of men and women, of language, the body, the imagination.

I believe that sex is the primary motivating factor in the course of human history, and in the twentieth century it has emerged from the taboos and controversy that have surrounded it throughout the ages to claim its rightful place in society. This was the century of sex, when mankind confronted the fears that controlled and shaped sex as they had since the beginning of time—and triumphed.

In this era of great change—in manners and morals, science and technology, art and literature—America has been on the vanguard. Its attitude toward sexuality has changed from a rigid propriety to an exhilarating celebration and, some believe, excess. In this book, James R. Petersen weaves together the stories of the events and the individuals who shaped them into a commanding narrative of the history of sexual liberation. He also reveals how the basic dance of dating and mating has evolved over the past one hundred years, attending

to the anecdotal details that distinguish the flapper from the philosopher, the pioneer from the prude.

Many of the issues we debate today—sexual expression, sex education, birth control, abortion, disease, law—were first framed at the turn of the century. Ending the silence about sex was the first phase of the revolution, and this is where the narrative begins.

Three vital factors emerged at the turn of the century that shaped the sexual awakening of the era. Urbanization was first, and perhaps foremost. The shifting of America's population from rural areas to cities freed individuals from the repression of provincial mores. It mixed classes, creeds, and races (many newly arrived through immigration) together into a densely populated city electric with dance halls and nickel arcades that pulsed with the energy of sex, the promise of pleasure.

Secondly, new forms of transportation allowed us to venture beyond ourselves and cross social boundaries. Prior to the turn of the century, an individual's sexual universe was limited to the distance he or she could walk or travel by horse in a day. With trolleys, trains, automobiles, and airplanes came the opportunity to escape—not only peers and parents, but the prison of the past.

Finally, the advent of mass communications made our sexual dreams visible. From the proliferation of newspapers and scandalsheet tabloids carrying cabled reports from coast to coast (and from abroad), to the increasing accessibility of film, radio, eventually television, and ultimately the Internet, sex could permeate all atmospheres, all places.

Not surprisingly, this increasing presence of sex came under attack from self-appointed censors who wanted to control imagination and play in all its forms. The conflict between puritan repression and hedonism is so deeply a part of the American psyche that a look back at the past one hundred years of sexual controversies that appear in the following pages can provide unique insights into our contemporary concerns. Why has America hailed as heroes the likes of Anthony Comstock, J. Edgar Hoover, Catharine MacKinnon, or Ken Starr? Why have sexual explorers from Ida Craddock to Alfred Kinsey had to defend their right to discuss a topic central to the human experience?

Sexual hypocrisy has always been with us, but it has become particularly obvious in this century, and the codification of sexual prejudices and repres-

sion is an important part of the story. This book is also a history that supplies the context for the sexual taboos that continue to plague us today. If this has been done properly, the readers of this book will no doubt understand how capricious and arbitrary these views and values are. And how unrelated they are to human happiness.

The story in this book is the story of how powerful forces in America did everything possible to impede the pursuit of pleasure and any expression of the sexual nature of man. It is also the story of those who struggled against this tide, and through their refusal to yield created a momentum for change that spread throughout the nation and across the globe.

In this century, America liberated sex. The world will never be the same.

<div align="right">

Hugh M. Hefner
Los Angeles, May 1999

</div>

INTRODUCTION

On one of my first days of research for this book I visited the Planned Parenthood offices in New York City to look at documents in the Margaret Sanger Library. Before I could enter, a security guard checked my bag for weapons or explosive devices. When I had finished copying pages from Sanger's *Woman Rebel* and birth-control tracts from the teens and twenties, the same guard escorted me to the street. Sanger's fight for a woman's right to control her own body had polarized the country. The abortion debate, for years conducted at rallies and teach-ins, was today the province of terrorists.

When I stopped a woman on the Indiana University campus to ask directions to the Kinsey Institute, she expressed envy that I was being allowed into the "innermost sanctum." I puzzled at her response until going through the rings of security before gaining access to their library. Even then, the books themselves were kept behind "the green door." I sorted through three separate card catalogs—from Kinsey's original guide to a modern, though not yet complete, computer index. The academic keys to the kingdom were as frustrating as they were useful. But when the intern brought out books and papers, the discovery began. Kinsey's meticulous notes in margins and on frontispieces were an inspiration. This is what the study of sex looks like, I recall thinking.

My research took me to the National Archives, to book and film collectors, university libraries, and *Playboy*'s own, not inconsiderable holdings. I read journals, novels, histories, magazines, and letters looking for signposts in the sexual revolution.

The change that began at the turn of the century found its name in 1946, when psychologist Wilhelm Reich translated *"Die Sexualitat im Kulturkampf."* He called the culture war *The Sexual Revolution*. Contrasting this tumultuous upheaval with the industrial revolution and the worker's revolution, Reich

proposed a more subtle confrontation. "The word revolutionary in this book does not mean the use of dynamite, but the use of truth; it does not mean secret meetings and the distribution of illegal literature, but open and public appeal to human conscience, without reservations, circumlocutions, and alibis. It does not mean political gangsterism, executions, appointments, making and breaking of pacts; it means revolutionary in the sense of being radical, that is, of going to the roots of things."

I looked for agents of change and agents of repression. Some of the discoveries were counterintuitive. Who changed sex more—Sigmund Freud or Henry Ford? Thomas Edison or J. Edgar Hoover? Havelock Ellis or Elvis? Margaret Mead or Mae West? The series charted the impact of singular forces on sex—from electricity, the automobile, the telephone, movies and music, to poverty, prosperity and war.

Consider this: shortly before the turn of the century, a respectable woman wore seventeen pounds of clothing when she worked about the home; she wore thirty-seven pounds of clothing when she went into the public sphere. Something as innocent as the bicycle craze caused women to shed clothes. (Some historians say the bicycle propelled women into previously unfeminine sports and eventually the workplace.) Are there objective measures of liberation? I found it quaint that in America, modesty was measured in inches. As fashion changed, a swimming association specified that a woman's bathing attire should extend to within three inches of the knee, while a man's attire had to reach eight inches below his crotch. If nothing else, this book chronicles the meddlesome nature of Americans. As one observer remarked, "Take any three citizens, and two of them will form a committee to tell the third one how to behave."

Trying to weigh the evidence was difficult. In the 1920s, Edmund Wilson began a journal that included remarkably frank details about his sex life. Some of the entries are innocent: He records a visit to a pharmacy to buy his first condom, and notes that it did not protect him from "entanglements and a broken heart." The journal contains a frank description of the effects of the hip flask on lovemaking: "At the climax of a bout, being drunk and thinking I was performing particularly successfully, I discovered that my cock had slipped out and that she was trying to put it back in again." Was this symbolic of the twenties (Wilson's chronological age) or the nineteen-twenties (the century's

chronological age)? Was it a young man's first brush with intoxication, or an apt description of America's sexual coming of age?

I recall reading an article about Mario Cuomo, then governor of New York, whose interest in the nature of man led him to pick up books on ethics. He would turn to the index to see what, if anything, the author had to say on evil. I picked up books and looked to see what, if anything, they had to say on sex. The silence was overwhelming. The Evanston Library, for example, had row after row of books on World War II. Only three mentioned the impact the war had on sex.

I realized that sex provides us a unique lens on the history of our country. The project grew from a history of the sexual revolution to a sexual history of America in the twentieth century.

This book is the product of an intense collaboration between the author and the editor. Hefner wanted this to be a history of repression; I wanted it to be the biography of sex.

Hefner sees sex in everything—from fashion, food, and drink, to sports cars, dating dilemmas, taste, and etiquette. Readers familiar with *Playboy* will recognize those topics as the kind of issues dealt with by The Playboy Advisor, a position I held for twenty-two years. I wanted to focus on what happened inside sex. Both of us wanted to answer a single question: How did America get to be this way?

Our confrontations produced some of the better discoveries of this book. In the thirties, for example, Hef wanted to cover the history of sex in cinema. I was not interested in what happened on the screen. I wanted to record what happened in the balcony. As I researched the effect of poverty on sex I came to view the Golden Age of Cinema as an obscenity. Hef's reply: The dustbowl is now somebody's backyard and lawn; the images of glamour that Hollywood produced in the 1930s shaped dreams of romance for the rest of the century.

The sexual revolution ignited conflict on two fronts: the public image of sex (be it the written word or images flickering on nickelodeons, silver screens, television sets, or computer monitors) and the private behavior of adults. What was to be allowed? At the core of the struggle was the issue of who controls sex—the church (through bully pulpit and the concept of sin and damnation), the state (through lawbook and prison), or the individual (through courage,

curiosity, freedom, and choice). Almost immediately I added a fourth estate—the role of scandal. We cannot even feed ourselves without running a gauntlet of gossip at grocery stores.

Consider how far we've come. In 1871 Victoria Woodhull addressed Congress, the first woman to do so, on the issue of women's suffrage. In speeches across the nation, she advocated free love. To the modern ear the term evokes images of hippies cavorting in hot tubs, of couples tangling in satin sheets on water beds, of naked bodies slithering through Wesson Oil orgies. Her intent was more noble. Woodhull challenged the authority of church and state to dictate affairs of the heart. "I have an inalienable, constitutional, and a natural right," she wrote, "to love whom I may, to love as long or as short a period as I can, to change that love every day I please, and with that right neither you nor any law you can frame have any right to interfere."

Woodhull attacked the "compulsory hypocrisy and systematic falsehood" that permeated society. When she exposed an adulterous affair between Henry Ward Beecher, a leading advocate of family values and pillar of the Plymouth Church, and Mrs. Theodore Tilton, a parishioner and the wife of his best friend, Woodhull, not Beecher, was ostracized. When her paper tried to expose a respected Wall Street gentleman who, after seducing a young girl, "carried for days on his finger, exhibiting in triumph, the red trophy of her viginity," she was arrested by Anthony Comstock for obscenity.

The book encounters the first trial of the century (in which millionaire Harry K. Thaw was found not guilty due to insanity in the killing of architect Stanford White). The case has held our attention for almost a hundred years, revived in literature, film, and stage. America's homemade morality plays—from the trials of Fatty Arbuckle and Charlie Chaplin to the attempted crucifixion of William Jefferson Clinton—provide a history of outrage and vicarious thrill. Sex has indeed shaped history, from the girl in the red velvet swing to the intern in the blue Gap dress.

Although this history starts with the city electric at the dawn of the century, the roots of the sexual revolution go back at least a quarter century before. The arrest of Victoria Woodhull was the opening salvo by forces that wanted to control sex. In 1871 Congress passed what became known as The Comstock Act, declaring that it was illegal to send through the mails informa-

tion about abortion, birth control, or sex. This chronicle begins at a time when the information highway was the Boston Post Road, when the favorite form of public debate was the stage at Town Hall. It follows the crusade against censorship, from the arrest of booksellers who dared promote Theodore Dreiser's *American Tragedy* to the persecution of publishers who reclaimed such banned expatriate classics as Henry Miller's *Tropic of Cancer,* D. H. Lawrence's *Lady Chatterley's Lover,* and John Cleland's *Memoirs of a Woman of Pleasure (Fanny Hill).* When I first came to work at *Playboy,* I did so because of the permission it gave to write about sex the way it actually happens. The liberation of language is one of the major triumphs of the revolution, one that I hope I present properly.

In revolutions past, the army that seized the radio station invariably won. In America today, the visual rules. Like it or not, Hollywood shapes the public image of sex. And while I claim to be interested in what went on in the balcony, the evolution in the right to look, the right to see sex the way it actually happens is one of the most fascinating arcs of the century, from the first images of a couple kissing to the athletic, explicit romps of today's X-rated fare.

The common wisdom that the sexual revolution was the result of the Pill, penicillin, and *Playboy* takes on new meaning when one looks at the world before these specific changes. At the turn of the century, sex moved from a moral issue to a medical one—the debates on venereal disease echo through the current battle over AIDS. I look at the role of researchers from Havelock Ellis to Masters and Johnson in the shedding of light into dark places. I celebrate the explorers and permission givers—from Ida Craddock, the turn-of-the-century marital adviser, to Alfred Kinsey and his most devoted convert, Hugh Hefner; from Betty Friedan and Germaine Greer to the riot grrls.

We in America have been swept by change, and almost every change has produced a moral panic. This book charts those convulsions –from the White Slave Traffic panic in 1910 to the homophobia of the fifties and the child porn hysteria of the eighties. In the sexual revolution, fearmongering is a weapon of choice, part of the psych-war fueled by propagandists for the past. George Santayana advised that those who cannot remember the past are condemned to repeat it. Nowhere is this more true than in the world of sex.

Chapter One

THE CITY ELECTRIC: 1900—1909

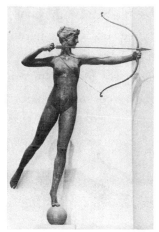

Augustus Saint Gaudens's statue of Diana looked out over New York City from atop Madison Square Garden from 1891 to 1925.

Imagine the city electric, some great switch thrown for the first time. At night the lights came on, turning each restaurant and theater into a blaze of bodies. Electricity poured through penny arcades and nickelodeons where, for pocket change, individuals witnessed *Little Egypt, Serpentine Dancers, How Girls Go to Bed, How Girls Undress, The Marvelous Lady Contortionist, Three Skirt Dancers,* and something called *The Kiss.*

Outside an arcade, someone tacked a review from the *New York Evening World:* "For the first time in the history of the world it is possible to see what a kiss looks like. Scientists say kisses are dangerous, but here everything is shown in startling directness. What the camera did not see did not exist. The real kiss is a revelation. The idea has unlimited possibilities."

A skyline once dominated by church steeples had a new deity. Atop the Madison Square Garden tower a copper and bronze statue of Diana the Huntress scanned the horizon. The thirteen-foot nude swung on gimbals, her drawn bow seeking the future.

The streets were filled with horse-drawn carriages and streetcars that rode the electric rail to a seaside wonderland called Coney Island.

Theodore Dreiser captured the mood in a novel that almost didn't get published. Frank Doubleday had deemed *Sister Carrie* (1900) immoral and tried to renege on his contract to publish the book, then to restrict its circulation. The book never described sex, but the heroine moved through a series of affairs without retribution. In passage after passage Dreiser evoked the swarming city, the lovely company of handsome men and elegantly dressed women, the moving fashion show of silver walking sticks, the perfumed air of scented hair. The city was a parade of equals, each aware of his or her desire. Dreiser spoke of "conscious eyes," of men and women "whose glances were not modified by any rules of propriety." The world was made for flirtation and seduction. "Women were made for men—and there was an end to it," explained one sporting male. "The glance of a coquettish eye was sufficient reason for any deviltry."

The city itself changed sex. Country girls grew up in protected households. Courters would make calls and sit on the front porch in full view of families. There was an accepted etiquette. An advice column in *Ladies' Home Journal* in 1908 offered this:

> Q: If a young man should take a girl unawares by kissing her, what should she do?
>
> A: She should show her displeasure in a dignified way that leaves him in no doubt of it. She has reason to be displeased—for it is a liberty.

In polite society a man would not dare call unless the woman had indicated interest. Kissing in public was bad form. Expressions of affection were for "private delectation."

There were no fence- and yard-protected front porches in the city. Crowded apartments filled with workingmen and -women or families were not designed to shelter the innocent. The streets beckoned. The young flocked

to the vast new temples of public entertainment—dime museums, vaudeville, penny arcades, amusement parks, baseball stadiums, dance halls, peep shows, and listening rooms. Technology created a new kind of voyeurism as Americans stood hunkered over kinetoscopes and projectoscopes, motorgraphs, cinematographs, biographs, rayoscopes, eidoloscopes, viveoscopes, graphoscopes, and animatographs—the instruments of entertainment.

A nickel in the slot and an Edison phonograph played the hit music of the day. Another nickel brought a flickering image of Little Egypt doing the hootchie-coo. The new amusements were intoxicating and, some feared, addicting. Newspapers carried stories about "nickel madness."

The amusements seemed to point, like Diana's arrow, toward a new world built on pleasure. Sex was in the air itself. One observer visiting a Yiddish music hall remarked, "The songs are suggestive of everything but what is proper, the choruses are full of double meanings and the jokes have broad and unmistakable hints of things indecent."

The city was carnal. The raucous, sexually charged world caught the attention of the Committee of Fourteen, a group of wealthy men who gathered to ponder the new energy. They were not puritans, but they viewed themselves as moral custodians of the great metropolis and, indeed, the entire country. The Committee of Fourteen evolved into a group of physicians called the Committee of Fifteen. After studying the new city, the old guard issued a tome called *The Social Evil*. It described the young man drawn to the city by opportunity, who postponed or abandoned the expectation of marriage. "His interests center almost wholly in himself. He is responsible to no one but himself," they wrote. "The pleasures that he may obtain from day to day become the chief end of his life. A popular philosophy of hedonism furnishes him with a theoretical justification for the inclinations that are developed by the circumstances in which he is placed. It is not unnatural then that the strongest native impulse of man should find expression in the only way open to it—indulgence in vice."

The American family faced a new challenge. A blueprint that had existed since the Pilgrims landed at Plymouth Rock, one that had been enforced by law, public punishment in the stocks, and the occasional hanging, was being ignored by millions.

In America, it was believed that the family unit was a support system for progress, a small corporation built on willpower, sacrifice, resolve, the work

ethic. Lewis Erenberg, a historian of nightlife, described the old order in *Steppin' Out.* "Passion was one element that could distract men from success," he wrote, "weaken their resolve and ultimately destroy their will. It was thus considered bad for business, and businessmen's wives and daughters were expected to conform to the kind of sexual relationship that made the least trouble."

America believed in the purity of women, whether it was good for them or not. Men had sexual appetites, women did not. "For both men and women, sexuality was separate from romance," writes Erenberg. "Women provided the order in life and the social order to men's identities, and for that reason they had to live in their own private world above the temptations of the town."

In a tiny office in the heart of New York City, Anthony Comstock studied the annual report for the New York Society for the Suppression of Vice. This bull-necked man, dressed in black, was physically stalwart, as grim and serious as the task he'd set for himself. Only muttonchop sideburns—once ginger-colored but now turning white—deviated from the severe. This was a man who, serving as a twenty-year-old in the Civil War, had persuaded three like-minded Christian recruits to take a pledge against swearing, drinking, and chewing tobacco. He'd acted as self-appointed chaplain for his unit. Now he had the higher office, also self-appointed, of national censor.

As usual, the report began with an apology:

It is always a difficult matter to write the report for this society. The character of the evils, often found circulating among young people in institutions of learning, is so gross that no adequate idea can be given of it to the members of this society, much less to the public in general. . . . We can neither reproduce the books and pictures nor describe their true character. We cannot name the child, family or school, nor show into what circles of society we are called to make investigations. The nearest approach to a description of the evils which we war against will be found in the following tabular statement:

Book and sheet stock seized and destroyed: 52 pounds. Obscene pictures and photos: 19,260. Negative plates for making obscene pho-

tos: 842. Articles for immoral use of rubber, etc.: 1,000. Boxes of pills and powders used by abortionists: 66. Circulars, catalogs, songs, poems, etc.: 7,891. Newspapers containing unlawful advertisements or obscene matter: 22. Obscene pictures framed on walls of saloons: 7. Obscene plays stopped or places of amusement closed: 1.

Anthony Comstock—special agent to the U.S. Post Office and secretary of the New York Society for the Suppression of Vice—did not read books. He weighed them. Depending on your point of view, he was either a Christian champion or a one-man American Inquisition. The son of a deeply religious farm couple, Comstock was born in New Canaan, Connecticut, in 1844. A former dry goods salesman, he applied the puritan work ethic to the rooting out of sin in all its tempting forms.

The report to the society provided career totals for Comstock's work. Prior to 1900, he had arrested 2,385 people. (By the end of his career, that figure would top 3,600—enough, he would say, to fill a passenger train of 61 coaches, 60 coaches containing 60 passengers each and the 61st almost full.) By the beginning of this century, he had destroyed 73,608 pounds of books; 877,412 "obscene" pictures; 8,495 negatives for making "obscene" photos; 98,563 articles for "immoral" use of rubber; 6,436 "indecent" playing cards; and 8,502 boxes of pills and powders used by abortionists.

Comstock looked forward to the new century. The vice report—sent out to schools and the pious with a request for funds—pointed out that in 1902 Comstock would celebrate the thirtieth anniversary of his crusade against smut. The society wanted to create a permanent fund of $300,000 so that it would no longer be dependent on annual contributions from the devout.

Comstock was a newspaper darling and, to a certain extent, a newspaper creation. He made for good copy, with boasts that he was hunting down sinners like rats. In March 1872 Comstock, accompanied by a police captain and a *New York Tribune* reporter, had raided two stationery stores. Comstock bought pictures and books, then declared them obscene. Six employees were arrested, and Comstock got his first headlines.

With the support of the YMCA and some of New York's wealthiest men (among them financier J. P. Morgan, real estate tycoon J. M. Cornell, mining baron William Dodge, and publisher Alfred Barnes), he formed a vigilante

group, the Committee for the Suppression of Vice. Cashing in on the notoriety from his raid, Comstock took a suitcase full of the choicest items of pornography to Washington. He persuaded a scandal-ridden Congress to pass a bill intensifying the punishment of those using the mail to send obscene materials. The new law, which came to be called the Comstock Act (1873), also added contraceptives, abortifacients, and "things intended for immoral use" to the list of materials prohibited from the mail. The politicians gave him an official appointment—special agent of the Post Office (without salary, at first)—and a badge, then turned him loose on the country.

The committee incorporated itself as the New York Society for the Suppression of Vice and provided Comstock with an office and a salary. According to its charter, the SSV would receive half of the fines collected from his activities.

Comstock guarded America from an invisible conspiracy that used the U.S. mail to disseminate evil. In a way, he was attacking the technology of the times, the first instrument of an emerging culture. The Post Office had noticed that after the Civil War the mail was being used to send erotic postcards and suggestive letters. The practice continued to increase during the Gilded Age and became a commercial form of entertainment. One could pick up the National Police Gazette and find ads for "Naked truth and secrets of nature revealed . . . engravings from nature" or "The Female form divine, five photos, not tights, 50 cents."

Comstock never described the objects he suppressed, but some pictures survive. Even today these postcards have the power to arouse. A series from San Juan shows a woman in a straw hat barely able to keep a straight face as she aims a stars-and-stripes dildo at a male partner. Another shows a woman reclining on a black velvet mattress. At one end of her body, an athletic young man prepares to enter her. At the other, a second woman plants a kiss so quickly, her hair blurs. In a third postcard a buxom woman giggles as she squeezes her partner's erect penis between her breasts. There is a sense of novelty, discovery, or daredevil abandon before the camera in such pictures.

For Comstock, these images held the danger of infectious disease. His tactics were the epitome of deceit. He posed as a woman and sent letters to abortionists, then arrested them when they mailed back items he deemed offensive. He posed as a collector of racy prose and busted the "nefarious"

publishers who solicited titillating fiction. Comstock cleared the shelves of titles such as *The Lustful Turk, Peep Behind the Curtains of a Female Seminary, Amorous Sketch Book, Voluptuous Confessions*—books that might incline one's thoughts toward the sexual, that might prompt the young to debase themselves through masturbation.

Consider this passage, from a 1904 edition of *The Modern Eveline,* printed for distribution among private subscribers, with the subtitle "The adventures of a young lady of quality who was never found out":

I had retained my white kid gloves to please him. I held his stiff member in my grasp. I shook it gently up and down.

"'Your little Eveline would like to suck it, papa." I suited the action to the word. I sucked it for a few minutes. I did not want to finish him off just yet. He threw me back on the sofa. He turned up my beautiful satin ball dress. He exposed my legs. He devoured my fine pink silk stockings in a frenzied gaze impossible to describe. He began to whisper indecencies. I replied with suggestions even more lewd. A demoniacal lust possessed us both. Our faces glared with the hot passion we felt consuming us. I stood before him again, in my stays, my long silk stockings, my gloves—long white evening gloves that fitted perfectly, extending almost to my elbows. I still retained my bracelets. My garters of rose and velvet and old gold set off my glistening hose, To his view I must have appeared a perfect houri, with only my light chemise of finest batiste to veil my skin, over which the delicate flush of health and good nourishment cast a roseate tint provocative of joy and love's delight. "Let us have our revenge now, dear papa. Let us outrage this false society all we can. Let us invert its hypocritical precepts. Let us be as indecent as we can."

The gauntlet, or in this case, the white kid glove, had been thrown down. Such literature was a call to revolution.

By the turn of the century only a quarter of Comstock's actions involved the mail. Many states had passed mini-Comstock laws and spawned similar anti-vice groups. Comstock would stalk the streets of New York, intimidating store owners into removing "offensive" material, demanding that the printing

plates to such classics as Henry Fielding's *Tom Jones* be destroyed. If something offended his eye, it was plucked.

Like other reformers to come, Comstock justified meddling in the affairs of adults by championing youth. He thought he was chosen by God to protect the moral purity of children. He viewed Satan as a foe who set traps for the young.

He found these traps in newspapers, dime novels, and saloon paintings. He despised circulars and advertisements that might lure innocent passersby. But his career as censor stretched beyond images and ideas into the realm of behavior. He was the Christian champion defending his view of the family in a war for the soul of the country.

Comstock's worldview did not go uncontested. In 1878 the National Liberal League and the National Defense Association sent a petition with more than 50,000 signatures, measuring 2,100 feet, to Congress, asking that it repeal the Comstock Act. "Your petitioners . . . are convinced that all attempts of civil government, whether state or national, to enforce or to favor particular religious, social, moral or medical opinions, or schools of thought or practice, are not only unconstitutional but also ill advised, contrary to the spirit and progress of our age and almost certain in the end to defeat any beneficial objects intended. That mental, moral and physical health and safety are better secured and preserved by virtue resting upon liberty and knowledge than upon ignorance enforced by governmental supervision."

Congress refused to change the law.

For Comstock, sex was a controlled substance. A modern eye looks at his tabulations and thinks of other government wars. Imagine a headline: FEDS SEIZE TEN TONS OF OBSCENE LITERATURE, STREET VALUE: 6 MILLION DOLLARS, and wonder, how much escaped Comstock's snare? The figures are valuable as a measure of the nation's appetite for sexual information.

Comstock had the government at his disposal; no one would stand up in favor of freedom for fear of being next on his list. D. M. Bennett, the author of a biography critical of Comstock's "career of cruelty and crime," clashed repeatedly with his enemy. Comstock arrested him for circulating obscene literature (tracts on free love). One could suspect a personal vendetta, but at Bennett's trial the assistant district attorney addressed the jury: "Gentlemen, this case is not titled 'Anthony Comstock against D. M. Bennett'; this case is not titled 'The Society for the Suppression of Vice against D. M. Bennett.' . . .

It is 'The United States against D. M. Bennett,' and the United States is one great society for the suppression of vice."

At night, Ida Craddock consorted with angels. She believed herself the wife of a divine spirit, "a heavenly bridegroom," and she felt called to relay the teachings of that angel. She called herself "Mrs." because, at that time, it was unheard of for a single woman to express any knowledge of sex.

Craddock had been associated with the free love movement for years and had worked as a secretary for the National Liberal League. At the turn of the century she wrote several pamphlets, including *The Wedding Night* and *Helps to Happy Wedlock,* as well as a longer guide, *Right Marital Living.*

The Wedding Night is one of the earliest marriage manuals in American history. In it, Craddock tells prospective husbands that an inexperienced, innocent bride might first view an erection as "a monstrosity," but that they must persevere:

> If you will kiss and caress her in a gentle, delicate and reverent way, especially at the throat and bosom, you will find that little by little (perhaps not the first night nor the second night, but eventually, as she grows accustomed to the strangeness of the intimacy) you will, by reflex action from the bosom to the genitals, successfully arouse within her a vague desire for the entwining of the lower limbs, with ever closer and closer contact, until you melt into one another's embrace at the genitals in a perfectly natural and wholesome fashion; and you will then find her genitals so well lubricated with an emission . . . that your gradual entrance can be effected not only without pain to her but with a rapture so exquisite to her that she will be more ready to invite your entrance upon a future occasion. . . .

> Do not, upon any account, use the hand for the purpose of sexual excitation at the bride's genitals. There is but one lawful finger of love with which to approach her genitals, and this is the male organ. . . . As to the clitoris, this should be simply saluted, at most, in passing, and afterward ignored as far as possible; for the reason that it is a rudimentary male organ, and an orgasm aroused there evokes a rudimentary male magnetism in the woman, which appears to pervert the act of

intercourse, with the result of sensualizing and coarsening the woman. . . . After a half hour or, still better, an hour of tender, gentle, self-restrained coition, the feminine, womanly, maternal sensibilities of the bride will be aroused, and the magnetism exchanged then will be healthful and satisfying to both parties. A woman's orgasm is as important for her health as a man's is for his. And the bridegroom who hastens through the act without giving the bride the necessary half hour to hour to come to her own climax is not only acting selfishly, he is also sowing the seeds of future ill-health and permanent invalidism in his wife.

Craddock distinguished clitoral orgasms, which were "distinctly masturbative," from those produced by "excitation within the vagina," which could satisfy the woman completely, awakening her "sweetest and most womanly, most maternal instincts."

Her instructions to women were equally graphic: "Bear in mind that it is part of your wifely duty to perform pelvic movements during the embrace, riding your husband's organ gently and, at times, passionately, with various movements up and down, sideways and with a semirotary movement, resembling the movement of the thread of a screw upon a screw. These movements will add greatly to your own passion and your own pleasure, but they should not be dwelt on in thought for this purpose. They should be performed for the express purpose of conferring pleasure upon your husband, and you should carefully study the results of various movements gently and tenderly performed upon him."

In *Right Marital Living,* Craddock encourages women to "go right through the orgasm, allowing the vagina to close upon the male organ. Keep self-controlled, serene, tranquil and aspire to the highest. Pray to God, if you believe in God and in prayer; if not, think steadily and quietly what a beautiful thing it is to be at that moment in harmony with Nature in her inmost workings and rejoice that you and your husband are part of Nature, pulsating with her according to her law. Rejoice that Nature at that moment feels through you also, and through your husband. Feel love, love, love, not only for your husband but for the whole universe at that moment."

Her crusade would cost Craddock her life. Comstock wrote that "any refined person reading her books would find all the finer and sweeter sensi-

bilities violently shocked, while to the ordinary mind it would be regarded as the science of seduction and a most dangerous weapon in the hands of young men, as educating them in a manner that would enable them to practice the wiles of the seducer to perfection upon innocent girls."

On February 3, 1902, Comstock wrote a decoy letter to Craddock:

Madame,

Would you oblige me with a copy of your *Wedding Night*? I enclose half a dollar. Do you admit young girls to your lectures? What do you charge for two chums who would like to come together? I am past 17 years. Please seal tight and oblige me. Address plain Miss Frankie Streeter.

P.O. Box 201, Summit, N.J.

Enc. 50 cents.

Craddock declined, with an elegant letter: "My chief reason for not admitting minors to my lectures is that there exists a social superstition that young people should be kept as ignorant as possible of all that pertains to the marriage relation. It is thought by many people that it would somehow render young people impure if they were told previous to marriage anything of details. . . . It does not matter how delicately and chastely the teacher may instruct that young girl or young boy; that she should instruct them at all is expatiated on as an effort to corrupt the morals of innocent youth. . . . For this reason, much to my regret, I could not even consent to give you and your chum the desired instruction, even in a private lecture all to yourselves; nor do I care to send you *The Wedding Night* for a similar reason; and I return you your 50 cents herewith."

Still, Comstock arrested Craddock for sending *Wedding Night* through the mail to others. A judge called the work "blasphemous." She got a three-month suspended sentence. Soon after that, one of Comstock's agents ordered a copy of *Wedding Night,* then prosecuted Craddock in federal court. Comstock told the judge privately that he had seen Craddock give the book to the daughter of the janitress of the building in which Craddock had her office. (The building had no janitress.) The judge refused to let the jury see the booklet, calling it "indescribably obscene." The jury took his word for it and found Craddock guilty, as Comstock would gloat, "without leaving their seats."

The day of her sentencing, Craddock placed her head in an oven and killed herself. She left a two-page public letter. "I am taking my life because a judge, at the instigation of Anthony Comstock, has declared me guilty of a crime I did not commit—the circulation of obscene literature," she wrote. "Perhaps it may be that in my death, more than in my life, the American people may be shocked into investigating the dreadful state of affairs which permits that unctuous sexual hypocrite Anthony Comstock to wax fat and arrogant and to trample upon the liberties of the people, invading, in my own case, both my right to freedom of religion and to freedom of the press."

The letter contained an insightful evaluation of Comstock. "The man is a sex pervert," charged Craddock. "He is what physicians term a Sadist—namely a person in whom the impulses of cruelty arise concurrently with the stirring of sex emotion."

She cut to the paradox of the professional censor, the man who commits his life to obscenity and lewd pictures. "If the reading of impure books and the gazing upon impure pictures does debauch and corrupt and pervert the mind . . . what are we to think of the probable state of Mr. Comstock's imagination today upon sexual matters?"

The public responded. The Reverend W. S. Rainsford, the rector of St. George's Church in New York, sent a letter to Comstock (and the press): "Mr. Comstock: I would not like to be in your shoes. You hounded an honest, not a bad, woman to her death. I would not like to have to answer to God for what you have done."

Newspapers picked up the campaign. To some, the Craddock case marked the beginning of the end. Contributions to the SSV fell off. The plans for a permanent fund disappeared. One by one the society's founders would die. But Comstock was undeterred.

Evelyn Nesbit came to New York in 1901. She was fifteen and accompanied by her mother. Her father had died when she was eight, and mother and daughter had worked as shopgirls at Wanamaker's in Philadelphia. But when they realized Evelyn had a certain effect on men, they came to seek their future in the glittering city. Evelyn was beautiful. She began to pose for New York artists such as Carroll Beckwith and George Grey Barnard (for a statue called

Innocence). Then Charles Dana Gibson sketched her hair to form the figure of a question mark and called it *The Eternal Question.*

Joel Feder began to use her as a fashion model. He would photograph her wearing various hats, gowns, and shoes, and *Sunday World* and *Sunday American* published the images. But people were more attracted to the model than to the accessories. The city was hungry for icons. Soon newspapers began to write about Evelyn Nesbit as "the most beautiful model in America." The first supermodel. Beauty refused to be hidden.

Nesbit landed a role in the chorus of the hit musical *Floradora,* then moved to a part in George Lederer's *The Wild Rose.*

Architect Stanford White had a voracious appetite for beauty. He designed homes for the rich and, indeed, was a principal architect of the new city. He designed the arch in Washington Square, Grand Central Station, the first Madison Square Garden. It was he who placed the gilded Diana in plain view of the city. He saw Nesbit perform and went back almost every night thereafter. She was sixteen. He was forty-seven and married.

White was the beneficiary of America's double standard, the belief and practice that men could cavort with sexually adventurous women in a secret world; respectable women stayed at home. Indeed, the term "public woman" was used to describe a woman of low repute. The city was the erotic domain of men, showgirls, and prostitutes.

White's wife and family lived on the north shore of Long Island. In the city, he had free rein. He sent Nesbit flowers, took her and her mother to lunches, paid the rent on better living quarters for both, paid for her brother's education. This benefactor soon became the only man in Nesbit's life. She called him Stanny.

Most visits were chaperoned, either by Evelyn's mother or another girl in the show. Evelyn would describe how, in his "hideaway" studio on West 24th Street, Stanny had asked her and the other girl to play on a red velvet swing for his amusement. They would try to kick their feet through each section of a Japanese parasol.

Finally, White paid for Evelyn's mother to return to Philadelphia, leaving her daughter in his care. In a room full of mirrors and kimonos, he took her virginity. Nesbit would write that she fell in love with White on that weekend, that he liked to watch her swing naked on the red velvet swing, that she

would sit on his shoulders naked, watching herself in the mirrors, that he trembled in her presence, that he wanted her so completely naked he would ask her to remove the pins from her hair. She told how they would climb to the top of Madison Square Garden and, hanging on to the statue of the naked Diana, view the city.

She enjoyed the parties he threw in his studio and the company of some of the most interesting men in America. But she knew White could never marry her or secure her place in society. She began to dine with other men who sent her flowers, jewelry, furs. She flirted with actor John Barrymore and went on boat trips with the heir to the Collier publishing fortune. Finally, she accepted the attentions of Harry Thaw, one of the Pittsburgh Thaws, who was as eccentric as White was elegant. He was deeply envious of the architect's success with showgirls, and he competed openly—if ineffectively—with White.

Thaw persuaded Nesbit and her mother to go to Europe for a "prenuptial honeymoon." There he questioned Evelyn about her relationship with White. At first she told Thaw that marriage would not be a good thing, that she had "been on the stage" and that she had "been to a great many apartments with Stanford White." Then she told him that White had "ruined" her when she was sixteen. Thaw became obsessed with the story of her lost virginity. He called White a beast. On one brutal night after her mother had returned to America, Thaw tore off Nesbit's nightgown and beat her with a dog whip. In her autobiography she told how she lay there "bracing herself for what followed."

She described how Thaw would use cocaine and, eyeballs bulging, enter her room in the middle of the night to ravage her. She told how he traveled about Europe with a bag of whips, hypodermic needles, drugs, and pictures of slave girls on the auction block. Nonetheless, Nesbit agreed in 1905 to marry him. He was, after all, worth $40 million.

Marriage only increased Thaw's obsession with White. He went to Anthony Comstock, telling him that White had debauched his wife and was indeed a beast who had defiled 378 virgins. He hired the vice crusader to stake out White's studio, but nothing came of it.

On the night of June 25, 1906, Nesbit and Thaw went to the opening of the musical comedy *Mamzelle Champagne*. White was seated across the room. Thaw walked over to White's table, pulled a gun from his overcoat, and shot

the architect three times. The bandleader launched the orchestra into "I Could Love a Million Girls."

In the ensuing homicide trial, Thaw's lawyer tried to paint a picture of White as a despoiler of American womanhood. He claimed that Thaw had been driven to a jealous rage by the stories Nesbit had told him.

"He struck as a tigress strikes to protect her young. He struck for the purity of the American home. He struck for the purity of the American maiden. He struck for the purity of the American wife. He struck—and who shall say that if he believed, on that occasion, that he was an instrument of God and an agent of Providence, he was in error?"

The courtroom listened in rapt attention as Nesbit described the night White took her virginity: "When I woke up all my clothes were pulled off me and I was in bed. I sat up in the bed and started to scream. Mr. White was there and got up and put on one of his kimonos, which was lying on a chair. I sat up and pulled some covers over me. There were mirrors all around the bed. Then I screamed and screamed and screamed."

It was a great performance. Comstock held press conferences on the steps of the courthouse, saying he had letters from the families of seven showgirls who had run away to the city and had been "befriended" by White. He claimed to have "much incriminating evidence against White and his associates in connection with their midnight revelry." He produced neither victims nor evidence.

The nation devoured the scandal. Newspapers ran stories about parties where showgirls would find twenty-dollar gold pieces under their plates, an indication that the party would turn lively later. "Those who stayed did so because they wanted to stay," said a member of the chorus of *Mamzelle Champagne*. "Most chorus girls considered it a great feather in their cap to be seen with Stanford White. . . . Every girl knew what his attentions meant, and most of us would have given a year's salary to get those attentions."

The country was spellbound by the image of the red swing, by the notion of a penthouse studio—a room that was not work, not home, halfway between heaven and earth, a secret world of sex that could only be hinted at in testimony. The tabloids stripped the veneer of propriety from the nation's rich and famous.

To most Americans Thaw was a hero; crowds outside the courtroom cheered him. When a second jury found him not guilty by reason of insanity,

he was ordered to the Asylum for the Criminal Insane in Matteawan, New York. Upon his release in 1912, he filed for divorce. Evelyn Nesbit would later say that Stanford White was the only man she ever truly loved.

In 1908 a film about the Thaw-Nesbit-White triangle was set to open in New York. Anthony Comstock and a group of religious leaders protested. Mayor George McClellan ordered every theater in the city closed. In the furor, the National Board of Review—the country's first movie watchdog group—was created.

The newspapers created a new kind of pornography, serving the nation hints of sex while moralizing sternly. The thirst for sensational stories created the perfect environment for the first great moral panic of the century.

At the turn of the century the world was obsessed with the rumor of young women being abducted or seduced into a life of prostitution. Fueled by stories in the press of proper women held captive in harems or, less romantically, in brothels and cribs, an international convention drew up a treaty to outlaw the practice (without ever establishing its existence). Comstock had suggested that Stanford White and his cronies were part of the white slave traffic, that they had sold innocent girls.

Historians trace the hysteria to an article in *McClure's* magazine in 1907. George Kibbe Turner, a muckraking journalist, claimed that a "loosely organized association . . . largely composed of Russian Jews" was supplying Chicago brothels with women. A young Chicago prosecutor named Clifford Roe started going after brothels. He knew the value of a good headline. Roe told the *Chicago Tribune:* "Chicago at last has waked up to a realization that actual slavery which deals in human flesh and blood as a marketable commodity exists in terrible magnitude in the city today. It is slavery, real slavery, that we are fighting. . . . The white slave of Chicago is a slave as much as the Negro was before the Civil War . . . as much as any people are slaves who are owned, flesh and bone, body and soul, by another person, and who can be sold at any time and place for any price at that person's will. That is what slavery is, and that is the condition of hundreds, yes, of thousands, of girls in Chicago at present."

Those figures spiraled. In 1910 the superintendent of the Illinois Training School for Girls warned that "some 65,000 daughters of American homes

and 15,000 alien girls are the prey each year of procurers in this traffic. . . . They are hunted, trapped in a thousand ways. . . . Sold—sold for less than hogs—and held in white slavery worse than death." The nation made a billboard of threat, plastering cities with posters that screamed: "Danger! Mothers beware! Sixty thousand innocent girls wanted to take the place of 60,000 white slaves who will die this year in the U.S.!" Wars had been fought with fewer casualties.

Some thought that all prostitutes came from foreign countries. A Senate immigration report even made the claim that prostitutes from Europe had introduced Americans to particular vices—namely oral and anal sex: "The vilest practices are brought here from Continental Europe, and beyond doubt there has come from imported women and their men the most bestial refinements of depravity. The inclination of the Continental races to look with toleration upon these evils is spreading in this country an influence perhaps even more far-reaching in its degradation than the physical effects which inevitably follow it."

Another Chicago prosecutor, Edwin Sims, told the press: "The legal evidence thus far collected establishes with complete moral certainty these awful facts: that the white slave traffic is a system operated by a syndicate which has its ramifications from the Atlantic seaboard to the Pacific Ocean, with 'clearinghouses' or 'distributing centers' in nearly all of the larger cities; that in this ghastly traffic the buying price of a young girl is from $15 up and that the selling price is from $200 to $600. . . . This syndicate is a definite organization sending its hunters regularly to scour France, Germany, Hungary, Italy and Canada for victims. The man at the head of this unthinkable enterprise is known among his hunters as 'the Big Chief.'"

The white slave panic produced two events that would influence sex for the rest of the century. In Washington, the government's newly created Bureau of Investigation (later to be known as the Federal Bureau of Investigation) grew to monitor international traffic. And, in 1909, Sims persuaded Congressman James Mann to sponsor the White Slave Traffic Act, or Mann Act.

The moral panic surrounding white slave traffic allowed a certain class to discuss prostitution in the most serious tone while being titillated by the sexual detail. This was porn for puritans. They could read in the newspapers what they had refused to see with their own eyes. And reformers confronted the world of commercial sex.

Men went to brothels, concert saloons, and clubs for an entire evening of entertainment. They would wine, dine, and watch vaudeville or live erotica. The Senate investigators were right on at least one point. There were houses that specialized in the "French art" or the "Greek practice." There were even a few houses that offered same-sex services. One could almost say that there was a brothel on every block, a prostitute in every tenement. In New York, entire neighborhoods—such as the Tenderloin—were known for their sexual offerings. In fact, prostitution stretched from the Atlantic to the Pacific.

Who were these prostitutes? The civic-minded Committee of Fifteen described them: "First there is a large class of women who may be said to have been trained for prostitution from earliest childhood. Foundlings and orphans and the offspring of the miserably poor, they grow up in wretched tenements contaminated by constant familiarity with vice in its lowest forms. Without training, mental or moral, they remain ignorant and disagreeable, slovenly and uncouth, good for nothing in the social and economic organism. When half-matured they fall the willing victims of their male associates and inevitably drift into prostitution." The committee identified another group of prostitutes as out-of-work needle women, day workers, domestics, or factory hands— forced by economic necessity into the profession.

But the third category was uniquely American, "made up of those who cannot be said to be driven into prostitution either by absolute want or by exceptionally pernicious surroundings." Trapped in "tedious and irksome" jobs, such women, it was said, went from boredom to rebellion. Like the errant males who embraced the philosophy of hedonism, these women "are impregnated with the view that individual happiness is the end of life. . . . The circumstances of city life make it possible for them to experiment with immorality without losing such social standing as they may have, and thus many drift gradually into professional prostitution."

In New Orleans, the city fathers sought to control the brothels, which had been proliferating at a surprising clip. Alderman Sidney Story proposed confining legal prostitution to a single neighborhood. To his chagrin, the red-light district became known as Storyville. Historian Bradley Smith describes it this way: "It became the Storyville where jazz was nursed and weaned, where every kind of sex at every price was available, where the day's work began in

the evening and ended at sunup. It was the place where men could gather to drink, gamble, tell jokes and use language that would not be tolerated at home. And they could participate in some of the violence and some of the playfulness of sex. Within this 38-block square worked more than 2,000 registered whores and another 2,000 servants, entertainers, bartenders and musicians. Basin Street counted 35 elaborate houses offering choice girls, expensive furnishings, good champagne and a gay, congenial atmosphere."

A traveler disembarking from a train could purchase a *Blue Book*—a guide to the offerings of the red-light district. Consider the following listings:

Miss May Evans, 1306 Conti Street: Miss Evans is one woman among the fair sex who is regarded as a jolly good fellow, and one who is always laughing and making all those around her likewise. While nothing is too good for May, she is clever to all who come in contact with her. Miss Evans also has the honor of keeping one of the quietest establishments in the city, where beautiful women, good wine and sweet music reign supreme.

Another ad reads:

Nowhere in this country will you find a more popular personage than Madam White, who is noted as being the handsomest octoroon in America and, aside from her beauty, she has the distinction of possessing the largest collection of diamonds, pearls and other rare gems in this part of the country. To see her at night is like witnessing the electrical display on the Cascade at the late St. Louis Exposition. Aside from her handsome women, her mansion possesses some of the most costly oil paintings in the Southern country. Her mirror parlor is also a dream.

And according to another:

To operate an establishment where everyone is to be treated exact is not an easy task, and Gipsy deserves great credit for the manner in which she conducts her house. Gipsy has always made it a mark

in life to treat everyone alike and to see that they enjoy themselves while in her midst.

Liberty, equality, fraternity—associating sex with upward mobility, the lifestyles of the rich and famous. It was a powerful formula.

In San Francisco, the Barbary Coast was in full swing. One could check into the Hotel Nymphia for a quickie, or spend hours at a luxuriously appointed brothel (complete with servants and fine silver). Sex was part of the American vision of upper-class life. The poor had to settle for a quick spasm on a gray sheet in a crib (where prostitutes indeed lived in conditions that approached slavery) but the middle class could afford an entire evening of entertainment.

In Chicago two sisters opened the Everleigh Club. The establishment had rooms with names such as Moorish, Gold, Silver, Copper, Oriental, Japanese, Egyptian. There were brass beds inlaid with marble, as well as cushions, divans, statues of Greek goddesses, mirrors on the ceiling, a golden piano. Girls would flirt, converse, play parlor games. Clients could spend anywhere from $50 to $1,000 for the evening's entertainment. When asked what he wanted, one man said he was content to listen to the scratchy records on the golden-horned phonograph. To be surrounded by attentive women, liquor, and music—that was a man's American dream.

The reformers saw the power of the combination. One of the first recommendations of the Committee of Fifteen was the need to "separate recreation from vice."

One of the nation's first attempts to regulate prostitution had occurred in 1870, when St. Louis tried to license brothels and monitor the health of prostitutes. American women were so offended they launched a reform movement. They wanted to abolish the double standard that demanded purity of women while condoning men's right to sow wild oats. They offered a solution—that men should be as chaste as women. Abstinence and self-control were the goal, even in marriage. It was, of course, a tragic delusion.

As long as Americans enforced a code of silence about sex, as long as the beast roamed outside the home, the illusion of the Christian family could

be maintained. Proper women were silent conspirators who traded the lives of streetwalkers for their own security and pretense of purity.

One feminist summarized the feeling of the time: "The higher sense of mankind says that the family is the essential unit of the state. Our practice says that the family plus prostitution is the essential unit."

But there was a hidden cost to this lifestyle. In 1901 Dr. Prince Morrow began a study of venereal disease. He approached prostitution as a medical problem, not a moral one. His findings were shocking. Dr. Morrow estimated that as many as 75 of every 100 men in New York City had at one time or another been infected with gonorrhea; 5 to 18 percent had syphilis.

Morrow's figures did not go unchallenged. Conservative doctors thought he had inflated the numbers to fuel reform—but their own figures put the overall infection rate at 35 percent.

Morrow's most troubling discovery was the effect of venereal disease on the centerpiece of the Victorian model—the innocent wife. In his 1904 tract *Social Disease and Marriage,* he claimed that "there is more venereal disease among virtuous wives than among prostitutes." The sins of the father passed through the wife to the next generation, and the cost was deadly: "Sixty to 80 percent of infected children die before being born or come into the world with the mark of death upon them."

Yet few in society would discuss the problem. When Morrow founded the American Society of Social and Moral Prophylaxis in 1905, only twenty-five doctors showed up for the first meeting.

Morrow called for education, at the same time admitting that there was an insurmountable obstacle: "The public press and periodicals which serve for the enlightenment of the masses, which have rendered such signal service in the campaign against tuberculosis and other infectious diseases through the popularizing of hygienic knowledge, are absolutely barred to mention the diseases which we wish to prevent. . . . Once the crust of conventional prejudice is broken by a courageous leader, there is no doubt that the other progressive periodicals will fall in line."

In 1906, *Ladies' Home Journal* attacked the code of silence and the deadly cost of the double standard. With a circulation of a million readers, it was the voice of middle-class America—not America as it was but as it wanted to be.

And in 1906 the middle class did not want to be told about sex. Edward Bok, its editor in chief, later said that as a result thousands of irate readers canceled their subscriptions.

He tried again in 1908, attacking as the cause of this great tragedy "the parental policy of mock modesty and silence with their sons and daughters about their physical selves" and "the condoning in men what is condemned in women. Fathers and mothers and, in consequence, girls have condoned in a young man this sowing of his wild oats because it was considered a physical necessity; that 'it would do him good'; that 'it would make a man of him'; that 'it would show him the world'—all arguments absolutely baseless. With hundreds of girls, the young man who has most promiscuously and profusely scattered his 'wild oats' has been looked upon as the most favored one among possible husbands. To many a girl there is always something alluring to marry a man with a past, because it appealed to her vanity to 'remake' or 'reform' him. The peril to herself she has never known, for silence has been the portion meted out to her by her parents."

Another editorial in the magazine put it plainly: "If parents would only believe this one vital truth—that it is ignorance that ruins little girls, not innocence that protects them."

In 1909, when Paul Ehrlich discovered a drug that destroyed the trypanosomes that cause syphilis, his cure was assailed on the grounds that it "encouraged sin." If Americans want to fornicate, said one reformer, they must pay the wages of sin.

To understand the level of sexual ignorance at the turn of the century, one has only to examine the state of sex education. Parents could order a series of pamphlets that included *What a Young Boy Ought to Know, What a Young Man Ought to Know,* and *What a Young Husband Ought to Know,* written by a clergyman—or its companion series, *What a Young Girl Ought to Know,* written by a female doctor. The series came with a commendation from Anthony Comstock and bore the subtitle "Purity and Truth."

The pamphlets were antimasturbation manuals. "Words are scarcely capable of describing the dreadful consequences which are suffered by those who persist in this practice," said one. "Boys often have to be put in a strait-

jacket or their hands tied to the bedposts or to rings in the wall." Many in the medical profession believed that semen was a vital bodily fluid—that it was the direct cause of virility. Semen was reabsorbed by the body, so this theory went, and turned into "new thoughts—perhaps new inventions—grand conceptions of the true, the beautiful, the useful, or into fresh emotions of joy and impulses of kindness."

Historian Bryan Strong found that sex manuals at the turn of the century linked repression to character. "The Victorian constellation of values included work, industry, good habits, piety and noble ideals. Indeed, without sexual repression the Victorians believed that it was impossible for those other values to exist in an ideal character. If a man was pure, he was also frugal, hardworking, temperate and governed by habit. If, on the other hand, he was impure, he was also a spendthrift, disposed to speculation and whiskey drinking, and ruled by his impulses."

Patricia Campbell, in her analysis of early sex manuals, reaches a more interesting conclusion. "The purity advocates," she writes, "were most especially concerned that young people should not learn 'solitary vice.' It was not only the significance they attached to the loss of semen, however, that inspired such strong emotions in addressing the young. The masturbatory act is done solely for pleasure: It can be carried on in secret and is easily hidden from parents; and most important, it sets a pattern for adult sexual attitudes. A teenager who masturbates is finding out that sex feels good, a very dangerous piece of knowledge by Victorian standards. On the other hand, a boy who can be taught to look at his own genitals and their needs with loathing and fear has been taught to repress sexuality all his life."

These early manuals offered wonderful advice to a teenager troubled by sexual thoughts. Sing hymns. Think of your mother's pure love. Read the *Sermon on the Mount.* Sleep on a hard bed. Take a cold bath. Sit with your testicles submerged in a bowl of ice water.

Those were the milder interventions. In 1903 an ingenious inventor named Albert Todd submitted two designs for medical apparatuses to the U.S. Patent Office. One was an electric antimasturbation device—an erection would cause a bell to sound. Expansion would then trigger an electric shock sufficient for "burning the flesh." Another device was designed to limit "longitudinal extension" of the wearer's penis. Other inventors followed

with sexual armor—devices intended to keep the wearer from coming into contact with his or her own genitals. One inventor said, in 1908, "It is a deplorable but well-known fact that one of the most common causes of insanity, imbecility and feeblemindedness, especially in youth, is masturbation or self-abuse."

The medical profession took a similar view of female sexuality. In 1900 a doctor asked the American Medical Association to publish a monograph on the physiology of sex—what actually happens to a woman's body during arousal. The AMA refused. Doctors would not admit that women were sexual creatures. Indeed, a woman's interest in sex or sexual fantasy was often diagnosed as "hysteria." Among the many symptoms: swelling in the genital area, wandering of attention and associated tendencies to indulge in sexual fantasies, insomnia, irritability, and "excessive" vaginal lubrication. The treatment was something to behold. In a delightful article called "Socially Camouflaged Technologies: The Case of the Electromechanical Vibrator," historian Rachel Maines relates: "The therapeutic objective in such cases was to produce a crisis of the disease. . . . Manual massage of the vulva by physicians or midwives with fragrant oils as lubricants formed part of the standard treatment repertoire for hysteria. . . . The crisis induced by this procedure was usually called the hysterical paroxysm. Treatment for hysteria might comprise three quarters of a physician's practice in the nineteenth century."

In 1904 John Harvey Kellogg described a woman undergoing "electrotherapeutics." The woman experienced "strong contractions of the abdominal muscles." And the earth moved, or at least a part of it: "The office table was made to tremble quite violently with the movement." There was a glimmer that what was happening on the exam table was sexual. One doctor suggested that "massage of the pelvic organs should be entrusted to those alone who have clean hands and a pure heart." By the turn of the century, massage was replaced by electrical vibration. The Chattanooga vibrator, available in 1904, sold for $200 to doctors only. For two dollars a visit, women could achieve their hysterical paroxysms in minutes. No wonder it constituted three quarters of doctors' visits. (By 1918 Sears, Roebuck & Co. would offer via their catalog a portable vibrator, with attachments, "very useful and satisfactory for home service," for $5.95.)

* * *

It was in this atmosphere that a doctor in England decided to solve once and for all the mystery of sex.

Havelock Ellis was an odd candidate for the job. In his twenties he fell in love with Olive Schreiner, a South African writer. He would recount how she would wander naked from the bathroom to discuss some idea, or on another visit ask to look at spermatozoa under a microscope. Although both requests were satisfied, their relationship was never consummated. He married Edith Lees, a lesbian, in 1891. At the age of thirty-two, he was still a virgin. Lees and Ellis had a passionate romance almost devoid of intercourse. Both had affairs. Indeed, he would find happiness after her death, when he married one of her lovers.

Ellis brought to the study of sex a great curiosity and sincerity. He collected sexual histories and used them to show that sex is varied and natural. These histories provide perhaps the most honest view of what sex was like at the turn of the century. In an essay on sexual inversion, for example, he recorded the stories of a man who had had sex with everyone from maids to male classmates:

> When I went home for the holidays I took a great interest in one of my father's maids, whose legs I felt as she ran upstairs one day. I was in great fear she would complain of what I had done, but I was delighted to find that she did nothing of the sort; on the contrary, she took to kissing and fondling me, calling me her sweetheart, and saying that I was a forward boy. This encouraged me greatly, and I was not long in getting to more intimate relations with her. She called me into her room one day when we were alone in the house, she being in a half-dressed condition, and put me on the bed and laid herself on me, kissing me passionately on the mouth. She next unbuttoned my trousers and fondled and kissed my member, and directed my hand to her privates. I became very much excited and trembled violently, but was able to do for her what she wanted in the way of masturbation until she became wet. After this we had many meetings in which we embraced and she let me introduce my member until she had satisfied herself, although I was too young to have an emission.

. . . The sight of a woman's limbs or bust, especially if partly hidden by pretty underclothing, and the more so if seen by stealth, was sufficient to give a lustful feeling and a violent erection, accompanied by palpitation of the heart. I had frequent coitus at the age of 17, as well as masturbating regularly. I liked to perform masturbation on a girl, even more than I liked having connection with her, and this was especially so in the case of girls who had never had masturbation practiced on them before. I loved to see the look of surprised pleasure appear on their faces as they felt the delightful and novel sensation. To gratify this desire I persuaded dozens of girls to allow me to take liberties with them, and it would surprise you to learn what a number of girls, many of them in good social position, permitted me the liberty I desired, though the supply was never equal to my demand.

Ellis was the first modern sexologist, taking on both the church and the medical profession. "I do not consider that sexual matters concern the theologian alone," he wrote, "and I deny altogether that he is competent to deal with them."

He attacked the Victorian notion of modesty, indicating tribes where women wore only loincloths or went completely naked, rediscovering cultures where "very beautiful maidens, quite naked, represented the sirens and declaimed poems," of foreign cultures where "everyone slept as naked as at birth." He poked fun at Americans, noting that there were some men, married twenty years, who could say they had never seen their wives entirely nude; and that there were women who had never looked at their own nakedness, let alone that of a man. He laughed at America's sex laws, "clearly a legacy of the Puritans."

Ellis refused to label masturbation a disease, saying that it formed part of the autoerotic impulse—a natural function that included erotic daydreams, fantasies, and nocturnal orgasms. Sex was an expression of self, a "central part of the constitution of man." "Sex lies at the root of life," he wrote, "and we can never learn to reverence life until we know how to understand sex."

He challenged the prevailing notion of women's lack of sexuality, claiming that some women were as filled with desire as men, as capable of orgasm. He used women to build his case for masturbation, telling of ancient cultures

where there were artificial penises of rose-colored rosin or wax, of Japanese women inserting spheres of metal, one hollow, one filled with quicksilver, of French nuns using "dil-dols" called *consolateurs*. He revealed that women working at sewing machines experienced sexual excitement leading to orgasm, that women riding bicycles, if not actually reaching orgasm, were made to feel "quite ready for it." He lampooned "a married lady, a leader in social purity movements and an enthusiast for sexual chastity, who discovered through reading some pamphlet against solitary vice that she had herself been practicing masturbation for years without knowing it. The profound anguish and hopeless despair of this woman in face of what she believed to be the moral ruin of her whole life cannot well be described."

He argued for sex education, for trial marriage, for an approach to relationships based on desire and joy rather than property. "Why," he wrote, "should people be afraid of rousing passions, which after all, are the great driving forces of life?"

Ellis eventually released seven volumes of essays titled *Studies in the Psychology of Sex,* in which he wrote, "If two persons of either or both sexes, having reached years of discretion, privately consent to practice some perverted mode of sexual relationship, the law cannot be called upon to interfere."

He argued for privacy, writing, "The sexual act is of no more concern to the community than any other private physiological act. It is an impertinence, if not an outrage, to seek to inquire into it." Sex was "the chief and central function of life . . . ever wonderful, ever lovely." Sex was "all that is most simple and natural and pure and good."

Havelock Ellis addressed the most basic problem: "They have acquired the notion that sexual indulgence, and all that appertains to it, is something low and degrading, at the worst a mere natural necessity, at the best a duty to be accepted in a direct, honorable and straightforward manner. No one seems to have told them that love is an art."

Ellis's work influenced thinking on both sides of the Atlantic. In Vienna, the young Sigmund Freud was also thinking and writing about sex. A 1905 work, *Three Essays on the Theory of Sexuality,* suggests that women are capable of orgasm and that there are two kinds of female orgasm, clitoral and vaginal, and that the latter is "mature" and produced only with penetration. Dr. Freud's work received mention in an American medical journal in 1908. He made his

first and only visit to America in 1909, where he saw Coney Island, Niagara Falls, and his first movie. He delivered a series of lectures at Clark University in Worcester, Massachusetts.

Anthony Comstock, ironically, had lectured at Clark only a few months earlier. Freud brought a completely different message. He told the audience that civilized men, cursed by prudery and lasciviousness, had created a harmful moral code. "They do not show their sexuality freely," he said, but "wear a thick overcoat—a fabric of lies" to conceal their sexuality "as though it were bad weather in the world of sex." He lectured that the sexual instinct needed gratification, and that abstinence was unnatural, concluding with an anecdote about an old horse that had its rations progressively cut down until it could work without food. Just when the experiment was a success, he explained, the ungrateful horse died.

At the end of his visit Freud expressed surprise that "in prudish America it was possible, in academic circles at least, to discuss freely and scientifically everything that in ordinary life is regarded as objectionable." Not every reader of his work, however, was persuaded. The dean of the University of Toronto scoffed: "An ordinary reader," he wrote, "would gather that Freud advocated free love, removal of all restraint and a relapse into savagery."

Toward the end of the decade, the tone of the annual report of the New York Society for the Suppression of Vice changed. Comstock added a paragraph titled "Not a Mythical Evil":

> The evil which we combat is real, aggressive, insidious and deadly. It is a foe to all the higher interests of the soul. It works through the reproductive faculties of the mind, imagination and fancy, and is one of Satan's most deadly weapons. It smothers conscience, debauches the mind, debases morals, hardens the heart, sinks virtue into the vortex of vice and sends the soul to hell's lowest depths. Read the following tabular statement and then say whether we are dealing with a myth. Shall this work stop for lack of funds? At least examine the facts before you condemn us or withhold that moral and pecuniary support which is requisite for our success.

Comstock's crusade was a very real battle over which view of sex would prevail in America: a puritanical myth that all pleasure was suspect, that sex was Satan's handiwork; or a modern perspective, which observed that sex was a form of play as well as procreation, that sexual expression was a natural function. More important, who would control sex?

The battle was just beginning.

TIME CAPSULE

Raw Data From the First Decade of the Century

FIRST APPEARANCES

Victrola. Brassiere. Electric typewriter. World Series. Hamburger. Hot dog. Times Square. Vacuum cleaner. Permanent wave. Psychoanalysis. Spermicidal jelly. IUD. Hotel Bibles. Wassermann test. Boy Scouts. Kodak Brownie. Geiger counter. Ziegfeld Follies. Milk baths. FBI. Carry Nation's hatchet.

WE THE PEOPLE

Population of the United States in 1900: 76 million. Population of the United States in 1910: 92 million.

Population by religion (1900): Roman Catholic: 12 million. Methodist: 6 million. Baptist: 5 million. Lutheran: 1.5 million. Presbyterian: 1.5 million. Jewish: 1 million.

Number of immigrants who came to the United States between 1901 and 1910: 8.8 million. Percentage of Americans who lived in urban areas in 1900: 40. Percentage of Americans who lived in urban areas in 1910: 45.

Number of Americans in 1900 reckoned as "Native American stock" (i.e., descendants of American-born citizens): 41 million.

Life expectancy for men in 1901: 48.23 years; life expectancy for women: 51.08 years.

In 1900, number of states with women's suffrage: 4 (Wyoming, Colorado, Utah, and Idaho).

THAT'S ENTERTAINMENT

Number of nickelodeons in New York in 1900: 50. Number of nickelodeons in New York in 1908: 500.

Length of 1903 feature film *The Great Train Robbery:* 12 minutes.

Number one with a bullet: "In the Good Old Summertime" sells 1 million

copies, as does Enrico Caruso's recording of Leoncavallo's *Vesti la giubba.*"
Other hits heard first: "Give My Regards to Broadway."

MONEY MATTERS

Average weekly wage for a male stenographer in 1900: $10; average wage for
a woman: $2.50. Average workweek in 1900: ten hours per day, six days a week.
Year the government endorsed an eight-hour workday for federal workers:
1901. Gross National Product in 1900: $18.7 billion. Gross National Product in
1910: $35.3 billion.

GETTING THERE

Number of automobiles in the United States in 1900: 8,000. Number of automo-
biles registered in 1910: 458,377. Number of pages of the Sears catalog devoted
to cars in 1900: 0. Number of pages devoted to buggies, harnesses, saddles, and
horse blankets: 67. First commercially successful car: Oldsmobile, in 1901.

Cost of a Model T Ford in 1908: $850. Price of trolley fare anywhere in New
York City: 5 cents. Miles of paved road in the entire country in 1900: 10; miles
of railroad track: 200,000. Distance of Orville Wright's flight near Kitty Hawk,
N.C., on December 17, 1903: 852 feet.

EARLY SEX SURVEYS

Estimated percentage of women who engage in premarital sex in 1903: 12. In
a 1915 survey, estimated percentage of college men who engage in premari-
tal sex: 36.

Percentage of Americans over the age of twenty-one who are married: 52.
Percentage of men visiting Nell Kimball's brothel in New Orleans who are
married: 70.

Number of divorces in 1900: 55,751; in 1910: 83,045. Percentage of divorces
in 1910 requested by women: 66.

Average number of children per family in 1800: 7.04; in 1900: 3.56.

ABORTION REMEDY

Number of ads for "difficult female complaints" (i.e., abortion cures) in a 1905
Chicago Tribune: 17. Number of ads after a postal order in 1907 forbidding such
ads: 0. Number of pages of the September 24, 1910, *San Francisco Examiner*

devoted to the death of Eva Swan, who, after a botched abortion, was buried in the doctor's cellar: 5.

DEFINE YOUR TERMS

Neither "heterosexuality" nor "homosexuality" appear in the 1901 Oxford English dictionary. In 1901, *Dorland's Medical Dictionary* defined heterosexuality as "abnormal or perverted appetite toward the opposite sex." The word "homosexuality" debuts in Webster's in 1909 with a similar meaning: "morbid sexual passion for one of the same sex."

FINAL APPEARANCES

In 1901 Queen Victoria dies. The monarch had supposedly counseled women on how to endure the physical act of sex: "Lie back and think of England."

In President Theodore Roosevelt's last term of office, he told American women that limiting the size of their families was "criminal against the race."

Chapter Two

THE END OF INNOCENCE:

1910—1919

WHEN WOMEN GET THEIR RIGHTS

Postcard, circa 1011, depicting a possible outcome of women's suffrage.

Women took to the streets by the thousands: suffragettes marching for the right to vote, women on soapboxes,women walking shoulder to shoulder with labor leaders, women in picket lines, women publishing literary magazines and anarchist manifestos. Women appealed to the conscience of the country, demanding change, fighting for emancipation.

The country seemed fascinated with womanhood in all its forms. Fresh-faced maidens appeared in ads for White Rock soda, Ivory soap, and the Packard automobile. There were eye-catching women on calendars, on magazine covers, on movie posters, on sheet music—millions of images flooding millions of homes. It was a world filled with appealing possibilities. Movie theaters presented larger-than-life heroines: the Vitagraph Girl, the Biograph Girl, the World's Most Perfectly Formed Woman. Florenz Ziegfeld's Follies showcased

the Follies Girls—a band of impossibly plumaged dancers culled from more than 15,000 applicants, Darwinian selection at its finest, all focused on finding and glorifying the American woman.

Upon arriving in New York, a young Peruvian artist named Alberto Vargas spent days walking the streets, "taking in the sights and sounds and all the electricity in the air." According to one account, "What excited him most were the American women. They were not shy and demure like the Latin women back home in Arequipa. They were not stolid and fleshy like the women in Geneva. They were not coy and coquettish like the women he had seen in Paris. No, to his eyes, American women seemed unique. He liked their jaunty stride, their openness, their air of independence, and their look of healthy, uncomplicated sensuality." "From every building came torrents of girls," he would later recall. "I had never seen anything like it. Hundreds of girls with an air of self-assuredness and determination that said, 'Here I am, how do you like me?'" Against his father's wishes, Vargas decided to stay in America and take up painting.

As a young writer, F. Scott Fitzgerald noted that the precious daughters of America had a new attitude: They could be seen, he wrote, "eating three-o'clock after-dance suppers in impossible cafés, talking of every side of life with an air half of earnestness, half of mockery, yet with a furtive excitement." Mostly they talked about sex. Malcolm Cowley, describing coming of age in this era, remembered fondly that "young women all over the country were reading Freud and attempting to lose their inhibitions." As a young man he had dreamt of moving to New York and taking one of these creatures—not as a wife but as a mistress.

The conspiracy of silence was shattered. The editors of *Current Opinion* declared in August 1913 that it was "sex o'clock" in America: "A wave of sex hysteria and sex discussion seems to have invaded this country. Our former reticence on matters of sex is giving way to a frankness that would startle even Paris."

Emancipated women were the topic of the day. As women left behind old role models (virtuous wife, virginal daughter), would they become more like men? Equality meant more than access to power; it meant access to pleasure. Would women demand the right to sow their own wild oats?

Until this decade it had been a man's world. Now, the New Woman had arrived.

* * *

In the heart of the city lay the devil's own dance hall. Young men and women swirled through the tango, the hesitation waltz, and "animal dances" such as the turkey trot, the grizzly bear, the monkey glide, and the bunny hug. The dance halls made visible the erotic, while the band played "Everybody's Doin' It Now."

On any given night in 1911, almost 100,000 young people flocked to dance halls in Chicago. Authorities tried to stop the trend. The *Ladies' Home Jorunal* fired fifteen employees for dancing at lunchtime. A Paterson, New Jersey, woman was sentenced to fifty days in jail or a $25 fine for dancing the turkey trot.

When Irving Berlin published a syncopated dance tune called "Alexander's Ragtime Band," more than a million copies of the sheet music sold within the year. The rhythms that filled the brothels of New Orleans had become a part of mainstream America.

"These dances," opined one journalist, "are a reversion to the grossest practices of savage man. They are based on the primitive motive of orgies enjoyed by the aboriginal inhabitants of every uncivilized land."

A sign at one popular nightclub inadvertently gave a dance lesson in the moves it tried to prohibit. It warned, "Do not wiggle the shoulders. Do not shake the hips. Do not twist the body. Do not flounce the elbows. Do not pump the arms. Do not hop—glide instead. Avoid low, fantastic and acrobatic dips." People who ignored these directions did so at their own peril.

Tom Faulkner, a former dance instructor converted to Christianity, campaigned against dance in a series of books. In a volume that combined *From the Ball Room to Hell* (1894) with *The Lure of the Dance* (1916), he described the fall of a young girl swept away by the dance. In the arms of a stranger, she loses her natural modesty and soon finds herself assuming positions that are "unladylike and indecent." Inevitably, she yields her body to the "sex excitements" and becomes "abnormally developed in her lower nature."

Again and again, Faulkner returns to the anatomical. "With head resting on his shoulder, face upturned to his," he continues, "her bare arms around his neck—with partly nude swelling breasts heaving tumultuously against his, face-to-face they glide, their limbs interwoven, with his strong right arm around her yielding form he presses her to him until every curve in the contour of her body thrills with amorous contact."

After the dance, the tango pirate takes her to a waiting automobile. "That beautiful girl who entered the dancing school as pure and innocent as an angel three months ago returns to her home that night robbed of that most precious jewel of womanhood—virtue!"

The dance craze launched its own celebrities. Vernon and Irene Castle—known for their elegant sensuality—changed the way America moved, the way it dressed. Gone forever were the bustle and the corset. Theirs was a world of silk.

Something this fun, this frenzied, inevitably attracted the attention of puritan politicians and reformers. In 1913 the Illinois Senate Vice Committee began a series of hearings on "the most vital problem of the chastity of our women and the sanctity of our home." Lt. Governor Barratt O'Hara chaired the inquisition, which focused on such matters as the tango. He went after a male patron of a dance hall: "Now, as a matter of fact, don't you wrap yourself up with this young woman almost as though you were one and glide together?"

"At times we do, but only at certain parts of our dancing. We have done certain things, but I do not consider that they are bad, because I object to anything that is licentious. I don't approve of it. I am a dancing teacher myself, and I don't see any good in indecent dancing."

O'Hara then called a witness, a teacher of art named Maude Josaphare: "Describe the dances you saw."

"The third dance was what I should call the tango. It was danced with a man. I have seen one there in the slums in New York. In the modern tango the man picks the girl up and throws her around, bends over to the floor that way, rests his arms on her arms and his head on her shoulder and vice versa."

"Is it art or suggestive?"

"I don't think there is any art in that. I think it is very suggestive, the kind of suggestiveness that may confuse the mind of a young girl. . . . I should not want my daughter to see it."

"Do you think that kind of dancing is a menace to womanhood?"

"Yes, sir. I think it is a menace to womanhood."

The witness recalled a golden era. "I thought there was once a time when women who gave balls or dances had to beg men to come and dance; now they have to give public dances to accommodate all the people who want to dance. It must be that the sort of dancing they do must be very different

from the old kind. There is something wrong with it when people want to dance everywhere."

The Illinois Senate Vice Committee was not an isolated example of political lunacy. Investigators spent hours delving into the meaning of song lyrics (a ditty called "All Night Long" presented an unusual threat) or the nature of costumes worn in a harem dance because these were of great concern to the sons and daughters of our Puritan forefathers. The so-called New Woman challenged the old order, the great design of puritan America.

Fifteen years earlier a minister had summed up the optimistic mood of the United States: "Laws are becoming more just, rulers humane; music is becoming sweeter and books wiser; homes are happier and the individual heart becoming at once more just and more gentle. For today, art, industry, invention, literature, learning and government—all these are captives marching in Christ's triumphant procession up the hill of fame."

Now the vision was coming apart. The old order rallied its forces. An obsession with vice created a coalition of women's groups and male reformers. Both believed that a woman's place was in the home, that purity was a virtue, that male sexual impulse was evil. The Women's Christian Temperance Union (WCTU) feared the animal nature of man as the devil in the flesh.

These groups sought to extend so-called maternal authority into the public sphere, to extend their rights by curtailing those of others.

There was a sexual undertone to all of their work. At the turn of the century Kentucky-born Carry Nation would storm saloons and, after smashing windows, mirrors, and whiskey bottles with a hatchet, would rip sporting images from the walls.

"There was scarcely any phase of human life," wrote one biographer of Nation, "from kissing to eating, into which she did not poke her disapproving nose. Did she observe a maiden expose a few inches of her ankle or glimpse the gleaming bosom of a lady of fashion? She forthwith shrieked a lecture on modesty and quoted Scripture to uphold her prediction that the offender was destined to stew in the infernal fires."

Carry Nation represented the extreme; other women's groups were better organized and more powerful. The WCTU had an impressive agenda. It

began in 1874 and almost immediately branched out with a Committee for Work with Fallen Women, which later became the Department for the Suppression of the Social Evil and then the Department of Social Purity. The group had launched a White Cross/White Shield campaign promoting the single standard (chastity before marriage and fidelity within). The WCTU wanted a single code of morals "to maintain the law of purity as equally binding on men and women."

One of the temperance movement's greatest triumphs was in incorporating into primary-school penmanship lessons the slogan "Lips that touch liquor shall never touch mine."

These women wanted greater protection in the home (e.g., freedom from abusive or drunken husbands). But they also wanted greater control over the environment outside the home. They worked to create red-light abatement laws that could be used to force brothels out of business. In San Francisco, when the enlightened city opened a venereal-disease clinic for prostitutes (an act that quickly resulted in a 66 percent drop in infection rates), social purity groups threatened a boycott against the upcoming Panama Pacific International Exposition of 1915 unless it was closed. The groups argued that the wages of sin had to have a price (in this case, disease). The clinic was closed.

Dr. Kate Bushnell, a leader of the WCTU, was clear on the breadth of the crusade: "The word temperance had been narrowed down till it only meant total abstinence. In America, the women of the WCTU had accepted it in its higher meaning, the combating of depraved appetite in every form, and for the abolition, all the world over, of all laws that protect depraved appetite."

These women could turn to their own champions—the men of the Progressive Party. Male reformers had taken over the problem of fallen women.

Whether the problem was quack medicine or impure food, "progressive" reformers tackled social issues with a clear plan. Recognizing the value of publicity—especially the power of headlines to galvanize political action—they launched a series of vice investigations. John D. Rockefeller funded the crusade, which allowed George Kneeland to publish *Commercialized Prostitution in New York City* in 1913. The Vice Commission of Chicago preceded it in 1911 with *The Social Evil in Chicago*. Within a few years, more than thirty-two municipalities and states had conducted investigations of vice. In towns as diverse as Lexington, Kentucky, Bay City, Michigan, and Lancaster, Pennsylvania,

stouthearted sons of middle-class America put themselves at risk, going night after night to brothels, concert saloons, candy stores, dance halls—the bars and haunts of the working class. Vice investigators diligently recorded every fondled buttock, every exposed breast, every offer of pleasure, every laugh from a girl in some young man's lap, every embrace, every departure of a couple for some secluded spot.

Prostitution was the apparent target. The Vice Commission of Chicago claimed as a motto "constant and persistent repression of prostitution the immediate method; absolute annihilation the ultimate ideal." But the true target, of course, was lust itself: "So long as there is lust in the hearts of men," announced the commission, "it will seek out some method of expression. Until the hearts of men are changed we can hope for no absolute annihilation of the social evil."

In 1914 writer Walter Lippmann took the Vice Commission of Chicago to task. He saw a parallel between political repression and Sigmund Freud's theory of psychological repression. Like Freud, he believed that sex surfaced in every human activity, and that attempts to contain it were doomed. "Lust has a thousand avenues," Lippmann wrote in his *Preface to Politics*. "The brothel, the flat, the assignation house, the tenement saloons, dance halls, steamers, ice-cream parlors, Turkish baths, massage parlors, streetwalking— the thing has woven itself into the texture of city life. Like the hydra it grows new heads everywhere. It draws into its service the pleasures of the city. Entangled with the love of gaiety, organized as commerce, it is literally impossible to follow the myriad expressions it assumes." Lippmann claimed the moral crusaders had become "panicky and reverted to an ancient superstition. They forbade the existence of evil by law."

The commission had published page after page of recommendations, new sexual taboos: No immoral or vulgar dances should be permitted in saloons; no intoxicating liquor should be allowed at any public dance. Laws against private wine rooms should be enforced. Lippmann scoffed at the attempt: "Nothing dynamic holds the recommendations together—the mass of them are taboos, an attempt to kill each mosquito and ignore the marsh. The evils of prostitution are seen as a series of episodes, each of which must be clubbed, forbidden, raided and jailed."

The vice investigators provide a look at a new sexuality—beyond the world of prostitutes. In *Vice in Chicago,* Walter Reckless describes a distinctly

noncommercial fling: "Young people, some visibly under the influence of liquor, others apparently sober, were repeatedly seen to dance or whirl about the floor with their bodies pressed tightly together, shaking, moving and rotating their lower portions in a way that undoubtedly roused their sex impulses. Some even were seen to engage in 'soul kissing' and biting one another on the lobes of the ears and upon the neck."

Peering through distorted glass, the vice investigators saw women—unchaperoned by family and freed from the front porch—experimenting with sexuality on their own terms. Are we to believe these fevered accounts? Years later, Polly Adler would describe the dance halls of the late teens differently. Adler, who became one of New York's most famous madams, wrote that the dance halls of her youth resembled "strenuous gymnasiums" more than they did "nightly mass deflorations."

In an essay on "'Charity Girls' and City Pleasures," feminist historian Kathy Peiss argues that the dance halls created a new code: "The heterosocial orientation of these amusements made popularity a goal to be pursued through dancing ability, willingness to drink and eye-catching finery. Women who would not drink at balls and social entertainments were often ostracized by men, while cocktails and ingenious mixtures replaced the five-cent beer and helped to make drinking an acceptable female activity. Many women used clothing as a means of drawing attention to themselves, wearing high-heeled shoes, fancy dresses, costume jewelry, elaborate pompadours and cosmetics. As one working woman sharply explained: 'If you want to get any notion took of you, you gotta have some style about you.'"

Vice investigators shared none of those traits for popularity. In one Pittsburgh report on dance halls, an investigator—after describing men and women intermingling joyfully—reports he could not get any of the local women to dance with him, and ended up having to partner with his co-agent, a female investigator.

Vice investigators were not ineffective buffoons. By 1915, seventeen states and the District of Columbia had red-light abatement laws. By 1917, thirty states had adopted the reform. The American Social Hygiene Association—heir to the group founded by Dr. Prince Morrow to combat venereal disease—could point to forty-seven cities that had closed their vice districts by 1916.

The results were mixed. "There were a great many of them who left the city," one reformer in Des Moines complained. "It was not our prime idea to drive them out of the city, but our idea to drive them into decency."

Lust was a chameleon that adapted to new technologies. B. S. Steadwell, president of the World's Purity Federation, bemoaned advances in 1913. "The advent of electricity brought us the telephone, which is a necessity to any modern house of shame whether located in the city or in the country, and connects every home with these dens of infamy," he opined. "It made possible the degrading picture show, and inventions which have been used largely to promote and cultivate immorality. During the past 50 years, girls and women have taken their places beside boys and men in schools, colleges, stores, offices, factories and shops, and have in constantly increasing numbers entered commercial life. This close association has brought opportunities for sexual gratification of which full advantage has been taken. The automobile has made possible the 'joyride' and has built up the palatial 'roadhouse,' or country brothel. Luxurious transportation facilities have also ushered in immoral practices never before known."

The new woman created her own rules. These "women adrift" were part of a new style of socializing. The vice investigators identified "charity girls" who traded sex for excitement or access to entertainment: "They simply take this means of securing more amusements, excitements, luxuries and indulgences than their wages would afford them," proclaimed the 1911 *Federal Report*. "They are not promiscuously immoral."

The vice investigator carried an indelible notion of madonna and whore. A woman's place was in the private sphere, supporting her husband, not in public cavorting with strangers. Young girls who expressed interest in sex were deemed incorrigible, and ended up in reformatories or worse. The vice inspector viewed himself as a Christian champion in a holy war—his mission was saving souls. Indeed, one crusader wrote, "The records of the Protestant churches of the U.S. show that in 1917 there were 458,400 new members enrolled. The secretary of the N.Y. Travelers Aid Society declares in 1917 there were 600,000 girls in houses of ill fame in the U.S. and 1 million clandestines. The referee of the Los Angeles Juvenile Court states that 95 percent of the delinquents are from the dance halls."

Lippmann saw the dangers of repression. "We have made a very considerable confusion of the life of joy and the joy of life," he wrote. "The first impulse is to abolish all lobster palaces, melodramas, yellow newspapers and sentimentally erotic novels. Why not abolish all the devil's works? the reformer wonders. The answer is in history. It can't be done that way. It is impossible to

abolish either with a law or an ax the desires of men. It is dangerous, explosively dangerous, to thwart them for any length of time. The Puritans tried to choke the craving for pleasure in early New England. They had no theaters, no dances, no festivals. They burned witches instead."

No single event marks the sea change in America more than this: In the second decade of the century a young entrepreneur named William Fox bought the most notorious concert saloon in New York City—the Haymarket on 29th and Sixth—and turned it into a movie theater. The palace of sin became a palace of cinema. The smell of sweat, semen, and beer gave way to the smell of popcorn. Men and women could attend movies together and watch in intimate darkness as beautiful creatures lived impossible lives. Where once no reputable girl would go—for fear of being mistaken for a prostitute—millions of families now flocked.

The films weren't about sex so much as about sex roles. In 1909 reformer Jane Addams had realized that for "hundreds of young people, going to the show is the only possible road to mystery and romance." What was "seen and heard there becomes their sole topic of conversation, forming the ground pattern of their social life."

As early as 1907, a pious professor attacked the new medium: "Pictures are more degrading than the dime novel because they represent real flesh-and-blood characters and import moral lessons directly through the senses. The dime novel cannot lead the boy further than his limited imagination will allow, but the motion picture forces upon his view things that are new; they give firsthand experience."

In 1915 the Supreme Court would agree. In *Mutual Film Corp. vs. Ohio* the court ruled that film was not protected by the First Amendment. "The exhibition of moving pictures is a business pure and simple, originated and conducted for profit, not to be regarded as part of the press of the country or as organs of public opinion. They are mere representations of events, or ideas and sentiments published or known; vivid, useful and entertaining, no doubt, but capable of evil, having power for it, the greater because of their attractiveness and manner of exhibition."

Filmmakers had realized early on that the market wanted sex. One historian recounts a meeting of the board of directors of the Biograph Co. When

one member questioned the heavy emphasis on sex, he was shown a list of titles playing at a local arcade, along with the daily take:

U.S. Battleship at Sea—25 cents.

Joseph Jeffersen in Rip's Sleep—45 cents.

Ballet Dancer—$1.05.

Girl Climbing Apple Tree—$3.65.

At a nickel a shot, sex beat battleships by fifteen to one. One Biograph board member said, "I think we had better have some more of the *Girl Climbing Apple Tree* kind."

Women added sensuality and spice to the movies. The Mack Sennett Bathing Beauties cascaded through scene after scene, revealing more leg than one would see at a beach. The curvaceous comedians brought out the censors, who snipped offending scenes and created great publicity for Sennett's work.

By the 1910s, the arcades with row upon row of nickelodeons had given way to movie palaces; and anonymous girls climbing trees gave way to screen celebrities. One of the earliest stars, an Australian swimmer named Annette Kellerman, was presented as "the world's most perfectly formed woman" in one aquatic epic after another. She pioneered the one-piece bathing suit. Her effect was such that a character in F. Scott Fitzgerald's first novel, *This Side of Paradise,* points out a swimming hole once visited by Kellerman, leaving one to fantasize on sharing water that had been cleaved by perfection.

And then came Theda.

In 1914 William Fox cast unknown actress Theda Bara in a film version of the play *A Fool There Was.* Bara portrayed a woman whose sexual instinct was unrestrained. She seduced a diplomat, lured him away from wife and family, then discarded him. Studio press agents created a ridiculous biography: Theda was the love child of a French actress and her Italian lover. She was born in the shadow of the Sphinx. Her lovers died of poison from mysterious amulets. Theda Bara was an anagram for "Arab Death." Publicity stills showed her kneeling over the skeleton of a lover, suggesting that she not only drained men of their vitality but also ate their flesh.

Theda was actually Theodosia Goodman, daughter of a Cincinnati tailor. But America remembers the character created by the willing press. In one interview she called her character a "vamp" (her first film was based on a Kipling poem called "The Vampire," and the shortened version stuck as a nickname).

According to biographer Eve Golden, "Until 1915, a vamp was either a piece of stage business or music done over and over between acts (to 'vamp until ready'). But by the end of 1915, the word had entered the American vocabulary as a woman who uses her charms and wiles to seduce and exploit men."

Theda became the screen's first sex star. It seemed implausible. One critic commented that Bara "had a maternal figure. She was, in fact, remarkably like a suburban housewife circa World War One, bitten by the glamour bug into imagining herself a supreme seductress of men, and by some weird turn of fate succeeding at it."

"She was the first popular star whose primary attraction was her sexuality," note film historians Jeremy Pascal and Clyde Jeavons. "She proved conclusively that audiences paid vast sums of money to see women projecting a highly sexual image. She showed that true sex symbols have a bisexual appeal in that they attract equally the fantasies of the opposite sex and the vanity of their own. Men adored, women emulated."

But the role proved a trap. Once a vamp, always a vamp. Bara's popularity lasted for more than forty films, but by decade's end the public would tire of the seductress.

Still, her effect reached far beyond the screen. Fitzgerald charted the evolutionary change in women in *This Side of Paradise:* "The belle had become the flirt, the flirt had become the baby vamp."

The birth of the fan magazine allowed women stars to talk about traditional women's roles through a safe layer. Lillian Gish, an actress who epitomized innocence in films by D. W. Griffith, would grumble, "Virgins are the hardest roles to play. Those dear little girls—to make them interesting takes great vitality, but a fallen woman or a vamp! Seventy-five percent of your work is already done."

As Lary May points out in *Screening Out the Past,* Bara played Cleopatra, Madame du Barry, Salome—"women whose erotic allure destroyed men who ruled over vast kingdoms. The vamp thus embodied the most ominous warning of the vice crusaders: Sex could destroy the social order."

Of course, to reformers, movies posed a threat as great as those of dance halls and brothels. They brought the lessons of the red-light district to young people. At the end of the first decade, America had taken steps to screen and censor films. The National Board of Review, created in 1908 by Anthony Comstock, labored to protect the nation's morals. More than a hundred female

volunteers viewed films nonstop. According to one account, "During October 1914, for example, its members reviewed 571 films and eliminated 75 scenes, ten reels and three entire movies." Comstock and company wanted to control more than behavior—they wanted to control the images and dreams that fascinated the new America.

The effort to inflict middle-class mores on movies created an immediate underground. In 1915 projectionists toured the country with a film called *A Free Ride*. Directed by A. Wise Guy and photographed by Will B. Hard, with titles by Will She, *Free Ride* is the earliest known stag film. It set the low standards that still guide the underground film world. A man driving along a country road picks up two girls who are walking home. He briefly fondles their breasts, remarking, "What a beautiful dairy." A while later, he pulls off the road.

The title card declares, "In the wide open spaces, where men are men and girls will be girls, the hills are full of romance and adventure." The sex that follows is, to the modern eye, hilarious. One girl lifts her skirt and rubs her vagina. The man fondles the other girl while she wrestles his penis through a button fly. Quick cut and she is lying on a blanket, legs spread. The man's pants are around his ankles and, thus hobbled, he takes the plunge. The second girl watches, then demands her turn. He enters her doggy fashion. There is no come shot, and the girls seem to pass out from pleasure. Another quick cut shows the man supine in the grass—still clothed. The girls appear sans dresses, but still in knee-length socks. One performs tentative oral sex; the man artlessly grabs her hair and forces her head down. Then, according to the title card, he says, "Hurry up, let's get out of here."

A Free Ride starred the Jazz Girls. In the second decade, jazz didn't just refer to the music; it also meant the act of sex itself. In a 1919 stag film called *Strictly Union*, a stagehand comes upon an aspiring actress in a changing room. As the hour hand spins on the clock, having tried oral sex and anal sex, he promises, "I'll give you a regular jazz." At the end of the film, after the stagehand punches a time clock and retires from the field, the woman complains, "Gee, I wish I could get a man with some pep."

The traveling projectionist played his images on the walls of local smokers—clubs where small-town businessmen gathered—and at college fraternity houses. As red-light districts disappeared, these films would act as sex education and a safe rite of passage for young men. For older men, this allowed them to share sexcapades with their buddies—a form of extramarital sex that

did not involve a visit to a brothel. For college students the films provided a clear look at sex—French postcards set in motion. Years later, historians would say that the "films revealed graphically what it was difficult to see in the dark confines of the backseat." The films also reinforced the obsessive myths of male sexual fantasy: "A real man can have any woman, all women want to be dominated sexually, sex can happen any time, anywhere, and human beings are universal sexual tinder."

On June 25, 1910, President William Howard Taft signed into law the White Slave Traffic Act. Named for its sponsor in Congress, the Mann Act stated:

> That any person who shall knowingly transport or cause to be transported, or aid or assist in obtaining transportation for, or in transporting, any woman or girl for the purpose of prostitution or debauchery, or for any other immoral purpose, or with the intent and purpose to induce, entice or compel such woman or girl to become a prostitute, or to give herself up to debauchery, or to engage in any other immoral practice shall be punished by a fine not exceeding $5,000, or by imprisonment of not more than five years, or by both such fine and imprisonment, in the discretion of the court.

The bill was aimed at the criminal traffic in women. But it also served as a rallying point for the social purity movement. As one supporter argued, those in favor of the bill included "every pure woman in the land, every priest and minister of the living God, and men who reverence womanhood and who set a priceless value upon female purity." On the other side of the bill, "you would find all the whoremongers and the pimps and the procurers and the keepers of bawdy houses. Upon that other side you would find all those who hate God and scoff at innocence and laugh at female virtue." In the face of such rhetoric, who could vote against that bill?

The white slave panic created a cottage industry in fear. Reginald Kauffman's *House of Bondage* was a best-selling novel. Two plays about white slavery—

The Lure and *The Flight*—opened on Broadway. Movie theaters drew throngs of people to *Traffic in Souls* in 1913. The movie played simultaneously in twenty-eight theaters in New York City, grossing $450,000 for the year.

America was suddenly afraid for its daughters. Stanley Finch, one of the first heads of the Bureau of Investigation, used the hysteria to build a personal fiefdom within the federal government. After he became Special Commissioner for the Suppression of White Slavery, he told audiences, "It is a fact that there are now scattered throughout practically every section of the U.S. a vast number of men and women whose sole occupation consists in enticing, tricking, or coercing young women and girls into immoral lives. Moreover, their methods have been so far developed and perfected that they seem to be able to ensnare almost any woman or girl whom they select for the purpose. This is indeed an extraordinary statement, and one almost passing belief, but that it is absolutely true no one can honestly doubt who reviews any considerable portion of the mass of evidence which is already in the possession of the Attorney General's Bureau of Investigation."

There was only one problem: No one could find a widespread, organized traffic in white slaves.

Investigators at the time interviewed 1,106 street prostitutes and found six who claimed white slavery was the cause of their entry into prostitution. The Vice Commission of Chicago looked at 2,241 juvenile delinquents (i.e., sexually active females) and found 107 self-described victims of white slavery.

Clearly, relatively few women were being forced into prostitution by white slavers. Some reformers looked at economic forces, even calculating the exact dollar value of purity. A woman could support herself without falling into sin if she made $8 to $10 a week. Unfortunately, most working girls—in factories, shops, and offices—earned wages of $6 per week.

Suffragists used prostitution to argue for economic equality and a minimum wage for women, but they also recognized the emotional appeal of the white slave myth. As one suffragist put it: "Remember, ladies, it is more important to be aroused than to be accurate. Apathy is more of a crime than exaggeration in dealing with this subject."

The Bureau of Investigation created a directory of brothels. Agents interviewed prostitutes regularly, attempting to identify those being held against their will. They would report the arrival of prostitutes from other states. But

the paperwork and moral accounting lacked the passion of a crusade. The national press soon began to express doubts that white slavery was more than hype and hysteria. Congress weighed cutting funds for the new bureau. Fearing a lost opportunity, a coalition of religious leaders called the World's Purity Association demanded greater appropriations.

The Chicago Church Federation Council resolved on September 29, 1913, to "call upon Christian churches and reform organizations and all men who desire the safety of our homes and upon all good women and women's organizations to support this law in its prohibition of debauchery, whether for gain or for personal indulgence, and we protest the weakening of the Mann Act for the evil gratification of influential men."

The purity movement demanded that the law be used to punish "personal escapades." The movement had its law and a national sex police, and it wanted action. But a law designed for one purpose—the elimination of white slavery— was also subverted for another.

Jack Johnson, born in Texas in 1878, was the first black boxer to win the heavyweight championship of the world. In a bout fought in Reno on July 4, 1910, he knocked out Jim Jeffries in the fifteenth round. He then became the most hated man in America—no longer, as one writer noted, "the respectful darky, hat in hand." He had defeated a white man. Not entirely coincidentally, in the aftermath of the fight, race riots swept the country.

Johnson, an educated man who read Shakespeare and Victor Hugo, was a connoisseur who collected exotic cars. And he threatened the old order in a more direct way by marrying a white woman; in addition, he kept several white mistresses scattered throughout the country.

Lucille Cameron was one of the latter. She had come to Chicago from Minneapolis, ostensibly to work at Johnson's Café de Champion. Cameron's mother reported Johnson to the feds. They arrested him in October 1912 on charges of abduction and violating the Mann Act.

Cameron refused to testify against Johnson, and upon her release from custody she married the fighter. (Johnson's wife had committed suicide.) The case seemed closed, until the feds located Belle Schreiber, another of Johnson's former mistresses, also white. The black fighter was convicted in 1913 and sentenced to one year in jail for transporting Schreiber for "immoral purposes." With racial tension high (the governor of South Carolina told fellow governors that "the black brute who lays his hands upon a white woman

ought not to have any trial"), Johnson fled the country. (He later returned and served his sentence.)

The law had another unanticipated consequence. The Mann Act created an industry of blackmailers who tracked wealthy men as they traveled with women who were not their wives. A member of the gang would pose as a federal agent, flash a badge, threaten arrest—and then collect hush money.

Women threatened reluctant suitors with arrest. Angry wives called on the state to arrest errant husbands who conducted reckless affairs.

Consider the case of Drew Caminetti and Maury Diggs. In 1912, the two Californians, both married, both the sons of wealthy parents, became captivated by a pair of young single women. The foursome ricocheted around the Sacramento area in an automobile, visiting roadhouses and having amorous picnics in the countryside and champagne orgies in their offices. As a result of their escapades, the four achieved an inevitable notoriety. In 1913, trying to avoid angry spouses and family members, the two men and their mistresses boarded a train in Sacramento. They crossed the state line into Nevada and took rooms in Reno. Four days later the men were arrested under the Mann Act.

The case went all the way to the Supreme Court. Did the statute's language—"debauchery" or "any other immoral purpose"—cover noncommercial sex? The court decided it did: "The prostitute may, in the popular sense, be more degraded in character than the concubine, but the latter nonetheless must be held to lead an immoral life, if any regard whatever be had to the views that are almost universally held in this country as to the relations which may rightfully, from the standpoint of morality, exist between man and woman in the matter of sexual intercourse."

Crossing state lines was not what mattered; crossing the line that keeps sex within marriage did. The Mann Act sought to limit the movement of emancipated women, though mostly men were prosecuted. It was a direct challenge to the phenomenon of the automobile.

The "free ride" depicted in America's first stag film was now, and for decades to come, threatened by federal law.

The moral panic surrounding white slave traffic extended into other areas associated with vice. Reformers noted that cocaine and morphine were con-

nected with prostitution and the new nightlife. "Society requires late hours," explained one frequenter of nightclubs and cabarets.

A member of the Philadelphia pharmaceutical board presented the following testimony to Congress on the dangers of cocaine: "The colored people seem to have a weakness for it. It is a very seductive drug and it produces extreme exhilaration. Persons under the influence of it believe they are millionaires. They have an exaggerated ego. They imagine they can lift this building if they want to, or can do anything they want to. They have no regard for right or wrong. It produces a kind of temporary insanity. They would just as leave rape a woman as anything else, and a great many of the Southern rape cases have been traced to cocaine."

One witness testified that women, especially those who liked nightlife, were susceptible to the drug: "The police officers of these questionable districts tell us that the habitués are made madly wild by cocaine."

Concern was not limited to drugs. The Harrison Narcotic Act of 1914 and the Volstead Act of 1919 (which enforced Prohibition) were largely attempts to remove all of the lubricants of vice. The Volstead Act was fueled by testimony from social workers about fallen girls whose ruination was summed up in one sentence: "I had a few drinks, then I don't remember what happened next." Was such amnesia an affect of modesty, a quirk of female physiology (i.e., the influence of alcohol being greater upon one gender), some kind of post-traumatic stress syndrome, or simply a literary device? How easy to blame demon rum for natural desire.

Nothing shows the overlap between social purity groups, suffragists, and temperance unions more than the phenomenon of dry states. Where women first got the vote—in Western states—prohibition immediately followed.

If the dance halls and movie theaters were creating a new kind of American woman, so were the salons and saloons in places like New York's Greenwich Village, where artists struggling with personal freedom congregated. Alfred Stieglitz, a photographer who ran the gallery 291, shocked his fellows by photographing his wife, painter Georgia O'Keeffe, in the throes of orgasm. An art show at the New York Armory in 1913 had recently introduced America to the works of Picasso and Marcel Duchamp, among many other modern artists.

Anthony Comstock viewed art as another of Satan's traps. While the public seemed to support his attempts to ban obscene books, it began to view Comstock as unsophisticated and an embarrassment when it came to art. In 1906 he had arrested a young woman who worked for the Art Students League for sending him a catalog containing a study of nudes. A subsequent flurry of satirical cartoons made Comstock the butt of jokes and almost cost him his position as special agent for the Post Office. When Comstock protested a play about prostitution written by George Bernard Shaw, the playwright coined the term "comstockery" to indicate such censorship. The controversy surrounding *Mrs. Warren's Profession* assured its success. In fact, the seal of Comstock's disapproval soon became a mark of distinction in society.

In 1912 Paris's Spring Salon had awarded a medal of honor to artist Paul Chabas for his painting *September Morn*. In May 1913 a manager put a copy of the innocent nude in the west window of Braun and Co., on West 46th Street in New York City. Comstock called the store and ordered the picture removed. "It is not a proper picture to be shown to boys and girls," he said. "There is nothing more sacred than the form of a woman, but it must not be denuded. I think everyone will agree with me that such pictures should not be displayed where schoolchildren passing through the streets can see them."

The manager refused to remove the picture and, indeed, kept it in the window for two weeks, until he realized that the crowd gathering daily kept customers away. The print sold millions of copies, and *September Morn* became a flag of the new freedom.

In his annual report to the society, Comstock wrote about his campaign against paintings that "had been exhibited in the saloons of Paris." Thanks to Dr. Freud, we have a term for such a revealing slip.

Comstock was a clown to the art world, but he was a serious threat to individuals fomenting change. He kept his own enemies list, and if someone mocked him, he or she would have reason to fear.

While in Greenwich Village, anarchist Emma Goldman, born in Russia in 1869, was an articulate champion for the New Woman—and a harsh critic of the old order. She had heard Freud speak at Clark University and had taken to heart his message that too much repression was destructive. Goldman discussed free love from a libertarian position. Individuals, she believed, had the right to choose sexual partners on the basis of love, not law. She viewed mar-

riage as a form of prostitution. "It is merely a situation of degree whether she sells herself to one man, in one marriage, or to many men."

Goldman argued for contraception, not as a means to weed out imbeciles and madmen, as most social Darwinists and eugenicists wanted, but simply as a way to free women from the trap of biology. Yet when she wrote letters to her longtime lover, Ben Reitman, she had to use a code for fear of giving Comstock cause to arrest her. Her vagina was a "treasure box," his penis was "Willie," her breasts were her "joy mountains—Mount Blanc and Mount Jura." His erect penis was "a fountain of life" that stood over her like a "mighty scepter."

"I press you to my body close with my hot burning legs," she wrote, "I embrace your precious head. But one condition I must make: no whiskers, no, the t-b cannot stand for that."

Comstock chilled expression in less direct ways. In 1913 D. H. Lawrence handed in the manuscript for his novel *Sons and Lovers.* A *New York Times* review of the published book warned that relations between Paul Morel and his lover Clara "are portrayed with absolute frankness." If the *Times* had only known; Edward Garnett, Lawrence's editor, had cut the book by ten percent. "He could smell her faint natural perfume," for instance, became "He could smell her faint perfume."

Another passage: "The first kiss on her breast made him pant with fear. The great dread, the great humility and the awful desire were nearly too much. Her breasts were heavy. He held one in each hand like big fruits in their cups and kissed them, fearfully. He was afraid to look at her. His hands went traveling over her, soft, delicate, discriminate, fearful, full of adoration. Suddenly he saw her knees and he dropped, kissing them passionately. She quivered. And then again, with his fingers on her sides, she quivered." This became, under the pen of editor Garnett, simply "He was afraid to look at her. His hands went traveling over her, delicate, discriminate, fearful, full of adoration."

Lawrence submitted to the edit, saying simply, "It's got to sell, I've got to live." Not until 1992, when Helen and Carl Baron restored the cuts, would the world read Lawrence as he had intended.

Despite the threat of government action, artists tackled sexual issues. In 1913 Eugene Brieux's play *Damaged Goods* opened on Broadway. The drama charted the downfall of a man infected with syphilis who passes the disease to

his wife, his newborn child, and a wet nurse. The outraged father of the bride, a lawmaker named Loches, confronts the man's physician, who, in an angry dialogue, condemns the hypocrisy that labels VD "the shameful disease." When asked if he had ever risked exposure to infection, the father falls silent. It is not virtue that has saved him, but luck.

The doctor delivers a thoroughly modern sermon: "I should like to know how many of these rigid moralists, who are so choked with their middle-class prudery that they dare not mention the name syphilis, or when they bring themselves to speak of it do so with expressions of every sort of disgust, and treat its victims as criminals, have never run the risk of contracting it themselves! It is those alone who have the right to talk. How many do you think there are? Four out of a thousand? Well, leave those four aside: Between all the rest and those who catch the disease, there is no difference but chance."

Into this radical environment came Margaret Sanger, a former nurse and mother of three. Goldman had given her the works of pioneer sexologist Havelock Ellis to digest. Soon Sanger was holding forth on the beauties of sex and orgasm at Mabel Dodge's Greenwich Village salon, and listening to other radicals attack the slavery of marriage.

At the request of a fellow radical organizer, Sanger started lecturing workers' groups on the facts of life. She later collected this information in a pamphlet called *What Every Girl Should Know.* What she preached would bring her the unwanted attention of Anthony Comstock.

To demonstrate how radical was Margaret Sanger's frank discussion of sex, consider how *Good Housekeeping* at the time suggested imparting the facts of life to a teenager: "Mother and Father love each other very much. All our friends know that. Where love is there God is, and God wants little ones to be. When God wants to send a little child into a home, he fits up just beneath the mother's heart a snug nest not unlike the nests birds live in. Then out of two tiny eggs the father and mother bring together in the nest, a little child is hatched just like a little bird. It is all very wonderful. No fairy tale is half so beautiful. And best of all, the story is true, every word of it."

Sanger was aware that birth was not a fairy tale. In 1912 she had attended a poor patient, Sadie Sacks, who was recovering from trying to abort her ump-

teenth pregnancy. Sanger listened as the woman pleaded with a doctor for information on how to prevent conception. "Oh ho," laughed the doctor. "You want your cake while you eat it, too, do you? Well, it can't be done. I'll tell you the only sure thing to do. Tell Jake to sleep on the roof."

Three months later the telephone rang. Sadie Sacks was dying. Finding herself pregnant, she had tried again to self-abort. She died within ten minutes of Sanger's arrival. Sanger says that on that night she vowed to fight abortion by finding ways of controlling conception.

She attempted in 1912 to serialize *What Every Girl Should Know* in the *Call,* a radical newsletter published by friends in the Village. When the editors told readers that the final installment would discuss venereal disease, the line was crossed. Comstock ordered the Post Office to revoke the *Call*'s mailing permit if it ran the article.

In exasperation Sanger wrote a replacement:

What Every Girl Should Know—Nothing.
By Order of the Post Office.

What Every Girl Should Know may have been radical, but it was also a reflection of the prejudice of the time, in some ways no different from the vile antimasturbation handbooks of the turn of the century.

"Let us take a sane and logical view of this subject," Sanger wrote. "In my personal experience as a trained nurse while attending persons afflicted with various and often revolting diseases, no matter what their ailments, I never found anyone so repulsive as the chronic masturbator."

She then tells of a young boy she had attended during a bout of measles. She discovers that he is a masturbator, and considers it a triumph when, after she has given him a lecture, he asks his brother to tie his hands to the bedpost during the night to help him overcome his struggle.

Sanger, revealing a prejudice against male desire, warned against a specific danger: "In the boy or girl past puberty we find one of the most dangerous forms of masturbation, i.e., mental masturbation, which consists of forming mental pictures or thinking of obscene or voluptuous pictures. This form is considered especially harmful to the brain, for the habit becomes so fixed that it is almost impossible to free the thoughts from lustful pictures. Every girl

should guard against the man who invariably turns a word or sentence into a lustful or, commonly termed, smutty channel, for nine times out of ten he is a mental masturbator." Other self-appointed sex experts at the time called flirtation "a form of mutual onanism."

Sanger's discomfort with male sexuality was about to undergo a radical change. She vacationed in Provincetown, Massachusetts, and socialized with the artists who made up the Provincetown Players. Her circle of friends included John Reed, the journalist who later covered the Russian Revolution. She began to experiment with the free love theory espoused by her friends— more on principle than desire, it would seem. She took lovers. When her husband, William, objected, she told him to take mistresses of his own. He refused, writing her, "I will let my name be associated with no other woman. I would be amiss to all the fine emotion that surges within me if I fell from grace. It cannot be, that's all. I still hold that intercourse is not to be classed with a square meal, to be partaken of at will, irrespective of the consequences. You speak, dear love, that in our life together you have given me the best and deepest love—yes, and I have felt it—that you were the only woman who cared to understand me. But you have advanced sexually—you once said that you need to be in different relations (with men) as a service for the women of your time. To all this I have no answer."

In 1913 Sanger raised money to start her own newsletter, *The Woman Rebel.* She promised subscribers that the paper would deliver facts about the prevention of conception. At one Village meeting, a writer named Robert Parker suggested she call her issue "birth control." She took the words as her own.

On August 25, 1914, two agents from the federal government arrived to tell her that she had violated the Comstock Act. Four issues of *Woman Rebel* had been suppressed; seven separate articles had been deemed obscene. Sanger faced forty-five years in prison. Planning to leave the country rather than appear in court, she printed a pamphlet called *Family Limitation,* outlining what she knew of birth control. The text is a straightforward description of condoms, pessaries, douches, and spermicidal suppositories. Her comments about the pleasure of sex are limited to: "A mutual and satisfied sexual act is of great benefit to the average woman, the magnetism of it is health-giving." Failure to give a woman an orgasm might lead to a "disease of her generative organs, besides giving her a horror and repulsion for the sexual act."

For Sanger, birth control was a liberation from sexual slavery, the duty to procreate. She told the poor, "While it may be troublesome to get up to douche, and a nuisance to have to watch the date of the menstrual period, and to some it may seem sordid and inartistic to insert a pessary or a suppository in anticipation of the sexual act, it may be far more sordid and the condition far worse than inartistic a few years later for the mother to find herself burdened down with half a dozen accidental children, unwanted, helpless, shoddily clothed, sometimes starved or undernourished, dragging at her skirt, while she becomes a worn-out shadow of the woman she once was."

Sanger arranged to have *Family Limitation* privately printed, 100,000 copies to be sold for 25 cents apiece. Rather than face trial, she took a train to Canada and, armed with a false passport, made her way to England.

Comstock would not be deterred. He ordered a decoy to pose as a woman in distress. The agent called on William Sanger and asked for a copy of the pamphlet. Arrest followed immediately, along with a suggestion that if William would tell the whereabouts of the author, he would go free. William refused.

He went to trial, was found guilty of distributing obscene literature, and was sentenced to thirty days by a judge who thundered: "Persons like you who circulate such pamphlets are a menace to society. There are too many now who believe it is a crime to have children. If some of the women who are going around advocating equal suffrage would go around and advocate women having children, they would do a greater service. Your crime violates not only the laws of the state but also the laws of God."

In England, Margaret Sanger met Havelock Ellis. She was thirty-one, he was fifty-five. He became a mentor. He told her to focus on one cause—birth control—and directed her research in the British Museum. The two became lifelong friends, possibly lovers.

She traveled from England to Holland and Spain before finally returning to the United States in 1915. As a result of publicity, the atmosphere had changed. She succeeded in having the charges against her dismissed.

Comstock had died in 1915 from pneumonia—reportedly from a chill caught at William Sanger's trial. It was the end of an era, or so it seemed. Comstock was gone but his laws were still on the books, and there were still many zealots willing to persecute the unwary. Police arrested Emma Goldman

for delivering lectures on "a medical question." Ben Reitman was arrested for merely announcing he would distribute a pamphlet on birth control.

In 1916 Sanger opened, in Brooklyn, the first American birth-control clinic. Staffed by her sister and a coworker named Fania Mindell, the clinic dispensed advice to the hundreds of women who soon lined up. It remained open ten days. A police decoy asked for information. The next day three plain-clothesmen from the vice squad arrived and arrested all three women. Sanger went to trial and received a sentence of thirty days in the workhouse. Upon her release, she was picked up by a limousine and taken to a luncheon of influential women. She had become a national figure. The cause of birth control had a martyr and a bible. *Family Limitation* would be translated into thirteen languages; some ten million copies would be distributed over the next few years.

America was undergoing a great social upheaval, but Europe was engaged in a bloodbath. Separated by an ocean, America wrapped itself in isolationism. That changed with the sinking of the *Lusitania* in May of 1915. On April 2, 1917, President Woodrow Wilson called on Congress to declare war against Germany: "We have no selfish ends to serve. We desire no conquest, no dominion." This was the war that would make the world safe for democracy. On the recruiting posters that followed, Democracy was often depicted as a vulnerable, flag-draped woman in the arms of Uncle Sam. On a single day, ten million American men registered for the draft.

The war also represented a great opportunity for women. Thousands entered the armed forces; a million more took factory jobs. Fashions changed almost immediately; soon there were as many women visiting barbershops as there had been men. (Historian Mark Sullivan points out that nurses found long hair couldn't be tended in the trenches, while women working in ammunition factories found that long hair attracted gunpowder dust, a decided danger at a candlelit dinner.) Women even donated the metal strips from their corsets—enough steel, it was said, to build two battleships.

World War I put steel into the suffragist movement. President Wilson became a champion of woman's suffrage, appealing to Congress to pass a resolution for a Woman's Suffrage Amendment. "The strange revelations of this

war having made many things new and plain to governments as well as to peoples," the president stated, "are we alone to ask and take the utmost sacrifice that our women can give, service and sacrifice of every kind, and still say that we do not see that they merit the title that gives them the right to stand by our side in the guidance of the affairs of their nation and ours? We have made partners of the women in this war."

The war provoked a puritan crisis. It achieved in a matter of months what the anti-vice crusade had struggled toward for more than a decade. In 1917 Secretary of War Newton Baker ordered the closing of all bawdy houses within five miles of a naval base. New Orleans' Storyville was shuttered; the Barbary Coast in San Francisco had received the same treatment earlier. Baker banned the sale of alcohol on military bases. Local purity movements forced dance halls to close in town after town.

A member of New England's Watch and Ward Society—the blue-blooded equivalent of the New York Society for the Suppression of Vice—called for the formation of an Army Corps of Moral Engineers. He got his wish. As America's entry into World War I drew near, the government turned to the social hygienists. Dr. Prince Morrow's followers—devoted to raising awareness about venereal disease—had a remarkable decade. They joined forces with the American Vigilance Association to become the American Social Hygiene Association. They pushed for the suppression of prostitution and persuaded seven states to pass laws requiring blood tests before marriage. The ASHA enlisted the aid of doctors to create fear- and purity-based sex-education programs.

Resistance from the community was strong. In Chicago, for instance, the school board rejected one course, explaining, "While there are certain things children ought to learn, it is far better they should go wholly untaught than that the instruction should be given to them outside the family circle. There are some kinds of knowledge that become poisonous when administered by the wrong hands, and sex hygiene is among them."

Another critic claimed that sex education itself was an insidious form of pornography: "Each venereologist has met psychopaths to whom each curve in nature or art suggests female breasts, napes or genitalia. For such not even the slightest education would be advisable. Indeed it would be harmful, because every step thereof would to them contain lubricious suggestions."

In 1917 Secretary of War Baker created a Commission on Training Camp Activities (CTCA). Information about sex that had once been deemed obscene would henceforth be policy. Reformers celebrated the rise to power of the social hygiene experts. "Rejoice with us that the growing movement for social morality is showing results in this important way." One social hygienist noted, "The government is putting into the hands of social experts a million picked men to do with them in compulsory regimen, protection and education what no so-called sane government would dare force upon the same men in time of peace."

The social experts came up with an avalanche of slogans. Secretary of the Navy Josephus Daniels proclaimed: "Men must live straight if they would shoot straight."

The CTCA wrote pamphlets such as *Keeping Fit to Fight*. They produced photo exhibits showing the "most devastating effects of untreated syphilis: twisted limbs, open lesions and physical deformities." A case of gonorrhea, recruits were told, was more devastating than a German bullet.

The CTCA had to deal with patriotic prostitutes, or charity girls. According to social workers, teenage girls flocked to military training camps, meeting soldiers in the woods, sometimes giving themselves to eight soldiers in a night. The traditional division between good girls and bad was blurred, but the CTCA found a new way to characterize sexual women: "Women who solicit soldiers for immoral purposes are usually disease spreaders and friends of the enemy."

War had a profound effect on the body politic, but the effect on individuals varied.

Nell Kimball, owner and operator of a brothel in New Orleans, wrote about the change: "Every man and boy wanted to have one last fling of screwing before the real war got him. Every farm boy wanted to have one big fuck in a real house before he went off and maybe was killed. I have noticed it before, the way the idea of war and dying makes a man raunchy, and wanting to have it as much as he could. It wasn't really pleasure at times but a kind of nervous breakdown that could be treated only with a girl between him and the mattress. Some were insatiable and wrecked themselves, and some just went on like the barnyard rooster after every hen in sight. I dreamed one night the whole city was sinking into a lake of sperm."

Once the Yanks arrived in Europe a new problem appeared. Americans came into direct contact with the sexual mores of decadent (or enlightened) Europe. Official flyers urged: "The U.S. government is permitting you to go on leave, not in order that you may sow wild oats, but to give you an opportunity to improve your health, and advance your education.

"If you become intoxicated, associate with prostitutes or contract a venereal disease, you are guilty of a moral crime. Wouldn't it profit you more to purchase with that money a little gift for mother, wife, sister, or sweetheart? Do not let booze, a pretty face, a shapely ankle make you forget. The American Expeditionary Force must not take European disease to America. You must go home clean."

But the threat of venereal infection was only one cause of alarm. One officer, who sent investigators to interview French prostitutes and discovered that Americans preferred a certain sex act above all others, deplored the twisted impulse known as "the French way" (a euphemism for oral sex): "When one thinks of the hundreds and hundreds of thousands of young men who have returned to the U.S. with those new and degenerate ideas sapping their sources of self-respect and thereby lessening their powers of moral resistance, one is indeed justified in becoming alarmed."

Years later, writer Malcolm Cowley would put the war into perspective. As one of the many who had volunteered as a driver for the French army, he summed up his experience. "They carried us to a foreign country," he wrote, "the first that most of us had seen; they taught us to make love, stammer love, in a foreign language. They taught us courage, extravagance, fatalism, these being the virtues of men at war; they taught us to regard as vices the civilian virtues of thrift, caution and sobriety; they made us fear boredom more than death."

But even more important was the impact of the war on those at home. Cowley continued:

> The war itself was the puritan crisis and defeat. All standards were relaxed in the stormy sultry wartime atmosphere. It wasn't only the boys my age, those serving in the Army, who were transformed by events: Their sisters and younger brothers were affected in a different fashion. With their fathers away, perhaps, and their mothers

making bandages or tea-dancing with lonely officers, it was possible for boys and girls to do what they pleased. For the first time they could go to dances unchaperoned, drive the family car and park it by the roadside while they made love and come home after midnight, a little tipsy, with nobody to reproach them in the hallway. They took advantage of these stolen liberties—indeed, one might say that the revolution in morals began as a middle-class children's revolt.

Cowley was not absolutely correct. The puritan ethic survived the war. Social experts would usher in national prohibition in 1919, and the federal government—observing the machinations of the Russian Revolution—routinely deported radicals, many of them on trumped-up vice charges. A young lawyer named J. Edgar Hoover oversaw the expulsion of Emma Goldman, calling her the most dangerous anarchist in America.

But Cowley was correct in assessing the impact of what would come to be known as the Lost Generation, the youth who were the first to be raised in the modern age, who had never seen puritan America, who, as Fitzgerald would say, had "grown up to find all gods dead, all wars fought, all faiths in man shaken."

TIME CAPSULE

Raw Data From the 1910s

FIRST APPEARANCES

Father's Day. *Good Housekeeping* Seal of Approval. *Women's Wear Daily*. Neon lights. Trench coats. The Mann Act. Lipstick. Keystone Kops. Mack Sennett Bathing Beauties. Eight-hour workday. Parachutes. Girl Scouts of America. Peppermint Life Savers. Camel cigarettes. Erector set. Manufacturing assembly line. Birth-control clinic. Aspirin tablets. Windshield wipers. Kotex sanitary napkins. Dial telephones. The Piltdown man (the supposed missing link). Selective Service Act. Gas mask. Feature film. Stag film. Sex education. The Talon slide fastener (zipper). Traffic lights. Jazz records. Tarzan. Jane.

MOVIE MADNESS

Number of Americans attending movies each week in 1910: 26 million.

First feature film shot in Hollywood: *The Squaw Man* (1914). Charlie Chaplin's first full-length comedy: *Tillie's Punctured Romance* (1914). Most popular serial, in which a heroine escaped weekly from "a fate worse than death": *The Perils of Pauline* (1914). First serious feature film: *The Birth of a Nation* (1915).

Weekly salary received by Theda Bara during 1914 filming of *A Fool There Was:* $150. Amount film studio grossed in 1915: $3 million. Weekly salary received by Bara in 1919: $4,000.

WHO'S HOT

Charlie Chaplin. Douglas Fairbanks. Mary Pickford. Lillian Gish. D. W. Griffith. Irving Berlin. George M. Cohan. Ty Cobb. Florenz Ziegfeld. Eddie Cantor. Will Rogers. Jim Thorpe. Bert Williams. The Original Dixieland Jazz Band. Jelly Roll Morton. Jack Dempsey.

BIRTH OF A NATION

Population of the United States in 1910: 92 million. Population of the U.S. in 1920: 105 million.

Life expectancy by the end of the decade: Male: 53.6 years; female: 54.6 years.

Number of children that a healthy woman living in wedlock should have, as estimated by the Vice Commission of Chicago: 10.

Number of women who visited Margaret Sanger's birth-control clinic in ten days in 1916: 464.

QUID PRO QUO

In 1912 corset makers in Kalamazoo, Michigan, went on strike to protest the behavior of supervisors, who regularly suggested to female workers that they trade sexual favors for sewing thread. The strikers were arrested.

MONEY MATTERS

Gross National Product in 1910: $35.3 billion. Gross National Product in 1919: $84 billion.

Average daily wage at Henry Ford's Highland Park, Michigan, plant, as of 1914: $5. Average daily wage for auto workers not employed by Ford: $2.40. Weekly wage a man should earn before daring to date, according to a 1919 Chicago newspaper headline: $18.

Estimated amount a woman needed to earn per week to lead a virtuous life: $10. Average weekly wage of a woman in 1910: $6.

Price of a portable vibrator (with attachments), as advertised in the 1918 Sears catalog as "very useful and satisfactory for home service": $5.95.

ON THE ROAD

Number of automobiles registered in the United States in 1912: 900,000. Number registered in 1919: 6.7 million.

THE WAGES OF SIN

Number of infants killed by syphilis in 1916: 73,000 (including 41,700 still-births). Estimated number of prostitutes who died each year as the result of

venereal disease: 40,000. Number of infected prostitutes imprisoned in detention homes and reformatories during World War I: 15,520.

TAILHOOK, CIRCA 1919

In the oddest sexual scandal of the decade, the Naval Training Station in Newport, Rhode Island, sends a squad of enlisted men into local bars to associate with "sexual perverts." The decoys—in the name of duty—willingly accept blow jobs. The subsequent trials prove to be an embarrassment. According to Colin Spencer, author of *Homosexuality in History:* "The decoys were asked how much sexual pleasure they had experienced. One protested, saying he was a man and if someone touched his cock, then it got erect and he could not do anything about it."

FINAL APPEARANCES

Carry Nation (1911). The *Titanic* (1912). Archduke Francis Ferdinand of Austria (1914). Anthony Comstock (1915). Mata Hari (1917).

Chapter Three

THE JAZZ AGE: 1920—1929

John Held's flapper taught her sugar
daddy some new tricks on a 1926
cover of *Life*.

A t a small church in Muncie, Indiana, a well-meaning Sunday school
teacher talked of the temptation, the spiritual dangers, posed by physi-
cal comfort, wealth, and fame.

"Can you think of any temptation we have today that Jesus didn't have?"
he asked.

"Speed!" one boy shouted out.

Speed. Not just the urge to step on the gas in the family Ford, but an
entirely new feeling of acceleration and excitement. Thomas Edison told the
readers of *The Saturday Evening Post* that "the automobile has accustomed
everyone to speed, to quickness of action and to control, as well as removing
the mystery from machinery. The motion picture has increased the quickness
of perception to a really remarkable degree. The motion picture—no matter

what one may think of the pictures presented—is the greatest quickener of brain action we have ever had." An ad in the same magazine proclaimed: "Go to a motion picture and let yourself go. See brilliant men, beautiful jazz babies, champagne baths, midnight revels, petting parties in the purple dawn, all ending in one terrific smashing climax that makes you gasp."

A Muncie judge interviewed for the 1929 study *Middletown* told Robert and Helen Lynd, two sociologists studying small-town America, that a weekly diet of movies was corrupting youth. The habitual "linking of the taking of long chances and the happy ending," he said, was one of the main causes of delinquency. It was also, one suspects, a formula central to the very soul of America.

F. Scott Fitzgerald captured the spirit of the age in stories about petting parties and daring debutantes, one of whom briefly ponders the nature of her reputation and the series of escapades that led to her nickname, "Speed." Fitzgerald's fiction revealed a flickering world of silk hats and fur, jeweled throats, women with tight coiffures and men with slick hair, a kaleidoscope of young people made beautiful by the bright lights of a carnival city. His *Tales of the Jazz Age* (1922) named this era of flaming youth, of flappers in short skirts and cloche hats, of college boys in bell-bottoms and raccoon coats, of hip flasks and frivolity, of decadence and debunking, of flagpole sitters and mah-jongg, of sheiks and shebas. *Jazz*—the music that left behind the score, that wrought sounds from instruments in ways that were never dreamt of by Johann Sebastian Bach. *Jazz*—slang for sex—now connoted all that was new and modern.

The nation seemed to be intoxicated by youth. John Held captured the life of the campus crowd in drawings for *Life* and *College Humor*. Joe College and Betty Coed set the standard for the decade. Coeds flattened their breasts with the newfangled brassiere; they not only showed a little leg, they drew additional attention to themselves by rolling down their stockings and powdering their knees. They smoked and, if not exactly indulging in sexual escapades themselves, admitted enough knowledge to enjoy a double entendre.

Dorothy Parker, a formidable member of the Algonquin Round Table, could and did opine that brevity was the soul of lingerie and that if all the girls in the Yale prom were laid end to end, she wouldn't be surprised.

America's precious daughters might leave home wearing corsets but they checked them at the door to dance the shimmy. The dance craze that swirled through the previous decade continued unabated with the Charleston. Despite the efforts of *Ladies' Home Journal* to launch a crusade against "unspeakable

jazz," flaming youth sang, danced, and fell in love to the music of George Gershwin. Down the same streets that suffragettes had marched, flappers conducted Charleston marathons.

The philosophy forged in World War I—"Live for the moment, for tomorrow we die"—flew its banner long after Armistice Day. Scott and Zelda Fitzgerald embodied the new spirit, riding down Fifth Avenue on the tops of taxicabs, diving into the fountain outside the Plaza Hotel, displaying what their friend Edmund Wilson described as a remarkable "capacity for carrying things off and carrying people away by their spontaneity, charm and good looks. They have a genius for imaginative improvisations."

Fitzgerald survived by writing articles such as "How to Live on $36,000 a Year" at a time when the average salary in America was less than $1,500 a year. The prosperity that gave the Roaring Twenties its name seemed to fuel extravagant gestures.

Life was a joyride, an adventure. What used to take years to unfold happened in an evening. And, it seemed, the whole world was watching. Americans turned to magazines such as *True Story* and *True Confessions,* magazines that offered "sex adventure" stories told in the first person. The stories contained glamorous settings, frantic action, high emotion, and heavy sentiment. "A moral conclusion," explained one editor to would-be tell-alls, "is essential." Where *Ladies' Home Journal* offered a vision of middle-class America as it wanted to be, *True Story* presented life in titillating, tawdry detail. Its circulation grew from 300,000 in 1923 to almost 2 million by 1926.

What the pulps missed, the daily newspapers supplied with all the tabloid ballyhoo the press barons could muster. Journalists captured the energy and enthusiasm of the age with a whole new language. Everything was keen, copacetic, screwy, or the Ritz. Walter Winchell invented "to middle aisle" (to marry), "on the merge" (engaged), and "uh-huh" (in love) and popularized "phooey," "giggle water," and "making whoopee."

When someone drew a crowd—be it a wingwalker or a flagpole sitter—the crowd extended to every breakfast table in the nation. The nation was fascinated by the frivolous and the fantastic. Local heroes became legends in their own time: Babe Ruth was the Sultan of Swat, Red Grange the Galloping Ghost, and the whole world cheered when Lucky Lindy flew alone across the Atlantic.

The tabloids dispensed fame and infamy in equal measure. A sordid lovers' triangle in Queens Village, New York—in which Ruth Snyder per-

suaded lover Judd Gray to bash in her husband's head with a sash weight—
generated more press coverage, according to one historian, than the sink-
ing of the *Titanic,* Lindbergh's flight, the Armistice, and the overthrow of
the German empire. None dared call it journalism: The press had elevated
scandal to a national sport. Millions followed the disappearance of evange-
list Aimee Semple McPherson, who concocted a tale of a seaside kidnapping
to cover a thirty-six-day dalliance with a lover. When fans of the gospel radio
star claimed to have seen her cavorting in Carmel, she appeared in public
with seven look-alikes.

Dorothy Dix, a "sob sister" whose column reached more than a million
readers, compared gossip to a moral force: "A young woman writes me that
she considers she has a right to live her own life in her own way and do ex-
actly as she pleases. So she has broken most of the Ten Commandments and
snapped her fingers in the face of Mrs. Grundy. And now that she finds her
reputation being torn to tatters, she thinks that she is being most unfairly
treated. Not at all. Gossip is one of the most powerful influences in the world
for good. We can stifle the voice of conscience, but we can't silence the voice
of our neighbors. We can dupe ourselves into believing that we have a right to
make our own code of conduct, but we cannot force the community in which
we live to take our point of view on the matter."

A young agent at the Department of Justice also knew the power of gos-
sip. John Edgar Hoover, the new chief of the General Intelligence Division,
took his experience as a clerk at the Library of Congress and began an index
of radical elements in America. The raw files, which would expand to include
Hoover's political enemies, contained rumors of sexual impropriety, episodes
of adultery and promiscuity, allegations of homosexuality. In 1924 he became
head of the Bureau of Investigation, which would soon be known as the FBI.

The radio—still an experiment at the beginning of the decade—had be-
come a member of the family. A mere curiosity a few years before, the Victrola
became a necessity. For the first time in history, the average man made love to
music. Mark Sullivan, a reporter who wrote *Our Times,* a six-volume history of
the first twenty-five years of the century, devoted sixty-seven pages to music.
"Many popular songs," he suggests, "are for humans the equivalents of the love
calls of birds and animals." Romantic love songs crammed years of courtship
into a few verses. "Your lips may say no, no, but there's yes, yes in your eyes."
Songs asked and answered the questions that were on everyone's mind.

Sullivan valiantly tried to determine the best love song of the age. Was it "Gimme a Little Kiss, Will Ya, Huh?" or the cosmic urge crooned by the featherless biped, "I Gotta Have You"?

A writer suggested that the appeal of women was the same as it had always been, only now there was more showing. The hemlines of skirts rose like the curtain at the Ziegfeld Follies. Lawmakers in Utah sought to pass a law to punish women whose skirts were higher than three inches above the ankle. At the other end of the candle, the Virginia legislature tried to prohibit evening gowns that showed more than three inches of throat. On Wall Street, statisticians charted the rise and fall of the stock market in terms of skirt hemlines. Another journal charted freedom in terms of the yards of cloth required to clothe a woman: from 1913 to 1928 the figure went from 19 ½ yards to 7. It was feared that more women read *Women's Wear Daily* than read the Bible. The Old Testament had given way to testimonials.

Ads warned that a woman who didn't use Listerine would always be a bridesmaid, never a bride. But ads also fostered an atmosphere of romance. A copywriter for a Jordan motor car called the Playboy celebrated a mythical "lass whose face is brown with the sun when the day is done of revel and romp and race."

The word-magic of advertising was infectious: America suffered an epidemic of self-improvement. Millions of 97-pound weaklings turned to Charles Atlas, and became new men after ten weeks of "dynamic tension." Émile Coué, author of *Self-Mastery Through Conscious Auto-Suggestion,* dispensed optimism to millions of disciples who were advised to recite: "Every day, in every way, I'm getting better and better."

Fitzgerald, whose novel *This Side of Paradise* launched the decade, created another character, Jay Gatsby, who reinvents himself by following a simple blueprint: "Rise from bed. Dumbbell exercise and wall scaling. Study electricity. Practice elocution, poise and how to attain it. Study needed inventions. Bathe every other day. Read one improving book or magazine per week." In one such magazine, *Physical Culture,* an ad asked: "Are you shackled by repressed desires? Psychoanalysis, the new miracle science, proves that most people live only half-power lives because of repressed sex instincts."

Novelist Elinor Glyn celebrated a certain quality: "It." "To have 'It,'" she wrote, "the fortunate possessor must have that strange magnetism which attracts both sexes. There must be physical attraction, but beauty is unnecessary." Americans started looking for that magical trait in one another.

It was an atmosphere saturated with romance. It was a world, said Fitzgerald, where "the biography of every woman begins with the first kiss that counts," where a man finds that "after half a dozen kisses a proposal is expected."

The YMCA issued a warning: "Pet and die young."

Words to live by.

"Question: Do you think your son will soon forget all he learned at college? Answer: I hope so. He can't make a living necking." (Joke in *Columbia Jester*.)

The change in courtship rituals that began with the turn of the century was almost complete. Instead of suitors and proper daughters, America had created two new creatures: boyfriends and girlfriends. No longer would men sit in parlors, under the scrutiny of parents, while the object of their affection played the piano. Now, hats in hands, they were met at the door by girls who expected to be taken out. A *Harper*'s article in 1924 bemoaned the fate of one boy caught in such an expectation, who ended up spending a month's salary on his date. The word "date" entered the vocabulary, having changed from its original meaning. No longer only the assignation of a prostitute and client, it denoted a day spent behind a six-cylinder engine, driving to parties halfway across the state, or an evening in a half-lit dance hall, knocking bare knees to the beat of a local band.

A poster from a dance hall of the twenties suggests some of the thrills available to attendees. These were the sort of activities the chief of police of Lansing, Michigan, tried to prevent: "No shadow or spotlight dances allowed. Moonlight dances not allowed where a single light is used to illuminate the hall. All unnecessary shoulder or body movement or gratusque [*sic*] dances positively prohibited. All unnecessary hesitation, rocking from one foot to the other and seesawing back and forth of the dancers will be prohibited. No beating of drum to produce jazz effect will be allowed."

A survey of boys and girls in Middletown, Indiana, revealed that the new forms of dating caused disagreement with parents. Almost half cited the number of times they went out on school nights as a source of friction. Almost as many mentioned fighting over the family car and the hour they got in at night. The telephone became love's ally. Advice columns, replacing pulpits as the

arbiters of courtship, answered queries about the new technology. "Ought a girl to give a man her telephone number after only brief acquaintance?" The answer was a firm no. But millions of girls did.

The telephone created instant intimacy. "As it was, a girl lying in bed could hear the voice of her boyfriend on her pillow, a voluptuous thrill which would have been regarded as wildly improper in days of prudery," wrote E. S. Turner in *A History of Courting*. "The man might be standing in a drafty telephone box, but in fancy he was right there on the pillow with his voice."

The new forms of courtship were perplexing. One teenager wrote to *American Magazine* in September 1924 to complain that he had spent about $5,000 over the past five years on dating, an average of about twenty dollars a week. "I must say that the conversation, entertainment and mental companionship that I have received in return for this $1,000 a year seem to me to be priced beyond their real value." His father had managed a three-year courtship on a mere sixty dollars.

Turner elaborates: "The entire cost of wooing, marriage license, preacher's fee and honeymoon was less than $200. One disillusioned writer complained that girls appeared to think it sufficient just to be girls, in return for which the world owed them a living: 'A whole lot of girls are making the mistake of giving too little and asking too much. They have a very good business and they are killing it.' The writer called for a buyers' strike, but he clearly did not expect to enlist any recruits."

Women who played the courtship game for high stakes were called gold diggers, a label that covered both stage girls who married millionaires and young girls who made boys spend money while giving nothing in return. Feminists said that since nothing was fair in the workplace (men made more money), then all was fair in love.

A cover of *Life* pictured the flapper as a butterfly. Beauty—a creation of the gods—had returned to the world, wrote Fitzgerald, as "a ragtime kid, a flapper, a jazz baby and a baby vamp." And when women change, everything changes.

The twenties saw the abandonment of the ideal Victorian woman, that angelic being free from the taint of sexual desire. Theodore Dreiser had complained

in an essay published in 1920 that "women are now so good, the sex relationship so vile a thing, that to think of the two at once is not to be thought of." But one looked at the flapper and thought of all sorts of things. "The emancipated flapper is just plain female under her paint and outside her cocktails," wrote Gertrude Atherton in her novel *Black Oxen.* "More so for she's more stimulated. Where girls used to be merely romantic, she's romantic, plus sex instinct rampant."

Frederick Lewis Allen, a magazine editor who tried to capture an entire decade while it was fresh in memory, described the flapper in his 1931 volume *Only Yesterday:* "In effect the woman of the postwar decade said to man, 'You are tired and disillusioned, you do not want the cares of a family or the companionship of mature wisdom, you want exciting play, you want the thrills of sex without their fruition, and I will give them to you.' And to herself she added, 'But I will be free.'"

Women developed a code. According to Peter Ling, author of a treatise on sex and the automobile in the 1920s, "each of the phases of petting came to be associated with a corresponding emotional stage in a couple's relationship. Kissing, while not automatic, was all right if the two merely liked each other; deep or French kissing indicated romantic attachment; breast-touching through the clothing heralded that things were becoming serious, and continued under the brassiere if the feelings intensified. Finally, explorations below the waist were reserved only for couples who considered themselves truly in love. The culmination of this logic was intercourse with one's fiancé."

The youth of the twenties were the first American generation to embrace sex as the central adventure in life. As one writer noted, "One is tempted to picture investigators hunting for that special morning between 1919 and 1929 when 51 percent of the young unmarried in America awoke to find that they were no longer virgins."

It's not that this generation discovered premarital intercourse—it had discovered erotic play. Characters in Fitzgerald's stories endlessly discussed the politics of the kiss. Gloria, the heroine of his novel *The Beautiful and Damned* (1922), could tell a suitor, "A woman should be able to kiss a man beautifully and romantically without any desire to be either his wife or his mistress." She had kissed dozens of men and expected to kiss dozens more. Zelda Fitzgerald would tell a friend, "I only like men who kiss as a means to an end. I never know how to treat the other kind." Americans read her husband's

descriptions of petting parties and diligently sought out darkened rooms or country-club greens to savor the new freedom. Fitzgerald even wrote about kissing for the *New York American:* "Why Blame It on the Poor Kiss If the Girl Veteran of Many Petting Parties Is Prone to Affairs After Marriage?" (On the other hand, an Englishman writing about the twenties asked bluntly, "What did Scott Fitzgerald precisely mean by 'kissing'?" Was it code for intercourse, or was the whole nation in high school?)

The twenties saw the loss of the vocabulary of sin, of the scarlet letter that said any woman who sampled sex outside marriage was doomed to a life of prostitution and white slavery. Sex was no longer absolutely equated with ruination.

The chaperone, that Victorian relic, became extinct, to be replaced by a new moral guardian, Mrs. Manners. In 1925 Anna Steese Richardson's *Standard Etiquette* addressed the modern woman. "The bachelor girl is a new figure in the social world. She is not even mentioned in etiquette books written as recently as two years ago. The girl who drove an ambulance in France is apt to think she can live her own life in America." Emily Post wrote *Etiquette: The Blue Book of Social Usage* for an upwardly mobile America. The book went through seventeen printings before the author discovered that the world had changed. Not all of her readers were interested in proper conduct at the opera. In 1927 Post would add a chapter that warned girls against the temptations of the Jazz Age. "Continuous pursuit of thrill and consequent craving for greater and greater excitement," she wrote, "gradually produce the same result as that which a drug produces in an addict; or to change the metaphor, promiscuous crowding and shoving, petting and cuddling, have the same cheapening effect as that produced on merchandise which has through constant handling become faded and rumpled, smudged or frayed and thrown out on the bargain counter in a marked-down lot."

The advice givers accepted that dating was an exchange. The new standard for moral decline, articulated by Post, was economic: "The typical meaning of the word cheapness is exemplified in the girl or woman who puts no value on herself; who shows no reserves mentally, morally or physically, who does not mind being nudged or pushed or shoved, is willing to be kissed and petted—in other words, to put herself in a class with the food on a free lunch counter."

Clearly a change was sweeping across America, if not the whole world. Overseeing a cultural revolution in Russia, no less a personage than Lenin dealt

with the problems posed by free love. "Of course thirst must be satisfied," he wrote, "but will the normal man lie down in the gutter and drink out of a puddle or out of a glass with a rim greasy from many lips?"

Gloria of *The Beautiful and Damned* recounts that one of her many suitors, a man she had kissed, had the audacity to compare her to "a public drinking glass."

During the twenties, America debated the nature of man and woman—in drugstores, speakeasies, classrooms, and courtrooms.

Were we descended from apes, as Charles Darwin maintained? Did the animal instinct—lust—govern all aspects of our life, as Sigmund Freud suggested?

Wasn't man created by God, in God's image? To teach that he was descended from apes was nothing short of blasphemy. In 1925 Tennessee passed a law forbidding the teaching of evolution in public schools.

The newly emergent American Civil Liberties Union (ACLU) decided to test this statute. John Scopes, a high school science teacher in Dayton, Tennessee, volunteered. He read from *Civic Biology,* a textbook previously approved by the state board of education: "We have now learned that animal forms may be arranged so as to begin with the simple one-celled forms and culminate with a group which includes man himself." Scopes was arrested.

Clarence Darrow, one of the nation's leading defense lawyers (he had earned the title the Great Defender for his work in the trial of thrill killers Nathan Leopold and Richard Loeb), represented the schoolteacher; William Jennings Bryan, thrice a candidate for president and a popular speaker at revival meetings, was the chosen champion of the fundamentalist viewpoint. The two had previously debated the issue of evolution in the *Chicago Tribune.* Now they would roll up their shirtsleeves and go for the kill.

The small town of Dayton found itself host to a media circus. Fundamentalists of every denomination arrived to hand out pamphlets on the courthouse lawn: *Evolution a Menace; Hell and the High Schools; God or Gorilla.* Sideshow barkers displayed apes in cages on Main Street. Holy rollers spoke in tongues on the fringe of the crowds; men claiming to represent armies of true believers held forth on the dangers of education. The police kept atheists under surveillance for their own protection.

The trial was indicative of the crisis facing America. For years church and state had rejected the animal nature of man; laws equated desire with sin and bestial behavior. If we embraced Darwin, it was then implied, we would have to embrace our sexual nature.

Bryan rose to argue, incredulously, that man was not a mammal, that evolution would destroy morality and promote infidelity (both in the heretical and sexual sense, though he seemed more concerned with the latter). H. L. Mencken, covering the trial for the *Baltimore Sun,* described Bryan as a "tinpot pope in the Coca-Cola belt" who ranted that "learning is dangerous, that nothing is true that is not in the Bible, that a yokel who goes to church regularly knows more than any scientist ever heard of."

Darrow demolished Bryan in a cross-examination that was held in the sweltering heat on the courthouse lawn. It was a Pyrrhic victory: Scopes was found guilty and fined $100. The law forbidding the teaching of evolution remained on the books in Tennessee until 1967. But for once the media circus served the forces of logic and reason: America had paused and considered the consequences of handing the nation over to fundamentalists.

At the same time, society pondered Freud's message that civilization, in seeking to control man's sexual instinct, had created an enveloping web of repression. If culture had destroyed the natural instincts, was it still possible to find a primitive culture, a Garden of Eden, where we could glimpse sexual paradise?

By 1929 two works attempted to answer these questions. Bronislaw Malinowski returned from the Trobriand Islands to give us *The Sexual Life of Savages,* and Margaret Mead had published *Coming of Age in Samoa.* Their messages were simple: Primitive cultures were permissive; and, because they were permissive, the people were free of neuroses.

Mead described a culture in which children grew up completely at ease with both nakedness and the details of sex. They masturbated (sometimes in groups) and experimented with members of their own sex without penalty. She summarized the difference between the cultures: "Our children are faced with half a dozen standards of morality: a double sex standard for men and women, a single standard for men and women, and groups which advocate that the single standard should be freedom while others argue that the single stan-

dard should be absolute monogamy. Trial marriage, companionate marriage, contract marriage—all these possible solutions of a social impasse are paraded before growing children while the actual conditions in their own communities and the moving pictures and magazines inform them of mass violations of every code, violations which march under no banners of social reform."

In contrast, she continued,

> The Samoan child faces no such dilemma. Sex is a natural, pleasurable thing. . . . From the Samoans' complete knowledge of sex, its possibilities and its rewards, they are able to count it at its true value. And if they have no preference for reserving sex activity for important relationships, neither do they regard relationships as important because they are productive of sex satisfaction. The Samoan girl who shrugs her shoulder over the excellent technique of some young Lothario is nearer to the recognition of sex as an impersonal force without any intrinsic validity than is the sheltered American girl who falls in love with the first man who kisses her. From their familiarity with the reverberations which accompany sex excitement comes this recognition of the essential impersonality of sex attraction which we may well envy them.

In the twenties, psychoanalysis was as popular a phenomenon as crossword puzzles or mah-jongg. Not that anyone bothered to read Freud. (Indeed, in 1927 there were only nine practicing psychoanalysts in New York City.) But even if few Americans fully understood Freud's theories of the unconscious, everyone seemed to be familiar with them. Interpreting dreams was a parlor game based on a simple principle: Everything could be traced to sex. Science—an authority challenging that of the churches—had given its stamp of approval to lust, proclaiming that desire was a drive equal to hunger or thirst.

It is hard to conceive of the level of sexual ignorance at the beginning of the century, but one example will suffice. An Englishwoman, Marie Carmichael Stopes, obtained a doctor of science degree in London and a doctor of philosophy degree in Munich. Yet she remained a virgin for the first six months of her marriage without realizing that the union had not been consummated. (Her

husband was impotent.) One of the most highly educated women of her time did not know the first thing about sexual intercourse.

She resolved to correct the oversight. She wrote *Married Love: A New Contribution to the Solution of Sex Difficulties.* Unable to find a publisher in England, she had the work printed in America. By 1924 the book was in its sixteenth edition, having sold almost half a million copies in the United States and abroad.

The decade witnessed the birth of a pro-sex crusade. Magazines published the essays of Havelock Ellis, who introduced most of Freud's sexual theory to America. (One observer called Freud's work "foreign propaganda," as though linking sex with Marxism and communism.) A few American physicians took over the task of spreading the word, writing "doctor's books," sex manuals that were supposedly restricted to members of the medical profession. Young swells took to reading the works of one Dr. Robie to impressionable young women. This pioneer guidebook, wrote Edmund Wilson, "aimed to remove inhibitions by giving you permission to do anything you liked."

William Franklin Robie, a doctor in Baldwinville, Massachusetts, and a "sometime fellow" at Clark University (where Freud had delivered his only American lectures), was a one-man crusade. Beginning in 1918 he argued for *Rational Sex Ethics for Men in the Army and Navy,* then branched out in 1920 with *Sex Histories: Authentic Sex Experiences of Men and Women Showing How Fear and Ignorance of the Sex Life Lead to Individual Misery and Social Depravity* and *Sex and Life: What the Experienced Should Teach and the Inexperienced Should Learn.* In 1925 he celebrated *The Art of Love.* Robie not only gave permission but also brought a can-do attitude to the nuts and bolts of lovemaking.

Dr. Robie told the man to stimulate the clitoris, the woman to "follow her inclinations as to the force, distance or rapidity of the in-and-out motion." He recommended positions other than the customary "husband above and astride." He counseled both partners to pause before orgasm to allow the other partner to catch up. He claimed that sex was "invigorating, stimulating and tending to a concentration of the best energy before an intellectual or physical effort."

If reading Robie aloud would not do the job, there was always the work of Samuel Schmalhausen.

Schmalhausen, another popularizer of Freud's work, wrote an enthusiastic treatise in 1928 called *Why We Misbehave.* (Reviewers thought the title

should be *Why We Should Misbehave*.) In this work, he notes the transformation in American mores: "Static morality has been repudiated in favor of dynamic experience. Fear yields its sovereignty reluctantly to fun. Passion's coming of age heralds the dawn of a new orientation in the life of the sexes. We may sum up the quintessence of the sexual revolution by saying that the center of gravity has shifted from procreation to recreation." Schmalhausen extolled the virtue of playful sex: "Sexual love as happy recreation is the clean new ideal of a younger generation sick of duplicity and moral sham and marital insincerity and general erotic emptiness. Sex as recreation is the most exquisite conception of lovers who have learned to look with frank delighted eyes upon the wonder in their own stirred bodies."

In 1929 James Thurber and E. B. White would look at the literature and ask, rhetorically, *Is Sex Necessary?*:

> During the past year, two factors in our civilization have been greatly overemphasized. One is aviation, the other is sex. Looked at calmly, neither diversion is entitled to the space it has been accorded. Each has been deliberately promoted. In the case of aviation, persons interested in the sport saw that the problem was to simplify it and make it seem safer. With sex, the opposite was true. Everybody was fitted for it, but there was a lack of general interest. The problem in this case was to make sex seem more complex and dangerous. This task was taken up by sociologists, analysts, gynecologists, psychologists and authors; they approached it with a good deal of scientific knowledge and an immense zeal. They joined forces and made the whole matter of sex complicated beyond the wildest dreams of our fathers. The country became flooded with books. Sex, which had hitherto been a physical expression, became largely mental. The whole order of things changed. To prepare for marriage, young girls no longer assembled a hope chest—they read books on abnormal psychology. If they finally did marry they found themselves with a large number of sex books on hand, but almost no pretty underwear.

The generation that came of age in the decade after World War I was the first of the moderns. Born and raised in the era of mass culture, with movies, maga-

zines, and advertising generating new ideas that could reach millions overnight, the young seemed to have little or no sense of the values that had shaped America. Theirs was the first generation, the first peer group since the Founding Fathers, that had to come up with its own rules.

Writing in 1931, Frederick Lewis Allen explained the transformation: "An upheaval in values was taking place. Modesty, reticence and chivalry were going out of style; women no longer wanted to be ladylike or could appeal to their daughters to be wholesome; it was not too widely suspected that the old-fashioned lady had been a sham and that the wholesome girl was merely inhibiting a nasty mind and would come to no good end. Victorian and puritan were becoming terms of opprobrium: Up-to-date people thought of Victorians as old ladies with bustles and inhibitions and of puritans as bluenosed, ranting spoilsports. It was better to be modern. Everybody wanted to be modern—and sophisticated, and smart, to smash the conventions and to be devastatingly frank. And with a cocktail glass in one's hand it was easy at least to be frank."

Writers in Greenwich Village supplied the credo for the new generation. According to critic Malcolm Cowley, self-expression was all. In his 1934 literary odyssey, *Exile's Return,* he spelled out the values that developed in the twenties. Each man should "realize his full individuality through creative work and beautiful living in beautiful surroundings." The Greenwich Village man and woman were pagans who believed that "the body is a temple in which there is nothing unclean, a shrine to be adorned for the ritual of love." Above all else was the idea of living for the moment. "Better to seize the moment as it comes, to dwell in it intensely, even at the cost of future suffering." Villagers and their kindred spirits across America believed in "the idea of liberty—every law, convention or rule of art that prevents self-expression or the full enjoyment of the moment should be shattered and abolished."

Edmund Wilson would describe meeting and falling in love with poet Edna St. Vincent Millay—she would go to his apartment to take hot baths (perfectly understandable in an era of cold-water flats). Millay was a disciple of sex. One of her poems describes her years in the Village simply: "Lust was there/and nights not spent alone." She became the apex of a ménage à trois; Wilson writes obliquely of an evening spent on the daybed. Millay told John Peale Bishop to attend to her upper half, Wilson to the lower half, then wondered aloud who had had the better share.

Millay was a modern Sappho, famous for having had eighteen affairs within several years of moving to the Village. Her ode to excitement ("My candle burns at both ends; It will not last the night") was as fierce as it was cryptic.

Edmund Wilson spent the decade developing a language of desire. Writing in the privacy of a journal, he tried to capture the texture of lovemaking, to find meaning in the sensory differences between acts.

> The time before, the cool moisture of her lips when she has bent lower for fellatio, so delightful, so curiously different from the warm and mucilaginous moisture of ordinary intercourse—the incredible feeling caress, gently up and down, until the delightful brimming swelling of pleasure seems to make it flow really in waves which fill her darling woman's mouth.—In taking hold of my cock and my balls she had a gentleness, reluctance and timidity which, as well as the way she rubbed over the glans and below, gave the whole thing a delicious and as it were tantalizing lightness, only satisfied, completed by the fullness and the richness of the final flow.

He wrote about anatomy and the personality suspended within: "Her little mouth under the moist kisses of my mouth and my finger on her little moist cunt rubbing its most sensitive spot—I felt that I was in contact with her two tenderest places—tiny, infinitely delicious, those two little spots on her slight small body where flesh, where personality melted into magic and delight."

Frederick Lewis Allen saw the limits of the revolutionary zeal. The youth of the Jazz Age "believed in a greater degree of sex freedom than had been permitted by the strict American code; and as for discussion of sex, not only did they believe it should be free but some of them appeared to believe it should be continuous. They read about sex, talked about sex, thought about sex and defied anybody to say no."

To a large degree, the values of the Lost Generation were shaped by that great American fiasco, Prohibition.

On January 16, 1920, the country went dry. John F. Kramer, the first Prohibition commissioner, described the Volstead Act: "This law will be obeyed

in cities, large and small; and where it is not obeyed, it will be enforced. The law says that liquor to be used as a beverage must not be manufactured. We shall see that it is not manufactured. Nor sold, nor given away, nor hauled in anything on the surface of the earth or under the earth or in the air."

Prohibition was the noble experiment. Since its origins following the Civil War, the dry crusade had sought to mandate "clear thinking and clean living" by legislation. The movement subsequently exploited the war effort in the first World War. The military had embraced prohibition. (The country's survival, it was believed, depended on straight-thinking soldiers and sober workers back home.) Now the whole country would. The Anti-Saloon League and the Women's Christian Temperance Union waltzed the Eighteenth Amendment through the Senate and House and through the necessary state legislatures with surprising ease. (A few observers noted that the amendment passed while some three million men were out of the country, having fought a war to make the world safe for democracy.) President Woodrow Wilson vetoed the insanity, but Congress overrode the veto with more than enough votes.

Prohibition was unenforceable. A handful of agents set about policing the drinking habits of millions. The experiment created almost immediately a generation of lawlessness. The Jazz Age, with its speakeasies and hip flasks, bathtub gin and home stills, was nothing short of a counterculture.

Gangsters were local heroes. Small-time hoodlums who had previously trafficked in prostitution, extortion, and gambling became big-time mobsters. Prohibition marked the ascension of organized crime in America. Where the original robber barons had made their fortunes by controlling a single resource, such as coal or steel, the new elite controlled alcohol. A Chicago gangster went into business with a formerly legit brewer and raked in more than $50 million in the first four years of Prohibition. Just like the robber barons, gangsters built mansions and bought governments. At the height of his power Al Capone made $105 million a year. His lifestyle was somewhat more ostentatious than that of a Boston blue blood. Greed begat gun battles. Newspapers covered gangland politics in more detail than they did Washington politics. Every week there were stories of frame-ups and fall guys, gun molls and torpedoes, diamond stickpins and stickup artists.

The crime lords created a new and exciting underworld. Limousines and taxis lined up outside nightclubs and speakeasies. Elegantly dressed men and

women whispered passwords through peepholes. Men and women drank side by side at the bar, or in candlelit booths or alcoves. Privacy plus intimacy, the thrill of rebellion, the sauce of secrecy—a heady recipe.

Prohibition was the creation of well-intentioned women whose lips had never touched lips that touched liquor. But now the flappers' lips were touching alcohol. On a regular basis, American women were getting "spifficated." Collegians crashed parties and automobiles, in roughly that order. The culture broke through other barriers as well: White customers drove to the Cotton Club in Harlem to see Duke Ellington and other notable musicians of the era and drink the night away. Drinking was sophisticated and sexy.

People began to drink at home as well, with not-unexpected results. Malcolm Cowley wrote, "The party conceived as a gathering together of men and women to drink gin cocktails, flirt, dance to the phonograph or radio and gossip about their absent friends had in fact become one of the most popular American institutions; nobody stopped to think how short its history had been in this country."

Fitzgerald described the role of alcohol this way: "It became less and less an affair of youth. The sequel was like a children's party taken over by the elders. By 1923 their elders, tired of watching the carnival with ill-concealed envy, had discovered that young liquor will take the place of young blood, and with a whoop the orgy began. A whole race going hedonistic, deciding on pleasure, the whole upper tenth of a nation living with the insouciance of grand ducs and the casualness of chorus girls."

Frederick Lewis Allen notes also the spread of petting parties from youngsters in their teens and twenties to older men and women. "When the gin flask was passed about the hotel bedroom during a dance," he wrote, "or the musicians stilled their saxophones during the Saturday night party at the country club, men of affairs and women with half-grown children had their little taste of raw sex. One began to hear of young girls, intelligent and wellborn, who had spent weekends with men before marriage and had told their prospective husbands everything and had been not merely forgiven, but told that there was nothing to forgive; a little experience, these men felt, was all to the good for any girl. Millions of people were moving toward acceptance of what a bon vivant of earlier days had said was his idea of the proper state of morality—'A single standard, and that a low one.'"

In combination with the automobile, the hip flask made seduction a certainty. Judge Ben Lindsey, a liberal from Denver, would say of the delinquents brought before him, "No petting party, no roadhouse toot, no joyride far from the prying eye of Main Street is complete unless the boys carry flasks. There are no actual statistics to be had on these matters, but it is very clear in my mind that practically all of the cases where these girls and boys lose their judgment in Folly Lane involve the use of drink."

Into this world came authors who believed that Victorian repression had crippled mankind. Writers such as Theodore Dreiser, Sherwood Anderson, Eugene O'Neill, and Ernest Hemingway refused to accept or spread what one literary historian called "the lying gospel that sexuality is somehow degrading."

Sherwood Anderson stated simply, "We wanted the flesh back in our literature, wanted directly in our literature the fact of men and women in bed together, babies being born. We wanted the terrible importance of the flesh in human relations also revealed again."

A character in Anderson's *Winesburg, Ohio* (1919) had expressed the same demand in narrative form. Burdened with a wife who was ashamed of passion, he feels cheated. "Man has a right to expect living passion and beauty in a woman. He has no right to forget that he is an animal," he declares. "I will fly in the face of all men and if I am a creature of carnal lusts, I will live then for my lusts."

The call to lust would not go unnoticed. Leaders of the dry crusade turned their energies to sex and literature. Robert Woods, a Boston social worker with a singular grasp of Freud, believed that Prohibition would "profoundly stimulate a vast process of national purification" by hastening "the sublimation of the sex instinct upon which the next stage of progress for the human race so largely depends."

The *Christian Century* asserted: "Prohibition is the censorship of beverages, and censorship is the prohibition of harmful literature and spectacles. In general principle, the two problems are one. Both undertake to protect individuals against their own unwise or vicious choices." Harlan Fiske Stone, dean of the Columbia University School of Law, saw the impending clash. "The whole country is in danger of being ruined by a smug puritanism," he wrote a

young lawyer, "and intelligent people with liberal ideas, especially lawyers, ought to fight this tendency." And fight they did. Freedom and the future of America went on the block in numerous courtrooms.

Police seized the printing plates for *The President's Daughter,* a memoir written by Warren G. Harding's mistress (she alleged that the president had had sex with her in a closet at the White House). Censors ignored steamy best-sellers such as Warner Fabian's *Flaming Youth* and *Unforbidden Fruit* and instead went after the best and the brightest.

In New York John Sumner—Anthony Comstock's successor at the Society for the Suppression of Vice—swore out a complaint against Margaret Anderson and Jane Heap, editors of *The Little Review.* The magazine had published excerpts of James Joyce's *Ulysses.*

Lawyers for the defendants tried to have the offending passages read into the record. The three-judge panel refused "out of consideration for the ladies present"—the same ladies who had published the erotic musings. The work was judged obscene.

In 1928 D. H. Lawrence had a thousand copies of *Lady Chatterley's Lover,* his final novel, privately printed in Italy. He sold the unexpurgated text by subscription to readers in England and America. Almost immediately, pirated editions began to circulate, making the story of an English aristocrat and her gamekeeper the world's most famous dirty book.

In Boston an agent of the Watch and Ward Society had James DeLacey, proprietor of the Dunster House Bookshop, arrested for selling one of the unexpurgated first-edition copies. He was sentenced to four months in jail and fined $800. The society also targeted Donald Friede, publisher of Theodore Dreiser's *An American Tragedy* (1925).

At Friede's obscenity trial, the district attorney read offending passages of *An American Tragedy* to the jury. One concerned the visit of the book's protagonist to a brothel:

> And now, seated here, she had drawn very close to him and touched his hands and finally linking an arm in his and pressing close to him, inquired if he didn't want to see how pretty some of the rooms on the second floor were furnished. And he allowed himself to be led up that curtained back stair and into a small pink and blue furnished

room. This interestingly well-rounded and graceful Venus turned the moment they were within and held him to her, then calmly and before a tall mirror which revealed her fully to herself and him, began to disrobe.

In his closing arguments, the district attorney defended community standards, and then tried to impose them on the entire nation: "Perhaps where the gentleman who published this book comes from it is not considered obscene, indecent and impure for a woman to start disrobing before a man, but it happens to be out in Roxbury, where I come from." The jury found the publisher guilty. The phrase "banned in Boston" thus entered the American language.

H. L. Mencken, a columnist for the *Baltimore Sun* and editor of *Smart Set* and the *American Mercury,* was the most vocal opponent of the old order. Vowing to "combat, chiefly by ridicule, American piety, stupidity, tinpot morality and cheap chauvinism in all their forms," he attacked reformers, moralists, the KKK, preachers, fundamentalists, patriots, politicians, poltroons, and censors.

In a brilliant essay published just after World War I, Mencken tracked the impact of puritanism as a literary force. What began on the mourner's bench in New England churches—the spectacle of an individual solemnly confronting his own sinfulness—had become a sport of tormenting "the happy rascal across the street." Mencken noted that prosperity created the purge; that following the Civil War, newly minted "Christian millionaires" bankrolled everything from vice crusades to Prohibition: "Wealth, discovering its power, has reached out its long arms to grab the distant and innumerable sinner; it has gone down into its deep pockets to pay for his costly pursuit and flaying; it has created the puritan entrepreneur, the daring and imaginative organizer of puritanism, the baron of moral endeavor." The American puritan, noted the sage of Baltimore, had instituted "a campaign of repression and punishment perhaps unequaled in the history of the world."

Elsewhere, Mencken ridiculed the "intolerable prudishness and dirtymindedness of puritanism" and its "theory that the enforcement of chastity by a huge force of spies, stool pigeons and police would convert the republic into a nation of moral esthetes. All this, of course, is simply pious fudge. If the notion

were actually sound, then all the great artists of the world would come from the ranks of the hermetically repressed, i.e., from the ranks of old maids, male and female. But the truth is, as everyone knows, that the great artists of the world are never puritans and seldom even ordinarily respectable. No moral man—that is moral in the YMCA sense—has ever painted a picture worth looking at, or written a symphony worth hearing, or a book worth reading, and it is highly improbable that the thing has ever been done by a virtuous woman."

Mencken directly challenged the Boston branch of the bluenoses. He sold a copy of the *American Mercury* to the spokesman of the Watch and Ward Society, knowing that it would lead to his arrest. When the man paid his 50 cents, Mencken—deliberately and in full view of a gathered crowd—bit the coin to see if it was genuine.

The legal climate had changed since Margaret Sanger opened the first birth-control clinic in America in 1916—an act for which she had gone to jail. Her lawyer had challenged the law and won. A New York court declared it legal to dispense birth-control information to women whose health demanded it. But obtaining the devices was a problem.

Sanger opened a two-room office on Fifth Avenue in 1923. In the first two months of operation, 2,700 women came to the office for advice. The clinic dispensed at least 900 diaphragms.

The diaphragms came from Holland. An Italian neighbor smuggled in the birth-control devices in liquor bottles—along with Dutch gin—from ships anchored beyond the twelve-mile limit. Sanger's second husband, J. Noah Slee, later brought in contraband items on trainloads of 3-in-1 Oil from Canada. Late in the decade an American company, Holland Rantos, would begin to produce rubber diaphragms, but one doubts the American product had the novelty of those brought in by smugglers.

Condoms were more available. The health lectures from the war had introduced an entire generation to their usefulness. Trojan, the first brand of latex condoms, debuted in 1920. The condoms were sold in gas stations, tobacco shops, barbershops, and drugstores—for the prevention of disease only. Proponents of birth control still faced legal obstacles. In 1918, eighteen states

had laws that prohibited the dissemination of contraceptive information. Another twenty-three had laws stating that "contraceptive information is immoral or obscene and therefore criminal." Only five states—Georgia, New Hampshire, New Mexico, North Carolina, and Washington—did not restrict birth-control information.

The churches still controlled the debate. At the beginning of the decade the archbishop of New York personally dispatched city police to prevent Sanger from delivering a lecture on birth control at Town Hall.

Two separate organizations—Sanger's American Birth Control League and Mary Ware Dennett's Voluntary Parenthood League—turned their attentions to Washington. If family limitation was to be a reality, the law drafted by Anthony Comstock in 1873 that forbade "mailing obscene or crime-inciting matter" would have to be changed. The two groups began to work their way through the Congressional Directory, trying to find sponsors for a law that would remove the words equating "prevention of conception" with "obscenity." Then, they believed, the individual states would fall in line. Doctors would have no fear of meddlesome vice agents; women returning from Europe with the latest contraceptive technology would not fall prey to U.S. Customs agents.

The two groups differed on one vital point, however: Sanger wanted doctors to dispense birth-control information to female patients (viewing it as a woman's issue), while Dennett wanted the information available to all (viewing birth control as a concern for both sexes—and none of the doctor's business).

Doctors were not comfortable with family limitation or birth control. For years, the profession had battled to distinguish itself from the quacks, dispensers of patent medicine, and herbalists who dealt with "women's problems." Birth control supposedly threatened their respectability. Robert Latou Dickinson, a New York obstetrician, headed a committee to look into the matter. The group tried to work with Sanger and Dennett, but the alliance failed.

The birth-control crusade was met with ambivalence among politicians as well. Few congressmen committed to a revision of the Comstock Act. Dr. Hubert Work, assistant postmaster general and former president of the American Medical Association, told Dennett that the purpose of the Voluntary Parenthood League was to "instruct everybody how to have illicit intercourse without the danger of pregnancy."

Dr. Work was promoted to postmaster general in 1922 when his predecessor, Will Hays, left to monitor the morals of Hollywood. Work posted a bulletin in all post offices stating that it was a criminal offense to send or receive matter relating to the prevention of conception.

When Dennett ridiculed the decision in an editorial, she received notice: "My Dear Madam: According to advice from the solicitor for the Post Office, the pamphlet entitled *The Sex Side of Life: An Explanation for Young People,* by Mary Ware Dennett, is unmailable under Section 211 of the Penal Code. As copies of this pamphlet bearing your name as the sender have been found in the mails, the decision is communicated for your information and guidance."

It was intimidation, pure and simple. In 1915 Dennett had written a pamphlet on the facts of life for her two sons. Far from being obscene, it had been endorsed by the YMCA (the same organization that had funded Comstock).

Dennett continued to lobby Congress to change the law, and she distributed more than 30,000 copies of *The Sex Side of Life.* In 1929 Mrs. Carl A. Miles—supposedly a member in good standing of the Daughters of the American Revolution—filed a formal complaint. (Mrs. Miles, it turned out, was the creation of the Post Office.) Dennett was charged with mailing a "pamphlet, booklet and certain printed matter, which were obscene, lewd, lascivious and filthy, vile and indecent, against the peace and dignity of the U.S." Dennett chose to fight. She hired Morris Ernst, a young lawyer with the recently formed American Civil Liberties Union, to defend her.

It became clear immediately that the law was being used to force a particular moral view on the women of America. On the day of the open hearing, Dennett discovered that Judge Grover Moscowitz had invited three Brooklyn clergymen to share the bench with him "to aid the conscience of the court."

Warren Booth Burrows, the eventual trial judge, was no improvement. The judge refused to hear any of the witnesses—including YMCA representatives and Dr. Dickinson—who found value in the pamphlet. The judge also refused to allow letters from supporters to be read into the record.

The prosecutor selected the members of the jury with great care. "Have any of you ever read anything by Havelock Ellis or H. L. Mencken?" he asked. Those who admitted they had were dismissed. The prosecutor then went on the attack, claiming Dennett was a defiler of youth, who not once mentioned chastity or self-control, who never distinguished simple lust from lawful pas-

sion. Her greatest crime was suggesting that sex might be joyful. Her book, he said, "describes the act as being accompanied by the greatest pleasure and enjoyment. Why, there's nothing a boy could see, on reading this book, except a darkened room and a woman! Where does the institution of honor and family come off if we let a gospel like that go out to the world?"

Dennett was found guilty and, like Sanger more than a decade earlier, became a heroine overnight. Senators promised to pass the bill to amend the Comstock Act (though once again they found inactivity to be the best political course). On March 3, 1930, Justice Augustus Hand delivered a reversal: "The defendant's discussion of the phenomenon of sex is written with sincerity of feeling and with an idealization of the marriage relation and sex emotion. We think it tends to rationalize and dignify such emotions rather than to arouse lust. We hold that an accurate exposition of the relevant facts of the sex side of life in decent language and in manifesting serious and disinterested spirit cannot ordinarily be regarded as obscene."

The 1920s revolved around three almost mythic centers: Greenwich Village, Paris, and Hollywood. Greenwich Village supplied the ideas (of underpaid writers and struggling artists whose free love and experimental styles provided the inspiration for the Jazz Age); Paris was the playground (where expatriates got to experience a Continental lifestyle away from puritan scolds and enjoy a good drink in the cafés of Montparnasse); and Hollywood provided the fantasies (the imagination made visible).

Hollywood was as free and unfettered as Greenwich Village or Paris, only everyone there was rich and beautiful. The film colony vied with the original colonies for control of the American dream. In 1920, 35 million people attended the movies each week. In 1920 Mary Pickford earned $1 million a year, more than ten times the salary of the president. Hollywood stars were the most famous people on the planet.

Douglas Fairbanks played characters who tumbled, boxed, fenced, and played golf and tennis. He was a bare-chested swashbuckler, the thief of Baghdad, Zorro. When he opened a string of gyms, he taught men to perfect and enjoy their bodies, insisting that athleticism was an "antidote to too much civilization" and an alternative to the "sea of sensuousness." The proper re-

sponse to temptation, it seemed, was a quick jog around the park or a few rounds in the gym.

Pickford was America's sweetheart, a resourceful, independent woman who in film after film tackled problems with her sleeves rolled to the elbows, who danced with Gypsies and workers, who gave advice to the young women of the day.

In 1920 these two perfect symbols of American manhood and womanhood divorced their respective spouses and married. Their home—Pickfair—became a gathering place for royalty, both real and of the sort created in Hollywood.

While Doug and Mary represented an all-American kind of sex appeal, an exotic new matinee idol who represented a different sort of sex appeal, more controversial and forbidden, soon took center stage.

Rodolpho Alfonzo Raffaele Pierre Filibert Guglielmi di Valentina d'Antonguolla, a.k.a. Rudolph Valentino, an Italian gardener and dancer by way of Long Island, did more to raise the sexual temperature of the nation than any other single individual. In *The Four Horsemen of the Apocalypse* (1921), he appeared painting three nudes in a studio, then went on to dance a smoldering tango. The *Horsemen* grossed $4.5 million. *The Sheik,* released the same year, established him as the sex symbol of the decade.

The movie poster for *The Sheik* proclaimed: "See: The auction of beautiful girls to the lords of Algerian harems. The barbaric gambling fete in the glittering casino of Biskra. The heroine, disguised, invade the bedouin's secret slave rites. Sheik Ahmed raid her caravan and carry her off to his tent. Her stampede his Arabian horses and dash away to freedom. The sheik's vengeance. The storm in the desert. A proud girl's heart surrendered."

At first American men were put off by this pomaded, smoldering Latin lover. But they noticed the effect he had on their wives and girlfriends. Valentino was a he-vamp.

American men began to call themselves sheiks, their girlfriends shebas. When Valentino kissed the palm of a lover, men copied the move and hoped for the same result. Those who couldn't flare their nostrils or make their eyes flash with sparks were doomed to failure. When a reporter for the *Chicago Tribune* blamed Valentino for the effeminization of American men, the actor challenged the writer to a duel.

When Valentino died unexpectedly of a perforated ulcer in 1926, more than 30,000 mourners visited the funeral home where he lay in state. For decades, an unidentified fan, the Lady in Black, visited his tomb on the anniversary of his death.

Clara Bow became a sex star when she starred in a spunky 1927 comedy called *It*. Novelist Elinor Glyn had converted her novel into the definitive flapper film. The movie begins with a man reading a story in *Cosmopolitan* (authored by Glyn) that describes whether or not a given person has sex appeal, that magical quality called "It." Bow portrayed a shopgirl who sets her sights on the owner of the department store in which she works. Finding herself with nothing to wear on the big date, she takes a pair of scissors to her work dress, cuts a neckline almost to her navel, and whips up a perfect evening dress. She gets the guy.

Offscreen she got the guy as well, being linked with everyone from Gary Cooper to the USC football team. She had "It," and knew how to use "It"—until the advent of talkies at the end of the decade revealed she also had a strong Brooklyn accent. Her career as a sex symbol ended soon after.

The culture depicted in films was singularly sexy. America watched a young Joan Crawford cut loose on a tabletop in *Our Dancing Daughters;* a heart-stopping Gloria Swanson emerge from a luxurious bath in a Cecil B. DeMille epic; a smoldering Greta Garbo seduce and abandon John Gilbert.

E. S. Turner claims in *A History of Courting* that movies changed the mating dance forever. "The cinema taught girls the peculiar potency of the female eye, how to halt or dismiss a man with a look; how to search his eyes at close quarters," he wrote. "It taught girls to recognize the symptoms of a kiss coming on, how to parry it, how to encourage it while apparently avoiding it, or how to return it with interest. There is evidence in more than one quarter that the cinema taught girls the trick of closing their eyes when kissed, which one had always supposed to be a natural instinct of women. It encouraged them to kick up one heel (or even two heels) when embraced. It also taught them how and when to slap."

On-screen, anything was possible. It was what happened offscreen that changed Hollywood.

In 1913 a self-described "funny man and acrobat" walked onto a movie lot in Los Angeles. Something about the fat man caught Mack Sennett's eye.

Within a year Roscoe "Fatty" Arbuckle was writing, directing, and acting in short comedies. Teamed with Mabel Normand (Sennett's girlfriend), Fatty was the victim of filmdom's first custard pie. He elevated the pratfall to a multistory art. His output was extraordinary: at least fifty titles his first year alone. Over the next three years his salary rose from $25 a week to more than $1 million a year. In 1920 Arbuckle starred in a feature called *The Life of the Party.* In 1921 he made *Brewster's Millions,* the first of six features he would film in seven months. He had recently signed a three-year contract worth $3 million and decided it was time for a break. "I'm taking a little trip to the city," he said.

In those days, the city was San Francisco. Los Angeles was a studio town, with a lot of open spaces, orange groves, sagebrush-filled back lots, and a few expensive mansions.

Arbuckle and friends drove a custom $25,000 Pierce Arrow up the coast to San Francisco and checked into three rooms in the St. Francis Hotel. A local bootlegger provided gin and whiskey. The front desk supplied setups. Another call produced a Victrola. The party was under way.

Shortly after noon on Labor Day, two guests arrived: Virginia Rappe, a sometime actress and party girl, and Bambina Maude Delmont, an occasional "dress model" and a provider of party girls. (She ran a badger game, putting rich victims in compromising positions.) After some drinking, Rappe apparently wandered into one of the bedrooms. Arbuckle followed.

Arbuckle said later that he found Rappe on the floor of the bathroom; he gave her a glass of water and placed her on a bed, then returned to the bathroom. When he emerged Rappe was tearing at her clothes and screaming, "I'm dying, I'm dying." Other partygoers flocked into the room and tried to calm Rappe, putting her in a cold bath, applying ice packs, finally calling the hotel manager to get the distraught woman her own room. A house doctor treated her for excessive drinking.

The party wound down. Arbuckle and friends checked out of the hotel and returned to Los Angeles. Four days after the party Rappe died in a hospital of peritonitis, the result of a burst bladder.

Delmont surfaced with a wild story. Arbuckle, she said, had dragged Rappe to the bedroom and ravaged her. Delmont claimed she had pounded on the door, trying to rescue her friend, and had found Rappe with her clothing torn to shreds, moaning on the bed: "I'm dying, I'm dying. He killed me."

Delmont told this story to the police, the press, and a grand jury and Arbuckle was arrested for murder. William Randolph Hearst and the tabloids exploited the tragedy. America's funniest fat man became a monster. Arbuckle, it was said, raped the actress with a Coke bottle, a champagne bottle, a jagged piece of ice. Rappe, whose portrait had graced the sheet music to "Let Me Call You Sweetheart" (earning her the title Sunbonnet Girl), was portrayed as purity incarnate, Arbuckle as everything corrupt about Hollywood.

The city of San Francisco rose to defend the honor of American womanhood. The Women's Vigilant Committee took over the courtroom. When Arbuckle arrived they stood and spat at him. An ambitious prosecutor played to the crowd, bullying or hiding witnesses and ignoring evidence, turning the judicial process into a show trial.

The facts? An autopsy showed that there had been no rape. A nurse said Rappe had confided in her that she suffered from syphilis. A doctor testified that syphilis can cause a bladder to burst. It appeared that Rappe had had a number of abortions; some argued that the peritonitis had resulted from a botched one.

Delmont, the only person who claimed that Rappe had been abused by Arbuckle, never took the stand. It seems the prosecution realized that its star witness was a blackmailer, a bigamist, and, in all probability, a panderer.

After two inconclusive trials, a third jury acquitted Arbuckle, asking that the following be entered into the record: "Acquittal is not enough for Roscoe Arbuckle. We feel that a great injustice has been done him, for there was not the slightest proof adduced to connect him in any way with the commission of a crime." The acquittal did not help. Arbuckle had already been convicted in the media and in the minds of the American public. The dream factory was caught in a nightmare.

On February 1, 1922, in the middle of Arbuckle's second trial, William Desmond Taylor, a director for Paramount, was found dead in his bungalow, two bullets through his heart. The surrounding scandal tainted the careers of some of Hollywood's most beloved actresses. Mabel Normand was the last to see Taylor alive (he'd given her a volume of Freud to read). Mary Pickford had to explain why her picture was hung prominently in the bachelor's apartment. Investigators found a scented love letter written by Mary Miles Minter in the director's bedroom. The murder was never solved, but, as in the Arbuckle

case, the flurry of rumors proved again that demons loomed large in America's sexual imagination. Taylor, it was said, dabbled in witchcraft, adultery, and sexual perversion. Former friends claimed that in the months before his death, Taylor had "visited the queer places in Los Angeles, where guests are served with marijuana and opium and morphine, where the drugs are wheeled in on tea carts and strange things happen."

The nation saw Hollywood as a modern-day Sodom, capable of seducing and destroying American daughters. One minister, inspired by the Arbuckle trial, proclaimed it time to cleanse the country of "movies, dancing, jazz, evolution, Jews and Catholics."

In 1921, thirty-seven state legislatures had introduced one hundred separate censorship bills. The General Federation of Women's Clubs reviewed 1,765 films and decreed that 59 percent were "not morally worthwhile" and another 21 percent were simply "bad."

To avoid congressional intervention, Hollywood studio heads hired Will Hays, postmaster general and former head of the Republican National Committee, to head the Motion Picture Producers and Distributors of America (MPPDA). A darling of the purity movements, Hays knew which buttons to push. "Above all is our duty to youth," he announced within months of taking office. "We must have toward that sacred thing, the mind of a child, toward that clean and virgin thing, that unmarked slate—we must have toward that the same responsibility, the same care about the impression made upon it, that the best teacher or the best clergyman, the most inspired teacher of youth, would have."

Within days of Arbuckle's acquittal, Hays announced that the actor would not work in Hollywood again. Hays demanded that morals clauses be put into every contract; henceforth, actors "would conduct themselves with due regard to public conventions and morals and will not do anything tending to degrade him or her in society, or bring him or her into public hatred, contempt, scorn or ridicule, or tending to shock, insult or offend the community or outrage public morals or decency, or tending to prejudice the company or the motion picture industry." Private detectives ferreted out 117 Hollywood names considered unsafe—whether because of drug use, roadhouse orgies, a taste for

members of the same sex, or too-flagrant affairs. The list was called "the doom book." One of its first victims was Wallace Reid, a dashing action-picture hero who also had a drug habit. He was spirited away to a sanitarium, where he eventually died.

Hays also created a list of dos and don'ts for film. The members of the MPPDA struck a gentleman's agreement to eliminate movies that dealt with sex in an "improper" manner, were based on white slavery, made vice attractive, exhibited nakedness, had prolonged passionate love scenes, were predominantly concerned with the underworld, made gambling and drunkenness attractive, might instruct the weak in methods of committing crime, ridiculed public officials, offended religious beliefs, emphasized violence, portrayed vulgar postures and gestures, or used salacious subtitles or advertising.

The list of forbidden topics was to be further refined by Hays. There would be—among two dozen or so potentially morally offensive topics—no profanity, no licentious or suggestive nudity (in fact or in silhouette), no inference of sexual perversion or white slavery, no scenes of actual childbirth, no mention of sex hygiene or venereal disease, no display of children's sex organs. Producers should be careful when dealing with the sale of women, rape or attempted rape, first-night scenes, men and women together in bed, deliberate seduction of girls, and the use of drugs.

Hollywood adapted to the new code with a simple formula: six reels of sin, one of condemnation. Directors such as Cecil B. DeMille became famous for showing women in sumptuous bathrooms, disrobing, sinking into oiled baths. He joked that cleanliness was next to godliness, and he created a sensuality that did not exist outside of Hollywood. DeMille's lurid epics would depict all of the sins of the Old Testament by cloaking them in the plain blue wrapper of "religion."

The so-called Hays code held out a promise to America—if we can control the make-believe, we can ignore the reality. It was, at first, pure posturing. Studio heads hung signs welcoming Hays to Hollywood. Charlie Chaplin, it is said, placed his over the bathroom door. By the twenties, Charlie Chaplin was the most recognized actor in the world. There were songs about the Little Tramp, Chaplin dolls, and a partnership in United Artists (a film company founded in 1919 by Chaplin, director D. W. Griffith, Douglas Fairbanks, and Mary Pickford).

When it came to his personal life, however, Chaplin was the most silent of the silent-film stars. His autobiography deals with one of his marriages in a single paragraph: "During the filming of *The Gold Rush* in 1925 I married for the second time. Because we have two grown sons of whom I am very fond, I will not go into any details. For two years we were married and tried to make a go of it, but it was hopeless and ended in a great deal of bitterness."

The woman, Lita Grey, was a kind of "Lolita." She first met Chaplin when she was seven. By the age of fifteen she was working as an extra. When she discovered she was pregnant, Chaplin and Grey were married. Her mother came along to run the house.

The divorce papers, widely circulated at the time, still make great reading. Lawyers alleged:

- that Chaplin had "solicited, urged and demanded that plaintiff submit to, perform and commit such acts and things for the gratification of defendant's said abnormal, unnatural, perverted and degenerate sexual desires, as to be too revolting, indecent and immoral to set forth in detail in this complaint."
- that Chaplin's demands of sex acts were a "shock to her refined sensibilities, repulsive to her moral instincts and abhorrent to her conception of moral and personal decency."
- that Chaplin recounted "to her in detail his personal experience with five prominent moving-picture women involving such practices."
- that Chaplin attempted to "undermine and distort plaintiff's normal sexual impulses and desires, demoralize her standards of decency and degrade her conception of morals for the gratification of the defendant's aforesaid unnatural desires."

The unnatural desire was for oral sex.

The divorce papers claimed that Chaplin demanded his wife "commit the act of sex perversion defined by Section 288a of the Penal Code of California. That defendant became enraged at plaintiff's refusal and said to her: 'All married people do those kinds of things. You are my wife and you have to do what I want you to do. I can get a divorce from you for refusing to do this.'"

Rather than face the kind of public wrath that had ended Arbuckle's career, Chaplin settled the divorce for $625,000. Grey split the money with her mother.

Years later, Grey would write her own account of life with Chaplin, one far more earthy than the legalistic description of the divorce papers. The loss of her virginity reads like a four-act play. The seduction took place in a hotel, at a beach, in the back of a limousine. Finally, in a steam room, she surrendered her maidenhood. Closing her eyes in the foglike mist: "Every picture and movie I'd ever seen of queens and princesses bathing in royal tubs, with slave girls drying them and anointing their bodies with perfumed oils, danced in front of me. I draped my arm over my forehead and crossed my ankles, wondering what was to happen next." What happened next was Charlie. Enduring pain, faking ecstasy, she gave herself completely. She was fifteen and supposedly a woman. "I felt I had surpassed Pola Negri and the other human sex symbols Charlie had known. And winning the contest exhilarated me."

The sad tale contains all the elements of sex in that era. The law was used to force marriage. (Lita's mom pointed out that sex with a minor was a jailable offense.) Law was used to leverage a divorce. (Oral sex was a punishable offense and the sex appetite itself was grounds for a mental-cruelty charge.) Sex was considered to be a competition against other women. And even in Hollywood, it seems women came to sex with images from the silver screen swirling through their heads.

Thomas Edison may have been too optimistic about America's love affair with speed, quickness of action, and control. Control was definitely hard to find in the Jazz Age. Prosperity—the roar of the twenties—offered the fantasy that anything was possible.

Dan Caswell, scion of a wealthy Cleveland family, boarded a train one day and noticed Jessica Reed, a star of the Ziegfeld Follies. He followed her to the hotel where Ziegfeld's chorus was staying. Marjorie Farnsworth, in her chronicle of the Follies, writes, "That night Caswell called all the Follies beauties down to the lobby and with a gesture that he hoped reeked of sophistication, opened a chamois bag of diamonds that belonged to his mother— diamonds worth $30,000—and sprinkled them over the marble floor. An instant later the floor was covered with scrambling girls, pulling, pushing and grabbing. It was at that moment that he asked the Titian-haired beauty to marry him, and, pausing only to remove a diamond from her mouth where she'd put it for safekeeping, she softly murmured 'Yes.'"

The diamonds—the family jewels—were to have been made into a necklace for his blue-blooded Boston fiancée.

As for the Fitzgeralds, the couple used heaps of cash to "add polish to their life." As Zelda would later explain, in a novel written within the walls of an asylum, "It costs more to ride on the tops of taxis than on the inside."

Once, when Scott told her they were broke, she answered, "Well, let's go to the movies."

With the same speed that characterized every other aspect of the decade, the prosperity came to an abrupt end. On October 24, 1929, the stock market crashed. Polly Adler, madam of an exclusive brothel in New York, told of the effect the crash had on her customers:

> I had thought my business would fall off, but it was just the opposite—I had almost more customers than I could take care of. Men wanted to go out and forget their troubles, blot out, at least temporarily, those headlines which each day told of more bankruptcies and suicides. The easiest escape, of course, was alcohol, and in the months immediately after the crash I had my biggest profits at the bar. Some men who had been terrific womanizers now came to the house solely to drink, and no longer showed the slightest interest in my girls. Others who had been separated from their wives for years, or steadily unfaithful to them, stayed home and turned into model husbands. And still others, who had been casual customers, now came in nightly and behaved like satyrs. The atmosphere, at times, was more that of an insane asylum than a bordello. One man told me he came there night after night because "a whorehouse is the only place I can cry without being ashamed."
>
> A man whom I had always liked and considered a gentleman appeared one evening, requested the company of a certain girl and then proceeded to practice the most vile, cruel and inhuman acts until the girl was a physical wreck. The following morning the man went to his office and shot himself.
>
> The party was over.

TIME CAPSULE

Raw Data From the 1920s

FIRST APPEARANCES

Trojan condoms. The tommy gun. Legal abortion (in the U.S.S.R.). American Civil Liberties Union. Plastic surgery. Rorschach inkblot test. Miss America. Rubber diaphragms. Maidenform bras. The Charleston. Art Deco. Penicillin. Motels. The electric jukebox. Ford's Model A. Academy Awards. Nudist colonies. Wheaties. Kleenex. The gas chamber. Miniature golf. Talkies. Broadcast radio. *Reader's Digest. Time. The New Yorker.* Mickey Mouse. Bubblegum.

WHO'S HOT

Charles Lindbergh, Louis Armstrong, Cole Porter, George Gershwin, Mary Pickford, Douglas Fairbanks, Rudolph Valentino, Clara Bow, Lon Chaney, Gloria Swanson, Charlie Chaplin, Greta Garbo, Pola Negri, Florenz Ziegfeld, Al Jolson, Paul Whiteman ("The King of Jazz"), Jack Dempsey, Babe Ruth, Red Grange, Bill Tilden, Bobby Jones, Man o' War, Mae West, Scott and Zelda Fitzgerald.

PROHIBITION

Number of people who die in one year from bad booze: 1,565. Number of people arrested per year for violating the Volstead Act: 75,000. Name of popular cocktail: between the sheets.

Number of alcohol stills seized in 1921: 96,000; in 1925: 173,000. Cost of a portable still: $6. Average amount of beer prescribed in 1926 by doctors for a variety of ailments: 2.5 gallons. Amount of whiskey that could be medically prescribed, according to the Supreme Court: one pint every ten days.

Number of speakeasies in Chicago controlled by Al Capone in 1929: estimated 10,000.

THERE SHE IS

Number of entrants in the first Miss America contest, in 1921: 8; number of entrants in 1924: 83; number of contestants in 1924 who were blond: 7. Most telling review: "These contests lack the wholesomeness of almost any kind of athletic contest, as victory is given for something which has no relation to achievement or skill."

MOVIE MADNESS

Weekly movie attendance in 1920: 35 million; in 1930: 90 million. For every $10 spent on movies, the amount spent on cosmetics: $7. Amount spent on the Protestant Church: 9¢.

BIRTH CONTROL

Number of condoms produced in one year by Youngs Rubber Corp.: 20 million. Number of the 2,200 women in a Bureau of Social Hygiene study who approved of birth control: 734. Number who used birth control: 730.

BY THE NUMBERS

Percentage of women who have sexual intercourse before marriage: 7. Percentage of wives who have sex once or twice a week: 40. Percentage who believe a man is justified in having sex with a woman other than his wife: 24. Percentage who think a woman is justified in sleeping with a man other than her husband: 21.

Number of divorces per 100 marriages in 1920: 13.4; in 1928: 16.5.

SEX AND THE LAW

Number of alleged Mann Act violations investigated by the FBI between June 30, 1922, and June 30, 1937: 50,500. Number of written complaints received by the Bureau in 1921: 9,949; number of convictions from 1920 to 1928: 3,756.

Of the 515 persons convicted in 1924, percentage involved in prostitution:

10; in seduction or false promise of marriage: 7; in interstate adultery or fornication: 70.

PRESIDENTIAL PASSION

I love your back, I love your breasts
Darling to feel, where my face rests,
I love your skin, so soft and white,
So dear to feel and sweet to bite . . .
I love your poise of perfect thighs,
When they hold me in paradise . . .

(Poem from Warren G. Harding to Carrie Phillips, his mistress.)

MONEY MATTERS

Gross National Product in 1920: $91.5 billion. Gross National Product in 1929: $103.9 billion.

Total amount spent on advertising in 1919: $1.4 billion; in 1929: $2.9 billion. Average yearly salary in 1920: $1,236; in 1930: $1,368.

WE THE PEOPLE

Population in 1920: 105 million; in 1930: 123 million. Average life expectancy of males in years: 53.6; of females: 54.6. In 1920, percentage of males over the age of fifteen who are single: 35. Percentage of females over the age of fifteen who are single: 27.

DEFINING DEVIANCE

Number of pages of *The Doctor Looks at Love and Life* (a 1926 best-seller) that discussed homosexuality: 39 out of 279. How the book defined a gay man: "A man of broad hips and mincing gait, who vocalizes like a lady and articulates like a chatterbox, who likes to sew and knit, to ornament his clothing and decorate his face."

ON THE ROAD

Cars sold in 1920: 1.9 million; in 1930: 2.7 million. In 1919, percentage of cars fully enclosed: 10; in 1924: 43; by 1927: 83. Date of first car radio: May

1922; of first commercially available car radio: 1927. Of twenty-six families surveyed in 1925, number of car owners who live in homes without a bathtub: 21.

FINAL APPEARANCES

Virginia Rappe (1921). Warren G. Harding (1923). William Jennings Bryan (1925). Rudolph Valentino (1926). The Model T (1927).

Chapter Four

HARD TIMES: 1930—1939

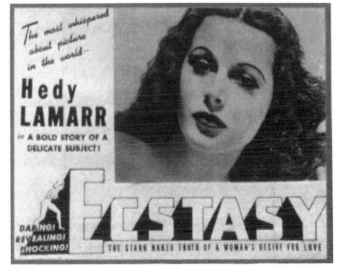

Hedy LaMarr's on-screen orgasm in 1933's *Ecstasy* made the film an underground classic.

The bottom dropped out of the stock market in October 1929. In the space of a few weeks $30 billion disappeared, $30 billion worth of giddy optimism, irrational speculation, and greed. At first, some people tried to explain the crash as some kind of Darwinian justice, or as God's wrath in response to avarice. The crash was simply a correction. Those who were going to jump had already jumped.

The country and its government seemed to be paralyzed, watching helplessly as banks failed and businesses disappeared. Mortgage lenders foreclosed on farms, houses, and dreams. For want of a single payment, the future vanished.

The joyous dance craze of the previous decade turned into a grueling sideshow industry, where couples held each other in monthlong marathons,

trying to keep moving in return for free food and the chance to win a prize. In Horace McCoy's dark 1935 novel *They Shoot Horses, Don't They?* the dance hall becomes a purgatory of exhausted souls, and one dancer helps his partner commit suicide.

Americans stood in line for food, for the chance of work, for a place to sleep. By 1932, eight million Americans were unemployed—one out of every five persons in the labor force, one out of every seven adults. Sure, there were people whistling "Happy Days Are Here Again," but the real anthems were "Brother, Can You Spare a Dime?" and "Love for Sale." Scarcity turned sex into a commodity; it destroyed both dignity and desire. Yet even here there was a double standard. America could forgive gold diggers, but not beggars.

In the twenties, middle-class couples did not consider marriage until the breadwinner was making $40 per week. In 1933 the average salary was about half that. If statistics can convey the death of romance, consider these: The marriage rate fell from 10.1 per 1,000 members of the population in 1929 to 7.9 in 1932; the birthrate fell from 18.9 in 1929 to 16.5 in 1933.

In his 1935 novel *Butterfield 8,* John O'Hara described the effect the Depression had on men. They took stock of what life had given them, itemizing wife, children, investment, cash, houses, cars, boats, etc. "They were— the men—able to see right away that the tangible assets in the spring of 1931 were worth on the whole about a quarter of what they had cost originally, and in some cases less than that. And in some cases, nothing. . . . Then a few men, a few million men, asked themselves whether the things they had bought ever had been worth what had been paid for them. . . . There were men, who, beginning their inventories with 'I have a wife and two children' went through the list of their worldly goods and then came back to the first item: wife. Then they discovered that they could not really be sure they had their wives."

Those who had been America's heroes in 1918 were now the country's outcasts—forgotten men. A ragtag army of World War I veterans gathered in Washington to ask for early payment of a promised war bonus. They erected their own shantytown and called it Hooverville. The president and Congress ignored them until July 28, 1932, when President Herbert Hoover ordered General Douglas MacArthur to send in troops. Saber-wielding cavalry cleared the capital. Yesterday's manhood, written in blood, was worthless.

America became a nation of transients: Almost a million hoboes and hitch-hikers roamed the country by 1933, some 200,000 of them adolescents. Women

dressed in men's clothing to avoid the kind of trouble their older sisters once sought with reckless abandon.

In 1930 an Iowa artist named Grant Wood asked his sister and his dentist to pose for a painting, a tribute to the tough rural stock of America. He dressed his sister in a simple frock, a white collar held close around her neck by a brooch. The dentist he outfitted in overalls, a band collar shirt, buttoned tight around the throat, a dark business jacket. He posed the couple, board stiff in front of a plain house. The man, transformed by art into a midwestern farmer, grips a pitchfork and stares straight ahead. The woman looks away. The resulting painting, called *American Gothic,* became one of the most enduring images of the decade, an icon of the spirit that survived the hard times of the Depression. Yet, it is impossible to imagine the couple having sex.

Poverty laid bare the ugly, brutal demons that lurked at the edge of the American dream. Observers noted a rebirth of prejudice, a wariness toward outsiders, noting, "Nerves too long frayed by unemployment and the humiliation of relief may again be finding a way to punish one's neighbor for the wrongs one's institutional world has done to one." In desperate times, people took comfort in conformity, an almost superstitious need to huddle together with "people like us"—and to hunt for and persecute scapegoats.

Near Scottsboro, Alabama, police arrested nine black youths riding on a freight train after an altercation with white youths. The blacks had thrown the whites off the train. Searching a boxcar, the police found two white girls. A doctor examined the girls and found traces of semen, but no signs of rape. The prosecution didn't care. As one historian noted, "Rape and rumors of rape were a kind of acceptable folk pornography in the Bible Belt." The girls, perhaps afraid of being arrested for vagrancy or prostitution, cooperated with the prosecution. Outside the courtroom, 10,000 whites gathered to ensure justice. The prosecutor asked the examining physician if the semen he had found belonged to a white man or a black man. In the first trial a state's attorney held up cotton panties and demanded the protection of southern womanhood. By the fourth trial, the panties had, miraculously, turned to silk.

Eight of the nine defendants were sentenced to death, igniting a national scandal. Although the Supreme Court eventually overturned the convictions, the Scottsboro boys would spend an aggregate of 130 years in jail.

The signs of crisis were everywhere, but it was not easy to derail a great nation. Those with faith in America—or with enough wealth to live beyond

the grasp of the Depression—were still building. A group of investors including Pierre Du Pont and Al Smith raised $52 million to construct the Empire State Building (completed in 1931), then the tallest in the world. The project took less than a year to complete; forty-eight workers died in the process, but the finished spire loomed over the city. They called it Al Smith's last erection. An enterprising businessman painted an ad on the roof of a nearby building: BUY YOUR FURS FROM FOX. The ad would not reach many eyes. Only a quarter of the office space had been rented.

A reporter attending the opening found a crude mural drawn in pencil by one of the workers in an empty loft on the 55th floor, which depicted "a towering masculine figure . . . fornicating, *Venere aversa,* with a stooping female figure who has no arms but pendulous breasts. The man is exclaiming, 'O Man!' Further along is a gigantic vagina with its name in four large letters under it." At the pinnacle of man's endeavor—pornography, the great equalizer.

In November 1932 the people of America elected Franklin Delano Roosevelt in a landslide. FDR promised a New Deal and the end of Prohibition. On taking office, the new president told the nation, "This great nation will endure as it has endured, will revive and will prosper. The only thing we have to fear is fear itself."

FDR gave his blessing to the 1933 Chicago World's Fair, an event dedicated to a Century of Progress. A ray of light from the star Arcturus actuated a switch that turned on the lights of the glittering pavilions along the shore of Lake Michigan. More than 22 million visitors came to the fair in its first year, crowding the Hall of Science, the re-creations of a Mayan temple, and a midget village. But by far the most popular attraction was a blond fan dancer named Sally Rand. The young woman, who admitted to being destitute until "she took off her pants," danced naked behind ostrich plumes and a giant opaque balloon.

Nudity, it seems, was the symbol of progress. Titillation, the power to divert public attention away from the unthinkable, would become a national resource. (Indeed, FDR's National Recovery Administration went so far as to dictate how many striptease acts could be performed in an evening of burlesque in New York. The figure: four.)

As dust gathered in the wind, as the floodwaters rose, Americans looked for escape. And America was discovering that poverty had the same power to change sex as prosperity. Where one gave permission, the other created a desperate indifference, or a fear that change might lead to chaos. The battle between the sexes, once fought for equality and respect, now was a struggle for survival.

With FDR came the repeal of Prohibition. What had been perceived as a moral crusade and called the Noble Experiment had become a national joke. The transition from dry to wet was a time of celebration. What had been naughty now bordered on the respectable. The gangsters who had peered through peepholes and listened for passwords now took reservations. Speakeasies became fashionable nightclubs such as 21, El Morocco, the Cotton Club, and the Stork Club. Rumrunners and respectable businessmen built Art Deco bars and restaurants and Café Society was born. At the Stork Club, a haunt frequented by gangsters and G-men alike, J. Edgar Hoover hung out with Walter Winchell, whose syndicated gossip column and radio broadcasts reached 30 million Americans a week.

Alcohol was no longer government business. If you had a problem with booze, you could join the newly created Alcoholics Anonymous. Former liquor control agents such as Harry Anslinger would have to create a new threat—"reefer madness"—to stay employed.

The end of Prohibition didn't mean the end of organized crime, however. The gangsters simply turned to other endeavors, among them extortion, gambling, and prostitution. Al "Scarface" Capone took the fall in Chicago on an income tax rap, but Charles "Lucky" Luciano made the Mob in New York into a national syndicate—with himself as the boss of bosses. He seemed beyond the reach of the law, until an enterprising assistant D.A. noticed that all the prostitutes who came through court had the same lawyer, same bail bondsman, and same sad story. Investigations revealed an organized sex trade that netted $12 million a year. Luciano allegedly ran more than two hundred houses of ill repute, an affront that could not be overlooked. Where the Mafia might adhere to a code of silence, the women they hired did not. One prostitute testified that she had been Luciano's personal property, that she had sat in his

bedroom while he organized the prostitution ring, listening to incriminating phone calls between sex acts. Prosecutor Thomas Dewey sent the father of organized crime up the river on a sex charge.

At the outset of the thirties the culture almost achieved a sexual breakthrough. An editorial in the November 25, 1931, *Nation* advised "permitting grown-ups to decide for themselves what books they shall buy, what plays they shall see and even what pictures of undressed females they shall look upon."

It was not to be. In times of economic chaos, the need for control focused on the erotic.

Other nations, facing the same upheaval, viewed sex and sexual expression as the roots of disorder. Hitler's thugs ransacked the Berlin Institute of Sexual Science and destroyed the works of Magnus Hirschfeld. Hitler suppressed Theodoor van De Velde's pioneering sex manual *Ideal Marriage,* a book that had gone through forty-two printings in Germany between 1926 and 1933. On May 10, 1933, five thousand Nazis started a bonfire that would consume a culture. Building a pyre in front of the University of Berlin, students put to the torch volumes by, among others, Albert Einstein, Thomas Mann, Karl Marx, H. G. Wells, Ernest Hemingway, Havelock Ellis, Margaret Sanger, and Sigmund Freud. (Freud dwelt on "the animal qualities of human nature," cried one of the book burners.) A Nazi justified the purge: "The fire is to us the sign and symbol of an inflexible will to purity. The nests of corruption shall be destroyed and the haunts of degeneration purified. Youth, prizing its human dignity, presses forward to the light, to the sun. O thou eternal longing of the soul to be free from degrading smut and trash!"

America looked at those flames and recoiled. More than 100,000 people in New York City and 50,000 in Chicago marched in protest of the Nazi book burnings.

John Sumner, who had inherited Anthony Comstock's New York Society for the Suppression of Vice, quietly removed the group's symbol—a top-hatted gentleman tossing a pile of books onto a bonfire—from the annual report. Sumner began to withdraw from the censorship crusade, noting that perhaps Comstock had been "somewhat of a religious fanatic who also loved notoriety."

Not everyone in America was opposed to censorship. There were those who heard the phrase "banned in Boston" and felt civic pride. Bluenoses in New England blacklisted Boccaccio's *Decameron,* Erskine Caldwell's *God's Little Acre,* and Hemingway's *The Sun Also Rises,* while Detroit censors protected citizens from Casanova's *Mémoires* and Hemingway's *To Have and Have Not.*

In 1930 Congress passed the Hawley-Smoot Tariff Act. A last-minute amendment gave U.S. Customs the power to ban obscene books or items. Senator Reed Smoot, like Comstock before him, had thrown a "senatorial stag party." Legislators leered over contraband copies of *Lady Chatterley's Lover,* the *Kama Sutra,* and Frank Harris's *My Life and Loves.* Lust was a foreign product, a foreign idea that should be kept from American shores. Apparently, there's nothing like sex to obscure a lawmaker's memory of the Bill of Rights. (The nonsexual parts of the Smoot-Hawley bill, intended to ease the effects of the Depression, actually cost the nation nearly $2 billion a month in lost trade opportunities, and was generally credited with contributing to the economic chaos that led to World War II.)

In the same year that the Nazis burned books, Morris Ernst, the general counsel of the American Civil Liberties Union, defied U.S. Customs by trying to bring a copy of James Joyce's *Ulysses* into the country. In December 1933 Judge John Munro Woolsey ruled that the book did not "stir the sex impulses." Nowhere could he find "the leer of the sensualist." Within weeks, 33,000 Americans bought—and were baffled by—Joyce's literary lust.

U.S. Customs did not readily relinquish its role as guardian of American morals, however. In 1934 it would ban Henry Miller's *Tropic of Cancer,* a ribald description of the writer's life in Paris.

While Customs seemed obsessed with controlling foreign ideas about sex, it let foreign ideas about censorship pass. The increasing influx of immigrants had introduced a Roman Catholic model into moral intervention. While the puritans relied on government and vigilante vice groups for repression, the Catholics looked to the Vatican. For centuries, the Catholic Church had published the *Index Librorum Prohibitorum,* a list of banned publications. The church not only burned books; it had, on occasion, burned authors. Churchgoers who sampled prohibited literature faced a different kind of fire.

Catholics believed in a single infallible authority, while among Protestants "every man was his own priest." In short, the Catholics were better orga-

nized than the Protestants. When "the agents of gang religion" tried to dictate the tastes of Americans, the results would be felt for decades.

From the outset, Hollywood had been plagued by freelance censors. It seemed that every city and township had a scissors-wielding crusader. Following the Fatty Arbuckle scandal in 1921, studios confronted nearly forty separate state bills calling for film censorship. They had responded by creating Will Hays's office. The industry would regulate itself according to a set of guidelines known as "the Don'ts and the Be Carefuls."

The Hays codes may have placated the Protestants; the Catholics had other ideas. George Cardinal Mundelein of Chicago, Martin Quigley (publisher of the *Motion Picture Herald*), Joseph Breen (a Catholic reporter and PR flack), and two Jesuits, Fathers Daniel Lord and Fitzgeorge Dinneen—all connected to the Archdiocese of Chicago—felt that the Hays guidelines had become a travesty and that Will Hays himself had become a studio stooge. Quigley and company drafted a model of the "Cardinal's Code," what became the Motion Picture Production Code in March 1930.

Under the rubric of General Principles, the code declared: "No picture shall be produced which will lower the moral standards of those who see it. Hence the sympathy of the audience shall never be thrown to the side of crime, wrongdoing, evil or sin. Law, natural or human, shall not be ridiculed, nor shall sympathy be created for its violation."

The Production Code prohibited scenes that made adultery or illicit sex seem attractive. (One critic wondered how the studios hoped to accomplish this goal. Did it mean that one had to show ugly mistresses?) Directors could not indulge in scenes of gratuitous passion; ardor could appear only when essential to the plot. (But the very nature of passion is that it is unexpected, that it leads only to romance and not to, say, the discovery of radio waves or a new planet.)

The new code was against "excessive and lustful kissing, lustful embraces and suggestive postures or gestures." As Gene Fowler, a Hollywood humorist, wrote, "Will Hays is my shepherd, I shall not want. He maketh me to lie down in clean postures."

If a plot demanded passion, then directors were to show it so as "not to stimulate the lower and baser emotions." Or, as Fowler noted, "Thou shalt not

photograph the wiggling belly, the gleaming thigh or the winkling navel, especially to music, as goings-on of this ilk sorely troubleth the little boys of our land and so crammeth the theater with adolescence that papa cannot find a seat."

The code prohibited treatment of rape, seduction, sexual perversion, white slavery, sex relationships between whites and blacks, scenes of child-birth, and the filming of a child's sex organs. Nudity was out of the question.

Hays and the Hollywood moguls saw the Production Code as a means of fending off real censorship.

During the first years of the Depression moviegoers vanished. Almost 90 million viewers had flocked to dream palaces weekly in 1930. By the end of 1931 the figure was down to 60 million. Father Daniel Lord, trying to justify the Production Code, blamed the downturn on "too much sex" in the movies.

Hollywood looked at the figures and came to the opposite conclusion. As the Depression deepened, directors by and large ignored the code. Studios on the edge of bankruptcy released increasingly explicit films. Marlene Dietrich, dressed in a man's tuxedo, kisses a woman to get Gary Cooper's attention in *Morocco* (1930). Joan Crawford plays a prostitute led astray by a preacher in *Rain* (1932). Jean Harlow uses sex as a passport to success in *Red-Headed Woman* (1932). Barbara Stanwyck does the same in *Baby Face* (1933), sleeping her way to the top of the corporate ladder. With titles such as *Illicit* (1931), *Sinner's Holiday* (1930), *Confessions of a Coed* (1931), *Forbidden* (1932), and *Skyscraper Souls* (1932), the movie studios pushed the limits of propriety. There was even a version of William Faulkner's controversial novel *Sanctuary,* a story that featured the raping of a woman with a corncob.

Musicals, too, ignored the code. In a single year, with *42nd Street, Gold Diggers of 1933,* and *Footlight Parade,* Busby Berkeley transformed near-naked chorines into kaleidoscopic erotic fantasies and Freudian fountains. In one scene, he turned women into musical instruments, prompting a mother to protest, "I did not raise my daughter to be a human harp."

In 1932 director Cecil B. DeMille, flouting the code, released a film that combined "sex, nudity, arson, homosexuality, lesbianism, mass murder and orgies."

The Sign of the Cross was spectacular. It followed Hollywood's old trade-mark formula of six reels of sin, one reel of condemnation, opening with the

burning of Rome, followed by Claudette Colbert, playing the Empress Poppaea, breast deep in a milk bath. A beautiful body, glistening, always on the edge of exposure—it held the nation's attention. According to at least one film historian, this film played a significant role in triggering the Catholic crusade against the movies.

The film pitted the Christian virgin Mercia, a model of purity, against all the vices of pagan Rome. It culminates in an afternoon of Roman programming. See a naked slave tethered to a stake as a love morsel for a crazed gorilla. Witness a woman clad in only a garland of flowers suspended between two stakes while crocodiles advance. Watch elephants crush the skulls of true believers, Amazons spike Pygmies on spears, gladiators slaughter slaves. See lions feast on Christians! In one powerful scene a Christian martyr carries a child into the arena, hiding the girl's face beneath his cloak so she will not see the slaughter. Father Lord and the others wanted to draw a cloak over the eyes of all Americans.

Realizing that the Production Code would not be enforced unless there was pressure from outside the industry, supporters began to organize, reaching out to other influential Catholics. In October 1933 the group persuaded Monsignor Amleto Giovanni Cicognani, the newly appointed apostolic delegate from Rome, to endorse a crusade: "Catholics are called by God, the Pope, the bishops and the priests to a united and vigorous campaign for the purification of the cinema, which has become a deadly menace to morals." In response, the American bishops appointed a committee to organize what would become known as the Legion of Decency.

More than seven million Catholics took a pledge: "I condemn indecent and immoral pictures and those which glorify crime or criminals. I promise to do all that I can to strengthen public opinion against the production of indecent and immoral films and to unite with all those who protest them. I acknowledge my obligation to form a right conscience about pictures that are dangerous to my moral life. As a member of the Legion of Decency I pledge myself to remain away from them. I promise, further, to stay away altogether from places of amusement which show them as a matter of policy."

"Purify Hollywood or destroy Hollywood" became the anthem of the new crusade. A priest from Buffalo came up with a new catechism: M = moral menace, O = obscenity, V = vulgarity, I = immorality, E = exposure, S = sex. Bishops and priests produced lists of blacklisted films, often in conflict with one another.

Film historian Gregory Black wrote, "The Catholic periodical *Extension Magazine* told readers that movies were 'an occasion of sin.' If Catholics knowingly went to a movie that the church had declared 'immoral,' they had committed a mortal sin. A mortal sin was considered a major breach of Catholic dogma, and if not forgiven through confession and serious penance, would result in eternal damnation. Suddenly, Catholics faced the prospect of eternal damnation for going to the wrong movie!"

In September 1934 some 70,000 students took to the streets of Chicago, not to protest book burning in Germany but to declare a new war. They carried placards that read: AN ADMISSION TO AN INDECENT MOVIE IS AN ADMISSION TICKET TO HELL.

It was not enough to pledge fidelity to a Catholic-approved code for the movies; the Production Code required an enforcer.

In 1932 Joe Breen, who had joined Hays's office as a special assistant to the president, wrote to Father Wilfrid Parsons, an influential Jesuit, complaining that Hollywood Jews would never honor the code. "They are simply a rotten bunch of vile people with no respect for anything beyond the making of money," he declared. "Here in Hollywood we have paganism rampant and in its most virulent form. Drunkenness and debauchery are commonplace. Sexual perversion is rampant. Any number of our directors and stars are perverts. These Jews seem to think of nothing but moneymaking and sexual indulgence. The vilest kind of sin is a common indulgence hereabouts and the men and women who engage in this sort of business are the men and women who decide what the film fare of the nation is to be. They and they alone make the decision. Ninety-five percent of these folks are Jews of an eastern European lineage. They are, probably, the scum of the earth."

In a meeting with studio heads, Joseph Scott, a Catholic lawyer invited by Breen and Los Angeles' Bishop Cantwell, called the Jews "disloyal" Americans engaged in "a conspiracy to debauch the youth of the land." Scott reminded the producers that there were groups in America "sympathetic with the Nazi assaults on Jews in Germany [that] were even now organizing further to attack the Jew in America."

Catholics represented one third of the movie audience in major cities. A boycott would have killed the industry. Hollywood capitulated. Hays hired

Breen to enforce the Production Code. Between 1936 and 1939 Breen's office handed down 26,808 opinions interpreting the code.

In the gospel according to Breen, the sophisticated married couple Nick and Nora Charles slept in separate twin beds throughout the half dozen *Thin Man* films. No women appeared pregnant on-screen. No bathroom had a toilet. And Betty Boop gave up her garter.

Under the Production Code the average length of a screen kiss dropped from 72 inches of film (about four seconds) to 18 inches (or 1.5 seconds). Nudity disappeared. Troubled by the trailer for *Tarzan and His Mate* that showed Jane swimming naked with Johnny Weissmuller, Breen demanded that the scene be cut from the finished movie. He also insisted on less revealing attire for the jungle couple. In a scene where Tarzan drags Jane into their tree-top abode, Breen ordered cut the sound of Jane's contented laughter.

In another film, he objected to the look of expectation on a bride's face as she climbed into bed with her husband on a Pullman train. You could not show sexual pleasure, and neither could you show the anticipation of sexual pleasure. The code insisted that great care be taken when filming in bedrooms because "certain places are so closely and thoroughly associated with sexual life and with sexual sin that their use must be carefully limited." According to some scholars, the code changed the nature of lovemaking, creating an unlikely *Kama Sutra* where couples on a couch or bed had to keep one foot on the floor.

Breen censored references to abortion, breast-feeding, pregnancy, and childbirth. Children fell from the sky (literally, when Boy was added to the cast of Tarzan). A highly acclaimed educational film titled *The Birth of a Baby,* which showed scenes of childbirth, was denied approval. The subject was "sacred."

Breen inflicted the standards of the Victorian era on movie dialogue. One could not utter the words "nerts," "nuts," "cripes," "fanny," "Gawd," "hell," or "hold your hat." You could not call a woman an alley cat, a bat, a broad, a chippie, a tart, a slut, or a madam.

According to Frank Walsh, author of *Sin and Censorship,* Joe Breen seemed obsessed with "the intimate behavior of barnyard animals." "At no time," opined a member of Breen's staff, "should there be any shots of actual milking, and there cannot be any showing of the udders of the cow." The code could not tolerate King Kong's lust for Fay Wray, and insisted on the cutting

of scenes that showed Kong peeling off the dress from the writhing sacrificial victim. (It was Breen, not Beauty, who killed the Beast.) If he did not get a film on its debut, he'd cut it on its rerelease. By the next decade, such sexually aggressive monsters as Frankenstein and Dracula had been reduced to straight men for Abbott and Costello.

As for relations between humans, the battles over the filming of *Gone With the Wind* (1939) were impressive. Breen's office shortened a shot of Scarlett O'Hara licking her chops following the night that Rhett Butler had carried her up the stairs. The censors requested that Rhett's parting shot be changed to "Frankly, my dear, I just don't care." More than two million people had read the novel without Western civilization being plunged into depravity. Producer David O. Selznick refused to change the line.

The censor's control reached beyond the cutting room. Hollywood studio heads went out of their way to police the private lives of actors and actresses. The fan magazines and gossip columnists played along. The public never learned that Loretta Young had Clark Gable's baby after costarring in *The Call of the Wild.* Or that Marlene Dietrich was a switch-hitter. Or that Cary Grant and Randolph Scott shared a beach house until the studio objected. The dateline on stories about the industry no longer read Hollywood Babylon—it was Anytown, U.S.A.

Mae West arrived in Hollywood in 1932, a thirty-nine-year-old veteran of Broadway, a woman in complete control of her public persona. West had already done what no Hollywood actor, actress, writer, or producer had done before. She had gone to jail for what she had to say about sex. West was arrested in 1927 during a crackdown ordered by Joseph McKee, acting mayor of New York City. West's raucous *Sex* had already played 375 performances on the Great White Way. She spent eight days in jail, then returned with an equally rowdy, even more successful play called *Diamond Lil.*

While Paramount tried to figure out a way to get a script of *Diamond Lil* past the Hays office, it gave West a small part in *Night After Night*, a 1932 George Raft movie. Writing her own lines for what amounted to little more than a cameo appearance, she stole the picture. West's first scene is a classic moment with a hatcheck girl who exclaims, "Goodness, what beautiful diamonds." To which

West replies, "Goodness had nothing to do with it, dearie." The exchange set the tone for West's characters in all the films that followed. She was constantly setting the world straight.

The Hays office might change the title of *Diamond Lil* to *She Done Him Wrong* (1933) and make the story incomprehensible, but nothing could restrain Mae. She had her own view of men, telling a young woman who had fallen on hard times, "Men's all alike, married or single. It's their game. I happen to be smart enough to play it their way."

"Who'd want me," sobs the girl, "after what I've done?"

Mae reassures her: "When women go wrong, men go right after them."

In *She Done Him Wrong* West, playing a singer in a saloon, pursues Cary Grant: "Why don't you come up sometime, see me? Come up, I'll tell your fortune." When Grant hesitates, she delivers the line that gets the laugh: "Aw, you can be had."

One of West's sultriest moments came when she took the stage to sing "A Guy What Takes His Time," a candid celebration of foreplay. Censors in New York, Ohio, Maryland, Massachusetts, and Pennsylvania excised the song. The Hays office, trying to salvage its reputation, cut the scene to an opening and closing verse, leaving a visible scar on the film.

Paramount teamed West and Grant in a second film, *I'm No Angel* (1933). Her slow shimmy during "Sister Honky-Tonk," shot largely off or below camera, was as knowing a sexual dance as was ever performed on film. The film is filled with classic one-liners. After a lawyer in a breach of promise suit tries to establish her promiscuity, West purrs, "It's not the men in your life. It's the life in your men." Representing herself, she cruises past the jury box with the aside, "How am I doing, hmm?"

West played for the real jury—her audience. More than 46 million Americans saw these first two films. She proved that sex sells, single-handedly bringing Paramount back from the edge of bankruptcy. However, facing pressure from the Legion of Decency, Mae's early films were removed from circulation. With the arrival of Joe Breen, each successive film was subject to increased scrutiny. Reviewing the script for *Klondike Annie* (1936), Breen objected to the presence of a Bible in a scene with West. He ordered the book's title changed to *Settlement Maxims*.

Whatever else she accomplished, Mae West proved the critics right. She confessed that the danger lay not in what she said but in how she said it. Be-

tween the talkies and radio, America had discovered how to listen for sexual innuendo. A single woman, narrating her own erotic script, had inspired millions and would continue to do so for the rest of the century. She was unafraid. She was funny. Newspapers celebrated her measurements (36-26-36) as a healthy return to lush womanhood, not fully comprehending that Mae wore the turn-of-the-century corset as a kind of defiant joke.

When aviators donned an inflatable life vest in World War II, they called it a "Mae West."

Breen and supporters of the Production Code claimed their efforts were responsible for the golden age of cinema. Even today proponents of censorship, rating systems, and family values point to the films of the thirties as proof that imposing controls over art can be beneficial. It's not that simple. Cutting a line here, a scene there, could not diminish either the excellence of many of the films or the basic sex appeal of Hollywood stars.

What the censors could not control was intangible. Biographer René Jordan notes simply that Clark Gable had machismo: "There was a constant aura of sex about him, and the plots of his movies often suggested that a night with Gable was a very special experience for the girl involved. The screen Gable insinuated he had a power to give orgasms, even to a generation of women who still were not too sure whether they were supposed to have them."

When Clark Gable took off his shirt to reveal a bare chest, it was said that sales of men's undershirts plummeted. The truth of the matter? In the Depression, sales of everything fell, including tickets to movies.

The code could not repress attitude, beauty, or pure animal magnetism. It could place its seal of approval on polite films and send the rest to the B circuit. Life as depicted in post–Production Code movies reminds one of Henry James's assessment of proper Americans at the turn of the century—all dressed up and with nowhere to go.

In 1933 *Ecstasy,* a distinctly noncode foreign film, introduced an unknown teenage actress named Hedwig Kiesler to the world. The film presents the sexual awakening of a young woman trapped in a love-starved marriage. She swims naked in a pond, then runs unclothed through the woods as her horse gallops

off with her clothes. But the most naked moment of the film is the shot of her face as she experiences sexual fulfillment for the first time.

In 1935 the Treasury Department confiscated the film. (Were they worried it was a counterfeit orgasm?) An appeals court judge upheld the ban, saying that the film was a "glorification of sexual intercourse."

The young actress married an Austrian munitions maker who tried to buy and destroy all the prints of the film, but *Ecstasy* would make the rounds of "adults only" art houses for decades, playing at more than four hundred theaters during the next twenty years. Changing her name to Hedy Lamarr, the actress went to Hollywood and became a star.

Just as Prohibition had produced a demand for bootleggers and speakeasies, the code's film prohibitions created a market for low-budget exploitation films. A group of independents known as the Forty Thieves produced and distributed features across the country on what was known as the grindhouse circuit. Grindhouse films dealt with subjects forbidden by the code, including sex, nudity, venereal disease, drugs, and prostitution, and had titles like *The Road to Ruin* (1934), *Reefer Madness* (1936), and *The Cocaine Fiends* (1936). Theaters, trying to escape local censorship, advertised them as "adults only" films. The ads were a con: Many of the Forty Thieves came out of carnival backgrounds and, like sideshow barkers, knew how to hawk their wares.

The films they showed were tawdry little dramas, the natural descendants of 1913's *Traffic in Souls* (a film that portrayed the horrors of the supposed white slave trade). Americans could learn how cocaine led to prostitution, producing in women the mad desire to stand around in lingerie. The titillation was cloaked as cautionary moral tales: *The Vice Rackets* (1937) showed "Scarlet Girls Chained to the Vultures of Vice," while, at the outset of the next decade, *Mad Youth* guided teenagers through the "Pitfalls of this Streamlined Age." *Secrets of a Model* asked, "Can a beautiful model stay pure?" Films called Goona-Goonas showed naked natives in their natural habitats. Nonwhite races were allowed to display bare breasts and raw passion, the virtue of being pagan primitives. Even Hollywood had learned from *National Geographic*.

The Forty Thieves took the 1935 sex hygiene film *Damaged Goods* and repackaged it as *Forbidden Desires*. The genre associated sex with sleaze, sex with shame, sex with horrible consequence, sex with fear. Anthony Comstock could not have asked for more.

Sex was relegated to specific locations in the city. In 1937 Fiorello La Guardia, the mayor of New York, closed the burlesque houses in Times Square. The theaters became grindhouses, projecting sexploitation flicks where the Minsky brothers had once staged the best bawdy shows in town.

The Depression had allowed censors to manipulate mainstream filmmakers, but the lone entrepreneur, his trunk filled with stag films, still drove around the country showing *A Stiff Game, Matinee Idol, Buried Treasure, Hycock's Dancing School, Mexican Dog,* and *Unexpected Company* to lodges, veterans' and fraternal organizations, at bachelor parties and smokers. The hard-core pornography of the thirties presented an unending line of traveling salesmen, icemen, repairmen, handymen, milkmen, and grocery boys visiting lonely, frustrated women in their homes. Even physicians made house calls to administer *Dr. Hardon's Injections*— though office visits to doctors and dentists in this film led to the same end.

In these male fantasies, every man had a job.

Fellatio could be found in almost half the films, but barely one in ten showed cunnilingus. Lesbian action was commonplace, but male homosexuality was virtually nonexistent. (Bestiality was actually more common than male homosexuality.) [Rachel Maines history of vibrators notes that when the devices showed up in stag films as sex toys, they disappeared from household catalogs.] The commercial stag-film market reflected the predilections and prejudices of its all-male, middle-class, heterosexual audience.

During the 1930s, New York City launched a major antiprostitution crusade. Polly Adler, girlfriend of gangsters and madam extraordinaire, was arrested, not for running a house of prostitution but for possessing stag films. Even brothels had become movie houses. Stag films were just another avenue of escape.

The censors had cleaned up Hollywood, but there was still plenty of titillation to be found at the corner newsstand.

Rack after rack of magazines held in place by long pieces of wire offered fantastic visions of the future, of the past, of the next few hours. The cover of *Screenland* showed a couple locked in a passionate embrace. *Film Fun* featured a sexy starlet in a shimmering nightgown. In *Hell's Angels* Jean Harlow had asked, "Would you be shocked if I put on something more comfortable?" "Apparently not" was the nation's answer.

Lingerie-clad models posed provocatively for the covers of *Spicy Stories, Spicy Mystery,* and *Spicy Detective Stories,* and cowgirls with low-slung peasant blouses graced the cover of *Spicy Western.* Women with torn dresses and imperiled breasts pleaded for help on the covers of *Dime Detective, Private Detective Stories,* and *True Gangster Stories.*

Then there were the unadorned nudes in *Artists and Models, Body Beautiful,* or *Spotlight: Photo Studies of the Female Form.* The art books presented models "selected on account of their supple lines, their artistic naturalness and their beautiful development. They reflect the artistic spirit of feminine beauty in our time."

The women's market had *True Confession, True Story, True Romances, Modern Romance.* Bernarr Macfadden's pulp empire reached 7.4 million readers. The publisher actually considered running for president. The editorial credo of *Candid Confessions* suggested a possible platform: "As long as the sex urge is one of the most powerful urges in creation, just so long will we have men and women searching for the love-happiness which is every person's birthright. Some of us find it through experiences which almost wreck our lives, others by an easier path. All of us are entitled to find our mate."

Alongside the pulps, with their usual array of ladies in lingerie, a new kind of men's magazine went on sale in the fall of 1933. *Esquire* featured articles on male fashion, fiction by Hemingway and F. Scott Fitzgerald, racy cartoons, and the Petty Girl. George Petty created an airbrushed beauty who was soon famous. She was a sexually liberated lady who reflected the Sugar Daddy/Gold Digger mentality of the magazine. The Petty Girl was always talking on the telephone and was refreshingly candid in her conversations, as reflected in this caption: "Western Union? Send me a boy—a big boy." By the end of the decade she had graduated to gatefold status; *Life* magazine would call her the "feminine ideal of American men."

Henry Luce launched *Life* in 1936, using something he called photojournalism to open a window to the world. *Life* depicted the depth of the Depression as well as the high jinks of Café Society. "*Life* Goes to a Party" was one of its most popular features. The magazine reflected middle-class, mainstream sensibilities, but it wasn't above printing a provocative pictorial from time to time. It ran a frivolous feature on "How a Wife Should Undress" in 1937. "Two excellent purposes are served by rolling down stockings instead of merely

pulling them off by the toes. Economically, a husband is pleased by the absence of runs; romantically, he is gratified by his wife's graceful method of displaying her legs."

A serious story on the film *The Birth of a Baby* the following year gave *Life* its first censorship problems. The issue was banned in more than fifty localities, including Boston (of course), Brooklyn, Chicago, Memphis, New Orleans, Savannah, Tucson, all of Pennsylvania, and Canada.

In addition, there were enough buxom beauties in the comics to satisfy the yearnings of the most precocious adolescent: Burma and the Dragon Lady in Milton Caniff's *Terry and the Pirates;* Daisy Mae, Moonbeam McSwine, and Stupefyin' Jones in Al Capp's *Li'l Abner;* Dale Arden in Alex Raymond's *Flash Gordon.*

By 1933 author Nathanael West had seen the obscenity of mass-culture distractions, the selling of dreams when dust hung in the air and people sold apples on street corners. In his novel *Miss Lonelyhearts* he writes, "He saw a man who appeared to be on the verge of death stagger into a movie theater that was showing a picture called *Blonde Beauty.* He saw a ragged woman pick a love story magazine out of a garbage can and seem very excited by her find." Americans were living on dreams. The nightmare hid behind the smile.

In West's best-known novel, *Day of the Locust* (1939), the protagonist looks at a publicity shot of an aspiring actress: "She lay stretched out on the divan with her arms and legs spread, as though welcoming a lover, and her lips were parted in a heavy sullen smile. She was supposed to look inviting, but the invitation wasn't to pleasure. . . . Her invitation wasn't to pleasure but to struggle, hard and sharp, closer to murder than to love. If you threw yourself on her it would be like throwing yourself from the parapet of a skyscraper. You would do it with a scream. You couldn't expect to rise again. Your teeth would be driven into your skull like nails into a pine board and your back would be broken. You wouldn't even have time to sweat or close your eyes."

Sex carried the threat of obligation, of consequence, of cost. In John O'Hara's novel *Appointment in Samarra* (1934), a small-time racketeer guards a torch singer at a roadhouse, his boss's girlfriend: "She was wearing a dress that was cut in front so he could all but see her belly button, but the material, the satin or whatever it was, it held close to her body so that when she stood up she only showed about a third of each breast. But when she was sitting

down across the table from him she leaned forward with her elbows on the table and her chin in her hands, and that loosened the dress so that whenever she made a move he could see the nipples of her breasts. She saw him looking—he couldn't help looking. And she smiled."

"You wouldn't want to get your teeth knocked down your throat would you?" he warns.

The Depression sparked a phenomenon unprecedented in American pop culture. Almost overnight, eight-page sexual parodies of comic strips appeared, depicting the secret lives of familiar friends. The same characters who made families laugh over the breakfast table ripped off their clothes and plunged into one another with reckless abandon. Harold Teen and Lillums, Dagwood and Blondie, Moon Mullins, Maggie and Jiggs, Dick Tracy, Mickey Mouse—all were revealed as sexual creatures with preposterous appetites. Betty Boop took on Barney Google, Jiggs, Popeye, Moon Mullins, and Joe Palooka within one eight-page book.

In the eight-pagers no one was too good for sex: Clark Gable did Joan Crawford, William Powell did Myrna Loy, Fred Astaire did Ginger Rogers, and Mae West did everybody. In Europe porn lampooned the ruling class, priests, and nuns. In America porn had fun with our own aristocracy: movie stars and outlaws such as John Dillinger and Al Capone.

Also known as Tijuana bibles, the eight-pagers depicted sex as the common denominator, the great equalizer—all this at a time when people were anything but equal. The bibles appeared with the Depression, then, inexplicably, began to disappear with the economic recovery of the following decade.

During the Great Depression, Americans sat huddled around their radios. FDR calmed the nation with his fireside chats, eloquent appeals to basic values in a time of strife. People stayed at home to listen to Amos 'n' Andy, Jack Benny, Fred Allen, Fibber McGee and Molly, *Major Bowes and His Original Amateur Hour, The Lux Radio Theater,* and *One Man's Family.*

The average family spent four and a half hours a day listening to the radio. The glowing tubes brought comfort. In one sense, the radio re-created the parlor and front porch of Victorian times.

Bing Crosby was the most popular crooner of the decade. And every night there were big band remotes from nightclubs, hotels, and ballrooms across the country with Benny Goodman, Artie Shaw, Tommy Dorsey, and Glenn Miller. Goodman was known as the King of Swing, and swing was the thing. The Lindy Hop replaced the Charleston, and those who dug the jive and could cut a rug were called jitterbugs.

Martin Bloch's *Make Believe Ballroom* played the most popular records of the day, but network censors wouldn't give Billie Holiday's "Strange Fruit" airplay because it was a powerful indictment of savage southern lynchings. Radio offered a make-believe world that fostered innocence and isolationism. Too many Americans didn't want to know what was going on in the rest of the world.

Mae West, the chosen target of Hollywood censors, provoked the same reaction when she appeared on the Edgar Bergen and Charlie McCarthy show:

MAE: "You're all wood and a yard long."

CHARLIE: "Yeah."

MAE: "You weren't so nervous and backward when you came up to see me at my apartment. In fact, you didn't need any encouragement to kiss me."

CHARLIE: "Did I do that?"

MAE: "Why, you certainly did. I got the marks to prove it. And splinters too."

In June 1934 Congress created a Federal Communications Commission (FCC) to monitor the radio industry. Frank McNinch, its newly appointed commissioner, claimed West's performance with Charlie McCarthy justified government control to ensure "against features that are suggestive, vulgar, immoral or of such character as may be offensive to the great mass of right-thinking, clean-minded American citizens."

The FCC would henceforth patrol indecency on the air; if a station didn't agree, it would lose its license. After her exchange with Charlie, the mere mention of Mae West's name was banned on 130 stations.

Perhaps the censors were correct in their estimation of the power of radio. When Orson Welles broadcast *War of the Worlds* on the night before Halloween

in 1938, thousands of Americans actually believed the country was being attacked by Martians and took to the streets in panic.

Actually, America did have a new species of life to worry about—the teenager. Grace Palladino, author of *Teenagers: An American History,* notes that "up until the thirties, most teenagers worked for a living on farms, in factories or at home, whatever their families required at the time. They were not considered teenagers then, or even adolescents. The Great Depression finally pushed teenage youth out of the workplace and into the classroom. By 1936, 65 percent were high school students, the highest proportion to date."

This would have an unusual impact on America. "When a teenage majority spent the better part of their day in high school," Palladino went on to say, "they learned to look to one another and not to adults for advice, information and approval. And when they got a glimpse of the freedom and social life that the high school crowd enjoyed, they revolutionized the concept of growing up."

Hollywood was the first to recognize teenagers. When a comedy about a small-town judge and his family proved an unexpected success, Louis B. Mayer had one of the most successful film series in history on his hands. Andy Hardy came of age in fifteen films.

The story lines in the Andy Hardy films usually showed Judge Hardy dealing with the problems of the town of Carvel—telling a man that it was not a legal matter that he had been caught kissing in a parked car, it was more a matter of taste; telling a woman that it was not her right to buy on installment if it meant that the store would garnishee her husband's wages. In "man-to-man" talks Lewis Stone would try to steer Mickey Rooney (as Andy) toward the proper choices. What makes you feel better, he'd ask, dating a girl who resists kissing or a girl who only wants to kiss?

The films showed the evolution of sexual barter, the politics of popularity. Andy tries to raise $20 to buy a roadster in time for the Christmas dance. Such a car, he explains to Judy Garland, creates a standard, a pressure to perform. "The girl I take to the dance has got to be sensational." Should she be able to dance? asks Garland. "Even if she dances like a horse," responds Andy, "it's an awful long ride home in the dark."

In real life Mickey Rooney had a much more interesting sex life than did his on-screen persona. He had worked as a child actor before getting his big break playing the younger version of Clark Gable's gangster in *Manhattan Melodrama* (1934). The highest-paid teenager in the land loved his celebrity. Phil Silvers, Sidney Miller, Jackie Cooper, and Rooney used to hang out together. One day, Silvers suggested they call out for a hooker. Waiting for her arrival, the boys made a bet. Whoever lasted longest would get a free ride.

The girl arrived and went into the bedroom. One after another, Miller, Silvers, and Cooper went in—and each emerged in three minutes flat. Rooney went in last. Twenty minutes passed; the three outside heard all sorts of assorted shrieks. Rooney finally emerged, acknowledged his victory, and left. When the hooker came out, Silvers asked, "Was Mickey really in the saddle 20 minutes?"

"Are you kidding? Four minutes of fucking and 16 minutes of imitations."

Rooney was famous for his impersonations of Gable, Lionel Barrymore, even Mae West, and like many another youth in America, he tried to entertain his bedmates with the best lines and moves of his Hollywood heroes.

What was life like in actual American high schools? Sociologists Robert and Helen Lynd returned to Muncie, Indiana, to follow up their classic study *Middletown*. The two reported on one impact of the Depression: "A symptom of this pressure of a blank future on the very youngest marriageable group, children 18 and under, is the rise in secret marriages among the high school population. This situation has doubtless been influenced by the growing restlessness of the younger generation and by the relaxation of discipline and lessened contact with their children by harried working-class parents. But it may also reflect in part the tendency of more reckless couples to plunge ahead in quest of the one thing two people can achieve together even in the face of a blind future—personal intimacy." What the Lynds called secret marriage would later become known as "going steady." Romance, not reality, gave permission for sexual experimentation.

The Lynds noted that there was a sharp demarcation between Muncie's adolescents and its adults. The former displayed a "sense of sharp, free behavior between themselves (patterned on the movies)." The adult posture on the subject of sex was strict silence.

"The truth of the matter," reported the Lynds, "appears to be that God-fearing Middletown is afraid of sex as a force in its midst, afraid it might break loose and run wild."

A newspaper editorial raised the alarm that sex was rampant in the eighth grade. The writer recommended a quick application of old-fashioned values—the paddle.

High schoolers asked teachers questions they had never before been asked. "Our high school does nothing about sex education," said one teacher, "because we don't dare to." When a local librarian was asked where people could learn about sex, her reply was, "Not here."

Whereas a few decades earlier the sex manuals available to youth had focused on the dangers of masturbation, times had changed. Doctors now felt that masturbation did not cause insanity, but that "like out bursts of anger or fear masturbation may leave a boy emotionally shaken and tired." The 1930s manuals found a new source of self-destruction: petting.

In a twisted 1930 volume called *So Youth May Know: New Viewpoints on Sex and Love,* Roy Dickerson wrote a chapter on the value of abstinence over promiscuity. "At the very outset it must be said," he wrote, "that it would be indeed ultrapuritanical and ill-advised to denounce altogether all the ordinary minor, more or less incidental and chiefly matter-of-fact physical contacts between the sexes." Having said this, he can't resist expressing the notion that "physical familiarity with women to the point of passion is bad." Promiscuity fostered a craving for variety, in both partners and techniques. The code of the petter recognized "no caress sacred to lovers alone."

These books enforced the Madonna/whore standard. "The first woman a man thinks of for a petting party is not often the first one he thinks of for a wife," Dickerson explains. "She may be all right for his good times, but ordinarily he does not want secondhand goods or a woman who has been freely pawed over for a sweetheart, wife and mother of his children." The boy who fools around "may never be able to become genuinely and permanently interested in any one girl." And finally: "As for a girl being interested in you, beware: 'If they go out with you, they go out with others and you are not safe.'"

Dickerson borrowed all the clichés of the antimasturbation movement to douse youthful desire: Keep busy. Leave alcohol strictly alone. Do not dally with your sex desires. Give up those pictures, books, plays, conversations, or forms of dancing and the like that arouse you. Pray. Keep your bowels open.

Dismiss unwelcome sexual thoughts. If you find yourself cursed with an erection, try brisk exercise; shadowbox; walk about rapidly. Fix your attention on something else. Find a hobby such as radio building, stamp collecting, or pig raising. Spend time with good books. Cultivate a vigorous religious life. Remember that kissing transmits syphilis.

Dickerson had less to say to young women. Indeed, he neglected to include the clitoris in the diagram of the female sex organs that appears in the appendix, lest women discover for themselves that sex could be pleasurable.

When the Lynds returned to Indiana to study the effects of the Depression on Muncie, they found that people there believed in strict sex roles. In the twenties a new woman had emerged, but no new man. Forget women's liberation, forget the flapper. Experimentation was a fringe benefit of prosperity. Scarcity created an almost superstitious faith in "the old ways." The people of Muncie believed that "men should behave like men, and women like women."

The Depression made that dream impossible for millions of American men: A man who could not support his family had no claim to manhood. In contrast, the Depression did little to change gender roles for women, who were still expected to care for the family at home. In fact, some cities passed laws that prevented married women from working.

We were no longer certain what it meant to be a man. Who were the proper role models? The movies offered enviable examples in the macho images of Clark Gable, Gary Cooper, and Errol Flynn. James Cagney knew his way around a dame and made a great gangster, but even with Jean Harlow as incentive, crime was not considered a great career move. The women were as tough as the times required and, as one of the "Gold Diggers of 1933" remarked, "had done things I wouldn't want on my conscience."

The battle between the sexes made for great comedy in films such as *One Hour With You* (1932), *It Happened One Night* (1934), *The Awful Truth* (1937), and *Bringing Up Baby* (1938). But the biggest box-office star of the thirties was Shirley Temple; when novelist and sometime film critic Graham Greene referred to the "dimpled depravity" of her cozy relationships with the older men in her films, her studio sued for libel.

The Depression precipitated new concerns over sexual identity and, in 1936, Lewis Terman (creator of the IQ test) and Catherine Miles developed a 456-item test that promised to determine a child's masculine or feminine nature.

Junior high school students answered word association tests: If "pure" made you think of milk, you were masculine; if it made you think of good, you were feminine. If "train" led to engine, you were manly; if it led to gown, you were womanly. If you selected lover or sin after reading the word "embrace," you were masculine; if you thought of your mother or arms, less so. Boys went from "knight" to armor or man, while the feminine went from "knight" to *Ivanhoe.* And, if you were masculine, the only correct association for "machine" was Ford—not engine, not ride, and certainly not sew.

In the Rorschach section of the test, men faced with two concentric circles were supposed to see a target, women a dish. That slinky thing, wider at one end than the other, was to the masculine eye a saxophone, to the feminine a snake.

Masculinity could be measured by what you knew ("the Yale is a kind of lock") and things you did not know. One received points toward masculinity by neglecting to complete sentences such as "A loom is used for . . ." or "Daffodils are grown from . . ." or "The Madonna is a favorite subject for . . ."

Those who were measurably masculine wanted to become detectives, auto racers, forest rangers, soldiers, draftsmen, and stock breeders. They did not want to become journalists, novelists, or preachers. If you had to be a journalist, then you would like to write about accidents and sporting news, as opposed to musical events or theatrical news. Those with a feminine streak yearned to become librarians, nurses, private secretaries, social workers, and music teachers.

The masculine types were known by the books they had read and liked (*Huckleberry Finn, Gulliver's Travels, Biography of a Grizzly,* or *The Adventures of Sherlock Holmes*) as well as by the books they had not read. (You scored a manly point for not having an opinion about *Rebecca of Sunnybrook Farm, Little Lord Fauntleroy, Peter Pan,* or *Through the Looking Glass.*)

No masculine guy kept a diary. A true man disliked taking baths and did not believe there should be perfect equality between men and women in all things. Feminine types were inclined to believe that "girls are naturally more innocent than boys." Yet males, not females, believed that "love at first sight is usually the truest love."

To the modern eye it is clear that Terman and Miles had a bias the size of a biceps. And nowhere on the scale did a question reveal how a masculine

or feminine character would behave in the bedroom. The test harked back to the days when being masculine was synonymous with being a Christian gentleman (the kind of man who was an "athlete of continence") and when the feminine was synonymous with virgin or mother, when all that was feminine was enshrined in the domestic world.

Economic insecurities created new sexual anxieties. The more liberal attitudes of the twenties and early thirties disappeared. The nation was suddenly caught up in a panic over homosexuality. Boys who scored too highly on the feminine side of Terman's scale were given healthy doses of exercise and outdoor activity. At least one doctor in Georgia used electroshock therapy to treat those suspected of being homosexual.

Science offered a solution, finally identifying and describing the role of hormones in the development of sex differences. Fred Koch, a biologist at the University of Chicago, found that if he ground up bull testicles and injected capons with the extract, the birds grew an "upstanding red comb." Men started taking extracts of ram testicles and considered animal gonad transplants in a vain effort to gain virility.

One catches glimpses here of what we now call sexual inadequacy and performance anxiety. Freud had introduced the idea of penis envy de claring that women had it (because they didn't have one) and that explained everything.

Edmund Wilson records an encounter between F. Scott Fitzgerald and Ernest Hemingway in which Fitzgerald wondered if his penis was too small. Hemingway offered Fitzgerald this solace: It only seemed too small because he looked at it from above. "You have to look at it in a mirror," said Hemingway.

People turned to sex as the one part of the world they could still control, that could still ensure happiness. It was the one green spot in a world of dust. The most popular sex manual of the day described simultaneous orgasm as the perfect solution to the battle between the sexes. But there was a great gulf between theory and practice.

In 1938 Terman moved from the study of sex differences—what it meant to be masculine and feminine—to the psychological factors of marital happiness. In a groundbreaking study, he delved into the intimate lives of 792 couples.

He found a dramatic trend away from virginity. Half of the men born before 1890 had been virgins when they married, while only 14 percent of those born after 1910 had been virgins. A similar decline had occurred in the women. Of those born before 1890, 87 percent had been virgins when they married; of those born after 1910, less than a third were virgins.

Terman was one of the first scientists to use his data to predict the future of sex. "If the drop should continue at the average rate shown," he wrote, "virginity at marriage will be close to the vanishing point for males born after 1930 and for females born after 1940. It will be of no small interest to see how long the cultural ideal of virgin marriage will survive as a moral code after its observance has passed into history." He dismissed the notion that petting had any negative impact on future relationships or that promiscuity put someone at risk for marital unhappiness.

Terman looked at what happened during sex and seemed confused. A third of the women he studied were "inadequate"—that is, they never or rarely reached orgasm. "The inability of a large proportion of women to achieve the climax that normally terminates sexual intercourse is one of the most puzzling mysteries in the psychology and physiology of sex."

Terman explored the many possible obstacles to pleasure. He found that wives who were married to men with strict religious upbringing were less likely to reach orgasm. He could not tell if too much religion cramped a man's style, or if such men were drawn to the "inadequates."

He found that "inadequate" women avoided intercourse, most of them preferring two or fewer copulations per month, while most "adequate" women preferred seven or more times. He wondered if a man's staying power contributed to pleasure, and concluded that if intercourse lasted less than seven minutes it hurt a woman's chances of being orgasmic, but that lasting longer than fifteen minutes "would not reduce the proportion of inadequate wives by more than five or six percent."

Terman asked wives to express a like or dislike of certain professions and subjects. It was a quirky list, with targets that included stockbrokers, Communists, and people who work for the YMCA. He found that inadequate women were more inclined to express a liking for YMCA types, while adequate women were more inclined to like musicians. For some reason, women who

reached orgasm easily had a peculiar dislike of pet canaries. Perhaps they knew that the caged bird doesn't sing.

Considering the year in which they were asked, Terman posed incredibly personal questions. Husbands could check off a variety of complaints about their wives: vagina too large, vagina too small, vagina not moist enough, too animal-like in her passion, likes to engage in unnatural practices. Wives could check off similar shortcomings: penis too large, penis too small, has difficulty in getting an erection, has difficulty in keeping an erection, has ejaculations too quickly, has too little regard for my satisfaction, does not pet enough before beginning intercourse, likes to engage in unnatural practices.

Women who reached orgasm were nearly twice as likely as those who did not reach orgasm to have no complaints. The "inadequates" were more than three times as likely to have seven or more complaints. But Terman did find that we were taking more time with the sex act. Men born after 1905 took 32 percent more time copulating than men born before 1880. Clearly, we were looking for something in sex.

Increasingly, personal happiness was to be found below the belt.

A Peter Arno cartoon published in a *New Yorker* of the era shows a collegiate couple carrying a car seat and reporting the theft of their automobile. Car sales declined dramatically during the Depression, but sex and the automobile were still linked in the minds of America. Police learned to patrol lovers' lanes. Tourist cabins and motels sprang up to accommodate the practitioners of make-believe marriage. A sociologist who studied camps on the outskirts of Dallas in 1936 found that "some 2,000 Dallas couples used the camps at weekends. In one sample only seven out of 109 Dallas couples gave correct names. Many remained only a few hours. Bona fide travelers were not too popular because they stayed all night, thus decreasing the turnover." J. Edgar Hoover decried the "hot pillow trade" of tourist camps as well as "the passion pits" at newly invented drive-in movie theaters.

In *Since Yesterday,* Frederick Lewis Allen attempted once again to capture the social history of an entire decade, and succeeded. In 1939 he wrote, "There was little sense of a change in the moral code being willfully made, little sense that stolen love was modern adventure. The dilemma was practical. One managed as best one could, was continent or incontinent according to one's indi-

vidual need and one's individual code, whether of morals or aesthetics or prudence or convenience. If the conventions were in abeyance, it was simply because the times were out of joint and no longer made sense."

Willard Waller described the evolving social etiquette in a 1937 article for the *American Sociological Review* called "The Rating and Dating Complex." Formal courtship, he noted, was a thing of the past. "The decay of this moral structure has made possible the emergence of thrill seeking and exploitative relationships. A thrill is merely a physiological stimulation and release of tension. Whether we approve or not, courtship practices today allow for a great deal of pure thrill seeking. Dancing, petting, necking, the automobile, the amusement park and a whole range of institutions and practices permit or facilitate thrill-seeking behavior."

Waller provides a glimpse of the values formed in high school and college: "Young men are desirable dates according to their rating on the scale of campus values. In order to have class-A rating they must belong to one of the better fraternities, be prominent in activities, have a copious supply of spending money, be well dressed, smooth in manners and appearance, have a good line, dance well and have access to an automobile."

Gone apparently were any considerations of character, or of a man's ability to provide security in the future. Waller describes men who practiced a calculated seduction. The line was a "conventional attempt on the part of the young man to convince the young woman that he has already at this early stage fallen seriously in love with her, a sort of exaggeration, sometimes a burlesque of coquetry." The mating dance was complicated. "It may be that each, by a pretense of great involvement, invites the other to rapid sentiment formation—each encourages the other to fall in love by pretending that he has already done so."

"Rapid sentiment formation"? Is that a pistol in your pocket, or are you undergoing rapid sentiment formation? College students read books such as Jack Hanley's 1937 *Let's Make Mary: Being a Gentleman's Guide to Scientific Seduction in Eight Easy Lessons.* Beth Bailey, in *From Front Porch to Back Seat,* suggests that sex was not the ultimate goal of dating. Image making, the appearance of popularity, guided our social dance. The rating system ignored talent, looks, personality, and importance in organizations if those attributes were not translatable into dates. "These dates," writes Bailey, "had to be highly visible and with many different people." Women who chose to

be faithful to a male friend at a different school (i.e., they did not play the dating game) were known as campus widows. On one campus they wore yellow ribbons and met to read letters from faraway lovers. Everyone else played the game.

In 1938 Dorothy Bromley and Florence Britten published a study of 1,300 college students. Their findings rocked the nation. The June 6, 1938, issue of *Life* reported on the study. One girl out of four in college had had sexual relations. Of every two male undergraduates, one was a virgin and one was not. Boys began having sex in high school, while girls tended to wait until they were in college. In great contrast to their fathers, wrote Bromley, "three quarters of the men were willing to marry nonvirgin girls— and this number included men who had not yet indulged in sex relations themselves."

If the world was no longer divided between women who did (fallen women and prostitutes) and women who didn't (wives or future wives), how did we describe ourselves? Bromley created new subspecies of sexually active humans. Male virgins were divided into those who were continent because of "ideals and standards" and those who avoided sex because of "fears and inhibitions." Sexually active males were "moderates" or "hotbloods"—the latter, the "crude, lusty young animals" popular on campus.

Women received similar treatment. Some 12 percent of college girls who hadn't yet had sex were "virginal"—either innocent or unawakened. Almost a quarter were "the wait for marriage" type, who were "awake but cautious." Some 37 percent were simply "inexperienced," the girl who had "not gone wrong yet, possibly because she was never given a chance, but she believes extramarital relations are all right." Among those who had sex were "the loving" (the 11 percent who had had an affair with one man) and "the experimenter" (the 9 percent who deliberately entered into sex relationships to see what they were like). "She pursues a trial and error course with different men as scientific subjects," reported *Life*. "She is intellectually serious, comes from a liberal home, expects to marry someday." And then there was "the sower of wild oats" (3.5 percent), a girl who was downright promiscuous.

Bromley found a few men and women who had had homosexual experiences. *Life* dismissed these with one sentence: "A small number of physiological and psychological misfits completed this study."

Typical of the times, *Life* ran Bromley's findings as a box accompanying an article on a teenage couple who, finding the girl pregnant, made a suicide pact. The girl died, the boy didn't.

The silence that once surrounded syphilis disappeared by the late 1930s. In 1937 Anthony Turano complained in the *American Mercury* that decorum kept the Associated Press and the United Press from using the words "syphilis," "gonorrhea," or "venereal disease" in news dispatches. Yet the same publications did "not hesitate to describe daily the absorbent qualities of Kotex, the latest thing in hernia supports, or the best nostrum for hemorrhoids."

The National Broadcasting Company had prevented a doctor from using the word "syphilis" on the air; the Columbia Broadcasting System refused to allow Dr. Thomas Parran, later surgeon general of the United States, to discuss the topic. "The reason in both cases," complained Turano, "was, of course, the indecency of mentioning copulation to mixed audiences. Presumably a wave of sexual promiscuity would overtake the Republic if it were generally known to persons of all ages that pathogenic germs may attack the genital region as well as other portions of the body, and that medical remedies are available in each case."

Yet magazines discussed the deadly details freely. Turano's article noted that 683,000 cases of syphilis were currently under treatment, and that 423,000 new cases arose each year. Because most never received medical care, the total estimated number of infected Americans was placed at 12 million.

One enlightened company gave blood tests to 36,800 workers in seventeen states, then referred infected workers to free clinics or family doctors. According to Turano, some physicians simply ignored the Wassermann results and issued "certificates of good moral character, testifying that their patients were not the kind of persons who could have contracted such a reprehensible disease."

Fear of venereal disease was the most powerful weapon left for puritan America. In August 1937 *Reader's Digest* published "The Case for Chastity" by Margaret Culkin Banning. The author, a mother of four, set for herself the task of answering the challenge, "If there is a case for chastity, it should be stated."

After bemoaning the "parked and lightless cars on side roads everywhere," the couples' trade at tourist cabins, the hotels adjacent to colleges, Banning described the consequences of unchastity. "The highest attack rate for syphilis occurs during the early adult years, 16 to 30. If venereal disease is ultimately stamped out, one risk of unchastity will be destroyed. But we are a long way from that yet. In the meantime there is a serious and constant danger of disease in premarital relations."

But the crusader for chastity was not done. Banning attacked the prevailing methods of birth control: 25 percent of condoms, she wrote, were imperfect. The strongest douche was successful only 10 percent of the time. "Figures show beyond a doubt that a tremendous number of unmarried young women go to abortionists. No doubt many of them have heard the current claptrap about an abortion being nothing at all to endure. Let them also hear this: Ten thousand girls and women lose their lives each year at the hands of abortionists."

The editors at *Reader's Digest* did not print Banning's estimated number of abortions (700,000), but they did note her claim that there were 50,000 births each year to unwed mothers. No one kept track of these numbers. As a moral argument against sex, illegitimate children stayed at the edge of the debate for the present. The numbers, though shocking, were small enough to be handled discreetly. Instead, Banning worked the fear angle. The article cited one Dr. Frederick Taussig: "Also, for every woman who dies as a result of abortion, several women are disabled, sometimes permanently, or rendered sterile or, at a subsequent pregnancy, suffer from the aftereffects of the abortion."

Unchastity kills.

An article in *Ladies' Home Journal* in the same year proclaimed, "In a citywide referendum of Chicago's 3.5 million people, 92 out of 100 persons voted to stamp out syphilis. In a nationwide poll by the American Institute of Public Opinion, 87 people out of 100 voted likewise."

America was willing to tackle the problem of venereal disease. Most Americans wanted to reduce the wages of sin or abolish them altogether. Some states passed laws requiring blood tests for a marriage license. Newspapers in Chicago published the names of couples who went out of state to avoid the test.

In 1936 Surgeon General Parran wrote an article for *Reader's Digest* entitled "Why Don't We Stamp Out Syphilis?" A year later, he coauthored another article for *Ladies' Home Journal* entitled "We Can End This Sorrow." "We might virtually stamp out this disease," Dr. Parran admonished, "were we not hampered by the widespread belief that nice people don't talk about syphilis, that nice people don't have syphilis, and that nice people shouldn't do anything about those who do have syphilis."

The science existed to beat the disease. A complete cure required some sixty weekly visits to a doctor or clinic for painful injections of arsenicals and heavy metals. Most patients, unfortunately, stopped treatment after symptoms disappeared. And many doctors simply cut off treatment for patients unable to pay. Parran called for doctors to take action, to overcome their own moral lethargy, not only to suspect that patients might harbor the microbe but to seek out the disease with treatment. Not everyone in government shared the surgeon general's view.

On May 17, 1937, J. Edgar Hoover ordered agents to raid ten vice dens in Baltimore. On August 30, 1937, he personally led more than a hundred agents in vice raids in Atlantic City, Wilmington, and Philadelphia. The *New York Times* noted that the G-men moved "by synchronized watches," meaning agents had entered sixteen disorderly houses precisely at midnight to arrest 137 prostitutes, their maids, proprietors, and a few men.

Hoover and the *New York Times* billed the raids as a blow against the white slave trade. But a follow-up story a few days later told a more chilling tale. Hoover arrested two physicians who had periodically examined and treated the "inmates of the raided disorderly houses." They were accused of "withholding knowledge of a felony." They had knowingly aided in the white slave traffic. Hoover's message was clear: Try to stop VD at its source and you will go to jail.

In early 1932 almost no one had heard of the Bureau of Investigation, let alone its director. The federal police force, which numbered only 326 in 1932, was responsible for enforcing federal laws on interstate commerce, antitrust, and vice, especially in the form of enforcing the Mann Act and policing the distribution and sale of obscene literature.

Hoover instructed agents to send obscene and improper material to Washington, where they became a permanent part of the Obscene File. The FBI collection included stag movies, photographs, books, pamphlets, freehand drawings, explicit cartoons, and playing cards. Like Comstock before him, Hoover invoked innocent youth to demonize "purveyors of obscene materials" who "disseminate their products among schoolchildren and adults with perverted minds." He told field agents that he wanted to see such material "regardless of the source from which they are obtained. Even though no federal violation exists, any material of this nature made available by local police agencies should be transmitted to the bureau in order to increase the effectiveness of the Obscene File." When an inventory of the Obscene File was conducted in 1966, it was found to contain more than 13,000 films, magazines, and the like.

Hoover's concern with policing the virtue of the nation surfaced in several ways. He personally reviewed every hint of impropriety. If someone was a suspected Communist, that information went into the official file. If someone had been accused of immorality, that information went into Hoover's private Official and Confidential File. Hiding the Obscene File and the private files kept Hoover's obsession hidden from Congress.

In 1933 an article in *Collier's* magazine ridiculed Hoover, claiming that he was an "immature" gumshoe out for publicity. "In appearance, Mr. Hoover looks utterly unlike the storybook sleuth. He dresses fastidiously, with Eleanor blue as the favored color for the matched shades of tie, handkerchief and socks. He is short, fat, businesslike and walks with a mincing step."

In 1933 Hoover, thirty-eight, was unmarried and still living with his mother. The allegation that he was less than manly prompted him to take action. Rumors that Hoover was gay would follow him to his grave. To be fair, Hoover would probably have taken equal offense at false reports linking him with a woman. He did not date, period. The FBI was his mistress.

When gangsters killed an FBI agent in a shoot-out in Kansas City, Missouri, Hoover launched a counteroffensive. He filled the department with hired guns and went after John Dillinger. Agents surrounded the bank robber in Little Bohemia (a resort in Wisconsin) but botched the operation, shooting three innocent bystanders, killing one. Working through an Indiana policeman, the FBI cut a deal with Mrs. Anna Sage, the madam of a local Chicago brothel,

who faced deportation. She would finger Dillinger in return for help with immigration authorities. The "lady in red" accompanied Dillinger and his girlfriend to a Chicago screening of *Manhattan Melodrama,* starring Clark Gable and William Powell. When they emerged from the theater, agents gunned down the gangster.

Dillinger was still the better man. He was a local hero and a ladies' man, and urban legend had it that he was uncommonly well endowed and that his organ was on display at the Smithsonian. The real souvenir was a death mask of the outlaw kept by Hoover in his outer office at the FBI building.

When the press scoffed that Hoover had never made an arrest, he showed up for the carefully orchestrated arrest of Alvin Karpis in New Orleans.

The gun battles and headlines diverted criticism of Hoover's role as chief of the sex police, for he was responsible for enforcing the Mann Act. Originally intended to control the largely imaginary interstate traffic in white slaves, the law had become the pet sex law of puritans, a law that was used to punish any sexual escapade that crossed state lines. Hoover wrote that noncommercial violations of the Mann Act were prosecuted only under "aggravated circumstances."

Legal scholars argue that Hoover used the law selectively to punish gangsters, black men who dared to travel with white girlfriends, the politically obnoxious, and undifferentiated riffraff (con men, brothel owners, and the like). Even if there was no prosecution, Hoover used investigations to fill his administrative files.

After Hoover's widely publicized vice raids in the late thirties, one journalist challenged the FBI, saying the Mann Act was an excuse for government to collect dirt and control politics through blackmail. Under Hoover, the average number of Mann Act prosecutions reached four hundred cases annually. The average sentence rose from a little longer than a year in 1930 to thirty-eight months in 1939.

"The soul of Cotton Mather marches on. Under the famous Mann Act, the enforcement of the Seventh Commandment is still the special business of the national constabulary and the wages of sexual sin are fixed at five years in prison and a $5,000 fine—a penalty considerably higher than is usually paid for bank robbery or manslaughter."

Thus did Anthony Turano characterize the Mann Act in the *American Mercury*. Noting that state laws already provided adequate penalties for rape or consensual sex with a minor, he attacked the feds for using the Mann Act to police the "voluntary indiscretions of mature citizens."

"When a biological accord has already been reached between man and maid," wrote Turano, "a moving vehicle is more of a nuisance than a provocation, and their purpose in traveling is seldom more wicked than the wish to be elsewhere. The ludicrous result is that for the first time in the history of law and morals, adultery is treated as a geographical offense: There is no crime unless the gentle passion combines with wanderlust."

In a 1930 case a man named C. W. Aplin lived with a twenty-two-year-old woman for four months, then moved with her from Salem, Oregon, to Las Vegas. As Turano noted, "No sane person would repeat a state peccadillo in order to elevate it into a federal felony," but Aplin was sent to jail for two and a half years because a jury thought the move was evidence of "debauchery." "It is difficult to see," wrote Turano, "what salutary social end is served by making the national government a smut-seeking referee in the private sins of the citizenry."

David Langum, author of *Crossing Over the Line: Legislating Morality and the Mann Act,* grants that, under Hoover, most noncommercial cases involved aggravated—if not ludicrous—circumstances. "In *United States vs. Grace* (1934) a bishop of the House of Prayer for All People engaged in sex with a female member of his flock, sometimes at the unusual location of the floor of his chauffeured automobile while motoring through New Jersey. Whether or not this ministration was good for her soul is problematic, but it did result in her pregnancy. In *King vs. United States* (1932) a traveling salesman, so the prosecutor alleged, convinced a naive young woman of eighteen that she had a disease which if left uncured would result in her inability to have children. He took her out in the country in the evening, crossing over a state line, to demonstrate the 'electrode' that would cure her. Whether he succeeded in alleviating a nonexistent disease is unclear, but he did succeed in seducing the young woman, giving her gonorrhea."

Critics pointed out that the Mann Act was hopelessly biased: A woman who transported a married man across state lines, doing the "devil's work" at every stop, could not be prosecuted. The courts would believe that a female

witness had been "mesmerized," and therefore was not responsible for repeatedly violating the Mann Act on a cross-country train trip.

In 1931 Francis Packard wrote the 1,266-page book *History of Medicine in the U.S.A.* The words "birth control" appear nowhere in the text. Five years later, Dr. Norman Himes tried to correct the oversight with his *Medical History of Contraception.* He found that the desire to control fertility existed in virtually every culture and age. Only the methods had changed.

By 1936 condom sales in the United States approached $317 million annually. The fifteen chief manufacturers produced 1.5 million condoms a day. The desire to limit fertility was as enormous as the methods were inefficient.

Dr. Hannah Stone studied nearly two thousand case histories from the Newark Maternal Health Center and found that 956 patients (48 percent) reported using condoms, 1,267 (64 percent) had relied on coitus interruptus, and 507 had used Lysol as a douche. None of the methods of controlling birth seemed particularly effective: 45 percent of those who used condoms found themselves facing parenthood, almost 60 percent of those who relied on withdrawal became pregnant, and douching failed 71 percent of the time.

In his journal, Edmund Wilson described the postcoital moment, some version of which occurred across America every night. His wife felt, "I ought to have engraved on my tombstone: You'd better go in and fix yourself up." At other times, he said, "she used to ask me why I didn't wear a condom so that she wouldn't be put to the trouble of going to take a douche."

Personal squabbles over birth control were nothing compared with the day's global debates. In 1930 the Anglican bishops had granted recognition of birth control. Pope Pius XI retaliated with *Casti Connubii* (*On Christian Marriage*), an encyclical forbidding any artificial regulation of fertility: "Any use whatsoever of matrimony exercised in such a way that the [sex] act is deliberately frustrated in its natural power to generate life is an offense against the law of God and of nature, and those who indulge in such are branded with the guilt of a grave sin."

The pope sentenced Catholics to "Vatican roulette." By 1933 two researchers had looked at the birth dates of military families and had been able to pinpoint the moment of conception. (Luckily, for most families, it coincided

with leave dates.) From that data, the researchers determined that a woman ovulated approximately two weeks before her period. Lab tests had discovered that an unfertilized egg died after thirty-six hours. By avoiding certain days of the month, couples could prevent conception. Dr. Leo Latz recommended that couples abstain for a week around the middle of each monthly cycle, and taught women how to chart their "rhythm calendars."

By 1930 there were more than 225 birth-control clinics in the United States. Some were associated with hospitals, and most were run by followers of Margaret Sanger. Birth control was not yet a medical discipline: Only 13 of the top 75 medical schools in the country bothered to teach contraception as a regular part of the curriculum.

Sanger smuggled diaphragms into the country. Both state and federal law had prohibited doctors from talking about contraceptives. For years, Sanger had tried to get the laws rewritten to allow doctors to prescribe and fit diaphragms. Her crusade met fierce resistance. Father Charles Coughlin used his national radio show to spread his message. "We know that contraceptives are bootlegged in corner drugstores surrounding our high schools," he reported. "Why are they around the high schools? To teach them to fornicate and not get caught. All this bill means is how to fornicate and not get caught."

Father Wendell Corey of Notre Dame University was more hateful. "Continue the practice [of birth control]," he said, "and the sons of the yellow man or the black will someday fill the president's chair in Washington."

The terms of the argument were mired in hate. Something had to give. In 1933 lawyer Morris Ernst, the same man who would defend *Ulysses,* contacted Dr. Hannah Stone. She placed an order for 120 pessaries from Japan. After U.S. Customs officials seized the shipment, Ernst took them to court. *The United States vs. One Package of Japanese Pessaries* was a brilliant victory. Ernst put doctors on the stand and solicited a list of cases in which a pregnancy could threaten a woman's life. Contraceptives thus served a medical need.

Then Ernst invoked the Depression: "How about a case where the mother has four or five children and the husband has been out of work or has a $6 or $8 income? Would the health of the family be imperiled if there were another child, and if that is so, because of lack of food, nutrition, decent home, decent housing, would there not be such cases where the health of the family would be benefited by such a prescription?" The judge ruled that Congress and Cus-

toms had no place coming between a doctor and his patients. The decision withstood an appeal.

In March 1938 *Ladies' Home Journal* published the results of a survey: 79 percent of American women favored birth control. (The figures by religion: Of Protestant women, 84 percent favored it; of Catholics, 51 percent.) More than three quarters of those supporting birth control cited family income, the notion that parents should not have more children than they can properly care for, as their moral justification.

It should be noted that the papal encyclical against artificial means of birth control included condemnation of abortion. The main objection to birth control was that people who practiced family limitation with unreliable methods inevitably became pregnant. Then they resorted to abortion, which the church viewed as the taking of innocent life. The most zealous priests even insisted that the embryonic remains of miscarriage should be baptized so that the souls could enter heaven.

Although millions of women had abortions, abortionists were still held in contempt as racketeers who corrupted coroners and medical examiners to cover botched illegal operations. Headlines claimed that abortion was a $100-million-a-year business. *Time* followed the case of a West Coast abortarium that had been closed by officials.

Abortion stayed underground. A few brave doctors began to defend the practice, arguing that abortion should be legalized to take it out of the hands of "unskilled quacks." In 1933 Dr. William Robinson wrote *The Law Against Abortion* (released by the Eugenics Publishing Co.), in which he argued that "the law has not done away with abortions—about two million of them are performed in the U.S. annually—but it has driven them into dark places." Dr. Robinson contended that abortion could preserve the health of the mother, including her mental health. It was an argument that would not prevail until another forty years had passed.

The most important issue of the decade would be who controlled reproduction. It was an issue that would eventually be settled by war. Eugenics—the theory of improving racial stock—had swept America. According to Garland Allen, a professor of biology at Washington University in St. Louis, by 1928

there were 376 college courses devoted to teaching Americans the dark side of birth control. By selecting proper parents, nations could breed traits such as leadership, humor, generosity, sympathy, loyalty, genius. By denying reproductive rights to "defectives," one could eliminate hereditary blindness, deafness, and epilepsy, as well as "alcoholism, pauperism, prostitution, rebelliousness, criminality and feeblemindedness." Leading eugenicists claimed that "social behaviors of not only individual family members but also whole nations were genetically fixed at birth." The Irish were deemed suspicious. Jewish people appeared to display a genetic trait of "obtrusiveness."

Such theories were used to limit immigration into the United States. Immigrants were frequently considered to be the dregs of humanity. In the depth of the Depression, it was argued that the social cost of caring for defectives placed a huge burden on an already taxed economy. (One much-quoted study noted that if the government had sterilized one woman—deemed defective in 1790—it would have saved an estimated $2 million in care for her descendants by the 1920s. For want of a $150 operation, went the argument, millions were lost.)

In America thirty states enacted compulsory sterilization laws for those considered likely to give birth to socially defective children. Between 1907 and 1941 more than 60,000 forced sterilizations were performed in the United States.

Nazi Germany borrowed American expertise to draft its own sterilization law. Between 1933 and 1937, Nazis sterilized 400,000 wards of the state, most involuntarily. The government decided who was valuable and who was valueless.

Carrying the cost-benefit analysis to its darkest extreme, the German state decided that euthanasia was cheaper than sterilization. State-controlled sexuality led to the Holocaust. Hitler had convinced Germans that the state held the ultimate solution—that Germany could achieve racial superiority and begin a thousand-year Reich. Today, Germany, he declared. Tomorrow, the world.

The 1939 New York World's Fair offered a vision of the World of Tomorrow. Fairgoers saw exhibits presenting technology's answers for a better world.

Murals celebrated hydroelectric power, the great dams and power lines built during the Depression. A car company that had survived the Crash showed streamlined models in "Futurama." A boy seeing a television broadcast for the first time would say he preferred radio because the pictures were better. The fair had a whole section designated the "Amusement Area," for which surrealist Salvador Dalí created the Dream of Venus concession. Inside four diving tanks "living girls, nude to the waist," played with giant rubber telephones and swam past melting watches.

Another exhibitor presented living magazine covers, where topless women posed for a *Romantic Life Magazine,* dated 1949. We were smart enough to realize that no matter what the future held, sex would play a part in it.

A local minister complained about the "menace to morals" posed by the Amusement Area, and officials issued a "Mandatory Bras and Net Coverings" order. Mayor La Guardia, invoking a little-used power of office, held court outside the fair, sentencing three men who had tried to hold a Miss Nude of 1939 beauty pageant in the Cuban Village.

The World's Fair held the promise that nations could work together to solve their problems. *Harper's* would note, "In a world swept by terror and hysteria, 60 nations have participated in the fair." One nation—Germany—was notably absent.

War had broken out in Europe. Soon, women would find themselves working in factories, fulfilling the suffragettes' dream of equality and liberation. And men, fighting to save the world, would become men again.

TIME CAPSULE

Raw Data From the 1930s

FIRST APPEARANCES

Airline stewardesses. Grant Wood's *American Gothic.* The New Deal: NRA; WPA; CCC; AAA; TVA. *Family Circle. Esquire.* The Petty Girl. The Empire State Building. King Kong. The pinball machine. Beer in cans. Alka-Seltzer. Electric razors. Zippo lighters. Monopoly. Comic books. Blondie. Dick Tracy. Li'l Abner. Flash Gordon. Superman. Batman. Drive-in movie theaters. Bra cup sizes. Tampons. Blood tests for marriage licenses. Dr. Seuss. Sam Spade. *Tropic of Cancer. Gone With the Wind.* Gallup Poll. Parking meters. Swing music. The jitterbug.

WHO'S HOT

Franklin Delano Roosevelt. Will Rogers. Clark Gable. Jean Harlow. Mae West. The Marx Brothers. Busby Berkeley. Bing Crosby. Amos 'n' Andy. John Dillinger. J. Edgar Hoover. Walter Winchell. Joe Louis. Jimmy Cagney. Fred Astaire and Ginger Rogers. Shirley Temple. Mickey Rooney. Sally Rand. Benny Goodman. Artie Shaw. Duke Ellington. The Duke and Duchess of Windsor. Adolf Hitler.

STRANGE FRUIT

Number of lynchings of blacks between 1889 and 1940: 3,800. Percentage of lynching victims accused of attempted rape from 1889 to 1929: 16.7; percentage actually convicted of rape: 6.7.

BIRTH OF A NATION

Population of the United States in 1930: 123 million. Population in 1940: 132 million. For every person entering the United States, number of people who return to the old country: 3.

MONEY MATTERS 85392.

Gross National Product in 1930: $90.4 billion. Gross National Product in 1940: $99.7 billion. Price of a share of U.S. Steel before the Crash: $261 ¾; in November 1929: $150; price in 1932: $21 ¼. Price of a share of General Electric before the Crash: $396 ¼; in November 1929: $168 ½; price in 1932: $34. Year the stock market would return to its 1929 level: 1954. Drop in wages between 1929 and 1932: 60 percent.

MOVIE MADNESS

Percentage of films that dealt with crime, sex, or love in 1920: 82; in 1930: 72. Weekly movie attendance in 1930: 90 million; in 1931: 60 million; in 1936: 88 million. Box-office earnings in 1930: $730 million; in 1932: $527 million. Of 16,000 theaters, number that closed by the end of 1933: 5,000. Number of scripts reviewed by the Production Code Administration in 1937: 2,584; number of films screened: 1,489; number of official opinions delivered: 6,477. Judy Garland's advice to Mickey Rooney in *Babes in Arms* (1939): "Someday you'll realize that glamour isn't the only thing in the world. If your show's a flop, you'll find you can't eat glamour for breakfast."

MARRIAGE

Number of colleges offering a course in marriage in 1926: 1; in 1936: more than 200. Name of zoology professor appointed to coordinate marriage courses at Indiana University in 1938: Alfred Kinsey.

Average age of marriage for men in 1930: 24.3; for women: 21.3. Average age of marriage for men in 1939: 26.7; for women: 23.3.

Of 777 married couples interviewed by psychologist Lewis Terman, number who slept in the same bed: 596; number who slept in separate beds: 130; number who slept in separate bedrooms: 51. Of the 792 couples, number of wives who had ever wished they were men: 242; number of husbands who had ever wished they were women: 20.

BANNED IN BOSTON

Books that had finally been admitted by U.S. Customs by 1933: Aristophanes' *Lysistrata;* Daniel Defoe's *Moll Flanders;* James Joyce's *Ulysses.* Book pub-

lished in 1934 but banned in U.S. until 1964: Henry Miller's *Tropic of Cancer*. Books banned in Boston: Boccaccio's *Decameron;* Hemingway's *The Sun Also Rises;* Caldwell's *God's Little Acre*. Banned in Detroit: Casanova's *Mémoires;* Hemingway's *To Have and Have Not*.

MANN ACT

Number of Mann Act convictions in 1930: 516; average jail sentence in months: 14. Number of Mann Act convictions in 1939: 524; average sentence in months: 37.9.

RADIO WAVES

Percentage of American homes that had a radio in 1929: 33; percentage in 1934: 60; by 1939: 86. Number of hours per day of listening in 1937: 4 ½. Number of soap operas in 1931: 3; number in 1939: 61.

NEWSSTAND MORALITY

Among stories in popular magazines circa 1900, percentage of plots that condoned the hero or heroine's extramarital sex relations: 3. Percentage of plots in the movies and magazines that condoned extramarital sex relations in 1932: 45.

FUNDAMENTAL VALUES

When asked about their fundamental values, the people portrayed in the study *Middletown* would say that they believed in the following: "The family is a sacred institution and the fundamental institution of our society. The monogamous family is the outcome of evolution from lower forms of life, and is the final, divinely ordained form. Sex was 'given' to man for purposes of procreation, not for personal enjoyment. Sexual relations before or outside of marriage are immoral.

"Men should behave like men, and women like women."

FINAL APPEARANCES

Judge Joseph Crater (1930). Thomas Edison (1931). Florenz Ziegfeld (1932). Roscoe "Fatty" Arbuckle (1933). Will Rogers (1935). Jean Harlow (1937). *The Hindenburg* (1937). Havelock Ellis (1939). Sigmund Freud (1939).

Chapter Five

MALE CALL: 1940–1949

Milton Caniff's elegant Miss Lace
gave World War Two a feminine face
as she helped the GIs achieve victory.

*G*reetings: *Having submitted yourself to a local board composed of your neigh-bors for the purpose of determining your availability for training and ser-vice in the land or naval forces of the United States, you are hereby notified that you have now been selected for training and service therein. . . ."*

In September 1940, as America listened to Edward R. Murrow describe the Battle of Britain from the rooftops of London, Congress passed the Selective Training and Service Act and instituted a national draft. More than 16 million men received registration cards. Almost a million men between the ages of twenty and thirty-six opened their mail to learn that Uncle Sam wanted them

to report for a year of service, with a provision that the term be extended to eighteen months in a national emergency.

In 1941 Congress extended the hitch to thirty months. After the Japanese attacked Pearl Harbor the fine print read simply "for the duration." Within a year, Congress had lowered the draft age to eighteen. Most Americans had never heard of Pearl Harbor, but as of December 7, 1941, the nation was at war. Mobilization was a blur; a constant leave-taking performed again and again in bus stations, on train platforms, at airports and ports of embarkation. The U.S. armed forces grew from eight divisions to ninety in the space of four years, from fewer than half a million men to almost 4 million by 1942, 9 million by 1943, 11 million by 1944, 12 million by 1945.

Men simply vanished from the streets of towns and cities across America, replaced by blue stars displayed proudly in the windows of families with boys in the military. When those boys died, the blue stars were replaced with stars of gold.

Posters encouraged girls to write: V-MAIL IS SPEED MAIL: YOU WRITE. HE'LL FIGHT. BE WITH HIM AT EVERY MAIL CALL. CAN YOU PASS A MAILBOX WITH A CLEAR CONSCIENCE? Love, deprived of touch, survived on paper.

Mail call was the most important time of day for a soldier, a five-minute furlough. The river of words flowed both ways. Men wrote about their plans for the future. Each letter was first read by an officer who would black out words that could prove useful to the enemy. One naval lieutenant entrusted with that task was surprised by how often the terms "helpmate" and "soul mate" appeared in the letters he had to censor. Perhaps, without realizing it, the men had put women on a pedestal the size of a piece of stationery.

Conducting a relationship long distance brought sex to the surface in charming and awkward ways. An article in *Yank* describes the Service Men's Service in New York. Men in the military could write to ask volunteer shoppers to buy gifts for wives and sweethearts back home. The most requested items were black lace underwear and black negligees. One guy described his girlfriend: "I suspect she's always had a suppressed desire to be slinky and sophisticated like Marlene Dietrich, so I'd like very much to get her one of them there negligees or whatever they are. You know, all glamorous and frothy and sultry-looking. The sort that will shock her mother and convince her that her future son-in-law has a lewd and depraved mind." A GI's wife wrote: "When

you come back I'm going to go out and buy some black paint and paint the windows so I can wear this black negligee for you all day long."

The article assured the reader that all requests were held in strictest confidence. "One man overseas forwarded the Service $50 to buy six presents—one for his wife and five others for five other girls. He was a sailor, and the shoppers could tell right off the places where his ship had docked while he was in the States because each of the girls lived in a different port. The Service was pleased to note that he'd ordered a $25 present for his wife but specified that the presents for the other girls were not to cost more than $5 apiece."

Ladies' Home Journal asked soldiers "What Is Your Dream Girl Like?" The article reported that "Uncle Sam's boys do a lot of thinking about girls. They have definite ideas about the sweetheart whose love and loyalty will keep their hearts warm and their spirits high while they are doing their jobs."

Most servicemen knew what they wanted: a domestic type, fond of cooking and children (28 percent); an outdoor girl, good at sports (20 percent); a good conversationalist and social mixer (19 percent); or shy and sweet (19 percent). The survey included the question: What do you notice first about a girl? Only one out of four servicemen admitted: her figure.

The rush to war had produced a passion, an impulsiveness that defied precedent. Some men in the United States believed they could avoid military service if they were married. As Congress debated the draft, the marriage rate increased by 50 percent, and nine months later the birthrate rose, too.

After Pearl Harbor, the same thing happened, only the motive was different. Men knew they were going and wanted someone waiting when they came back. Americans got hitched at the rate of about a thousand a day, a 20 percent jump in the first month of 1942. Time for one good weekend and another jump in the birthrate, the so-called good-bye babies.

GIs were paper fathers. A soldier's family lived on $50 a month—the $22 allotment and $28 allowance from Uncle Sam. The government had taken his place at the family table, sending out 5.2 million checks each month to the families of servicemen. What kind of family was it with an empty chair at the head of the table? What kind of marriage with an empty space in the bed? *Reader's Digest* wrote about a new kind of gold digger: "A girl has married thirteen soldiers and divorced none of them. Need any of them support her? Yes—the first."

Articles described Allotment Annies, women who married as many servicemen as possible, hoping to collect the Uncle Sam paychecks and maybe the $10,000 insurance payout if one took a bullet.

Often it was the mail that contained a bullet to the heart. Called Dear John letters after a popular radio show that featured someone reading letters aloud, the missives informed soldiers and sailors that the girls they'd left behind had found someone else. Perhaps more than any other single piece of evidence, the Dear John letter destroyed the double standard, proving that women were sexual creatures with appetites and yearnings of their own. Desire could not be put on a shelf, nor kept in a drawer, secured with a ribbon.

Both *Yank* and *The Stars and Stripes* published letters from servicemen in columns titled "Mail Call." Soldiers groused about a California law that let married women put up for adoption children born out of extramarital affairs without notifying their husbands overseas.

After the war, film director Billy Wilder captured the bleak side of mail call in a scene from his film *Stalag 17*. An American POW in a German prison camp is reading a letter from home. "I believe it. I believe it," he says.

"You believe what?" asks his buddy.

"My wife. She says, 'Darling, you won't believe it, but I found the most adorable baby on our doorstep. And I've decided to keep it for our very own. Now, you won't believe it, but it's got exactly my eyes and nose.'

"Why does she keep saying that I won't believe it? I believe it . . . I believe it. . . . [With less certainty.] I believe it."

The soldier had his dream girl, a blend of memory and imagination. Nothing he came up with kept pace with the real thing. The war provided women with unprecedented opportunity. When women change, sex changes. The war promoted a heady blend of patriotism and promiscuity. Some women waited, others would not. Some women kept to traditional roles. They dressed in powder blue outfits based on uniforms, wrapped bandages, grew vegetables in Victory gardens, and wrote letters. Others played a more active part: The nation got to know Rosie the Riveter, Wanda the Welder, WAACs, WAVES, and the Petticoat Army—as well as legions of passionate patriots known as V-girls, young women who would give their wartime all. Even the comics had a new heroine. Wonder Woman now joined Superman and Batman in the fight against evil.

* * *

With the war, America went back to work, effectively ending the economic hardships of the Depression. The unemployed, still 15 percent of the workforce (some 8 million people) in 1940, dropped to 1 percent by 1944.

Women who had marched shoulder to shoulder for the right to work (twenty-six states had passed laws during the Depression prohibiting married women from working) now labored shoulder to shoulder with men on the job. Women would help build the arsenal of democracy called for by FDR. But not without controversy. Women in the workplace posed a threat to those who stayed at home. Magazines routinely ran articles about seduction in the office and sex on the assembly line, about the danger posed by "office pals" and "man stealers."

John Costello, author of *Virtue Under Fire,* reports that there was an attempt to blame the bosom. "The management of some war plants banned women from wearing makeup," he writes, "in an attempt to contain the temptation. When the Boeing Aircraft Corp. sent home 53 women for wearing tight sweaters, it became a cause célèbre. Their union objected that what was considered perfectly moral attire in the office should not be considered immoral on the shop floor. Management brought the National Safety Council into the dispute by claiming that sweaters caught fire, attracted static electricity and were a dangerous hazard because they might snag in rapidly turning machinery."

Ann Sheridan, a Hollywood star whose way with a sweater had earned her the title of the Oomph Girl, came to the aid of the factory women. Her retort: "While a small figure in a large sweater might be a threat to safety, a big girl in a tight sweater is only a moral hazard to men."

Prosperity reminded women of the power of sex appeal. Skirts revealed knees for the first time in a decade. When Du Pont introduced nylon stockings nationwide in 1940, almost 4 million pairs walked out the door in a matter of days. When nylon was needed for the war effort, women painted their legs and drew lines down the backs of their calves with eyeliner.

Women, who had learned to ration sugar, butter, cheese, meat, canned foods, shoes, gasoline, and alcohol, also had to face the man shortage. A hit song of 1943 captured the woman's view of a nation stripped bare of its most eligible bachelors: "They're Either Too Young or Too Old." Scarcity had as much of an impact on sexual behavior as did the more frequently cited "war aphrodisia"—the live-for-the-moment mentality that swept over men and women alike.

Beth Bailey, in her history of dating, *From Front Porch to Back Seat,* recalls that the male call directly affected young single women and shattered the social expectations of the day. One casualty was the dating system that had evolved since the turn of the century, in which a woman's popularity was measured by the number of men who asked her out, by the number of men lined up to cut in on the dance floor, and by the sum of money a man was willing to spend on an evening of entertainment. Imagine the envy, the sense of lost opportunity or outrage, of a girl who read this bit of advice from a 1940 *Woman's Home Companion:* "If you have dates aplenty, you are asked everywhere. Dates are the hallmark of personality and popularity. No matter how pretty you may be, how smart your clothes—or your tongue—if you have no dates, your rating is low. The modern girl cultivates not one single suitor but dates lots of them. Her aim is not a too obvious romance but general popularity."

"This generation of women," Bailey writes, "had expected to have their years of popularity, of commanding the attention of men." The ratio of men to women on one campus was suddenly one to eight, where it had previously been five to one in women's favor. Colleges opened dating bureaus to help coeds find escorts, either civilian or in service. Men in uniform were preferred, especially officers. At some colleges, 75 percent to 90 percent of the students were female. The war was a disaster for those who had gone to college to improve their social lives or to find husbands. Without irony, Bailey comments, "To complain about lacking dancing partners seemed selfish and unpatriotic when former dancing partners were fighting and dying in foreign lands." But complain they did. They stooped to advertising for dates to the prom, offering to supply the car and pay for the date as well.

For the first time in the century, men were valued for being young, virile, and available—and women competed for them. Colleges held seminars on how to make oneself attractive to the few good men left to be had. *Ladies' Home Journal* reported that women spent $800 million in 1942 on "keeping beautiful."

The war gave rise to a new phenomenon known as the wolf. Take a young man, surround him with other young men, deprive him of female companionship except in a concentrated burst of hormonal energy known as the weekend pass, and you have a wolf. Not the type to go from camp to church social, he had time only for sexual shorthand, best communicated by a wolf whistle. Anyone who knew his way around the ladies was considered a wolf, and he

became a part of the pop culture of World War II. To build up a buddy to his shipmates in the 1942 film *The Fleet's In,* Eddie Bracken refers to retiring William Holden as the biggest wolf in the Navy. Tex Avery turned the big bad wolf of fairy tale into a sexual predator in popular animated cartoons such as *Red Hot Riding Hood* and *Swing Shift Cinderella.* When cartoonist Leonard Sansone was drafted he created a wolf in GI's clothing for the Camp News-paper Service that also distributed Milton Caniff's classic *Male Call.* (After the war Sansone's *Wolf* made an uneasy and ultimately unsuccessful transition to civilian life. A postwar America was not so accepting of unbridled lust.)

In horror films, male sexuality was often identified with the beast. The Wolf Man, a sexual monster in 1941, returned in a postwar send-up of mon-ster movies titled *Abbott and Costello Meet Frankenstein.* Lon Chaney, Jr., con-fesses to the two comics, "In a half hour the moon will rise, and I'll turn into a wolf." Costello replies, "You and twenty million other guys."

The wolf had a sexual counterpart in the V-girl. As one female commen-tator, a hopelessly outnumbered advocate for chastity, described the situation, "Patriotism, vast admiration, fervor and precocious sex urge get all tangled up in adolescent bodies that are not yet equipped with the necessary adult intellectual processes with which to make decisions. Juvenile girls are avid to show soldiers a good time: In one meeting they become the girlfriend, the pickup, with no inherent adult standard of sex conduct to offset emotionalism." She called these girls bobby-socks amateurs, but they were simply doing what their big sisters were doing.

Thousands of girls flocked to the ports and bases, greeting servicemen on furlough and proving they too were doing their part. Eliot Ness, the former Untouchable, took on a new task as director of the Federal Social Protection Program. He found his new foe to be "a casual fun-seeking girl, wanting male companionship, a young experimenter, somewhat lonely, easing her con-science by quixotic references to patriotism."

In many cities the V-girls were organized and supervised. The Red Cross held "practice parties" for hostesses. There were camp dances, YMCA socials, and USO clubs. The stars came out at the Hollywood and the Stage Door can-teens, where men in uniform could dance with the likes of Hedy Lamarr, Joan Crawford, Bette Davis, and Olivia de Havilland to the big band music of Benny Goodman and Count Basie. "I Left My Heart at the Stage Door Canteen" be-came a popular song of the day. The scene was repeated across America. In

Seattle 12,000 young women, volunteers aged eighteen to twenty, spent more than nine million hours dancing with servicemen during the war. It is interesting to note that dancing—considered the devil's handiwork at the turn of the century—was now a patriotic duty.

It was against the rules, but the hostesses were very touchable.

In the 1944 Preston Sturges film classic *The Miracle of Morgan's Creek,* Betty Hutton portrays a small-town girl named Trudy Kockenlocker who, after a wild "kiss the boys good-bye" dance, wakes the next morning with the vague memory that she may have married one of the soldiers. Was it "Private Ratziwatski, or was it Zitzikiwitzky?" The troops are long gone, but the cock in the locker becomes a bun in the oven. Finding herself pregnant, Trudy marries Norval Jones, a 4-F friend played by Eddie Bracken. She becomes a celebrity when she delivers sextuplets, and Norval is made an honorary colonel in the state militia.

An affectionate and often hilarious look at patriotism and promiscuity, the film sailed right past the censors. Far from being branded a fallen woman or a bigamist, Trudy is applauded for her part in the war effort. The prudes at the Production Code Administration wanted the studio to cut a line delivered by Trudy's sister: "She's not the first dumb cluck who got herself in a snarl. What with the war and all, there'll probably be millions of them. They say they make the cutest babies." The sister wasn't far off: Some 650,000 wartime babies were born out of wedlock in the United States.

In 1944 Betty Grable played a canteen hostess in *Pin-up Girl* who boosted the boys' morale by never saying no to a marriage proposal. One musical number provided the observation, "Battles are won in the daytime, but history is made at night." In another song Betty's character asserts the new standard of discretion: "Don't carry tales out of school. If you're a blabbermouth, you're off my list."

James Jones, author of *From Here to Eternity,* gave an eyewitness account of life near military bases in his history of World War II. Having been wounded at Guadalcanal, he returned to Memphis to find, "At just about any time of day or night there were always between half a dozen and a dozen wide-open drinking parties going in the rooms and suites, where it was easy to get invited simply by walking down the corridors on the various floors until you heard the noise. Money was not much of a problem. Nor were women. There was always plenty of booze from somebody, and there were also unattached women at the hotel floor parties. You could always go up to the Starlight Roof and find

yourself a nice girl and dance with her awhile and bring her down. Everybody screwed. Sometimes it did not even matter if there were other people in the room or not at the swirling, kaleidoscopic parties. Couples would ensconce themselves in the bathrooms of the suites and lock the door."

It is clear that servicemen were aware of the advantage those at home enjoyed. When a skinny 4-F crooner named Frank Sinatra opened at the Paramount Theater in December 1942, thousands of screaming bobby-soxers jammed the streets, reportedly swept away in near sexual hysteria. The men overseas resented Sinatra and booed him when he appeared on a USO tour. Despite the controversy, Sinatra would become the most important singer of the decade, acclaimed as "the Voice," as influential to a new generation as Bing Crosby had been the decade before.

Music and movies were major morale boosters for the home front and for those away from home. Glenn Miller's "Chattanooga Choo Choo" earned a gold record and "Juke Box Saturday Night" celebrated an industry that took in $80 million, an incredible 5 billion nickels a year. Each nickel evoked a few moments of pure emotion, from the heartbreaking "I'll Be Seeing You" to the heartsick "Don't Sit Under the Apple Tree (With Anyone Else but Me)." During the musicians' strike in 1943 the big bands still recorded V discs of the latest hits for the boys in service.

Hollywood made movies as escapist fare and as propaganda. Americans watched John Wayne and Errol Flynn, neither of whom saw service, win the war on the silver screen. Musicals such as *Star-Spangled Rhythm, Two Girls and a Sailor, Seven Days' Leave, Something for the Boys, Kiss the Boys Goodbye,* and *Anchors Aweigh* were about as complicated as Fourth of July parades and just as popular.

Hollywood's commitment to the war was total. Directors Frank Capra, John Ford, and William Wyler turned out documentaries for the government. When Carole Lombard died in a plane crash returning from a bond rally, husband Clark Gable enlisted and flew bombing missions over Germany, carrying her earrings in a special case behind his dog tags. Other stars signed on, including James Stewart, Tyrone Power, Robert Montgomery, and Mickey Rooney. The film palaces sold war bonds and acted as collection points for strategic materials and blood donations.

In the movies war was a grand adventure. America knew that Pearl Harbor had been a day of infamy and that real lives had been lost, but the public would

not know how many until after the war. The government controlled all wartime information, as it did almost every other aspect of Americans' lives. John Jeffries, author of *Wartime America,* states that grisly photos of combat were the first to be censored. "Not until 1943 were photos of dead Americans released for publication," he writes. "Not until 1945 did *Life* show American blood being shed."

The phrase "Don't you know there's a war going on?" was often heard on the home front. Overseas, men needed no reminder. The prospect of death rewrote the rules of sex.

"Over there" was not a single sexual state. The sex life of a bomber pilot stationed in England differed vastly from that of a Marine on an island in the Pacific or an infantryman marching through the mud in Italy.

In the Rodgers and Hammerstein musical *South Pacific,* sailors sing a ribald tribute to the members of the opposite sex, extolling the substitutes—packages from home, movies, shows, speeches, advice from Tokyo Rose. "We get letters doused in perfume, we get dizzy from the smell. What don't we get? You know damn well."

Soldiers stationed in the Pacific tried to remember what it felt like. "It" was pussy, and men talked about it, dreamed about it, and died thinking about it. In a bull session recorded by novelist Norman Mailer, one character recalled a woman with a pussy so sweet "it was like dipping it in a barrel of honey."

James Jones provided another account from the Pacific. The men who spent the first six months of the war pulling anti-invasion duty on the beaches of Hawaii knew there was nothing like a dame. "A half-Hawaiian gentleman with a good eye for business drove up in a pickup truck with four wahines in the back. While our lieutenant and his staff sergeant looked the other way, the four girls, utilizing one of our five pillboxes and a sheltered ledge open to the wind directly behind it, managed to take care of the whole 37 of us on the position in just over 45 minutes. The lieutenant timed it, while ordering five men who had already been to go and relieve the five men on post in the pillboxes so they could go. The fee was ten bucks a man and everybody was happy with the price."

Sex, no matter how quick and tawdry, no matter if it was timed by a lieutenant, was still a moment of affirmation, a moment that was entirely your own. Your heartbeat, your erection.

One of the earliest war films, *A Yank in the RAF* (1941), followed Tyrone Power as he joined the Battle of Britain. He fell for Betty Grable, playing an American showgirl. By June 1944, a million and a half Americans had relocated to British soil. They flew bombing raids in broad daylight and partied the night away at the Rainbow Club, the Hammersmith Palais, and the Paramount. Almost everyone, from Ike on down, was taken by the charm of British women. Anthropologist Margaret Mead visited Britain and wrote home about American men, with their "exuberant informality," having "morning tea given to them in bed by a titled hostess, without any servants, who has nevertheless opened her house to them. 'And wouldn't that make Sioux City open its eye?'" She painted a picture of a soldier forming permanent ties with a family, "packing up his weekend ration allowance so that at the British dinner table he will have his little jars of butter and sugar, too, and a bit of something special for his harried hostess."

Hers was not the first bit of disinformation given to the American public. British soldiers, who had already been at war for years in the deserts of North Africa and on the beaches of Dunkirk, complained about the presence of the Yanks, who were, they said, "Overpaid, oversexed and over here."

American soldiers found comrades in arms. The women they met had lost loved ones, seen neighborhoods disappear under the air raids. Women overseas did not share the same prejudice as Americans; in both Italy and Britain Negro soldiers were often treated as equals. Interracial sex sparked riots between white and Negro troops in Launceston, Manchester, and Newbury. American bigotry begat bloodshed.

English women knew there was a war going on. Civilian casualties were a brutal, inescapable fact. Some 92,700 were killed in Britain. Fear was an aphrodisiac. They were willing to steal moments of comfort, to build a picnic or dinner around a gift of ham, bread, real butter, and beer. Companionship, an evening in each other's arms, offered a moment of normalcy. And, sorry, the morning tea in bed came after a night of less printable activity.

There were a third of a million illegitimate babies born in Britain during the war. The experience was repeated in Australia. After the war, American servicemen would take 50,000 British war brides. About 10,000 Aussie girls came back to the United States (giving up the outback for a world of refrigerators and electric stoves).

American magazines ran articles asking, "Are the British Stealing Our Men?" When American women learned that our soldiers were sleeping with German women, they protested loudly. The War Department responded by levying a $65 fine for fraternizing with fräuleins.

If letters kept love alive, photographs fired the imagination. Soldiers put pin-ups on the walls of their barracks, on the insides of tanks and bombers, inside their helmets, on palm trees next to their shaving mirrors, in footlockers. An officer in the Pacific sent out pin-ups with intelligence reports to make sure they were read. The code breakers kept a huge collection of photos under glass on their desks, a calm center amid the chaos of enemy ciphers. GIs clipped magazine ads and sent away to Hollywood studios for glamour shots of the stars.

During the war, cheesecake was as American as apple pie. After Pearl Harbor, the Army decided that the enlisted man needed his own magazine. Former author, now editor in chief Hartzell Spence told the newly recruited staff of *Yank,* "We've got to have a pin-up." Ralph Stein recalled, "None of the rest of us had ever heard the term. I think Hartzell might have invented it." Each issue of the Army weekly would contain a full-page black-and-white photograph of a pretty girl wearing relatively few clothes.

The *Yank* "Pin-up Girl" almost did not get off the ground. An early layout went all the way to General Henry Stimson, who sent it to his superior officer—Mrs. Henry Stimson. She saw the pencil-drawn dummy and ordered it quashed. Hornier heads prevailed.

An estimated two million servicemen ended up with the still shot of Betty Grable in a bathing suit, looking over her shoulder. She was the girl with the million-dollar legs, whose musicals made her the highest paid woman in America. She married bandleader Harry James but was still "the enlisted man's girl." Her title as the ultimate Pin-up Girl was celebrated in her 1944 film of the same name.

Rita Hayworth posed in lingerie for *Life* and became another favorite. Almost all the distaff stars and starlets posed for pin-up photographers, doing their part to boost the boys' morale, many with their own trademark looks: Veronica Lake had her peekaboo hairstyle, Lana Turner her sweater, and Dorothy Lamour her sarong. Carole Landis was the Ping Girl, and Marie McDonald was The Body.

The most sexual pin-ups were the work of Alberto Vargas, an artist who had spent his early years glorifying the girls of the then graduated-to-Hollywood Ziegfeld Follies. In 1940 the first Varga Girl appeared in *Esquire,* eventually replacing the streamlined creations of George Petty. When the editors released a calendar of twelve Varga Girls, *The New Yorker* declared Vargas "an artist who could make a girl look nude if she were rolled up in a rug."

The first calendar sold 325,000 copies; the 1944 version 2.5 million. Despite the rationing of paper (which meant magazines that went overseas were printed in miniature versions), the military insisted on receiving *Esquire* full size.

Military historian John Costello notes that the pin-up had a special status for many: "The extensive personal testimony to the emotional impact of World War Two suggests that what men and women were fighting for had less to do with abstract notions of freedom or patriotism than with the need to protect the personal values represented by sweethearts, wives and families. Sex, therefore, played an extensive role in the war experience. Whether with its pin-ups of Hollywood stars, well-thumbed pictures of the girl back home, Rosie the Riveter, the archetypal female factory worker, or women pilots, World War Two acquired an undeniable feminine aspect."

The pin-up was reassuring to women worried about women over there. *The Saturday Evening Post* ran an article about a wife who wondered, "Are there any blondes at the front?" She had been married for only four months before he left for war. She had not seen him for nearly two years. The author of the piece answered, "Yes. There were lots of beautiful blondes, but I wouldn't be alarmed about them. They were all pin-ups."

As more than one soldier commented, the pictures "give us guys a good idea of what we're fighting for."

James Jones, in a discussion on Hollywood pin-ups in World War II, recalls a sergeant who heard a famous story that swept the Pacific. It seems that Paulette Goddard and director Anatole Litvak were having dinner at Ciro's in Hollywood. As the evening progressed, the couple became amorous. An obliging waiter put up a screen to shield them from view. Accounts vary, but apparently one of the celebrities disappeared under the table to pleasure the other. The sergeant, grinning, said, "Now, man, that's what I'm fighting this war for. That kind of freedom. Where could that happen but in the good old U.S. of A.?"

To Roosevelt's four freedoms, the GI added the fine art of fellatio (or whatever happened under that table).

Gary Valant, an art historian fascinated by a particular kind of pin-up—the kind painted on bombers—writes this chilling rationale for the practice:

It's midwinter 1943, you're 20 years old, it's 4:30 in the morning, it's raining, it's cold. You've got a slight hangover, and you're walking in mud (there's always mud). You're wearing a fur-lined flying suit because where you're going it's 30 degrees below zero. You've got an oxygen mask because where you're going it's hard to breathe. You're carrying a map because at 25,000 feet there are no signs. Prior to December 7, 1941, your main goal in life was to get a car and marry Ginger Rogers, but now it's just to stay alive another day because you're a crewman on a B-17, and where you're going people are going to die. But not you, not your plane, not your crew because you're special, and the special people always come back. They don't blow up in the sky or go in at 400 miles per hour, one wing gone, no chutes, on fire—not the special ones. They always come back. So we need a special name for our plane—and a special picture on it. Maybe a picture of Betty Grable, or one of those Varga Girls from *Esquire.*

Valant collected images in a book called *Vintage Aircraft Nose Art.* "The origin of nose art goes back to some ancient time when the first proud charioteer decorated his vehicle so that it would be distinguishable from others," he explains. "Few crew members would talk about 247613 or 34356 [their B-17 tail numbers], but many tales would be told about Sack Time or the Dragon Lady."

A GI artist would copy a Varga Girl or Milt Caniff's sumptuously reclining Miss Lace from *Male Call* and maybe come up with a sexual name: *Target for Tonight, Night Mission,* or *Lucky Strike.* And next to her he might paint a bomb for each successful mission, each dawn ascent into flak-infested skies. More than 100,000 crewmen flew to their deaths in World War II. The military set the number of missions men had to fly at a level that would give them

a 50 percent chance of survival. One artist, trying to paint the signs of the zodiac on twelve bombers flying out of England, had to start Taurus three times. The first two planes had taken off and never come back. After the war, a man given the job of converting bombers to aluminum scrap found himself moved by the art. He had a workman remove the panels with a fire ax. On a whim, they were kept from becoming toasters, frying pans, and washing machines.

Most Americans focused on morale, not on morals. But the forces that for two hundred years had controlled sex in America did not go AWOL. The roar of the war machine tended to drown out prudes and puritans, but these people still walked the perimeter.

Throughout the war Monsignor William Arnold sat at a desk in Washington, D.C., cataloging the sins of mankind. As Chief of Chaplains, with the rank of Brigadier General, he oversaw eight thousand or so military chaplains serving around the world. His legions filed monthly reports and letters of complaint about profanity, pin-ups, camp newspapers, ads for offerings from the Charm Photo Co. (shots of girls disrobing), risqué and irreverent magazines, indecent literature, VD campaigns, pro kits and rubbers, houses of prostitution, bomber art, and USO tours.

Arnold moved these letters through the bureaucracy the way commanders moved models of ships around the war room. He kept meticulous files that would become the only surviving record of the war between morale and morals. Let other historians chart the battles and bloodshed; Arnold charted the corruption of souls. He was the puritan conscience in a world gone mad.

He kept the letter from a chaplain at Camp Sutton who had run amok in the officers' club and torn down pin-ups from the wall. When the camp commandant ordered the pictures replaced, the field chaplain fired off an angry reply: "As I am the depot chaplain, I feel that it is my duty to have removed all such literature and posters that are destructive to the morals of this command. This property was two pictures of nude women. I have been taught for the past 17 years that such pictures lead men to immoralities and destroy all the good that is in them. As one looks upon such scenes, his passions become stirred and then he seems to satisfy them in any manner possible. It was my desire in removing these pictures to keep the thoughts and acts of these men pure and

clean. I thought sure that to remove such poison to the mind and soul of mankind from the sight of your officers would be pleasing to you."

A chaplain in charge of moral counsel in China, Burma, and India sent a letter to all chaplains serving in the area reminding them that "no chaplain wants to pose as a prude, nor does one desire to be a thorn in the flesh of anybody," but that a chaplain's duty was "to propose suitable means to promote 'right thinking and right acting,' and to 'promote character building and contentment.'"

The chaplain enclosed a careful study of the number of pin-ups in a headquarters company. He found fifteen Varga Girls, twenty flesh-colored nudes and seminudes, fifteen collections of various types. Some 51 out of 723 enlisted men kept photos on the wall; the rest, noted the chaplain, kept ordinary photos of home folks in their footlockers. He blamed the incidence of girlie photos on the makeup of the unit, "some of whom evidently were reared in gutters rather than homes."

He recorded and categorized the types of applause at USO shows, noting the hearty, normal initial response to a "radiant American girl as she makes her appearance" and bemoaning the "vociferous . . . response to daring or coarse humor, loud features of dress or lack of it"—as though applause were the sound of the devil's artillery.

He found little support from the brass, whose philosophy, as expressed to the chaplain, was "what the soldiers want is, first, more beer, then a woman." The chaplain confessed that "the actual number who perhaps do merit such an estimate is regrettably large."

A chaplain at Camp Van Dorn, in Mississippi, complained, "Does the morale of the American soldier depend upon pin-up girl pictures and lewd cartoons? I cannot believe this; for if it be true, our soldiers are on the same low level as the Nazis and the Japs."

The chaplain was wrong. The Nazis worshiped the Führer and had a drive toward purity that seized degenerate art and consigned books to bonfires. The Japanese worshiped the emperor and did not tolerate distraction. The Japanese actually used pin-ups against Americans, dropping pictures of a naked woman beckoning seductively on troops in Guadalcanal. On the back of the photo were instructions on how to surrender to Japanese troops.

A copy of *Male Call,* Milt Caniff's cartoon strip drawn for men in service, prompted the Chaplain General to act. Caniff had drawn a strip showing the arrival of a new lieutenant. Walking into the barracks, the fresh-faced officer

lectures the men about the pin-ups on the wall. "Do you mean that combat troops go in for such childish displays? Take those things down!" When the unit commander invites the replacement into his office, the walls are covered with nudes. "Now, Lieutenant," he says, "what was it you wanted to speak to me about?"

Arnold wrote the commanding general, saying, "Many camp papers would be sent home to parents and families if soldiers did not fear that these cartoons, pin-up pictures, etc. might cause apprehension in the minds of home folks and a false impression be given that these things are normal and encouraged." Arnold also complained about the implication that "the questioner of suggestive art is a 'pantywaist' and that experienced officers of higher echelons definitely approve."

Perhaps stinging under the label of pantywaist, Monsignor Arnold tried another tack on bomber art, forwarding a letter from a woman who described herself as a "person of no importance whatsoever" but who as a "citizen and a Catholic" wanted to protest a certain practice she had seen in a newsreel. "The film featured pictures of unclothed women, which some of the pilots had placed on their planes. I cannot believe that such pagan, barbarous pictures represent the choice of a majority of the pilots. A few of the women were lightly draped, but the majority had no garments. The film spoke of the representatives as being morale builders. We all have reason to be proud of the courage and heroic self-sacrifice of our splendid aviators. Large numbers of the young men have left wives and little babies at home. It can be very little comfort to their suffering wives to see their husbands represented as wild pagans with no thought of decency. America is fighting for freedom, not for license, and I am certain that a majority of her aviators are upholding her standards and are not dragging them in the mire."

Arnold drafted an order reminding the Air Corps of standards of decency: "The expression of a normal interest in the opposite sex has occasionally, through exercise of bad judgment under the stimulation of unfamiliar wartime circumstances, resulted in pictorial, textual and spoken representations that exceed the bounds of normal good taste and decency. It is desired that every effort be exerted to correct these untypical occurrences."

The men who flew the bombers were nearer to God, every day, than was the Chaplain General. The first American bomber to complete twenty-five missions was brought home a hero. On her side was painted: *Memphis Belle*.

The pictures stayed or were blown out of the sky.

The Chief of Chaplains kept track of a campaign waged by the National Organization for Decent Literature, a movement started by the Most Reverend John Noll, bishop of Fort Wayne, Indiana. The NODL had concocted a Code for Clean Reading, banning all magazines that "(1) glorify or condone reprehensible characters or reprehensible acts; (2) contain material offensively sexy; (3) feature illicit love; (4) carry illustrations indecent or suggestive; or (5) advertise wares for the prurient minded."

The NODL, like the Legion of Decency before it, was perfectly willing to pass judgment on reading material for the rest of America. Its list of banned magazines encompassed nearly two hundred titles, targeting, among others, *College Life, Cowboy Romance, Film Fun, Modern Romance, Police Gazette, True Love, Uncanny Tales,* and *Zest* as well as more racy titles such as *Breezy Stories, Spicy Adventure, Garter Girls, Keyhole Detective Cases, Scarlet Confessions,* and *The Ideal Woman.*

The NODL recruited chaplains who would peruse the base newsstand and report any magazines that showed up on the NODL's list. Most base commanders shrugged off these complaints.

Unfortunately, the NODL had an ally in one of the richest and most powerful Catholics in Washington. Frank Walker became Postmaster General in 1940. This reincarnation of Anthony Comstock went after magazines with a vengeance, stripping them of their second-class mailing privileges. In two years he had declared twenty-three magazines obscene and revoked or denied the second-class mailing privileges of another sixty-two. Chaplains would then take the list of unmailable magazines (ranging from *Real Screen Fun* to *College Humor*) to a base commander and argue that if Uncle Sam deemed them unmailable, they should not be sold on PX newsstands.

Such was the power of the Postmaster General that chastened editors soon took layouts of their magazines for approval to the solicitor of the Post Office Department in Washington. They should have learned from Neville Chamberlain's lesson at Munich: Appeasement sucks.

Walker went after *Esquire* in January 1941. Founding editor Arnold Gingrich was forced to make monthly trips to Washington to meet with the solicitor. The solicitor would go over the dummy of the next issue page by page, cartoon by cartoon, making changes on the spot. In his memoir Gingrich

recalled, "Some of the things I had to tone down seemed to me to be a case of bending over backward to avoid offending even the most sensitive of sensibilities to a degree that was nearly ludicrous." In a vain attempt to satisfy the Post Office, Gingrich went so far as to clothe Petty's nude gatefolds in transparent chemises in subscription copies. It wasn't enough.

On Labor Day weekend in 1943 Walker challenged *Esquire* to show cause as to why it should not lose its second-class mailing permit. (He presented it as a privilege—one that if revoked would cost *Esquire* $400,000 a year in postage, effectively putting the magazine out of business.)

The Post Office cited as obscene ninety items that had appeared in *Esquire*. The list included twenty-two Varga Girls, short stories, various photographs, a parody of "The Night Before Christmas," and cartoons reprinted from military base newspapers. In one a woman asks, "Would you like to see where I was operated on?" A man replies, "No, I hate hospitals."

Walker considered specific words to be obscene—bottom, juke, diddle, bawdy house, prostitute, streetwalker, syphilis, sunny south (referring to a woman's posterior), fanny, and son of a bitch.

H. L. Mencken, who was for decades the avowed enemy of bluenoses and puritan twits, took the stand in *Esquire*'s defense. "Sunny south," he explained, "is obviously an attempt at humor. I myself in such a situation use the word caboose, but then everybody has his favorites. The idea that it was [considered] obscene shocks me. It seems to be a term of limited situation. What he would call it if she were facing south, I don't know."

The Postal Board found in *Esquire*'s favor, but Walker overruled his own panel. The case worked its way to the circuit court of appeals in Washington, D.C. On June 4, 1945, Judge Thurman Arnold thanked the Post Office for its valiant effort to set a new national standard for readers. But, he observed, "We believe that the Post Office officials should experience a feeling of relief if they are limited to the more prosaic function of seeing to it that neither snow nor rain nor heat nor gloom of night stays these couriers from the swift completion of their appointed rounds."

The Post Office persevered, taking the case all the way to the Supreme Court. Justice William O. Douglas upheld the appeals court ruling with a stern rebuke: "The provisions [of the second-class mailing act] would have to be far more explicit for us to assume that Congress made such a radical departure

from our traditions to clothe the Postmaster General with the power to supervise the tastes of the reading public of this country."

Hugh Merrill, author of *Esky: The Early Years at Esquire,* summed up the case. "On the surface," he wrote "the *Esquire* trial was about censorship and the Varga Girl. But there is a deeper meaning to those years in court. The trial was also about rural versus urban sensibilities, about the dominance of old-time Christianity and about changing sexual mores in America. The magazine stood alone among mainstream periodicals as an advocate of the new sexuality. The Court's decision gave the final push into reality to a country whose popular culture still tucked its sexuality into twin beds with the lights out."

The Chief of Chaplains now let others try to control the reading tastes of America, but he reserved the full weight of his office for a campaign against Hollywood and USO shows.

The United Service Organizations sprang forth in 1941 to send 3,500 performers on the Victory Circuit, the Blue Circuit, the Hospital Circuit, and the Fox Hole Circuit. Performers racked up more than 35,000 personal appearances in three years.

Bob Hope described the role of touring shows in his autobiography *Don't Shoot, It's Only Me.* "It took me a long time to realize that all the rules of comedy were going to be changed," he remembered. "We represented everything those new recruits didn't have: home cooking, mother and soft roommates. Their real enemies, even after war broke out, were never just the Germans or the Japanese. The enemies were boredom, mud, officers and abstinence. Any joke that touched those nerves was a sure thing."

Hope was the star of the number-one show on radio. Shortly before the war broke out, his sponsor, Pepsodent, suggested he broadcast a show from an air base. On May 6, 1941, he took Frances Langford, Jerry Colonna, and Bill Goodwin over to March Field near Riverside, California. His reception was nerve-tingling. One of the soldiers told Hope the revue was the best thing that happened to the U.S. military since Gettysburg—Hope had gotten live girls past the sentries at the gate.

Hope performed before an audience whose laughter was unlike anything he had ever encountered. On a normal show, the director figured on twenty-three minutes of jokes and music, three minutes of commercials, and a little over three minutes for laughter. "Once we started playing Army camps, we had to allow six minutes for the laughs."

At the show's first broadcast at a base for WAACs the laughs increased to more than twelve minutes and Hope had to cut the show while he was on the air. The WAACs even drowned out jokes with wolf whistles (proving that sexually appreciative predators were not strictly male). Hope realized that the troops used the radio broadcast to let their voices be heard across America. They were alive, and the wolf whistle and roar of laughter were the best ways to send that message.

Hope took his troupe to London and North Africa. John Steinbeck recorded the other emotions these USO entertainers encountered. After touring a hospital, he wrote, "There is a job. It hurts many of the men to laugh, hurts knitting bones, strains at sutured incisions, and yet the laughter is a great medicine. . . . Finally it came time for Frances Langford to sing. The men asked for 'As Time Goes By.' She stood up beside the little GI piano and started to sing. She got through eight bars when a boy with a head wound began to cry. She stopped and then went on, but her voice wouldn't work anymore, and she finished the song whispering and then she walked out so no one could see her and broke down. The ward was quiet and no one applauded."

Perhaps it was a legacy of the Hays office, the success of the Legion of Decency in pressuring Hollywood, but Monsignor Arnold took it upon himself to lecture the special branch. The file contains letters between Arnold and Lawrence Phillips, the executive vice president of the USO Camp Shows. Chaplains at camps were the first to complain. "A stage show was presented by members of the armed forces to the armed forces with dialogues and jokes that were unwarranted for a mixed audience, including Army nurses." Two of the gags given in this show were as follows:

FIRST MAN: "What is the difference between the Hudson River and a woman's leg?"

SECOND MAN, after hesitation: "I don't know, I have never been up the Hudson River."

Jack and Jill went up the hill,
Each had a dollar and a quarter.
When they came down the hill,
Jill had two dollars and a half.

Now I ask you, did they go up for water?

Chaplains even complained about Hope, saying he laced his routines with inappropriate jokes. Perhaps they referred to his classic response to the fashions of the day on his radio show: "If skirts get any shorter, women will have two more cheeks to powder."

Someone in the 60th Troop Carrier Group complained about comedian Otis Manning telling the Jack and Jill joke, then quoted an exchange between the short comedian and performer Barbara Long:

"What would you do if you met a beautiful girl?" Long asked.

"I'd kiss her."

"What would you do if she were a tall girl?"

A ventriloquist on the same show had this exchange with his dummy:

"Do you know who Charlie McCarthy was?"

"He was the son of a birch."

"Do you know who his mother was?"

"She was the best piece of ash in the party."

Long, it seems, wore a split dress and danced seductively, pulling her dress aside to say, "That's all right, fellows, there's enough here for all of you." At the other end of the stage, she said, "That's all for you. That's your ration for today." Going through suggestive motions, she remarked, "How does it look from down there, honey?"

The Chief of Chaplains forwarded the complaint to USO exec Phillips, who asked that the performers be given a second chance. The USO finally gave in to the pressure and offered a human sacrifice. Arnold's file contains copies of Phillips's letter asking that Long, the ventriloquist, and Manning be recalled and not be allowed to tour again. The blacklist—dormant since Will Hays's Doom Book—had been reborn.

Arnold invoked the image of an army of 8,000 chaplains who would return to civilian life with a negative opinion about the entertainment industry.

The threat of a boycott by the Legion of Decency was still fresh in the minds of Hollywood executives. But one reads the files and realizes how few of these chaplains were concerned about such matters. They went about the daily business of comforting the wounded, writing letters for those unable to hold a pen, performing last rites for the dying. And some were pushed over the edge.

I am writing you with regard to a problem as to which I am peculiarly helpless. A very dear friend of mine, a man of high ideals and moral convictions, is a captain in the Medical Corps. Displaced persons constitute the bulk of the patients he must care for, and he is disturbed beyond words that the discipline of his unit with regard to these unfortunate victims of Nazi brutality is deplorable. His letter to me constitutes an indictment of his superiors and, alas, even of the chaplain of the unit. Several other medical officers feel as he does but cannot do much about it. A few quotations from his letter will illustrate what I mean:

"Our chaplain—not drunk—went through the hospital raising sheets from the female patients to see what they're made of. On another occasion, while drunk, he proceeded to the DP Camp and attempted to enter the rooms of several girls."

"Our MAC officer on two occasions has got drunk and attempted to rape DP nurses working in the hospital. On a third occasion he did have intercourse with a German girl."

"The major has got drunk on several occasions and has made a practice of running into the street firing a pistol into the air."

"Certainly if the chaplain requires disciplining, it must be done. But apparently, he is a symptom of all that is transpiring and is not resisting the current—as he should."

Even the keeper of souls wanted to lift the sheet to see what women were made of.

Call her the unknown pin-up. On a wall of every barracks in the Army an attractive brunette gazed into the distance, the kind of shot you see in yearbooks,

the kind of heartthrob you carried in your wallet. The poster carried the warning SHE MAY LOOK CLEAN—BUT.

The VD poster girl had legions of accomplices. Hollywood churned out dozens of VD training films that followed a simple plot. A soldier follows a girl to her room for a few minutes of fun. (One film showed a guy leaving his burning cigarette on the staircase railing outside the love nest. He entered, did the dirty deed, and came back to finish the same cigarette.) The film then would cut to the consequences. Needles. Lesions.

Uncle Sam wanted to put men wise: "Prostitutes and pickups are not safe. And cannot be made safe." Any girl willing to have sex with a soldier was dangerous. Commander (and former boxing champ) Gene Tunney encouraged soldiers to wear "the Bright Shield of Continence." Writing in *Reader's Digest,* Tunney warned that out of every thousand prostitutes, 500 had gonorrhea and 360 had syphilis. Surely the champions of democracy knew enough to avoid "the cheapest and most diseased harlots." Every six months soldiers sat through the medical films that showed the horrific images—sores the size of bomb craters, eyes eaten away by the late stages of syphilis.

Sergeant George Baker, an artist who had worked for Walt Disney before the war, created a classic cartoon character known as Sad Sack. Potato peeler, goldbrick, the lowest of the enlisted men, Sad Sack appeared in *Yank* every week. A comic strip called *Sex Hygiene* shows the excruciating reactions of the dismayed dogface as he watches a VD film. When introduced to a buddy's girlfriend, faced with the need to shake her hand, the terrified Sad Sack first puts on a rubber glove.

The war marked a turning point in the nation's approach to VD. Although some experts said fear was the best weapon, others were not sure. One medical officer declared, "The sex act cannot be made unpopular." Another official concluded, "We cannot stifle the instincts of man, we cannot legislate his appetite. We can only educate him to caution, watchfulness and the perpetual hazards of promiscuous intercourse and furnish him with adequate preventive measures."

Incredibly, prior to 1940 the American Social Hygiene Association had never mentioned condoms as a means of preventing disease. Thomas Parran, the Surgeon General who had fought for a National Venereal Disease Control Act and who had pioneered elaborate screening and treatment programs, avoided any reference to condoms as too controversial.

The military studied the problem. During World War I, venereal disease took a toll, costing the armed forces seven million days in manpower—soldiers taken from active duty by the need for long, arduous treatment. At the outset of World War II, 60,000 men out of the first million drafted had VD: 6 out of 100, 1 in every 16.

Manpower was everything. You owed it to your buddies to stay healthy. Measles cost 5,000 days a year, mumps 10,000, venereal disease 35,500. Public-health officials viewed soldiers as "human machinery." These accountants took pride in the fact that a VD campaign in Britain preserved the health of an esti-mated 15,000 men, in effect freeing a frontline infantry division of men to die on the beaches of Normandy.

The VD posters subtly suggested that women were sexual creatures with appetites similar to those of men. Historian Costello reports that at a secret 1942 conference, top brass considered the problem of venereal-disease pre-vention among enlisted women. A scholar from Johns Hopkins University presented the results of a startling survey: Only a quarter of unmarried men abstained from intercourse, 25 percent regularly engaged in sexual inter-course, and the other 50 percent did so sporadically. Among unmarried women 40 percent had abstained from intercourse, 5 percent were promiscuous, and 55 percent reported having sexual experience from time to time. The decision to issue prophylactics to WAACs was leaked to the press in 1943 and promptly withdrawn. When it came to sex, women were on their own.

During the war, some 50 million condoms a month were being distrib-uted to servicemen overseas, eight per man per month. In a classic snafu, after V-E Day, when the bullets stopped in Europe and lust blossomed, the ration dropped to four a month.

During World War I, the War Department had closed every brothel within five miles of a military base. At the onset of World War II, epidemiologists warned America about "well-dressed women in smart automobiles patrolling the roads around Army camps giving soldiers a lift—to houses of ill fame, to brothels on wheels, to a deadly trailer camp near Fort Knox populated by eld-erly parents, each with a surprisingly large family of dubious and dangerous daughters, to one powerful syndicate organizing a great band of Panzer pros-titutes operating in mechanized units among the roadhouses and juke joints from Chicago to the Dakotas."

Although Congressman Andrew May launched an antiprostitution drive early in the war, the Pentagon had a more realistic approach. It created pro stations/pit stops where servicemen could line up for chemical disinfectant treatments. Oahu, where brothels were tolerated, averaged some 50,000 pro treatments a month in 1942.

After the war, comedian Mort Sahl would joke that GIs had different reactions to the government's protection plan. "The men reacted in three different ways to the Army's protection. First of all, there were the conformists. No imagination. The worst, you know. The Good Soldier. They simply did as they were told—got sick, followed the arrows in. First aid. Thanks. And that was that. The second group was a little sharper. They weren't actually sick, but they reported in anyway, you know, in an attempt to build reputation. The last were the real sophisticates. They were the perceptive people. What they did was to follow the arrows in reverse direction and find the action."

Overseas, the VD records provided a map of license. A survey revealed that eight out of ten men stationed overseas for longer than two years had sex. Half of married men had liaisons. In one of the great public-relations moves of the war, the military kept this report classified for nearly forty years.

Naples had some 50,000 women working as prostitutes; they infected one out of every ten allied soldiers. The conquering hero had a target painted on his private parts. Two thirds of the troops who contracted a sexual infection attributed it to their stays in Paris.

In Italy, an infected soldier was hauled off to the stockade, a treatment facility known as Casanova Camp. The letters "VD" were painted in red on his uniform and he was fined $65 if the infection came from a German. In 1944 Congress repealed a law that docked pay for soldiers with VD, but many men simply didn't report infections in the waning years of the war.

Even more interesting was the campaign against VD on the home front. The blend of patriotism and promiscuity created a new problem, this time with the girl next door. Albert Deutsch alerted readers of *The Nation* to the failure of the campaign (according to figures, infection rates of U.S. troops had increased from 26 per 1,000 in 1943 to 43 per 1,000 by 1945; for overseas troops, the figure was 150 per 1,000). But the real news was that among some Ameri-

can teenagers the infection rate had risen by 200 percent. Prostitutes were no longer the major threat.

"Fully 90 percent of the Army's cases in this country are traceable to amateur girls," wrote Deutsch, "teenagers and older women—popularly known as khaki wackies, victory girls and good-time Charlottes." She may look clean, but . . .

As the war escalated, Howard Florey and Ernst Chain, researchers at Oxford University, foresaw the need for new agents to treat battlefield infections. The pair recalled a 1929 paper by Alexander Fleming on his discovery of penicillin, a mold that seemed to kill bacteria. They contacted Fleming and started working with a descendant of the original spore. Florey and Chain soon found a more efficient way to grow and store penicillin. Biochemist Norman Heatley found a way to freeze-dry and concentrate the substance. They confirmed that the concentrate wasn't toxic to rabbits and humans. On February 12, 1941, they began injecting penicillin into an Oxford policeman who had suffered a massive infection following a scratch from a rosebush. Penicillin was so rare that they had to recover the substance from the policeman's urine. His condition improved until the penicillin ran out. Deprived of the drug, he died.

Florey tried penicillin on five more patients, with miraculous results. Supplies went to doctors in Africa, where patients were exposed to every bacteria the tropics could throw at them. Florey brought samples to the United States. Doctors treated survivors of a fire at Coconut Grove in Boston in late 1942 and five patients who had been wounded on Guadalcanal. In America, a research team found that penicillin grew well in vats of corn steep liquor; a young assistant found a sample of penicillin mold on a cantaloupe she'd bought in Peoria, Illinois. Without hesitation, the U.S. Surgeon General ordered 150 million units a week for clinical investigations in Army hospitals.

Between July 1943 and July 1944, penicillin production rose from fewer than a billion units a month to nearly 1.3 trillion units. The government tried to keep news of the discovery under wraps; above all, this was a weapon of war. Triage dictated that penicillin go to soldiers overseas. The amount left over for civilian use was to be strictly rationed. A penicillin "czar" would handle citizen requests case by case. *Newsweek* wailed, "Public Vies With Army for

Penicillin, Miracle Drug That Comes From Mold." America faced a moral choice: "When there is only enough of the newest miracle drug to save either a child or wounded soldier, which one would you save?"

In October 1943 Dr. John Mahoney told the American Public Health Association that he had injected four patients suffering from syphilis with 25,000 units of penicillin every four hours for eight days. After sixteen hours the dreaded spirochetes could not be found.

Subsequently, Captain Monroe Romansky and T/4 George Rittman, two researchers at Walter Reed General Hospital, announced that penicillin had cured 64 out of 65 gonorrhea patients with a single injection. The magic bullet, the cure for diseases that had haunted mankind for centuries, had been found.

Former Congressman William Fitzgerald was outraged at the use of a miracle drug on an immoral disease. Citing the loss of an upstanding constituent, who had not had access to the drug, he noted, "I think it is a crime that the Health Department in Washington refused to release any of this drug for his benefit, and then I read in the paper that men who have been careless in their lives and have contracted a dreadful disease can obtain this medicine."

Publications in the United States concocted articles on how to grow your own miracle cure at home. Fleming was alarmed at the proliferation of quack products such as penicillin ointments, penicillin lotions for the eyes, and penicillin beauty preparations. "I wonder what they're going to invent next?" he told a friend. "I shouldn't wonder if somebody produces a penicillin lipstick."

"That's more than possible," answered the friend. "Kiss whom you like, where you like, how you like. You need fear no tiresome consequences (except marriage) if you use our Penicillin Rouge."

Not everyone celebrated the discovery of penicillin. Indeed, the moralists who had dealt with the VD question came face-to-face with a new moral dilemma. If we are to teach sexual abstinence, argued William Snow, head of the American Social Hygiene Association, it can no longer be simply as the best method for avoiding venereal disease.

"Won't penicillin open up the floodgates of vice?" asked a physician in William Styron's play *In the Clap Shack*. "For if a libertine knows he can indulge himself with impunity, he will throw all caution to the wind. What universal debauchery this might portend for our nation."

The news that there was a cure for the clap reached the front in a small single-paragraph item in the November 10, 1944, issue of *Yank*. Soldiers reacted pretty much the way you would expect. The VD rate skyrocketed, and soldiers complained about disciplinary actions taken for health problems contracted "not in the line of duty." Live for the moment and let the cure catch up with us was the new motto.

Specially equipped armored trucks—with medics and hypos—followed troops from Italy and France into Germany, administering little golden ampules of penicillin to the bared arms and buttocks of soldiers, keeping men fit to fight in the final hours of the war. In the decade after the war VD rates would plummet, almost to the point of extinction.

One disturbing footnote suggests the government had different standards over who should or should not receive penicillin. A U.S. Health Department study in Macon County, Alabama, which would become known as the Tuskegee experiment, tracked six hundred black patients for more than a decade. Doctors wanted to determine the path of untreated syphilis to see, among other things, if the consequences were worth treatment with the sometimes deadly combination of arsenical and heavy metals then in use. Two thirds of the patients had syphilis. If they were told anything, it was simply that they had "bad blood." Penicillin rendered the experiment meaningless, but doctors did not inform the patients that a cure existed.

In every sense, the government response to the disease and its cure was baffling. After the war, public-health money would be turned over to others to fight more lethal (or socially acceptable) diseases. It has been argued that an opportunity was lost to eradicate a sexual plague. Funds for clinics and contact tracing would decline. Sexual infection (and education) would return to the private sphere.

Even so, a fear that had shaped sexuality for centuries had been defeated. We could kiss anyone, anywhere, even in Times Square on V-J Day, without fear.

William Laurence, a journalist for the *New York Times,* watched the end of the war through arc-welder's glasses. "A giant ball of fire rose as though from the bowels of the earth," he reported. "Then a pillar of purple fire, 10,000 feet high,

shooting skyward. At one stage it assumed the form of a giant square totem pole, with its base about three miles long. Its bottom was brown, its center was amber, its top white. Then, just when it appeared as though the thing had settled down, there came shooting out of the top a giant mushroom that increased the height of the pillar to a total of 45,000 feet. The mushroom top was even more alive than the pillar, sizzling upward, a thousand Old Faithful geysers rolled into one." Nagasaki had ceased to exist.

The world had entered the Atomic Age. Even after peace came, the military continued to test the new weapon of destruction. Scientists taped a pin-up of Rita Hayworth to Gilda, a bomb named after her 1946 movie, and dropped it at Bikini Atoll. When Hayworth heard the news, she expressed outrage. "My two brothers fought in the war," she said. "They were never the same when they came home."

The French had a different reaction. They named a skimpy bathing suit after the famous site.

Bill Mauldin, an eighteen-year-old cartoonist who served mostly in Italy, created two world-weary dogfaces named Willie and Joe. Mauldin, better than most historians, captured the foot soldier's view of World War II. His cartoon ran in *Stars and Stripes* and in local newspapers around the world. He would describe two guys sitting in a foxhole, feeling homesick.

"You wanna go home?" asks one. "Hell, you found a home in the Army. You got your first pair of shoes and your first square meal in the Army. You're living a clean, healthy, outdoor life, and you want to go back and get henpecked?"

Almost eight million men and women were overseas. The prospect of their return—these heroic warriors who had made the world safe for democracy—was much discussed. Magazines ran articles on "What You Can Do to Help the Returning Veteran." *Good Housekeeping* offered this advice: "After two or three weeks he should be finished with talking, with oppressive remembering. If he still goes over the same stories, reveals the same emotions, you had best consult a psychiatrist. This condition is neurotic."

Emily Post told how to treat the seriously wounded. "We will do well to follow the first rules of good manners," she instructed. "Which are: Don't stare, don't point, don't make personal remarks."

The country did not know what to expect. One psychiatrist, offered an opportunity to interview the crew of the *Memphis Belle* on the crew's return tour, wrote of her great relief when she could not find "any signs of ruthlessness."

In 1946 there were 35,000 discharges a day. The men returned and tried to revive marriages scarred by years of separation. A soldier who had carried a condom in his wallet—unused for the entire war, a shield of continence that left a familiar ring embossed in leather—came home to find that his fiancée had not waited. Soldiers who had been spared Dear John letters walked into situations that could not remain hidden. Even Mauldin, whose reunion with his wife and child was the subject of an article in *Life,* saw his marriage fall apart after his return.

Marriages consisting of a weekend pass and a thousand letters could not hold. The divorce rate in America doubled between 1940 and 1946. By the end of the decade a million veterans had added divorce to their battle ribbons.

William Wyler, a daring filmmaker who had flown with the *Memphis Belle* and produced one of the war's best documentaries, captured the difficulties of returning servicemen in the Academy Award–winning *The Best Years of Our Lives* (1946). In the film, one bombardier returns to a faithless wife and a meaningless job. A sergeant who discovers his family grown up and independent finds his old job at the bank stifling and takes to drink. A sailor who suffered the loss of both hands cannot find the touch that will heal his relationship with his childhood sweetheart. In Hollywood, as in real life, the war was, for the most part, segregated. These returning servicemen were all members of the white middle class.

For the duration, America had believed in the propaganda. "Throughout the war," writes John Jeffries in *Wartime America,* "advertisers painted reassuring and sentimental pictures of home-front America as a place of sacrifice, hard work and common cause, where traditional values and patterns of life would sustain the fighting men, themselves products and protectors of a timeless Norman Rockwell America." What the American soldiers carried around in their minds was the image "of small-town America, of the corner drugstore, of old-fashioned virtues and folkways—and of Mom's pies." White houses, white fences, white steeples.

The fantasy could not hide the flaws. The foreign war had preserved freedom abroad but the situation at home was far from serene. The battles for individual freedom—both sexual and racial—escalated dramatically.

The GI Bill sent a million veterans to college, reversing the ratio of males to females on campus. But Beth Bailey points out that the returning veteran was different from Joe College of the 1930s. "Angry exchanges in student newspapers often boiled down to one issue. Veterans claimed they simply wanted women, not girls. Coeds angrily insisted that they knew what that meant—and publicly said no. But the misunderstandings went deeper than standards of sexual behavior. College men were saying that the American college girl was spoiled, self-centered, that she knew nothing of the realities of life."

Bailey notes that one war correspondent said "he'd heard more complaints from American women over the lack of nylons than he had heard from European women over the destruction of their homes and the deaths of their men." The men were serious. They wanted to return home, buy a piece of land, build a house, and put a woman in that house. They had dreamed of a future, fought for that future, and wanted to get on with that future.

Fortune declared that the average GI didn't "want a new America. He wants the old one—only more of it."

"Those boys have been through a hell of a lot," an Air Force officer told *Mademoiselle.* "And they're going to want to come back to somebody more like the old style. I don't care about the bright lights now. I want a pretty, solid, all-round girl . . . and a sincere one. A boy wants to know where he stands . . . not all this beating around the bush. I'm not looking for the most popular girl on the dance floor now."

In 1946 the marriage rate hit 16.4 per 1,000, 25 percent higher than in 1942. No long courtships or competitive dating. No gradual getting to know each other. It was a matter of taking the final hill.

Women who entered the workplace were expected to return to the private sphere of the family, into a world of supermarkets and tract houses. The GI Bill, with its low-interest mortgages, sparked a building boom, and a new American dream. Betty Friedan described the transition in *It Changed My Life:* "During the war, we'd had jobs like researcher or editorial assistant and met

GIs at the Newspaper Guild Canteen, and written V-Mail letters to lonesome boys we'd known at home, and had affairs with married men—hiding our diaphragms under the girdles in the dresser. And then the boys our age had come back from the war. I was bumped from my job on a small labor news service by a returning veteran."

Women turned to Freud and psychoanalysis. In 1941 Moss Hart created a lonely woman editor in the Broadway hit *Lady in the Dark,* which interpreted women's dissatisfaction as simply the need for a man. In 1947 Ferdinand Lundberg and Marynia Farnhan, two Freudians, authored a bestselling book, *Modern Woman: The Lost Sex,* which counseled females to seek fulfillment as housewives, mothers, and lovers. "Where the woman is unable to admit and accept dependence upon her husband as the source of gratification and must carry her rivalry even into the act of love," they wrote, "she will seriously damage his sexual capacity. To be unable to gratify in the sexual act is for a man an intensely humiliating experience; here it is that mastery and domination, the central capacity of the man's sexual nature, must meet acceptance or fail."

Scholars would ponder the paradox of derailed feminism in the postwar years. Women who had held jobs and wielded power in the public sphere retreated to old roles. They gave up hard-earned freedom, for what? "It was fun at first, shopping in those new supermarkets," wrote Friedan. "And we bought barbecue grills and made dips out of sour cream and dried onion soup to serve with potato chips, while our husbands made the martinis as dry as in the city and cooked hamburgers on the charcoal, and we sat in canvas chairs on our terrace and thought how beautiful our children looked, playing in the twilight, and how lucky we all were, and that it would last forever."

The war changed the battle between the sexes. During the Depression we saw gold diggers and ditsy socialites career across the movie screen in musicals and screwball comedies. The most memorable film of the war years, *Casablanca* (1942), touched a different emotional chord. The film offered romantic obsession, male camaraderie, and an appropriately patriotic ending. Rick, abandoned by Ilsa in Paris, overcomes his bitterness, saying the "problems of three little people don't amount to a hill of beans." Rick accepts Ilsa's infidelity as

something wrought by the havoc of war. What would have happened if Rick and Ilsa had met again, after the war was won?

Humphrey Bogart's cynical tough guy became the new male role model, one to match the new female who appeared in the forties. Hollywood had discovered the works of Dashiell Hammett, James M. Cain, and Raymond Chandler—hard-boiled mystery writers whose women were frequently femmes fatales, seductive beauties who used sex as a tool, who turned desire into betrayal.

The directors of the era created a genre that became known as film noir. The trend began in 1941 with Bogie starring in Hammett's *The Maltese Falcon,* followed by *Laura, Double Indemnity, The Woman in the Window,* and *Murder, My Sweet,* among many others. In 1946 and 1947 Hollywood released a series of increasingly darker films: *Gilda, The Big Sleep, The Postman Always Rings Twice, The Blue Dahlia, Dead Reckoning,* and *Out of the Past.* The films fed off the suspicion and sexual paranoia manifesting in these postwar years. Marriage no longer placed female sexuality on a pedestal. Sam Spade was having an affair with his partner's wife, and she not only thought he had killed her husband, she found the thought romantic.

Wives were deemed uncontrollable. In *Gilda,* Rita Hayworth would declare, "If I'd been a ranch, they would have named me the Bar Nothing."

In these films, the husband was often a cuckold or worse. One of Gilda's lovers dismisses the threat of an irate spouse: "For a long, long time I've taken husbands little by little, in small doses, so that now I've developed a complete immunity to them."

Frank Krutnik, author of *In a Lonely Street,* traces the new treatment of women back to the pin-ups of the war. We had put women on a pedestal and surrounded that pedestal with barbed wire—juggling our fantasies with stories of infidelity, confusing longing with the threat of infection in VD films. The dream girl had become a nightmare.

The women in film noir had killer looks. They knew the effect of a low-cut dress, a veiled glance from behind a shower of hair. The moviemakers couldn't show sex—the Production Code wouldn't allow that—but they filled the screen with sexual tension and innuendo. Lauren Bacall was "sizzling, slinky, husky, sultry," and could bring Bogart down with the challenge, "I'm hard to get—all you have to do is ask me." The perfect match for Bogie, Bacall could even instruct him in sexual matters, saying after one kiss, "It's even better when you help."

Krutnik points out the dilemma posed by the femme fatale: "The noir hero frequently agonizes about whether or not the woman can be trusted, whether she means it when she professes love for him, or whether she is seeking to dupe him in order to achieve her own ends."

In *The Blue Dahlia,* Alan Ladd returns from the war to find that his wife has been unfaithful. She tells him, "I go where I want to with anybody I want. I just happen to be that kind of a girl." He walks away—right into the arms of Veronica Lake. She is as familiar as the pin-up he'd worshiped in the war. "Every guy's seen you before, somewhere," he tells her. "The trick is to find you."

Film noir pushed the boundaries of Production Code propriety. Howard Hughes ignored them completely. The maverick millionaire playboy made his own rules, whether constructing *The Spruce Goose*, a two-hundred-ton airplane made of plywood, or working on a more interesting fuselage. Beginning in 1941, he fought a one-man, two-weapon war against the man known as the Hollywood Hitler.

Joe Breen had been the chief enforcer of the Production Code since the early thirties. In March 1941 Breen sat through a screening of Hughes's new film, *The Outlaw*. He then fired off a letter. "In my more than ten years of critical examination of motion pictures," he began in alarm, "I have never seen anything quite so unacceptable as the shots of the breasts of the character of Rio. This is the young girl whom Mr. Hughes recently picked up and who has never before, according to my information, appeared on the motion picture screen. Throughout almost half the picture the girl's breasts, which are quite large and prominent, are shockingly emphasized and in almost every instance, are very substantially uncovered."

Breen, shell-shocked after years of defending the country's virtue, was losing his grip. He had issued injunctions against sweater shots "in which the breasts are clearly outlined," against strapless evening gowns and flimsy negligees. Now, overwhelmed by Jane Russell's cleavage in the movie, he ordered the filmmaker to cut "37 breast shots." Hughes refused. He was well aware of his star's attributes. He had designed a device that would add a certain upthrust to Russell's anatomy, though it really wasn't necessary.

Hughes initiated his own campaign against the censors. PR agents released still photos of Russell from a film that no one had yet seen. And without

a seal of approval from the Production Code Administration, Hughes booked the film into a San Francisco theater in 1943. "How would you like to tussle with Russell?" asked a billboard that showed the star reclining in a haystack. Another ad proclaimed, *"The Outlaw* conclusively proves that sex has not yet been rationed." Russell became one of the most popular pin-ups of the war.

The booking was a sellout, but the mysterious millionaire decided to table the film for another three years. Was he waiting for a changing of the guard? Perhaps. In the interim, Will Hays—the general who had orchestrated the Production Code—retired.

In 1946 Hughes released the film nationally without a seal, with a publicity campaign that emphasized the attempted censorship and Jane Russell's monumental endowment. A skywriter filled the sky with smoke trails giving the film's name followed by two circles topped by two dots. Everyone knew what the circles represented.

A Baltimore judge, upholding a local ban on the film, declared that Russell's breasts "hung over the picture like a thunderstorm spread over a landscape."

Hughes showed that a film could ignore the code and make a profit.

Following the war the country was flooded with foreign films, ungoverned by Hollywood morality and promising a new realism. "When these people talk about realism," Joe Breen said, "they usually talk about filth."

Throughout the 1930s, the industry had protected its own. Fearing a repeat of scandals similar to the Fatty Arbuckle trials, gossip columnists painted rosy pictures of stars and starlets. But the gentleman's agreement that had protected Hollywood for a decade began to unravel, replaced by a tragic hunt for scapegoats. Those who refused to conform to sexual and political norms became targets.

In 1942 Los Angeles police picked up a young vagrant named Betty Hansen. Among her possessions was a slip of paper with Errol Flynn's telephone number. The swashbuckling star of *Captain Blood* and *The Adventures of Robin Hood,* Flynn was also famous as a master swordsman in the bedroom. Hansen, who happened to be under eighteen, said she had met Flynn at a pool party and that the evening had ended with sex. The star, she said, kept his socks on.

Perhaps sensing a weak case, the D.A. rummaged around Hollywood for another "victim." They brought in Peggy Satterlee, a well-endowed young woman making her living as a dancer. She was supposedly sixteen. Flynn admitted entertaining Satterlee on his yacht. "Who asks for a birth certificate at a time like that?" he wondered. "Especially when she is built like Venus?"

The headlines announced ROBIN HOOD CHARGED WITH RAPE. Flynn hired Jerry Giesler, the Hollywood lawyer who specialized in celebrity cases that smacked of scandal. Under cross-examination, the girls seemed confused. The jury acquitted Flynn on all counts. A newsboy hawking his paper said simply, "Wolf freed!" The phrase "In like Flynn" became a popular euphemism for sexual conquest.

Everyone loved Charlie Chaplin's Little Tramp, but the actor's offscreen life generated considerable controversy. In the twenties, his predilection for young women had filled the tabloids. Now his political views made him a target. An avowed antifascist, he had parodied Hitler in the 1940 film *The Great Dictator.*

In 1943 Hedda Hopper announced to the world that aspiring actress Joan Barry was bearing the illegitimate child of Charlie Chaplin and she denounced him in her column. Chaplin didn't deny knowing Barry. He had met her in 1941 and—perhaps under the sway of the breastmania that blossomed with the war—he would describe her as a "big, handsome woman of 22, well built, with upper regional domes immensely expansive." On June 3, 1943, Joan Barry filed a paternity suit. That this was more than a sexual scandal was soon apparent. Barry was aided in her pursuit of justice by no less than J. Edgar Hoover and William Randolph Hearst.

Chaplin denied paternity but offered to support Barry until the child was born and a blood test could be performed. Eventually, three doctors would testify that the test proved conclusively that Chaplin was not the father of the child. A first trial ended in a hung jury. A second jury would eventually decide, despite the evidence, that Chaplin would have to pay child support.

When Barry first surfaced, the case came to the attention of J. Edgar Hoover. Barry had told investigators that she had joined Chaplin in New York when he traveled there to make a speech urging that America enter the war in Europe to help Russia fight the Nazis. The FBI arrested Chaplin for a violation of the Mann Act. Hoover put Chaplin, newly married to Oona O'Neill, under

surveillance and allegedly bugged his hotel rooms. Agents quizzed servants, asking about "wild parties and naked women."

On the witness stand, Chaplin admitted that he had paid Barry's train fare but said he did not travel with her. He did not pay her hotel bills; indeed, he had seen her only once in his twenty-three-day stay. He said the visit lasted thirty minutes; under coaching from the FBI Barry said it had lasted three hours—in bed.

The government's agenda was evident in the questioning. The prosecutor asked: "Are you sure you didn't go into the bedroom with her and undress?"

"I did not," Chaplin replied.

"Didn't you have a bedroom conversation regarding the second front?"

"No, I did not."

After acquitting Chaplin on the criminal charges, one of the jurors told him, "It's all right, Charlie. It's still a free country."

The juror was mistaken. When Chaplin produced the pacifist film *Monsieur Verdoux* in 1947, Hedda Hopper launched a vicious smear campaign. With Hoover's blessing, the American Legion staged a boycott of all Chaplin's films. Accused of being a Communist sympathizer, Chaplin declared, "I am what you call a peacemonger."

When Chaplin and Oona traveled to London for the premiere of *Limelight* in 1952, he learned that the U.S. Attorney General had instructed immigration authorities to deny the English-born Chaplin a reentry visa unless he submitted to an inquiry on his politics and moral worth. Thenceforth, Charlie Chaplin would be a citizen of the world.

A similar fate befell actress Ingrid Bergman. Her public persona was beyond reproach. On the screen the beloved actress had played a nun in 1945's *The Bells of St. Mary's* and Saint Joan in 1948's *Joan of Arc.* But postwar America was turning ugly. A witch-hunt had begun and it was only a matter of time before someone was burned at the stake.

In 1949 Bergman left a husband and daughter to move in with Italian director Roberto Rossellini. He was the innovative creator of such films as *Open City, Paisan,* and *Ways of Love,* the very type of neorealism that Joe Breen had dismissed as filth. America felt betrayed. Saint Ingrid would conform to her public image, and our expectations, or pay the price.

Breen actually wrote her a letter begging her to reconsider her relationship with Rossellini, warning of the possible impact on her career. She thanked him for his concern, but chose to remain with the Italian, bearing him a son and twin daughters. America turned its back on the actress. Hollywood blacklisted her; she would not make another Hollywood film until 1956. *Time* announced that she was "Off the Pedestal": "They saw me in *Joan of Arc* and thought I was a saint," Bergman would say. "I'm not. I'm just a human being."

The Bergman scandal became a political cause célèbre. Senator Edwin Johnson of Colorado vowed to confront "the mad dogs of the industry." He proposed legislation that would require entertainers to be licensed. If an actor, director, or producer violated the law or moral standards of the country, he or she would not be allowed to work. The government could bar any film that encouraged "contempt for public or private morality" or starred "persons of ill repute." Raving on, he called Rossellini a "narcotics addict, Nazi collaborator and black-market operator," a love thief who had turned Bergman into "a powerful force for evil," one of the current "apostles of degradation."

Bergman was ostracized because she broke with convention. But her plight also symbolized the war between Washington and Hollywood. In the aftermath of World War II, Hollywood directors had begun to make films about social issues. *Gentleman's Agreement* (1947) looked at anti-Semitism; *Home of the Brave* (1949) addressed racial bigotry.

The House Un-American Activities Committee (HUAC) had a different view of what it took to be a true American. In 1947 HUAC began questioning the patriotism of its fellow Americans, including those from Hollywood. A number of stars testified and were encouraged to name names, identifying those in the industry they suspected of being Communist sympathizers. Several highly regarded artists (known as the Hollywood Ten) refused to cooperate and were cited for contempt of Congress. Humphrey Bogart, Lauren Bacall, and others flew to Washington, D.C., to protest the hearings. But intimidation took its toll. The Hollywood Ten—along with three hundred other writers, directors, and actors—were blacklisted by an industry that should have supported them.

HUAC turned its attention to radio and television, to advertising agencies, to college campuses, and even to members of the clergy. Neighbors in-

formed on neighbors. Reputations were ruined, lives destroyed. America, infected by paranoia, became what it had just fought a war to defeat.

During the war J. Edgar Hoover had recruited an estimated 60,000 volunteers, mostly from the American Legion. These self-appointed patriots were to glean information about subversive activities. Not surprisingly, sex that did not fit Hoover's idea of morality was one such activity. Into the files went information that so-and-so liked to walk around his house in the nude, that Senator X liked boys, that W. C. Fields had paintings of Eleanor Roosevelt that, when viewed upside down, revealed her sexual organs.

Sexual intelligence was a weapon of war. The FBI had bugged brothels in the capital, trying to gain leverage on foreign diplomats. Washington also sought information on American citizens, including Eleanor Roosevelt. When Army Counter-Intelligence tried to monitor the activities of Joseph Lash—a friend of the First Lady's—it bugged hotel rooms where the entourage was staying. Microphones captured the sound of Lash and Trude Pratt (a leader in the American Student Union) making love. The surveillance report announced, "Subject and Mrs. Pratt appeared to be greatly endeared to each other and engaged in sexual intercourse a number of times." By the time the information got to Hoover, it was Mrs. Roosevelt, not Mrs. Pratt, who was reported to have been the lady in Lash's arms.

More than anyone else in Washington, Hoover knew the power of sexual blackmail, and he used his network of informants in self-defense. In the previous decade he had dealt with journalists who had derided his "mincing step." Attacks on Hoover's sexuality were attacks on the Bureau. In *The Boss,* Athan Theoharis and John Stuart Cox recount how a woman attending a bridge party held by the aunt of an FBI agent had confided that "the director was a homosexual and kept a large group of boys around him." Almost before the dishes had dried a local FBI agent had called her into his office and "severely chastised her."

When a beauty parlor operator gossiping with one of her beauticians breezily stated that "the Director was a sissy, liked men and was a queer," she found herself facing two agents who told her she would "be given the opportunity to testify as to exactly what she did or did not say."

English novelist George Orwell wrote a book about an authoritarian society in which sex was a subversive activity. Citizens in *1984* lived with the warning: Big Brother Is Watching You. Members of the Ministry of Love turned in those suspected of engaging in sexual activity. Orwell was writing about postwar England, but America already had its own version of Big Brother.

Edmund Wilson, the prolific diarist and now literary critic for *The New Yorker,* had waited long enough. Having labored in private creating his own palette to describe passion, in 1946 Wilson thought he could make these topics public. He turned the material from his journals into a series of interlocking stories titled *Memoirs of Hecate County.*

The book sold 50,000 copies within five months. It was too much for the Old Guard, who, having established repressive victories over movies, magazines, and radio, still had to pursue books on a case-by-case basis. John Sumner, of the New York Society for the Suppression of Vice, had for thirty years been the voice of American censorship. Near the end of his career, he launched one more attack. He raided four bookstores in Manhattan, confiscating 130 copies of Wilson's book.

William Randolph Hearst ordered his newspapers to crusade against indecent literature. PUNISH WRITERS OF FILTH, urged his headlines. PRURIENT FICTION LINKED TO CRIME.

Sumner found a willing champion in New York District Attorney Frank Hogan. Hogan, too, seems to have been sensitive to wartime adultery. He charged that Wilson's book celebrated "the immense delight of sexual intercourse with the wife of another man." He filed a brief that underlined every sexual scene in the book, itemizing twenty separate acts of sexual intercourse, four unsuccessful attempts at sexual intercourse, various daytime reveries about sexual intercourse, and ten or more filthy conversations about sex. "Finally," he harrumphed, "the story is not without its disgusting embellishments."

A three-judge panel declared the book obscene. A divided Supreme Court upheld the decision in 1947. Not until 1959 would a publisher try to put *Hecate* back into print.

Book censorship proceeded along several fronts. At the beginning of the decade, Postmaster Walker had declared as unmailable both Ernest Hemingway's *For Whom the Bell Tolls* and John O'Hara's *Appointment in Samarra.* Blue-

noses in Detroit, Newark, and Milwaukee banned Irving Shulman's *The Amboy Dukes,* while the Boston contingent went after Lillian Smith's *Strange Fruit,* charging that it promoted "lascivious thoughts" and might "arouse lustful desire." The Massachusetts Attorney General sought an injunction against Kathleen Winsor's *Forever Amber,* citing some seventy references to sexual intercourse, thirty-nine illegitimate pregnancies, and assorted descriptions of women undressing in the presence of men. The judge said the book put him to sleep; the controversy put *Forever Amber* on the top of best-seller lists for two years.

The prosecutions intimidated both publishers and writers. In 1948, when Norman Mailer tried to describe the reality of World War II, including the language, in his first novel, *The Naked and the Dead,* he had to resort to using a three-letter euphemism: "fug."

When Mailer was introduced to Broadway actress Tallulah Bankhead, she reportedly said, "Oh yes, you're the dear boy who doesn't know how to spell fuck."

In 1948 a book would appear that would change the way Americans viewed sex. At the very least, we would learn a new sexual lexicon, which would replace euphemisms such as Norman Mailer's fug. The proper word was "coitus." And should we have occasion to refer, in polite conversation, to fellatio and cunnilingus, we could use the term "oral-genital contact." *Sexual Behavior in the Human Male*—most often referred to simply as the Kinsey Report—was an objective look at sex. The book caused a sensation.

In 1938 Indiana University had instituted a course in marriage. Looking for someone to coordinate it, school officials picked an unlikely candidate. Alfred Charles Kinsey was an entomologist with a passion for gall wasps. He had spent the past seventeen years collecting some four million of the little creatures; he believed in the empirical method—that before you commented on a certain structure in a wasp wing, for example, you would have to look at many wasp wings.

Kinsey recognized his own lack of knowledge regarding the new subject. There was no suitable text for a course in marriage (at the time the college dealt with sex in a single lecture in a required course on hygiene). Putting together a list of questions, he began to interview students. He asked about everything, from the frequency of orgasm to when and how it was achieved.

Kinsey encountered controversy from the outset. Thurman Rice, the same professor who gave the annual sex-hygiene lecture, attacked him for interviewing coeds behind closed doors, for showing slides considered too stimulating, and for not declaring that premarital sex was wrong. Besides, he said, the subject did not warrant a whole course; it would, he believed, put sex out of proportion to its importance. Local church leaders joined the protest.

In 1940 Kinsey gave up the course, but the university president suggested he continue his research. Over the next fifteen years, Kinsey and his team of researchers interviewed more than 17,000 people, both male and female.

His network of informants matched that of Mr. Hoover's. Kinsey contacted clergymen, psychiatrists, social workers, persons in the social register, prison inmates, and women's club leaders. He went out of his way to explore the world of homosexuals, traveling to Times Square and the gay underworld of Chicago. He conducted interviews in hotels, prompting one manager to throw him out with the comment that he did not intend that anyone should have his mind undressed in his hotel.

Some of Kinsey's conclusions:

- 85 percent of the white male population had premarital coitus and 50 percent had extramarital coitus.
- By the age of fifteen, 95 percent of males had experienced some form of sexual release. (Kinsey used the term "sexual outlet" and noted six kinds: masturbation, nocturnal emissions, petting, heterosexual intercourse, homosexual contact, and intercourse with animals.)
- 92 percent of men masturbated.
- 37 percent of men had reached orgasm at least once through homosexual contact.
- 69 percent of the white male population had some experience with prostitutes.

Kinsey was a scientist, not a preacher. He collected facts without judging behavior. "This is first of all a report on what people do," he wrote, "which raises no question of what they should do." To give you a sense of how dramatic and liberating this view was, consider the best-selling sex manual of the day.

Theodoor Van de Velde published *Ideal Marriage* in 1926. The book had sold millions of copies by the time Kinsey published his report. Van de Velde had his own sense of what was normal. "But let us first of all make unmistakably clear that by sexual intercourse, we refer exclusively to normal intercourse between opposite sexes," he declared. "If we cannot avoid occasional reference to certain abnormal sexual practices, we shall emphatically state that they are abnormal. Ideal marriage permits normal, physiological activities the fullest scope, in all desirable and delectable ways; these we shall envisage without any prudery, but with deepest reverence for true chastity. All that is morbid, all that is perverse, we banish: For this is holy ground."

What was perverse? Van de Velde taught the world that it was perfectly appropriate to perform the genital kiss as a means of precoital arousal, but that one must stop short of orgasm or, oh God, "the hell gate of the realm of sexual perversion" would open and devour the souls of all involved.

Kinsey simply noted, "Mouth-genital contacts of some sort, with the subject as either the active or the passive member in the relationship, occur at some time in the histories of nearly 60 percent of all males."

Furthermore, there were no distinctions between erogenous zones; there were no erroneous zones. "While the genitalia include the areas that are most often involved in sexual stimulation and response," Kinsey stated, "it is a mistake to think of the genitalia as the only sex organs, and a considerable error to consider a stimulation or response that involves any other area as biologically abnormal, unnatural, contrary to nature and perverse. Mouth, breast, anal or other stimulations involve the same nervous system (namely the whole nervous system)."

Kinsey's report on sexual behavior in the human male prompted considerable controversy. A professor at one scientific institute told *Reader's Digest* that after "publication of one recent survey on sex, the number of illegitimate pregnancies among our girl students has been multiplied four times over."

The head of the Salvation Army said such reports become "weapons for temptation" and warned that "the effect of unchastity on the nervous system is severe. You may start out rebelling against 'stuffy old moral and religious systems' and wind up in a psychiatric hospital."

Even J. Edgar Hoover had his say: "It is important to the very future of our national life that we hold fast to our faith. Man's sense of decency declares

what is normal and what is not. Whenever the American people, young or old, come to believe there is no such thing as right or wrong, normal or abnormal, those who would destroy our civilization will applaud a major victory over our way of life."

Kinsey's book—an 804-page compilation of charts, statistics, and interpretation intended for the scientific community—sold more than 200,000 copies in two months. *Time* reported that a grain merchant gave his mistress a copy with the inscription, "I hope this will help you to understand me better." In a greater bit of hyperbole, *Time* described a Miami Beach playboy who had sent a copy to each of fifty women he knew. Comedians worked Kinsey into gags. "Hotter than the Kinsey Report" became a national figure of speech. Kinsey was asked to endorse everything from religious works to bras to Simone de Beauvoir's *The Second Sex.* Mae West asked to meet him.

With a perverse appetite for records, America focused on extremes. Everyone, it seems, knew about the guy who averaged more than thirty ejaculations a week for more than thirty years, or the poor guy who had ejaculated only once in the same period of time. Americans stopped thinking in terms of normal or abnormal and began comparing themselves to averages on number of orgasms per week (around five for married males) and to minutiae such as the angle achieved by an erection (slightly above the horizontal for most, but 45 degrees above in 15 to 20 percent of cases). Three quarters of all white males reach orgasm after two minutes of sexual intercourse? Pull out the stopwatch, Betty.

Edward Brecher, in *The Sex Researchers,* notes that Kinsey had run into a prototype of Big Brother. While conducting research for the marriage course in 1938, Kinsey had interviewed a campus policeman, a man with an eighth-grade education, who thought Indiana students were perverts. "They would lie under trees in pairs and just pet and pet," writes Brecher. "Sexual intercourse the policeman could understand, but this interminable petting must be some form of perversion."

His research turned Kinsey into a sexual radical. In a culture where class and education dictated sexual attitudes and mores, who had the right to impose their standards on the rest of America? Who policed the sex police?

Kinsey approved of laws that protected person and property—such laws could be defended rationally. Injury was easy to define. But a wealth of other

laws policed the most personal of behavior. "If society's only interest in controlling sex behavior were to protect persons," Kinsey wrote, "then the criminal codes concerned with assault and battery should provide adequate protection. The fact that there is a body of sex laws which are apart from the laws protecting persons is evidence of their distinct function, namely that of protecting custom. Just because they have this function, sex customs and the sex laws seem more significant and are defended with more emotion than the laws that concern property or person."

Kinsey ended the era of "hush and pretend." Surely, laws should reflect the desires of the people and be based on real facts. Throughout his study, Kinsey challenged ridiculous laws such as the U.S. Naval Academy's practice of rejecting "any candidate who showed signs of masturbation."

Morris Ernst, the lawyer who had successfully defended *Ulysses* against a U.S. Customs ban and who had fought to make the dissemination of birth-control information legal, saw the meaning immediately. In 1949 he addressed a gathering of scientists: "Our laws have attempted to abolish all sexual outlets except marital intercourse, nocturnal emissions, and to some extent solitary masturbation. The first Kinsey Report says that 85 percent of all younger males are criminals, since they make use of other sexual outlets. Forty-four states have laws against adultery. There have been only a handful of prosecutions. Yet the Kinsey Report may well, in its final national overall figures, show that one third of all husbands should be in jail if fact and law were the same."

Ernst saw the injustice of capricious and spiteful sex laws. "For example, is there more fornication in Louisiana, where it is not a crime, than in Arkansas, where a first offense is appraised as worth twenty dollars? What about the amount of sodomy in Georgia, where the punishment is life, compared with New Hampshire, where it is not covered by a special statute? And if you have seduction in your heart, or wherever it resides, I suggest you pick Vermont or Utah rather than Georgia. It may spell a difference of twenty years of freedom to you."

At the University of Illinois, a former GI turned psychology student, deeply impressed by the Kinsey Report, wrote an editorial on the subject. Upon graduation, he continued his studies at Northwestern University. In a term paper

titled "Sex Behavior and the U.S. Law," he wrote, "Somewhere along the line, sex became separated from the rest of the moral freedoms."

He continued:

> Why does tolerance turn to intolerance, rationality to irrationality, when man contemplates the problem of sex? Why does Webster's Collegiate Dictionary define masturbation as "self-pollution," why do the lawmakers become so emotional in their legislation against sodomy, why are excellent literary works sometimes banned as obscene, why is it still against the law in some states to circulate information regarding birth control and venereal disease?
>
> It is impossible to undo the mistakes of centuries in a few years, but Krafft-Ebing and Freud have started the work, and Kinsey's statistics will undoubtedly help too. Let us see if we cannot begin to find our way out of this dark, emotional, taboo-ridden labyrinth, and into the fresh air and light of reason.

The student would have more to say on the subject in the decade ahead. His name was Hugh Hefner.

TIME CAPSULE

Raw Data From the 1940s

FIRST APPEARANCES

Nylon stockings. Wonder Woman. Varga Girl. Zoot suit. Radar. Selective Service. *Yank*. Sad Sack. Snafu. The Jeep. Bazooka. K rations. Napalm. The Voice. Bobby-soxers. Eighteen-year-olds vote. Chiquita Banana. Atomic bomb. GI Bill. United Nations. Baby boom. Fluoridation. Nikon 35mm. Porsche sports car. Zoom lens. Tupperware. Network television. Cannes Film Festival. Bikini. Slinky. Transistor. The Cold War. Electric guitar. Jet aircraft. CIA. HUAC. Velcro. Dior's New Look. Kinsey Report. Silly Putty. Scrabble. Howdy Doody. UFOs. 45 rpm and LP records.

WHO'S HOT

FDR. Winston Churchill. Dwight Eisenhower. Douglas MacArthur. Betty Grable. Humphrey Bogart. Ingrid Bergman. Lauren Bacall. Mickey Rooney. Judy Garland. Spencer Tracy. Katharine Hepburn. Alan Ladd. Veronica Lake. Rita Hayworth. Jane Russell. Gene Kelly. Joe DiMaggio. Joe Louis. Jackie Robinson. Ernest Hemingway. Frank Sinatra. Bing Crosby. Bob Hope. Dorothy Lamour. Glenn Miller. Tommy Dorsey. Harry James. Abbott and Costello.

WE, THE PEOPLE

Population of the United States in 1940: 132 million. Population in 1950: 151 million. Number of Americans in 1948 with religious affiliations: 79 million. Number of federal civilian employees in 1939: 950,000; number in 1945: 3.8 million.

MILITARY MATTERS

Number of men who served in the military: 16.4 million. Number of women who served in the military: 350,000. Percentage of American men in the military: 14; percentage of women: 0.1. Number of American war dead: 405,399. Minimum age for male recruit: 18. Minimum age for female recruit: 20.

Number of the 23,000 women in the Marine Corps discharged for being lesbians: 20.

HOLLYWOOD GOES TO WAR

Weekly movie attendance in 1941: 55 million. Weekly movie attendance in 1944: 100 million. Of the 1,700 features produced between 1942 and 1945, number that had to do with the war: 500. Hollywood in uniform: Clark Gable, Jimmy Stewart, Robert Taylor, Tyrone Power, Robert Montgomery, Mickey Rooney, Frank Capra, John Ford, William Wyler. Number of personal appearances made by performers on USO tours during war: 35,000. Number of volunteers serving at the Hollywood Canteen: 50,000. Number of servicemen entertained there: 2 million.

ROSIE THE RIVETER

Number of women in the workforce in 1940: 12 million; in 1945: 18.6 million. Percentage of civilian workforce occupied by women in 1940: 26; percentage in 1945: 36. Unemployment rate in 1940: 15 percent. Unemployment rate in 1944: 1 percent. Average weekly wage of women in defense jobs: $31; average wage of men: $55. Number of days it took to build a cargo ship: 17. Number of man-hours it took to build a bomber: 13,000. How frequently a Jeep rolled off the assembly line: one every 80 seconds.

MONEY MATTERS

Gross National Product in 1940: $99.7 billion. Gross National Product in 1949: $256.5 billion. National debt in 1940: $43 billion. National debt in 1945: $259 billion. Number of individuals who paid income tax in 1939: 4 million. Number who paid income tax in 1945: 43 million.

SCARCITY

Average ratio of men to women on college campuses in the 1930s: five to one. Ratio of men to women in the early 1940s: one to eight.

VD VICTORY

Cases of syphilis per 100,000 population in 1941: 368; in 1950: 146. Cost of a vial of penicillin in early 1941: $5,000; cost in 1945: less than a dollar; cost in 1947: 30 cents.

SUBURBAN BLUES

Number of houses started in 1944: 114,000; number started in 1946: 937,000; in 1948: 1.1 million. Price of basic Cape Cod in Levittown: $7,990. Number of houses bought in one day in 1949: 1,400. Number of houses completed per week (in 1948): 180; number completed before lunch: 18. Total number of houses built in the first Levittown: 17,400.

BOYS WILL BE BOYS

Kinsey's list of the things that excited young males to their first ejaculation: sitting at desk; sitting in classroom; lying still on floor; lying still in bed; moving water in bath; general stimulation with towel; sliding on a chair; sliding down a banister; chinning on bar; climbing tree, pole, or rope; wrestling with female; wrestling with male; riding in an automobile; tight clothing; daydreaming; reading a book; walking down a street; vaudeville; movies; being kissed by female; watching petting; peeping at nude female; sex discussion at YMCAs; milking a cow; when bicycle was stolen; a bell ringing; an exciting basketball game; reciting in front of class; injury in a car wreck.

FINAL APPEARANCES

F. Scott Fitzgerald (1940). James Joyce (1941). Carole Lombard (1942). Glenn Miller (1944). Franklin Delano Roosevelt (1945). Benito Mussolini (1945). Adolf Hitler (1945). Henry Ford (1947). General Hideki Tojo (1948).

Chapter Six

COLD WAR COOL: 1950—1959

Father Knows Best—television's fantasy of family together-ness—ran from 1954 to 1963.

The Fabulous Fifties. The Decade Deluxe. The Ike Age. These were the good old days, the happy days, the source of many an American's earliest, fondest memories and many of our postwar institutions.

For the past two decades Americans had lived in the grip of poverty and war. Now they were ready for some giddy, goofy fun. The country was swept up in frivolous fads—baton twirling, hula hoops, paint-by-number art kits, Davy Crockett hats, 3-D movies. Life seemed a wide-screen, stereophonic special effect.

Culture popped—in shades of turquoise, pink, salmon, and, if one color wasn't enough, delicious two tones. Madison Avenue created an unlikely world of perfect appliances and perfect families, of highballs and hi-fis, Bermuda shorts and backyard barbecues. In the ads, the wives are beautiful (mowing

the lawn in peasant blouses and a hint of lingerie); the children above average (exuberantly joining in the Saturday-morning car wash). Over the clink of ice cubes, Americans mingled. And misbehaved.

Teenagers went to sock hops, wrestled in rec rooms, and practiced unhooking bras in the backseats of cars. College boys staged panty raids, marching across campuses chanting, "We want girls! We want sex!" But they settled for cotton underwear as a sorry substitute for the real thing.

When motivational researchers claimed that advertising contained subliminal sexual messages, no one was surprised. Automobiles were obvious sex symbols. Even steel seemed affected by raging hormones. Cars were phallic-shaped rocket ships. The grille of the Edsel was a Ford engineer's hymn to female genitalia. It didn't sell.

Conformity became a national passion, part of a return to sexual and political conservatism. Male executives wore the same gray flannel suits and drank the same cocktails at mandatory two-martini lunches. Women wore Dior dresses that hid their legs and lived in tract houses that hid their very existence. Students crammed themselves into molds of every sort, from telephone booths to VWs.

Television moved in, a new and welcome member of the nuclear family. Lucy, Ricky, Fred, and Ethel became everyone's next-door neighbors. In 1950 only 3.1 million American homes had television sets. By 1955 the number would reach 32 million. Television relocated the family table. Henceforth, food would be served on trays.

Television offered a portrait of the American family as viewed in a funhouse mirror. Donna Reed did housework while wearing pearls. Still, Americans watched other families on *Father Knows Best, The Adventures of Ozzie and Harriet, Leave It to Beaver,* and *Life With Father* and identified with them, not noticing that the one thing TV families never did was watch television.

Critics called it the boob tube, but they weren't referring to female anatomy. Television, from the very start, reflected mainstream middle-class morality, and the Federal Communications Commission made sure that TV was as sanitized as radio had been before it. No one had sex on TV; parents slept in separate beds in offscreen bedrooms. Still, a whole generation of youngsters synchronized hormones by watching Annette Funicello blossom on *The Mickey Mouse Club.*

Lucille Ball's pregnancy was played for laughs on *I Love Lucy* (they called it her "expectancy"). Millions of women followed her to term, spawning fami-

lies of their own. In 1950 birth-control pioneer Margaret Sanger organized funding for research into an oral contraceptive that would make family planning as easy as taking aspirin. Sanger's crusade had reached the world (she was now the head of International Planned Parenthood) but no one on the home front seemed interested. America was in the midst of a baby boom, with women turning out children as though on assembly lines. The Depression had forced the birthrate to a low of 18.4 per thousand women; now it rose to 25.3 per thousand. The birthrate for third children would double; for fourth children triple.

America's return to fertility belonged in a Norman Rockwell painting, but fault lines were visible. Two of the best-selling authors of the time were Dr. Benjamin Spock (on how to raise children) and Mickey Spillane (on how to deal with them when they grew up and became Commie, pinko, pansy punks).

America had vanquished enemies abroad, only to have new ones surface. When Russia exploded its first nuclear device, the country entered a world of deadly threat. Kids practiced duck-and-cover drills under school desks. Newspapers ran maps showing circles of destruction around major cities. They called it the Cold War, but it didn't stay cold.

American troops went to Korea to be slaughtered in a "police action"— whatever that was.

America was no longer the world's only superpower, and confidence gave way to suspicion, a demonic quest for the enemy within. The country became a surveillance society, with citizen spying on citizen. Self-proclaimed protectors of the American way destroyed careers and ruined lives—all in the name of security.

For every frivolous fad there was a dark tic in the American psyche. Newspapers reported an epidemic of UFO sightings. The government insisted that flying saucers did not exist, but it had said that about U-2 spy planes as well. The nation, feeling that it was being watched, sought divine surveillance. Reconfirming that America was one nation "under God," schools inserted that phrase into the pledge of allegiance. Americans had more money than their parents had dreamed of, but added the comfort of "In God We Trust" to the country's paper currency.

Wilhelm Reich, a former disciple of Sigmund Freud who in 1946 had called for a sexual revolution, concocted a theory of sex that suggested orgasm released a kind of energy into the air. The energy, he said, could be collected by orgone boxes—six-sided, zinc-lined, coffin-sized containers—and used to

restore orgiastic potency. Reich worried that atomic tests were poisoning this free-ranging sexual energy, that repression was crippling mankind's genital character. Instead of laughing off these ideas, the Food and Drug Administration sent agents with axes to destroy all the orgone boxes, and to burn every published work by Reich that mentioned the dreaded orgone. Reich was charged with contempt of court, for which he was undeniably guilty. The doctor, diagnosed as a paranoid, died in prison in 1957.

America had saved the world and become the first superpower, and yet instead of pride came paranoia. Reich may have been right. Something was contaminating the air we breathed. Suspicion and fear spread across the land, from small towns to the very seat of government.

The letters began to arrive in the spring. A family with two teenage daughters received mail that accused one daughter of sordid sexual behavior. A businessman read detailed accounts of his wife servicing other men. Those who read the letters believed the charges. Husbands and wives quarreled. The quarrels led to divorce and to abandonment.

And still the letters came. The poison pen touched the lives of families in College Park and East Point, Georgia. According to John Makris, author of *The Silent Investigators,* the rumormonger "alleged perverse sexual activities" and "disgusting and filthy sexual misconduct." Many parents refused to discuss the letters with authorities.

Makris tried to explain the bizarre impulse that caused such scandal. "This type of poison-pen letter is the outgrowth of sexual frustration," he wrote. "Beauty- and popularity-contest winners, pretty models, movie and television actresses and girls whose pictures—along with their addresses—appear under engagement or wedding notices in the newspapers are among those who most frequently receive these letters. Nor are these letters confined only to the opposite sex. A high school football star, for instance, who gets his name and his picture in the newspapers, becomes the target of homosexuals."

A newlywed received a letter accusing her husband of bigamy. She committed suicide. Investigation revealed that the charge was unfounded.

Sexual frustration? That might explain the perverts who wrote such letters, but not why so many people believed what was written. In the fifties we lived in a world of lies, of deception and deceit—and the lies wrecked human

lives. America was more than ever a schizophrenic nation, trying to hold to a pretense of virtue while never acknowledging the other America, the one of human lust and frailty.

Scandal was infectious. It became the lens through which we viewed life. An article in the March 1952 *Coronet* described one apocalypse:

> Mark and Eva were discreet. They never risked idle gossip. They always met by a prearranged plan in a neighborhood where neither one was known. Sometimes they would park Eva's car and take Mark's for their few hours together. Sometimes it would be Eva's car. Their absence from their respective homes was always well covered. Not a soul who knew either even speculated about clandestine meetings.
>
> This very fact is why the sudden knowledge of their double living came as such a shock to all who knew them. "It just pulls the props right out from under you. If a guy like Mark can be that two-faced, who on earth can be trusted?" gasped Mark's closest friends when they read the lurid headline GAS TRUCK CRASHES LOVE-TRYST CAR!
>
> "It's unbelievable," said Eva's friends. "It makes you feel there isn't anything decent or fine that you can have faith in anymore."

The lovers were dead. Instead of grief, the only emotion their friends could summon was stunned indignation.

The scandal magazine *Confidential* appeared on newsstands in 1952, promising that it "Tells the Facts and Names the Names." It was simply a commercial version of the poison-pen letter, one with a mass audience. Robert Harrison, publisher of such titles as *Beauty Parade* and *Eyeful,* got the idea for the bimonthly after watching the widely televised hearings from the previous year on organized crime, prostitution, and vice chaired by Senator Estes Kefauver. The nation, not to mention the senator, had been captivated by the testimony and "extraordinarily long silk-clad legs" of Bugsy Siegel's mistress, Virginia Hill. Harrison's insight was simple: "Americans like to read about things that they are afraid to do themselves."

Harrison exploited human weakness. He sent spies into the house of love. Would-be models and aspiring actresses, eager to earn a $1,000 fee, would

haunt the bars along Sunset Strip, making themselves available to the rich and famous. And like government agents, they kept miniature tape recorders in their purses, the better to catch the boasts and bedroom confidences of their victims. In this milieu informing on one's neighbor became a national pastime. While Herbert Philbrick might write the 1952 best-seller *I Led Three Lives: Citizen, "Communist," Counterspy* or another recruit might confess "I Was a Communist for the FBI," anonymous agents penned articles that could have been titled "I Was a Slut for *Confidential.*"

America learned that Frank Sinatra consumed a bowl of Wheaties between sexual encounters, Errol Flynn had a two-way mirror installed in his bedroom, Dan Dailey liked to dress in drag, Kim Novak and Sammy Davis, Jr., were an item, Lana Turner shared a lover with Ava Gardner, and Liberace liked boys.

Infrared film. Telephoto lenses. There were photos of alleged love nests, if not the offending parties in action. Harrison used the available technology of the time to invade the privacy of America's aristocracy. *Confidential* was not above blackmail. Harrison allegedly opened an agency called Hollywood Research Inc. Investigators would take copies of "compromising materials" to the victims and suggest that their stories would be quashed in exchange for certain fees.

The rag reached a circulation of four million before it began to self-destruct. A story on Robert Mitchum stated that the star had stripped naked at a party thrown by Charles Laughton, covered himself with ketchup, and bellowed, "I'm a hamburger." Mitchum filed suit.

Maureen O'Hara took issue with a published story that had her grappling with a Latin lover in the balcony of Grauman's Chinese Theatre. She sued for $5 million (and collected $5,000).

One of the witnesses in O'Hara's trial, Polly Gould, killed herself the night before she was to testify. A member of *Confidential*'s editorial staff, she had been selling secrets to the prosecutor. Soon after the trial, Howard Rushmore, the magazine's editor, shot his wife in the backseat of a cab, then turned the gun on himself.

Harrison's reign of terror ended when the State of California charged *Confidential* with conspiracy to commit criminal libel and distribute obscenity. He sold the magazine in 1958 and disappeared from view.

Harrison had kept sex mired in the tawdry for decades. He was a product of the tabloid journalism of the first half of the century. As a teenager he had worked for a national rag, *The Daily Graphic*—a kaleidoscope of scandal, confession, and doctored photographs that earned the title *The Daily Pornographic*. He had moved from that job to working for Martin Quigley, publisher of the *Motion Picture Daily* and the *Motion Picture Herald*. Quigley was also one of the straitlaced Catholics who had bullied Hollywood into adopting the Production Code. In the shadow of propriety and repression, Harrison had put together a girlie magazine called *Beauty Parade*. When Quigley discovered the project, Harrison was out of a job. He took the basic formula—shots of models in sexy costumes, bikinis, loincloths, and lingerie—and arranged it in short storyboards titled "What the French Maid Saw" or "Confessions of a Nudist" or "If Girls Did As Men Do." Harrison's empire of girlie magazines grew through the forties to include *Titter, Wink,* and *Flirt,* simple fare that combined baggy-pants humor and pin-ups.

A female editor who had read Krafft-Ebing's *Psychopathia Sexualis* contributed a little kink. As Americana chronicler Tom Wolfe noted, this unsung heroine of the revolution brought us "the six-inch spike-heel shoes and the eroticism of backsides, or of girls all chained up and helpless, or of girls whipping the hides off men and all the rest of the esoterica of the Viennese psychologists."

Others saw the girlie magazines as pure Americana. These women, said Gay Talese in *Thy Neighbor's Wife,* portrayed sex as bizarre behavior. "His high-heeled heroines with whips and frowning faces were, in the best Puritan tradition, offering punishment for pleasure."

This was supposedly a time of innocence. But there was something unhealthy loose in the world, a repressive tide that became increasingly visible in the postwar years. In fashion, Christian Dior sheathed women in the New Look—chastity garments that hid and hobbled the female form. Dior moved from the hourglass to the H shape, a look that inspired the sack dress, trapeze, and balloon—fashions that made the female figure disappear. Panty girdles and brassieres bound the woman and dehumanized her. "Without foundations," declared Dior, "there can be no fashion." But foundations were unnatural molds

that forced women into ideal static shapes. They seemed to take us back to the turn of the century, when a woman's place was in her corset, controlled and inaccessible. America had crossed a line from fashion to fetish. John Willie, the pseudonym of an enthusiastically perverse mind, recorded this sense in the pages of *Bizarre*. Willie, whose real name was John Alexander Scott Coutts, was the "Leonardo da Vinci of fetish." In the introduction to his first issue, Coutts wrote, "*Bizarre* is, as its name implies, bizarre! It has no particular sense, rhyme nor reason, but typifies that freedom for which we fought . . . the freedom to say what we like, wear what we like and to amuse ourselves as we like in our own sweet way."

Bizarre was a bondage magazine, a postwar phenomenon that achieved considerable underground cult status. Covers showed women blindfolded, gagged, manacled. One of the earliest copies showed a devil holding a fashion pattern while looking at a chained model. Another depicted a woman riding an exercise bike. As she pedaled, revolving switches lashed her buttocks. There were articles on punishment techniques of the Puritans, with pictures of women held captive in pillories, of women bound and lowered into cold ponds. Americans amusing themselves in their own sweet way.

Puritans had their witch trials, but Americans of the 1950s had a witch-hunt of their own. The House Un-American Activities Committee hearings, launched in 1947, had run amok. Responding to Republican charges that he was soft on communism, President Truman established loyalty oaths for government employees. Soon loyalty boards sprang up all across the country. They were star chambers playing havoc with people's lives on the basis of rumors and innuendo.

Truman tried to rein in the anti-Communist hysteria by pointing out that after periods of great upheaval such as the Civil War and World War I there had been similar panic, with the excesses of the Ku Klux Klan and other forms of vigilantism. At a press conference in June 1949, Truman ridiculed a HUAC proposal to screen the books in America's schools and colleges for subversion.

On February 9, 1950, an obscure United States senator from Wisconsin named Joseph McCarthy gave a speech to a Republican Women's Club in Wheeling, West Virginia, in which he said, "I have here in my hand a list of

205 names known to the Secretary of State as being members of the Communist Party and who, nevertheless, are still working in and shaping the policy of the State Department."

The charge electrified America. Over the next few weeks, McCarthy changed the accusation—the 205 Communists became 205 "security risks." When the accusation became "57 card-carrying Communists," the FBI urged the senator to be less specific. The fewer the details, the better.

The McCarthy Era had begun. America was trampled by what Senator Margaret Chase Smith called "the four horsemen of calumny—fear, ignorance, bigotry, and smear."

An unsubstantiated charge by the senator, or a snickering remark by one of his aides, could end a career. McCarthy's investigation of the State Department and the U.S. Army never produced a Communist nor exposed any wrongdoing. But Tailgunner Joe held the country hostage for four years, finally self-destructing during a televised Army/McCarthy hearing in 1954. Censured by his fellow senators, McCarthy died in disgrace, an alcoholic, at the age of forty-eight in 1957. But the damage lasted more than a decade, spread by others practiced in the art of what came to be known as McCarthyism. For some, the damage lasted a lifetime.

Many historians say the witch-hunt was inspired by the power of television. While McCarthy was pursuing subversives, Senator Estes Kefauver, in 1950–51, was holding televised hearings on organized crime. The spotlight took this unknown Tennessean and made him a national figure, as it would Richard Nixon two years later.

The box brought sensation and scandal into the home. Within the space of a few years there were probes of vice and prostitution, organized crime, comic books, pornography, obscenity, the Post Office, the State Department, the U.S. Army, and Congress itself. America's top cop exploited the new technology. Hoover had steadfastly denied the existence of organized crime. His reputation was built on a few well-publicized shoot-outs with Depression-era desperadoes, a kidnapping here and there, and catching spies during the war. He picked on prostitutes and radicals, but he knew the value of a good conspiracy theory from his crusade against the Red Menace.

Kefauver paraded crime kingpins such as Meyer Lansky and Frank Costello before the camera and entertained America with tales of the Mafia, codes of silence, gunsels, and bag ladies. The Kefauver Committee was more than an embarrassment to Hoover; it was a direct threat to his political turf. On the eve of the hearings on organized crime the FBI, through the U.S. Attorney General, was still denying the Mob's very existence.

When McCarthy came to Hoover and said he had gotten an enthusiastic response to his speech on subversives in the State Department, Hoover saw a way to regain the limelight. The new inquisition—the world of unsubstantiated charges and televised confrontation, the pressure to name names and betray fellow travelers—was custom-made for Hoover's favorite form of blackmail.

Athan Theoharis, author of *J. Edgar Hoover, Sex and Crime,* describes the birth of the great homosexual panic of 1950. "The same month as McCarthy's charges the head of the Washington, D.C., police vice squad publicly asserted that at a 'quick guess' 3,500 'sex perverts' were employed in the federal bureaucracy, of whom 300 to 400 were State Department employees. In response to this publicity, State Department security officers admitted that the department had fired 91 'sex perverts' since the establishment of the Federal Employee Loyalty Program."

"Communists, deviants—they're one and the same," said one senator, thus wedding the Red Scare to homophobia. Senator Clyde Hoey, described by *Time* magazine as a "frock-coated" North Carolinian, had been "quietly looking into a sordid matter: the problem of homosexuals in the government."

Senator Hoey found a record of "sexual perversion" among workers in thirty-six sectors of the government and a host more in the armed forces. He targeted 4,954 deviants, most in the military. There were 574 suspect civilian government employees—some 143 in the State Department—who had quit, were fired, or were cleared. The Veterans Administration housed 101 perverts, the Atomic Energy Commission 8, the ECA 27, the Library of Congress and other agencies 19, the White House none.

"It follows," Hoey warned, "that if blackmailers can extort money from a homosexual under threat of disclosure, espionage agents can use the same type of pressure to extort confidential information."

J. Edgar Hoover told Congress that FBI investigators possessed derogatory information on 14,414 federal employees and applicants and had identi-

fied 406 "sex deviates in government service." He asked for and received greater appropriations to launch a special Sex Deviates program. FBI agents began to hang out at leather bars and other gay haunts, collecting names. Theoharis writes that in 1977, when the FBI received permission to destroy the files in the Sex Deviates program, more than 300,000 pages had been accumulated.

Each file contained the name of a suspected pervert, his occupation, and the charges that had brought him to the attention of the Deviates division. Theoharis reports that little is known of the use of these cards, but evidence exists that Hoover approved letters to those outside of government, warning college heads and law-enforcement agencies of the "security risks" within their own organizations.

Homosexuality, wrote Ralph Major in the September 1950 issue of *Coronet* magazine, was the "New Moral Menace to Our Youth."

This panic may be traced to the Kinsey Report on American males that had appeared in 1948. Kinsey had reported that "37 percent of the total male population has had at least some overt homosexual experience between adolescence and old age." If our men weren't growing up to be men, there was something hideously wrong with America.

Science was one source of the panic, literature another. James Jones's 1951 novel, *From Here to Eternity,* hinted at a hidden homosexual network within the Army. The story begins when a gay officer in the Bugle Corps promotes one of his "angels" over the more deserving Prewitt. Most Americans remember the 1953 movie version with Burt Lancaster and Deborah Kerr rolling about in the surf as a hymn to heterosexual passion and the danger of getting sand in the wrong places. The novel discussed queer baiting and FBI fairy hunts.

Ironically, the same panic that McCarthy unleashed came back to topple him. The Army/McCarthy hearings in 1954 came about because of charges that McCarthy had pulled strings to try to get the Army to promote David Schine—a protégé of McCarthy staffer Roy Cohn. These two, devoted to driving out the "lavender lads" and "cookie pushers" from the State Department, were widely rumored to be gay and using favoritism to advance their own angels. Roy Cohn died of AIDS in 1986, still an outspoken gay basher.

The Brick Foxhole, a 1945 novel by future film director Richard Brooks, concerned a gay murder in the military in wartime Washington. In the 1947

movie version, called *Crossfire,* the bigotry became anti-Semitism. In postwar America, some prejudice was more acceptable than others. We were prepared to question intolerance related to race and religion, but not toward sex. The film was a hit for RKO, but both the director and the producer of the film were called by HUAC to testify about their leftist leanings.

During the war, the Pentagon tried to weed out gays by using profiles based on Stanford psychologist Lewis Terman's Male-Female Quotient to identify and turn away those of questionable sexual orientation. There are some who argue that the screening process actually alerted homosexuals to the presence of others of similar persuasion.

In 1951 Henry Hays founded the Mattachine Society, devoted to "the protection and improvement of Society's Androgynous Minority." (Lesbians, in 1955, would organize the Daughters of Bilitis.) Of course, Hays was forced to testify before the House Un-American Activities Committee.

Confidential warned America that the Mattachine Society had a war chest of $600,000. The idea of secret cells of perverts fascinated America. That so many were willing to believe that sexual preference could be betrayed or subverted by homosexuals indicates the state of innocence (or ignorance) of the country at the time on the subject of sex. Did we believe that our own sexual identity was in danger? It appeared that the American male could be disloyal even to his own gender. In 1952 ex-GI George Jorgensen underwent the first publicly acknowledged sex-change operation, going to Denmark a man and returning as Christine Jorgensen, a woman.

The sexual undercurrent in national politics surfaced in the 1956 presidential election when Hoover crony Walter Winchell would declare that "a vote for Adlai Stevenson is a vote for Christine Jorgensen."

"All too often," warned Eugene Williams, a special assistant attorney general for the state of California, "we lose sight of the fact that the homosexual is an inveterate seducer of the young of both sexes and that he presents a social problem because he is not content with being degenerate himself: He must have degenerate companions and is ever seeking younger victims."

The homosexual panic was fueled by the mainstream press of the day. Americans had no clear picture of this sexual minority, and the uninformed mind created monsters.

In 1949 the nation had been stunned by brutal sex crimes on the West Coast and in Idaho. The local incidents had turned into a national obsession.

Newsweek ran an article on "Queer People," *Time* on "The Abnormal." *Collier's* ran a thirteen-part series on "Terror in Our Cities."

J. Edgar Hoover wrote a widely reprinted article asking "How Safe Is Your Daughter?" and distributed coloring books that taught children to distrust strangers. The government produced statistics that claimed sex crimes other than prostitution were escalating—from 46 per 100,000 in 1953 to 51 per 100,000 in 1954, and 54 per 100,000 in 1955.

Historian George Chauncey, in his essay "The Postwar Sex Crime Panic," shows how expansive the propaganda campaign became. "The press reports that shaped public perceptions of the problem usually blurred the lines between different forms of sexual nonconformity," he explains. "They did this in part simply by using a single term (sex deviate) to refer to anyone whose sexual behavior was different from the norm. Like the term abnormal, the term deviate made any variation from the supposed norm sound ominous and threatening, and it served to conflate the most benign and the most dangerous forms of sexual nonconformity. People who had sex outside of marriage, murdered little boys and girls, had sex with persons of the same sex, raped women, looked in other people's windows, masturbated in public or cast 'lewd glances' were all called sex deviates by the press."

Once you strayed from the norm, you were a monster.

Once again, America began to fear for its children. And there arose new crusaders with new concerns. Anthony Comstock, the prototype for all puritan champions, once railed against "traps for the young," warning about the dangers of penny dreadfuls, dime novels, and police gazettes. In the late forties a new and most unlikely menace had appeared comic books.

With Hollywood chafing under a Production Code that sanitized all forms of sin, comic books filled a growing appetite for more lurid fare. The old standards—*Superman, Batman, Wonder Woman,* and *Sheena*—still entertained devoted fans, but they were soon joined by *Gangbusters, True Crime Comics,* and *Crime Does Not Pay.* Americans may have left the city for the suburbs, but crime had followed—at least as far as the local newsstand. And a wave of ever more frightening titles appeared, including *Crypt of Terror, The Vault of Horror,* and *The Haunt of Fear.* Critics claimed that comic books were "sex horror serials" and "pulp paper nightmares" that created "ethical confusion" and

moral decline. E.C. Comics even gave its most subversive title the warning label "Tales calculated to drive you Mad."

Fearing that a diet of pulp would lead to juvenile delinquency, city fathers across the country cracked down. In 1947 the Indianapolis police department labeled comic books "vicious, salacious, immoral and detrimental to the youth of the nation."

In Rumson, New Jersey; Cape Girardeau, Missouri; Binghamton, New York; and Chicago, Cub Scouts and other schoolchildren collected comic books and tossed them on bonfires. Boston and Cincinnati appointed special comic book censors. The National Office for Decent Literature, long the watchdog of magazines and books, took to rating pulp panels.

Into this maelstrom walked Fredric Wertham, a psychiatrist who had worked with troubled youths in New York City. In 1948 he began crusading against the comics. According to Wertham, 90 percent of the nation's children read an average of eighteen comic books a week. The average sixteen-year-old reader had "absorbed a minimum of 18,000 pictorial beatings, shootings, stranglings, blood puddles and torturings to death from comic books alone."

He would recount horror stories of innocent children led astray. Kids in the fifties threw rocks at trains and automobiles, beat candy store owners with hammers, trampled siblings to death, poured kerosene over classmates and set them afire, led safecracking expeditions, and committed "lust murders." "There is nothing in these juvenile delinquencies," Wertham would write, "that is not described or told about in comic books. These are comic book plots."

Some of his stories reveal parental overreaction. Telling about a group of kids who, acting out things they'd read in comic books, tormented one girl, he noted, "They handcuffed her with handcuffs bought with coupons from comic books. Once, surrounding her, they pulled off her panties. . . . Now her mother has fastened the child's panties with a string around her neck, so the boys can't pull them down."

Wertham's crusade at first was a failure. When the New York legislature passed an anticomics bill in 1952, Governor Tom Dewey vetoed it. Kefauver's Senate Committee investigation initially scoffed at the role of comics in creating juvenile delinquents. In 1950 the headlines had announced its conclusion: COMICS DON'T FOSTER CRIME.

Wertham continued his crusade in one magazine article after another. Comic books were "pollution," the source of "unhealthy sexual attitudes."

Wertham warned that children copied crimes from crime comics, and that they developed a taste for rape, torture, mutilation, cannibalism, and worse. Plus, the comics would create a nation of breast fetishists, he said. "Comic books stimulate children sexually," he warned. "Attention is drawn to sexual characteristics and to sexual actions."

He warned about headlight (a slang term for breast) books. "One of the stock mental aphrodisiacs in comic books is to draw girls' breasts in such a way that they are sexually exciting. Wherever possible, they protrude and obtrude. Or girls are shown in slacks or negligees with their pubic regions indicated with special care and suggestiveness. Many children miss that, but very many do not."

Some books emphasized girls' buttocks. "Such preoccupations, as we know from psychoanalytic and Rorschach studies, may have a relationship to early homosexual attitudes." Wertham's grasp of the psychodynamics of homosexuality was novel, to say the least.

Wertham held the nation's attention because he drew a target around innocent youth. "The difference between the surreptitious pornographic literature for adults and children's comic books is this: In one it is a question of attracting perverts, in the other of making them."

Some 90 million comic books were consumed each month by American innocents.

In his 1954 Book-of-the-Month-Club selection, *Seduction of the Innocent,* he pinpointed the villains. To the well-trained eye the supermasculine heroes Batman and Robin were gay. "They live in sumptuous quarters, with beautiful flowers in large vases, and have a butler, Alfred. Batman is sometimes shown in a dressing gown. It is like a wish dream of two homosexuals living together." And listen to his description of Robin: "a handsome ephebic boy, usually shown in his uniform with bare legs. He is buoyant with energy and devoted to nothing on earth or in interplanetary space as much as to Bruce Wayne. He often stands with his legs spread, the genital region discreetly evident." The stories were devoid of "decent, attractive, successful women." Instead, there was Catwoman, "who is vicious and uses a whip."

Lesbians were the by-products of *Wonder Woman,* Wertham said. "For boys, Wonder Woman is a frightening image. For girls, she is a morbid ideal. Her followers are the gay girls."

Comic books glorified "assertiveness, defiance, hostility, desire to destroy or hurt, search for risk and excitement, aggressiveness, destructiveness,

sadism, suspiciousness, adventurousness, nonsubmission to authority"—the very qualities that research had shown were the building blocks of juvenile delinquency.

Wertham's book caused a sensation. In 1954 Senator Kefauver—who had taken to wearing a Davy Crockett coonskin cap during political campaigns—reopened the comic book question. Not surprisingly, he discovered a plot against America. "Almost without exception," he warned, "the comic books were displayed indiscriminately in the midst of magazines notorious for their emphasis on sex, nude torsos and exaggerated accentuation of some physical characteristics of male and female alike. We have a strong feeling that this step-by-step development of adolescent curiosity is more design than coincidence."

The comic industry responded, not with laughter but by creating the Code of the Comics Magazine Association of America. Modeled on the Hollywood Production Code and prepared with the spiritual guidance of Roman Catholic, Protestant, and Jewish leaders, the comic book guidelines prohibited nudity, profanity, obscenity, smut, and vulgarity, as well as any salacious illustration or suggestive posture. "Females shall be drawn realistically," wrote the censors, "without exaggeration of any physical qualities."

So much for the headlights. "Respect for parents, the moral code and for honorable behavior shall be fostered," noted the code. "The treatment of love-romance stories shall emphasize the value of the home and the sanctity of marriage. Passion or romantic interest shall never be treated in such a way as to stimulate the lower and baser emotions."

The code was created by the industry in order to survive, for without the government's seal of approval titles were essentially banished from newsstands. Companies went out of business and artists were driven underground. William Gaines, publisher of such E.C. Comics classics as *Tales From the Crypt,* was particularly hard hit. He had tried to defend one cover—a severed head dripping blood—as tasteful. He discontinued most of his titles and focused on an upstart magazine created by Harvey Kurtzman called *Mad.*

"It was as if comic books were castrated," said John Tebbel in an article on the comics code. "People couldn't keep their children from growing up, but they could keep the comic books from growing up."

* * *

Adults had their own source of sex and violence. Since the mid-forties, the paperback rack at the corner store had become a fixture. It was one of the great things to come out of the war, when servicemen relied on pocket-size books for entertainment overseas.

The paperbacks played with provocative covers; one, *The Private Life of Helen of Troy,* was known to an entire generation as simply "the nipple cover." A painter grappled with models on a book titled *Art Colony.* The covers of Mickey Spillane novels showed women in tight dresses clutching handguns, not handbags. A rash of novels exploited the juvenile delinquent motif, from Irving Shulman's *The Amboy Dukes* and Bernard Williams's *Jailbait* to Evan Hunter's *The Blackboard Jungle.*

The plotline of the latter is a fifties-era classic. The adult protagonist comes upon a student trying to rape a teacher. "The boy turned suddenly, moving to Miss Hammond's side. It was then that Rick saw the torn front of her suit jacket and the ripped blouse and lingerie. My God, he thought, wildly, that's her breast, and then he was clamping his hand on the boy's shoulder and spinning him around." The teacher screams, the protagonist pummels the scoundrel. "The boy bounced back against the radiator, and Miss Hammond screamed again, holding her hand up to cover the purple nipple and roseate of her breast behind the torn slip and brassiere."

The hero hands his jacket to the victim. "The jacket was too large for her, but she clutched it to her exposed breast thankfully, her cheeks flushed with excitement. Rick looked at her again, at the delicate features, the full body thrusting against his jacket. He thought of the innocent exposure of Miss Hammond's breast as he had seen it, full and rounded, the torn silk of her underwear framing it, providing a cushion for it. A youthful breast it had been, firm, with the nipple large and erect. He concentrated on the embarrassment he felt for her, and he concentrated on his hatred for the boy, and he seized the boy roughly and shouted, 'Come on, mister. The principal wants to see you.'"

Of course, Congress could not miss the opportunity for a another full-scale investigation, creating a Select Committee on Current Pornographic Materials (not to be confused with older pornographic materials). The pols wanted to take the entire country to the principal's office.

Chaired by E. C. Gathings (D-Kans.), the investigation would go after "the kind of filthy sex books sold at the corner store which are affecting the

youth of our country." The publishers of paperbacks were spreading "artful appeals to sensuality, immorality, filth, perversion and degeneracy. The exaltation of passion above principle and the identification of lust with love are so prevalent that the casual reader of such literature might easily conclude that all married persons are adulterous and all teenagers are completely devoid of any sex inhibitions." The committee members were particularly upset by "lurid and daring illustrations of voluptuous young women on the covers of the books" and by books that extolled "homosexuality, lesbianism and other sexual aberrations." The Reverend Thomas Fitzgerald, a director of the National Organization for Decent Literature, presented a list of 274 objectionable books, but Gathings had his own list. *Women's Barracks,* a sexy story of French army women, drew particular heat.

The hearings did not result in new laws, but they ignited a series of vigilante-style crusades. Church groups and local police chiefs in Detroit, Minneapolis, Chattanooga, Scranton, and Akron, in Augusta, Maine, and Manchester, New Hampshsire, intimidated store owners who stocked books considered objectionable. Youngstown Police Chief Edward Allen personally banned more than four hundred paperback books on the logic that "all such books are obscene." In August 1953 a federal judge reminded Chief Allen that "freedom of the press is not limited to freedom to publish, but includes the liberty to circulate publications."

J. D. Salinger's contemporary classic *The Catcher in the Rye* appeared in 1951. It would become one of the most censored books in American history. Not a day passes, or so it seems, without some parents, somewhere, believing that Holden Caulfield's musings on alienation and sex will be the ruin of their children.

Government already controlled radio and television, and had previously put the fear of censorship into Hollywood. The point was clear: If kids didn't read about it, and if parents didn't read about it, the world would be safe from sex.

August 20, 1953, would be known as K-day, the moment that sex became front-page news in almost every newspaper in the country. The long-awaited second volume of the Kinsey Report—this one on sexual behavior in the human female—was the most important story of the year. It distracted us from the

Cold War, at the same time that the existence of a Russian H-bomb was confirmed. The solid, red-bound book, almost the twin of the male report, sold nearly 200,000 copies within a matter of weeks. A paperback special explaining the report would top the charts in the following year.

In the volume on males, Alfred Kinsey and his associates at Indiana University had set out to describe sex not as it should be but as it was. The reaction had been swift and mostly negative. Everyone from college presidents to J. Edgar Hoover had condemned the depiction of American morality. Kinsey noted that one woman wrote to say that she could not fathom the controversy over the first book. The report had shown only that "the male population is a herd of prancing, leering goats." Women had known that forever and, indeed, the whole of Puritan morality was predicated on constraining the goat. But what of women?

Americans were not so tolerant of the truth about women. Without bothering to read the study, Congressman Louis Heller from Brooklyn demanded that the Post Office block all shipments. Heller condemned Kinsey for "hurling the insult of the century against our mothers, wives, daughters and sisters." He threatened an investigation of the Institute for Sex Research, saying Kinsey was "contributing to the depravity of a whole generation, to the loss of faith in human dignity and human decency, to the spread of juvenile delinquency and to the misunderstanding and the confusion about sex."

Hoover opened a file on Kinsey, but nothing came of it.

Ernest Havemann, a prominent science writer asked to interpret the study for *Life,* warned that the interviews of 5,940 women "constitute a sort of mass confession that American women have not been behaving at all in the manner in which their parents, husbands and pastors would like to think, and doubtless a great many people will even be loath to believe that Dr. Kinsey has got his facts straight."

In a world swirling with rumor, scandal, and gossip about sex, Kinsey offered facts. He had talked to women of all ages and had discovered that your date of birth was the single most important indicator of sexual behavior. Women born before 1900 were morally circumspect; those born after, who came of age in the Roaring Twenties, were a different breed. The flaming youth of the Jazz Age had set sex afire. The petting parties described by F. Scott Fitzgerald had become a rite of passage. Nearly 99 out of 100 women born between 1910 and 1929 had petted.

We tended to think of Victorian women as corseted, or dressed neck to ankles, too ashamed to make love with the lights on. And Kinsey did find that a full third of the women born before 1900 made love with their clothes on, but only eight percent of the younger women he studied kept their nightgowns on during sex. Women born in this century were riding a wave of experimentation that would have shocked their elders. They were doing more of everything, from petting to French kissing to oral sex.

While women born before the turn of the century had held on to their virginity (86 percent of unmarried women were still virgins at the age of twenty-five), the modern woman was more inclined to go all the way—a third of unmarried women were no longer virgins by the age of twenty-five.

Kinsey discovered a great continent of premarital sex. Of the women who were married, half had lost their virginity before the wedding bells rang. Almost half of those had limited their lovemaking to their fiancés—making the sex truly premarital. But some had not: A third had had coitus with two to five partners, and 13 percent had had coitus with six or more. (In contrast, some 85 percent of married men, those leering, prancing goats, had had premarital sex—about a third with two to five partners, almost half with more than six.)

The Kinsey Report reflected the guilt-free attitude of the modern girl. Almost 69 percent of the unmarried women who had had premarital sex expressed no regret, according to the study. Of those married women who had been sexually active before their wedding night, more than 77 percent saw no reason to regret their earlier sexual experiences. The more partners they had had, the less likely they were to feel regret. Initial regrets disappeared with experience.

Kinsey listed twenty classic arguments against premarital sex, then demolished them with twelve modern arguments in favor of fooling around. Fear of reputation? Fear of disease? Fear of pregnancy? Forget the sex panic of the past. Kinsey had numbers, the force of empirical science. In a sample of 2,094 single white females, who among them had had coitus approximately 460,000 times, there were only 476 pregnancies (one pregnancy for each one thousand acts of copulation). Only 29 women out of 2,020 had been caught in the act. In a sample of 1,753 women who had had premarital intercourse, only 44 had ever had a venereal infection. Science put fear into perspective, into odds you could live with.

Even more startling than the figures on premarital sex were those for adultery. One out of five married women had been unfaithful by the time they were thirty-five. Among younger married women the figure was two out of five. Again, the figure for men was approximately 50 percent.

Interpreting the study, Havemann tried to emphasize the differences between men and women: "Nearly half the unfaithful wives (41 percent) had only one partner. For nearly a third the act of unfaithfulness had occurred only a few times, often just once. The whole pattern of infidelity, except in rare cases, was unpremeditated and often accidental. The husband went out of town on a business trip, a friend happened to drop over to return his golf clubs, wife and friend had a few drinks, and Kinsey's adding machine rang again."

Can you believe it? In the fifties guys loaned one another their golf clubs. Kinsey explained that sometimes infidelity was "accepted as an accommodation to a respected friend, even though the female herself was not particularly interested in the relationship." Havemann was not buying this. All in all, he wrote, "It appears the figures on woman's promiscuity are mostly a reflection of the fact that the male wolf is always with us, providing as much temptation as he can to as many women as he can."

But Kinsey demolished the stereotype of the frigid woman. In the first year of marriage, one wife out of four could not reach orgasm during sex, but by the tenth year of marriage that figure was only one in seven. About half the wives reached climax every time they made love.

One statistic jumped from the page: Women who had had premarital sex were more responsive in marriage and were more likely to be among the earliest orgasmic wives. Kinsey wrote that there was a marked positive correlation between experience in orgasm obtained from premarital coitus and the capacity to reach orgasm after marriage. And with subtle wit he destroyed another stereotype. A nymphomaniac, he said, is simply a woman "who has more sex than you do."

Dr. Iago Galdston, a New York public-health official, found the study corrupt: "What magic is there in premarital coitus that is missing in the legitimized act? Why can't the female learn as well by one as the other?"

Kinsey's answer: "The girl who has spent her premarital years withdrawing from physical contacts has acquired a set of nervous and muscular coordinations that she does not unlearn easily after marriage."

At the core of Kinsey's second report is a comparison of male and female sexual sensitivity. He placed the sexes side by side: In a comparison of thirty-three psychological factors related to sex, he found that men scored higher on all but three. Women, it seemed, were more excited by reading romantic literature, by love scenes in movies, and by being bitten during sex. Go figure.

On the other hand, men were more likely to have an erotic response to observing the opposite sex; looking at photographs, drawings, or paintings of nudes; observing their own genitals or those of the opposite sex; watching burlesque; watching other people having sex; watching films of other people having sex; watching animals mate; or turning on a light to watch themselves having sex. Men fantasized about the opposite sex during masturbation, during nocturnal dreams, while reading pornography, while writing pornography. Men were less likely to be distracted during intercourse, and were more likely to be turned on by erotic material, stories, writing, and drawing. Men were more likely to talk about sex, as revealed by the odd statistic that most women learned about masturbation by "self-discovery" while men did so from printed or verbal sources. Men were more likely to be aroused by sadomasochistic stories (which probably explained the success of Mickey Spillane). And sure, men wanted a home and family, but if marriage meant no sex, forget it.

This, in itself, was not news. For centuries observant guys had noticed the differences between the way men and women approached sex. The Victorian double standard was based on the perception that men were predatory animals and women were merely the objects of men's beastly desires. For the first half of the century, puritans and reformers had argued that a female standard should apply to all of society. Men should dance to a woman's tune. Kinsey, though, said there was no physiological reason for the gap between the sexes. Women were not sexless; their natural responses had simply been repressed.

In a best-selling book, Ashley Montagu argued that such differences amounted to proof that women were superior. He regarded a lack of responsiveness as a virtue. After all, the devil was in the flesh. But Kinsey concluded that women had been crippled by culture, by religion, and by silence. Repression turned most people into "conforming machines."

The antisexual prejudice of our essentially puritan society demanded conformity. Benjamin Gruenberg, a biology teacher and sex educator called

on to critique Kinsey, defended repression. "Conformity in sex behavior," he wrote, "is as necessary for the stability of any society as conformity in relation to property or in the daily intercourse of individuals or groups. In any given society there is rarely any doubt as to what is considered right and what is considered wrong. And for all practical purposes, the 'right' is absolute, as it has been in our traditions."

And in an oddly prescient moment, he warned against the possible rebellion against such unthinking conformity: "The polarity of good and evil, when both are absolutes, will make the individual who rejects the code, or its sanctions, seek good at the opposite pole. Sex becomes a major good for its own sake, so that, for example, the typical playboy will make his chief game a career of sex."

Anthropologist Margaret Mead also saw the Kinsey Report as an unfortunate, ill-timed attack on conformity. Young people, she said, had a need to conform. It was their only defense. To confront sexual diversity—the idea that humans could be sexual creatures—would be a major threat to the "previously guaranteed reticence" of young people.

The Reverend Billy Graham read the news of the report and concluded, "It is impossible to estimate the damage this book will do to the already deteriorating morals of America." Another religious leader called the report "statistical filth."

According to Henry Pitney Van Dusen, head of the Union Theological Seminary and one of Kinsey's most relentless critics, the studies depicted "a prevailing degradation in American morality approximating the worst decadence of the Roman Empire." Kinsey, said Van Dusen, viewed sex as being "strictly animalistic."

Not unexpectedly, Congress convened a special committee to investigate the funders of the Kinsey Institute. Was the entomologist from Indiana part of a Communist plot? Not likely. A fruit of capitalism, the Rockefeller Foundation, had underwritten Kinsey's research for years. Under pressure (and a new leader, Dean Rusk) the foundation terminated Kinsey's funding, opting instead to give more than half a million dollars to Van Dusen's Union Theological Seminary.

The local U.S. Customs agent at Indianapolis took to opening packages addressed to the Institute and decided that the erotica being collected from

around the world was "damned dirty stuff." Washington, D.C., Customs officials agreed; in their opinion, Kinsey's status as a scientist did not redeem the material. At issue was not just sexual freedom but scientific freedom as well. Eventually judge Edmund Palmieri would rule that Customs officials did not have the right to dictate to scientists what they should or should not study.

It was too late. Kinsey died an exhausted and broken man on August 25, 1956. His hope of inciting a sexual revolution remained unfulfilled. That task would fall to someone else.

In 1953 a young Hugh Hefner sat at the kitchen table of his Chicago apartment making plans for the launch of a new magazine for the indoor male.

"We like our apartment," he wrote. "We enjoy mixing up cocktails and an hors d'oeuvre or two, putting a little mood music on the phonograph and inviting in a female for a quiet discussion on Picasso, Nietzsche, jazz, sex."

He would create a romantic men's magazine, the first of its kind. One had only to look at what passed for men's magazines in 1950 to realize the boldness of the idea.

Macho men's magazines such as *True, Argosy,* and *Stag* dominated the market after the war. They reflected the male camaraderie and bonding of the war years, with an emphasis on outdoor adventure and derring-do. A generation of men had returned from the war restless and discontent. These magazines perpetuated the segregation of the sexes—a woman's place was in the home; a man's place was at the poker table, in the barroom, or camping in the wilderness with the guys. Hefner wanted something more sophisticated. "I wanted a romantic men's magazine," he would write, "one based on a real appreciation of the opposite sex. It would act as a handbook for the young urban male."

Esquire had suffered a lengthy battle with the Post Office over second-class mailing privileges. Chastened by the skirmish, the postwar Esky had lost its way. Gone were the sexy cartoons and pin-up pictures by Petty and Vargas. By the end of the decade the editor of *Esquire* would actually be calling for a New Puritanism.

Esquire may have been afraid of the Post Office, but Hefner wasn't. "I had less to lose," he said, "but I was also convinced that sex and nudity were

not obscene per se. The Post Office was acting as if it had won the *Esquire* case back in 1945—but I knew better. I planned on publishing a sophisticated men's magazine and I didn't think the Post Office had the right to stop me. This was the revolutionary thought on which *Playboy* was based, because no other magazine containing nudity was being sent through the mail at the time.

"I didn't have any money, but I had taken a loan on my apartment furniture, and a printer had promised me credit." And Hefner had something special for that first issue—a full-color nude of Marilyn Monroe. She was the most promising star on the horizon. She had posed for photographer Tom Kelley with "nothing on but the radio" when she was still a starlet. The calendar picture had caused some controversy, but few had seen it. The calendar company was afraid to send it through the mail; like everyone else, it was afraid of the Post Office.

Hefner wrote a letter touting the new magazine—and the nude photo of Marilyn—to wholesalers across the country. With orders for 70,000 copies, all that was left was to create the magazine. He spent the summer and fall of 1953 working on the first issue. It went on sale in November with no date on the cover, "because I wasn't sure there would be a second." But it was a sellout. And so were the second and third issues. Hefner's editorial mix of fiction, satire, sexy cartoons, lifestyle features, and a centerfold was an unbeatable combination in a decade as conservative as this one.

Years later, social critic Max Lerner would explain that in the sexual revolution Kinsey was the researcher and Hef its pamphleteer. "What Kinsey did was give the American male permission to change his basic life way, his basic lifestyle. And what Hefner did was show the American male how to do it."

Comedian Dick Shawn would say that Hefner "introduced clean, wholesome sex at a time when a male and a female were not allowed to be shown in the same bed. I remember Doris Day and Rock Hudson. In two different beds. Two different rooms. Two different movies."

Hefner celebrated sex as a part of the total man. He loved women, but he also cared about jazz, sports cars, art, literature, gear, gadgetry, grooming, good food and drink. He reinvented masculinity. In the pages of *Playboy,* men cooked for women, appreciated art, and refused to surrender to anyone else's definition of what it meant to be male. They would not, to use Kinsey's phrase, become "conforming machines."

The magazine created and described a new male authority. Articles by Philip Wylie attacked "The Abdicating Male" and "The Womanization of America." Mourning the day that the women's movement broached the saloon and invaded the men's club, Wylie gave a glimpse, at the heart of the magazine, of a place where "he and his fellow men could mutually revive that integrity which Victorian prissiness, superimposed on Puritanism, elsewhere sabotaged. He could talk and think of himself as a sportsman, a lover, an adventurer, a being of intellect, passion, erudition, philosophical wisdom, valor and sensitivity. In sanctuary he could openly acknowledge that his true male feelings did not in his opinion make of him the beast that 19th century Western Society claimed he was. He could furthermore discuss females as other than the virginal, virtuous, timid, pure, passionless images that constituted the going female ideal."

Wylie attacked the nightmare of togetherness: "The American home, in short, is becoming a boudoir-kitchen-nursery, dreamed up by women, for women, as if males did not exist as males."

In 1983 Barbara Ehrenreich, author of *The Hearts of Men: American Dreams and the Flight from Commitment,* would give this feminist assessment of the magazine: In Hef's world, "Women would be welcome after men had reconquered the indoors, but only as guests—maybe overnight guests—not as wives. In 1953 the notion that the good life consisted of an apartment with mood music rather than a ranch house with a barbecue pit was almost subversive. . . . A man could display his status or simply flaunt his earnings without possessing either a house or a wife—and this was, in its own small way, a revolutionary possibility."

She continues, "*Playboy*'s visionary contribution—visionary because it would still be years before a significant mass of men availed themselves of it—was to give the means of status to the single man; not the power lawnmower, but the hi-fi set in a mahogany console; not the sedate, four-door Buick but the racy little Triumph; not the well-groomed wife, but the classy companion who could be rented (for the price of drinks and dinner) one night at a time. So through its articles, its graphics and its advertisements, *Playboy* presented something approaching a coherent program for the male rebellion: a critique of marriage, a strategy for liberation (reclaiming the indoors as a realm for

masculine pleasure) and a utopian vision (defined by its unique commodity ensemble).

"Critics," she writes, "misunderstood *Playboy*'s historical role. *Playboy* was not the voice of the sexual revolution, which began, at least overtly, in the sixties, but of the male rebellion, which had begun in the fifties. The real message was not eroticism, but escape—literal escape, from the bondage of breadwinning. For that, the breasts and bottoms were necessary not just to sell the magazine, but to protect it. When, in the first issue, Hefner talked about staying in his apartment, listening to music and discussing Picasso, there was the Marilyn Monroe centerfold to let you know there was nothing queer about these urbane and indoor pleasures. And when the articles railed against the responsibilities of marriage, there were the nude torsos to reassure you that the alternative was still within the bounds of heterosexuality. Sex—or Hefner's Pepsi-clean version of it—was there to legitimize what was truly subversive about *Playboy*. In every issue, every month, there was a Playmate to prove that a playboy didn't have to be a husband to be a man."

Her tone is oddly biased. Hefner wanted to liberate males. When feminists borrowed the same blueprint a decade later (in finding their identity outside the home), it was hailed as heroic. When a man dreamed of the same sort of freedom, women saw it as a flight from commitment.

Not all feminists would express the same prejudice. Postmodern feminist Camille Paglia, defining today's man, remarked, "Hugh Hefner has never received the credit he deserves for creating a sophisticated model of the suave American gentleman in the Marlboro Man years following shoot-'em-up World War Two. Contemporary feminism has tried to ditch male gallantry and chivalry as reactionary and sexist. Eroticism has suffered as a result. Perhaps it's time to bring the gentleman back. He may be the only hero who can slay that mythical beast, the date-rape octopus, currently strangling American culture."

By the end of the decade, *Playboy* was selling a million copies a month. The Rabbit Head logo was recognized around the world. Men were cutting out the logo and taping it to car windows. Colleges were holding *Playboy* theme parties. And the centerfold—the idealized image of the girl next door —had become an American icon. Magazines tried to duplicate Hefner's formula of "torso, only more so," making *Playboy* the most imitated magazine in America.

Mort Sahl would quip that an entire generation of men was growing up convinced that women folded in three places and had staples in their navels.

To understand the appeal of *Playboy*, one had only to look at the alternative.

The 1950s saw the start of a great exodus that changed sex as significantly as the Depression or war had in previous decades. The American dream of the city on a hill gave way to a nation of Cape Cods grouped across the land. These enclaves, in an ironic twist on their actual effect on the libido, were called bedroom communities. Every morning throngs of commuters in Burberry raincoats would board a train, or drive off in the family Buick. Every night, at exactly the same hour, they would return.

The era sugarcoated repression and called it conformity. The spread of cookie-cutter houses and mass-produced dreams was as relentless as Chinese water torture.

John Keats, one of the first journalists to investigate suburbia, described this new vision of America: "For literally nothing down . . . you too can find a box of your own in one of the fresh-air slums we're building around the edges of American cities . . . inhabited by people whose age, income, number of children, problems, habits, conversation, dress, possessions and perhaps even blood type are also precisely like yours. . . . [They are] developments conceived in error, nurtured by greed, corroding everything they touch. They actually drive mad myriads of housewives shut up in them."

In 1954 the editors of *McCall's* tried to put a positive name to the phenomenon. They called the new lifestyle "togetherness." The magazine noted that "men and women in ever increasing numbers are marrying at an earlier age, having children at an earlier age, rearing larger families. For the first time in our history the majority of men and women own their own homes, and millions of these people gain their deepest satisfaction from making them their very own." Suburbia represented a wider range of living that was "an expression of the private conscience and the common hopes of the greatest number of people in this land of ours."

There was a new social organism—the magazine reported—the American family, in which "men, women and children are achieving it together . . . not as women alone, or men alone, isolated from one another, but as a fam-

ily, sharing a common experience." According to one profile given, husband Ed likes to "putter around the house; make things; paint; select furniture, rugs and draperies; dry dishes; read to the children and put them to bed; work in the garden; feed and dress the children and bathe them; pick up the babysitter; attend PTA meetings; cook; buy clothes for his wife; buy groceries." What Ed doesn't like, we were told, was to "dust or vacuum, or to finish jobs he's started, repair furniture, fix electrical connections and plumbing, hang draperies, wash pots and pans and dishes, pick up after the children, shovel snow or mow the lawn, change diapers, take the babysitter home, visit school, do the laundry, iron, buy clothes for the children, go back for the groceries Carol forgot to list."

Doesn't Ed like to fuck? *McCall's* wasn't saying.

Bob Hope saw the humor of "togetherness" almost immediately, joking that there was so much togetherness "now the old folks have to go out to have sex."

Betty Friedan, a writer turned housewife turned writer, began to research a book on the togetherness phenomenon. She found that a whole generation of women had turned their backs on dreams of emancipation, settling instead for the security of being housewives. She claimed that togetherness was concocted by male editors at women's magazines, a revisionist scheme foisted on receptive women. It had begun as early as 1949, when the *Ladies' Home Journal* ran the feature "Poet's Kitchen," showing Edna St. Vincent Millay cooking. "Now I expect to hear no more about housework's being beneath anyone," said the magazine. "For if one of the greatest poets of our day, and any day, can find beauty in simple household tasks, this is the end of the old controversy."

Whether it was a conspiracy of magazine editors, the seductive vision of Madison Avenue, or the plot of prime-time television, we had returned America to the Victorian era, with a perverse twist. The world of work was man's domain; the home was woman's. The sex of the guys wearing the aprons was unclear.

Togetherness drove women crazy. Friedan would find that housewives survived by wolfing down tranquilizers "like cough drops." Consumption of tranquilizers in 1958 was 462,000 pounds per year. By 1959 it reached 1.1 million pounds. Some women just snapped, and ran naked through the streets of suburbia screaming.

Jack Finney's 1955 science-fiction novel [*Invasion of*] *The Body Snatchers* (made into an equally engrossing film the following year) captured the horror of suburbia, with its image of pod people taking over individual humans. The cover of the paperback asked the question: "Was this his woman, or an alien life-form?"

Americans turned their backs on the sensual city, the city electric, to sit huddled around the cold fire of television. They watched fictitious families live perfect lives. Ozzie and Harriet, the fathers in *Father Knows Best* and *Life With Father*—these were the pod people. No one on these shows ever dragged a spouse into the master bedroom or copped a feel from the next-door neighbor under the bridge table. This was an America dreamed of by the Puritans.

Some called this progress. The automotive industry acquired trolleys and train lines—those avenues of escape that had made the city possible—and put them out of business. Eisenhower ordered interstate highways, which Detroit filled with gas-guzzling cars, cars big enough to comfortably hold the new family. What had once been a vehicle for escape and escapades became another room of the house. In the space of a decade about 4,500 drive-in movies sprang up, catering to the family trade (and subsequently to teenage lust). It was possible to do almost everything as a family—except to get away.

Oddly enough, this congested landscape contained the seeds of the sexual revolution of the next decade. Friedan found women who said the only time during the day that they felt alive was during sex. And when left alone for hours at a time, sex filled their time—in fantasy at least.

David Riesman, a sociologist whose book *The Lonely Crowd* became a surprise best-seller in 1950, charted the shift in the American personality from rugged individualist to tradition-worshiping conformist. "The other-directed person," wrote Riesman, looks to sex "for reassurance that he is alive." Sex became part of keeping up with the Joneses. Riesman noted that while any person could assess a Cadillac parked in a driveway, knowing the horsepower, the accessories, and how much it cost, sex remained "hidden from public view." "Sex," he said, is "the last frontier."

There was pressure to find paradise in the bedroom. According to Riesman, "Though there is tremendous insecurity about how the game of sex should be played, there is little doubt as to whether it should be played." And new to the game was the specter of the "Kinsey athletes" with their "experi-

ence" and "freedom." The modern American male, said Riesman, was "not ambitious to break the quantitative records of the acquisitive consumers of sex like Don Juan, but he does not want to miss, day in, day out, the qualities of experience he tells himself the others are having."

Sex had been drawn into the postwar phenomenon of rising expectations. The problem for women who lost themselves in sexual fantasy every day were the husbands who couldn't keep up, who came home tired. Magazine ads promoted stimulants such as No-Doz: "Too Pooped to Play, Boy?" An ad for Rybutol showed a distraught, sexually frustrated woman next to a sleeping husband. (Lenny Bruce would lampoon this ad, saying the woman discovered the real reason for her husband's listless libido when she found the wig, dress, and makeup in his closet.)

Friedan's women wrapped their fantasy lives in torrid novels and magazines that offered articles asking, "Can This Marriage Be Saved?" By 1958 some six million of them had bought *Peyton Place,* a salacious novel by Grace Metalious that "lifts the lid off a small New England town." Rape, incest, illegitimate children, spectacular affairs, teenage lust—bring it on.

This was sex according to Metalious:

> He stepped in front of her and untied the top strap of her bathing suit. With one motion of his hand, she was naked to the waist and he pulled her against him without even looking at her. He kissed her brutally, torturously, as if he hoped to awaken a response in her with pain that gentleness could not arouse. . . . When he lifted his bruising, hurtful mouth at last, he picked her up, carried her to the car and slammed the car door behind her. She was still crumpled, half naked on the front seat, when he drove up in front of her house. Without a word, he carried her out of the car and she could not utter a sound. He carried her into the living room where the lights still blazed in front of the open, uncurtained windows and dropped her onto the chintz-covered couch.
>
> "The lights," she gasped finally. "Turn off the lights."

Whether the heroine is modest or concerned about nosy neighbors is moot. By most accounts, suburbia was a goldfish bowl that made fooling around

almost impossible. Herbert Gans, in his sociological study *The Levittowners,* found that "a woman neighbor did not visit another when her husband was home, partly because of the belief that a husband has first call on his wife's companionship, partly to prevent suspicion that her visit might be interpreted as a sexual interest in the husband."

Friedan also noted that extramarital sex was frustrated by the "problems posed by children coming home from school, cars parked overtime in driveways and gossiping servants." Women, she said, were turned into sex seekers, but not sex finders. If sex was the last frontier, it would remain unexplored—and unsettled—for at least another decade.

Gans found a disturbing side effect of life on the suburban frontier:

> Some adults seem to project their own desires for excitement and adventures onto the youngsters. For them, teenagers function locally as movie stars and beatniks do on the national scene—as exotic creatures reputed to live for sex and adventure. Manifestly, teenagers act as more prosaic entertainers: in varsity athletics, high school drama societies and bands, but the girls are also expected to provide glamour. One of the first activities of the Junior Chamber of Commerce was a Miss Levittown contest in which teenage girls competed for honors in evening-gown, bathing-suit and talent contests—the talent contest usually involving love songs or covertly erotic dances. At such contests unattainable maidens showed off their sexuality—often unconsciously—in order to win the nomination. Men in the audience commented sotto voce about the girls' attractiveness, wishing to sleep with them and speculating whether that privilege is available to the contest judges and boyfriends. From here it was only a short step to the conviction that girls were promiscuous with their teenage friends, which heightens adult envy, fear and the justification for restrictive measures.

The paranoia exploded in a whispering campaign that swept the town with "rumors of teenage orgies in Levittown's school playgrounds, in shopping center parking lots and on the remaining rural roads of the township. The most fantastic rumor had 44 girls in the senior class pregnant, with one boy

single-handedly responsible for six of them. Some inquiry on my part turned up the facts: Two senior girls were pregnant and one of them was about to be married."

The sexual paranoia of parents became one of Hollywood's favorite themes in the fifties. *A Summer Place*—the make-out movie of 1959—depicted mother as monster. After Sandra Dee is shipwrecked with Troy Donahue for an unchaperoned evening, the first thing her mother does is have her virginity inspected by the local doctor.

The 1955 film classic *Rebel Without a Cause* offered the definitive portrait of the breakdown in family communications. The only point of contact between teens and parents seemed to be the booking room at the local police station. Getting in trouble was a way of life for juveniles. Faced with an ineffective father and a manipulative mother who bombarded him with conflicting messages, James Dean would scream in anguish: "You're tearing me apart!"

So much for togetherness.

Parents and schools attempted to regulate teenagers in ways both ludicrous and ineffective. The enforcement of dress codes (shirts and ties for boys at school dances, skirts for girls) led to truly aberrant forms of social control. Principals might force a golf ball down a boy's trouser leg, for instance, to make sure his pants weren't too tight.

The house in Levittown might represent the American dream for a returning veteran, but it was a prison cell for a teenager. The Depression may have created a separate substratum for teens, with high schools as holding pens, but the adolescent of the fifties had more autonomy and ready cash than Andy Hardy ever did. Soon enough, theirs became a viable subculture. Previously, teenagers had shared their parents' world—watching the same movies, listening to the same songs on the radio. Now they had their own teenage idols, their own films, music, fads, and fashions. They borrowed the family car, bought their own, or stole one for joyrides. Any kid with a convertible was guaranteed a sex life.

Wheels allowed one to cruise, to hang out at the drive-in, to explore sex while parked for a little submarine-race watching, listening to songs coming in over new stations devoted to a new teenage music called rock 'n' roll. Teens

staked out the balcony of the local theater, or their own row of cars at the drive-in, and feasted on movies made just for them—low-budget science-fiction thrillers such as *The Blob* (1958), *Teenagers From Outer Space* (1959), and the 1957 hit *I Was a Teenage Werewolf.* (As one baby boomer would recall, when Michael Landon watched a leotard-clad gymnast working out alone in the gym, every teenage male in America grew hair on his face). Sex was science fiction, a monster movie, or a shortcut to crime. Exploitation flicks such as *High School Confidential!* (1958), *The Cool and the Crazy* (1958), *Hot Rod Girl* (1956), *Joy Ride* (1958), *High School Hellcats* (1958), and *Eighteen and Anxious* (1957) made sex seem an act of reckless abandon.

Some schools instituted "health" or "life science" lectures, sermons delivered separately to male and female students by members of the athletic department. The sight of a coach with a whistle around his neck giving a chalk talk about sperm may have temporarily reduced lust to the level of calisthenics, but we doubt it. The alternative experts—the biology teachers—still had the scent of formaldehyde and dissected frogs about them.

Teenagers traditionally learned about sex from their peers. Patricia Campbell, author of *Sex Education Books for Young Adults,* reports that in 1938 only 4 percent of young people learned the facts of life from the printed page. But by the end of the 1950s, that figure had increased to 33 percent for girls and 25 percent for boys.

The available books had more to do with etiquette than with sex. Consider this detailed advice about the proper way to end a date, from Evelyn Duvall's long-selling 1950 classic *Facts of Life and Love for Teenagers:* "Mary gets out her key, unlocks the door and then turns to John with a smile. She says, 'It's been a lovely evening. Thank you, John.' Or something similar that lets John know she has enjoyed the date. John replies, 'I have enjoyed it too. I'll be seeing you.' Then she opens the door and goes in without further hesitation. Since this is the first date, neither John nor Mary expect a goodnight kiss. So Mary is careful not to linger at the door, which might make John wonder what she expects him to do."

Duvall warned against petting ("the caressing of other, more sensitive parts of the body in a crescendo of sexual stimulation"), stating, "These forces are often very strong and insistent. Once released, they tend to press for completion." Girls were given the job of controlling male arousal. "Changes

in his sex organs are obvious," warned Duvall. Oh, yes. Especially if you were slow-dancing to "Earth Angel."

This was the decade that labeled the stations of lust in terms such as "first base," "second base," and "all the way." The focus on female anatomy turned the body into an erotically charged battleground. (No girl in her right mind would respond by, say, touching the male genitals. Unless you begged.)

In *Heavy Petting,* a documentary devoted to the state of sex in the fifties, David Byrne recounts the stages of making out: "There was kissing with your mouth closed. Arm around. Kissing with your mouth open and French kissing. Feeling a girl's breast with her bra on. Then with her bra off. Then beyond that, all hell kind of broke loose. If you wanted to feel somebody's genitals— if the girl felt yours, or you felt hers—you were getting beyond the bases. The steps didn't go in order anymore."

In the same film Spalding Gray remembers learning about masturbation from a friend, who told him that if he stroked his penis with a piece of animal fur, something nice would happen. "I didn't have any animal fur around the house. But I remember a lot of Davy Crockett hats. They were really popular then."

Holden Caulfield, the antihero of Salinger's *Catcher in the Rye,* captured the confusion: "Sex is something I really don't understand too hot. You never know where the hell you are. I keep making up these sex rules for myself, and then I break them right away. Last year I made a rule that I was going to quit horsing around with girls that, deep down, gave me a pain in the ass. I broke it, though, the same week I made it—the same night, as a matter of fact. I spent the whole night necking with a terrible phony named Anne Louise Sherman. Sex is something I just don't understand. I swear to God I don't."

Grace Palladino, author of *Teenagers: An American History,* says that "the real difference between good teenagers and bad was a matter of appearance. Good teenagers kept their private lives private."

The ethic, if that's what it could be called, was simply: Don't get in trouble. The sexually active lived in fear of pregnancy. The Kinsey Report had revealed that a large number of women were having premarital sex. A third Kinsey Institute report on *Pregnancy, Birth and Abortion,* which was published in 1958, would reveal that one out of every five women who had premarital sex became pregnant. Of those, one in five would be forced into marriage. The other four women had their pregnancies terminated by abortion.

Scandal tormented many from the daily headlines. In 1956 girls read about a young fashion designer whose "body was cut into 50 pieces, placed in Christmas wrapping paper and dumped into various trash cans." She was the victim of an illegal abortion. On the East Coast, girls read this story in the *Daily Mirror:* DIG UP BODY OF GIRL, 17, ON LONG ISLAND. "The body of a pretty, blonde, 17-year-old bank clerk, missing ten days from her home, was dug out of a rubbish heap yesterday near the Jamaica Racetrack. Police said she had died after an abortion." Marvin Olasky, author of *The Press and Abortion,* tells how "the girl had put together $300 to pay an abortionist her boyfriend had found for her. He went with her and she died. When the boyfriend demanded a refund he was given back $160 to give the kid a decent burial, but he dumped her body in the rubbish near the racetrack."

Teenage rebellion bubbled right below the surface, rooted in the cruel hypocrisy of their parents' world, but it would take another decade for the rebels to find a cause worth fighting for. For now, they identified with the inarticulate confusion of James Dean and Marlon Brando. In 1954, when a town girl asked Brando in *The Wild One,* "What are you rebelling against, Johnny?" the biker replied, "Whaddya got?"

In 1955 we got a look at the future: Director Richard Brooks's *Blackboard Jungle* was an exposé of juvenile delinquency in inner-city high schools. The film had everything the paperback had—sex, unruly students, attempted rape, heaving breasts—plus a great sound track featuring Bill Haley and the Comets playing "Rock Around the Clock."

The music went right into the veins of teenage America. No more togetherness, singing along with Mitch Miller or slowly going crazy to your parents' mood music. But rock was hot. It was visceral. It had a beat and you could dance to it.

When a young truck driver named Elvis Presley stood in Sam Phillips's Memphis studio and told a crew of backup musicians, "Let's get real, real gone," the nation followed. "Heartbreak Hotel." "Don't Be Cruel." "Love Me Tender." Each single sold more than a million copies.

The voice was only part of the show. Elvis sang with his whole body. He was sex personified, straddling the microphone, then breaking into wild gyrations. His band said Elvis was "wearing out britches from the inside." A critic for the *New York Times* noted that Elvis was a "virtuoso of the hootchy-kootchy. His one specialty is an accented movement of the body that heretofore has

been primarily identified with the repertoire of the blonde bombshells of the burlesque runway. The gyration never had anything to do with the world of popular music."

But it had everything to do with sex.

Elvis had what one critic would call his "I'm-gonna-get-your-daughters zeitgeist." Elvis, one review noted, was "a terrible popular twist on darkest Africa's fertility tom-tom displays," and his performance was "far too indecent to mention in any detail."

Girls attacked Elvis, tore off his clothes, wrote their names and numbers in lipstick on his limousines. A judge in Jacksonville threatened to arrest Elvis's body for obscenity. When Elvis appeared on *The Ed Sullivan Show* in 1956, the camera was allowed to show him only from the waist up—but it didn't matter.

Years later, the lead singer for the rock group U2 would say that Presley did what years of the civil rights movement had failed to do: "He jammed together two cultures, and in that spastic dance of his you could actually see that fusion and that energy. It has the rhythm and the hips of African music and the melody of European music."

Elvis and other rock musicians may have jammed together two cultures to create a sexual frenzy, but it opened a Pandora's box of racial fears and animosity.

Protecting white girls from black sexuality had been the excuse for demonic behavior on the part of white Americans for centuries. As Americans struggled with integration in the mid-fifties, sex was never far from the conversation. At a White House dinner in the spring of 1954, President Eisenhower told Supreme Court Chief Justice Earl Warren that the lawyers arguing in favor of segregated schools weren't all bad. They just didn't want their young daughters sitting next to "big, overgrown Negroes."

The Supreme Court's unanimous decision in favor of school integration had dramatic consequences. On August 24, 1955, Emmett Till, a fourteen-year-old black boy from Chicago, walked into Bryant's Grocery and Meat Market in Money, Mississippi. Depending on which account you believe, Till was told there was a white woman in the store. He entered the store, bought some bubble gum, and, as he left, either whistled at Carolyn Bryant, or said, "Bye,

baby," or grabbed her wrist and made a lewd suggestion, adding, "Don't be afraid of me, baby. I been with white girls before."

Three days later Bryant's husband, Roy, and his half brother, J. W. Milam, went hunting for the Chicagoan. They dragged the fourteen-year-old from his bed and drove to the banks of the Tallahatchie. They stripped him naked, and when he refused to show fear (they said), they fired a .45 bullet into his head. They wired a propeller from a cotton gin to the body and dumped it into the river.

Till's family called the police. A few days later the mangled, waterlogged body was found. Pictures appeared in *Jet, Life, Look*—and in the nightmares of black families all across the country. You could die for being black, and for being fresh with the wrong people.

Police arrested Bryant and Milam. The trial took five days. After an hour, the jury acquitted both men. Milam bragged, "As long as I live and can do anything about it, niggers are going to stay in their place. Niggers ain't gonna vote where I live. If they did, they'd control the government. They ain't gonna go to school with my kids. And when a nigger even gets close to mentioning sex with a white woman, he's tired of living."

Milam wanted to make an example of the Chicago boy, "just so everybody can know how me and my folks stand."

Not all Americans stood for ignorance or prejudice. World War II had taken millions of Americans overseas, and some of those who returned did not care to continue the repressive patterns of the past. They rejected conformity and its illusion of security. They wanted new scripts in every area of life, from personal and political freedom to the pursuit of pleasure.

While middle America was buying chrome-plated bulgemobiles, there were some who preferred the Thunderbird, Corvette, Jaguar, or Mercedes 300SL. While mainstream America was watching television, others preferred FM radio and foreign films. They ignored rock 'n' roll and dug the new post-Oscar Frank Sinatra, Ella, Chet Baker, and Bird. Mainstream America had Martin and Lewis, but the more discerning college crowd was listening to Mike Nichols and Elaine May, Mort Sahl, and Lenny Bruce.

These young moderns were the Lost Generation reincarnate, people who came home from the war hoping to re-create the energy of the Roaring Twen-

ties and were appalled at the Cold War repression. Leisure time, discretionary income, and the American desire for upward mobility soon merged into a quest for sophisticated entertainment—in film, literature, and other art forms. What had been isolated voices would reach out to a growing audience, and, in doing so, expand the boundaries of expression.

In retrospect, the events that broke the stranglehold on the arts and entertainment in America seem inconsistent with the conservative climate of the decade. In 1950 the New York screening of Roberto Rossellini's *The Miracle,* about a simpleminded peasant girl (Anna Magnani) seduced by a stranger she believed to be Saint Joseph, encountered fierce Catholic opposition, headed by Francis Cardinal Spellman and the Legion of Decency. Theaters that attempted to show the film were picketed, and there were bomb threats. The state censor board revoked the license for the film, calling *The Miracle* "sacrilegious," an action that was upheld by the New York courts. In 1952, however, the Supreme Court ruled in favor of the film. For the first time in history, the highest court held that motion pictures were protected by the First and Fourteenth Amendments.

The Cardinal and the Legion of Decency might try to tell Catholics what films they could see, but local governments could not.

Foreign films offered earthy tales of sex and passion, but Hollywood still had to contend with the Production Code. Howard Hughes had challenged the code with *The Outlaw,* but a far more chaste film changed history. In 1952 Otto Preminger submitted the screenplay for *The Moon Is Blue,* based on a play he had produced on Broadway without causing any undue concern to the citizenry. It was a lighthearted tale of seduction, but the Production Code Administration rejected the script, saying the story made sex between consenting adults "a matter of moral indifference." Preminger went ahead anyway. The PCA refused to grant the film a seal in 1953, saying it had an "unacceptably light attitude toward seduction, illicit sex, chastity and virginity."

As the success of *Playboy* would prove later that same year, the country was ready for just that attitude. The film was a major hit, grossing nearly $6 million. Preminger had proved that Hollywood could make a successful film without Production Code approval. He did it again in 1955 with *The Man With the Golden Arm,* starring Frank Sinatra and Kim Novak.

Nudity was still taboo in Hollywood movies, but it could be found in foreign films as well as in the low-budget fare of the grind houses. As American

audiences became more sophisticated, the grind houses became art houses, sprouting coffee machines, chocolate stands, and background jazz.

Theater owners redefined the way we viewed sex. The former grind houses showed the same old imported films, such as *Devil in the Flesh* and *One Summer of Happiness,* and homegrown hymns to nudism such as the 1954 classic *Garden of Eden.* That film prompted a New York judge to declare that nudity was not indecent, and that *Garden* was neither sexy nor obscene. "Nudists are shown as wholesome, happy people in family groups, practicing their sincere but misguided theory that clothing, when climate does not require it, is deleterious to mental health by promoting an attitude of shame with regard to natural attributes and functions of the body."

Misguided theory? Nudity was art-house fare. Americans discussed the French New Wave, Italian neorealism, and auteur filmmaking, while watching Sophia Loren and Gina Lollobrigida fill peasant blouses, or Anita Ekberg take a spontaneous dip in the Trevi Fountain of Rome. European films did not condemn the erotic; they simply presented its many complications. Foreign films showed us sin and sex the way continentals did it, after centuries of practice.

American film directors struggled with sexuality. Film versions of Tennessee Williams's *Baby Doll* (1956) with Carroll Baker; *A Streetcar Named Desire* (1951) with Marlon Brando, Vivien Leigh, and Kim Hunter; *Cat on a Hot Tin Roof* (1958) with Paul Newman and Elizabeth Taylor; and *Suddenly, Last Summer* (1959) with Elizabeth Taylor, Katharine Hepburn, and Montgomery Clift were dark testaments to the power of sexual repression. *Tea and Sympathy* (1956) portrayed Deborah Kerr's seduction of a young student as an act of kindness because he thought he might be gay, although by the time the PCA finished with the script he was merely "sensitive."

The major sex star of the decade—if not the century—was Marilyn Monroe, though she never appeared nude on the screen. In contrast, her continental counterpart, Brigitte Bardot, could be counted on for some nudity in almost every one of her films. *And God Created Woman,* Roger Vadim's 1957 hit, opened with a wide-screen caress of Bardot's bare buttocks.

The Lovers, Louis Malle's 1959 tale of a repressed wife finding salvation through adultery, gave us the details of a sophisticated affair. Jeanne Moreau and her lover made love in a rowboat and in a tub, traced the letters of each other's names on bare skin, performed finger-curling oral sex. The usual stuff—

if you lived in France, maybe. *The Lovers* would play at more than a hundred theaters in the United States, eventually resulting in the arrest of a theater manager in Ohio. The theater's owner launched a challenge that worked its way to the Supreme Court.

The test case resulted in one of the most famous lines in judicial lore. When asked to define obscenity, Justice Potter Stewart remarked, "I know it when I see it." By that standard, *The Lovers* was judged to be not obscene.

Foreign films educated the Supreme Court. When New York tried to ban a film version of *Lady Chatterley's Lover* because it advocated immoral ideas, Justice Stewart said in 1959 that the First Amendment protected ideas, including the idea that "adultery may sometimes be proper."

American studios responded to the European invasion by churning out a series of movies about seduction that the entire family could see. In *Pillow Talk* (1959), Doris Day played a professional virgin who steadfastly resists the advances of Rock Hudson. His apartment is the classic playboy pad—one switch turned out the lights, turned on the stereo, and locked the front door. A critic for *Time* said of Doris and Rock, "When these two magnificent objects go into a clinch, aglow from the sunlamp, agleam with hair lacquer, they look less like creatures of flesh than a couple of Cadillacs parked in a suggestive position."

Doris Day played the chaste career girl in so many movies that Oscar Levant was prompted to observe, "I knew Doris Day before she was a virgin."

But the increasing sophistication of American audiences started to have an effect on Hollywood. By the end of the decade Billy Wilder would film *Some Like It Hot* (1959), with Jack Lemmon and Tony Curtis escaping gangsters by going drag. When Lemmon's cross-dressing prompts a proposal from Joe E. Brown, Lemmon is forced to confess the deception. To which Brown simply replies, "Well, nobody's perfect." The gender-bending signaled that perhaps the great homosexual panic of the decade was abating.

For years, European directors had made two versions of many films, one for continental tastes and another, more subdued take for America. In 1959 Hollywood reversed the trend. The American director of *Cry Tough,* Paul Stanley, shot two versions of a love scene between Linda Cristal and John Saxon. In the U.S. release, Cristal wore a slip; in the export version, she did not.

When *Playboy* published stills from the two scenes, the police chief in San Mateo, California, pulled the magazine from the stands. Hefner responded,

"If the reading matter of the citizens of any community is to be preselected—a pretty abhorrent thought in itself—I can't think of anyone less qualified to do it than a local police chief."

Congresswoman Kathryn Granahan, one of Washington's several sex-obsessed crusaders, flew to California to express her views on the subject. A newspaper headline declared: SMUT PROBER HERE—HINTS RED PLOT.

In the fifties anything controversial—from sex to fluoridation—was considered to be Communist-inspired.

Mort Sahl stood on the stage in a red sweater, a folded newspaper clutched in his hand. America's only stand-up philosopher launched into a free-form rap, touching on hi-fi, sports cars, McCarthy, and Sahl's reaction to a sexy, over-size billboard.

> Outside the theater there's this picture of a girl about twenty-five feet high and she has a towel around her from the Hilton Hotel chain. It's kind of like, you know, like good taste in panic. And she's got this kind of terror in her face, she looks real bugged and her face is a social indictment of the entire insensitivity of society, you know, and there's a synthesis within her expression of a rejection of old-world thinking and yet a kind of dominance of this phony puritanical strain, which makes our mores, you know. In other words, she's operating under the ostensible advantages of suffrage and, on the other hand, this phony standard of morality. So, anyway, over her head there's an indictment of all of us and it says, "You did it to her." Wonderful. I was standing there on the street digging this sign and I noticed a lot of young men walking by had looks of communal guilt across their faces.

Sahl landed his first job at the Hungry i in San Francisco with a joke about a McCarthy jacket. Like the famous Eisenhower example, this one would have lots of flaps and zippers—plus one that could be closed over the mouth. "Tell your children about McCarthy and Roy Cohn," he would say, "before they find out about it on the streets."

The hipster rebellion had begun. Defiance through humor. If Americans could laugh at repression, perhaps it would slink off into the night.

In another part of town, Lenny Bruce waxed profane. Having started out as an emcee at strip clubs, Bruce developed irreverent and, some thought, obscene humor. Like Sahl he was an archetype of the hipster. Having grown up around jazz musicians, Bruce used routines that were closer to improvisation than to punch line/pratfall shtick. Above all, he was a social critic: "The truth is what is, not what should be. What should be is a dirty lie."

Bruce had an eye for the underdog. Referring to a newspaper with the headline FLOODWATERS RISE. DYKES THREATENED, he would deadpan, "It's always the same. In times of emergency, they pick on minorities."

He articulated his own fantasy of a surveillance culture: "Sometimes when I'm on the road in a huge hotel, I wish there was a closed-circuit television camera in each room and at two o'clock in the morning the announcer would come on: 'In room 24B there is a ripe, blue-eyed, pink-nippled French and Irish court stenographer lying in bed tossing and turning, fighting the bonds of her nightgown. . . . This is a late model, absolutely clean, used only a few times by a sailor on leave.'" On sex: "If you put a guy on a desert island, he'll do it to mud. A girl doesn't understand this: 'You'd do it to mud—you don't love me!' Sex is a different emotion for women."

The hip subversives went from playing in basement clubs to national exposure in *Playboy,* on television, and on best-selling comedy albums. A Harvard student named Tom Lehrer built a campus following all across the country with an LP of his songs spoofing sex, drugs, and atomic annihilation. He could take the Boy Scout motto and turn it into a public information campaign for condoms:

> *If you're looking for adventure*
> *of a new and different kind*
> *And you come across a Girl Scout*
> *who is similarly inclined.*
> *Don't be nervous, don't be flustered,*
> *Don't be scared: Be Prepared!*

Improv comedy was not limited to the stage. Jules Feiffer did his sketches on paper for *The Village Voice.* He explained the rebellion of the hip humorists in Tony Hendra's *Going Too Far:* "Whether it was your mom or your boss

or your teacher or your president, there was no confusion in targets. They were all the enemy. Because—and this is about language—they were all lying to us. They were all saying things they didn't mean. They were all using language as code. . . . It took years to find anything wrong with this. You know, to feel outraged. Hypocrisy is too mild a word. The blatant, mischievous disinformation practiced on us from birth seemed like such a norm that you didn't know you had a right to expect anything different."

Cynicism was a form of self-defense. The establishment called the new art form Sick Humor, but it was the culture that was sick. The hip subversives were members of some kind of underground, a privileged social movement, said Feiffer. "You did get a sense that something was happening. That the laughter was a laughter of real humor, but also of defiance, that there was anger here. That these perceptions were necessary in order to breathe. It wasn't just about being funny. It was about being true."

Tony Hendra, who was one of the founding editors of *The National Lampoon,* noted the same thing. "People began to draw strength from the simple awareness that they were not alone," he stated. "The subversives were exchanging handshakes all over the place, as nightclubs proliferated, comedy album sales soared, banned books were passed from hand to hand. Old Uncle Joe's worst fears were being realized. The things were coming out from under the bed, but instead of slipping six frames of Lenin into the latest Doris Day movie, they were doing something much worse—they were laughing. And what's more, they were laughing at him and his cherished vision of a rigid-with-fear, screwed-shut, dumbly obedient, boot-in-the-mouth America."

Joe McCarthy may have been booed off the scene by 1955, but Senator Estes Kefauver still roamed the country, stomping out the forces of sin and nonconformity. With aspirations for higher office, he posed as a homespun hero.

He needed a new target, but most of the obvious ones—from Communists to comic books—were taken. He picked pornography and its supposed connection to juvenile delinquency. He compared porn to narcotics, calling it addictive. The only problem Kefauver faced in this investigation was that there wasn't a lot of real pornography around in the 1950s, so he settled for the next best thing—Irving Klaw, "the Pin-up King," and Klaw's favorite model, Betty Page.

In the hinterlands, Kefauver's investigators had collected circulars advertising "real nudes unretouched in any way" and "snappy photographs, the kind men like." He expressed shock and outrage at a "deck of 52 playing cards with different scenes of perverted acts shown on each card" and the eight-page comic books that showed "some popular comic strip character or prominent person performing perverted sex acts." And he sent his political posse after the itinerant stag-film projectionist who showed lusty loops at smokers.

Kefauver defined a pornographer as loosely as McCarthy defined a Communist. When he came to New York, he focused on Klaw, calling him "one of the largest distributors of obscene, lewd and fetish photographs throughout the country by mail." Irving Klaw and his sister, Paula, ran *Movie Star News*. They sold publicity photos of movie stars and pin-up pictures of burlesque queens and camera-club models—the kinds of shots that servicemen carried through World War II and in Korea.

When Klaw's customers wanted something more provocative, he provided playful photos of girls wrestling, spanking one another, or practicing the kind of knot tying one didn't learn in Girl Scouts. These were the same burlesque and bondage sensibilities found in Robert Harrison's *Beauty Parade, Wink*, and *Titter*. But if Kefauver was in need of a damsel in distress, he had a beauty in Betty Page.

Betty had come to New York in 1950 with acting aspirations, a twenty-seven-year-old with a trim, athletic body and a winning, fresh-faced, wholesome personality and appearance. By 1952 she was the most popular model on the camera-club circuit and a favorite in Harrison's girlie magazines.

Irving and Paula Klaw had become her close friends. "We had a big sister-little sister relationship," Paula said. Betty appeared in a feature-length burlesque film titled *Striporama,* starring Lili St. Cyr, in 1953. Its success prompted Irving Klaw to produce two similar films titled *Varietease* and *Teaserama*, starring St. Cyr, Tempest Storm, and Betty.

Hef purchased a picture taken by Bunny Yeager, in which Betty is trimming a Christmas tree and wearing naught but a Santa Claus cap and a smile, and made her Miss January 1955. By then she had become the most popular pin-up model of the decade, appearing on the covers of everything from *Jest* and *Breezy* to John Willie's *Bizarre*.

She was the living embodiment of the "naughty but nice" calendar art of the thirties and forties, but it was the bondage and fetish photos for Klaw that earned Betty the title Dark Angel. She brought the same playful innocence to her spanking and bondage photos as she did to her other pin-up poses, turning perversion into parody.

Senator Kefauver's investigators tried to get Betty to testify against Klaw, but she defended her friend. "I told them very frankly that Irving Klaw never did any pornography at all, not even nudes, and that I would say that if they put me on the stand," she said.

The committee blamed the strange death (possibly from autoerotic asphyxiation) of a seventeen-year-old Eagle Scout in Florida on a bondage photo of Betty Page. His father had found the boy's body tied up in a manner similar to a photo in Klaw's catalog. There was no actual connection between the youth's death and the photo, but no matter.

Kefauver called Dr. Benjamin Karpman, a Washington-based psychotherapist, who claimed, "A normal 12- or 13-year-old boy or girl exposed to pornographic literature could develop into a homosexual. You can take healthy boys or girls, and by exposing them to abnormalities, virtually crystallize and settle their habits for the rest of their lives."

Klaw pleaded the Fifth and Betty never testified, but the harassment continued. In 1957, weary of the conflict and in ill health, Irving called Betty and told her that he was getting out of the business. She then left Manhattan and simply disappeared.

Four decades later, Betty Page had become a cult icon. Rock stars wrote songs about her, artists captured her on canvas, books and magazines were devoted to her legend, she became the heroine of the comic book *The Rocketeer,* and fashion models and superstars such as Madonna paid tribute to her Dark Angel persona.

The government also targeted Samuel Roth, an anarchist and sexual radical who had a long string of run-ins with censors and with other members of the literary community. When he reprinted excerpts of James Joyce's *Ulysses* without the author's permission, even some supporters turned against him. He went to jail for selling unexpurgated copies of *Ulysses* in 1930, and again for selling

copies of *The Perfumed Garden* to agents of the New York Society for the Suppression of Vice. A book that described 237 sexual positions no doubt offended those who were comfortable with only one—the missionary.

For decades, Roth was the sexual underground. He published unauthorized editions of *Lady Chatterley's Lover,* the *Kama Sutra,* and a book on masturbation called *Self-Amusement.* He smuggled in works by Henry Miller and Frank Harris. In 1936 the Postmaster General charged him with sending obscenity through the mail. Roth served three years in prison.

He learned to survive the harassment of raids and federal indictments. He sent his advertising circulars first class—mail that could not be opened legally by inspectors. If a citizen complained about a solicitation from one company, he would switch to a different letterhead for the next mailing. Roth was *American Aphrodite,* Seven Sirens Press, Gargantuan Books, Falstaff Press, Paragon Press, Candide Press, Golden Hind Press, Hogarth House, or Book Gems, as the need arose. He had 400,000 customers and he claimed to have sent out ten million flyers. Critics accused Roth of lacking discretion, claiming that he had sent circulars "to many small children—even to orphanages."

From 1928 through 1956, no fewer than ten postal inspectors maintained open files on Roth, placing orders to a degree that Roth joked he was being supported by the Post Office. In the December 1953 issue of Roth's *American Aphrodite,* he wrote an open letter to Postmaster General Arthur Summerfield. "While I have no wish to offend persons who seem to me both prudish and unrealistic," he began, "neither have I any wish to trim my sails to their faint breezes. I want freedom of speech as a publisher.

"I know that people are interested in sex, as they are interested in all other aspects of living, and I believe that this is healthy, normal interest—vigorous and creative. Those people who think that sexual love is dirty may leave my books alone. I do not publish for such as those."

On July 30, 1955, the feds indicted Roth on twenty-six separate violations of the Comstock Act, the federal statute that forbids sending obscenity, or advertisements for obscenity, through the mails. At Roth's trial the government paraded a prude's gallery of mothers, ministers, lawyers, plumbers, and housewives willing to testify they had been shocked by the circulars, ads for an issue of *American Aphrodite* that contained a story and drawings by Aubrey Beardsley. The jury found Roth guilty on four counts. The judge sentenced him to

five years and a $5,000 fine. At the age of sixty-two, Roth went to jail. His lawyers appealed.

In April 1957 the Supreme Court heard arguments in the case. At issue was the Comstock Act. Did the federal government have the constitutional right to keep the mails free of "obscene materials"?

The Solicitor General brought in a crate of hard-core porn. Evidently the idea came from Postmaster General Summerfield, who kept an exhibit of provocative photos, films, books, and drawings at the Post Office building. Visitors could get a crash course in kink. The photos, booklets, and comics were not connected to Roth, but they served to shock the Justices. When Justice William Brennan sent the box back to the solicitor's office after the hearing, rumor has it he got an irate call that half the stuff was missing.

The Court voted six to three to uphold the conviction, concluding that obscenity was not protected. The Comstock Act was, it seems, constitutional. But here Brennan, speaking for the majority, tried to define his terms: "Sex and obscenity are not synonymous," he wrote. "Obscene material is material that deals with sex in a manner appealing to the prurient interest. The portrayal of sex in art, literature and scientific works is not itself sufficient reason to deny material the constitutional protection of freedom of speech and press. Sex, a great and mysterious motivating force in human life, has indisputably been a subject of absorbing interest to mankind through the ages; it is one of the vital problems of human interest and public concern."

Prior to this decision, if a work depicted sex—no matter how briefly—it could be considered obscene. For decades jurists had worried about the effect of isolated passages on "the most susceptible" persons. Brennan had greater faith in the citizenry and proposed a new test. "The test," he wrote, "is not whether it would arouse sexual desires or sexually impure thoughts in those comprising a particular segment of the community, the young, the immature or the highly prudish, or would leave another segment, the scientific or highly educated or the so-called worldly-wise and sophisticated indifferent and unmoved. . . . The test in each case is the effect of the book, picture or publication considered as a whole, not upon any particular class, but upon all those whom it is likely to reach. In other words, you determine its impact upon the average person in the community."

Obscenity was "utterly without redeeming social importance" in the Court's view and, in the future, the test would become "whether to the aver-

age person, applying contemporary community standards, the dominant theme of the material, taken as a whole, appeals to prurient interest."

The Supreme Court integrated sex into the context of the whole work. A book couldn't be banned just because it had what some considered to be "good parts." They took sex out of the ghetto. In a way, the decision confirmed Hefner's view that sex was part of the complete man, of interest to all, and that any work that hoped to capture the human experience would have to deal with sex.

But the decision sent Roth to prison. One writer noted with irony that Roth was put behind bars for mailing material far more innocent than the magazines and books that appeared in the wake of the Court's decision.

The Post Office hailed the decision and used it to tighten the screws on sexual expression. It hadn't read the small print. In 1958 it conducted four thousand separate investigations relating to the mailing of obscene and pornographic matter and caused the arrest of 293 persons.

The media reprinted the government claim that mail-order porn was a $500 million-a-year business. Postal inspectors estimated that 200,000 circulars went out every day, "decorated with teasing pictures and spiced with provocative erotica." According to an article in the April 27, 1959, *Newsweek,* the Post Office received an average of 700 letters of complaint each day "from parents protesting the corrupting of their children." (One assumes the other 199,300 recipients of the circulars were not bothered.)

J. Edgar Hoover, always vigilant and ready to confront a paper villain, warned the nation that "millions of innocent children are exposed in their formative years to reading matter and art depicting shocking sexual travesties" and that such material was "creating criminals faster than jails can be built."

The panicmongers moved for greater control of the mails, including the suspension of all mailing privileges to anyone suspected of producing obscenity. But Justice Brennan had opened a door that invited change. In the next few years the courts used the Roth decision to encourage increasing communication on sex. In a case involving *One,* an overtly gay magazine, the Supreme Court ruled that discussions of homosexuality were not obscene. In a case involving *Sunshine & Health*—involving those misguided sunbathers—it declared that nudity also was not obscene.

A jury of average persons had a better sense of justice than the crusaders. Gay Talese, in *Thy Neighbor's Wife,* reported that, in 1959, "after a Chicago vice squad had arrested 55 independent news vendors for selling girlie magazines, a jury of five women and seven men—uninfluenced by a church group that sat in the courtroom holding rosary beads and silently praying—voted to acquit the defendants. After the verdict had been announced, the judge seemed stunned, then slumped forward from the bench and had to be rushed to a hospital. He had had a heart attack."

In the wake of the Roth decision, Americans discovered long-suppressed classics. During the war soldiers had filled duffel bags with the works of Frank Harris, Henry Miller, and D. H. Lawrence. Throughout the fifties it had been a mark of sophistication to come back from Paris with the green-bound volumes published by the Olympia Press. One of Shel Silverstein's first travel satires in *Playboy* showed the bearded artist at a book stall ordering "10 copies of *Tropic of Cancer,* 12 copies of . . ."

Literati went to Paris to acquire Vladimir Nabokov's dark tragicomedy about an obsessive love for an underage girl. (*Lolita* had been published in France in 1955, but then was declared obscene. It was finally published in America in 1958, after being turned down repeatedly by major houses.) Or the hip could visit Paris to devour Terry Southern's delightful *Candy.*

In 1959 Barney Rosset published an unexpurgated edition of *Lady Chatterley's Lover.* Post Office inspectors promptly confiscated twenty-four cartons of the books. Rosset asked Charles Rembar, an occasional tennis partner and the lawyer who had suggested to Norman Mailer the word "fug," to prepare a defense.

Rembar's notion was inspired. He wanted to put an end to the term "obscenity." Rembar noted that, according to the law, literature was that which moved one above the waist. Porn was in the groin of the beholder. Indeed, a Jesuit had labeled as pornography anything that caused "genital commotion."

Yes, Lawrence's work—the whole living, breathing masterpiece—was concerned with sex, and might actually arouse, but arousal, in the hands of an artist, might not be obscene; and it was certainly not offensive to the average person with an appetite for sophistication. Literary critic Malcolm Cowley tes-

tified that Lawrence's views on sexual fulfillment could be found in any copy of *Ladies' Home Journal*.

On July 2, 1959, a court agreed. The Post Office could no longer deny the mails to this book. An appeals court upheld the decision, noting that Lawrence wrote "with power and indeed with a moving tenderness once our age-long inhibitions about sex revelations in print have been passed."

At last, Americans could legally read Lawrence: "And softly, with that marvelous swoon-like caress of his hand in pure soft desire, softly he stroked the silky slope of her loins, down, down between her soft warm buttocks, coming nearer and nearer to the very quick of her. And she felt him like a flame of desire, yet tender, and she felt herself melting in the flame. She let herself go. She felt his penis risen against her with silent amazing force and assertion, and she let herself go to him. She yielded with a quiver that was like death, she went all open to him. And oh, if he were not tender to her now, how cruel, for she was all open to him and helpless!" Between 1959 and 1960, *Lady Chatterley* sold six million copies.

In an article celebrating the decision, critic Alfred Kazin tried to put the novel into perspective. "Lawrence's exultant, almost unbearably sensitive descriptions of the countryside can mean little to Americans," he wrote, "for whom the neighborhood of love must be the bathroom and the bedroom, both the last word in sophisticated privacy. Lawrence's descriptions of the naked lovers gamboling in the rain, his ability to describe a woman's sensations and a man's body with feminine sureness—all this belongs to another world. *Lady Chatterley's Lover* brings back memories of a time when men still believed in establishing freedom as their destiny on earth, when sex was the major symbol of the imprisoned energies of man, for when that castle was razed, life would break open and flow free." Contrary to what Kazin assumed, though, at least one American couple knew exactly what *Lady Chatterley* represented.

In Princeton, New Jersey, a family of five went into an 8' x 9' fallout shelter as part of an experiment. They would spend two weeks in isolation, trying to duplicate the response to an atomic catastrophe. There was a panic button in case the isolation proved too great. (Unbeknownst to the couple, the scientists performing the experiment taped every sound through hidden microphones.) This was the ultimate test of togetherness. The *New York Times* reported that the couple had "tranquilizer pills for the children, a bottle of whis-

key for themselves and a library that included a copy of the unexpurgated *Lady Chatterley's Lover.*"

By the end of the decade, new role models were capturing America's attention. The hip humorists celebrated bohemia (defined by Mort Sahl as one of those neighborhoods where Jews tried to act like Italians). A significant number of Americans were turning their backs on conformity, conservatism, and the notion that money assured happiness. They gathered in coffeehouses, digging the cool sounds of Bach, Bartók, and Bird. They smoked dope, listened to poetry and folk music, and spoke in a hipster's language derived directly from black musicians. Organization Men they were not.

Detachment, not rebellion, marked these Beats. In "Howl," poet Allen Ginsberg spoke of seeing "the best minds of my generation destroyed by madness, starving hysterical naked." The poem, published by Lawrence Ferlinghetti's City Lights in 1956, was seized in San Francisco in 1957 by Customs officials and declared obscene. A judge eventually ruled the work had redeeming social importance. A journalist from *Time* described Ginsberg as "leader of the pack of oddballs who celebrate booze, dope, sex and despair."

To the new bohemians, mainstream America was Squaresville. The Beats offered a crack in the conformity and an alternative lifestyle that simply ignored the rat race.

In 1957, the movement went mainstream with the publication of Jack Kerouac's novel *On the Road.* More than half a million people read the picaresque account of hitchhiking, wild parties, and casual sex. Suddenly there were beatniks in Venice Beach, beatniks in Greenwich Village, and beatniks on Long Island, at least on weekends—all looking for satori, or at least the chance to get laid.

In the pages of *Playboy,* Kerouac explained the origins of "Beat" in a long, rambling, mystic invocation of Americana—everything from King Kong, Clark Gable, Krazy Kat, and Buddhism to private eyes and great baseball players. The Beats, he said, were not against anything. "Why should I attack what I love out of life? This is Beat. Live your lives out? Naw, love your lives out. When they come and stone you at least you won't have a glass house, just your glassy flesh."

They were outsiders by choice, who rejected traditional values and relationships, who could find love over a bottle of wine. They believed in the great goof and offered an escape route from the conservatism of the fifties. Who could say where they were heading? The hero of Kerouac's *On the Road* sounded a new call—to move, to flee, to escape. "Somewhere along the line I knew there'd be girls, visions, everything; somewhere along the line the pearl would be handed to me."

TIME CAPSULE

Raw Data From the 1950s

FIRST APPEARANCES

The Mickey Mouse Club. Disneyland. 3-D movies. Cinemascope. McCarthyism. *Red Channels. Playboy.* Centerfolds. Rock 'n' roll. Tranquilizers. Transistor radios. Xerox copiers. Credit cards. Frozen TV dinners. *TV Guide. Sports Illustrated. Mad.* Diet soft drinks. Kentucky Fried Chicken. Corvette. Thunderbird. Edsel. The sack dress. Panty hose. Stereo records. Videotape recording. Mercedes 300SL. Nikon 35mm SLR. 007. Sputnik. Astronauts. ICBM. Barbie. Lolita. Frisbee. Hula Hoops. Ann Landers. Vibrating mattresses. Mattachine Society. Daughters of Bilitis. Society for the Scientific Study of Sex. Citizens for Decent Literature. John Birch Society. Beat Generation.

WHO'S HOT

Ike. Uncle Miltie. Joe McCarthy. Edward R. Murrow. Frank Sinatra. Marilyn Monroe. Marlon Brando. James Dean. Elvis. Annette Funicello. Brigitte Bardot. Liz Taylor. Doris Day. Rock Hudson. Lucille Ball. Sid Caesar. Martin and Lewis. Mitch Miller. Liberace. Harry Belafonte. Mickey Mantle. Willie Mays. Rocky Marciano. Sugar Ray Robinson. Mort Sahl. Lenny Bruce. Mickey Spillane. Grace Metalious. Jackson Pollock. Jack Kerouac. Hef. Lady Chatterley.

WHO'S NOT

People blacklisted for suspected Communist leanings: Larry Adler, Alvah Bessie, Bertolt Brecht, Charlie Chaplin, Norman Corwin, José Ferrer, John Garfield, Jack Gilford, Lee Grant, Dashiell Hammett, Lillian Hellman, Kim Hunter, Ring Lardner, Jr., Canada Lee, Gypsy Rose Lee, Arthur Miller, Zero Mostel, Larry Parks, Dore Schary, Pete Seeger, Irwin Shaw, Lionel Stander, Dalton Trumbo, Josh White.

WE THE PEOPLE

Population of the United States in 1950: 151 million. Population of the United States in 1960: 179 million. Life expectancy of a male in 1950: 65.6 years; life expectancy of a female: 71.1 years. Life expectancy of a male in 1960: 66.6; of a female: 73.1. Marriages per 1,000 in 1950: 11.1; in 1960: 8.5. Births per 1,000 in 1950: 24.1; in 1960: 23.7. In the 1930s, number of months after marriage first baby born: 24. In the 1950s: 13. Total number of babies born 1946 to 1964: 76.4 million. Percentage of population that believes in God: 94.

MONEY MATTERS

Gross National Product in 1950: $284.8 billion. Gross National Product in 1960: $503.7 billion. Year the Dow Jones Industrial Average reached 404, surpassing the level of the pre-Crash high of 1929: 1954. The year minimum hourly wage rose from 75 cents to $1: 1955. Median income of a U.S. family in 1948: $3,187; in 1958: $5,087. The number of individuals earning $1 million or more a year in 1929: 513. Number earning $1 million or more in 1954: 154.

THE TUBE

Number of U.S. homes with television sets in 1948: 172,000; in 1952: 15.3 million; in 1955: 32 million. Percentage of population that owns a television by 1959: 86. Circulation of *TV Guide* in 1954 (after one year of publication): 1.5 million. Number of TV stations in 1950: 97; in 1960: 579. Number of hours average person spends watching TV per week in 1959: 42.

BACHELOR BLUES

Percentage of people interviewed in 1955 who thought an unmarried person could be happy: 10. Typical adjectives used to describe bachelors, according to *The Way We Never Were:* immature, infantile, narcissistic, deviant, pathological. Percentage of people interviewed in 1957 who thought bachelors were sick, neurotic, and immoral: 80. Name of one man who didn't: Hugh M. Hefner.

DRIVE-IN MOVIE TRIVIA

Year the first drive-in movie theater built (by Richard Hollingshead in Camden, New Jersey): 1933. Number of drive-ins built between 1946 and 1953: 2,976.

What teens watched when they weren't making out: *Eighteen and Anxious; Born to Be Bad; I Was a Teenage Werewolf; Teenagers From Outer Space; Hard, Fast and Beautiful; High School Confidential!; Born Reckless; Teenage Crime Wave; Untamed Youth; The Beat Generation; Vice Raid; The Innocent and the Damned.* Number of these twelve motion pictures that starred Mamie Van Doren: 7.

SLANG ME

New terms added to the language, according to *American Chronicle:* captive audience, integration, mambo, rat pack, spaceman, cool jazz, hot rod, panty raid, printed circuit, drag strip, countdown, doublethink, girlie magazine, split-level, fallout, hip, cool, crazy pants, greaser, isolation booth, cue card, blast off, atomic rain, fuzz, cop-out, put-on, shook up, funky, sex kitten, action painting, reentry, beatnik, gung ho, joint, head, make the scene, a groove, bugged, chick.

FINAL APPEARANCES

Edna St. Vincent Millay (1950). Theda Bara (1955). James Dean (1955). Charlie Parker (1955). Alfred Kinsey (1956). H. L. Mencken (1956). Humphrey Bogart (1957). Senator Joseph McCarthy (1957). Errol Flynn (1959). Billie Holiday (1959). Buddy Holly (1959).

Chapter Seven

MAKE LOVE, NOT WAR: 1960—1969

In 1960, the Pill fulfilled Margaret Sanger's dream of making birth control as simple as taking an aspirin.

The generation that would be known as the baby boomers would accomplish by sheer numbers what no generation before could even contemplate. In 1960 there were 24 million people aged fifteen through twenty-four; by 1970 there were 35.3 million. By 1966, 48 percent of the population was under the age of twenty-six. The flood of immigrants at the turn of the century had created a new America; this time the flood came from within. They were the volunteers.

In 1960 a bureaucrat at the Food and Drug Administration gave approval to Enovid, an oral contraceptive based on a hormone made from Mexican yams. By the end of the decade more than six million women would be on the Pill, performing a daily ritual once occupied by worry beads; its dispenser the badge of the new liberated woman.

In the summer of 1960 a Harvard lecturer named Timothy Leary sat by a swimming pool in Cuernavaca and ingested psychedelic mushrooms. Placing himself at the head of the parade initiated by the Beats, he would tell the world to "turn on, tune in, and drop out."

A generation of Americans rejected their parents' world of booze and backyard barbecues to sample mind-altering recreational drugs. By the end of the decade nearly half of America's youth would belong to this counterculture. And the backlash was immediate. By 1967 the cops were making 300,000 marijuana arrests a year.

Television, the tool of togetherness in the 1950s, now tore families apart. America watched police and National Guardsmen turn firehoses on civil rights and antiwar demonstrators, saw water pressure that could "strip the bark off a tree" spin protesters around as though they were dolls. A handful of students sitting down at a lunch counter became 100,000 marching through the South.

Television brought a foreign war into our living rooms. And again the numbers spun out of control. In Vietnam, 700 advisers in 1961 became 16,000 troops in 1963—542,000 by 1969. Buddhist monks set themselves afire in protest. Young men burned their draft cards and marched on the Pentagon, arm in arm with older radicals, chanting the new anthem of the decade: "Make Love, Not War."

Marshall McLuhan, a professor of culture and technology at the University of Toronto who seemed to have an explanation for almost everything, tries to make sense of the revolution. In *Understanding Media: The Extensions of Man* and other books he propounds a theory of social change. We live, he says, in a global village connected by electronic media. Type, he says, is linear and has trained man to adopt a single point of view. Television, on the other hand, is a cool medium, a mosaic, a field of tiny moving dots, an incomplete image that "commands immediate participation in depth and admits of no delays." Television creates an urge for involvement. We yearn, he says, to complete the picture. He calls this new force of energy "participation mystique."

Seventy-three million people watched the Beatles on *The Ed Sullivan Show*. An adolescent sexual response that began with bobby-soxers going wild in the streets over Sinatra in the forties had gained momentum in the following decade with female fans who fainted at the sight of Elvis. In *Re-Making*

Love, Barbara Ehrenreich credits Beatlemania with unleashing the teenage sexual revolution of the 1960s. "For the girls who participated in Beatlemania, sex was an obvious part of the excitement," she reminds us. "One of the most common responses to reporters' queries on the sources of Beatlemania was, 'Because they're sexy.' And this explanation was in itself a small act of defiance. It was rebellious (especially for young fans) to lay claim to sexual feelings. It was even more rebellious to lay claim to the active, daring side of sexual attraction. The Beatles were the objects, the girls were their pursuers. The Beatles were sexy; the girls were the ones who perceived them as sexy and acknowledged the force of an ungovernable, if somewhat disembodied, lust. To assert an active, powerful sexuality by the tens of thousands and to do so in a way calculated to attract maximum attention was more than rebellious. It was in its own unformulated, dizzy way, revolutionary."

Everywhere one looked there was change—sudden, unexpected revelation. In England, designer Mary Quant created something called the miniskirt. "Am I the only woman," she asks, "who has ever wanted to go to bed with a man in the afternoon? Any law-abiding female, it used to be thought, waits until dark. Well, there are lots of girls who don't want to wait. Miniclothes are symbolic of them." Thus the world rediscovered women's legs, flashing scissors of energetic skin cutting through crowded city streets. After a decade of girdles and bullet bras, the female body was free.

Designer Rudi Gernreich introduced a topless bathing suit and within days Carol Doda sported her own version in the first modern topless bar, in San Francisco's North Beach. In subsequent weeks customers watched Doda's breasts grow from 34D to a monumental 44DD, augmented by silicone injections. Like volcanoes that appeared overnight in a farmer's backyard, Doda's breasts seemed to symbolize a force of nature, something that could evoke awe and wonder.

Marshall McLuhan had lunch with writer Tom Wolfe in a topless restaurant. Even here he found evidence of the participation mystique, the urge to complete the picture. "Don't you see?" McLuhan remarked. "They're wearing us." McLuhan looked at the waitresses' breasts and declared, "The topless waitress is the opening wedge of the trial balloon."

The body politic rediscovered the body. By the end of the decade, actors romped naked on Broadway in *Hair* and *Oh! Calcutta!* Each night the

cast of *Dionysus in '69* pulled a woman from the audience and made love to her onstage. In Peter Weiss's *Marat/Sade,* the inmates in the asylum of Charenton rioted, singing, "What's the point of a revolution without general copulation?"

The revolution in sex roles, in appearances, in what it means to be a man or a woman, could unfold in the time it took to grow a beard or long hair or to don a shortened skirt. Early reports labeled these changes youthful phenomena, something akin to the Flaming Youth of the Twenties. The revolution did seem to belong to those under twenty-five, but something more was at work here. The Lost Generation ran headlong into the Depression. Youth in the fifties had grown up in the paranoia and conservatism of the Cold War, an era marked by the politics of fatigue.

What was different about the 1960s?

Hugh Hefner was a master of participation mystique. By 1960, his magazine, offering "diversion from the worries of the Atomic Age," was reaching a million readers a month. He had created a fantasy, and now he moved to make that fantasy real, for himself and for his readers.

On February 29, 1960, he opened the first Playboy Club, in Chicago. *Variety* called the Playboy Clubs "a Disneyland for adults." Within two years there were 300,000 keyholders; by the end of the decade almost a million. Playboy Clubs spread across America and abroad. *Time* complained that the clubs were "brothels without a second story." These descriptions were not inaccurate. The clubs recalled the private speakeasies of the Roaring Twenties, and even earlier versions of a male world. Like the Everleigh Club in Chicago, the Haymarket in New York, or Storyville in New Orleans, Playboy Clubs presented an intoxicating mix of food and alcohol, music and other entertainment in a sophisticated, sexually charged atmosphere.

In 1963 Norman Mailer described the scene in *The Presidential Papers:* "The Bunnies went by in their costumes, electric-blue silk, Kelly green, flame pink, pin-ups from a magazine, faces painted into sweetmeats, flower tops, tame lynx, piggie, poodle, a queen or two from a beauty contest. They wore Gay Nineties rig that exaggerated their hips, bound their waists in a ceinture, and lifted them into a phallic brassiere—each breast looked like the big bullet on

the front bumper of a Cadillac. Long black stockings—up almost to the waist on each side—and to the back, on the curve of the can, as if ejected tenderly from the body, was the puff of chastity, a little white ball of a Bunny's tail that bobbled as they walked. The Playboy Club was the place for magic."

The clubs and the magazine celebrated the erotic without a hint of the tawdry. Generations of Americans may have associated sex with sin, but the Bunnies, like their Centerfold counterparts, were nice girls. As Hefner pointed out to the editors of *Time,* the "Look But Don't Touch" rule was strictly enforced. If the editors of *Time* wanted more, that was their problem.

In a way, the Playboy Clubs marked the end of an era, a time of sexual innocence that would soon be gone. Hefner said that he envisioned the Bunny as a "waitress elevated to the level of a Ziegfeld Follies Girl." Florenz Ziegfeld hadn't felt obliged to make the Ziegfeld Girls available to the customers during intermission, he said. Hefner thought he had created a sex symbol for the sixties. Not surprisingly, the Bunnies were controversial just the same, requiring litigation in both Chicago and New York to acquire and retain licenses. Beauty, it was said, was in the eye of the keyholder.

Like everything associated with *Playboy,* the clubs were politically controversial as well. The Playboy Clubs were integrated in Miami and New Orleans when southern states were still opposed to integration. And the clubs became a launching pad for black comedians who had never worked in white establishments before. Dick Gregory got his start making racial equality the topic of his humor by telling keyholders, "I sat at a lunch counter nine months. When they finally integrated, they didn't have what I wanted."

The Playboy Clubs also helped launch the career of budding journalist and future feminist Gloria Steinem. On assignment for *Show* in 1963, she went underground as a Playboy Bunny at the New York Club. Her first impression of the club was unexpectedly favorable: "The total effect is cheerful and startling," she said. Steinem announced that the costume was troublesome, however. The satin had to be taken in two inches for a proper fit. The built-in bras came in just two sizes: 34D and 36D. She kept a list of unofficial bosom stuffers: "Kleenex, plastic dry cleaners' bags, absorbent cotton, cut-up Bunny tails, foam rubber, lamb's wool, Kotex halves, silk scarves and gym socks."

Later she would complain that two weeks as a Bunny had left her feet "permanently enlarged by a half size by the very high heels and long hours of

walking with heavy trays." If Prince Charming arrived with the glass slipper, would it still fit? Steinem concluded: "All women are Bunnies."

In 1960 Hefner says, "I came out from behind the desk and started living the life the magazine promoted."

He moved into a seventy-room mansion on Chicago's Gold Coast and began hosting a syndicated television show titled *Playboy's Penthouse*. As Hef would write years later, "It was a black-tie party featuring Centerfolds and celebrities such as Lenny Bruce, Ella Fitzgerald, Tony Bennett, Sammy Davis, Jr., Ray Charles, Sarah Vaughan, Dizzy Gillespie, Count Basie, and Duke Ellington. The interracial nature of this social gathering assured no syndication in the South.

"The party format was a reflection of the real party that was going on at the Playboy Mansion. The brass plaque on the door announced: *Si Non Oscillas Noli Tintinnare* (If you don't swing, don't ring). All America knew about the round-the-clock revelry, the indoor pool, the underwater bar, the woo grotto, the Bunnies and Playmates in residence and—at the center of it all—the round, rotating, vibrating bed."

Hef struck one writer as a latter-day Gatsby who had assembled all the props—the never-ending parties, the red velvet jacket, the pipe, the white Mercedes 300SL convertible, the incredible Big Bunny jet. Hef was living out a bachelor's version of the American dream.

Hef wasn't alone. Even the president of the United States was a bachelor at heart. Although the country didn't know it at the time, JFK was having similar parties in the pool at the White House. He swung with Sinatra and his Rat Pack pals in Vegas and had an affair with Marilyn Monroe. When Marilyn sang "Happy Birthday, Mr. President," wearing a dress that hardly covered the essentials, it was deemed somehow appropriate that a Hollywood sex star pay homage to the Washington icon. Kennedy, it was said, would do for sex what Eisenhower had done for golf.

Kennedy was a James Bond fan, and Agent 007 was the quintessential bachelor. Ian Fleming's hero was an ongoing part of *Playboy* in the sixties. Bond was a *Playboy* reader, Fleming said, and in the film version of *Diamonds Are Forever* he was also a member of the London Playboy Club. James Bond—

and the superspy phenomenon he inspired—was clearly a part of the sixties *Playboy* mystique, with its emphasis on gadgetry and girls. (The license to kill was strictly Fleming's invention.) Dean Martin's Matt Helm actually used working for a fictional version of *Playboy* as his cover and cavorted in a rotating round bed with Slaymates.

If guys were going to save the world, they would do so stylishly, with the right wine and appropriate company. There would always be time for one last fling before getting back to business. Fancy fucking would win the Cold War. America's fascination with superspy spoofery was a sign the Cold War was no longer producing the paranoia of previous decades. The Red Menace was still here, but films such as *Dr. Strangelove or: How I Learned to Stop Worrying and Love the Bomb* (1964) ridiculed the military, with its puritan zeal to preserve precious bodily fluids.

The last thing Hefner cared about was preserving precious bodily fluids.

At the start of the decade *Playboy* had been a literary magazine with a Centerfold, devoted to satire, science fiction, and the art of seduction. In the sixties, Hefner added new sections to the magazine. The Playboy Advisor, launched in September 1960, invited readers to share sexual information. The Playboy Interview created a dorm room the size of a nation, staging candid conversations with Miles Davis, Malcolm X, Bertrand Russell, George Lincoln Rockwell, and Martin Luther King, Jr., among others. The magazine added a social consciousness, taking controversial and frequently unpopular positions on sex, drugs, race, religion, and the war. *Playboy* actively campaigned against involvement in Vietnam, but supported the servicemen who were sent there. The *Washington Post* reported that *Playboy* played the same part in Vietnam that *The Stars and Stripes* had played during World War II. The men in Vietnam turned their rec rooms into Playboy Clubs and painted the Rabbit Head logo on jeeps and helicopters. The troops papered the walls of hutches with Centerfolds. Thousands of miles from home, they still had the girl next door. They may not have known what they were fighting for, but the Playboy Playmate represented what they hoped to find on their return. (It was said that you could tell when a particular battalion had arrived in Nam by the month of the first Centerfold hanging on the wall.)

Hef had created *Playboy* for the young urban male of his generation, but no one, not even Hefner, was prepared for what happened when the baby

boomers came of age and began to buy the magazine. Circulation climbed from one million a month in 1960 to nearly six million at the end of the decade. One out of every four college men purchased the magazine every month—and the rest were presumably reading a classmate's copy. More than in any other medium, the sixties happened in the pages of *Playboy*.

In 1962 Hefner sat down to write what he immodestly referred to as "the Emancipation Proclamation of the sexual revolution." The Playboy Philosophy would spell out—"for friends and critics alike—our guiding principles and editorial credo." It was, he said years later, "a personal response to the hurt and hypocrisy of our Puritan heritage."

The Philosophy was a twenty-five-part teach-in on sex, a consciousness-raising session that defined freedom in terms of the individual. Hefner believed that "man's personal self-interest is natural and good," that "morality should be based upon reason," that "the purpose in man's life should be found in the full living of life itself and the individual pursuit of happiness."

Hefner attacked "the utter lack of justification in the State's making unlawful certain private acts performed by two consenting adults" and said flatly, "There can be no possible justification for religion's using the State to coercively control the sexual conduct of the members of a free society.

"If a man has a right to find God in his own way," he wrote, "he has a right to go to the Devil in his own way also." If we were not free in our minds and our bodies, we were not free.

Critics claimed that *Playboy* had become a bible for young men and warned, "The Playboy Philosophy has become a substitute religion." Benjamin DeMott, a professor of English at Amherst, charged in an article called "The Anatomy of *Playboy*" that the magazine presented "the whole man reduced to his private parts."

Harvard theologian Harvey Cox attacked *Playboy* for being "basically antisexual." He declared that the magazine emphasized "recreational sex," and claimed that girls are just another "*Playboy* accessory."

But Hefner was espousing a sexual ethic that was based on an acceptance of the sexual nature of man. Sex was neither sacred nor profane, he said. He attempted to separate sex from its traditional associations with "sickness,

sin and sensationalism." He argued that society's sexual dialogue had come to resemble George Orwell's newspeak. Hefner stated that some sex outside marriage was moral, and that some sex inside marriage was clearly immoral. He railed against early marriage, decrying the church-state licensing of sex. More than anything else, Hefner was frustrated by the hypocrisy of the past, by the lies and failures of an older generation that thought "sex is best hidden away somewhere, and the less said about it the better."

"The sexual activity that we pompously preach about and protest against in public," he wrote, "we enthusiastically practice in private. We lie to one another about sex; we lie to our children about sex; and many of us undoubtedly lie to ourselves about sex. But we cannot forever escape the reality that a sexually hypocritical society is an unhealthy society that produces more than its share of perversion, neurosis, psychosis, unsuccessful marriage, divorce and suicide."

Sex, he wrote, "is often a profound emotional experience. No dearer, more intimate, more personal act is possible between two human beings. Sex is, at its best, an expression of love and adoration. But this is not to say that sex is or should be limited to love alone. Sex exists with and without love—and in both forms it does far more good than harm. The attempts at its suppression, however, are almost universally harmful."

Sex was sex. More often than not it was fun. This was a message that invited participation.

The quest for a contemporary sexual ethic ricocheted throughout the culture. A college professor in North Carolina taught a course in philosophy that ranged from "Socrates to Hefner." Presbyterian minister Gordon Clanton stated the challenge posed to the churches: "The church of Jesus Christ stands at the threshold of total irrelevance vis-à-vis one of man's most pressing concerns—his sexuality and the religious and societal demands associated with it. Although our people live in the age of Kinsey, Hefner and Enovid, the church and its spokesmen continue the futile attempt to extrapolate a full understanding of sex from the thought of Moses, Augustine and Calvin."

The old guard tried to play catch-up. Father Richard McCormick, in an article on the new sexual morality in *The Catholic World,* wrote that the church's greatest challenge lay in "[*Playboy's*] ultimate formula for significance: Sex equals fun. Mr. Hefner is making a tremendous effort to be taken seriously, and it is a measure of our confusion that he is partially succeeding."

Time magazine claimed that the new sexual morality could be reduced to one sentence from Hemingway: "What is moral is what you feel good after, and what is immoral is what you feel bad after."

In an article called "The Second Sexual Revolution," *Time* paraded the new crop of moral experts. State University of Iowa sociologist Ira Reiss described "permissiveness with affection." Boiled down, his theory was: "(1) Morals are a private affair. (2) Being in love justifies premarital sex and, by implication, extramarital sex. (3) Nothing really is wrong as long as nobody else gets hurt."

Lester Kirkendall, author of *Premarital Intercourse and Interpersonal Relationships,* offered this: "The moral decision will be the one which works toward the creation of trust, confidence and integrity in relationships." Teachers would ask one simple question of students who came to them for counseling: "Will sexual intercourse strengthen or weaken your relationship?" Better that men and women explore the possibilities, discover who they were and what they wanted, before choosing a lifetime partner. Hefner expanded the universe of premarital sex to include experimentation that would not necessarily lead to marriage.

In place of marriage, the sixties gave America the meaningful relationship. Critics of Hefner identified him as a prophet of hedonism, and incorrectly reduced The Playboy Philosophy to: "If it feels good, do it." (That phrase never appeared in the Philosophy, but it echoed through the culture.)

In 1962 psychologist Abraham Maslow elevated hedonism to an existential tenet in *Toward a Psychology of Being.* Pleasure, he wrote, was a path to growth. We should be like children, spontaneously living for the moment. Living, not preparing to live. "Growth," he said, "takes place when the next step forward is subjectively more delightful, more joyous, more intrinsically satisfying than the last; the only way we can ever know what is right for us is that it feels better subjectively than any alternative. The new experience validates itself rather than by any outside criterion."

"Joy," a word seemingly long missing from American discourse, reentered the vocabulary. "The joy consideration, I think, is really at the heart of the thing," Hefner told members of a 1963 panel discussion on the sexual revolution in America, hosted by David Susskind. "It is the joy and the understanding and the truth and the pleasure of sex that are the good parts."

The 1963 Susskind panel discussion with Hefner was deemed too controversial to air. The transcript recorded psychologist Albert Ellis's remark about the younger generation: "They are behaving, while we are still thinking about behaving."

The revolution nailed the new morality to the doors of the church. In *Christianity and Crisis,* Harvey Cox continued to discuss the problems raised by *Playboy* (noting that "Hefner's wearisome attack on the religious repression of sex has reached its 16th turgid installment"). Robert Fitch, dean of the Pacific School of Religion, tried to devise "A Common Sense Sex Code" for the readers of *The Christian Century.* "Either you control sex, or sex controls you," he wrote. "Needed right now are bigger and better inhibitions. Surely there is something ludicrous in the notion that while liquor, cigarettes and ice cream must be put under the most strict and rational controls, sex, on the contrary, is something to which you may help yourself when, as and if you please."

Joseph Fletcher, a theologian, lamented the loss of the old punishments, the repressive trinity of "conception, infection and detection."

In early 1965 more than 900 clergymen and students attended a convocation at Harvard Divinity School to discuss the New Morality. Delegates heard Paul Ramsey of Princeton declare, "Lists of cans and cannots are meaningless." Yale chaplain William Sloane Coffin argued for "guideposts," not "hitching posts." How had we become so hung up on sexual morality, asked others, when the true obscenities were unfolding in war-torn Asia and in riot-stricken U.S. ghettos?

The debate on the New Morality was mostly men talking among themselves. What was the status of women in America? Critics charged sexual liberation demeaned women. Hefner responded that women were the major victims of our traditional taboos. Our Judeo-Christian heritage supported the double standard that makes women second-class citizens.

Ira Reiss noted, "The Christians of the Roman era opposed from the beginning the new changes in the family and in female status. They fought the emancipation of women. They demanded a return to the older and stricter ideas and, beyond this, they instituted a very low regard for sexual relations and for marriage. Ultimately, these early Christians accorded marriage, family life, women and sex the lowest status of any known culture in the world."

In 1963 Betty Friedan would address these issues in *The Feminine Mystique.* A journalist, she had abandoned her career to raise a family in the suburbs. Like many postwar women, she traded her brains for a broomstick. Women, she wrote, had been seduced and betrayed by "the feminine mystique," the notion that a woman could find fulfillment as a wife and mother. Her book, originally titled *The Togetherness Woman,* was a full-frontal attack on the family togetherness phenomenon of the 1950s.

Friedan found that a house in the suburbs was a comfortable concentration camp. "The problem lay buried, unspoken, for many years in the minds of American women," she wrote. "It was a strange stirring, a sense of dissatisfaction, a yearning. Each suburban wife struggled with it alone. As she made the beds, shopped for groceries, matched slipcover material, ate peanut butter sandwiches with her children, chauffeured Cub Scouts and Brownies, lay beside her husband at night, she was afraid to ask even of herself the silent question: Is this all?" Friedan called this malaise "the problem that has no name." Millions of women bought *The Feminine Mystique.* Out of their dissatisfaction emerged a new feminist movement. The goals of this movement were not unlike those expressed by Hefner when he launched *Playboy.* What Friedan called the feminine mystique, he called the womanization of America. He, too, had seen the trap of suburbia. And now, it seemed, women wanted to be more like men—single men.

Friedan claimed that the pressure cooker of suburbia turned women into insatiable sex seekers. One housewife had told her that "sex was the only thing that made her 'feel alive.'" Denied status in the public sphere, these women would turn to sex, demanding more from their husbands or ricocheting into affairs. But sex did not remedy their lack of fulfillment in the outside world.

Friedan was not antisexual; she recalled fondly her years as a single woman during World War II, when every girl kept a diaphragm under her girdle and had affairs with married men at work. But when sex was the last frontier (as David Riesman called it) or the last green thing (as Gerald Sykes described it), it became stripped of its power to rejuvenate. For sex to thrive, it had to occur among equals. Friedan wondered if her housewives, in need of the "feeling of personal identity, of fulfillment, seek in sex something that sex alone cannot give."

In 1962 Helen Gurley Brown released *Sex and the Single Girl.* This slim volume tackled the same question Friedan's book did but came up with a different answer. When Brown looked at marriage and asked, "Is that all there is?" her answer was, "Yes. So put it off for as long as you can." Brown made a great confession: "Theoretically, a nice single woman has no sex life. What nonsense! She has a better sex life than most of her married friends."

The reasons were simple. "Why else is a single woman attractive? She has more time and often more money to spend on herself. She has the extra 20 minutes to exercise every day, an hour to make up her face. Besides making herself physically more inviting, she has the freedom to furnish her mind. She can read Proust, learn Spanish, study *Time, Newsweek* and *The Wall Street Journal.*" More important, wrote Brown, "a single woman moves in the world of men. She knows their language—the language of retailing, advertising, motion pictures, exporting, shipbuilding. Her world is far more colorful than the world of the PTA, Dr. Spock and the jammed clothes drier."

Brown was the female version of Hefner (even though *Playboy* was not as inclined to sprinkle its philosophy with words like "pippy-poo" and "mouseburger"). She, too, was living proof of her own idea. She wrote her book having made the good catch, a husband who encouraged her work. "He wouldn't have looked at me when I was 20. And I wouldn't have known what to do with him."

The book devoured the best-seller lists, was soon translated into ten languages, and was made into a movie, netting $200,000 for the film rights. Just as Hefner had made it safe to be a bachelor, Brown made being "the girl" into a great adventure. She wrote a follow-up called *Sex and the Office,* declaring that it was completely honorable to seduce and even to marry the boss. In 1965 the Hearst Corporation hired her to take over *Cosmopolitan* and turn it into the female counterpart to *Playboy.*

Betty Friedan founded the National Organization for Women. Helen Gurley Brown gave us the singles bar. One thing made women's transitions into the world of work and the world of play possible: the Pill.

Margaret Sanger, the grande dame of birth control, was seventy-one in 1950 when she sought out an old benefactor, Katharine McCormick, seventy-five, a

true believer who had helped smuggle diaphragms into the United States during the twenties. What Sanger wanted was a perfect contraceptive, something as simple as aspirin, that women could take to prevent unwanted pregnancies.

Sanger and McCormick went shopping for a scientist. Sanger contacted Gregory Pincus at the Worcester Foundation in Massachusetts. Pincus had experimented with the effects of hormones on rabbits. A single dose of progesterone, he found, stopped ovulation in 90 percent of the rabbits tested.

On June 8, 1953, McCormick visited the Foundation, promised Pincus $10,000 a year, and soon gave him $50,000 from her family fortune to build an animal lab. Over the years, McCormick's contributions grew to between $125,000 and $180,000 a year. Faced with the prospect of using hormones in human research, Pincus brought in Dr. John Rock, who was one of the nation's leading gynecologists. Dr. Rock had been using progesterone to aid fertility. He had noticed that women who took progesterone stopped ovulating. Rock wondered if, by giving the reproductive system a rest, he could cure sterility. About 16 percent of the women who took progesterone and then stopped became pregnant. (The effect was called the Rock Rebound.)

Progesterone works by tricking the body into believing it is pregnant. Many of the women who took progesterone believed that they actually were pregnant. Their breasts swelled, they experienced nausea, and they stopped having periods.

One of Pincus's first suggestions was to interrupt the doses of progesterone. Women would take the Pill for twenty days, stop, menstruate, then go back on it. All the other delightful side effects of being a little bit pregnant would persist.

Pincus and Rock conducted experiments in Puerto Rico in the late fifties. Rock contacted women who had already given birth and asked if they wanted to test a pill that would prevent pregnancy. In the first test of 221 women, not one became pregnant. Sanger had her magic pill, one that would make birth control the responsibility of the individual. At last, women were masters of their reproductive fates. Well, almost.

Further trials resulted in one caveat: The Pill was effective only when used properly. Sexologist Vern Bullough recounts in *Science in the Bedroom,* "Twenty-five women had quit taking the pill either because they were frightened by the side effects or because their priest or personal physician advised

them against it. Others appeared to have been confused about what they were supposed to do. One woman took the tablets only when her husband was not traveling. Another, who became pregnant, complained that the pills had not worked at all, even though she had made her husband take them every day."

John Rock, one of the fathers of the Pill, was a devout Catholic. He not only risked arrest in Massachusetts, a state that outlawed all contraceptive devices, but also was threatened with excommunication for developing a form of birth control that appeared to violate Catholic doctrine. In 1930 Pope Pius XI had issued his *Casti Connubii* encyclical, in which he prohibited the use of artificial contraception.

But the pope left a door open. Married persons who had intercourse but who for "natural reasons either of time or of certain defects" could not bring forth new life did not sin. The rhythm method, timing intercourse to a "safe" period, was not an obvious sin.

In 1963 Rock published *The Time Has Come: A Catholic Doctor's Proposals to End the Battle Over Birth Control*. He argued that the Pill was not artificial, that it duplicated nature in its effects on a woman's body, and that it did not destroy organs or block semen artificially. It was a form of contraception that controlled time. If the rhythm method was moral, then a pill that expanded the "safe period" was also moral. In a world devastated by the population explosion, limiting conception was a moral choice that could not be ignored.

Briefly, Pope John XXIII held out hope. He convened the Papal Commission on Population, the Family and Natality in June 1963. In June 1966 the theological scholars studying the Pill's moral challenge voted for a change in the Catholic Church's teaching—by a margin of 60 to 4.

On July 29, 1968, Pope Paul VI issued *Humanae Vitae*. Roughly translated, the message was this: "Every sex act must remain open to the transmission of life. Man does not have total dominion over his sex organs, because they are God's instruments for new life."

The decision was a tragedy. Father Andrew Greeley surveyed American Catholics. In 1964, he found 45 percent approved of artificial contraception; by 1974 the figure would be 83 percent—a startling rejection of *Humanae Vitae*. "We don't speculate that the cause of Catholic decline was the birth control decision," wrote Greeley, "nor do we simply assert it. We prove it with the kind

of certainty one rarely attains in historical analyses. Historians of the future will judge *Humanae Vitae* to be one of the worst mistakes in the history of Catholic Christianity."

The numbers tell the story. In 1960 Enovid received FDA approval. Within a year and a half some 408,000 women were taking the drug. By 1964 the figure was 2.5 million for Enovid, another million for a similar product by Ortho. By 1966 more than half of married women under the age of twenty were on the Pill. Among non-Catholic college graduates under the age of twenty-five, the figure was 81 percent. Even more remarkable, Catholic women embraced the Pill; one out of five wives under the age of forty-five used it.

Women took the Pill to postpone their first pregnancies, to avoid falling into the family trap described by Friedan in *The Feminine Mystique.* Their parents may have had the perfect family—four children one after another—but that model shackled a woman to one role. Wives of the sixties used the Pill to space the births of their children, to create time to complete degrees or advance careers. The Pill granted the means to achieve the original feminist vision. Single women used the Pill to postpone their first marriages. By 1969 it was estimated that more than half of unmarried college coeds were on oral contraceptives.

The Pill sparked the sexual revolution. By separating sex from procreation, women were finally free to pursue pleasure without risk. And pursue they did. One study conducted during the mid-sixties showed that married women on the Pill had sex 39 percent more frequently than married women using other, less effective forms of contraception. But the same study showed that coitus increased for everyone over the decade. Between 1965 and 1970, the average frequency of coitus jumped from 6.8 times per month to 8.2 times. People on the Pill mated an average of ten times per month, a frequency matched only by those couples who were trying to get pregnant. Sex for recreation and sex for procreation were in a dead heat.

Loretta McLaughlin, author of *The Pill, John Rock and the Church: The Biography of a Revolution,* lists the challenges posed by the new technology:

> Far more than just unpopular, the idea of a birth control pill was still widely regarded as socially immoral and medically questionable. A birth control pill would be the first medicine in history given to well people solely for a social purpose.

Sex would be set free, not only for the married, but for any woman, anywhere, any time, with anyone. Not only would the risk of pregnancy be eliminated, but, astonishingly, only the woman concerned would know. . . . It amounted to handing over to women, for the first time in history, not only total governance over their sexual behavior, but total privacy—some would say secrecy. Women's sexual prerogatives would equal men's.

In the pages of the November 21, 1965, *New York Times Magazine* Andrew Hacker described the changing etiquette of sex. "For a long time there has been a certain ritual, not without moral overtones, connected with birth control as practiced by unmarried people," he wrote. "The young man is 'prepared' on a date, the girl is not. If there is a seduction, he takes the initiative; she is surprised. If she succumbs, he deals with the prevention of conception—which is proper because she had no advance warning as to how the evening would turn out. Vital to this ritual is the supposition that the girl sets off on the date believing that it will be platonic. If it ends up otherwise, she cannot be accused of having planned ahead for the sexual culmination. But now, for a girl to be on the Pill wipes out entirely the ritual of feminine unpreparedness."

In April 1966, *Mademoiselle* responded to Hacker, noting that while the Pill made it difficult for women to be demure, "surely, nowadays, it is both aesthetically and psychologically preferable for a girl who engages in sex to do so wholeheartedly, joyously, responsibly and responsively—rather than as an innocent victim."

The word "no" was banned (perhaps exiled is a better descriptive). Suddenly sex was no longer the carrot, the reward for a proposal of marriage. The technical virgin—that elaborately entangled novitiate who had been able to achieve orgasm with tongue or fingers, in cramped quarters—was an endangered species.

A young man growing up in the sixties tells about the pre-Pill dangers of dry humping: "I spent an afternoon at my girlfriend's house, rubbing against her. I must have come four times. When I left, my underwear was soaking wet. I walked out into a 20-degree winter day and suddenly, my underwear froze. My penis felt like a tongue stuck to an ice cube tray. I was in public, so I couldn't touch my crotch to warm up. I waited for a bus, worried that I would never get

to use it again." He survived to grow into a world where sex was not a struggle, where sex became a way to say hello, a way to find out if you liked a person.

A woman was no longer fettered to her purse nor by proximity to a diaphragm. No more barefoot dashes across cold wood floors to interrupt sex for safety. In an odd way, the Pill was less premeditated than diaphragms and condoms. Each day a woman looked at the dial of pills, took one, and said, "I am a sexual being, free to be spontaneous." The Pill would become for many women the most important recreational drug of the century.

The press, always conservative, charted the darker impact of the Pill. Reporters told of a jealous husband who substituted aspirin for his wife's pills, to see if she was sleeping with someone else, interviewed housewives on Long Island who supplemented their incomes by Pill-protected prostitution, and profiled girls who played at entrapment by telling boys that they were on the Pill when they weren't.

Science would change sex in other ways during the sixties as well.

We may never know her name. Dr. Leslie Farber, the first person to describe her, called her "the Lady of the Laboratory." Malcolm Muggeridge, in an apoplectic tirade titled "Down With Sex," called her "the Unknown Onanist" and said she deserved her own monument, like that of the Unknown Soldier.

She was one of 382 females who had had sex with an artificial penis—a clear plastic tube filled with cold light and a camera—while being observed by two sex researchers in St. Louis named Dr. William Masters and Virginia Johnson.

What that camera saw would change the most basic notions of female sexuality. A film would show a woman's hand stroking her clitoris, would show the walls of the vagina glisten with lubrication, would show the clitoris bow and withdraw behind folds of flesh, would show the oceanic swells of orgasm ripple those vaginal walls. Never mind that the scientists had also observed 312 males in the acts of intercourse and automanipulation. Who cared about male sexual response? A woman's orgasm, a woman's anatomy, a woman's potential—that demanded the world's attention.

The drumroll of publicity, most of it adverse, preceded the 1966 publication of *Human Sexual Response* by more than a year. Dr. Farber, a psychoana-

lyst in Washington, D.C., criticized almost every aspect of the research project, claiming that Masters and Johnson dehumanized sex. Not only had the scientists done away with "modesty, privacy, reticence, abstinence, chastity, fidelity, shame"—the emotional arsenal of a repressed society—they had reduced them to "rather arbitrary matters that interfered with the health of the sexual parts."

What seemed to bother Farber most was that the unidentified woman in the film had achieved her orgasm without male help. "According to the lesson of the laboratory," he wrote, "there is only one perfect orgasm—if by perfect we mean one wholly subject to its owner's will, wholly indifferent to human contingency or context. Clearly the perfect orgasm is the orgasm achieved on one's own. No other consummation offers such certainty and moreover avoids the messiness that attends most human affairs. Nor should we be too surprised if such solitary pleasure becomes the ideal by which all mutual sex is measured."

Muggeridge saw Masters and Johnson's research as the ultimate result of America's newfound belief in sex as pleasure. "Thus stripped, sex becomes an orgasm merely. To those self-evident rights in the famous Declaration there should be added this new, essential one: the Right to Orgasm."

Colette Dowling and Patricia Fahey also found the uppercase key on their typewriter. In an article in *Esquire* they wrote that "the new female status symbol is the orgasm." Women were suddenly embarked on "the Quest for the Holy Wail"; all of women's accomplishments paled next to "the Quality Orgasm." The Lady of the Laboratory described by Farber had "long been the woman of the American Sex Daydream." If only Masters and Johnson would release the film, they argued, every woman would be able "to raise her Orgasm Capacity."

How was a woman to attain this goal? Dowling and Fahey invoked images of belly dancers lifting eggs off tables with their genitals and quoted a sex manual that said the sexual responsibilities of women included exercising that magical pubococcygeus muscle.

When *Human Sexual Response* appeared it was an immediate best-seller, remaining on the charts for six months. Masters and Johnson presented the physiology of arousal, breaking down the sex act into four phases: excitement, plateau, orgasmic, and resolution. The book read like an owner's manual for

the human body, recording myriad minute details: the clitoris retracting under its hood, the rising of the testicles as the male approaches orgasm, the skin rash sweeping across a lover's body like a summer squall. This is what the body did during sex, whether the sex was premarital, extramarital, solo, or whatever.

Dr. Masters would later explain the impact of defining sex purely in terms of physiology. In a 1968 Playboy Interview he said: "Sexual demand seems to be a unique physiological entity. Unlike other demands, it can be withdrawn from; it can be delayed or postponed indefinitely. You can't do this with bowel function or cardiac or respiratory function. Perhaps because it can be influenced in this unique manner, sex has been pulled out of context. Lawyers and legislators have taken a hand in telling us how to regulate sexual activity. They don't, of course, presume to regulate heart rate."

In the eyes of the scientist, all orgasms were equal. Masters and Johnson put sex back into the context of the body. There was no sin in a vital sign, be it a rapid heartbeat or the powerful contractions of the penis or vagina. With one hand, the Lady of the Laboratory swept away the cobwebs and America saw sex in a new light. She made the world aware of the clitoris. As someone would say (probably me), prior to 1966 everyone thought the clitoris was a monument in Greece. Indeed, the word "clitoris" appeared in the pages of *Playboy* for the first time in Masters and Johnson's 1968 interview.

Forget penis envy. The clitoris, which researchers called the homolog, anatomically, of the penis, was the only organ in the human body whose sole purpose was pleasure. Women had one. Men didn't.

It wasn't as though mankind hadn't known the clitoris existed. Turn-of-the-century marital adviser Ida Craddock had declared the clitoris "should be simply saluted, at most, in passing and afterward ignored as far as possible." Freud had charmingly compared it to pine kindling used to ignite the whole body. Then he queered sex for sixty years by insisting that orgasms created by stroking and stoking the little fire were immature. Mature women went past that sideshow barker to experience deeper, vaginal orgasms produced by penetration and the great god Cock.

Masters and Johnson showed that at climax the whole body was involved in orgasm. Nipples became erect. Nostrils flared. The mind set off its own electrical show. It was absurd to divide the body and create hierarchies

based on some analyst who studied people while they lay fully clothed on his couch.

Masters and Johnson were acutely aware of how phallocentric American sex had become. Intercourse was the only course. Only once in a 366-page book did they mention oral sex; anal sex was not mentioned at all. They knew these behaviors existed, but oral sex was still against the law in almost every state. They worried that even to mention such practices would cost them their careers. "We didn't have the courage," they told *Playboy* years later.

The book was filled with treasures. Women had another ability denied men. The chart for male sexual response showed a one-hill roller-coaster ride. Up. Peak. Down. The chart for female sexual response showed a single peak cycle, a multipeak cycle, and one curve that looked like a stone skipping across water. Women were capable of multiple orgasms.

That potential challenged male readers, who had grown up with the gold standard of simultaneous orgasm. Masters and Johnson set males to looking inside the sex act, to prolonging it, to playing with different buttons, to lighting up the universe and going for bonus points. Some women claimed that the emphasis on orgasm and multiple orgasms turned them into objects; others simply lay back and collected on a debt long overdue.

There is an irony here: At the very moment the Pill made intercourse safe for the unprotected penis, intercourse was deemed irrelevant. On the other hand, a woman could ride an erection, a tongue, or a vibrator all night.

In the realm of applied science, a California inventor named Jon Tavel sought a patent for a battery-powered, bullet-shaped vibrator. The Post Office reported that mail-order companies were deluging widows and housewives with advertisements for "a fairly expensive fornication machine."

On your mark. Get set. Go.

To fully appreciate the social upheaval that swept through the 1960s, one must look at a different laboratory. The college campus was a microcosm of the culture outside. What did the first war babies and baby boomers encounter as they came of age?

In 1960 Leo Koch, a biology professor at the University of Illinois, wrote a letter to the campus newspaper describing a novel idea. "With modern con-

traceptives and medical advice readily available at the nearest drugstore, or at least from a family physician, there is no valid reason that sexual intercourse should not be condoned among those sufficiently mature to engage in it without social consequences and without violating their own codes of morality and ethics." A strongly worded letter from the Reverend Ira Latimer, an alumni dad, accused Koch of being part of a Communist conspiracy aimed at subverting "the religious and moral foundations of America."

Koch was suspended, then dismissed. One headline stated: PROFESSOR TO BE FIRED FOR URGING FREE LOVE. Students who demonstrated for Koch's free-speech rights were photographed by the school's head of security, a former FBI agent.

In 1962 Sarah Gibson Blanding, the president of Vassar, reminded students that "the college expects every student to uphold the highest standards." She stated that premarital sex relations constituted "offensive and vulgar behavior" and that anyone who disagreed could simply leave campus. Yalies predicted "a mass exodus from Poughkeepsie of indignant Vassar women wearing their diaphragms as badges of courage."

Blanding was simply exercising the power known as in loco parentis, the notion that the college should act in place of parents. A *National Review* editorial noted that in the past this had meant keeping Joe College sober enough to make his classes, but in the sixties it became one of the last barricades to fall in the sexual revolution. As the baby boomers came of age, the college population increased dramatically, with a record six out of ten high school grads going on to higher education. More important, the percentage of women attending higher education doubled, creating a balance between the sexes. College offered a room of one's own, no parental supervision, and a jury of one's peers.

Colleges traditionally relied on a sexual time clock—known as parietal hours—to control romance. Women's dormitories were subject to lockouts. As Margaret Mead noted in an article prompted by Blanding's Vassar crusade, "Any girl who stayed out under circumstances in which she might be suspected of having had premarital sex relations was removed from the college—sometimes gently, sometimes harshly." This was an era when married college women were not allowed to live in dormitories for fear they might provide "a contaminating atmosphere." Some Catholic colleges forbade students from

going steady, saying the behavior was an "occasion for sin." They worried that when young lovers ran out of things to talk about, they would turn to sex.

Schools created bizarre and elaborate rules to control young lust. Handbooks dictated the number of dates students could have each semester, the hours in which the sexes could intermingle. Males and females could visit one another, but lights had to be on. (Students got around this by leaving a closet light on.) A school rule that said a door had to be open "the width of a book" sparked creative students to meet the letter of the law with a matchbook. A male student who wanted privacy would hang a tie from the doorknob of his room. (Mort Sahl tells of a campus Romeo who employed the code so often his roommate got suspicious and discovered the supposed Romeo alone, reading.) The college handbooks were a *Kama Sutra Americana*—demanding that a male and a female in a dorm room keep at least three feet on the floor.

Some schools even tried to put a stopwatch on dating, defining the term as spending more than fifteen minutes in the company of a member of the opposite sex.

Russell Kirk, an influential conservative columnist, tried to defend in loco parentis in the *National Review*. "A great many students at Columbia or Harvard—perhaps the majority," he wrote, "are decent people who have enrolled to learn something or other. They aren't alcoholics or satyrs. They might even enjoy a little quiet in which to read a book or converse. Decent people too have their rights, particularly the right not to have to endure a nuisance and a stench. If young people prefer the atmosphere of a sporting house, let them go thither—and leave the dormitories of Columbia and Harvard to these horrible prigs who actually still believe, after their reactionary fashion, that a college is a place of learning and meditation."

Barely three years into the decade, an off-Broadway theater group called the Premise was using humor to ridicule the public posture of college administrators. Mocking a commencement speech, an actor intoned, "Ladies of Vassar and your guests from Harvard and Yale: I would like to say that premarital sex is indecent, immoral, and wrong—and the least that you could do is stop while I'm talking to you."

By 1964 seven of nineteen private colleges in the East had abandoned in loco parentis and restrictive dorm rules; none of the eighteen public universi-

ties had yielded. By the end of the decade even Vassar had gone coed and created coed dorms.

Gael Greene, author of a 1964 book called *Sex and the College Girl,* reported that the myth of the virgin was ridiculed on almost every campus. The owl at DePauw University was supposed to hoot when a virgin walked by, a Confederate soldier at the University of Mississippi salute, a statue of Abe Lincoln at the University of Wisconsin rise. Of course, they never did.

Students questioned the need for special protection. Many young people had gone away to college specifically to get away from parental supervision. The previous decade had encouraged early marriage. Nearly a quarter of eighteen-year-olds were already married. A student at Cornell told Greene that she couldn't see what the fuss was all about. After all, she said, "We're the high school girls who didn't get pregnant."

Some campus doctors actually prescribed the Pill to female students, saying they would rather see them now than six months later asking for an abortion. But it was done discreetly.

As the war in Vietnam escalated, male students had a new argument against in loco parentis. If an eighteen-year-old could be drafted and sent to war, an eighteen-year-old student should have control over his own actions, specifically sexual actions. The concept became known as Our Bodies, Our Selves. Let me fuck before I die.

Coeds examined their coyness, the false front of flirtation. Students at Radcliffe complained that teasing was cruel. A Wesleyan teacher noted the girl who teased was a "sexual pirate." If you are going to do it, do it with affection. Students took courses in sexual ethics. A UCLA coed told Greene that Bertrand Russell's *Marriage and Morals* was "more or less my undoing." Philosophy courses introduced them to Norman O. Brown and Freud's concept of polymorphous perversity—the notion that the entire body is an erogenous zone.

In a September 1962 article for *Esquire* Gloria Steinem would call the phenomenon "The Moral Disarmament of Betty Coed." She concluded that "the main trouble with sexually liberating women is that there aren't enough sexually liberated men to go around."

Everything happening in the culture at large swept through colleges. Walls sprouted posters of Che Guevara, the Beatles, the Stones, Jimi Hendrix.

A million guys bought the poster of Raquel Welch as a cavewoman in *One Million Years B.C.* and turned the Playmate of the Month into an icon. Some actually believed if you put a poster of a naked woman on the wall of your room, it would attract real naked women.

Cult classics such as Robert Heinlein's *Stranger in a Strange Land* encouraged a new kind of sexuality—a "growing closer." Heinlein's science-fiction novel, published in 1961, proved remarkably prophetic. The story of Valentine Michael Smith, the sole survivor of an expedition to Mars, foresaw cults, hot tubs (or at least communal nude bathing), group sex, the girl next door as a vagabond striptease artist and sacred prostitute, and the government destruction of communes. The tale also foreshadowed altered states of consciousness, with a technique called "grokking."

In 1966 Robert Rimmer's *The Harrad Experiment*—a tale about an experimental college program in New England in which students were assigned roommates of the opposite sex, took phys ed classes together in the nude, and attended nightly seminars in sexual ethics—billed itself as the "Sex Manifesto of the Free Love Generation." In Rimmer's fantasy world students were expected to sleep together. One of the few rules was to limit yourself to one partner per menstrual cycle, so that if a girl became pregnant there would be no question who the father was. One of the coeds in Rimmer's book becomes a centerfold for *Cool Boy Magazine,* but only after demanding that the photographers and the publisher take off their clothes as well.

By 1969 many colleges were experimenting with coed dormitories. *Look* reported on what happens when members of the opposite sex spend time in continual close proximity: "There's more sex when you live like this, just because girls are here. I mean, sex is sort of in the air." But with a new twist: "You think twice about sleeping with a girl when you know you have to face her the next morning at breakfast—and at lunch, and at dinner, and at breakfast."

Coed dormitories changed courtship, the hideous formality of fraternity parties, the desperate fumbling for sex before lockout, the pressure to be pinned or spoken for. Gone were the makeup and rented tuxedo. "You see a girl at all her moments," said one guy, "not just her dressed-up ones." Gone were the corsages.

Leo Koch, the visionary professor who was tossed out of the University of Illinois, moved on to better things. With Jefferson Poland, a former civil rights activist, Professor Koch formed the New York Sexual Freedom League. The idea caught on. Poland moved to California, formed the San Francisco Sexual Freedom League, and got arrested for staging a nude wade-in in the Bay. The University of California Sexual Freedom Forum sold buttons that said I'M WILLING IF YOU ARE. Some scoffed at the buttons, arguing that you didn't need to join a movement to practice sexual freedom. On the other hand, weekly orgies involving twenty to forty-five students didn't just happen by themselves.

The sexual freedom leagues moved off campus and blossomed into a network of wife-swapping couples and swingers' clubs. In loco parentis gave way to parents gone loco with lust. The freedom of the campus had spread into the culture at large.

There were those who turned their back on higher education. The walls around campus could not keep the real world at bay. Issues such as race and war made the rat race for a degree seem obscene. At Berkeley students fought for four months to have the right to raise money for political causes on campus. At the height of the furor students staged a sit-in on Sproul Plaza, holding a police cruiser hostage.

Increasingly, students simply dropped out and formed radical new communities, along New York's St. Mark's Place, Berkeley's Telegraph Avenue, Los Angeles' Sunset Strip, San Francisco's Haight Street, Chicago's Wells Street, and Madison's Mifflin Street. They formed co-ops and collectives, or simply announced the existence of crash pads. These communities had enormous drawing power for the young. In 1966 the FBI reported that 90,000 teenagers had been arrested as runaways.

The counterculture re-created America, starting with underground newspapers. In *Uncovering the Sixties: The Life and Times of the Underground Press,* Abe Peck, one of the founders of Chicago's *The Seed,* gives this comparison: "Mainstream newspapers ran crime news and arts reviews and Dick Tracy. Underground papers ran demonstration news and rock reviews and *The Fabulous Furry Freak Brothers,* a comic about three amiable heads Tracy would

have busted for their rampant pot smoking. The dailies carried ads for pots and pans and suits; the undergrounders sold rolling papers, LPs and jeans." By 1967, Peck notes, there were twenty underground papers, and by 1969 there were at least five hundred. The underground press was rude and confrontational. Pioneer Ed Sanders's 1962 magazine was called simply *Fuck You: A Magazine of the Arts.*

The new culture embodied the McLuhanesque insight that in the global village people did not need jobs, they needed roles. The counterkids raided thrift shops and became gypsies, Elizabethan ladies, shamans, knights, clowns, cowboys, gurus, and the like. Head shops supplied love beads, incense, cabalistic texts, massage oils, Indian fabrics, and Lava lamps.

The counterculture turned the entire world into an art school. Mime troupes staged guerrilla theater in the streets, bands played in parks and old union halls. Borrowing a page from The Playboy Philosophy, a group called the Open Theater read aloud from a nineteen-century sermon on the consequences of masturbation. Later, they staged a series of happenings called Revelations, in which motion pictures were projected onto the bodies of naked actors and actresses. The young and the hip wore the movies as a second skin.

Those in the counterculture lived the Beat vision, and treated as saints figures such as Allen Ginsberg, William Burroughs, Gary Snyder, and Lawrence Ferlinghetti. Ken Kesey's 1962 novel about inmates taking over an asylum, *One Flew Over the Cuckoo's Nest,* became the bible of the new rebellion. Kesey then gave up writing for a form of living art. He and the Merry Pranksters threw Trips Festivals, exploring the potential of LSD, which was not yet illegal. Some estimate that he turned on more than 10,000 people. Acid was as cheap and plentiful as confetti at a parade.

In 1966, the counterculture staged a Love-Pageant Rally to celebrate "the freedom of the body, the pursuit of joy and the expansion of consciousness." The invitation read: "Bring children. Flowers. Banners. Flutes. Drums. Feathers. Bands. Beads. Flags. Incense. Chimes. Gongs. Cymbals. Symbols." In 1967 that spirit culminated in the Summer of Love and the first be-in.

The authentic counterculture would end almost as quickly as it had begun. In October 1967 a group of weary young in Haight-Asbury paraded a giant coffin through the streets, announcing "the Death of the Hippie, Son of

Media." A community of maybe 7,000 gentle souls became a tourist attraction warding off 75,000 hippie wannabes over a single summer. Concerned citizen Chester Anderson printed a flyer warning of the danger of the dream: "Pretty little 16-year-old middle-class chick comes to the Haight to see what it's all about and gets picked up by a 17-year-old street dealer who spends all day shooting her full of speed again and again, then feeds her 3,000 mikes and raffles off her temporarily unemployed body for the biggest Haight Street gang bang since the night before last. Rape is as common as bullshit on Haight Street."

The idea of the Haight disturbed conservatives and created new demagogues. An actor named Ronald Reagan successfully campaigned for governor of California by promising to restore capital punishment, punish rebellious students at Berkeley, and crack down on obscenity. Within a week of Reagan's election, police busted the Psychedelic Shop for selling obscene literature. Two days later the City Lights Bookstore in North Beach was raided.

The obscenity in question was *The Love Book* by Lenore Kandel, a small-press collection of four poems. The community sponsored a protest read-in. Professors from local universities read aloud from a poem called "To Fuck With Love." When the book was declared obscene by a court, the poet thanked the police and pledged part of her earnings to their retirement fund. Their action had taken a book that had sold "about fifty" copies and turned it into a local best-seller (with more than 20,000 copies sold after the bust).

Hippies took up a new address. In 1967 *Hair* was performed at the Public Theater of New York, then moved to Broadway. It was, they sang, the dawning of the Age of Aquarius.

The counterculture, though, was an idea, not an address; an energy, not a neighborhood. It represented the fusion of three forces—sex, drugs, and rock 'n' roll. Gone was the coy music of such hits as "Itsy Bitsy Teenie Weenie Yellow Polka Dot Bikini." Now, the Rolling Stones snarled "(I Can't Get No) Satisfaction." Rock heroes were phallic personalities who had sex with an entire nation. Jim Morrison of the Doors grabbed his genitals during performances and simulated oral sex. In Miami he mimed masturbation and attempted to expose himself, earning an arrest.

When the Stones toured America in 1965, groupies lined up to get a taste of rock's nastiest boys. Every tour had a sexual sideshow as female fans traded oral sex for access to the stars, working their way through doormen, bellhops,

roadies, and managers. Kathy and Mary, known as the Dynamic Duo, partied with the Beatles, Led Zeppelin, and Terry Reid. But they had their clits set on Mick. Indeed, he was the benchmark. Their morning-after conversations went something like this: "Brian Jones? He's great." Pause. "But he's no Mick Jagger."

"Keith Richards? Fantastic." Pause. "But he's no Mick Jagger."

When they finally bedded Mick, the morning-after review went: "Mick? He's cool." Pause. "But he's no Mick Jagger."

Little wonder that two groupies in Chicago honored their heroes by making plaster casts of their private parts.

The Grateful Dead, Jefferson Airplane, and Youngbloods were gypsy bands. The rock of the counterculture was migratory. Concerts became social events, with audiences numbering in the tens of thousands, hundreds of thousands, culminating in Woodstock, in 1969, with numbers half a million strong. This was the body politic gone Dionysian—youth culture went from alienation to Woodstock nation.

Abe Peck remembers rock "radiating what life could feel like if only people got together. 'Like a Rolling Stone,' 'Satisfaction,' 'My Generation,' 'A Day in the Life,' 'Purple Haze,' 'Down on Me' were stunning songs, vinyl diary entries marking a listener's first apartment, demonstration, orgasm, trip."

Rock heroes were the journalists of the new culture. When the Beatles discovered LSD, it showed in their music. Recreational drugs had their stamp of approval. The leap from "Lucy in the Sky With Diamonds" (a tribute to lysergic acid) to "Magical Mystery Tour" was rapid. Millions climbed onboard the bus.

By his own estimate, Timothy Leary had tripped more than a hundred times before the thought occurred to him to try sex on psychedelics. So much for the value of a Berkeley Ph.D. Leary, who had first sampled magic mushrooms at the dawn of the decade, had been relatively unchanged by the drugs. "I routinely listened to pop music, drank martinis, ate what was put before me," he admitted.

Flora Lu Ferguson, wife of jazz musician Maynard Ferguson, suggested that Leary learn what life was like "in the first-class lounge." Leary consented and found himself tripping with Malaca, a model from Morocco. "We rose as one and walked to the sunporch. She turned, came to me, entwined her arms around my neck. We were two sea creatures. The mating process in this uni-

verse began with the fusion of moist lips producing a soft-electric rapture, which irradiated the entire body. We found no problem maneuvering the limbs, tentacles and delightful protuberances with which we were miraculously equipped in the transparent honey-liquid zero-gravity atmosphere that surrounded, bathed and sustained us." After this experience, his hostess explained to him the secret of the universe: "It's all sex, don't you see?"

Leary brought Malaca back to Harvard but "it was hard for her to adjust to my domestic scene. After a week I still saw Malaca as a temple-dancer divinity from the 33rd Dynasty. But it soon became obvious that up here in the middle-class 20th century she was out of place, turning into a petulant, spoiled Arabian girl. The image from the drug session was slowly fading."

Leary checked with his guru. Aldous Huxley, author of *The Doors of Perception,* told him that of course psychedelics were aphrodisiacs, but "we've stirred up enough trouble suggesting that drugs can stimulate aesthetic and religious experiences. I strongly urge you not to let the sexual cat out of the bag." But outside the ivy-covered walls of academe people were discovering the delicious combination of sex and drugs on their own.

On the West Coast Ken Kesey was conducting Acid Tests—winner-take-all mind games with light shows that duplicated atomic apocalypse, a battle of the bands between the Jefferson Airplane and the Grateful Dead, and Elysian romps through the woods of Big Sur. The press initially rhapsodized about the drug's potential for elaborate problem solving, for creativity, for psychoanalysis. Hallucinogenic drugs let you hear color, smell music, touch a scent.

It made tripping sound like kindergarten class. Who would let the cat out of the bag? By the time *Playboy* caught up with Leary in 1966, he had tripped 311 times. Sex was all he could talk about. "Sex under LSD," he said, "becomes miraculously enhanced. It increases your sensitivity a thousand percent. Compared with sex under LSD, the way you've been making love—no matter how ecstatic the pleasure you think you get from it—is like making love to a department store dummy. When you're making love under LSD, it's as though every cell in your body—and you have trillions—is making love with every cell in her body."

Recognizing a charismatic salesman, we let him talk on: "An LSD session that does not involve an ultimate merging with a person of the opposite

sex isn't really complete. One of the great purposes of an LSD session is sexual union. In a carefully prepared, loving LSD session, a woman will inevitably have several hundred orgasms."

The Leary interview fused sex and drugs, but the magazine felt a responsibility to investigate further. The editors asked R.E.L. Masters, a researcher in the field of psychedelics and religious experience, to comment on the delights and hazards of "Sex, Ecstasy and the Psychedelic Drugs" in November 1967. Masters dismissed Leary's claim for the hundred-orgasm woman: "I have yet to hear from anyone else about a single instance remotely approximating this. I feel rather confident that if it had been happening with any frequency, the world would not have had to wait for Leary to announce it." Masters admitted that during psychedelic sex intercourse does last longer, but this is due to a distortion of time that gives the act "the flavor of eternity."

You could fill an erection with wonder. Sex was just a beginning, a stage set for awe-inspiring theater. You could genitalize any part of your body. One subject had told Masters that "he became aware of his entire body as 'one great, erect penis. The world was a vagina and I had a sense of moving in and out of it, with intense sexual sensations.'"

Whoa.

The backlash was inevitable. All America was in danger of becoming a drug culture. In 1967 Americans consumed some 800,000 pounds of barbiturates, some 10 billion amphetamine tablets. But a drug that turned your whole body into an erection? Harry J. Anslinger, former Prohibition agent and father of *Reefer Madness,* was quick to respond to the Leary interview. "If we want to take Leary literally," he said, "we should call LSD Let's Start Degeneracy."

The Drug Abuse Control Amendments of 1965 outlawed the manufacture and sale of "dangerous drugs"—amphetamines, barbiturates, and hallucinogens. In 1966 California and New York criminalized possession of psychedelics. In 1970 Congress passed the Controlled Substances Act, which classified LSD as a Schedule I hallucinogen and made possession a federal crime.

The counterculture believed that sex was political. It marched into battle with "banners flying from erect penises." And it knew how to play with the fears of the older generation.

The planners of a 1967 march on the Pentagon—a protest against the escalating war in Vietnam—petitioned the government for a permit to levitate the Pentagon. Abbie Hoffman invited members of the press to his apartment for a demonstration of a new hippie weapon, a psychedelic bomb. He told reporters that a group of radicals called the Diggers had come up with a high-potency sex juice called Lace. In his biography of Hoffman, *For the Hell of It,* Jonah Raskin recounts, "When reporters showed up at Hoffman's apartment, two couples volunteered to demonstrate the power of the chemical. They sprayed one another with the purple liquid, then undressed and began to make love while reporters watched with glee. Making love would triumph over making war."

Hoffman wrote in *East Village Other,* "We will fuck on the grass and beat ourselves against the doors. Secretaries will disrobe and run into the streets, newsboys will rip up their newspapers and sit on curbstones masturbating."

By 1968 Hoffman and Jerry Rubin had founded the Youth International Party, the yippies. They called for a celebration of life to counteract the 1968 Democratic Convention being held in Mayor Richard J. Daley's Chicago. When the yippies applied for a park permit, they wrapped their request in a *Playboy* centerfold, on which was written the greeting: To Dick with Love, the Yippies.

Hoffman called for like-minded individuals to bring their "eager skin" to Chicago. He circulated rumors to the effect that yippie women would seduce convention delegates. Abbie stood outside the Federal Building with a list of demands, one of them being, "People should fuck all the time, any time, whomever they wish."

Jerry Rubin gave this description: "A kid turns on television and there is his choice. Does he want to be smoking pot, dancing, fucking, stopping traffic and going to jail or does he want to be in a blue uniform beating up people or does he want to be in the convention with a tie strangling his throat making ridiculous deals and nominating a murderer?"

When "the pigs" tried to clear the streets the world was watching. What it saw was a police riot. But afterward, a Harris Poll showed that 70 percent of Americans sided with the police. When the dust cleared, Richard Nixon was our president.

In the fifties, the nation had learned to wield scandal as a weapon of social control. In the sixties, the federal government used sex to discredit those with

dangerous ideas. One was the father of rock 'n' roll, the other the father of the civil rights movement.

In 1960 Chuck Berry faced trial on two charges of violating the Mann Act. According to prosecutors, he had transported two women across state lines for immoral purposes. David Langum, author of *Crossing Over the Line,* writes that the trial was racially motivated. "Berry had a longtime business associate and secretary, a white woman named Francine Gillium. The federal prosecutor insulted her, using phrases such as, 'This blonde claims to be a secretary,' and demanding answers to questions such as, 'What kind of secretarial duties do you perform?' and 'Did you tell your people you work for a Negro?'" Berry was convicted and sentenced to three years in jail. He served twenty months.

In 1962 the Department of Justice directed U.S. Attorneys to refrain from prosecuting noncommercial Mann Act violations without approval. Only those connected to kidnapping, rape, or organized prostitution would receive government attention.

J. Edgar Hoover didn't need the Mann Act to carry out personal vendettas against those he perceived to be the enemies of the country. At the time his major target was Martin Luther King, Jr. The head of the FBI had placed King under surveillance in the fifties, when the young minister drew national attention as the leader of the Montgomery bus boycott. Hoover ordered wiretaps on King's home and offices and the hotel and motel rooms where King stayed.

Mark Felt, a deputy associate director of the Bureau, says that Hoover was "outraged by the drunken sexual orgies, including acts of perversion, often involving several persons. Hoover referred to these episodes as 'those sexual things.'" Hoover thought King was a "tomcat with obsessive, degenerate sexual urges."

In 1964, after King criticized the FBI's handling of the murders and church bombings in the South, Hoover decided to use the wiretap evidence he had compiled. He told associates, "It will destroy the burrhead." The task fell to Assistant Director William Sullivan, who swore that King would be "revealed to the people of this country and to his Negro followers as being what he actually is—a fraud, demagogue and moral scoundrel."

The tapes revealed that King was a sexually active male who, according to Curt Gentry, author of *J. Edgar Hoover: The Man and His Secrets,* had enjoyed an "unbuttoned fling" with two female employees of the Philadelphia

Naval Yard. Taylor Branch, in *Pillar of Fire,* writes that on January 6, 1964, the FBI had bugged King's room at the Willard Hotel near the White House. "In the midst of an eventual 11 reels and 14 hours of party babble, with jokes about scared Negro preachers and stiff white bosses, arrived sounds of courtship and sex with distinctive verbal accompaniment. At the high point of the recording, Bureau technicians heard King's distinctive voice ring out above others with pulsating abandon, saying, 'I'm fucking for God!' and 'I'm not a Negro tonight!'"

The Bureau offered highlights of the tapes to the *Washington Post, Newsweek,* the *New York Times,* the *Los Angeles Times,* the *Chicago Daily News,* the *Atlanta Constitution,* and the *Augusta Chronicle.* Not one paper published the story. In the sixties, the private lives of public figures were not considered appropriate subjects for journalism. A decade earlier the story would have been planted in *Confidential* or in Walter Winchell's column.

Frustrated, the FBI sent copies of the tapes to the office of the Southern Christian Leadership Conference, assuming that Coretta King would open the mail. Accompanying the tapes was a letter threatening, "King, there is only one thing left for you to do. . . . There is but one way out for you. You better take it before your filthy, abnormal, fraudulent self is bared to the nation."

The threats and the tapes were ignored. It would take an assassin's bullet to end the dream.

Hoover was not the only man in Washington obsessed with sex. The homosexual witch-hunt of the fifties had spread to all branches of the government and to all sexual orientations. Federal employees were routinely questioned about their sex lives. In March 1965 Congressman Cornelius Gallagher told fellow lawmakers that the government regularly outdid Kinsey, asking male and female federal employees to answer such true-or-false statements as: "My sex life is satisfactory. I enjoy reading love stories. I believe women ought to have as much sexual freedom as men do. I dream frequently about things that are best kept to myself. There is something wrong with my sex organs. I masturbated when I was an adolescent. I have had a great deal of sexual experience."

Both married and unmarried employees had to give written answers to questions asking if they had been troubled by such things as "petting and

necking. Wondering how far to go with the opposite sex. Being too inhibited in sex matters. Feeling afraid of being found out. Being bothered by sexual thoughts or dreams. Worrying about the effects of masturbation."

Tristram Coffin, author of *The Sex Kick,* devoted a chapter to these American inquisitions, noting that a sadistic streak of voyeurism ran through the accounts. "The rationale used to justify this peeping," he writes, "was that a homosexual, an adulterer, a fornicator or a masturbator could, if discovered by communist agents, be blackmailed into turning over government or defense or industrial secrets. This assumed that communists were as thick as flies and were especially sensitive to erotic behavior or were leading innocent typists into sin. Later, when this appeared patently silly, the psychologists moved in and developed a new theory. Sexually aberrant individuals had unstable personalities and might cause personnel problems. Sexual aberration was most loosely defined, and the secretary who had daydreams of a love affair with Brando or the junior executive who kissed the comely chief of files behind the screen at the office party might be adjudged guilty of aberrance."

There were 512 polygraphs scattered through government agencies, including the CIA and the National Security Agency. Before the use of the polygraphs was curtailed following investigations by Congress, the sophisticated developed a strategy. Says Coffin: "In the true or false, reject every statement that might be considered by, say, a conservative congressman as antisocial. You don't like young people with beards, you don't approve of premarital sex relations, you never daydream about sex."

A national concern for our right to privacy was just one of the revolutionary ideas that came out of the 1960s.

The idea that the state had no business in the bedroom was an idea whose time had come. In 1960 the American Law Institute (ALI), a group of judges, attorneys, and professors, issued the final draft of a Model Penal Code that attempted to establish which sexual acts warranted government interference and which did not.

The new code recommended the punishment of "public indecency, prostitution, the public sale of obscenity (not the private production or noncommercial dissemination of obscenity, however), rape, sex with minors, indecent

exposure, bigamy, incest and abortion." But "private behavior will not be punished." The committee drafted a code predicated on the "danger to society rather than moral indignation."

The committee voted overwhelmingly to decriminalize adultery and fornication. When it came to the topic of sodomy, Judge Learned Hand said, "I think it is a matter of morals, a matter very largely of taste, and it is not a matter that people should be put in prison about."

Still, it was a close call. The members voted 35 to 24 to recommend that sodomy be "removed from the list of crimes against the peace and dignity of the state."

The institute stated that the Model Penal Code would "not attempt to use the power of the state to enforce purely moral or religious standards. We deem it inappropriate for the government to attempt to control behavior that has no substantial significance except as to the morality of the actor. Such matters are best left to religious, educational and other influences."

With the publication of the code, a major offensive in the sexual revolution began. In 1961 Illinois became the first state to repeal its sodomy statute, while oddly leaving in place statutes against fornication and adultery. Near the end of the decade three more states—Oregon, Montana, and Connecticut—would adopt more tolerant sex statutes. Others would follow.

Hefner devoted two entire installments of The Playboy Philosophy (February and March 1964) to the absurdity of state sex laws. As a graduate student, he had first expressed his concern in a term paper titled "Sex Behavior and the U.S. Law." Now he used the full power of the magazine to press for acceptance of more liberal legislation. "No human act between two people is more intimate, more private, more personal than sex," he wrote. "And one would assume that a democratic society that prides itself on freedom of the individual, whose Declaration of Independence proclaims the right of every citizen to life, liberty and the pursuit of happiness, and whose Constitution guarantees the separation of church and state, would be deeply concerned with any attempted infringement of liberty in this most private act."

The following month he continued: "America is presumably the land of the free and the home of the brave. But our legislators, our judges and our officers of law enforcement are allowed to enter our most private inner sanctuaries—our bedrooms—and dictate the activity that takes place there."

Other media that covered the ALI initiative downplayed the importance of reform. The statutes under attack admittedly seemed a little out of date, but how many people got arrested? A *Time* story on the original ALI initiative in 1955 had pointed out that actual enforcement was limited. In a single year, the editors noted, only 267 people had been arrested for adultery. Boston led the way with 242 arrests.

When Connecticut considered the Model Penal Code, New Haven police chief James Ahern claimed, "We hardly ever make a morals arrest anymore." The numbers seemed to back him up. *Time* reported that from 1965 to 1968, the number of prosecutions for fornication and lascivious carriage had dropped from 1,048 to 349. One policeman explained what justified an arrest: "When you see a black boy and a white girl together, well, you just know what's going on."

Hefner objected to state interference on principle. But he needed an individual case to drive the point home. In 1965 the magazine received a letter from Donn Caldwell, a radio disc jockey in West Virginia who was serving a ten-year sentence for committing "a crime against nature."

In Caldwell's case the act was fellatio with a teenage fan. Local authorities threatened the girl with prosecution if she didn't testify against Caldwell. Upon Caldwell's conviction, the judge ignored a psychiatric evaluation of the defendant that recommended leniency and, denying bail, remarked that he considered oral sex to be as serious a crime as murder. The case prompted Hefner to establish the Playboy Foundation as the activist arm of The Playboy Philosophy. "To put our money where our mouth was," he said.

The outpouring of sympathy for Caldwell from *Playboy* readers and in the West Virginia press supported a successful appeal of the conviction, funded by the Foundation. It was the first in a series of such cases, including one that led to the release of a husband who was serving a two- to fourteen-year sentence for having consensual anal sex with his wife in Indiana. After a marital spat, the wife had been persuaded by a neighbor to accuse the husband of the "abominable and detestable crime against nature." After the couple reconciled, the wife tried to withdraw the charge only to be told she was no longer the plaintiff. "The State of Indiana is the plaintiff."

The Playboy Foundation also helped free a young girl who was arrested, at her father's request, for fornication. His philosophy: "I'd rather see her in jail than debauched."

Over the years, the Playboy Foundation supplied funding for a series of cases involving birth control, abortion, and sexual behavior. It made significant contributions to sex research (the Kinsey Institute, Masters and Johnson), sex education (the Sexuality Information and Education Council of the United States), and other controversial causes, as well as to civil rights and antiwar initiatives. The Foundation also provided the initial funding for the National Organization for the Repeal of Marijuana Laws.

Tiny skirmishes at first, the fights for the right to privacy would turn into a full-scale crusade.

On November 10, 1961, police arrested Estelle Griswold, the executive director of the Planned Parenthood League of Connecticut, and Dr. Charles Lee Buxton, a physician at the New Haven Planned Parenthood clinic. Their crimes? They had given birth-control information, instruction, and advice to married couples. The clinic had been open for nine days.

The law that they had broken might as well have been drafted by Anthony Comstock, the Connecticut-born puritan who had raised so much hell at the turn of the century. It read: "Any person who uses any drug, medicinal article or instrument for the purpose of preventing conception shall be fined not less than $50 or imprisoned not less than 60 days nor more than one year, or be both fined and imprisoned."

The case arrived before a Supreme Court that had already accepted the American Law Institute's concept of public and private spheres of sex. On June 7, 1965, Justices William O. Douglas and Arthur Goldberg, writing for the majority, declared that marital sex was clearly protected by a right to privacy. "Would we allow the police to search the sacred precincts of marital bedrooms for telltale signs of the use of contraceptives?" wrote the Court. "The very idea is repulsive to the notions of privacy surrounding the marriage relationship."

Justice Douglas waxed poetic. "We deal with a right of privacy older than the Bill of Rights—older than our political parties, older than our school system. Marriage is a coming together for better or for worse, hopefully enduring and intimate to the degree of being sacred."

In a concurring opinion Justice Goldberg invoked a definition of privacy first outlined by Justice Louis Brandeis in a 1928 case: "The makers of our Constitution undertook to secure conditions favorable to the pursuit of happiness. They sought to protect Americans in their beliefs, their thoughts, their emotions and their sensations. They conferred as against the government, the right to be let alone—the most comprehensive of rights and the right most valued by civilized men."

Justice Brandeis had earlier articulated that thought in a dissenting opinion. Now the voice of the majority embraced the right to privacy. It was the first time the Justices used the Ninth Amendment to reflect "the collective conscience of our people" against both federal and state action.

Not everyone was overwhelmed by the victory. The editors of *Life* wondered "what Thomas Jefferson would have thought of the Supreme Court's recent gloss on his immortal handiwork." The right of privacy "may have an interesting future if the Court should apply it to such issues as wiretapping and homosexuality."

The Court soon found additional use for the newly articulated right of privacy. Federal and state agents entered the home of Robert Eli Stanley, a suspected bookmaker, and found three reels of stag movies. They arrested Stanley for "knowingly having possession of obscene matter."

The Supreme Court overturned the conviction: "Whatever may be the justifications for other statutes regulating obscenity," wrote Justice Thurgood Marshall, "we do not think they reach into the privacy of one's own home. If the First Amendment means anything, it means that a state has no business telling a man, sitting alone in his own house, what books he may read or what films he may watch. Our whole Constitutional heritage rebels at the thought of giving government the power to control men's minds."

Two years after the Griswold Planned Parenthood case was decided, Bill Baird was arrested while lecturing to a crowd of students in Boston about contraception. He had handed out samples of spermicidal foam to a female member of the audience, who may have been single. State law prohibited the distribution of articles designed to prevent conception. Massachusetts argued that it had the right to protect morals through "regulating the private sexual lives of single persons."

The case would make its way to the Supreme Court, supported in part by funds from the Playboy Foundation. The Justices scoffed at the idea that the state could hold over its citizens the threat of pregnancy and the birth of an unwanted child as punishment for fornication. In 1972 the Court would argue: "If the right of privacy means anything, it is the right of the individual, married or single, to be free from unwarranted governmental intrusion into matters so fundamentally affecting a person as the decision whether to bear or beget a child."

The following year, this rationale would provide a basis for one of the most controversial decisions of the century. In *Roe vs. Wade,* the Court would extend the right of privacy to include a woman's right to get an abortion.

Hugh Hefner was not the only American to turn a term paper into a publishing empire. In 1941, as a freshman at Swarthmore, Barney Rosset had written on "Henry Miller vs. Our Way of Life." Rosset sided with the iconoclastic. As the head of Grove Press, he published the first unexpurgated American edition of D. H. Lawrence's *Lady Chatterley's Lover.* A long battle had resulted in a surprising victory that would free language forever and remove the brown-paper wrapper from literary sex. Rosset's lawyer had forced the court to acknowledge that culture was sexual.

Into this sea of provocation Rosset tossed more than two million copies of *Tropic of Cancer,* Miller's exuberant account of a writer fucking his way across Paris. Published in 1934, the book had become an underground classic, smuggled in from France by expatriates and students. In the wake of the *Lady Chatterley* ruling, neither Customs nor the Post Office took action.

The 1961 paperback edition topped the charts for two years, despite the fact that nervous dealers returned 600,000 copies. The book was banned in more than nineteen cities and two states, as police visited bookstores, physically clearing shelves and intimidating shop owners. These local vigilantes, claiming to reflect the will of the people, were just as effective as a national censor. Rosset promised to pay the legal costs of any bookseller arrested for offering the book. Defending *Tropic* would cost his company in excess of $250,000.

A Massachusetts judge found Miller to be "filthy, disgusting, nauseating and offensive to good taste." Defense attorney Charles Rembar acknowledged that the author's concentration on lice, turds, and the clap made it a bit difficult to put him in a category with Lawrence, but he persevered. Trials continued in New Jersey, Pennsylvania, California, New York, Florida, and Wisconsin.

Not all judges wanted to burn *Tropic.* In Chicago a professor at Northwestern University brought suit, claiming the police had bullied bookstore owners into dropping the work, thus denying him his freedom to read.

Judge Samuel Epstein weighed the content of the pornographic passages against the overall value of the book and decided against censorship, writing, "Let the parents control the reading matter of their children; let the tastes of the readers determine what they may or may not read; let not the government or the courts dictate the reading matter of a free people. The Constitutional freedoms of speech and press should be jealously guarded by the courts. As a corollary to the freedoms of speech and press, there is also the freedom to read. The right to free utterances becomes a useless privilege when the freedom to read is restricted or denied."

Judge Epstein became the target of crank calls and poison-pen letters. Catholics demanded that he be impeached. The Illinois Supreme Court overruled his decision on June 18, 1964, only to change its mind four days later.

On June 22, 1964, the U.S. Supreme Court declared that *Tropic of Cancer* was not obscene, that for a work to be proscribed it had to be "utterly" without social importance.

Next to rise through the judicial gauntlet was John Cleland's *Memoirs of a Woman of Pleasure,* known simply as *Fanny Hill.* Published in 1749, *Fanny* was, according to an article in *Time,* "the first deliberately dirty novel in English." In a decade in which Americans devoured everything English, from James Bond to the Beatles, *Fanny Hill* was hard to swallow. The Reverend Morton Hill of St. Ignatius Loyola in New York City went on a hunger strike, which ended when the mayor launched an antipornography drive, one that targeted *Fanny Hill.*

On July 8, 1963, the city took action. In his affidavit, the corporation counsel attacked *Fanny:* "Described in lurid detail are repeated meticulous recitals of sex acts, including acts of sexual perversion, set forth in a style which is a blow to the sense of the reader, and for the evident purpose of teaching the reader about sins of impurity and arousing him to libidinousness. In its 298 pages, the book describes in detail instances of lesbianism, female masturbation, the deflowering of a virgin, the seduction of a male virgin, the flagellation of male by female and female by male and other aberrant acts, as well as more than 20 acts of sexual intercourse between male and female, some of which are committed in the open presence of numerous other persons, and some of which are instances of voyeurism."

Fanny Hill won in New York, the decision upheld on appeal. Attorney Rembar had to fight the same battle in Massachusetts and New Jersey, building a trial record of experts testifying that *Fanny Hill* possessed literary merit and psychological value. When *Fanny* reached the Supreme Court, Rembar told the Justices that they did not even have to read the book, that both the critics and the lower courts felt the book had value, thus placing it outside the reach of the law. On March 21, 1966, the Court agreed.

On the same day that they freed *Fanny Hill,* the Justices sent publisher Ralph Ginzburg to jail. Ginzburg's soft-core quarterly, *Eros,* was not sexually explicit nor patently offensive, but the way in which he advertised the publication seemed to convey the "leer of the sensualist."

According to the Court, Ginzburg had requested bulk-mailing privileges from Blue Ball, Pennsylvania, and Intercourse, Pennsylvania. Twice rejected, he was successful in his effort to mail five million advertisements for *Eros* from Middlesex, New Jersey. Ginzburg, said the Court, was an expert "in the shoddy business of pandering." An outside observer remarked that Ginzburg's only crime was being a smartass.

But the floodgates had opened. By the end of the decade *Fanny* would be joined by *The Story of O,* [*The Memoirs of the Marquis de Sade,*] Terry Southern's *Candy,* William Burroughs's *Naked Lunch,* and Frank Harris's *My Secret Life* as well as such work as *Sex Life of a Cop, Sex Kitten,* and *College for Sinners.*

Philip Roth gave us Portnoy, with his fist flying, coming in the wrapper of a Mounds bar in the balcony of a theater, coming in an old sock, using a

cored apple as a masturbation aid, coming on liver ("I fucked my own family's dinner"), ejaculating on lightbulbs, exercising the only part of his body that was his, that was free.

Literature used sex as a window on the soul. Writers took us inside the sex act, filling it with other meanings. The hero of John Updike's *Couples* (1968) would muse on oral sex: "To eat another is sacred." The protagonist of Norman Mailer's *An American Dream* (1965) would murder his wife, then sodomize the maid, experiencing "the pure prong of desire to bugger." Kate Millett would find in that three-page scene the seeds of her 1970 feminist manifesto *Sexual Politics*. Where some women found liberation in the sex act, others found a microcosm of oppression.

Sexual writing revealed what Malcolm Cowley had called the secret language of men—"words that were used in the smoking room, in the barroom, in the barbershop"—words that no respectable woman would admit knowing. Now those words came to symbolize for some not freedom but the howls of the beast.

The battle over obscenity was not limited to courtrooms and the dry arguments of lawyers and judges. Barney Rosset would walk to work one day and find that someone had thrown a grenade into the Manhattan offices of *Evergreen Review* magazine, a product of Grove Press that combined erotica with left-wing politics.

As free expression gained support in the courts, there were those who organized new forms of repression. In 1958 Charles Keating, a Catholic businessman in Cincinnati, created Citizens for Decent Literature. By 1964 there were 200 chapters of the CDL scattered across the country. By 1965, 300 chapters claimed a combined membership of 100,000. Some 1,000 delegates would attend a CDL conference in 1965.

Keating was an odd bird. Charles Bowden and Michael Binstein, authors of *Trust Me: Charles Keating and the Missing Billions,* report that when Keating met Mary Elaine Fette, the woman who would become his wife, he took her to a striptease joint. He pounded a cane on the floor, shouting, "Take it off. Take it off." But he would "not let Mary Elaine lift her eyes and see the naked woman who dances before them."

In the fifties, the local FBI office had briefly investigated Keating for possible fraud and espionage (involving a deal with atomic scientists) and warned J. Edgar Hoover to distance himself from Keating. More than one state looked at the CDL's cost-to-cause ratio, and decided that the group was raising money for self-indulgence, not decency.

Keating was a one-man crusade. Before a speech he would cruise newsstands to buy such periodicals as *Love's Lash, Sensational Step Daughter,* and *Lesbian Lust.* He would wave magazines in the faces of church groups, offer to read the most offensive passages aloud to congressmen. By 1969 he would recruit four senators and seventy representatives to the honorary committee of the CDL. The authors of *Trust Me* point out that one of those, Representative Donald Lukens, would be convicted twenty years later of having sex with a minor.

Delegates to conventions got to stroll through the CDL's private stash of smut: nudist magazines, paperbacks, a yearbook showing high school students reading *Playboy,* and, finally, a cheap novel called *Youth Against Obscenity.* The novel claimed to be an exposé of a CDL-type movement: "In the crowded auditorium they preached and screamed about obscenity in magazines, but on secluded beaches and in private bedrooms they enjoyed their sex in about every imaginable way."

Keating cloaked his crusade in apocalyptic visions. On a 1963 television show called *News Impact: Eyes of the Storm* he said, "If the filth peddlers are allowed to freely infiltrate and deprave our community, pervert an entire generation, if they have their way, then I think our civilization is doomed, as 16 of the 19 major civilizations in the history of the world have been doomed."

Hefner called attention to the CDL in the twelfth installment of the Philosophy, calling it a front for the National Organization for Decent Literature, a Catholic group that had tried to expand its power from declaring books unfit for Catholics to banning books for all denominations.

Keating was a classic fearmonger. He told Congress that mail-order porn "causes premarital intercourse, perversion, masturbation in boys and wantonness in girls and weakens the morality of all it contacts." He dismissed the expertise of Kinsey and sexologists Eberhard and Phyllis Kronhausen, claiming that they wanted only to disseminate "dirty bleatings and pagan ideas."

He embodied the nineteen-century attitude toward masturbation. "I take for granted that most people think that it is a very bad thing and very danger-

ous to the physical and mental health and the moral welfare of the people who have the habit," he testified. "But we had a psychiatrist [a defense witness for adult magazines] on the stand in Cincinnati recently who said, 'Sure, these magazines stimulate the average person to sexual activity, but it would be sexual activity which would have a legitimate outlet.' The prosecutor said to him, 'Doctor, what is a legitimate or socially acceptable outlet for an 18-year-old unmarried boy?' The doctor answered, 'Masturbation.' When you are met with that kind of situation, you begin to wonder."

Keating traveled from city to city, encouraging and inciting militant action, letter-writing campaigns, and good old-fashioned political pressure. One newspaper gave the CDL credit for 400 arrests, among them those of Lenny Bruce and Hugh Hefner.

Lenny Bruce's bawdy, unabashed humor had attracted the attention of police in San Francisco, Los Angeles, Chicago, and New York. Yes, he used words such as "cocksucker" and talked about men fucking mud. But he raised serious issues about sexual morality, religion, and other subjects of controversy. Hefner could write about the same topics in the privacy of his mansion. Bruce was in your face, and he paid the price.

The Chicago bust in December 1962 at the Gate of Horn nightclub was clearly religiously motivated. Bruce took on organized religion with lines such as "Let's get out of the churches and back to religion."

Police also threatened Alan Ribback, the owner of the Gate of Horn. After the bust, one of the cops cornered Ribback and told him, "I want to tell you that if this man ever uses a four-letter word in this club again, I'm going to pinch you and everyone in here. If he ever speaks against religion, I'm going to pinch you and everyone in here. Do you understand? I'm speaking as a Catholic. I am here to tell you your license is in danger."

Lenny Bruce was the final victim of the blacklist mentality, one of the last political prisoners of the sexual revolution. The Gate of Horn bust and others that followed made him unemployable. The collusion of state and church deprived him of the right to work, the right to speak, the right to live. He died of a drug overdose in 1966. After his death, higher courts would at last overrule his convictions.

Hefner became the target of behind-the-scenes CDL intrigue in June 1963. One late afternoon, police rousted him out of bed and charged him with

publishing and distributing an obscene publication. The obscenity in question? Pictures of a nude Jayne Mansfield from the film *Promises, Promises!* Chicago Corporate Counsel John Melaniphy claimed that captions describing the actress as "she writhes about seductively," or as "gyrating," aroused "prurient interests and defeat any claim of art." Say what?

The Supreme Court had held that nudity was not in itself obscene. The city fathers surely knew that, but Melaniphy went ahead with the arrest and subsequent legal charade to appease the CDL. At least one newspaper detected the ruse. An article in *The New Crusader* declared, "The Citizens for Decent Literature, a group of Victorian housewives, still smarting from the effects of a recent edition of *Playboy* magazine's Philosophy that hailed the Supreme Court for liberalizing obscenity tests, prevailed upon the office of John Melaniphy, city prosecutor, to secure a warrant for Hefner." The creation of an enemies list was central to the CDL.

In 1968 Chief Justice Earl Warren volunteered to step down during the current term so that President Lyndon Johnson could promote Justice Abe Fortas to the top spot. The CDL arranged a counteroffensive that became known as the Fortas Obscene Film Festival. Collaring legislators and members of the media, the CDL projected *Target Smut,* a 35mm slide-and-film history of twenty-six Supreme Court decisions that were, it said, "directly responsible for the proliferation of obscenity in this country." Senators got to view films such as *Flaming Creatures* (Jack Smith's classic tribute to transvestites) and assorted porn loops.

Senator Strom Thurmond acted as projectionist, feeding quarters to a coin-operated movie projector. Bruce Allen Murphy, author of *Fortas: The Rise and Ruin of a Supreme Court Justice,* tells how some twenty reporters and editors watched as "an attractive young girl was doing a striptease down to her garter belt and transparent panties. For 14 minutes the actress undressed and writhed erotically, with the camera repeatedly focusing on various parts of her anatomy, ensuring that no viewer missed the point."

Within the course of a year, lawmakers introduced twenty-three bills targeting smut. Columnist James Kilpatrick would say, "Boil the issue down to this lip-licking slut, writhing carnally on a sofa, while a close-up camera dwells lasciviously on her genitals. Free speech? Free press? Is this what the Constitution means?"

The CDL helped to block the Fortas nomination. Under pressure from religious groups, Lyndon Johnson appointed a President's Commission on Obscenity and Pornography. Social scientists would spend nearly $3 million in the first serious study of the presumed effects of explicit erotica. President Richard Nixon declared the commission "morally bankrupt." Upon election he declared, "So long as I am in the White House there will be no relaxation of the national effort to control and eliminate smut from our national life."

In one of his first acts in office, Nixon appointed Charles Keating to the commission.

America witnessed a changing of the censorial guard. As the CDL gained power, the old order of Catholic bluenoses, the Legion of Decency, disbanded. Monsignor Little, the executive secretary of the Legion, retired in late 1965, saying that he preferred "to die in the stations of the cross, not looking at Gina Lollobrigida."

In 1965 when Sidney Lumet directed *The Pawnbroker,* the film was denied Production Code approval, and was banned by the Legion of Decency (which would soon call itself the National Catholic Office for Motion Pictures). The film was a serious study of a Jew haunted by his experiences in a Nazi prison camp. A critical scene showed a black prostitute baring her breasts for Rod Steiger. The event triggered a flashback to a concentration camp scene, where Steiger's character had been forced to watch his wife being raped by soldiers. History had one truth, the Production Code another. Since 1934 Hollywood films had included not a hint of nudity. What made this ludicrous was that nudity was now commonplace in independent and foreign films and in mainstream magazines such as *Playboy*

Lumet appealed. The Motion Picture Association of America relented. The MPAA scrapped the Production Code, replacing it with a simple formula "designed to keep in close harmony with the mores, the culture, the moral sense and the expectations of our society." Jack Valenti introduced a warning for films that were "suggested for mature audiences only."

To get a sense of the arc of the sixties, consider the careers of individual stars. Natalie Wood, having grown from the little girl in *Miracle on 34th Street* (1947), began the decade with the steamy *Splendor in the Grass* (1961). She

played a teenager driven to attempt suicide by social taboos that forbade an illicit affair with Warren Beatty. (Offscreen the two consummated the relationship and broke up Natalie's marriage to Robert Wagner.) In 1969 she played a would-be spouse-swapper in Paul Mazursky's hilarious look at extramarital sex, *Bob & Carol & Ted & Alice.* (The film depicts middle-aged couples trying to pass as swingers and gave us the memorable line: "Okay, first we'll have an orgy, and then we'll go see Tony Bennett.")

Jane Fonda debuted in *Tall Story* in 1960, a light comedy about a cheerleader who goes to college to catch a husband. But she followed that with the role of a prostitute in *Walk on the Wild Side* (1962), and the sci-fi fantasy *Barbarella,* made in France for Roger Vadim in 1968. The movie opens with a weightless striptease, then follows Fonda through one sexual misadventure after another. Strapped into a torture device called the Excess Pleasure Machine, she defeats the villain (and destroys the machine) with the best orgasm scene since Hedy Lamarr's triumphant *Ecstasy.*

Hollywood filmmakers were still nervous about portraying sex and nudity; they would merely imply oral sex and impotence in a film like *Bonnie and Clyde* (1967), yet at the same time celebrate new levels of explicit violence.

Foreign films filled the art theaters and Americans saw things they had never seen before. Fellini's *La Dolce Vita* (1960) was a blueprint for "hedonism and debauchery." Michelangelo Antonioni's *Blowup* (1966) provided a glimpse of pubic hair when David Hemmings wrestled with two models in a photo studio. *I Am Curious (Yellow)* (1967) showed an unabashedly nude Lena Nyman casually stroking Börje Ahlstedt's postcoital penis, not to mention simulated intercourse in trees and ponds and on city streets. These examples are vivid because they are rare. While major writers explored themes such as masturbation, sodomy, and sadomasochism, filmmakers tested boundaries, then withdrew from the field.

Independent filmmakers tackled nudity head-on. The phenomenon was most visible on the grind-house circuit—the outlaw theaters that showed Adults Only fare. Russ Meyer created a new genre of "nudie cuties," beginning with 1960's *The Immoral Mr. Teas.* The hero had the uncanny ability to undress women with his eyes—a simple enough plot, on which Meyer hung the sort of pin-up nudity found in *Playboy.* Indeed, Meyer had worked as a photogra-

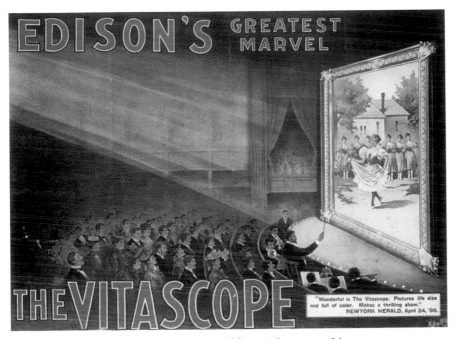

An 1896 ad for Thomas Edison's dream machine.

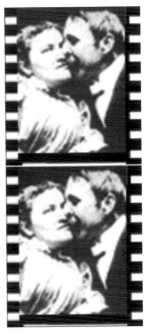

Still from *The Kiss*, circa 1896.

Ad for Warner Bros. corsets, circa 1900.

Albert Todd's electrified anti-masturbation device, 1903.

Actress Anna Held's perfect figure.

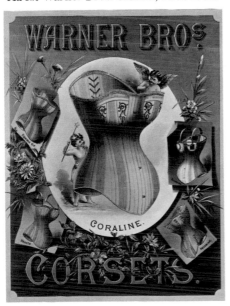

Hand-tinted postcard of
Evelyn Nesbit, circa 1901.

 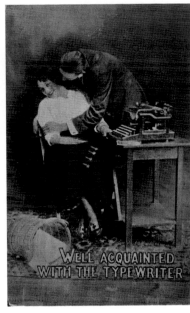 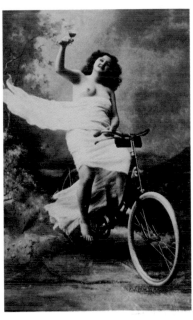

Postcards and magazine photos, circa 1900–1910, portrayed changing sex roles.

A cigar band, circa 1900, displayed the risque art of Adolphe-William Bouguereau.

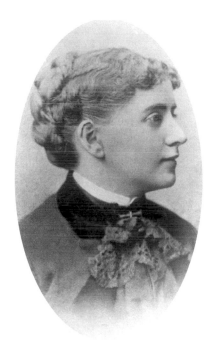

Ida Craddock, author and sex activist.

Seal of The New York Society for the Suppression of Vice.

Anthony Comstock, Secretary of the Society from 1872 until his death in 1915.

From virgin to vamp: A calendar depicting Paul Chabas's *September Morn* drew Comstock's ire in 1913.

Unlikely sex symbol Theda Bara made her film debut in 1915 in *A Fool There Was.*

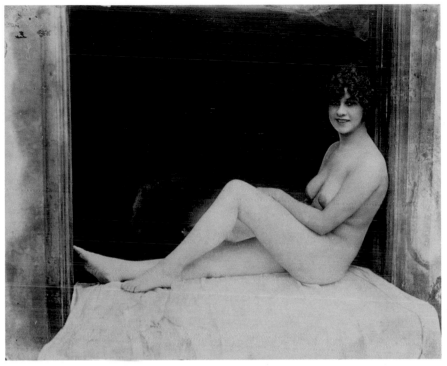

E. J. Belloq's portrait of a prostitute in New Orleans's red light district, Storyville, circa 1903.

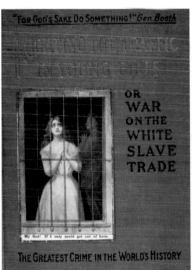

Cover of *Fighting the Traffic in Young Girls*, circa 1910.

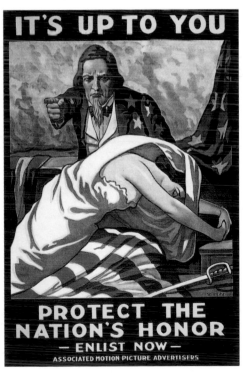

Hollywood goes patriotic: WWI recruiting poster, circa 1917.

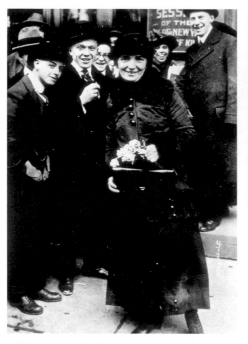

Birth control advocate Margaret Sanger outside the New York State Court of Appeals in 1917.

1918 ad for Woodbury's soap, also available as a wall hanging.

Sheet music covers of the 1910s were sexually suggestive and helped to sell millions of copies.

Alberto Vargas perfected his art creating posters and sheet-music covers for the Zeigfeld Follies.

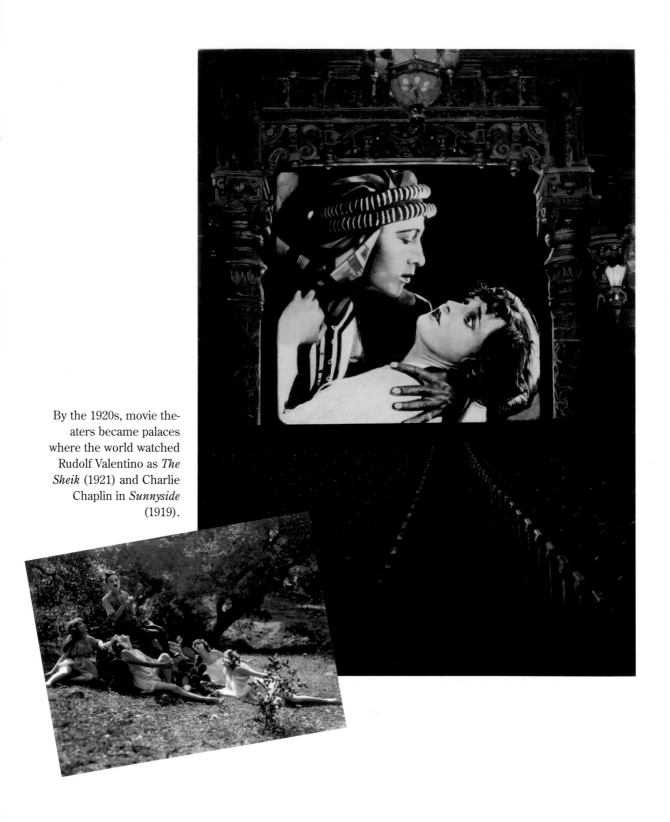

By the 1920s, movie theaters became palaces where the world watched Rudolf Valentino as *The Sheik* (1921) and Charlie Chaplin in *Sunnyside* (1919).

Autographed publicity still of film star
Roscoe "Fatty" Arbuckle.

Anthropologist Margaret Mead claimed to have found
sexual paradise on Samoa.

Popular magazines heralded changing sex mores: John Held's flapper encountered Freud on
the cover of *Life*, in 1926; H.L. Mencken's *Smart Set* offered true stories from real life.

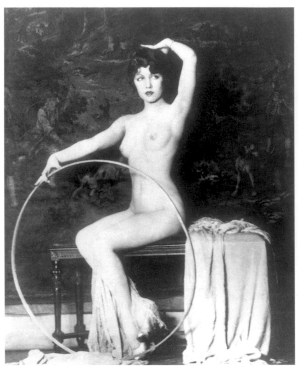

A figure study of a Ziegfeld Girl, circa 1930.

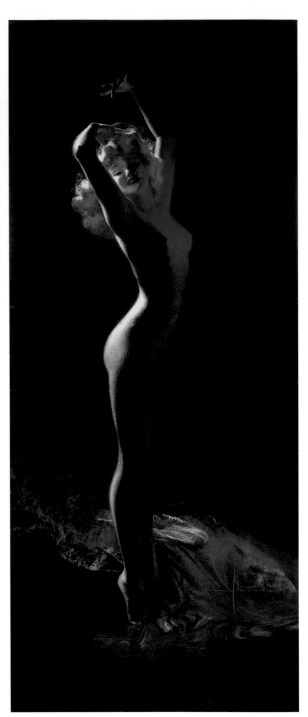

Advertising trinket, circa 1920. For full effect, cover her face and turn upside down.

Rolf Armstrong's nude calendar art, circa 1926.

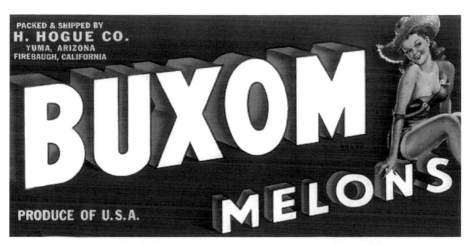

Fruit crate art, circa 1930.

Below left: Carmen brand condom package, circa 1930.

Below right: Sex and the Sunday comics: Panel from *Flash Gordon*, which debuted in 1934.

Panels from a depression era eight-pager, which were also known as "Tijuana Bibles."

Mae West shattered taboos on the stage
and screen.

J. Edgar Hoover, sex cop, ran the FBI from
1924 to 1972.

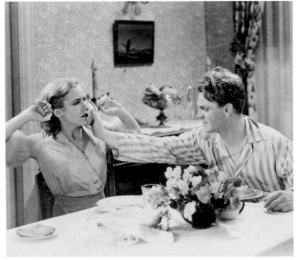

Two versions of the battle between the sexes: Clarke Gable and Claudet Colbert in *It Happened One Night*
(1934); Mae Clarke and James Cagney in *Public Enemy* (1931).

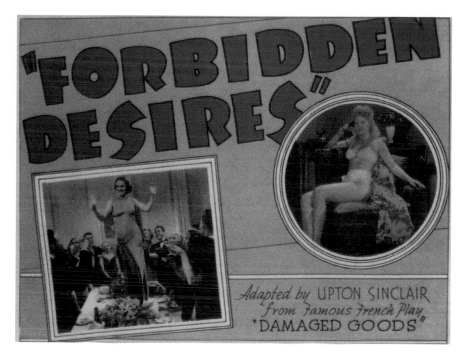

The lobby card for *Forbidden Desires*, a repackaged 1935 film about venereal disease.

The *Esquire* Petty Girl debuted in 1933.

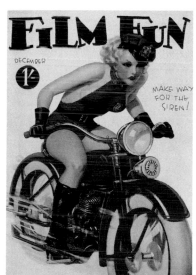

1930s pulp magazine covers exuded a wholesome sexuality: note the National Recovery Administration symbol on *Cupid's Capers*.

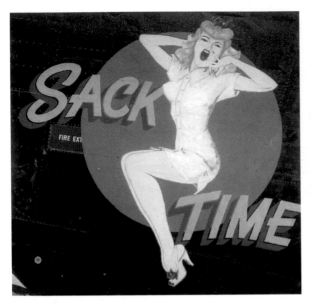
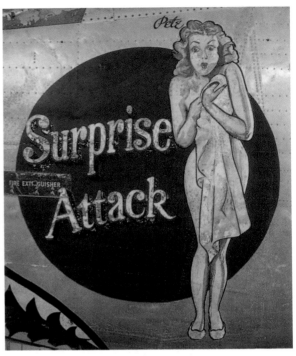
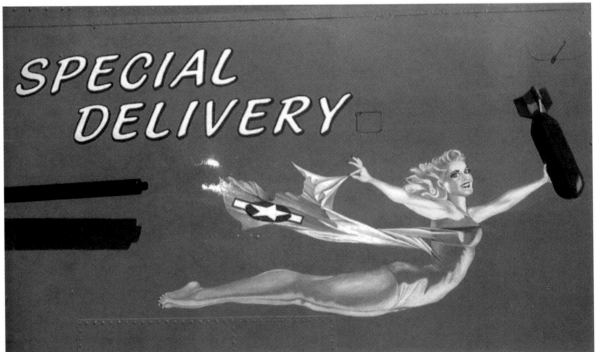

In World War Two, pin-up girls became bomber art.

The many faces of Eve: The damsel in distress returned in WWII poster, circa 1942. An entirely different image of women surfaced in sex-hygiene films, Sad Sack cartoon panels, and VD posters.

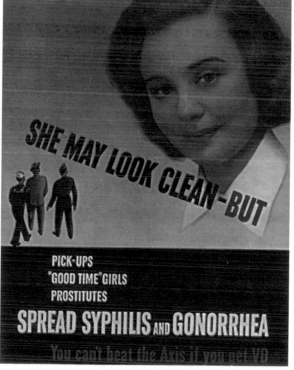

The American male as wolf in Tex Avery's
Swingshift Cinderella (1945).

Above: The Pin-up:
Publicity still of Betty
Grable, 1942.

Right: Poster for Howard
Hughes's 1946 film *The
Outlaw*.

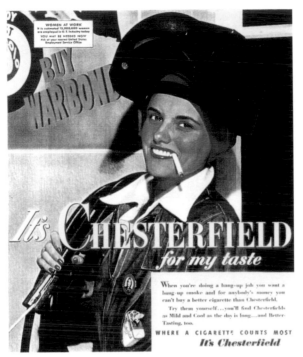

A WWII Chesterfield ad celebrated Wanda the Welder.

Alfred Charles Kinsey's landmark surveys revealed the sexual behavior of American men and women.

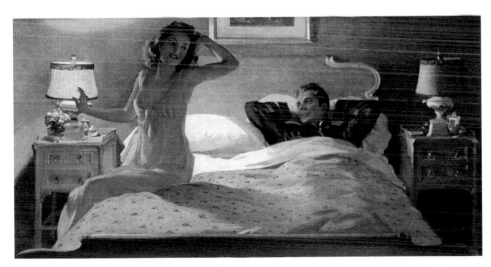

A 1941 Beautyrest ad depicted the ideal American bedroom of the era.

Matchbook covers paid tribute to the less heralded V-girls.

Barbie made her debut in 1959.

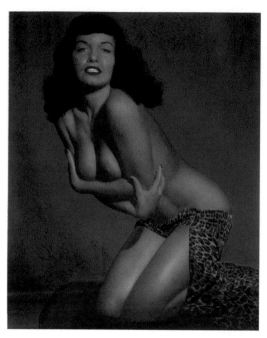

Have body, will pose: 1950s photographer's delight Betty Page.

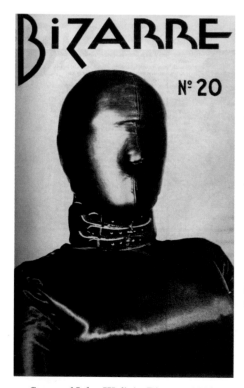

Cover of John Wylie's *Bizarre*, 1956.

Hugh Hefner in 1953, with cover of first *Playboy*.

Opposite: Marilyn Monroe centerfold from the first issue of *Playboy*, 1953.

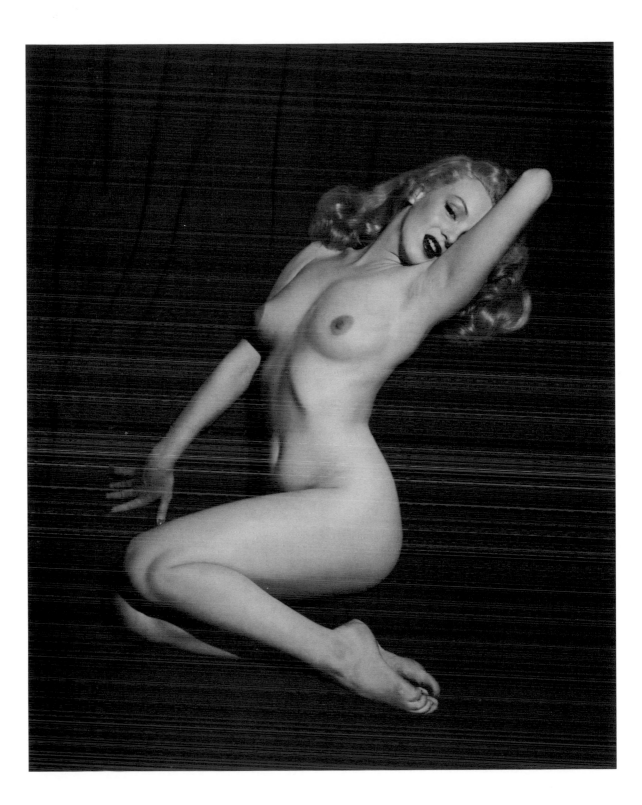

Pulp sex from the fifties: A cover of a Mickey Spillane paperback mystery; the comic book *Crime* launched a congressional investigation; *Archie* comics celebrated the American teenager.

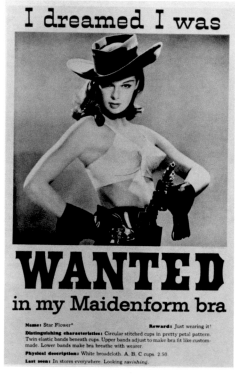

Femme fatale: A Maidenform ad, circa 1954.

Male fatale: Elvis in 1957's *Jailhouse Rock*.

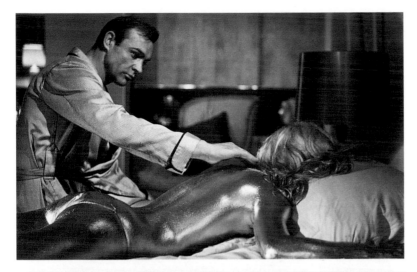

Sean Connery as James Bond in *Goldfinger* (1964).

Chet Suski's illustration for a *Playboy* article on "Sex, Ecstasy, and Psychedelic Drugs."

Timothy Leary, advocate of free love and LSD.

Playboy in Vietnam.

Ad for clothing store from the underground
newspaper *Chicago Seed*.

Poster for the Broadway musical *Hair*, 1968.

Playboy bunnies Virginia, Ashlyn, and Kiko in
action, circa 1963.

Sophisticated cinema:
a lobby card featuring
Sue Lyon for Stanley
Kubrick's *Lolita*
(1962); the poster for
The Graduate (1967).

Sex researchers William Masters and Virginia Johnson.

The hippy as free love icon: R. Crumb underground comic (1968); Goldie Hawn on "Laugh-In" (1968); John and Yoko on the album cover of *Two Virgins* (1968).

Richard Fegley's photo illustration for a 1972 *Playboy* article called "My First Orgy."

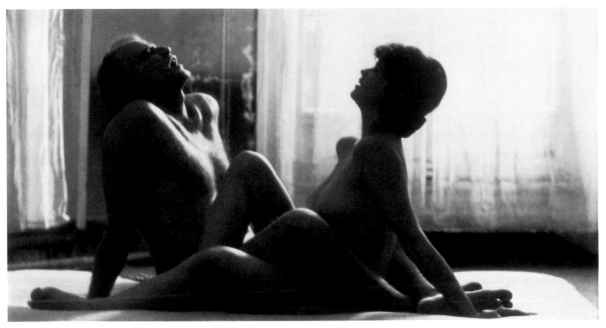

Marlon Brando and Maria Schneider in Bernardo Bertolucci's *Last Tango In Paris* (1972).

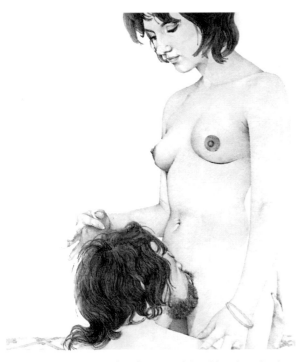

The unnamed couple who posed for Alex Comfort's 1972 book *The Joy of Sex*.

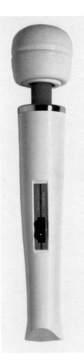

The Hitachi Magic Wand.

Cover of Erica Jong's *Fear of Flying* (1973).

Porno chic: Linda Lovelace from a 1973 *Playboy* pictorial "Say Ah"; Marilyn Chambers with Ivory Snow box.

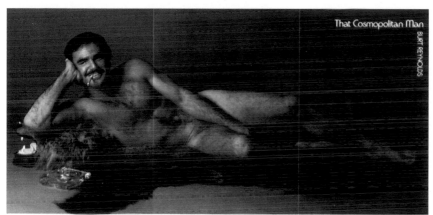

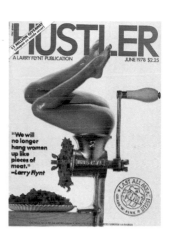

Actor Burt Reynolds's nude centerfold from *Cosmopolitan* (1972).

1978 *Hustler* cover.

Controversial promo shot for The Rolling Stones's 1976 album *Black and Blue*.

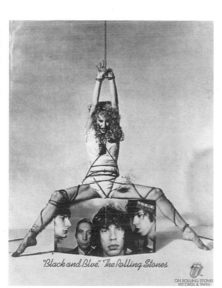

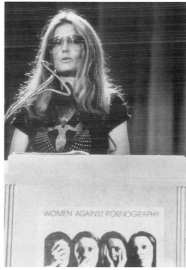

Gloria Steinem speaking to the 1979 Women Against Porn conference.

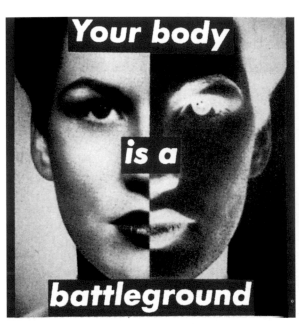

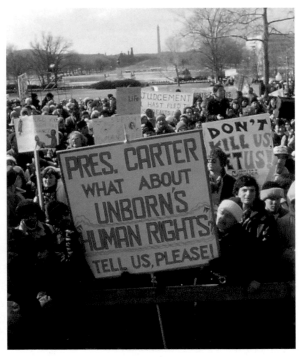

Artist Barbara Kruger's 1989 silk-screen poster for the
Washington abortion rights march.

Antiabortion forces march on Washington in 1979.

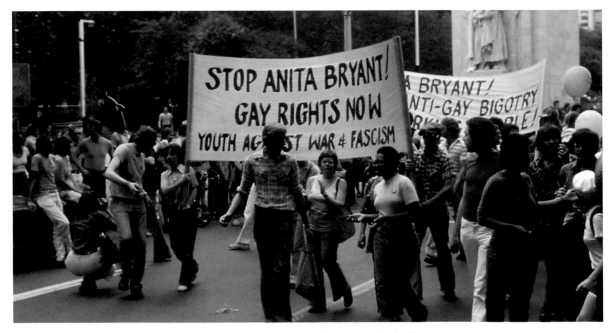

Late 1970s gay-pride parade in New York City.

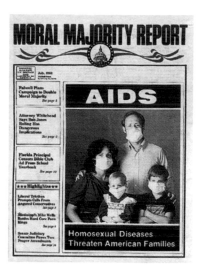

Fear of sex: Mainstream media declared that herpes was "The New Scarlet Letter," and announced "The End of Sex"; Jerry Falwell's Moral Majority exploited the AIDS epidemic.

Benneton's much-censored safe-sex ad, circa 1991.

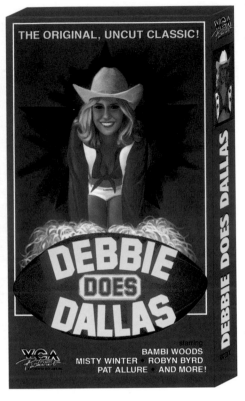

In the 1980s, video-cassettes put porn (including *Debbie Does Dallas*) in the bed-room.

Celebrity skin: Demi Moore appeared nude—and painted—on the cover of *Vanity Fair* in 1992.

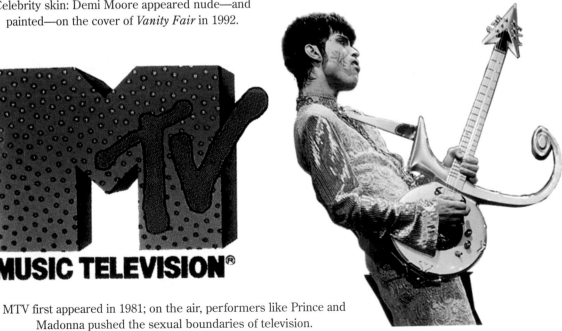

MTV first appeared in 1981; on the air, performers like Prince and Madonna pushed the sexual boundaries of television.

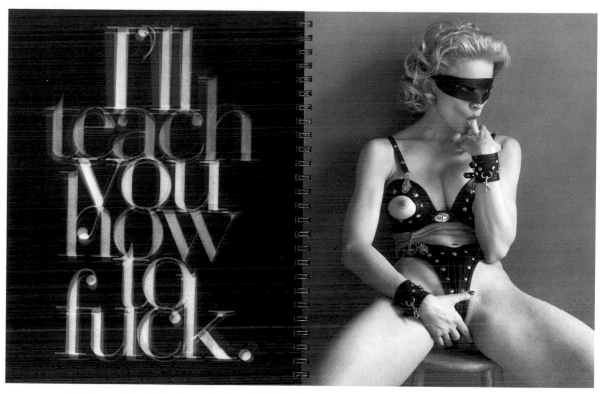

Madonna shared her fantasies in a 1996 book of photographs and erotic fables called *Sex*.

Anita Hill at the 1991 confirmation hearings of Clarence Thomas.

Ken Starr surrounded by reporters at the height of his investigation of President Clinton in 1998.

Supermodels Emma Sjoberg, Tatjana Patitz, Heather Stewart-Whyte, Fabienne Terwinghe, and Naomi Campbell use nudity as a form of social protest against fur, 1994.

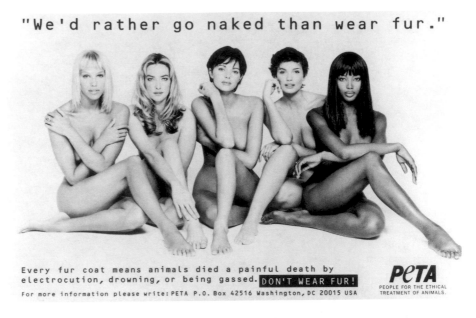

1992 cover of *Future Sex* magazine.

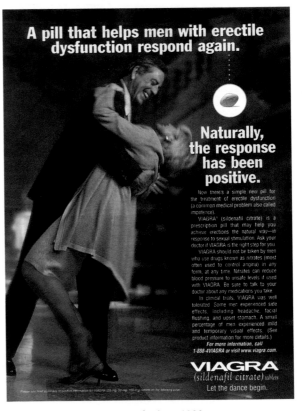

Viagra ad, circa 1999.

pher for *Playboy.* His wife, star, and coproducer, Eve Meyer, was Miss June 1955. He churned out films that featured big-breasted women and square-jawed men, with titles such as *Eve and the Handyman, Lorna, Mondo Topless, Mudhoney,* and *Faster Pussycat, Kill! Kill!* Nudity filled theaters by showing what television and mainstream films could not: the naked female form.

Eddie Muller and Daniel Faris, two fans of the sexploitation circuit, claim the nudie cutie films created stars such as Marsha Jordan. In *Grindhouse,* they explain why. "She had no qualms about doing Adults Only movies because at the time it meant she only had to show her body, not do anything particular with it. Within a few years Jordan was headlining films by most of the major Adults Only producers: *The Golden Box, Lady Godiva Rides, Brand of Shame, Office Love-In*—through them all Marsha performed make-believe sex with numerous men and women." Hollywood sex stars from the fifties such as Jayne Mansfield and Mamie Van Doren had made similar films, baring all in *Promises, Promises!* and *Three Nuts in Search of a Bolt* when their careers began to fade.

The nudie cuties, too, provided a training ground for filmmakers. Before Francis Coppola completed studies at UCLA, he directed *Tonight for Sure*—a nudie Western.

But something else was going on in the grind houses. When real sex is taboo, the impulse becomes perverted and crops up in bizarre, fetishistic images. A legion of films called roughies subjected the female form to abuse. Muller and Faris, in *Grindhouse,* explain the thinking behind a film called *Blood Feast:* "In 1963 the sight of a single pubic hair could bring out the riot squad. A penis penetrating a vagina? Showing that was absolutely inconceivable. But what about a knife? Or better yet, an ax?" The film starred fresh-faced Playmate Connie Mason and featured dismemberment and blood-splattered human sacrifice. *Blood Feast,* of course, made millions.

Film fare would soon become kinkier. *White Slaves of Chinatown* (1964) would show young girls manacled and whipped by Olga the dominatrix. Olga returned with her whip in *Olga's House of Shame.* Nazis appeared as sadistic beasts in *Love Camp 7* to torture female prisoners. The animosity was not directed solely at women. Sometimes the victims were men. Lila, the heroine of *Mantis in Lace,* was billed as "just another psycho stripper with a meat ax."

During the silent era, mainstream filmmakers had combined sex and horror. Low-budget horror films had placed women at risk for decades. Alfred Hitchcock traumatized a generation with the unforgettable shower scene in his 1960 hit *Psycho*. (He'd left a great deal to the imagination.) But by the end of the decade, filmmakers would build slow-motion ballets of blood and bullets in such films as *Bonnie and Clyde* and *The Wild Bunch*.

Tom Wolfe called it pornoviolence. "In the new pornography," he wrote, "the theme is not sex. The new pornography depicts practitioners acting out another murkier drive: people staving teeth in, ripping guts open, blowing brains out and getting even with all those bastards." He traced the phenomenon to the aftershock of the Kennedy assassination, the "incessant replay, with every recoverable clinical detail, of those less than five seconds in which a man got his head blown off."

The authors of *Grindhouse* make the same point: "Before the rifle's report had faded, the nation seemed hopelessly lost in nightmarish terrain. The jungles of southeast Asia consumed American boys, and no one could explain why. Robert Kennedy, Malcolm X and Martin Luther King, Jr., were all murdered by gunfire. Outraged African Americans tore apart Watts. Paranoia struck deep. Conspiracy theories suggested that maybe we weren't the good guys anymore. Charles Manson babbled and fresh-faced California girls slaughtered people for him. With all this roiling through the culture, is it any wonder that Adults Only movies, almost overnight, went from bouncy frolics to brutal rapes?"

Jack Valenti responded to the tumult by creating a new rating system for Hollywood films, dividing them into four categories: G, PG, R, and X. The last category proved to be a mistake. The MPAA wanted a rating system that would allow legitimate filmmakers to tackle mature topics without their works being confused with Adults Only exploitation flicks. The rating scheme backfired.

Midnight Cowboy, John Schlesinger's 1969 tale of a hustler, earned an X rating. The film proved that sex and excellence were not mutually exclusive. *Midnight Cowboy* won three Academy Awards.

In 1968 Russ Meyer filmed the soft-core *Vixen* for $72,000, slapped on his own X, and took the rating all the way to the bank. (The film grossed $6 million in two years.)

The independent filmmakers usurped the X rating. By the next decade, X and XXX would represent hard-core. The X floated like crosshairs on a scope; it was only a matter of time before a film would go all the way.

If sex was the politics of the sixties, it wasn't a two-party system. The changes that swept the country—the revolutions toward racial equality and gender equality—took longer to liberate sexual minorities.

The numbers started small. At the beginning of the decade, the San Francisco chapter of the Mattachine Society (viewed as a gay counterpart to the NAACP and the Anti-Defamation League) could claim 200 members. Its monthly magazine, filled with articles and fiction on homosexuality, reached 2,500 readers. A Los Angeles–based magazine, *One,* reached 5,000.

The growing awareness of the gay community can be traced in the day's headlines. A September 11, 1963, issue of *The Christian Century* asks: HOMOSEXUALITY: SIN OR DISEASE? By the end of that year, the *New York Times* would assign a reporter to cover "the city's most sensitive open secret"—that gays had become visible. In 1964 *Life* published "The Gay World Takes to the City Streets," a pictorial essay on modern gay life, complete with an article that seemed like a road map to the territory staked out by homosexuals. John D'Emilio and Estelle Freedman, the authors of *Intimate Matters,* suggest that the media created beacons for gays; these exposés sparked migrations to Greenwich Village, Times Square, Chicago's Bughouse Square, Hollywood's Selma Avenue, San Francisco (which had more than thirty gay bars), and the warmer climes of New Orleans and Miami.

Increased visibility in turn began to draw more gays from the closet. In 1967 the *New York Times Magazine* ran an article that proclaimed: "A Four Million Minority Asks for Equal Rights."

Drew Shafer, an officer of the North American Homophiles Conference, declared, "The average homosexual is a person who spends his entire life in hiding. He would really like to feel like a citizen, like every other person. Not ill but free. A real human being." According to Shafer, a gay person wants "to be free to pursue homosexual love, free to serve in the armed forces, free to hold a job or advance in his profession, free to champion the cause of homosexuality."

Shafer also championed the cause of gay marriage, but the *Times* concluded that "professional scholars of homosexual culture cannot foresee any institutional equivalent of matrimony for homosexuals. The average homosexual marriage lasts at most three or four years."

Gays picketed the White House and began to forge political alliances. In 1955 the ALI had voted to decriminalize gay sex: "No harm to the secular interests of the community is involved in atypical sexual practice in private between consenting adult partners. This area of private morals is the distinctive concern of spiritual authorities."

In 1967 the ACLU would come out for gay rights, saying, "The state has a legitimate interest in controlling, by criminal sanctions, public solicitation for sexual acts, and particularly sexual practices where a minor is concerned," but that "the right of privacy should extend to all private sexual conduct and should not be a matter for invoking penal statutes."

By the end of the decade gays had begun to take their place at the cultural table. Matt Crowley's 1968 play and subsequent movie, *The Boys in the Band,* presented a thought-provoking portrait of homosexual men.

And gays found unexpected allies. The National Institute of Mental Health formed a task force on human sexuality, with a "special focus on homosexuality." The FBI, which for years had hounded gays under J. Edgar Hoover's Sex Deviates program, broke up a seventy-man antigay extortion ring. Gang members would entice victims into hotel rooms, then associates would break in posing as police officers. According to the *New York Times* the victims included "two deans of Eastern universities, several professors, business executives, a motion picture actor, a television personality, a California physician, a general and an admiral, a member of Congress, a British theatrical producer and two well-known singers." To maintain silence, the victims (some 700 homosexuals and bisexuals scattered across the United States) had paid hundreds of thousands of dollars.

A gay man's sexual preference came fully equipped with paranoia. Articles pointed out what gays had always known—that every approach might result in arrest, humiliation, or worse. Police might claim tolerance, and point to declining arrest statistics. (Between 1965 and 1969 annual arrests dropped from 800 a year to fewer than 80 in New York.) Illinois may have decriminalized sodomy in 1961, but Chicago police still made a hundred arrests in one

year for public solicitation. Los Angeles police, armed with an educational pamphlet that warned that homosexuals wanted "a fruit world," made 3,069 arrests in 1963. A "token number," said Inspector James Fisk.

On June 28, 1969, a squad of police entered a bar in Greenwich Village. The Stonewall Inn on Christopher Street was a well-known gathering place for gay men, lesbians, and transvestites. It was said that the owners of the bar paid off the police; that in return, the police staged only token raids in which they would stop the dancing, ask for IDs, and cart off the most vivid of the queens. But the raid on June 28 broke the pattern for all time.

On that date, angry patrons filed out of the bar, only to linger in Sheridan Square. They picked up rocks, bottles, and garbage and began to hurl them at the bar and the startled officers still inside. The cops barricaded the door. Projectiles shattered the window. Someone threw a firebomb through the window. Another squirted lighter fluid under the door. Chanting "Gay Power," the crowd uprooted a parking meter and tried to batter down the door of the bar. The effort ended when police reinforcements arrived.

For nights thereafter, gays gathered at the site. They held meetings, formed committees, and finally staged a Gay Power march up Sixth Avenue. Today, the annual Gay Pride march attracts hundreds of thousands of gays, lesbians, bisexuals, transgenderists, and their supporters yearly. They paint the stripe down Christopher Street lavender.

The sign for Gay Street—situated a few doors down from the Stonewall—is one of the most frequently stolen artifacts in the city. One can see the bands where previous signs were attached to posts and streetlights rising ever higher, like a carnival indicator of strength.

The sexual revolution swept through the culture, but by mid-decade there were some who felt slighted. The leaders of the various movements fighting for change were invariably men. Civil rights workers and antiwar activists, yippies and rock stars were charismatic spokesmen who could dominate and inspire a rally, or "fuck a staff into existence," as Marge Piercy confessed in an essay on women's experiences within the movement. "Yet always what was beautiful and real in the touching becomes contaminated by the fog of lies and half-truths and power struggles until the sex is empty and only another form of manipulation."

Women in the counterculture found themselves in the same old roles: girlfriend; dishwasher; typist. When they demanded that the leaders acknowledge their many contributions, they frequently received daunting, chauvinist replies.

In 1966 black activist Stokely Carmichael brushed off women's libbers with a remark heard round the country: "The only position for women in the Student Nonviolent Coordinating Committee is prone." Abbie Hoffman crowed, "The only alliance I would make with the women's liberation movement is in bed." Eldridge Cleaver, in 1968, joked: "Women? I guess they ought to exercise pussy power."

Women's equality was treated as a joke in the sixties. Indeed, Representative Howard Smith of Virginia had added the category of sex to Title VII of the 1964 Civil Rights Act on a political whim, to distract liberals and make the bill harder to pass. The law prohibited discrimination on the basis of an "individual's race, color, religion, sex or national origin." But what exactly did that mean?

Radical women began talking to one another in "bitch sessions" about consciousness-raising. Sexual dissatisfaction was at the core of the new political rhetoric. Anne Koedt delivered a paper in Chicago on "The Myth of the Vaginal Orgasm" at the first National Women's Liberation Conference, on Thanksgiving weekend 1968. Taking a cue from Masters and Johnson, she proclaimed, "Although there are many areas for sexual arousal, there is only one area for sexual climax; that area is the clitoris.

"All this leads to some interesting questions about conventional sex and our role in it. Men have orgasms essentially by friction with the vagina, not the clitoral area, which is external and not able to cause friction the way penetration does. Women have thus been defined sexually in terms of what pleases men. Our own biology has not been properly analyzed. Instead we are fed the myth of the liberated woman and her vaginal orgasm, an orgasm which in fact does not exist."

She condemned men who used the clitoris only for foreplay, to create sufficient lubrication for penetration. A clitoral sexuality would make the male expendable. The *Kama Sutra* needed to be rewritten. "We must begin to demand that if certain sexual positions now defined as standard are not mutually conducive to orgasm, they no longer be defined as standard," said Koedt.

"New techniques must be used or devised that transform this particular aspect of our current sexual exploitation."

In her 1977 novel *Loose Change: Three Women of the Sixties,* Sara Davidson tried to re-create the moment. One of her heroines dicsovers masturbation at a woman's consciousness-raising session. "'I'd never heard people talk about this stuff. I didn't even know women masturbated.' The group read Masters and Johnson—that was a mindblower—to see proof that all orgasms are centered in the clitoris and that the vaginal orgasm, that holier-than-holy supercome, was a myth. Susie had to ask where the clitoris was. Jeff had never touched her there because Freud and his father had informed him that mature women have vaginal orgasms."

When did these mythical father/son conversations occur?

Robin Morgan found she could no longer stand to fake vaginal orgasms (though she admitted she'd become "adept at faking spiffy ones"). She feared confronting pornography for fear of being labeled a "bad vibes, uptight, unhip chick." She became a refugee from the male-dominated left, or what she called "the boys' movement." But she and others had learned much from the movement's style of electric drama.

On September 7, 1968, New York Radical Women organized a protest against the Miss America Pageant. Morgan wrote, "The pageant was chosen as a target for a number of reasons: It is of course patently degrading to women (in propagating the Mindless Sex Object Image). It has always been a lily-white, racist contest; the winner tours Vietnam, entertaining the troops as a Murder Mascot. The contestants epitomize the roles all women are forced to play in this society, one way or the other: apolitical, unoffending. Passive, delicate (but drudgery-delighted) things." The protesters denounced the quest for male approval, saying women were "enslaved by ludicrous beauty standards. Miss America and *Playboy*'s Centerfold are sisters over the skin. To win approval we must be both sexy and wholesome, delicate but able to cope, demure yet titillatingly bitchy. Deviation of any sort brings, we are told, disaster: 'You won't get a man!'"

Sex object? Degrading? In one article are the first drops of poisoned rhetoric that would reignite the battle between the sexes. The protesters tossed dishcloths, steno pads, high-heeled shoes, false eyelashes, hair curlers, girdles, and bras into a Freedom Trash Can, along with copies of *Cosmopolitan, Ladies'*

Home Journal, and *Family Circle.* They did not, as some in the media claimed, burn bras.

Make war, not love? An ironic message with which to end the decade.

What would women become in the next decade? Joan Terry Garrity, taking the nom de plume J, wrote a book called *The Sensuous Woman* (1969). In lighthearted prose she extolled the wonders of oral sex and described various techniques such as "the Butterfly Flick," "the Hoover," "the Whipped Cream Wriggle," and "the Silken Swirl."

The book sold nine million copies.

TIME CAPSULE

Raw Data From the 1960s

FIRST APPEARANCES

The Pill. IUDs. Librium. Valium. Freedom Riders. Sit-ins. Be-ins. Love-ins. Peace Corps. Learjet. Instant replay. Ford Mustang. Topless bathing suits. Topless bars. Jacuzzis. Water beds. Lava lamps. National Organization for Women. *Cosmo* Girl. *The Sensuous Woman.* Hair. Moog synthesizers. Motown. *Penthouse. Screw.* The Twist. Playboy Clubs. The Playboy Mansion. Bunnies. Hippies. Yippies. Cassettes. Pop art. Op art. Happenings. Computer dating. Singles' bars. "Here's Johnny!" Woodstock. Ken. G.I. Joe. Stonewall.

WHO'S HOT

JFK. Jackie. The Rat Pack. George. Paul. John. Ringo. James Bond. Bob Dylan. Joan Baez. Rolling Stones. Aretha Franklin. Barbra Streisand. Supremes. Jim Morrison. Jimi Hendrix. John Coltrane. Andy Warhol. Sean Connery. Paul Newman. Steve McQueen. Clint Eastwood. Raquel Welch. Natalie Wood. Jane Fonda. Elizabeth Taylor. Richard Burton. Peter Fonda. Dennis Hopper. Dustin Hoffman. John Glenn. Joe Namath. Martin Luther King, Jr. Muhammad Ali. Marshall McLuhan. Timothy Leary. Hef. Henry Miller. Twiggy.

WE THE PEOPLE

Population of the United States in 1960: 179 million. Population of the United States in 1970: 205 million. Percentage of population under the age of twenty-six in 1966: 48. Life expectancy of a male in 1960: 66.6 years; of a female: 73.1. Life expectancy of a male in 1970: 67.1 years; of a female: 74.8. Marriages per 1,000 people in 1960: 8.5; in 1970: 10.6. Number of unmarried couples living together in 1960: 17,000; in 1970: 143,000. In 1967, number of clients of Operation Match, a computer dating service: 5 million; number who found mates: 130,000. Number of marriages per year circa 1966 involving teenagers: 500,000;

percentage of those that resulted from pregnancy: 50. Percentage of teen marriages that ended in divorce: 50.

MONEY MATTERS

No, it doesn't.

MONEY MATTERS, TAKE TWO

Gross National Product in 1960: $503.7 billion. Gross National Product in 1970: $1 trillion. Percentage of a white male's salary earned by a black male in 1970: 70. Percentage of a white male's salary earned by a white female in 1970: 58. Percentage earned by a black female: 50.

COLLEGE BOUND

Number of college students in 2,175 institutions in 1965: 5.4 million. Number of demonstrations between January 1 and June 15, 1968, at 101 colleges and universities: 221; number of students involved: 39,000. Number of universities facing student strikes or forced to close in 1969: 448.

VIETNAM

Number of U.S. advisers in Vietnam in 1961: 700; in 1963: 16,000. U.S. troops in Vietnam in 1969: 542,000. Number of names on the Vietnam War Memorial: 58,209.

MEDIUM COOL

What we watched on TV when we weren't watching the war in Vietnam: *Gunsmoke, Have Gun Will Travel, Andy Griffith Show, Rawhide, Candid Camera, The Untouchables, Bonanza, Perry Mason, Dr. Kildare, Ben Casey, The Beverly Hillbillies, Dick Van Dyke Show, Bewitched, I Dream of Jeannie, Batman, The Fugitive, Get Smart, Mission: Impossible, The Man From U.N.C.L.E., The Avengers, Gilligan's Island, Smothers Brothers Comedy Hour, Rowan & Martin's Laugh-In.*

THE PILL

Number of U.S. women taking Enovid in 1961: 408,000. Number of women taking birth-control pills in 1966: 6 million. Amount of money spent on contra-

ceptive devices in 1961: $200 million; percentage spent on condoms: 75. Number of malformed babies born to women who took thalidomide, "the sleeping pill of the century": 12,000. Year thalidomide was withdrawn from the market: 1962. When Sherri Finkbine, host of *Romper Room,* realized she had taken thalidomide during the first and second months of her pregnancy, number of hospitals in Phoenix willing to perform an abortion: 0. Name of country where Finkbine obtained an abortion: Sweden. According to *Time* in 1964, number of abortions performed in the United States that year: 1 million. Percentage of those abortions deemed illegal: 99.

SLANG ME

New words and phrases: acid test, fake out, splashdown, status report, camp, kook, crash, crash pad, groovy, groupie, rap, vibe, straight, abort, psychedelic, mind-blowing, zap, go-go, mod, pop, flower power, hawk, miniskirt, hotpants, uppers, downers, peak experience, power to the people, sock it to me, don't trust anyone over 30.

FINAL APPEARANCES

Marilyn Monroe (1962). John F. Kennedy (1963). Malcolm X (1965). Lenny Bruce (1966). Margaret Sanger (1966). Jayne Mansfield (1967). Robert Kennedy (1968). Martin Luther King, Jr. (1968). Sharon Tate (1969).

Chapter Eight

THE JOY OF SEX: 1970–1979

The couple in Alex Comfort's wholesomely illustrated sex manual taught America how to play.

The sexual revolution flared on a thousand fronts. Call it "the great permission."

Bathroom graffiti announced A LITTLE COITUS WOULDN'T HOITUS. Bumper stickers invited strangers to HONK IF YOU'RE HORNY. The staid *Oxford English Dictionary,* after almost a century of silence, finally included the word "fuck" in its pages.

Joan Terry Garrity, the "J" who penned *The Sensuous Woman,* had startled the world by declaring that "oral sex is, for most people who give it a try, delicious."

A woman recently converted to oral sex wrote *The Playboy Advisor* and asked an obvious question: Oral sex may be delicious, but what, exactly, is the caloric content of ejaculate? The Advisor found the answer (approximately one to three calories). When the magazine tried to run the letter in 1970, the

head of production and the printer refused to publish the offending passage. It would take two years before the answer finally saw print.

The revolution flexed its muscle in the fashion. The miniskirt became a micromini. "Hotpants" was a noun and an adjective. Norma Kamali popularized Lycra spandex, a fabric so formfitting that "it's like wearing your body on the outside."

Men became peacocks. Commenting on a green velour Edwardian suit, one man recalled that "wearing it on a date was like starting foreplay early. And when you were alone, you just turned it inside out." The whole world, it seems, slept on satin sheets.

Male nudity went mainstream when *Cosmo* published a centerfold of Burt Reynolds. Oliver Reed and Alan Bates wrestled naked in the 1970 hit *Women in Love.* In January 1974 students across the nation abandoned clothes (with the exception of running shoes) in mad cross-campus dashes. A streaker at Texas Tech set a record for five hours of uninterrupted nude jogging. At the University of Georgia 1,548 bare-assed students staged a group streak. Lone streakers disrupted graduation ceremonies and the Academy Awards.

The revolution had its silly moments.

In 1972 FBI agents arrested Philip Bailley, a Washington, D.C., defense attorney, on twenty-two morals charges, including violation of the Mann Act. The agents found 164 photographs of nude women, four address books, and various sexual devices. Bailley's defense was classic: "Women get a thrill out of having their pictures taken in the nude. You take them up to your apartment, make love to them, take their picture, make love to them again. It sure as hell beats watching television." He explained the sexual paraphernalia this way: "Hell, anybody who digs sex has stuff like that around his apartment. Those Justice Department bureaucrats just don't understand my lifestyle, which is the lifestyle of half the people in America my age."

Welcome to the Permissive Society, the Me Decade, the Whee Decade. In an essay called "The Sexed-Up, Doped-Up, Hedonistic Heaven of the Boom-Boom Seventies," Tom Wolfe described the moment. "It was in the seventies, not the sixties," he declared, "that the ancient wall around sexual promiscuity fell. And it fell like the wall of Jericho. It didn't require a shove. By the mid-seventies, any time I reached a city of 100,000 to 200,000 souls, the movie fare available on a typical evening seemed to be two theaters showing *Jaws,* one

showing *Benji* and 11 showing pornography of the old lodge-smoker sort, now dressed up in color and 35mm stock. Two of the 11 would be drive-in theaters, the better to beam the various stiffened giblets and moist folds and nodules out into the night air to become part of the American scene."

The territory held by sexual revolution could be charted in any number of ways. A December 1970 *Newsweek* article described the wall map of a New York City vice squad: "Pink pins for the 55 dirty bookstores, silver for the 16 theaters showing sex films, yellow for the six emporiums of lewd eight-millimeter movies, black with white crosses for the six burlesque houses, green for the eight figure-modeling studios, red for the one live peep show and blue for the five live sex exhibitions." The editors noted that the phenomenon was nationwide: "Within seven blocks of the White House, 27 adult bookshops and moviehouses are currently in business."

The idealism of the sixties, the vast tribal frenzy, seemed to disappear overnight. Baby boomers moved the previous decade's wild-in-the-streets energy into the bedroom. And millions embarked on a decade of adventure.

Alex Comfort was an unlikely hero of the sexual revolution. A tweedy, owlish Englishman, he was reminiscent more of Q than of James Bond. (In fact, a boyhood fireworks accident had obliterated four fingers on Comfort's left hand.) Comfort had tinkered around the edges of the topic for years. *The Anxiety Makers,* a 1967 look at the history of sex manuals, had condemned the medical profession's treatment of sex, suggesting that doctors unjustifiably assumed a mantle of expertise on moral conduct.

Comfort was known in England as the Doctor of Fun, in part for his suggestion that fifteen-year-old boys should carry contraception. He had announced two new commandments: "Thou shalt not under any circumstances produce an unwanted baby. Thou shalt not exploit another's feelings." He had written a comic novel about a couple who open a sex clinic in Paris and a chemist who invents a drug called 3-blindmycin that reduces inhibitions.

When a friend at a London hospital complained that sex was not being taught properly, Comfort set out to write a serious text on the sexual customs of different cultures. After a few days he became bored with the project. The world didn't need another tour of the Trobriand Islands. He decided to write

something slightly funnier instead and in two weeks had cobbled together *Cordon Bleu Sex.* The metaphor was inspired. Here was a menu of delight that, like a cookbook, was "a sophisticated and unanxious account of available dishes." Comfort defined permission this way: "As to the general repertoire, the whole joy of sex with love is that there are no rules, so long as you enjoy, and the choices are practically unlimited."

The Joy of Sex, published in 1972, would go on to sell more than ten million copies. The book took sex out of the bedroom and put it on the coffee table: It was above all a thing of beauty. In a series of illustrations, artists Charles Raymond and Christopher Foss captured the stations of lust. A bearded man and an equally hairy, uninhibited woman kiss, caress, fondle, tug, tease, and ride each other through worlds of obvious pleasure. The drawings were inviting— the couple seemed to live in a private kingdom, infused with permission. The trust, the willingness to explore, be it by using vibrators on each other or tying one partner's ankles and wrists to a bed to boost her orgasm or inviting the neighbors over for "foursomes and moresomes," were pure propaganda for pleasure.

The main dish was "loving, unself-conscious intercourse." The spice rack was filled with exotic variations. Beyond the full matrimonial (man on top) lay *cuissade* (half-rear entry with one leg between), *croupade* (squarely from behind), *flanquette* (half-facing), and *inversion* (letting one's partner hang upside down off the bed). *Pattes d'araignée* was fancy talk for a fingertip caress of body hairs, *postillionage* the insertion of one finger into your partner's anus just prior to orgasm. *Florentine* was the adjective to describe lovemaking in which the woman stretched her partner's foreskin to the point of tautness, and never let go. *Pompoir* encouraged a woman to milk the penis through vaginal contractions. On the last of these, Comfort quoted the explorer Richard Burton: "This can be learned only by long practice and especially by throwing the will into the part affected."

"Throwing the will into the part affected" could have been the motto of the decade.

Comfort had odd biases: a mere eleven paragraphs on "mouth music"; almost seven pages on bondage. Another segment celebrated the big toe as a sex organ. "The pad of the male big toe applied to the clitoris or the vulva generally is a magnificent erotic instrument." He gave readers the naughty image of a man removing shoe and sock in a dark restaurant to keep his partner in

almost continuous arousal with their hands still in view on the table. Dining out thus became a sexual adventure.

Comfort included erotic art from Japan and India that prompted one female reader to comment, "If you've seen one Persian penis, you've seen 'em all." He tantalized readers with various techniques described by ethnographers. Put a goat's eyelid on your cock to stimulate your partner's clitoris? Let's go back a few pages to feathers, dear.

And there were the pure put-ons. The Grope Suit was a "diabolically ingenious gadget which has just come on the Scandinavian market to induce continuous female orgasm." It supposedly consisted of a "very tight rubber G-string with a thick phallic plug which fits in the vagina and a roughened knob over the clitoris. The bra has small toothed recesses in the cups which grip the nipples and is covered all over inside with soft rubber points." Every movement would touch a sensitive area. The Grope Suit was a figment of Comfort's imagination, but hundreds of people wrote *The Playboy Advisor* to ask where one might obtain the attire.

Comfort moved to America to work for the Center for the Study of Democratic Institutions. He became a frequent guest at Sandstone, an erotic retreat near Los Angeles. He wrote a follow-up manual, titled simply *More Joy.* He soothed the fear of exploration, saying "that there is nothing to be afraid of, and never was, and that we manufacture our own nonsenses." He rarely gave interviews and came to view *Joy* as "frankly, an albatross." It was just one of fifty books he would write. He devoted most of his energy to the study of aging.

But he had taught the band to play. *Joy* was the product of the century-long fight to liberate language, but the book's truly subversive power came from the elegant illustrations. America never learned the identity of the people whose sexual coupling was captured in sketch after sketch. Christopher Foss, one of the artists who illustrated *Joy,* having made the world safe for sex, went on to become a "visualizer" for such movies as *Alien, Dune,* and *Superman.*

Alex Comfort told an interviewer that "the trouble with the English was that the men didn't mind reading about it but didn't want to do it, and that the women didn't mind doing it but didn't want to read about it." Americans, it seemed, had the opposite problem.

The sixties had unleashed literary lust, and the sexual revolution was a war of words, carried out in essays, term papers, magazine articles, and pamphlets. But most of the disputed classics had been written by men. Now women abandoned centuries of silence and tried out what had been an exclusively male vocabulary. Coeds looking for role models devoured, for example, the diaries of Anaïs Nin.

In the seventies, radical feminists attacked Freud. He was the perfect paper villain, the father of repression and creator of the myth of the vaginal orgasm. He had single-handedly queered sex for a century, they said. Now women wanted to find a sexuality based on their own experiences of what worked. In 1971 feminist Alix Shulman told women to "think clitoris." In *Re-Making Love: The Feminization of Sex,* Barbara Ehrenreich, Elizabeth Hess, and Gloria Jacobs declared, "If the vagina was the stronghold of Freudian, male-dominated sexuality, the clitoris was the first beachhead of feminist sexuality."

The rage against doctors and psychiatrists unleashed not sexual anarchy but sexual self-reassessment. A women's collective in Boston put together *Our Bodies, Ourselves,* a sort of *Whole Earth Catalog* of female sexuality.

Betty Dodson, an artist born in the Bible Belt, had already produced exhibits of erotic art when she became an advocate for masturbation. She promoted body-sex workshops and urged women to become "cunt positive" by showing color slides of the genitals of twenty different women. Students would examine their genitals in mirrors, and learn techniques of noncoital pleasure. Dodson wrote and illustrated a booklet called *Liberating Masturbation.* "Masturbation," she wrote, "has been a continuous part of my sex life since the age of five. It got me through childhood, puberty, romantic love and marriage and it will, happily, see me through old age."

Her instructions were lyrical:

> When I masturbate, I create a space for myself in the same way I would for a special lover—soft lights, candles, incense, music, colors, textures, sexual fantasies, anything that turns me on. If I use my hand I also use oil or cream. The slippery, moist feeling of oil on my genitals is very sensuous. I use one finger or my whole hand, making circular motions above the clitoral body, below, on top or to the side. I

experiment with several techniques—going slow, fast, soft, firm, observing the arousal potential of each. I'll lie on my stomach, side, back; put my legs up and stretch them out. I have also experimented with watching myself in a mirror. I saw that I didn't look awful or strange—I looked sexual and wonderfully intense.

Germaine Greer blazed into our consciousness in 1971 with the publication of *The Female Eunuch.* "The feminist who loves men," Greer was a jill-of-all-trades—a Ph.D. who lectured on Shakespeare at Warwick University, a motorcyclist, a performer on comedy shows on English TV, an editor of an underground journal called *Suck,* a model who posed nude for the same magazine. She was six feet tall, beautiful, and an advocate of free love.

Journalist Claudia Dreifus tried to explain Greer's popularity in terms of other feminists. "Betty Friedan had no appeal for the literary lions—she was too old, too bourgeois, too organization-conscious," she began. "Shulamith Firestone, author of *The Dialectic of Sex* and organizer of New York Radical Feminists, was strikingly attractive; but, alas, antilove, perhaps even antimen. Ti-Grace Atkinson, an advocate of extrauterine birth, was considered too far-out for a whirl through the major networks. For a while it seemed as if the brilliant and beautiful Kate Millett, whose *Sexual Politics* was for a short time on the best-seller list, might be star material. But she made the mistake of openly asserting her bisexuality. Greer was everything those messy American feminists were not: pretty, predictable, aggressively heterosexual, media-wise, clever, foreign and exotic."

Greer attacked the ancient role of the passive female. She challenged the new tyranny of the clitoris favored by American feminists. In *The Female Eunuch* she complained, "If we localize female response in the clitoris we impose upon women the same limitation of sex which has stunted the male's response. The male sexual idea of virility without languor or amorousness is profoundly desolating: When the release is expressed in mechanical terms it is sought mechanically. Sex becomes masturbation in the vagina."

Arguing for the restoration of female sexual energy, Greer declared that personality was inseparable from sexuality. Whether you called it élan vital or libido, without it you were a female eunuch.

She opposed the institution of marriage. She thought women should have the same right to be promiscuous as men had. "The acts of sex are themselves forms of inquiry," she wrote, "as the old euphemism 'carnal knowledge' makes clear. It is exactly the element of quest in her sexuality which the female is taught to deny." The old formula for lovemaking would not do: "The process described by the experts, in which the man dutifully does the rounds of the erogenous zones, spends an equal amount of time on each nipple, turns his attention to the clitoris (usually too directly), leads through the stages of digital or lingual stimulation and then politely lets himself into the vagina, is laborious and inhumanly computerized."

Greer wanted to reawaken the cunt. "Any woman can be a good fuck lying on her back," she wrote, "but poised over her man and his rigid penis she must proceed with sensitivity and control and with all her strength. Now she must cooperate, responding to her lover's spasms and trembling with delicate alterations in the speed and pressure of her movements. She can control the degrees of penetration, drawing herself up so that the smooth lips of her vagina nibble at the velvety head of her lover's penis, letting herself down again, slowly or swiftly, violently or softly, fluttering and squeezing him with her vaginal muscles, which are now free to respond to her desires, instead of being deadened by the impact of the heavy male body. She is at last conscious of female potency, the secret power of her lovely, complex genitals." Say amen, somebody.

In an essay on the politics of female sexuality, Greer declared, "It is time to dig cunt, to establish a woman's vocabulary of cunt—prideful, affectionate, accurate and bold." *The Female Eunuch* sold more than a million copies.

Greer was fearless. She told *Playboy* that "every man should be fucked up the arse as a prelude to fucking women, so he'll know what it's like to be the receiver. Otherwise, he'll think he's doling out joy unlimited to every woman he fucks." She debated Norman Mailer, who'd described feminists as "legions of the vaginally frigid, out there now with all the pent-up buzzing of a hive of bees, the souped-up, pent-up voltage of a clitoris ready to spring!" And spring they did. That evening climaxed when two lesbians rushed the stage to demonstrate do-it-yourself-without-men lovemaking.

Women learned the consequences of being outspoken. Nancy Friday explained what made her write about sex in her 1973 best-seller *My Secret*

Garden. Her lover had, midstroke, invited her to "tell me what you are think-ing about." "As I'd never stopped to think before doing anything to him in bed (we were that sure of our spontaneity and response), I didn't edit my thoughts. I told him what I'd been thinking."

She told him that while they were fucking she was imagining that she was at a Colts-Vikings game. She was wrapped in a blanket, watching Johnny Unitas race down the field. While she was screaming with excitement, a male fan standing behind her pulled his cock out and somehow put it between her legs. "He's inside me now, shot straight up through me like a ramrod. My God, it's like he's in my throat. We scream together, louder than anyone, making them all cheer louder, the two of us leading the excitement like cheerleaders, while inside me I can feel whoever he is growing harder and harder, pushing deeper and higher into me with each jump until the cheering for Unitas be-comes the rhythm of our fucking. My excitement gets wilder, almost out of control, as I scream for Unitas to make it as we do, so that we all go over the line together. And as the man behind me roars, clutching me in a spasm of pleasure, Unitas goes over and I . . ."

Her lover, wrote Friday, "got out of bed, put on his pants and went home."

Friday placed an ad in newspapers and magazines that read: "Female Sexual Fantasies wanted by serious female researcher. Anonymity guaran-teed." The letters began to arrive, filled with fantasies that depicted women having sex with an octopus, sex with delivery boys, sex with strangers. In their erotic daydreams women performed before audiences at Madison Square Garden and in the courts of Eastern potentates. They masturbated with "the familiar finger, dildos, the increasingly popular vibrators, cucumbers, vacuum cleaner hoses, battery operated Ronson toothbrushes, silver engraved hair-brush handles, exotic phallocrypts made by native houseboys, down to simple streams of water."

Friday discovered there were many rooms in the house of fantasy, some devoted to faceless strangers, some to incest, some to pain, domination, and terror. Fantasy was an exercise in sexual power, no matter what the script. Al-most every scenario culminated in ecstasy. Indeed, throughout her book, or-gasm becomes a form of punctuation, the perfect way to end a paragraph.

My Secret Garden appeared with an introduction by J. The original sensu-ous woman warned readers they might "have to fight off shock, prurient inter-

est and distaste," but that the final message was "it isn't freaky to fantasize." The book and its sequel, *Forbidden Flowers,* were million-sellers.

Not all women were converts. Gloria Steinem's *Ms.* magazine scoffed at Friday's work. "This woman is not a feminist," said a reviewer, after an editor had declared, "*Ms.* will decide what women's fantasies are."

The most famous female fantasy of the century was yet to come. Erica Jong had published two volumes of poetry filled with quirky observations. ("Beware of the man who praises liberated women; he is planning to quit his job.") While living in Germany she had commuted by train to visit an analyst in Frankfurt. The rocking motion inspired erotic fantasies, which she scribbled down. Years later she would describe the inspiration for one of the most famous novels of the 1970s.

"*Fear of Flying* was conceived on those train rides. On trains you can dream that the man opposite you will take off his thick glasses, strip to his savage loincloth and make passionate love to you in an endless tunnel, then disappear like a vampire into the sunlight. The train rocks you back and forth on your wettest dreams; it merges the moist divide between inner and outer. I have come on trains without touching myself. It is only a matter of concentration. The impossible he (or she) comes into me. The fantasy takes over. Time stops as the train rocks. Suddenly my lap is full of stars."

Fear of Flying (1973) described a young woman who finds her identity through sex. Jong's heroine Isadora Wing had discovered a new use for masturbation. "I am keeping myself free of the power of men," she thought, "sticking two fingers deep inside each night." Wing marries a psychoanalyst, a mercurial lover with wings on his prick. "He soared and glided when he screwed. He made marvelous dipping and corkscrewing motions. He stayed hard forever, and he was the only man I'd ever met who was never impotent— not even when he was depressed or angry. But why didn't he ever kiss? And why didn't he speak?"

Jong's heroine exercised her freedom through affairs, a quest for the zipless fuck. "The zipless fuck was more than a fuck. It was a platonic ideal. Zipless because when you came together zippers fell away like rose petals, underwear blew off in one breath like dandelion fluff. Tongues intertwined and

turned liquid. Your whole soul flowed out through your tongue and into the mouth of your lover."

She describes a scene from an Italian movie, where a widow has sudden sex with a soldier. "The incident has all the swift compression of a dream," she muses, "and is seemingly free of all remorse and guilt. The zipless fuck is absolutely pure. It is free of ulterior motives. There is no power game. The man is not taking and the woman is not giving. No one is attempting to cuckold a husband or humiliate a wife. No one is trying to prove anything or get anything out of anyone. The zipless fuck is the purest thing there is. And it is rarer than the unicorn."

Permission. *Fear of Flying* sold more than three million copies in two years. Jong was hailed as the matron saint of adulteresses. She moved from novelist to the nation's resident expert on women's sexuality. A Playboy Interview recorded Jong's famous response to porn films: "After the first ten minutes I want to go home and screw. After the first 20 minutes I never want to screw again as long as I live."

Perhaps the oddest permission giver of the decade was Marabel Morgan, author of *The Total Woman* and founder of Total Woman, Inc. The Christian wife of an attorney and mother of two children, she created legions of apostles dedicated to putting the fun back into fundamentalism.

She found her sex advice in the Bible. "That great sourcebook, the Bible, states, 'Marriage is honorable in all, and the bed undefiled.' In other words, sex is for the marriage relationship only, but within those bounds, anything goes. Sex is as clean and pure as eating cottage cheese." (You can't get more middle America than cottage cheese.)

"Your husband wants a warm, comforting and eager partner. If you're stingy in bed, he'll be stingy with you. If you're available to him, you need not worry about him looking elsewhere. Fulfill him by giving him everything he wants, and he'll want to give back to you."

Total Women would call their husbands at work to say, "Honey, I'm eagerly waiting for you to come home. I just crave your body." Total Women prepared for sex, every night of the week: "For a change tonight, after the children are in bed, place a lighted candle on the floor and seduce him under

the dining room table. Or lead him to the sofa. How about in the hammock? Or the garden? Even if you can't actually follow through, at least the suggestion is exciting. He may say, 'We don't have a hammock.' You can reply, 'Oh darling, I forgot!'"

Morgan encouraged women to dress like pixies, pirates, cowgirls, and showgirls, even to risk the "no-bra look." One Total Woman greeted her husband at the door in black mesh stockings, high heels, an apron, and nothing else. The husband "took one look and shouted, 'Praise the Lord!'"

The Total Woman sold more than two million copies, many through Christian bookstores. Of course, Morgan offended feminists. Joyce Maynard looked at Total Women and mused, "It is quite a different kind of liberation these women long for. How distant Gloria Steinem in her aviator glasses must seem; how unreal this talk of open marriage and bisexuality and vibrators that free women from male tyranny. Faced with a choice between certain safety and a decidedly uncertain chance for ecstasy, they will choose safety. If it is the aim of Steinem and Greer and Abzug and Millett to wage a war, it is the heartfelt aim of this other kind of woman to keep the peace."

But Morgan was part of a wave of sexual permission within the church. The Reverend Tim LaHaye and his wife, Beverly, found that the Song of Solomon seemed to approve clitoral manipulation: "Let his left hand be under my head and his right hand embrace me" described the best position for fondling. The Reverend Charles and Martha Shedd, authors of *Celebration in the Bedroom,* admitted on *The Phil Donahue Show* that they had "a whole drawerful" of vibrators, which were also "inspired" by God.

Helen Andelin, a competitor of Marabel Morgan's, headed her own movement, called Fascinating Womanhood. Andelin encouraged her followers to pretend they were little girls, even to the point of buying Mary Janes, anklets, and ruffled gingham dresses inspired by the children's department.

All the permission givers had one goal: greater pleasure.

Thea Lowry, a sex therapist in San Francisco, summed up the lesson of the sexual revolution in one sentence: "Although sex is perfectly natural, it is not always naturally perfect." What JFK had once said about the economy, that a rising tide floats all boats, both large and small, simply was not true for sex. The people drowning in the sea of provocation were legion.

In 1970 Dr. William Masters and Virginia Johnson released *Human Sexual Inadequacy,* the second volume based on their landmark research. Volume one, *Human Sexual Response,* had described the physiology of healthy sex. The second volume focused on dysfunctional sex. The St. Louis–based research team estimated that half of all marriages in the United States were crippled by one type of sexual inadequacy or another. But most problems could by cured by education or through two-week interventions. Masters and Johnson developed techniques for treating impotence, frigidity, and premature ejaculation.

Masters and Johnson insisted on treating couples as units: A sexual problem did not involve just the individual. Take premature ejaculation, or coming too quickly. This had not been exactly a household affliction or a topic of discussion at the bridge club. Masters and Johnson defined the term not with a stopwatch but in its effect on the female partner. A man was premature if, during intercourse, he reached orgasm before his partner at least half the time. Her satisfaction was as important as his. Conversely, a woman wasn't simply frigid—she may have felt too guilty to give herself permission to enjoy sex, or her partner may have been ignorant of sexual anatomy. There was no one way to reach orgasm, no right way. Finding something that worked for the couple was the goal of therapy.

Masters and Johnson claimed their therapy had an 80 percent cure rate after just two weeks. Critics such as psychiatrist Natalie Shainess complained that "teaching 'push here' and 'rub there' is not going to change people."

But apparently it could. The squeeze technique could stop in his tracks a man about to ejaculate. Something called sensate focus—a kind of total body massage—could relieve the performance demand on impotent men and restore erections. An awareness of the clitoris could make the earth move for formerly nonorgasmic women. The Playboy Foundation gave a grant to the Masters and Johnson Institute to train therapists, and within a few years there were thirty certified Masters and Johnson sex therapists in practice across the country.

The pair also wrote articles exploding sex myths, such as the notions that masturbation causes physical or mental harm, that penis size really matters, that the missionary position is the most satisfying, that anal intercourse is perverted or dangerous, and that there is any kind of meaningful difference between clitoral and vaginal orgasms.

Sex clinics spread like mushrooms: Some 5,000 opened within the decade. Linda Wolfe, writing for *Playboy* in June 1974, gave a glimpse of the new Yellow Pages. Have a problem? Dial up the Center for Intimacy and Sexuality. The Institute for Sensory Awareness. The Institute for the Advancement of Sensuality. Discovery Institute. Human Sexuality Foundation. The Center for Sex Therapy and Education. Wrote Wolfe, "Often a California sex-therapy institute is nothing more than a male or female therapist with towels, a jar of coconut oil or petroleum jelly and a telephone answering machine."

At the National Sex Forum in San Francisco, Ted McIlvenna grossed $40,000 a month providing something called Sexual Attitude Restructuring. The forum staged a fuckarama and desensitized clients by projecting old stag films, then showing the same behavior performed by loving couples. Some clinics offered group massage, some found the meaning of life in eroticized foot massage, some introduced couples to the power of the vibrator. A few used surrogates, allowing a sexually experienced woman or man to show an anxious client how to experience arousal and release. Masters and Johnson had used this Arthur Murray approach to sex until the husband of one of the women used as a surrogate sued for $2.5 million.

It was inevitable that the permission givers would meet their critics. At the very start of the decade, *The Dick Cavett Show* corralled Hugh M. Hefner, psychologist Rollo May (looking and sounding like a benign Barry Goldwater), the Jefferson Airplane, and Susan Brownmiller and Sally Kempton "for the women's liberation movement."

Rollo May, the author of *Love and Will,* attacked the counterculture. "The trouble with love in our day, as it comes out in, say, the hippies, is that they have spontaneity, but they don't have fidelity. They don't have commitment, responsibility. And these are all matters of will." There is too much freedom, May said. Too many choices. He criticized Hefner's hedonism: "In *Playboy* . . . the aim is to play it cool, not to commit yourself, don't get caught."

Hefner reduced The Playboy Philosophy to a single paragraph: "The best kind of sex and the best kind of love includes involvement. But I also think there should be a period of discovery, of self-discovery, immediately after the teens, to find yourself as a human being. A time of exploration and play. *Playboy* is devoted to those years."

The talk drifted to the subject of impotent men and whether frigid women were becoming extinct. When Hefner invoked the names Masters and Johnson, rock star Grace Slick jumped in with a one-sentence assessment of sex research: "Wire me up and fuck me wired." Even bleeped, the sentiment grabbed one's attention. Cavett then introduced Susan Brownmiller and Sally Kempton, saying, "Maybe we can find out what the women are all upset about."

Feminists had become hot copy, turning dissertations into best-selling political broadsides. The sisterhood-is-powerful SWAT teams traveled in pairs. Their message was the same: Men don't deserve power. Men don't deserve women. Women deserve women.

Asked what men were doing wrong, Brownmiller replied, "They oppress us as women. They won't let us be. And Hugh Hefner is my enemy. Hefner has built an empire based on oppressing women." She railed on: "The role that you have selected for women is degrading to women because you choose to see women as sex objects, not as full human beings."

Grace Slick rejoined the conversation, expressing deep skepticism at sisterhood's precious view of men. "Some of them are great, some of them are crummy," she said. "Why do you have to form a theory? Some of them look at you as a sex object, fine. You fuck them. The ones who like to both go to bed with you and talk to you, you do both of those things. The ones who like to make music and talk to you and go to bed with you and write, whatever you do—draw?—you do all those things with. I don't see where the problem is, maybe because I don't see what you're talking about. Yet. I don't see the problem. Yet."

The audience applauded.

In one hour the show captured the great themes of the decade: Permission. Play. Love. Will. Choice. Freedom. Or, simply, "different strokes for different folks." There was no single script. The sexual revolution had not made things simpler.

In 1972 Shere Hite, a former model, sent out questionnaires on National Organization for Women stationery. "Do you have orgasms?" she asked. "When do you usually have them? During masturbation? Intercourse? Clitoral stimu-

lation? Other sexual activity? How often? Is having orgasms important to you? Do you like them?"

In 1976 she published the responses from more than 3,000 women in *The Hite Report on Female Sexuality*. She declared that "the purpose of this project is to let women define their own sexuality—instead of doctors or other (usually male) authorities. Women are the real experts on their sexuality; they know how they feel and what they experience."

Hite announced that 70 percent of the women who responded to her questionnaire did not regularly reach orgasm as the result of intercourse only. They did not reach orgasm without clitoral stimulation. Hite declared that men had constructed sexuality to benefit themselves, that the penis-in-vagina formula was cultural, not biological. If sex was for pleasure, rather than just for procreation, men must worship at the altar of the clitoris.

One wondered if Hite's astonishing statistic (one that contradicted every study from Dr. Alfred Kinsey to Morton Hunt's *Sexual Behavior in the Seventies* to *Redbook* magazine) was biased by the sample. Were women who were dissatisfied in bed turning to feminism, or were feminists, through frustration with men, unable to participate fully in the heterosexual sex act? The Hite Report was as much kvetch as kaffeeklatsch consciousness-raising. Still, the premise was intriguing. Intercourse resembles male masturbation. Hite declared that men and women must find acts that resemble female stimulation.

She wanted to redefine sex, and she started with the basic terminology. "Why orgasm should be a verb" was the heading of one section: "What is the difference between 'to orgasm' and 'to have an orgasm'? This idea that we really make our own orgasm, even during intercourse, is in direct contradiction to what we have been taught. Most of us were taught that you should relax and enjoy it—or at most help him out with the thrusting—because he would give you the orgasm."

She noted that the 30 percent of the women who reached orgasm did so because each took "responsibility for and control of her own stimulation. The ability to orgasm when we want, to be in charge of our stimulation, represents owning our own bodies, being strong, free and autonomous beings."

Lonnie Barbach, a San Francisco–based therapist, saw a flaw in Masters and Johnson's therapy. The St. Louis model treated couples. Barbach thought therapy should begin at home, with individual women. She was

optimistic, calling the women who came to her groups "preorgasmic" rather than nonorgasmic. She would give women daily homework exercises, asking them to spend at least an hour each day getting to know their genitals, stimulating themselves, then going for the orgasm. Barbach's insights were reflected by the titles of her two landmark books: *For Yourself* (learn the basics through masturbation) and *For Each Other* (take what you've learned on the road).

In 1972, the Playboy Foundation asked a private research group to conduct the first national sex survey since the Kinsey Report. Social scientists contacted more than two thousand people in twenty-four cities. Morton Hunt interpreted the results in *Sexual Behavior in the Seventies.* The book was a snapshot of the sexual revolution, showing in clear statistics exactly how far we had come since the 1940s.

Hunt found sweeping changes, stating that Americans now had "the right to enjoy all the parts of the body, the right to employ caresses previously forbidden by civil or religious edict and social tradition and the right to be sensuous and exuberant rather than perfunctory and solemn—but all within the framework of meaningful relationships."

The single most important factor in the study was age: Those under twenty-five were growing into a lifestyle that was dramatically more pleasure-prone than their elders.

* Only one third of the females in Kinsey's sample had had premarital intercourse by the age of twenty-five. More than two thirds of the women in the 1972 sample had had sex before marriage. Almost the same number of young women (64 percent) thought premarital sex made for a better and more stable marriage. Only 19 percent of women over fifty-five thought so.

* Only four out of ten of Kinsey's married men said they had *ever* kissed or tongued their own wives' genitals. In contrast 63 percent of the men in the 1972 survey had had oral sex in just the past year. Broken down by age, more than four out of five married men and women under thirty-five practiced oral sex; nine out of ten men and women under twenty-five had done so.

* Kinsey estimated that the typical duration of coitus was one to two minutes. The new generation averaged ten minutes—about five times as long as Kinsey's couples.

The survey showed that we had become more liberated in the bedroom, and more athletic. Alex Comfort's *Joy of Sex* introduced America to the ballet of lovemaking, but Morton Hunt found that many couples had already expanded their repertoire. Only a third of Kinsey's married couples had had sex with the woman on top; nearly three quarters of the new generation had. Only a quarter of Kinsey's couples ever had sex side by side; half of the new generation did. Only a tenth of Kinsey's couples had tried rear entry sex; four out of ten of couples now had.

The new recruits in the sexual revolution also were experimenting with behavior that escaped Kinsey's notice.

- "Touching or probing the anus with the fingers or contacting it with lips or tongue was so rare and was viewed with such general revulsion and suspicion," wrote Hunt, "that Kinsey failed to collect anything publishable on the incidence of such practices." In contrast, Hunt found that more than half of the under-thirty-five men and women had experienced manual anal foreplay, more than a quarter some form of oral-anal foreplay. Almost a quarter of those under thirty-four had tried anal intercourse.

Kinsey wrote one sentence about group sex. Hunt was so startled by his findings he kept stirring the statistics: 18 percent of the married men and 6 percent of the married females had had sex in the presence of other couples; 13 percent of married men and 2 percent of the married women had progressed further—to group groping or "cluster fucking." (Once again the under-twenty-fives led the way, with 17 percent of the males and 5 percent of the females exercising a taste for orgy.) For single people, the figures were significantly higher: 40 percent of the single men and 23 percent of the single women had had sex in the presence of others; 24 percent of the men and 7 percent of the women had had sex with multiple partners. (Could this have been the result of communes or coed dorms? By 1970, four out of five colleges had coed dorms.)

- The figures for formal mate-swapping were small (about 2 percent). And Hunt was pleased to report that only 2½ percent had experienced S&M activities.

Hunt concluded that we were engaged in a form of sexual liberation, rather than in a full-scale revolution. "A genuine overthrowing of the past," he wrote, "would be evidenced by such things as the displacement of vaginal coitus by nonvaginal sex acts . . . or by sex acts violating biological or psychological criteria of normality, such as sexual connection with animals, sadomasochistic acts and homosexuality; or by a major increase in sexual acts that fundamentally alter the connection between sex and marriage, such as mutually sanctioned extramarital affairs, mate-swapping and marital swinging; or by a growing preference for sex acts devoid of emotional significance or performed with strangers."

Hey, give it time. The seventies hadn't even gotten off the ground yet.

If sex experts encouraged do-it-yourself sex, it was only a matter of time before Handy Andy and Handy Ann asked for better tools.

What began as a cottage industry making prostheses for surgical companies progressed to selling novelty items for adult book and porn stores, and then turned into a national phenomenon. Ventriloquist Ted Marché had taken to carving dildos at the dining room table in the middle sixties. Setting up a small factory in North Hollywood, he was soon turning out dildos by the truckload. In March 1978 D. Keith Mano sat down with the first family of fun for a *Playboy* article, "Tom Swift Is Alive and Well and Making Dildos." Steve Marché told this story: "Basically we had three sizes: small, medium and large—five, six and seven and a half inches in length. They were prosthetic; they strapped on. Then people requested larger. So we went from five by one and a half inches to nine by two."

The Marchés moved on to other novelty items: a penis pacifier ("for women who talk too much"), blow-up Judy dolls, penis-shaped walkie talkies, penis-shaped erasers, breast-shaped doorbells, a combination dildo and harmonica (called a Mouth Organ), and the ever-popular Peter Heaters ("hand-knitted in Pasadena by a little old lady from memory"). On the occasion of the nation's bicentennial they produced a red, white, and blue dildo. Then there were the versions of French ticklers (rubber-spiked devices that fit around the shaft of the penis) that the Marchés simply fashioned out of doormats. By the mid-seventies Marché Manufacturing was selling almost five million units a year.

These were not the items that would take sex toys to the mainstream. The seventies spun on Good Vibes—the little bullet-shaped personal vibrators that the magazine ads said were excellent for relieving neck aches (of which there seemed to be an epidemic). Sex shops introduced a line of Doc Johnson's Happy Helpers—ben-wa dancing eggs, French ticklers, and vibrators.

In 1971 Duane Colglazier and Bill Rifkin opened the first Pleasure Chest, an erotic boutique, in New York City. They sold water beds and erotic toys, including a dildo that was thirty inches long and three and a half inches in diameter. There were Emotion Lotions, flavored body lotions, and salves that grew heated when breathed upon. For more serious explorers, the store offered a complete line of head harnesses, labia spreaders, handcuff belts, blindfolds, ball gags, cock rings, harnesses, and shackles. Before the end of the decade the Pleasure Chest was a national phenomenon, with many variations on the theme. Thirty percent of the customers were women.

That statistic, more than any other, reflects the spirit of the seventies. Women in hot pursuit of pleasure had become a major force in the marketplace. In 1974 Dell Williams opened Eve's Garden, a sex boutique and mail-order business. Joani Blank followed with Good Vibrations, a store, catalog, and vibrator museum in San Francisco. Vibrators came in all shapes and sizes, from cute imported snake charmers with hooded-cobra clit stimulators to baseball bat–sized Hitachis (called, appropriately, Magic Wands).

There was some reticence. A March 1976 *Redbook* article, "Plain Talk About the New Approach to Sexual Pleasure," apologized to readers: "The following article may make a number of readers uncomfortable. Their feelings of discomfort or embarrassment are completely understandable and virtually inevitable. Until very recently the subject—the use of vibrators for self-stimulation—has been considered unworthy of serious consideration. But in the past few years, on the basis of knowledge gained from studies of human sexual response, some of the country's most reputable sex therapists have reconsidered the matter and have come to new conclusions." Vibrators were "the only significant advance in sexual technique since the days of Pompeii." The same magazine found in a 1976 survey that one in five women had "used some device during their lovemaking"—and half of those devices were vibrators.

Autoeroticism was in, and what's more, it had horsepower. Not many people forked over $299 for the Accu-Jac, however, a toolbox-sized device that probed women or sucked off men. The original was powered by a washing-machine motor that could be heard halfway down the block.

Stanley Kauffmann, a literary critic, was one of the first writers to pick up on the revelation that sex had gone public; it had moved from fantasy—the fevered imagination of writers and artists—into the actual, the world of "performed pornography." Fanny Hill could romp in print, but now one could watch other people have sex—the flood of Danish imports had given way to home-grown X-rated features in the space of a few months. And, reported Kauffmann in *The New Republic,* for $5 you could watch a live sex act: "Porno (performed) tells the truth about sex: that it is impersonal, that the complete identification of love with sex is a romantic fabrication. Porno is ruthless. It proves that love or anything remotely like it is not essential to sex; that love is an invention and has a limited congruence with sex."

In 1970 San Francisco hosted the first International Erotic Film Festival. Some saw new possibilities. Instead of a single two-minute glimpse of silent anonymous sex, entrepreneurs tried to weave sex throughout a feature-length film. In 1968 Alex de Renzy spent $15,000 on a documentary called *Pornography in Denmark.* The film grossed $2 million. Sensing the profit potential, he put together a collection of vintage stag films, *The History of the Blue Movie,* with Bill Osco. (Osco is credited with making the first hard-core feature film, *Mona: The Virgin Nymph,* about a young girl addicted to oral sex.) De Renzy opened the Screening Room and began producing more extravagant features. Across town, the Mitchell brothers opened the O'Farrell Theater. America would soon get used to the sight of forty-foot penises probing wide-screen vaginas.

In New York City, Gerard Damiano was filming hard-core loops for the Times Square bookstore circuit. One day he interviewed a couple named Chuck and Linda Traynor. "Linda had on this old army jacket," he recounted, "army boots, dungarees and a wool hat pulled down over her face. She looked like a mess, but when she lifted the wool hat, she had these bright, innocent eyes. I

liked her. She was nervous, but so was I. They were nervous about coming up to audition for a fuck film. I was nervous because I was making the fuck film and trying to be very open and free and matter-of-fact about the whole thing."

The following day, Damiano filmed the two with another couple. "I made them switch partners, Rob with Linda and Chuck with Rob's old lady. Rob was really hung, and he had no trouble getting it right up to 11 inches when Linda started sucking him. In two seconds, she had swallowed the whole thing.

"I dropped my script, my cameraman's eyes bugged and we stared at each other. 'What was that?' I asked. It was the most fantastic thing I'd ever seen. Right down her throat."

Damiano worked all weekend on a script about a girl whose clitoris is located deep within her throat. Unable to reach orgasm from intercourse, the heroine would tell her friend that she wanted to hear rockets, bombs, dams bursting. "Do you want to get off or do you want to destroy a city?" the friend asked.

The film would destroy more than a city. It would make porn chic. Filmed in Florida for about $25,000, *Deep Throat* would make more than $100 million. It would also make a legend of the star.

Consider this fevered review: "Faster than Raquel Welch, more powerful than Gloria Steinem, able to swallow tall men in a single gulp. Look! Up on the screen! It's a sword swallower! It's a vacuum cleaner! It's Linda Lovelace. Yes, Linda Lovelace, strange visitor from Bryan, Texas, who came to the World Theater with powers and abilities far beyond those of mortal women. Linda Lovelace, who can change the course of film history, bend flesh in her bare throat, and who, disguised as a mild-mannered nymphomaniac for a small metropolitan film company, fights a never ending battle for free speech, free love and the French way!"

Linda radiated innocence, even as a roomful of men tried to bring her to orgasm. The camera kept cutting from shots of anal sex, oral sex, and intercourse to a dreamy smile on her face. The title act, when Linda first swallows the entire shaft of Harry Reems's cock, seemed almost Wagnerian. But equally memorable was the calm, nonchalant way she shaved her pubic hair, an image that touched millions.

Nora Ephron interviewed Linda for *Esquire,* creating this memorable exchange: "'Why do you shave off your pubic hair in the film?'

"'I always do,' Linda Lovelace replies. 'I like it.'

"'But why do you do it?'

"'Well,' she says, 'it's kind of hot in Texas.'

"That stops me for a second. 'Well,' I say, 'I think it's weird.'

"'Weird? Why?'

"'Well, I don't know anyone who does that.'

"'Now you do,' says Linda Lovelace."

Ephron hung up the phone feeling like a "hung-up, uptight, middle-class, inhibited, possibly puritanical feminist."

Looking back at the film years later, reviewer Bruce Handy spoke of "the lingering hippie notions of free love and liberating sensuality that inform the film, the idea that indiscriminately getting it on served some kind of social good." The film was "pruriently playful."

Staid critics such as the *New York Times*' Vincent Canby faced the difficult question "What are we to think of *Deep Throat*?" What made this film chic? Canby saw it as "at best only a souvenir of a time and place." The name of the theater where it played seemed to offer the best answer. It was called the New Mature World Theater.

Busloads of middle-class tourists were pouring into Manhattan to see the nude revue *Oh! Calcutta!* Now mainstream America made its way to see *Throat*. It became a source of humor on Johnny Carson's talk show; sidekick Ed McMahon had been seen holding court outside a screening of *Deep Throat*. Two Washington reporters used the movie's title as the code name for an unidentified source in a series of articles they wrote on the Watergate break-in. The *New York Times* announced the era of Porno Chic and reported that Mike Nichols, Sandy Dennis, Ben Gazzara, Jack Nicholson, and Truman Capote had been seen in the audience of *Throat*. Linda posed for *Playboy,* hung out at the Mansion with Hefner, appeared at the premiere of *Last Tango in Paris,* and socialized with Sammy Davis, Jr., in Las Vegas.

In August 1972 police arrested the owner and a cashier at the New Mature World Theater. Judge Joel Tyler listened to film critic Arthur Knight defend the movie as the "first film of this genre to acknowledge the importance of female sexual gratification." Other experts debated the difference between prurient and normal eroticism. Dr. Edward Hornick, a New York psychiatrist, said simply, "An erection in the male or the female is a sign of sexual arousal.

Such arousal may take place on the basis of normal, natural appeal or prurient appeal. The same erection is going to be there." A woody is a woody. A stiff dick does not make moral distinctions. A wonderful argument.

When Tyler ruled against the film, the theater marquee read: JUDGE CUTS THROAT—WORLD MOURNS. Gene Shalit said Judge Tyler took "another step toward making *Deep Throat* the best-known movie in America."

On the West Coast, the Mitchell brothers interviewed Marilyn Briggs, a model and actress. The two brothers had shot more than 330 loops for the growing crowds at the O'Farrell Theater. Now they wanted to film a full-length feature based on a porn classic called *Behind the Green Door*. Taking the name Marilyn Chambers, the young actress joined the project.

The story line was simple: A young girl is kidnapped and taken to a private club. A coven of female attendants in black robes prepares her body in a cross between an Esalen massage session and a lesbian feeding frenzy. Johnny Keyes, a black actor wearing a bone necklace, war paint, and white tights, ravages her onstage. A set of trapeze swings descends from the ceiling, and Chambers has sex with four guys at once—one in each hand, one in her mouth, one in her cunt. The on-screen audience—a weird collection of dwarfs, fat women, transvestites, masked men in tuxedos, stewardess types, and street people— breaks into an orgy. Hands reach for genitals and nipples as casually as they would for popcorn. A truck driver in the audience rescues the girl and the movie ends with an almost tender act of one-on-one intercourse.

The film premiered at the Cannes Film Festival to a standing ovation. Then, in one of those moments that shows that the marketing gods move in mysterious ways, Procter & Gamble unknowingly shipped a couple million boxes of Ivory Snow soap adorned by the smiling face of Marilyn Briggs/ Chambers. The Mitchells sent out a PR release that touted the star as "99 and 44/100ths percent pure."

Porn had arrived. It was no longer part of the underground, no longer wrapped in shame or anonymity. Performers became stars. Directors put their names (or pseudonyms) on films and developed cult followings. Alex de Renzy produced *Baby Face* (1977) and *Pretty Peaches* (1978). Damiano turned out *The Devil in Miss Jones* (1972) and *The Story of Joanna* (1975), an early S&M classic. Bill Osco filmed a ribald version of *Alice in Wonderland*

(1975) and the camp classic *Flesh Gordon* (1978). Radley Metzger contributed *Private Afternoons of Pamela Mann* (1974) and *The Opening of Misty Beethoven* (1975).

In 1976 Sony introduced the first home video recorder. Not surprisingly, porn drove the conversion to the new technology. Fans paid up to $300 for a private copy of *Deep Throat.*

Porn's argument was subtle and seductive. Who could say the girl next door would never do this or that, when the girl next door was obviously doing just that on a giant screen? Couples would see a movie and bring the images home, and join that audience of dwarfs and clowns at an orgy.

In New York, Al Goldstein and Jim Buckley's fledgling newspaper was developing a following. Founded at the end of the previous decade, *Screw* was a guide to the changing sex scene. Goldstein provided a consumer's report on porn movies, scoring films on the Peter Meter. He gave three-penis and four-penis ratings to massage parlors, peep shows, and bookstores. America, it seemed, had rediscovered commercial sex. It was Storyville, with Emotion Lotion and Kama Sutra massage oil replacing the gin and jazz of turn-of-the-century brothels. Entrepreneurs turned studios into sexual spas that had theme rooms featuring hippie fantasies with beads and pillows or the toga-clad attendants of a Roman orgy. The Pink Orchid, the Perfumed Garden, and Caesar's Retreat suggested ancient erotic sites. The massage parlor in the Biltmore Hotel had a mirrored Infinity Room, complete with Jacuzzi, champagne, and up to three attendants.

Gay Talese, who spent most of the seventies researching a book on the sexual revolution, briefly managed two parlors. In *Thy Neighbor's Wife,* he wrote that the masseuses were college students, aspiring actors, and dancers, "the adventurous young divorcées, the drifting dropouts, the grisettes with an aversion to straight office work, the *Belle du Jour* wives, the girlfriends of the owners, the pretty lesbians and bisexuals." Although the majority of customers were old enough to be the masseuses' fathers, Talese wrote, "there was a curious reversal of roles after the sexual massage had begun. It was the young women who held the authority, who had the power to give or deny pleasure, while the men lay dependently on their backs, moaning softly with their eyes closed, as their bodies were being rubbed with baby oil or talc. For these men

it was possibly their first intimate contact with the sexually emancipated youth movement they had read and heard so much about, the world of Woodstock and the Pill."

There were thousands of Green Doors across America: No longer was the bedroom door the only gate to heaven.

Porn offered one form of public sex. Couples learned that sexual energy was a movable feast, that watching sex was a turn-on. For some, the cinematic version wasn't enough. They wanted to break the fourth wall, to participate. The seventies unleashed an unprecedented wave of exhibitionism, of public sex, of shared sex.

In 1971 Gilbert Bartell wrote *Group Sex: A Scientist's Eyewitness Report on the American Way of Swinging.* He had spent three years in the pools and rec rooms of wife-swapping middle-class adventurers, and estimated there were up to one million people involved in organized swinging. (A less authoritative book on wife-swapping clubs that appeared in the mid-sixties had put the figure as high as eight million.) Some couples belonged to organized clubs such as the Wide World of Contemporary People and met swingers at annual Lifestyles Conventions, or on cruises sponsored by Lifestyles Tours and Travel. Others placed ads in magazines such as *Select* and *Kindred Spirits:*

- Seek girls or young couples who like French culture and all things exotic. AC/DC girls welcome.
- Discreet couple, late 40s, desires to meet discreet, kind, broad-minded couples of any age for fun and pleasure. Discretion an absolute must.
- Couple, early 30s, interested in threesomes, foursomes, parties and photography. She's versatile, loves all but B&D. Send photo, phone number and address.

Bartell described a ritualized subculture: "Every swinging host has a radio, phonograph or hi-fi set with a selection of mood music that is preferred as background. We never heard rock or other modern styles—just melodious tunes, mostly from the forties or fifties. Mantovani and Mancini are popular."

There was closed swinging, with couples switching and moving off to private bedrooms; and open swinging, where everyone shared the same bed or rec room. Almost two thirds of the women admitted to having sex with other women, and Bartell claimed that 92 percent of the women he saw interacted while their husbands watched. Another favorite activity, known as more-on-one, would make one person the center of attention, pouring the energy of three or more lovers into one.

The invention of the Polaroid SX-70 underscored the trophy nature of swing clubs. Couples would take pictures and divide the shots at the end of the evening. Bartell claimed 99 percent of the males involved in swinging were *Playboy* readers. Many had taken the magazine's philosophy to heart: They would not allow marriage to end sexual exploration. George O'Neill called the concept "open marriage," and, according to one study, some 15 percent of husbands and wives practiced it. Among unmarried couples living together (another lifestyle choice) the figure rose to 30 percent.

Americans clearly had developed a taste for sexual adventure. At Sandstone, the erotic retreat outside of Los Angeles, up to 275 couples gathered in a kind of sexual commune. In California, one couldn't breathe without developing an accompanying philosophy, and Sandstone was no different. The brochure for potential members gave this message: "The concepts underlying Sandstone include the idea that the human body is good, that open expressions of affection and sexuality are good. The strength and lasting significance of the Sandstone experience lies in human contact divorced from the cocktail party context, with all its games and dodges and places to hide. Contact at Sandstone includes the basic level of literal, physical nakedness and open sexuality."

Alex Comfort was a regular visitor and described Sandstone in *More Joy*. Gay Talese spent time there as well, offering this description of a typical Bosch-like orgy:

> After descending the red-carpeted staircase, the visitors entered the semidarkness of a large room, where, reclining on the cushioned floor, bathed in the orange glow from the fireplace, they saw shadowed faces and interlocking limbs, rounded breasts and reaching fingers, moving buttocks, glistening backs, shoulders, nipples, navels, long blonde hair spread across pillows, thick dark arms hold-

ing soft white hips, a woman's head hovering over an erect penis. Sighs, cries of ecstasy could be heard, the slap and suction of copulating flesh, laughter, murmuring music from the stereo, crackling black burning wood.

. . . It was a room with a view like none other in America, an audiovisual aphrodisiac; everything that Puritan America had ever tried to outlaw, to censor, to conceal behind locked bedroom doors, was on display in this adult playroom, where men often saw for the first time another man's erection and where many couples became alternately stimulated, shocked, gladdened and saddened by the sight of their spouses interlocked with new lovers.

Sandstone was not the only place in America with a view. There were party homes scattered across the country. Blake Edwards's hilarious movie *10* had a subplot wherein Dudley Moore spies on a house of orgiasts. When they meet, the host, who has his own telescope trained on Moore's house, complains, "I've been providing X-rated entertainment and you reciprocate with PG." A far more physically attractive guest list graced the weekend orgies at Hefner's Mansion West.

In New York, gays had turned bars and bathhouses into underground sexual arenas. At the Continental Baths in the Ansonia Hotel, Bette Midler performed while towel-clad males jousted about in the pool and on the dance floor. At Hudson River haunts such as the Anvil, the Sewer, and the Cock Ring, the sex was of a no-holds-barred variety. The clientele found off-label uses for Crisco and axle grease. The fist became a sexual organ. Some say gays were leading the way, that lines between straight and gay were blurred. Pop culture flirted with androgyny.

The club phenomenon crossed over in the mid-seventies. In 1976, on the nation's bicentennial, Larry Levenson opened Plato's Retreat in Manhattan. Steve Rubell and Ian Schrager opened Studio 54 in 1977, cashing in on the disco craze. The two clubs reflected different approaches to permission. Rubell cordoned off the entrance to his club with a velvet rope, and the politics of the door was something to behold. He said he was casting a play. Celebrities such as Mick and Bianca Jagger were admitted; celebrity was almost as liberating as anonymity.

A gossip column was more discreet than a police blotter. Many reporters were so blinded by big names that they didn't notice the favors at the door—pockets filled with quaaludes, packets of cocaine. Jim Fouratt told Anthony Haden-Guest that "Studio 54 gave license. That was what the door policy was about more than anything else. It was to make you feel that if you got in, you were in a world that was completely safe for you to do whatever you wanted."

So women danced in sleek outfits, perky little nipples popping like flashbulbs. (When *Playboy* ran a photo of an unidentified woman dancing at Studio 54 without panties, she filed a suit claiming invasion of privacy. She insisted the magazine had airbrushed out her underwear and added the pubic hair.)

And there was on-premises sex. Photographer David Hamilton told Haden-Guest, "You would look around and you'd see somebody's back. And then you'd see little toes twinkling behind their ears." The celebrity set played at adventure, flirting with the darker side of sex. Rubell had to rescue one socialite from the basement of the club, where she had allowed herself to be handcuffed to the pipes. Her sex object, a boy who tended bar, had rushed back to work without unlocking the cuffs.

At Plato's, fitness counted more than fashion. You earned celebrity through what you did on the mats, in the pool, on the dance floor, in the shower rooms, and in private cubicles. You put on an attitude when you walked through the door with a partner, paid $30 for a one-night admission and a six-week membership. Screenwriter Buck Henry recalls that when he and a companion signed in, they used the names Scott and Zelda. The maître d'hôtel looked at the names and said, "Oh, yeah—Scott and Zelda. You've been here before."

Plato's took the outside world, the bold experiments in promiscuity and license that filled the singles' bars, and condensed them into a single night. A filmmaker recounted his first impressions of the club to a *Playboy* writer, how you walked through the door to be overwhelmed by the almost psychedelic aroma of orgy. You focused on what you were seeing and became a connoisseur of techniques. Then you'd study personalities: "You single out a beautiful girl and watch her for the whole evening, trying to figure out from her behavior why she's there. Last week I watched a woman in the pool go through 21 guys. She was into underwater oral sex. Maybe she was training to be a pearl diver. Maybe she had always had the fantasy of giving head to a crowd."



core films such as Russ Meyer's *Beyond the Valley of the Dolls* (1970) and Just Jaeckin's *Emmanuelle* (1974).

Sexual issues became dramatic plot concerns in major motion pictures. Jane Fonda earned an Oscar for her portrayal of a high-class call girl in *Klute* (1971), in which she confesses to her analyst that she prefers her life as a hooker to that of a model, because as a hooker she is more in control of the relationships. In *Coming Home* (1978), Fonda leaves Bruce Dern, a gung ho Vietnam officer, for Jon Voight, a disabled vet who brings her to climax through cunnilingus. War is phallic; peace is a warm tongue.

Major Hollywood stars bared their bodies and their souls. In Bernardo Bertolucci's *Last Tango in Paris* (1973), Marlon Brando and Maria Schneider have an alienating, anonymous affair without bringing in the outside world, without even telling each other their names. "Maybe we can come without touching" is one of the games they play. Anal sex with the aid of a stick of butter is another. Bertolucci could claim simultaneous discovery of the zipless fuck— but as with Erica Jong's characters, the illusion was hard to maintain. At the end of their relationship, Schneider shoots Brando. *In the Realm of the Senses* (1976), a Japanese film about an actual relationship between two lovers who leave their families and disappear into an exhausting affair, presented a similar message. Lust is not sustaining: She strangles her lover to produce a heightened orgasm, then castrates the corpse.

Cinematic sex ranged from an exuberant trailer-park fuck between Jack Nicholson and Karen Black in *Five Easy Pieces* (1970) to the explicit scene between Donald Sutherland and Julie Christie in *Don't Look Now* (1973). Warren Beatty established himself as Hollywood's leading cocksman in *Shampoo* (1975). (The scene in which Julie Christie goes down on him at a political fund-raiser, while on television sets in the background Spiro Agnew speaks of Nixon's stand against permissiveness, is a classic.) Beatty's character, a hairdresser who is asked if he sleeps with his client, replies: "Let's face it—I fucked them all! That's what I do. . . . That's it. It makes my day, makes me feel like I'm going to live forever. Maybe that means I don't love 'em. I don't know. Nobody's going to tell me I don't like 'em very much."

Just as the sixties could be traced in the career of one actress (be it Natalie Wood or Jane Fonda), two films featuring Diane Keaton came to summarize

the seventies. As the title heroine in Woody Allen's *Annie Hall* (1977), she portrayed a quirky, adventuresome city girl. The film explored the questions of a modern relationship. Woody and Diane discussed their sex problems while standing in line for movies, with friends, with analysts. Why did something that bound you to one lover (an escaped lobster and the resulting chaos) seem completely meaningless when tried with another? Why were men's and women's expectations so different? When asked by their analysts how often they have sex, Allen says, "Hardly ever. Maybe three times a week." Keaton says, "Constantly. I'd say three times a week."

Annie Hall changed the way American women dressed, but *Looking for Mr. Goodbar,* made the same year, changed women's nightmares. Director Richard Brooks took Judith Rossner's novel and turned it into a scary cautionary tale about the dangers of promiscuity. The movie and the novel were based on a true crime. Katherine Cleary, an Irish Catholic schoolteacher, was murdered by a man she had picked up in a bar called Tweeds on New Year's Day. The victim had been stabbed repeatedly. Police found a red candle stuffed up Cleary's vagina.

Each of the men Keaton brings home in the film version represents a walking dysfunction. The English professor who sleeps with his student is a premature ejaculator who cheats on his wife. The overprotective welfare worker who insinuates himself into her family has a problem with Keaton's sexuality. The Richard Gere character never seems to reach a climax and is abusive. Tom Berenger, as the man who kills her, is a troubled bisexual who has just abandoned a relationship with a queen. When Keaton taunts him for not being able to get it up, he becomes enraged. The film climaxes in a strobe-lit orgy of bloodletting.

The press had been filled with war stories from the sexual frontier. Nora Ephron wrote about books that caught perfectly "the awful essence of being a single woman in a big city. False pregnancies. Real pregnancies. Abortions. Cads. Dark bars with married men. Rampant masochism." She reviewed a tape-recorded tell-all called *The Girls in the Office,* in which women living in the city were "surrounded and tormented by exhibitionists, flashers, rapists, muggers, goosers, breathers, feelers and Peeping Toms. The acts of violence become so commonplace in this book that at one point, when one Vanessa Van Durant is locked in her apartment by her boyfriend and beaten and

buggered for two weeks, I found myself shrugging and thinking, Ah, yes, the old 'lock her in the apartment and beat her and bugger her' routine."

Writer Jane Howard, reporting from the front for *Mademoiselle* in July 1974, spoke of a woman who had admitted to "a recent attack of free-floating lust." The friend had considered going to the lobby of the Americana Hotel and hanging around as if she were a hooker, to see whom she might pick up. "I thought of answering one of those 'Unlicensed Masseur' ads in the *Voice*. There was a Cowboy Ken whose ad sounded interesting, but how could I know he wasn't an ax murderer?"

Lord deliver us from premature ejaculators and from ax murderers. Some rallying cry.

The November 1976 cover of *Esquire* portrays Hugh Hefner, pipe clenched between teeth, glowering at a copy of *Hustler* magazine. "What have they done to the girl next door?" asks the cover line.

The feminist movement had tried to free itself from male definitions of womanhood. And, not surprisingly, it had singled out Hefner, a man who had spent two decades defining new roles for both sexes. Hefner believed the girl next door was a sexual being, and the men who read *Playboy* approved.

Playboy became the most imitated magazine in America, but each men's magazine celebrated its own variations on the theme. The girls of *Oui* magazine were the Continental sisters of Brigitte Bardot. The girls of *Club* magazine were English—sturdy, with a slight taste for fetish, leather boots, and whips.

In 1969 Bob Guccione brought the UK's *Penthouse* to America. His ads declared, "We're going rabbit hunting," and showed the *Playboy* Rabbit Head caught in the crosshairs of a gun sight. *Penthouse* Pets were the girls next door—if you lived next door to a massage parlor. Some chroniclers of the sexual revolution make a lot of the so-called pubic wars. *Playboy* had first published pubic hair in a pictorial of *Sweet Charity*'s Paula Kelly in August 1969. The first Playmate to show pubic hair was Liv Lindeland in the January 1971 issue, nine months after *Penthouse* Pets went pubic. Pubic hair had long been considered obscene, but full frontal nudity was a natural progression.

Larry Flynt, owner of a series of strip clubs in Ohio and Kentucky, turned his club newsletter into *Hustler* magazine in 1974. He expressed contempt for

the romantic images of Hefner's girls next door and Guccione's soft-focus strumpets. Their coyness was hypocritical; *Hustler* would deliver raunch. Flynt's battle cry was "Think Pink." His models were the girl next door if you lived next door to a low-rent gynecologist's office. Laura Kipnis, a feminist scholar whose topic is porn, describes Flynt's approach to publishing in *Bound and Gagged:* "From its inception, *Hustler* made it its mission to disturb and unsettle its readers." If *Penthouse* was a more explicit imitation of *Playboy, Hustler* found inspiration in Al Goldstein's *Screw.*

Kipnis catalogs *Hustler*'s "Rabelaisian exaggeration of everything improper," its "partial inventory of the subjects it finds fascinating: fat women, assholes, monstrous and gigantic sexual organs, body odors (the notorious scratch-and-sniff centerfold), anal sex and anything that exudes from the body—piss, shit, semen and menstrual blood, particularly when it sullies public, sanitary or sanctified sites. And especially farts: farting in public, farting loudly, Barbara Bush farting, priests and nuns farting, politicians farting, the professional classes farting, the rich farting."

In June 1978 Flynt, after a highly publicized but short-lived religious conversion, announced, "We will no longer hang up women like pieces of meat." That month's cover proclaimed, "Last All-Meat Issue—Grade-A Pink," and showed a woman's body passing through a meat grinder. Feminists turned the image into a recruiting poster.

Like a twentieth-century Tocqueville, French novelist Alain Robbe-Grillet visited 42nd Street and discovered "a kind of great national theater of our passions" where we could "at last contemplate quite openly our hidden faces, thereby transforming into freedom, play and pleasure what was merely alienation and risked becoming crime or madness." He happened to be looking at the cover of a magazine depicting a naked woman tied to a cage, her breasts exposed to ravenous rats.

Why did men need these images? "No bull, however deprived, will let its gaze be attracted by the photograph of a cow's rump," Robbe-Grillet wrote. "Man is fully human only if everything passes through his head, even (and especially) sex. An adult needs pornography as a child needs fairy tales." Porn

was a way of dealing with things that go bump in the night, he believed, uniting both the pleasure and the danger of sex in a fantasy format.

Peter Prescott, reviewing Peter Michelson's *Aesthetics of Pornography* for *Newsweek* in March 1971, asked, "Can anything intelligent be said about pornography? Like prayer, it causes an alteration in our brain waves and our blood. In both prayer and pornography, sparks are struck from some part of our cortex that knows no language. The sparks from prayer fly up, the sparks from pornography fly the other way." Michelson had suggested that pornography was "the imaginative record of man's sexual will."

Margaret Mead, no fan of the genre, said that "pornography is fantasy material about forbidden activities put together by people who probably never have experienced what is depicted, in order to meet the needs of other people who are unlikely to carry out in reality the fantasized activities shown. So pornography in all its various hard-core and soft-core forms plays upon the ignorance, the impotence and the feeble reveries of persons—women or men—for whom lusty sexual activities in the past, present or future pose a threat or are inaccessible." Porn, Mead felt, was "an exploitation of sexual weakness or of unmet sexual needs, for the purpose of financial gain." But now she saw healthy people embracing porn at their own peril, using it to take their sexual lives into new terrain. She said porn gave "some illusion of participation" in something beyond the individual.

West Coast porn came right out of the counterculture, with the Mitchell brothers filming loops with hippies high on controlled substances. One of the legacies of the sixties is the belief that sex combined with an exuberance for public display is perfectly natural. If you expressed politics by marching 100,000 strong, by going tribal, what would be the best way to express sex? When you look at the early porn community you see an X-rated equivalent of the Provincetown Players—a small group of sexual radicals, volunteers whose pure willingness to get it on soon infiltrated the American scene. They were pruriently playful, willing to do it in or out of costume, in chains, swings, beanbag chairs, swimming pools, hot tubs, on trapezes, covered with oil in gas station garages, flung over motorcycles, tossed into piles of straw or on banquet tables covered with fine silverware. The early porn films that were shot on elegant estates seem to invoke and taunt old-world urbanity.

The best had an air of instruction. *The Opening of Misty Beethoven* was a prurient retelling of the Pygmalion story, with Jamie Gillis teaching Constance Money, a street whore, the finer details of sex. The instruction on cunnilingus: Approach your partner as you would a ripe mango. These films showed women in control. (Misty depicts a woman strapping on a dildo and taking a man.)

The films made a man's ejaculation a banner event—the special-effect shot in *Behind the Green Door* caught the come and strung it across the screen like northern lights. The come shot would become a cliché, but the original impact was like a fireworks display on the Fourth of July. This is how sex feels for a man. This is how it looks to feel this good. Porn depicted sexual liberation and the extinction of Victorian prudery. The backlash had to attack the apparent willingness of women to participate in such male fantasies.

If porn was a fairy tale for adults, there had to be monsters. Puritan America has a talent for creating moral panics around nonexistent threats. The white slave trade hysteria that resulted in the Mann Act is one such example, the snuff film another.

In 1969 reporters covering the Tate-LaBianca murders repeated a rumor that the Manson family had filmed home movies of their brutal slayings. Press accounts coined the term "snuff film." No Manson film ever surfaced, but the idea clawed at the dark side of the American psyche. Everyone knew someone who knew someone who had seen "the real thing." The *New York Post* did much to tantalize the gullible, running the headlines SNUFF PORN: THE ACTRESS IS ACTUALLY MURDERED and SNUFF: TURNING ON TO THE LAST TABOO.

No matter that police were unable to locate a copy. The press invented details: "There are apparently more than one sex and murder film circulating," wrote the *Post*. "The films are distributed by pornography merchants associated with organized crime and they are offered only to trusted customers." Sources told of one film made in Latin America, possibly Argentina. The film was said to begin with an assortment of sex acts between a woman and one or more actors. "But soon a knife is produced," writes the *Post,* "and the horrified woman—clearly unaware of the true nature of her role—is stabbed to death and then savagely dismembered." The film supposedly sold for $1,500 a set. Private screenings cost viewers $200. The *Post* reported with a straight face that a producer had offered "a large amount of

money to someone who would be murdered on film." Would you mind talking to my agent first?

In 1975 Alan Shackleton purchased *The Slaughter,* a trashy girl-gang biker movie shot by Roberta and Michael Findlay in South America. He tacked on a scene at the end in which a film crew kills and disembowels a script girl. The special effects can be summed up in one sentence: Pass the ketchup. Shackleton tacked on a new title, *Snuff,* and a tag line: "From South America, where life is cheap."

Murder for entertainment was a chimera, but fake murder for entertainment made tons of money. Feminists flocked to the theater—to picket and protest the abuse of women. (Never mind that there were other, more gory films playing just up the street; *The Texas Chainsaw Massacre,* for instance, was an equal-opportunity exploitation flick, with victims of both sexes.)

America has always toyed with a domino theory of debauchery. At the turn of the century, one kiss placed women on the road to ruin. By the seventies, the acts had escalated. Customers of commercial pornography, it was feared, would tire of fuck films and want something more outrageous. And once you crossed the line, anything was possible.

It was an unusual hysteria, a case of rhetorical hemorrhage. Susan Brownmiller, author of *Against Our Will,* a powerful indictment of rape, was the first to wed the issues of porn and power. Clearly, she was offended by explicit erotica, elevating "the gut distaste that a majority of women feel when we look at pornography" to a political mandate. "Hard-core pornography is not a celebration of sexual freedom," she charged. "It is a cynical exploitation of female sexual activity through the device of making all such activity, and consequently all females, dirty."

Her distaste came from the "gut knowledge" that "our bodies are being stripped, exposed and contorted for the purpose of ridicule to bolster that masculine esteem which gets its kick and sense of power from viewing females as anonymous panting playthings, adult toys, dehumanized objects to be used, abused, broken and discarded. This, of course, is also the philosophy of rape. There can be no equality in porn," she wrote, "no female equivalent, no turning of the tables in the name of bawdy fun. Pornography, like rape, is a male invention, designed to dehumanize women, to reduce the female to an object of sexual access, not to free sensuality from moralistic or parental inhibition."

Porn, she wrote, "is the undiluted essence of antifemale propaganda." Brownmiller took the serious issue of rape and used it as a cattle prod. She compared porn to the gassing of Jews and the lynching of blacks.

Robin Morgan, editor of *Sisterhood Is Powerful,* pushed the same buttons. In 1974 she offered this formula: Pornography is the theory and rape is the practice. "Knowing our place," Morgan said, "is the message of rape—as it was for blacks the message of lynchings." She fanned the terror, saying that for four years, feminist students had been the prey of "lesson rapes"—committed with the idea that all frustrated feminists needed was a good rape to show them the light.

Then she expanded the definition of rape to include all unwanted male desire. "For instance, I would define rape not only as a violation taking place in the dark alley or after breaking into and entering a woman's home. I claim that rape exists any time sexual intercourse occurs when it has not been initiated by the woman, out of her own genuine affection and desire."

Morgan decried the Madison Avenue image of the liberated woman, "a glamorous lady slavering with lust for his paunchy body." And argued that most women relented to sex out of fear—"fear of losing the guy, fear of being a prude"—and that "the pressure is there, and it need not be a knife blade against the throat; it's in his body language, his threat of sulking, his clenched or trembling hands, his self-deprecating humor or angry put-down or silent self-pity at being rejected." Picture a wanted poster of Woody Allen as your rapist next door.

Morgan went from lesson rapes to snuff movies in the same rap. "The *New York Post* carried a story about a nationwide investigation into snuff films, or slashers—pornographic movies which culminate in the actual murder and dismemberment of the actress. These movies, shot for the most part in South America, appear to be circulating, according to the *Post* story, on the pornography connoisseur circuit, where the select clientele can afford $1,500 for a collection of eight reels. A porn movie called *Snuff* opened at a first-run movie theater on New York's Broadway. Advertised as the bloodiest thing ever filmed, this print was priced to make it available to Everyman. As usual, the message is clear through the medium." Except of course that *Snuff* was a hoax, with ketchup for blood.

Gloria Steinem addressed the issue frequently in the pages of *Ms.* She tried to distinguish erotica from porn, with all the success previous generations had in distinguishing nice girls from bad ones. "Look at any photo or film of people making love," she commanded. "Really making love."

Okay.

"The images may be diverse, but there is usually a sensuality and touch and warmth, an acceptance of bodies and nerve endings. There is always a spontaneous sense of people who are there because they want to be, out of shared pleasure."

Okay.

"Now look at any depiction of sex in which there is clear force, or an unequal power that spells coercion."

Her list of bad sex included whips and chains, torture and murder, wounds and bruises, body poses that convey conqueror and victim, and—brace yourself—"unequal nudity."

These two sorts of images, she wrote, "are as different as love is from rape, as dignity is from humiliation, as partnership is from slavery, as pleasure is from pain."

In 1979 Susan Brownmiller opened a storefront on Times Square. The brainwashing began. Women Against Pornography ran two tours a week, taking groups of women into bookstores, live sex shows, peep shows. The tours began with a slide show of the most concentrated hard-core, a witless sampler of women bound, gagged, poked, and prodded—all selected with the avowed purpose of raising the level of outrage. What offended Brownmiller should offend the world. An August 27, 1979, article in *People* pictures Brownmiller standing dourly outside the Show World Center. "The basic content of pornography is male violence against women," she says. "It makes men feel that it is normal and rational to be sexually hostile to women and makes women define themselves through sexually masochistic images. We're all for sex, but we're for healthy, equal sex."

Not quite. The feminist movement had lost its momentum. The sources of outrage, the causes around which activists could organize, had dwindled.

The Supreme Court had legalized abortion. Lawsuits brought by NOW had done much to lessen discrimination in the workplace. Rape laws had been changed to aid prosecution. In 1973 *Esquire* had dismissed the movement with an article called "302 Women Who Are Cute When They're Mad." In 1976 a *Redbook* survey found that "seven out of ten men say the women's movement has had little or no effect on them." In 1974 a *Newsweek* editorial wondered in print, "Is Gloria Steinem dead?" Michele Wallace, writing in the February 1978 issue of *Ms.,* was honest about the new agenda. Men must be "made so uncomfortable by the lunacy of sexism that they feel compelled to do a few things males seem rarely to do—explore their motivation and become suspicious of their desires in regard to women."

Like the Puritans, these feminists dealt in guilt and shame. They wanted to poison the well of eros.

At the outset of the decade, the nation seemed to be moving toward sexual maturity. Reason and research had triumphed over America's fear of sex. Science seemed to give the green light. Sexual information would set us free.

In 1970, after three years of research, the President's Commission on Obscenity and Pornography completed its report. Social scientists had spent nearly $3 million observing the effects of erotica. They had wired college students and had shown them sex films for ninety minutes a day, five days a week, for three weeks. They found "no evidence that exposure to or use of explicit sexual materials plays a significant role in the causation of social or individual harms such as crime, delinquency, sexual or nonsexual deviance or severe emotional disturbances."

Sometimes it takes a ton of tax dollars to affirm common sense. The report found that people who were aroused by pornography did not become sexual predators. They simply masturbated or had sex in the usual ways with their regular partners. Indeed, the report found that there was a positive side to sexual material. People who were exposed to "erotic stimuli" tended to talk about sex, and sexual material could "increase and facilitate constructive communication about sexual matters within marriage." Erotica was used as "a source of entertainment and information by substantial numbers of American adults."

Studies of sex offenders found that most had sexually deprived child-hoods, that they had less exposure as adolescents to erotic material than normal citizens did. The one image that most convicted pedophiles recalled was a billboard for Coppertone suntan lotion that showed a tiny dog pulling down the bathing suit of a young girl.

The report confirmed a generation gap. Young people were more likely to become aroused by erotica than were their elders. People who were college-educated, religiously inactive, and sexually experienced were more likely to report arousal than persons who were less educated, religiously active, and sexually inexperienced.

The commission noted the Danish experience: When laws against sexually explicit materials were eliminated in 1969, the rate of sex crimes in that country dropped. By a vote of 12 to 5 the President's Commission voted to repeal all federal, state, and local laws prohibiting the sale, exhibition, or distribution of sexual materials to consenting adults. One commissioner openly questioned "the wisdom and validity of encasing its moral and social convictions in legal armor." The government should get out of the business of trying to dictate sexual morality: "Governmental regulation of moral choice can deprive the individual of the responsibility for personal decision, which is essential to the formation of genuine moral standards. Such regulation would also tend to establish an official moral orthodoxy, contrary to our most fundamental constitutional traditions."

Not all commissioners were so enlightened. Charles Keating, Nixon's belated appointee to the commission, tried to have the report suppressed. Failing that, he wrote a bitter dissent. So did Commissioners Father Morton Hill and the Reverend Winfrey Link. "For many of us who have been battling smut," Keating cried, "these words are no less than a Magna Carta for pornographers."

President Nixon rejected the commission's conclusions outright. "American morality is not to be trifled with," he declared. "Smut should be outlawed in every state of the Union. So long as I am in the White House there will be no relaxation of the national effort to control and eliminate smut. The commission contends that the proliferation of filthy books and plays has no lasting, harmful effect on man's character. Centuries of civilization and ten minutes of common sense tell us otherwise."

William Hamling, a California publisher, released an unauthorized illustrated version of the commission's report. The Greenleaf Classic volume featured 546 hard-core illustrations that ranged from engravings by Pablo Picasso to child pornography. Photographs showed couples in poses that could have been lifted from temple carvings in India to a gut-wrenching shot of a woman fellating a horse.

Hamling printed 100,000 copies of the report and sent out a brochure to 55,000 citizens. On one side of the brochure were samples of illustrations—women with come on their faces, lesbian shots, orgies, and the horse lover. On the flip side was the provocative THANKS A LOT, MR. PRESIDENT.

Attorney General John Mitchell dusted off the Comstock Act and arrested Hamling and three others on charges of using the U.S. mail to deliver an obscene book (as well as the brochure). Two of the commissioners testified on Hamling's behalf, saying the illustrated report was actually better than the original. The jury agreed, but found that the brochure, which simply printed explicit pictures with a tirade against Richard Nixon, was obscene. Hamling was sentenced to four years in prison and a $32,000 fine. His conviction was upheld by the Supreme Court.

Sex became a national issue as President Nixon campaigned against permissiveness. Nixon became the most actively antisexual president of the century. Attorney General Richard Kleindienst put together 680 pages of proposed changes in the Federal Crime Statutes. The statutes defined obscenity as "an explicit representation or detailed written or verbal description of an act of sexual intercourse, or violence indicating a sadomasochistic sexual relationship; an explicit close-up representation of a human genital organ." The proposed changes also defined as obscene devices "designed and marketed as useful primarily for stimulation of the human genital organs." There go our sex toys.

Actress Shirley MacLaine wrote an editorial for *Newsweek* in May 1973 decrying Nixon's repression. She pointed out that the Nixon administration's definition would outlaw *Deep Throat, The Devil in Miss Jones, Last Tango in Paris, Cries and Whispers, Carnal Knowledge, A Clockwork Orange,* and *Straw Dogs.* It would suppress the fiction of John O'Hara, Norman Mailer, John Updike, James Joyce, and Thomas Pynchon. "As a citizen, I resent being told what I can or cannot see, read or enjoy. These choices belong to me. Not to

the FBI. Not to the Justice Department. Not even to the President of the United States." The president felt otherwise.

Even as President Nixon was being driven from office by the Watergate scandal, his strategy for a moral America was taking shape. In 1973 the Supreme Court, stocked with four Nixon appointees, heard a series of cases involving obscenity.

In the first, a California man had been found guilty of knowingly distributing obscene material. He had advertised through the mail four books entitled *Intercourse, Man-Woman, Sex Orgies Illustrated,* and *An Illustrated History of Pornography* and a film entitled *Marital Intercourse.* A manager of a restaurant and his mother opened their mail (what kind of family opens mail together?) and complained to the police, setting into motion *Miller vs. California.*

Previous Supreme Court cases had ruled that if a work was to be judged obscene and beyond the protection of the Constitution, it had to be "utterly without redeeming social value." The Burger Court closed that loophole. The Supreme Court conceded that "the sexual revolution of recent years may have had useful by-products in striking layers of prudery from a subject long irrationally kept from needed ventilation. But it does not follow that no regulation of patently offensive hard-core materials is needed or permissible; civilized people do not allow un-regulated access to heroin because it is a derivative of medicinal morphine."

The Nixon Court voted five to four to turn matters of taste over to local prosecutors. While the First Amendment does not vary from community to community, "this does not mean that there are, or should be or can be, fixed uniform national standards of precisely what appeals to the prurient interest or is patently offensive. These are essentially questions of fact, and our nation is simply too big and too diverse for this Court to reasonably expect that such standards could be articulated for all 50 states in a single formulation."

Justice William O. Douglas was outraged. "What shocks me may be sustenance for my neighbor," he wrote in his dissent. "What causes one person to boil up in rage over one pamphlet or movie may reflect only his neurosis, which is not shared by others. Obscenity—which even we cannot define with precision—is a hodgepodge. To send men to jail for violating standards they cannot understand, construe and apply is a monstrous thing to do in a nation dedicated to fair trials and due process."

The Court handed down a second ruling that further threatened sexual expression. The owners of the Paris Adult Theater in Atlanta had been arrested for showing two explicit films, *Magic Mirror* and *It All Comes Out in the End.* The theater posted warnings: "Atlanta's Finest Mature Feature Films" and "Adult Theater: You must be 21 and able to prove it. If viewing the nude body offends you, please do not enter."

In an earlier case, *Stanley vs. Georgia,* the Supreme Court had held that a man had the right to own and show stag films in the privacy of his home. Did that same right to privacy not give the Stanleys of the world the right to enjoy the same films projected for consenting adults outside the home?

The Supreme Court thought not. Chief Justice Warren Burger declared war on "sex and nudity," saying that "ultimate sexual acts" were not protected in public just because they were allowed—in some places—in private.

The Court ignored the recommendation of the President's Commission, citing instead the minority report of Father Hill and the Reverend Link. The Court agreed there is a "right of the nation and of the states to maintain a decent society." Privacy rights and public accommodation rights were mutually exclusive. It was ridiculous to suggest the Constitution protected the public showing of a movie that shows explicit sex acts, any more than it would "a live performance of a man and woman locked in a sexual embrace at high noon in Times Square. It is neither realistic nor constitutionally sound to read the First Amendment as requiring that the people of Maine or Mississippi accept public depictions of conduct found tolerable in Las Vegas or New York City."

At most, the Court was willing to accept that sexual pictures might have serious value if used in "medical books that necessarily use graphic illustrations and descriptions of human anatomy for the education of physicians and related personnel." Anything else was fair game for the porn vigilantes.

Nathan Lewin, writing in *The New Republic,* saw the strategy: "Caught in the vise are those who are in the business of expression—book publishers, movie distributors and even booksellers. Chief Justice Burger's ruling leaves them at the mercies of hundreds of local jurisdictions. What is there now to prevent the institution of criminal proceedings in one or several small Midwestern towns against the publishers of *Playboy* or *Penthouse* or against those who print or market Madam Xaviera Hollander's memoirs?"

The first film attacked under the new standard was *Carnal Knowledge,* a dark comedy directed by Mike Nichols, starring Candice Bergen, Jack Nicholson, Art Garfunkel, and Ann-Margret. A jury in Albany, Georgia, convicted a theater operator for showing the film, which evidently did not possess the seriousness of an anatomy textbook.

Russ Meyer, king of the nudie cuties, canceled production plans for a movie called *Foxy,* telling *U.S. News and World Report,* "I think I'll go fishing."

Charles Keating contributed an article for the January 1974 *Reader's Digest,* "Green Light to Combat Smut." Concerned citizens now had a legal weapon to stamp out "rampant erotica." Local vigilantes went to work.

The federal government's antiporn crusade had deep pockets. Prosecutors would spend more than $2 million on several highly publicized trials. And their strategy—forum shopping—was obvious. Choose a jurisdiction where the community standard was something just this side of Old Testament. Assistant U.S. Attorney Larry Parrish hauled the producers and distributors of *Deep Throat* to Memphis on charges of conspiracy to distribute porn on an interstate scale. Those indicted included actor Harry Reems (who had never been to Memphis) and director Gerard Damiano. A later trial went after Georgina Spelvin, star of *The Devil in Miss Jones.* The Bible Belt jurists found the defendants guilty. When those verdicts were overturned on a technicality, Parrish retried the major players—Louis Peraino, Anthony Battista, T Anthony Arnone, Bryanston Distributors, and Gerard Damiano Film Productions. With the conviction, they were sentenced to prison terms of less than six months and fines of up to $10,000.

The feds also targeted Al Goldstein, editor and publisher of *Screw* and *Smut,* for geographical entrapment. Postal inspectors in the Kansas cities of Lawrence, Salina, Hutchinson, and Pratt subscribed to *Screw* and *Smut* under assumed names. When copies arrived, a local jury indicted Goldstein and Jim Buckley, his former partner, on twelve counts of obscenity. Mind you, the tabloids were not sold in Kansas and, indeed, only eleven people in the state other than the postal inspectors had ever bothered to subscribe.

At the first trial, in Wichita, the prosecutor called Goldstein "the mayor of 42nd Street" and accused him of trying to introduce degeneracy and indecency into the state of Kansas. *Newsweek* reported that a woman juror burst

into tears when she saw the evidence. A federal judge declared a mistrial. A second trial in Kansas City resulted in a plea bargain. Goldstein and Buckley remained free, but Goldstein would have to pay a $30,000 fine.

The government could not stop pornography, but it could raise the cost of doing business. The strategy took a darker turn in 1978.

Police in Lawrenceville, Georgia, bought copies of *Hustler* and *Chic*, and then the county solicitor filed charges against Larry Flynt. On March 6, 1978, as Flynt returned to the Fulton County Courthouse after lunch, he walked into an ambush. A sniper fired several rounds, felling Flynt. A bullet lodged in Flynt's spinal cord and left him paralyzed for life. (Never prosecuted for the crime, the alleged sniper, Joseph Paul Franklin, was a white supremacist who had reportedly been offended by a *Hustler* pictorial showing interracial sex.) The judge declared a mistrial, but Georgia was not done with Flynt. In 1979 he was found guilty on eleven counts of distributing obscene material. He was fined $27,500 and given an eleven-year suspended sentence on the stipulation that he observe Georgia's obscenity laws.

Clearly, he did not.

The same court that was so concerned about the public expression of sex resolved an issue that had troubled the country for at least a century. Taking up the question of abortion, the Nixon-era court eliminated the last barrier to women's complete freedom.

Between one million and three million women obtained abortions each year—99 percent of them illegal. Doctors had the right to perform so-called therapeutic abortions to save the mother's life, but hospital committees were notoriously unresponsive to procedural requests. A private patient might find a sympathetic doctor; a poor patient almost never. Doctors might refuse an abortion if they discovered the patient was unmarried. Leslie Reagan, author of *When Abortion Was a Crime,* describes one physician as saying, "Now that she has had her fun, she wants us to launder her dirty underwear. From my standpoint she can sweat this one out." Pregnancy, Reagan points out, "exposed an unmarried woman's sexual activity. This hostile physician acted on the common view that such a woman deserved the shame of pregnancy and child-

bearing out of wedlock as punishment for her sexual misbehavior (and, perhaps, pleasure)."

Doctors were aware of a dramatic shift in America's sexual habits. In the forties single women accounted for only 7 percent of abortions. By the early sixties the figure was 41 percent. Women sought abortions to avoid the entanglements of family, not usually to limit the size of existing ones.

Wealthy women could fly to Japan or Puerto Rico or Mexico for the procedure, but not everyone was that fortunate. Women told of abortionists who demanded sex in return for an operation, and of being forced to endure an abortion without anesthesia. Underground referral services blossomed. Between 1969 and 1973, a Chicago group called Jane routed between 11,000 and 12,000 women to practitioners. In 1971 *Playboy* published a guide to the Clergy Consultation Service, a group that had helped 6,000 women between 1967 and 1973.

The need for safe medical abortions was clear. Dr. Robert Hall, founder of the Association for the Study of Abortion, wrote in a 1970 *Playboy* article that hospitals were treating per year 350,000 postabortion patients with complications and that more than 500 of these were dying annually. Other sources estimated that between 5,000 and 10,000 women died each year from illegal abortions. Yet these figures alone did not create a climate for change.

Two events were catalysts. In 1962 Sherri Finkbine, a popular TV entertainer, discovered she had taken thalidomide during her pregnancy. Fearing a deformed child, she sought an abortion in the U.S. without success.

Even more devastating than that event was an epidemic of rubella. Between 1963 and 1965, 30,000 deformed babies had been born to mothers who had contracted measles early in their pregnancies.

That experience created sympathy for the changing of archaic laws. A poll in 1965 found that a majority of Americans supported the American Law Institute's abortion law model: A woman was entitled to an abortion if her physical or mental health were endangered, if she had been the victim of rape or incest, or if there were fetal deformities. By 1970, twelve states had adopted the ALI model, but reform became bogged down in political debate. Catholics argued on the floor of state legislatures that abortion was murder and that the innocent unborn had a greater right to life than the mothers did.

In a *Georgetown Law Journal* article, Eugene Quay argued that a woman who was willing to sacrifice her child for her own health was lacking something. "It would be in the interests of society to sacrifice such a mother," he wrote, "rather than sacrifice the child who might prove to be normal and decent and an asset."

Critics feared abortion on demand or abortion "for the convenience of the mother." But by the late sixties a chorus of voices cast the debate in terms of personal liberty. Dr. William Ober, author of an influential *Saturday Evening Post* article, argued, "Every woman should be able to have an unwanted pregnancy aborted at her own request, subject only to the consent of her husband and the advice of her physician. To me it is unthinkable that a civilized society should require a woman to carry in her womb something she does not want, whatever the reasons." The following year, Betty Friedan and the National Organization for Women called for repeal, not reform, of all abortion laws. Feminist theologian Mary Daly argued that abortion laws were the epitome of sexism. "One hundred percent of the bishops who oppose the repeal of anti-abortion laws are men," she wrote in *Commonweal*. "One hundred percent of the people who have abortions are women."

Grassroots organizations sprang up to demand the repeal of antiabortion laws. In California, lawyers representing doctors who had performed rubella abortions argued that the right to privacy extended to a woman's choice to bear or not to bear children. Within a few years, test cases began to wind through lower courts. Roy Lucas, a law student at NYU, wrote a provocative paper that argued a right to abortion could be found in the 1965 Supreme Court case of *Griswold vs. Connecticut,* noting that if the right to marital privacy covered contraception, surely it covered other aspects of reproduction. The ACLU approached the Playboy Foundation, seeking the means to pursue a test case with Lucas. The Foundation developed a relationship with Cyril Means, a professor at the New York University law school and author of a brief on the history of abortion law. (Means's brief would be cited in *Roe vs. Wade*.)

California ruled that its abortion law was unconstitutional; so did Washington, D.C. But not all courts were so disposed. One Ohio judge upheld an abortion law. "It may seem cruel to a hedonist society," he wrote, "that 'those who dance must pay the piper,' but it is hardly unusual. If it is known generally that an act has possible consequences that the actor does not desire to

incur, he has always the choice between refraining from the act or taking his chance of incurring the undesirable consequences."

The case that changed America originated at the University of Texas. Women associated with a radical paper, *The Rag,* opened the Women's Liberation Birth Control Information Center. The founders declared, "Every woman has the right to control her own body, to decide when and if she wants a child." The center attacked the punitive role of archaic laws: "By making abortions illegal, our society makes the abortion operation a punishment for sin." As part of their service, they referred students to qualified doctors in San Antonio, Dallas, and in Mexico.

The group approached Sarah Weddington, a recent graduate of the UT law school, and asked if she would challenge the Texas abortion law in federal court. (An indication of gains made by women: Weddington was one of about 40 women in a school of 1,600 students.)

Weddington and Linda Coffee, a former classmate at UT, began recruiting clients. A doctor who had been arrested twice for performing abortions (his office was under surveillance by police, who took down license plate numbers of patients) signed on. "John and Mary Doe," a husband-and-wife team, sued for the right to a safe abortion in Texas (the wife had suffered a life-threatening abortion in Mexico). "Jane Roe," a twenty-two-year-old waitress who didn't want to put a child from a third pregnancy up for adoption, sought the right to terminate her pregnancy "on behalf of herself and all other women."

The Supreme Court handed down its decision on January 22, 1973. Justice Harry Blackmun found that the "right of privacy is broad enough to encompass a woman's decision whether or not to terminate her pregnancy." But he contended the right to privacy was far from absolute.

The state and various religious groups had argued that life begins at conception; that the fetus is a person with the right to live. Weddington contended there was no precedent under Texas law for treating the fetus as a person. A fetus had no property rights. The state didn't issue death certificates for stillborn fetuses (at least those carried less than five months). There was no record of a personal injury suit involving harm to a fetus.

The court accepted that a fetus altered the privacy argument: "The pregnant woman cannot be isolated in her privacy. She carries an embryo and later a fetus. It is reasonable and appropriate for a state to decide that at some point

another interest—that of health of the mother or that of potential human life—becomes significantly involved. The woman's privacy is no longer sole and any right of privacy she possesses must be measured accordingly."

Justice Blackmun sidestepped the argument that life begins at birth, that the fetus is a "person." He sketched out a new standard: (a) During the first trimester, the abortion decision must be left to the judgment of the pregnant woman's physician; (b) during the second trimester, the state, in promoting its interest in the health of the mother, may regulate the abortion procedure in ways reasonably related to maternal health; (c) for the stage subsequent to fetal viability, the state—in promoting its interest in the potentiality of human life—may regulate or proscribe abortion except where necessary, in appropriate medical judgment, for preserving the life or health of the mother.

A few days after passing down the decision, Justice Blackmun encountered protesters at a speaking engagement. In the fall of 1973 the National Conference of Catholic Bishops called for organizations to fight for the right to life at the grass roots. One year after the decision, 7,000 pro-lifers marched on Washington. The abortion wars were just beginning.

One year after the 1969 riot at the Stonewall, gays in New York City held the first Gay Pride week. Up to 15,000 newly visible gays marched from Greenwich Village to Central Park for a gay-in. San Francisco, Los Angeles, and Chicago saw similar celebrations.

The same public visibility that sparked the heterosexual revolution flared among gays. A twelve-hour PBS series on the typical American family introduced the country to one Lance Loud. According to reviewers, he was "too witty and attractive to be repellent," or simply "everything you were afraid your little boy would grow up to be." His silver hair and blue lipstick were a shock to some, who saw him as the "evil flower of the Loud family." But there it was: The boy next door might be gay. Aren't we supposed to love our neighbor?

In 1973 gay activists challenged the American Psychiatric Association to reevaluate its diagnostic definition of homosexuality, which labeled it a "sexual deviation"—along with sadism, masochism, and fetishism. Judd Marmor, a sexologist from the University of Southern California, argued, "It is quite clear that from an objective biological viewpoint there is nothing sick or un-

natural about homosexual object choice." Psychiatrists, he said, had to take the blame for many of the stereotypes. "Let us base our diagnoses of psychiatric disorders on clear-cut evidence of serious ego disturbance or irrational behavior," he argued, "and not on the basis of alternative lifestyles that happen to be out of favor with the existing cultural conventions. It is our task to be healers, not watchdogs of social mores."

On December 15, 1973, the APA's Board of Trustees voted 13 to 0 to remove homosexuality from its list of psychiatric disorders. Dr. Charles Socarides demanded a full referendum. Marmor became president of the APA at the same time results were announced on April 9, 1974: Some 58 percent of the membership had voted to remove homosexuality from the list of mental illnesses, while 37.8 percent had voted against.

Charles Kaiser, author of *The Gay Metropolis: 1940–1996,* believes the vote was a landmark, converting the gay liberation movement's "most potent enemy into an important ally." Marmor agreed, saying, "There was no reason why a gay man or woman could not be just as healthy, just as effective, just as law-abiding and just as capable of functioning as any heterosexual. Furthermore, we asserted that laws that discriminated against them in housing and in employment were unjustified."

Gays may have won an important ally, but they had provoked a more ancient enemy. In 1977, the Metropolitan Dade County Commission passed an ordinance that would allow qualified homosexuals to teach in private and parochial schools. Onetime Miss America contestant Anita Bryant had a vision. Homosexuality was a sin, she said, and if homosexuals were permitted to glamorize their deviant lifestyle, the American family would be destroyed and the American way of life would disappear forever. The entertainer formed a group (which would eventually be called Protect America's Children) and launched a crusade against gays.

In response, homosexual activists staged a gaycott of Florida orange juice. (Bryant had served as the official spokesperson for the Florida Citrus Commission.) In the ensuing controversy, Bryant lost bookings and sponsors for a television show.

Bryant told *Playboy* her views on a kind of sexual domino theory in a May 1978 interview. "God says the wages of sin is death and one little sin brings on another. The homosexual act is just the beginning of the depravity. It leads

to—what's the word?—sadomasochism. It just gets worse as it goes on. You go further and further down the drain and it just becomes so perverted and you get into alcohol and drugs and it's so rotten that many homosexuals end up committing suicide."

She was disturbed that homosexuals "ate the male sperm," which she compared to the "forbidden fruit of the tree of life." Her opinion of the ordinance was based on religious intolerance: "The ordinance the homosexuals proposed would have made it mandatory that flaunting homosexuals be hired in both the public and the parochial schools. If you believe that adultery, homosexuality, drunkenness and things like that violate your religious standards, you have a right to prevent a teacher from standing up in front of your children and promoting sin. We were fighting religious bigotry. What gives the homosexual any more right to stand up in front of children and talk about his sexual preferences than a man who has a Great Dane as his lover has?"

She stated that if we allowed gays to consider themselves a legitimate minority, we would have to condone minority status for "nail biters, dieters, fat people, short people and murderers."

Protect America's Children wrapped itself in the mantle of Christian family values. (Bryant was similarly offended by unmarried couples who lived together.) Bryant was accused of printing bumper stickers that declared KILL A QUEER FOR CHRIST.

Homophobia was still alive and well across America. On November 27, 1978, another conservative defender of family values named Dan White shot and killed George Moscone, San Francisco's mayor, and Harvey Milk, the city's first openly gay city supervisor. White's lawyer offered what became known as the Twinkie defense (too much junk food had made his client deranged). White was convicted of voluntary manslaughter but served just five years for the double homicide.

The following year, a Lynchburg, Virginia, minister named Jerry Falwell would help launch an association called the Moral Majority.

The backlash had begun.

TIME CAPSULE

Raw Data From the 1970s

FIRST APPEARANCES

No-fault divorce. Legal abortion. *Doonesbury.* Prime-time football. Polaroid SX-70. Pong. *Hustler.* The zipless fuck. *Ms.* Legalized gambling in Atlantic City. The *Big Bunny* jet. Playboy Mansion West. Streaking. Home computers. Earth Day. Light beer. Disposable razors. *Saturday Night Live.* Betamax. VHS. Jogging. Nike shoes. Sony Walkman. Moral Majority. Palimony. Disco. *Deep Throat.* Studio 54. Plato's Retreat. Satellite TV. Cable. Susan B. Anthony dollar. Test-tube babies. Trivial Pursuit. *Roots.* Mood rings. Pet rocks.

FIRST FEMALE

Jockey. TV anchor. Cadet at military academy. Little Leaguer. Indy race-car driver. Rhodes scholar. Mayor of a major city. Recipient of a college athletics scholarship. Episcopal priest. Aerobic dance class instructor.

WHO'S HOT

Warren Beatty. Jack Nicholson. Woody Allen. Diane Keaton. Paul Newman. Robert Redford. Clint Eastwood. Steve McQueen. Bruce Lee. Muhammad Ali. Sylvester Stallone. George Lucas. Steven Spielberg. Francis Ford Coppola. Martin Scorsese. Robert De Niro. Al Pacino. Harrison Ford. John Travolta. Farrah Fawcett. Suzanne Somers. Cher. Steve Martin. John Belushi. Chevy Chase. Cheryl Tiegs. Woodward and Bernstein. Henry Kissinger. Linda Lovelace. Marilyn Chambers. John Holmes. Stevie Wonder. Bruce Springsteen. The Rolling Stones. David Bowie. Donna Summer. Diana Ross. Elton John. The Bee Gees. The Eagles. Led Zeppelin. Stephen King. Billie Jean King. Velvet Underground. Patty Hearst. Gloria Steinem. Germaine Greer.

WE THE PEOPLE

Population of the United States in 1970: 205 million. Population of the United States in 1980: 226 million. Marriages per 1,000 people in 1970: 10.6; in 1980: 10.6. Number of unmarried couples living together in 1970: 143,000; in 1978: 1.1 million. Percentage of people in 1969 Yankelovich poll who say marriage is obsolete: 24; in 1971: 34. Percentage of people in a 1969 *New York Times* poll who say premarital sex is okay: less than 27; in 1979: 55. Estimated number of communes in 1970: 2,000. Percentage of driver's licenses held by women in 1940: 24.3; in 1970: 43.2.

MONEY MATTERS

Gross National Product in 1970: $1 trillion. Gross National Product in 1980: $2.7 trillion. Number of men earning more than $25,000 per year in 1978: 4.2 million. Number of women earning more than $25,000: 140,000. Out of 600 men surveyed in 1974, number who expect a woman to pay her share of a date: 25.

SEX ED

Percentage of the nation's 111 medical schools that offer courses in sex: 33. What some medical texts still recommend to curb male desire: hobbies and cold showers. Number of sex therapy clinics in 1970: 1; in 1977: 6,000.

DISCO MADNESS

Number of orgasms audible in Donna Summer's "Love to Love You Baby": 22. Number of discos in 1960: 0; in 1978: 10,000. Number of people who admitted visiting a disco at least once in 1977: 37 million. Number of copies sold in America of the Bee Gees' *Saturday Night Fever* by 1978: 12 million; worldwide: 30 million. In a survey of 1,000 unwed teenage mothers in Florida, number who say they conceived while listening to pop music: 984.

THE WASTELAND

What we watched on TV when we weren't watching the Watergate hearings: *All in the Family, The Odd Couple, The Waltons, Kung Fu, The Mary Tyler Moore Show, Happy Days, Monty Python's Flying Circus, The Sonny and Cher Comedy Hour, Maude, The Six Million Dollar Man, The Bionic Woman, Laverne and*

*Shirley, Saturday Night Live, Charlie's Angels, Wonder Woman, Police Woman, Mary Hartman, Mary Hartman, Three's Company, Soap, The Love Boat, M*A*S*H, 60 Minutes, Upstairs, Downstairs, The Tonight Show.*

PORNO CHIC

Year Sony introduced Betamax: 1975. Year JVC introduced VHS: 1976. Cost of a VCR: $1,100. Average price of early porn tapes: $300; price by end of decade: $99. Percentage of prerecorded tapes sold in America that were "adult": more than 50. Cost of filming *Deep Throat:* about $25,000. Number of showings per day of *Deep Throat* at the Pussycat Theater in Los Angeles: 13; number of years the movie ran at Pussycat: 10. Estimated gross for *Deep Throat* at the Pussycat: $6.4 million; nationally: $100 million.

SLANG ME

New words and phrases: hype, dingbat, AC/DC, up front, recycling, encounter group, hassle, put-down, body language, sexism, sexual harassment, gross out, let it all hang out, biofeedback, interface, may the force be with you, chairperson, fireperson, craftsperson, waitperson, midshipperson, elder statesperson, access hole cover (for manhole cover), fornicator (for mistress).

FINAL APPEARANCES

Jimi Hendrix (1970). Janis Joplin (1970). Gypsy Rose Lee (1970). Bertrand Russell (1970). Jim Morrison (1971). J. Edgar Hoover (1972). Betty Grable (1973). Bruce Lee (1973). Busby Berkeley (1976). Howard Hughes (1976). Elvis Presley (1977). Bing Crosby (1977). Margaret Mead (1978). Harvey Milk (1978). John Wayne (1979).

Chapter Nine

THE GREAT REPRESSION:

1980–1989

U.S. Attorney General Ed Meese delivered *The Final Report of the U.S. Attorney General's Commission on Pornography* in 1900.

The pitch began with a Sensuality Quiz: "If you've ever greeted your mate in the nude, give yourself ten points.

"If you have ever had sex outdoors, give yourself another ten points.

"If I say 'whipped cream' and you blush, give yourself twenty points."

Sales reps for Undercover Wear Inc. and Just for Play toured the nation staging sex toy Tupperware-type parties. A reporter who covered one such event expressed shock at "women who would look at home in a Betty Crocker ad" snatching up crotchless panties and lacy brassieres with the nipples snipped out, introducing themselves by their sexual preferences like patrons at an AA meeting. "My name is Linda, and I like luscious lip service."

Marabel Morgan, author of *The Total Woman,* confessed to *Time* magazine that she was too busy to greet her husband at the door each night, naked

and wrapped in saran wrap, but less beleaguered housewives were arming themselves for delight; and sharing what they had learned about sex in the tumult of the sixties and seventies. A group of women in the Bay Area formed the Kensington Ladies' Erotica Society to pen homespun porn. The resulting collection, *Ladies' Home Erotica,* started a cottage industry.

The sexual revolution recruited the young and the old. In television ads, a fifteen-year-old Brooke Shields informed the world: "Nothing comes between me and my Calvins." In store windows, a poster of Nastassia Kinski wearing only a serpent embodied temptation, the union of sex and danger.

On radio and TV a silver-haired mother figure dispensed sex advice. Dr. Ruth asked callers, "Are you having good orgasms?" trilling her Rs, swinging her feet off the floor. She talked of "brue balls," the joys of masturbation, the delights of throwing fried onion rings on an erect penis. America couldn't seem to get enough and eagerly bought her book, *Dr. Ruth's Guide to Good Sex,* and her board game, *Dr. Ruth's Game of Good Sex.* (Land on the wet spot, you lost a point.) And if good sex wasn't enough, Dr. Ruth offered a video, *Terrific Sex.*

The great permission unleashed during the seventies continued to pulse through the culture in the following decade. Bookstores bulged with a new generation of experts. Alan and Donna Brauer revealed ESO: *How You and Your Lover Can Give Each Other Hours of Extended Sexual Orgasm.* Naura Hayden divulged the secrets of *How to Satisfy a Woman Every Time and Have Her Beg for More.* John Perry, Alice Kahn Ladas, and Beverly Whipple, authors of *The G Spot and Other Recent Discoveries About Human Sexuality,* announced a new erogenous zone. An inch or so up the anterior wall of the vagina, they said, was a small bean-shaped area that when stimulated supposedly produced a profound orgasm (and sometimes a female ejaculation). At least six book clubs offered the title, including the Better Homes and Gardens Book Club and the Cooking and Crafts Club. For lovers whose sexual fondling had been gridlocked at the clitoris, the discovery inspired a new quest. At the very least, it was a peace offering, a distraction from the anatomical war between clitoral and vaginal orgasms.

Not everyone could locate the elusive trigger. A stand-up comic, after months of exploration, announced the discovery of the Y spot. "You touch it and your partner asks, 'Why are you doing that?'"

"What's the difference between the G spot and a golf ball?" another comedian wondered. "A man will take half an hour trying to find a golf ball."

Chapter Nine

THE GREAT REPRESSION:

1980—1989

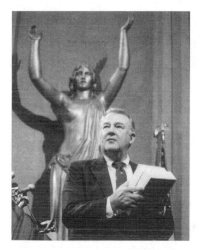

U.S. Attorney General Ed Meese delivered *The Final Report of the U.S. Attorney General's Commission on Pornography* in 1986.

The pitch began with a Sensuality Quiz: "If you've ever greeted your mate in the nude, give yourself ten points.

"If you have ever had sex outdoors, give yourself another ten points.

"If I say 'whipped cream' and you blush, give yourself twenty points."

Sales reps for Undercover Wear Inc. and Just for Play toured the nation staging sex toy Tupperware-type parties. A reporter who covered one such event expressed shock at "women who would look at home in a Betty Crocker ad" snatching up crotchless panties and lacy brassieres with the nipples snipped out, introducing themselves by their sexual preferences like patrons at an AA meeting. "My name is Linda, and I like luscious lip service."

Marabel Morgan, author of *The Total Woman,* confessed to *Time* magazine that she was too busy to greet her husband at the door each night, naked

and wrapped in saran wrap, but less beleaguered housewives were arming themselves for delight; and sharing what they had learned about sex in the tumult of the sixties and seventies. A group of women in the Bay Area formed the Kensington Ladies' Erotica Society to pen homespun porn. The resulting collection, *Ladies' Home Erotica,* started a cottage industry.

The sexual revolution recruited the young and the old. In television ads, a fifteen-year-old Brooke Shields informed the world: "Nothing comes between me and my Calvins." In store windows, a poster of Nastassia Kinski wearing only a serpent embodied temptation, the union of sex and danger.

On radio and TV a silver-haired mother figure dispensed sex advice. Dr. Ruth asked callers, "Are you having good orgasms?" trilling her Rs, swinging her feet off the floor. She talked of "brue balls," the joys of masturbation, the delights of throwing fried onion rings on an erect penis. America couldn't seem to get enough and eagerly bought her book, *Dr. Ruth's Guide to Good Sex,* and her board game, *Dr. Ruth's Game of Good Sex.* (Land on the wet spot, you lost a point.) And if good sex wasn't enough, Dr. Ruth offered a video, *Terrific Sex.*

The great permission unleashed during the seventies continued to pulse through the culture in the following decade. Bookstores bulged with a new generation of experts. Alan and Donna Brauer revealed ESO: *How You and Your Lover Can Give Each Other Hours of Extended Sexual Orgasm.* Naura Hayden divulged the secrets of *How to Satisfy a Woman Every Time and Have Her Beg for More.* John Perry, Alice Kahn Ladas, and Beverly Whipple, authors of *The G Spot and Other Recent Discoveries About Human Sexuality,* announced a new erogenous zone. An inch or so up the anterior wall of the vagina, they said, was a small bean-shaped area that when stimulated supposedly produced a profound orgasm (and sometimes a female ejaculation). At least six book clubs offered the title, including the Better Homes and Gardens Book Club and the Cooking and Crafts Club. For lovers whose sexual fondling had been gridlocked at the clitoris, the discovery inspired a new quest. At the very least, it was a peace offering, a distraction from the anatomical war between clitoral and vaginal orgasms.

Not everyone could locate the elusive trigger. A stand-up comic, after months of exploration, announced the discovery of the Y spot. "You touch it and your partner asks, 'Why are you doing that?'"

"What's the difference between the G spot and a golf ball?" another comedian wondered. "A man will take half an hour trying to find a golf ball."

College students discovered a sexual use for Pop Rocks, a candy that fizzes when wet. Fellatio and cunnilingus would henceforth end in a grape-flavored foam. On *L.A. Law*, scriptwriters created a running gag around a sex technique known as the "Venus butterfly." The trick, never described, involved something one ordered from room service. Female recipients of the technique, it was claimed, had been known to pass out from the pleasure. The Playboy Advisor turned itself into a sexual patent office, inviting readers to devise a sex trick that would match the Venus butterfly.

Prime-time television hinted at sexpertise. On *Hill Street Blues* several episodes revolved around the benefits of heating peppermint oil in the micro-wave. But now the home of *Ozzie and Harriet/Father Knows Best* family values faced competition from cable. For a few dollars a month viewers could connect to the sexual underground and experience adult programming in the privacy of their homes. *Time* described the fare as "the first programming made directly for people who still own water beds."

The programming ranged from the exotic (*Private Screenings* and *Esca-pade* are two of the options) to the curious. In *The Ugly George Hour of Truth, Sex and Violence,* a lone cameraman with a video backpack sprouting a para-bolic microphone toured Manhattan, asking women to disrobe for their fifteen minutes of fame. In doorways, stairwells, and apartments, a surprising num-ber complied. Why not?

Cable gave birth to MTV, a twenty-four-hour world of music videos. At first considered a novelty, MTV became a hypnotic art form. As one fan recalled, "The stars don't just lip-synch, they body-synch, fashion-synch and sex-role synch." Videos taught America how to look, how to move (Michael Jackson's moonwalk drew more attention than Neil Armstrong's), how to yearn.

The Pointer Sisters sang of wanting a lover with a slow hand, someone who would spend some time, not come and go in a heated rush. Cyndi Lauper told the world that "Girls Just Want to Have Fun." Madonna adorned herself with thrift-shop lingerie, crucifixes, and a belt buckle proclaiming BOY TOY and became an international sensation, a sexual role model for millions of girls. Powered by music videos, *Like a Virgin* and *Material Girl* sold millions. America discovered the power of the exposed midriff.

The music channel presented unprecedented sexual diversity. No mat-ter one's preference, somewhere on MTV there was a band to match, from

the androgynous to the ridiculous. Video producers became the journalists of the sexual revolution, crafting songs about teenage pregnancy and domestic violence with a beat you can dance to.

Some songs conveyed a sense of premonition. Phil Collins sang, "I can feel it coming in the air tonight, oh Lord. And I've been waiting for this moment, for all of my life, oh Lord." The song found its way into the pilot of *Miami Vice*—a TV show about narcs driving Ferraris and wearing designer clothes while in pursuit of bad guys. The show killed Friday night, with 20 million people staying home to watch the war on drugs; at the same time many of them were doing the drug in question.

Cocaine replaced the user-friendly drugs of the sixties with a substance that defined appetite and greed. George Carlin joked about it, saying you do a line of coke and you feel like a new man. Then the new man wants some. Richard Pryor, while freebasing cocaine, set himself on fire. Scientists reported that monkeys, given free access to cocaine, would forgo all other pleasures—including food, sleep, and sex—until they died.

Something in the air tonight. In 1983, *Risky Business* used the Phil Collins song to set up a late-night sexual tryst on the Chicago Transit Authority. The scene between Tom Cruise and Rebecca De Mornay (playing a high school student and a prostitute who enter into an unusual partnership) suggested that if you rode the train long enough, you could have it all to yourself, have the best sex of your life, and still get accepted into Princeton.

The public-sex explosion of the seventies seemed to recede as the VCR made X-rated entertainment private. One video exec boasted, "The VCR put porno where it belongs: in people's bedrooms." Bruce Taylor, a lawyer for a Cleveland-based antipornography group, complained that "people are bringing home the kind of movies people used to go to jail for."

At the start of the decade, some three million homes had the ability to turn their TVs into sex toys. The X-rated film industry responded. Between 1969 and 1979, porn directors had shot features on film. In 1979 some 1,000 titles were available on video. Switching to less costly video, they saw their output quintuple; more than 5,000 titles were available by 1990. Before the end of the decade, Americans were renting 100 million X-rated tapes a year. Some 40 percent of the devotees were women. Lovers grappled with one eye cast toward the blue light, making love in the presence of someone else's fantasy.

It was a shift no less profound than when the phonograph and the radio allowed Americans to make love to music.

Technology evolved to tempt long-neglected senses. The telephone company relaxed its hold on 976 numbers; suddenly Americans could experience 57 seconds of heavy breathing and short recorded sexual scenarios at the touch of a finger. Dial-A-Porn competed with Dial-A-Prayer and won, hands down. One company got 500,000 calls a day. An audit of the Virginia state phone bills revealed that, in one month alone, state employees made 2,509 calls to a porn line. None, reported the spokesperson, came from the governor's office.

Almost immediately, aural sex became interactive. Americans, long familiar with the heightened intimacy of radio and records, found that phone sex created a sense of sexual conspiracy. Voice-activated lust. An article in *Rolling* Stone gave a sample of the art of "giving good phone."

GIRL: Hi, baby, where are you?
CALLER: In the bedroom. On the bed.
GIRL: What are you wearing?
CALLER: Just some underwear.
GIRL: Mmmm. I'm wearing a black silk robe, and nothing else. You can see my tits. They're so big. Do you want them?
"You're very close now. I can feel your breath. I want you to kiss me."
"I want to do it so badly it hurts."
"You are now biting my nipples."
"I'm coming."
"I love you."(Click)

It was out-of-body sex, where a voice could sound blond, where everything was permitted, no one was harmed, and the caller was in complete control of the relationship. Such freedom cost a dollar a minute. Phone bills of $2,000 a month, the press reported, were not uncommon.

For every out-of-body experience, there was an inner-body equivalent. The sexual revolution ignited a fitness revolution. Hedonists located their world in the pleasures of their bodies. Now it was time to see what the suckers could do. The ads for Soloflex home gym equipment teased, "A hard man is good to

find." Jane Fonda's 1981 workout book and subsequent tapes did for the leotard what Frederick's of Hollywood did for lingerie. Millions followed her instructions to "feel the burn." And millions just watched.

Gyms replaced singles' bars and discos as the place to meet. In the locker rooms, the conversation switched from sex to success, how to survive on $100,000 a year.

Flashdance, a 1983 Hollywood hit, captured the sexuality of the fit. Jennifer Beals, playing a welder who moonlights as a cabaret dancer, became famous for "that thing with the bra." Young women cut the shoulders off T-shirts and sweatshirts, and mastered the art of taking off bras without removing an outer garment. Insouciant sexuality. Beals's character is an independent woman with a rule about not sleeping with the boss. What the heck. She breaks that rule. After a knockout audition, she too gets into the school of her choice.

The obsession with the body knew no limits. Body artists rediscovered piercing and tattoos—and even greater extremes. On late-night television David Letterman asked The Playboy Advisor what's the weirdest letter he'd ever received. "A guy wrote in and said, 'I masturbate with sandpaper. Do I have a problem?' the Advisor said, 'Yes, but not for long.'"

The Advisor continued: "The guy went to two therapists out in California. They cured him of the habit by switching him to lighter grades of sandpaper. Then velvet. Then a real woman."

The progression seemed to convey the message of the sexual revolution, that no one really got hurt. It was all right to go to the edge; someone would bring you back.

The revolution was in full roar. But there was something in the air.

A September 1980 poll of readers of *Cosmopolitan* magazine reported the beginning of a backlash. "So many readers wrote negatively about the sexual revolution—expressing longings for vanished intimacy and the now elusive joys of romance and commitment—that we began to sense there might be a sexual counterrevolution under way in America."

By December 6, 1982, *New York* magazine would ask, "Is Sex Dead?" The editors then concluded, "In popular culture, the sexual backlash is readily

apparent." As proof, the article told of a post–casual sex syndrome known as Windows: "You look at the woman sleeping next to you, then you look out the window and you want to jump."

Some veterans of the sexual revolution spoke of changing attitudes. "The rule of thumb for sleeping with someone in the sixties and seventies was, you'd sleep with them if you couldn't think of any reason not to. Now, you don't sleep with them unless you have a compelling reason to."

The author noted that "on the *New York Times*' best-seller list, Leo Buscaglia's *Living, Loving and Learning* has superseded Alex Comfort's *The Joy of Sex.*"

Esquire announced "The End of Sex," illustrated by a tombstone with the legend "The Sexual Revolution—R.I.P." George Leonard wrote, "As it has turned out, the sexual revolution, in slaying some loathsome old dragons, has created some formidable new ones."

A July 1983 *Psychology Today* article bemoaned "A Revolution's Broken Promises." An April 9, 1984, *Time* cover story announced, "The Revolution Is Over." According to writer John Leo, "There is growing evidence that the national obsession with sex is subsiding. Five-speed vibrators, masturbation workshops, freshly discovered erogenous zones, and even the one night stand all seem to be losing their allure. Veterans of the revolution, some wounded, some merely bored, are reinventing courtship and romance and discovering, often with astonishment, that they need not sleep together on the first or second date. Many individuals are rediscovering the traditional values of fidelity, obligation, and marriage." "Caution" and "commitment" were the new buzzwords.

Who would celebrate the end of sex? Would any magazine announce the end of civil rights? The end of freedom? What made writers so willing to capitulate, to surrender the gains of liberation?

As the sexual revolution reached its peak, doctors began to notice and comment on the rise of venereal infections. The Pill had removed the threat of conception. Penicillin had defeated the specters of syphilis and gonorrhea. Promiscuity flourished without consequence. The resulting complacency was soon to be shattered. An article in the May 1980 *McCall's* echoed turn-of-the-century VD warnings about sin. "Sexual Freedom: The Medical Price Women Are Paying."

Scientists had reclassified a disease, isolating two viruses called herpes simplex. But herpes was not simple. The affliction had been around for centuries, but it was not identified as sexually transmitted until 1967. Dr. Walter Dowdle, a virologist at the Centers for Disease Control in Atlanta, and Dr. André Nahmias, a physician at Emory University School of Medicine, identified the cause of cold sores as Herpes Simplex I. They announced that a related virus, Herpes Simplex II, could cause a sometimes painful rash on the genitals. The two viruses could change places through oral sex. A disease that had been as morally neutral as the common cold would become a new plague.

At first, the discovery languished. Most doctors had ignored cold sores as harmless, and had even misdiagnosed the rashes as the heartbreak of psoriasis. Genital herpes was at worst a medical curiosity, something the body seemed able to cure by itself. No one kept track of the disease; while doctors were required by law to report the more familiar syphilis and gonorrhea, no one collected data on herpes.

Dr. David Reuben, the man who had told us everything we wanted to know about sex but were afraid to ask—including much that was wrong—tried to sound the alarm in the mid-seventies, telling readers about "the grim new venereal disease in our midst." Dr. Reuben claimed that conservative estimates indicated 300,000 cases per year.

"If a pregnant woman is actively infected with venereal herpes, there is a one in four chance that her child will die or be seriously damaged." The sins of the mother could be passed to the innocent. And "six of every 100 women with HSV-2 of the cervix will develop cervical cancer." There was no cure, he said. The virus lingered in the body and could, without warning, multiply and produce a vigorous recurrence.

As wave after wave of baby boomers became sexually active, doctors were seeing more of everything. The young and the restless—those walking point for the sexual revolution—were turning up with bacterial vaginitis, pelvic inflammatory disease, yeast infections, chlamydia, trichomoniasis, venereal warts. Rumors circulated about bugs brought back from Vietnam, of new strains that resisted antibiotics. A doctor told the readers of *Harper's Bazaar* to toss their lingerie in the microwave.

But only herpes infected the imagination. On August 2, 1982, *Time* magazine ran a cover story on herpes titled "The New Scarlet Letter." John Leo and Maureen Dowd reported that herpes was "the scourge, the new scarlet letter,

the VD of the Ivy League and Jerry Falwell's revenge." As though the head of the Moral Majority, like an Old Testament prophet, had the power to call down plague.

The Centers for Disease Control reported new estimates. Up to 20 million Americans had genital herpes, with as many as half a million new cases each year. "Those remarkable numbers are altering sexual rites in America," claimed Leo, "changing courtship patterns, sending thousands of sufferers spinning into months of depression and self-exile and delivering a numbing blow to the one night stand."

Time magazine concluded: "The herpes counterrevolution may be ushering a reluctant, grudging chastity back into fashion."

The article produced a former swinger who said he would go to Plato's Retreat only if he could wear a full wet suit, and a prostitute who claimed to have given herpes to a thousand clients. Another woman angrily stated she had infected seventy-five men in three years. One man bragged he had infected twenty women. "They were just one night stands, so they deserved it anyway."

The article described the "leper effect," the feelings of guilt, of feeling "unclean, dirty," of being "damaged goods." (The last phrase echoes Eugene Brieux's 1913 play *Damaged Goods*, which dramatized the plight of syphilis victims.)

Just as Prince Morrow had described the impact of VD on innocent wives in 1905, *Time* reported, "In a monogamous relationship the unsuspecting person who picks up herpes from a partner is hit with a double whammy: evidence of betrayal and a lifelong disease as a memento of the event." Herpes is the gift that keeps on giving.

As evidence that the disease had changed behavior, *Time* dragged out Stan the pickup artist. "When the chitchat has moved far enough along that the woman is peering his way with bedroom eyes, he caresses her right hand, then presses his thumb sharply down on her wrist and barks, 'You have herpes, don't you?' 'If her pulse jumps, she has it,' he says. 'If she doesn't, she just laughs.' Sometimes, of course, a woman is offended by his personal lie-detector test. 'I lose a few women that way,' he says with a shrug, 'but at least I don't have herpes.'"

The final sermon was puritan newspeak: "For all the distress it has brought, the troublesome little bug may inadvertently be ushering in a period in which sex is linked more firmly to commitment and trust."

Phyllis Schlafly brought up the article at a meeting of the Moral Majority and got a round of applause when she said the herpes epidemic could again make virginity something to be prized.

Dressed to Kill, a 1980 movie by Brian De Palma, captured the panic on film. Angie Dickinson portrays a wife dissatisfied with her marriage. She pursues a stranger at an art museum, then, with barely a word, follows him into a taxicab for a scorching act of oral sex and an afternoon of pleasure at his apartment. Wanting to leave a note, she opens his desk drawer to find a letter from the Department of Health, Lower Manhattan District that reads: YOU HAVE CONTRACTED A VENEREAL DISEASE. The zipless fuck was not what it had seemed in the Erica Jong version.

She recoils in horror and flees the apartment, only to be slaughtered in the elevator by her analyst's alter ego, a pre-op transsexual who is wearing a wig and sunglasses.

Transgress the boundaries of marriage and you die.

In the 1980 film *Cruising,* Al Pacino portrays an undercover cop who dons leather to hunt for a serial killer prowling Manhattan's S&M bars.

The director had recruited leather boys from the bars. Pacino walked through crowds of bodies buffed by hours on Nautilus machines. In nooks and crannies of underground bars, men were fondling, sucking, fucking, fisting. In apartments and on walks, someone was killing and dismembering victims.

Gays protested the film. "The most positive benefit of *Cruising,*" one extra said, "would be for it to make gay men examine their promiscuity, the areas they frequent, the type of sex they seek out, even the thrill of danger. The life we save may be our own."

Writer Arthur Bell defended the clubs. "These places are not hellholes of murder. It is all theater and these guys are pussycats."

Gays were not the only ones testing life on the edge. In 1983, *Playboy* assigned a writer to take "A Walk on the Wild Side." Attending Mistress Belle's S&M theater in a loft in downtown Manhattan, he witnessed the following:

> A girl is forced to perform a pagan ritual, to hold a skull above
> her head. A man who is swathed in a tattoo of indecipherable design

lights a candle and then, with a sweep of his arm, throws hot wax across her body. The act is exact, graceful, succinct. As the drops of wax meet her skin, she does not flinch. He takes the skull from her hands, binds her feet, then hoists her upside down till she spins free of the floor. He works his way through a ring of candles, splashing her body with wax, then extinguishes each one in turn. He removes a knife from his belt and slips it beneath her panties. Blood flows down her stomach in rivulets. He lowers her and they leave the stage.

A man comes out and sits on a chair. He places a board between his thighs. Mistress Belle approaches. She swabs a nail in alcohol, then proceeds to drive it through his scrotum into the board. She follows with a second nail. The man wails, in mock horror. "My cock! You've ruined it! It will never work again!"

Belle answers, "That's just a piece of flesh. You still have a mind." The man stands up, holding the board, and walks off the stage. His genitals look like a tray of canapés.

The act was not something the writer had read about in *The Joy of Sex*. It was underground theater. Perhaps it was a response to the confused sex roles in the world above ground. Participants explained that the blood was calf's blood, that the descending hammer was a test of trust. In the world of sado-masochism, trust became the ultimate aphrodisiac.

But trust would be betrayed from within.

Something was killing gays. A headline in the *New York Times* in 1981 gave the first mainstream indication: RARE CANCER SEEN IN 41 HOMOSEXUALS.

Dr. Alvin Friedman-Kien had noted outbreaks of Kaposi's sarcoma in New York City and San Francisco. Most of the victims were "homosexual men who have had multiple and frequent sexual encounters with different partners, as many as ten sexual encounters each night, up to four times a week."

Many reported having used amyl nitrate inhalers and LSD to heighten sexual pleasure. The article cautioned, "Cancer is not believed to be conta-gious, but conditions that might precipitate it, such as particular viruses or environmental factors, might account for an outbreak among a single group." Dr. Friedman-Kien reported that some of the patients had severe defects in their immunological systems.

Charles Kaiser, author of *The Gay Metropolis,* says that "at the beginning, in Manhattan, it was known as Saint's disease in honor of the downtown discotheque favored by the most beautiful and sought-after men—because so many of the best-looking were among the first to die."

On May 11, 1982, the *New York Times* reported that a serious disorder of the immune system had afflicted at least 335 people, of whom 136 had died. Researchers called it gay-related immune deficiency or acquired immunodeficiency disease. The disorder had been identified in 13 heterosexual women. The number was "just the tip of the iceberg."

"Preliminary results of immunological tests," reported Dr. Lawrence Altman, "have led some Federal health officials to fear that tens of thousands of homosexual men may have the acquired immune dysfunction."

Magazines such as *Us* and *New York* called it the "gay plague." *Rolling Stone* asked, "Is There Death After Sex?" *The Saturday Evening Post* declared, "Being Gay Is a Health Hazard."

The hunt was on. Epidemiologists discovered that the median number of male sexual partners for an infected man was 1,100. Journalist Randy Shilts recorded the moment one researcher was told some victims had had as many as 2,000 sexual contacts: "How on earth do they manage that?"

By August 8, 1982, the disease had killed more people than toxic shock syndrome or the original outbreak of Legionnaires' disease. It had appeared in Haitians, hemophiliacs, IV drug users, and homosexuals. Researchers spoke of risk groups and routes of infection. They had somehow managed to identify one man, a Canadian airline steward named Gaetan Dugas, whom Shilts made famous as "Patient Zero." Dugas, who viewed himself as "the prettiest one," had jetted back and forth between France, New York, and San Francisco. At least 40 of the first 248 gay men diagnosed with AIDS before April 1982 "had either had sex with Dugas or had had sex with someone who had." Doctors spoke of avoiding bodily fluids—blood, urine, saliva, and semen. Bill Kraus, a San Francisco gay activist, wrote a warning: "We believe it is time to speak the simple truth—and to care enough about one another to act on it. Unsafe sex is—quite literally—killing us. Unsafe sex with a number of partners in San Francisco today carries a high risk of contracting AIDS and of death. So does having unsafe sex with others who have had unsafe sex with a large number of partners. For this reason unsafe sex at bathhouses and sex clubs is particularly dangerous."

"The sexual revolution has begun to devour its children," wrote Pat Buchanan in the spring of 1983. The former speechwriter for Nixon, and an archconservative, saw AIDS as Old Testament revenge: "The poor homosexuals—they have declared war on nature, and now nature is exacting an awful retribution." He warned that Democrats who traveled to a convention in San Francisco were putting their spouses and children at jeopardy by exposing them to homosexuals "who belong to a community that is a common carrier of dangerous communicable and sometimes fatal diseases."

The Moral Majority urged the government not to waste tax dollars on research, to allow the wages of sin to be death. The Reverend Jerry Falwell spoke of a "perverted lifestyle" and "subanimal behavior." "When you violate moral, health and hygiene laws," he thundered, "you reap the whirlwind. You cannot shake your fist in God's face and get by with it."

A Baptist minister in Reno was less subtle: "I think we should do what the Bible says and cut their throats."

We faced two epidemics: one involving an unknown agent that wreaked havoc with our immune system, the other an epidemic of fear. So little was known about routes of transmission that police and firemen began wearing face masks and rubber gloves at accident scenes. Conservatives spoke of quarantining gays, or of tattooing carriers of the disease.

AIDS presented scientists with a medical mystery. In the spring of 1983, Dr. Luc Montagnier isolated a virus at the Pasteur Institute in Paris from patients suffering the immune disorder. A year would pass before Health and Human Services Secretary Margaret Heckler announced that a team of U.S. scientists led by Dr. Robert Gallo had discovered the culprit. (Later, it would be revealed that Gallo had actually cultured a sample of lymphadenopathy-associated virus sent by Montagnier.) The discovery held promise of a blood test for antibodies. Heckler boldly announced that a vaccine would be forthcoming.

When an antibody test was finally developed it indicated that more than half the men in one San Francisco test were already infected, that 35 percent of gays tested on the East Coast harbored the virus, that 87 percent of intravenous drug users at one clinic in New York had tainted blood.

On July 23, 1985, headlines reported that actor Rock Hudson was fatally ill with cancer of the liver. The star of *Pillow Talk,* the square-jawed hero forever linked with professional virgin Doris Day, had contracted AIDS.

In the fall of 1986 Surgeon General C. Everett Koop issued a blunt thirty-six-page report. AIDS was a major public-health issue. He recommended AIDS education at the "lowest grade possible." He advised that people restrict themselves to "mutually faithful, monogamous sexual relationships." Everyone else should use condoms.

The report ignited a firestorm. According to Randy Shilts, Phyllis Schlafly claimed that the "disgusting, embarrassing, pornographic, offensive descriptions of sexual activity forced on children in the classroom are a major factor in the problem of promiscuity." Koop, she said, wanted to teach elementary schoolers "safe sodomy."

Church leaders condemned condoms as promoting perverse lifestyles, as a "shortsighted, self-defeating and ultimately false solution to a serious moral problem."

Koop addressed the National Religious Broadcasters' convention in February 1987. He wanted broadcasters to join in the "fundamentally moral crusade [against the] brutal, humiliating and fatal disease." The virus was the enemy. He would not condemn the people who "engage willingly and knowingly in sexual and drug-taking practices that risk their own lives."

The "moral bottom line," he said, was to save lives.

Americans got the message. Between 1980 and 1986 annual condom sales rose from $182 million to $338 million. Women bought half of the estimated 800 million condoms sold yearly. Ads for Life Styles condoms showed a lovely young woman saying, "I enjoy sex, but I'm not ready to die for it."

America did not see the ads on television until 1987. Networks were more afraid of offending viewers than losing them. Planned Parenthood ran an ad that claimed television characters had sex 20,000 times a year without ever mentioning the C words ("condoms" and "consequences").

Cagney and Lacey, a show about two female cops, worked condoms into a script. Tyne Daly tells her husband to advise their sixteen-year-old son about protection, then does the job herself: "Harv, if you care enough about a girl to make love with her, you should also care enough to keep safe."

Talk shows carried the message. "On *Donahue,* we're discussing body cavities and membranes and anal sex and vaginal lesions," said the host of

America's leading talk show. "We've discussed the consequences of a woman's swallowing her partner's semen. No way would we have brought that up five years ago. It's the kind of thing that makes a lot of people gag."

In 1986 the porn industry produced *Behind the Green Door: The Sequel,* in which the actors all wore condoms or otherwise practiced safe sex. The movie bombed. People interested in fantasy did not want to be reminded of caution.

Mainstream Hollywood movies didn't call the prop department. In *Broadcast News* (1987), Holly Hunter drops a condom into her purse before going out with William Hurt. In *Cross My Heart* Annette O'Toole plays a condom-packing, self-assertive heroine. In bed, she asks Martin Short, "If I sleep with you, am I going to die?" He responds: "I don't think so, I'm not that good."

On the other hand, fear of AIDS gave us a new lens through which to view movies. Some viewers saw *Fatal Attraction* (1987) as a disguised AIDS movie. When Michael Douglas has an affair with Glenn Close the audience knows that he is putting his family at risk, although the plot has Close portray a psychopathic career woman, who slaughters the family's pet rabbit and goes after everyone with a butcher knife. AIDS lurked outside the plotlines of a rash of nouveau film noir hits.

On college campuses activists handed out T-shirts that proclaimed DON'T SWING YOUR BAT WITHOUT A PARTY HAT. Or Sammy Safe Sex (a cartoon condom) said, SLIP IT ON BEFORE YOU SLIP IT IN! Another cartoon condom cropped up on T-shirts with the slogan WRAP THAT RASCAL. Schools handed out matchbooks containing condoms and the message SLEEP WITH A LIFEGUARD.

Dorms stocked condom machines. Some schools handed out safe-sex kits with condoms, spermicidal foams with Nonoxynol 9 (it appeared to kill the virus on contact), K-Y jelly, and dental dams. The last was a three-inch square of plastic. Those who practiced rimming—anilingus—were supposed to cover the anus before tonguing. Heterosexuals and lesbians were supposed to use the dam over the vagina before oral sex.

Complained one student: "It's like going down on Tupperware."

Activists intent on salvaging sex became creative. Pleasure was still possible. *The Boston Phoenix* published a guide to alternate activities.

Try talking to each other about safer sex. Kissing and hugging. Back rubs, foot rubs and body rubs while still partially dressed. Listen-

ing to music and/or dancing together. Caressing, tickling, pinching and nibbling each other through clothes. Reading erotic literature together. Looking at erotic pictures. Watching erotic movies on the VCR. Talking sexy or sharing fantasies. Showering together. Petting with no clothes on. Stroking, caressing and fondling your partner's body (including the genitals and anus). Mutual or simultaneous masturbation to orgasm with your hands (with or without condoms, with no exchange of semen or vaginal fluids). Body painting with non-petroleum-based body paints. Holding each other. Talking to each other. Sleeping together. Eating breakfast, lunch or dinner in bed. Starting over.

In San Francisco, an enterprising young man organized the first Jack-and-Jill-Off, a coed safe-sex orgy.

Old-fashioned sermons against promiscuity took a new form. Although early reports showed that most heterosexuals who contracted the disease did so as a result of a long-term relationship with a single seropositive partner (an IV drug user or bisexual), the fearmongers pulled out dossiers. "Now," said Dr. Otis Bowen, the Secretary of Health and Human Services in 1987, "when a person has sex, they're having it with not just that partner. They're having it with everybody that partner has had it with in the past ten years." This defined group sex in the eighties, a broad swipe at promiscuity. Freudians used to say that whenever two people had sex there were actually six people in bed—the lovers and their respective parents. Now sex was a chain letter. A company manufactured safe-sex videos that actually showed past lovers climbing into bed with a reckless couple. Should that happen in real life, someone might die, but not from AIDS.

The religious right used the public-health threat to push their own agenda. *Sex Respect: The Option of True Sexual Freedom* was developed in 1983 by a former Catholic school teacher and antiabortion activist. Her message was simple: "Just say no." The *Sex Respect* workbook told students, "There's no way to have premarital sex without hurting someone." As for AIDS: "Anyone can be carrying your death warrant." In direct mockery of the Brooke Shields Calvin Klein ads, *Sex Respect* warned, "Keep all of your clothes all the way on all of the time. Don't let any part of anyone else's body get anywhere between you and your clothes. *Avoid arousal.*" The program sold T-shirts that proclaimed STOP AT THE LIPS. *Sex Respect* told teenagers, "You can choose to go

on having sex before marriage with all its risks or you can choose to stop and gain sexual freedom." The latter choice was called "secondary virginity." It was never too late to be a born-again virgin.

The Reagan-inspired Adolescent Family Life program pumped more than $26 million into chastity programs by 1992. Government-sponsored pamphlets urged teens to "Pretend that Jesus is your date."

In a tour of campuses, The Playboy Advisor tried to calm a building hysteria. "You've heard the line about sleeping with every person your lover has slept with for ten years? No wonder I'm tired. Face it, though. Ten years ago you were sleeping with your teddy bear. Unless Teddy was shooting up drugs or getting butt-fucked in San Francisco, you're relatively safe. You can count your lovers on one hand, and, for many of you, the only lover was your hand."

Americans began to look at prospective partners as petri dishes. Robin Williams tried to make light of the paranoia. "In the eighties, you meet someone you like and say, 'God, Helen, I really care about you. Can I have some blood and urine?'"

Casual sex, spontaneous sex, enthusiastic sex—all were signs of irresponsibility. AIDS enforced a new reticence. Bruce Weber, writing in *Glamour*, told of meeting an attractive woman at a bar. She scribbled her number on a matchbook: "'Call this number and change your life.' I carried it around in my wallet for a day or two, puzzling over what to do. I'm not saying what I finally decided, just that I regret it."

Damned if you do, damned if you don't. *Mademoiselle* reported on this friend-of-a-friend story in September 1987: "She told me about this friend of hers who lives in Chicago. Her friend went to a club one night and met a really attractive man and they got a little drunk and ended up going back to her place. He spent the night, but in the morning when she woke up he wasn't there. When she went into the bathroom she saw a message written on the mirror in her lipstick. WELCOME TO THE WONDERFUL WORLD OF AIDS."

The AIDS epidemic seemed to fall upon the country like a plague. There were those who were willing to exploit the tragedy.

Near the end of the seventies the religious right launched a crusade to take over America. In a *Playboy* article entitled "The Astonishing Wrongs of the New

Moral Right," Johnny Greene reported on a secret meeting in Washington, D.C., where the Moral Majority created the agenda it would take to the Republican Party.

"When the Christian majority takes over this country," one of the planners said later, "there will be no satanic churches, no more free distribution of pornography, no more abortion on demand and no more talk of rights for homosexuals. After the Christian majority takes control, the state will not permit anybody the right to practice evil."

Religion had discovered the power of electronic media. The same cable channel that brought you blondes in lingerie also carried the bully pulpits of Jerry Falwell, Jimmy Swaggart, Jim Bakker, and Pat Robertson. The new congregations numbered in the tens of thousands. The collection plate was the size of a satellite dish.

The language of fire and brimstone collided with the sexual revolution. The preachers spoke in terms of pestilence and plagues. Robertson railed against such sins as "the plagues of abortion, homosexuality, occultism and pornography. We see a virulent humanism and an anti-God rebellion of which blatant homosexuality, radical feminism, the youth revolt and the Year of the Child, drug abuse, free sex and widespread abortion are just symptoms."

Falwell used his *Old-Time Gospel Hour* to attack "secular humanism" and the burning issues of "pornography, homosexuality and obscene school textbooks." For $10, viewers could receive a Jesus First pin and join Jerry in the fight to stamp out "pornography at home and in the streets."

By 1980, the Moral Majority claimed it had recruited 72,000 ministers and 4 million laypersons, creating a political machine that rivaled the old Legion of Decency. It spent an estimated $5 million, sending volunteers door to door, targeting liberal Democrats and delivering the evangelical vote for Ronald Reagan.

Two days after his inauguration, Reagan welcomed Falwell to the White House, the first representative of a special-interest group to be honored by the new president. Outside, more than 60,000 members of the New Right staged a March for Life.

At the meeting Secretary of Health and Human Services Richard Schweiker pledged to end funding for sex education and family planning information for minors and indigents. In the sixties the John Birch Society had viewed sex ed

crimes, abortion as a cause of insanity, abortion as a cause of the decline of Western civilization, transvestites, transsexuals, cohabitation, drugs, illegitimate children, Dial-A-Porn, Walt Disney, Ozzy Osbourne, and, of course, *Playboy*.

Wildmon wasn't alone in demonizing *Playboy*. He would soon be joined by Judith Reisman, a former songwriter for *Captain Kangaroo*. The religious right turned amateurs overnight into experts. Instead of real science, they relied on rabid sound bites and overheated headlines. The propaganda machine was up and running.

The headlines were unrelenting and unchallenged. The eighties was a decade of slander against male sexuality, almost unprecedented in scope.

- A survey in San Francisco claimed 44 percent of women had been victims of rape or attempted rape.
- A study funded in part by *Ms.* declared that one out of four college females had been a victim of rape or attempted rape. One in four. The figure appeared on protest buttons, on posters, and in date-rape literature that was handed out at freshmen orientations.
- At UCLA, Neil Malamuth asked college-age males: "If you could be assured that no one would know and that you could in no way be punished, how likely, if at all, would you be to commit such acts" as "forcing a female to do something she really didn't want to do" and "rape"? The headlines screamed the shocking answer: 35 percent of males admitted some likelihood of rape.

Line up any four college women and one of them would have been a victim of rape. Line up any three college males and one of them was a rapist. And researchers seemed to know what would summon the beast.

As part of an ostensible learning experiment, University of Wisconsin researcher Dr. Ed Donnerstein put students into a situation where they could administer electric shocks to confederates. He then showed different groups neutral films, erotic films, or slasher films. The students who saw violent films or violent erotica administered higher levels of shock. This too made headlines: "Sexually violent movies on TV and in theaters—now at an all-time high— increase men's willingness to inflict violence on women, including wife beating,

viewer subject to sexual arousal by such fare is so autoerotic as to need no television for the purpose, and should have an operation—for his or her own good, if not for the overriding reason of public safety. Lots of people watch this stuff. Statistically speaking, few of them misbehave."

Most people viewed the reverend as harmless. The networks said Wildmon was trying to impose the will of the Moral Majority on the rest of America, that they would let the marketplace decide what was worth viewing. Americans would vote with the remote.

But Wildmon was far from harmless. He turned the *NFD Informer* into a kind of *Red Channels*. (In the 1950s, rabid anti-Communists had listed the names of performers, writers, composers, and producers who were alleged to be friendly to the Communist cause. *Red Channels* became an unofficial blacklist. Advertisers, networks, and program packagers who wanted to avoid controversy avoided names on the list.) Wildmon published lists of advertisers who sponsored "sex-oriented programs," "violence-oriented programs," or "profanity-oriented programs." The friends of sex were the enemies of the Reverend Donald Wildmon.

By the end of the eighties, Wildmon and his crew (having changed their name to the American Family Association) had protested movies (*The Last Temptation of Christ*), taken credit for forcing Pepsi to drop an ad campaign with Madonna, and hounded advertisers of *Saturday Night Live* (30,000 letter writers protested that the word "penis" was used twenty-three times in one show). The AFA attacked Dr. Ruth: "For 60 minutes every night, Dr. Ruth gets to undo 2,000 years of Christian teachings on the beauty and joy of sex." The diminutive sex therapist's "free sex philosophy is the ultimate in hedonism and antifamily, anti-Christian values." Wildmon protested the use of a blow-up sex doll on *Night Court,* implications of incest on *The Golden Girls* and *Alf,* bitchiness on *Murphy Brown,* bondage on *L.A. Law,* drug use in a Mighty Mouse cartoon, and a made-for-TV movie on *Roe vs. Wade.* Arthur Kropp, of People for the American Way, pointed out, "Wildmon can find an antifamily conspiracy in a test pattern."

Wildmon's journal revealed the demonic imagination of the religious right. In one eighteen-month period it offered up human sacrifice, sexual molestation, incest, child pornography, public masturbation, teen suicide, rape and/or murder caused by viewing pornography, porn addicts who commit

Wildmon had launched the National Federation for Decency (NFD). He'd recruited silver-haired church ladies to monitor television. He would publish the naughty bits (profanity, drinking, sexy ads, and jiggly scenes) in the *NFD Informer,* a sort of fundamentalist version of *TV Guide.* The bias was pure Bible Belt. The *Wall Street Journal* wrote, "One monitor, a woman, cited the September 13 episode of *Charlie's Angels* for 23 jiggly scenes. Another monitor, also a woman, didn't note any such scenes. 'Obviously the other monitor didn't look for jiggly scenes,' Mr. Wildmon says. 'I'd just use the higher estimate and not bother with the other one.'"

The NFD listed among its tenets of faith, "We believe the Holy Bible contains all information necessary whereby man can be saved from his sins and live a godly life following the will of God." The National Federation for Decency existed "to promote the biblical ethic of decency in American society, especially—but not exclusively—in the communication media." Apparently, the Bible's prohibition against bearing false witness was not part of the NFD's "ethic of decency."

Falwell promised $2 million to the crusade. Recruiting 4,000 monitors from the Moral Majority, Phyllis Schlafly's Eagle Forum, and the American Life Lobby, Wildmon went after the networks. In the spring of 1982, the monitors found prime-time filth on all three networks—2,138 incidents of sex, 300 scenes that suggested intercourse outside of marriage, 71 scenes that suggested intercourse inside marriage, and 831 skin scenes.

The *CBTV/NFD Informer* attacked such hits as *Archie Bunker's Place, Cheers, Dallas, Falcon Crest, Dynasty, Fantasy Island, Hill Street Blues, Knots Landing, Magnum, P.I., M*A*S*H, The New Odd Couple, Saturday Night Live,* and *Three's Company,* as well as movies and miniseries.

Wildmon told *Time* magazine that "everything on the air has a message. TV represents behavior modification, or monkey see, monkey do. A child sees it and it leaves an impression."

George Higgins, a former prosecutor turned novelist, scrutinized *Dynasty, Hotel, Dallas,* and *Falcon Crest* to see if Wildmon's observers were accurate. In a *Harper's* article titled "TV Puritans: Who Killed J.R.'s Sex Life?" he announced the results: "What these shows don't offer is sex. There isn't any nudity—I didn't see a single naked nipple, not even a male one. The scripts don't tell how to do it and the camera doesn't show what to do with it. Any

as a Communist conspiracy; the religious right viewed it as the handiwork of Satan.

At the time, it seemed that Ronald Reagan bought the election for peanuts: a promise to appoint Supreme Court Justices who might undo *Roe vs. Wade,* a little seed money to social scientists to find evidence that pornography was related to sexual aggression and juvenile delinquency. Reagan appeared tolerant. His son, after all, wrote for *Playboy;* his renegade daughter, Patti Davis, would pose for a pictorial in 1994.

But he gave a bullhorn to the antisex forces and, wittingly or unwittingly, unleashed a reign of terror. The New Right had a scapegoat. Porn, the most visible expression of the sexual revolution, was evil incarnate. Porn was everywhere. The fundamentalists wanted to control the public image of sex, if not the actual behavior.

Shortly after the Reagan landslide, a Methodist minister from Tupelo, Mississippi, approached Jerry Falwell with a modest proposal. Would the Moral Majority be interested in a crusade to rid television of sex, profanity, and violence? The goal: a boycott of companies that advertised on the most offensive shows.

Falwell signed on. The Reverend Donald Wildmon created a letterhead and a fund-raising machine called the Coalition for Better Television. Claiming to represent five million families in all fifty states, Wildmon was the ambassador for Christian couch potatoes.

Wildmon was well suited for the job. The son of a venereal-disease inspector, he had experienced an epiphany one night in 1976 when he sat down to watch television and discovered it was "filled with sexual comments and skin scenes." The next show contained "earthy language and unbelievable profanity." He decided then to devote his ministry to cleaning up television. He called for a national boycott, an idea that greatly amused the press.

The *Wall Street Journal* sent a reporter in November 1978, who recorded Wildmon's reaction to an ad for English Leather. Sitting in a motel room, the two watched a leggy blonde in white shorts and a white T-shirt lean toward the camera. "All my men wear English Leather," she says, loosening her hair, "or they wear nothing at all."

"Did you hear that?" the good reverend asked the reporter. "Did you catch the suggestiveness in that?"

random rape and forced sex in dating," read one summary. The *New York Times* leaped from the lab to the street in a single bound—VIOLENT PORNOGRAPHY ELEVATES AGGRESSION, RESEARCHERS SAY—reporting that "violence against women depicted in pornographic films may lead to criminal behavior."

And the same researchers sounded the alarm that violent content in mainstream men's magazines was on the increase. Neil Malamuth and Barry Spinner looked at five years of *Playboy* and *Penthouse* (from 1973 to 1977) and announced that violent images had increased. Such images, the authors warned, could contribute to a cultural climate that sanctioned violence against women.

No one questioned the scientists. The government funneled money into "victim research"—studies that would amplify danger or that would suggest a cause-and-effect relation between sexual expression and sexual violence. Many of the researchers came not from psychology departments but from schools of communication where they taught, the reading of cultural messages.

At first glance Judith Reisman seemed a strange bedfellow. During the seventies, as an antiporn feminist writing under the nom de guerre Judith Bat-Ada, she had warned that the moral arbiters of the sexual revolution were a "triumvirate—Hugh Hefner, Bob Guccione and Larry Flynt—who are every bit as dangerous as Hitler, Mussolini and Hirohito." Reisman made waves (and a friendship with conservative Pat Buchanan) when she charged (without evidence) that Alfred Kinsey was a child molester who was "involved in the vicious genital torture of hundreds of children" and who had cooked the books to make homosexuality look normal. Such a revisionist stance was just what the party needed.

She soon came to the attention of Al Regnery, son of conservative publisher Henry Regnery and crony of Jerry Falwell, Phyllis Schlafly, and Pat Robertson. Regnery had wound up as head of Reagan's Office of Juvenile Justice and Delinquency Prevention. That Regnery was completely uncredentialed and inexperienced did not seem to bother anyone. Reporters noted that he drove an automobile with a bumper sticker that read: HAVE YOU SLUGGED YOUR KID TODAY?

In December 1983 Regnery approved a grant for $798,531 to allow Reisman to study "images of children, crime and violence in *Playboy, Penthouse*

and *Hustler* magazines." If she could link mainstream erotica to antisocial activity, it was believed, the sexual revolution surely would be over.

The size of the grant (but not the topic) sparked a controversy. Congress, accustomed to paying $640 for a toilet seat, could not comprehend the cost of cartoon counting (especially when an internal memo noted that the "research" could be done for between $20,000 and $60,000).

At a congressional hearing into the need for such a study, Senator Arlen Specter (R-Pa.) said he had "never seen pictures of crimes against children appear in those magazines" and asked Reisman for an example. She offered a cartoon showing people at a beach. "A man is underwater with his hands" on a girl, she explained.

"You're seeing a different picture than I am," said Specter.

When Regnery suggested cartoons that depicted child fairy-tale characters might "affect the mind of the adult," Senator Howard Metzenbaum (D-Ohio) stated, "It's difficult to understand how an adult gets turned on by Dorothy or the Wizard of Oz or Snow White."

Regnery trimmed the grant slightly, and Reisman went to work. After twenty-two months, Reisman's staff came up with "a total of 6,004 photographs, illustrations and cartoons depicting children in the 683 magazines from 1954 to 1984. These 6,004 images of children were interspersed with 15,000 images of crime and violence, 35,000 female breasts and 9,000 female genitalia."

The report was loopy. Reisman accused *Playboy* of creating "cut and paste female images" with older faces on adolescent bodies. And you thought airbrushing was bad? A model in pigtails or holding a teddy bear was a "pseudo-child." Little Annie Fanny, a cartoon character with breasts the size of bazookas, was "an image of a child." Reisman counted each panel as a separate child image.

The Justice Department shelved the study as worthless. Dr. Robert Figlio, a University of Pennsylvania criminologist who served on a peer review panel, critiqued the manuscript and questioned the researcher. "Quite frankly," he said, "I wondered what kind of mind would consider the love scene from *Romeo and Juliet* to be child porn."

This was terrible social science, but totally effective political science.

Reisman would tour the country with her slide show and her executive summary. An unquestioning press generated doomsday headlines: KIDDIE PORN

MAY BE TIED TO SEXUAL ASSAULTS, EXPERTS SAYS. Reisman would become a "consult-ant" for various religious groups.

Regnery resigned before *The New Republic* revealed his secret life as a porn consumer. A reporter investigating his background had uncovered a fantastic story. In Madison, Wisconsin, while running for district attorney in 1976, Regnery told audiences he was the target of "Watergate-style" dirty tricks. One night his wife called the police to say she had been attacked by two men (one white, one black), that she had been cut repeatedly with an embroidery needle, violated with a can of feminine hygiene spray, and forced to perform oral sex. The police did not believe her story. Doctors who examined her found seventy-three faint scratches, none of which required medical attention. There were no signs of rape. When police searched Regnery's house they found a cache of pornography under the bed.

When you follow the trembling finger of the self-appointed moral guardian back to the mind behind the call to censor, you inevitably uncover a nightmare.

In 1982 a group of prosex feminists met at Barnard College, concerned about the direction in which radical feminists were taking the movement. Anthropologist Gayle Rubin saw America descending into a moral panic akin to the white-slavery hysteria of the turn of the century or the antihomosexual frenzy of the fifties: "During a moral panic, the media become ablaze with indignation, the public behaves like a rabid mob."

The target of the latest moral panic was demon porn. "This discourse on sexuality is less a sexology than a demonology," Rubin said. "It presents most sexual behavior in the worst possible light. Its descriptions of erotic conduct always use the worst available example as if it were representative. It presents the most disgusting pornography, the most exploited forms of prostitution and the least palatable or most shocking manifestations of sexual variation. This rhetorical tactic consistently misrepresents human sexuality in all its forms. The picture of human sexuality that emerges is unremittingly ugly."

The women's libbers who had tossed bras into trash cans at the 1968 Miss America Pageant now fired bullets into bookstores that sold men's magazines. Radical feminists stormed newsstands and poured blood over *Playboys* and adult films and sex toys. They found crimes against women everywhere

they looked. In 1976, they had protested a Sunset Boulevard billboard for a Rolling Stones album that had a bound model proclaiming, "I'm black and blue from the Rolling Stones, and I love it." The zealots of the radical left were as frightened by sex as the religious right. The posse members went by different names (Women Against Violence Against Women, Women Against Pornography, Women Against Violence in Pornography and Media) but their target was clear. They were against images of sex. What the sexual revolution had made visible, they wanted burned. They had hijacked the feminist movement, charging that sexual liberation was not the same as female emancipation.

Betty Friedan, the visionary whose *Feminine Mystique* created the modern feminist movement, was aghast at the direction taken by these daughters of the sexual revolution. In 1981 she published *The Second Stage,* a plea for sanity. Friedan warned that sexual politics "distorted the main thrust of the women's movement for equality and gave its enemies a powerful weapon."

The radical fringe, she warned, "directed too much of its energy into sexual politics, from personal bedroom wars against men to mass marches against rape or pornography. Sexual war against men is an irrelevant, self-defeating act of rage. It does not change the conditions of our lives. Obsession with rape is a kind of wallowing in that victim state."

"It was easier to liberate yourself from the missionary position," Friedan lectured, "than to take the test for law school, to fight for parenting leave or lobby the state legislature to ratify the Equal Rights Amendment."

The daughters of the feminist revolution did not listen.

They had their own mantra of rage, a manifesto called *Take Back the Night.* "In the last few decades," its editor claimed, "women have been bombarded with ever increasing numbers of pornographic images in liquor stores, bookstores and drugstores; in supermarkets; in the hands of fathers, uncles, brothers, sons, husbands, lovers and boyfriends; in films and on street corner newsstands; on the covers of record albums, on the walls of poster stores and in shop windows. The media have subjected women to dramatized rapings, stabbings, burnings, beatings, gaggings, bindings, tortures, dismemberments, mutilation and deaths in the name of male sexual pleasure or sheer entertainment."

Cadres hit the college circuit with a blood-soaked slide show that could have been titled "Fear and Loathing in Times Square." A visual barrage of

bondage shots, S&M fashion ads, and clips from purported snuff movies assaulted the audience, while organizers read an account of a woman being raped. These performances had the subtlety and objectivity of a lynch mob.

Although they targeted porn as "antifemale propaganda," the shows were antimale and antisex. Women Against Pornography had its own notions of politically correct sex, its own versions of Orwellian newspeak. Andrea Dworkin, a militant feminist known by her bib overalls and fiery rhetoric, stated, "Sexual relations between a man and a woman are politically acceptable only when the man has a limp penis."

Barbara Ehrenreich, Elizabeth Hess, and Gloria Jacobs issued a report on the sex crisis for *Ms.* The debate on porn was also a debate among women about the future of female sexuality. Freud had once asked, "What do women want?" Now the question was, "What do liberated women want?" The radicals, however flamboyant, seemed to yearn for a return to the straitlaced Victorian era, a time when women believed, "as the late 19th century feminist writer Eliza Duffey did, that women's sexual needs could be satisfied by six episodes of intercourse per lifetime." Or less.

Modern women wanted erotica that was "personal, emotional, refreshing, with an element of trust or caring or love, natural, circular." Applying the new rhetoric of sexism, women were wary of images that catered to male desire. Porn "defined by the penis shows a power imbalance, suggests violence; is heavy, voyeuristic, linear and depicts bodies contorted."

At meetings of the National Organization for Women, Robert's Rules of Order collided with resolutions about female lust. Pat Califia, a lesbian and practicing sadomasochist, ridiculed the cuddly sex of her sisters. "Sex will consist of wimmin holding hands, taking their shirts off and dancing in a circle. Then we will all fall asleep at exactly the same moment. If we didn't all fall asleep, something else might happen—something male-identified, objectifying, pornographic, noisy and undignified."

The campaign against male sexuality took a new form in 1983. Catharine MacKinnon, a graduate of Yale Law School described as an "itinerant lawyer/

lecturer" (meaning she had not been granted tenure by any university), and Andrea Dworkin were teaching a course in pornography at the University of Minnesota. The city council in Minneapolis asked their help in drafting a zoning ordinance that would restrict adult bookstores.

Instead, the two wrote a proposed ordinance that treated pornography as a form of discrimination based on sex and a violation of the civil rights of women. Wrote Dworkin, "We hallucinated those rights in a frenzy of hope, in a delirium of dreaming. We hallucinated that women could be recognized as human beings in this social system, human enough to assert those rights in the face of systematic sexual exploitation, brutality and malice."

Hallucination was the proper word.

The sixties taught America the evils of discrimination. Bigotry and racism had denied millions the right to the American dream, be it employment, labor union membership, housing accommodations, property rights, education, public accommodations, and public services. The Minneapolis ordinance was a catalog of biases involving race, color, creed, religion, ancestry, national origin, sex, sexual harassment, affectional preference, disability, age, marital status. These were weapons that degraded individuals, fostered intolerance and hate. They created and intensified unemployment, substandard housing, undereducation, ill health, lawlessness, and poverty. They injured the public welfare and were against the law.

MacKinnon and Dworkin wanted to add pornography to the list of acknowledged biases. They completely bypassed the city's commissioners on civil rights, the men and women who dealt with real harm on a daily basis. They wanted the council to endorse a special finding—that porn was central in creating "the civil inequality of the sexes," that porn was a "systematic practice of exploitation and subordination," that porn promoted "bigotry and contempt," that porn harmed women's opportunities for "equality of rights in employment," that porn "damages relations between the sexes [and restricts] women from full exercise of citizenship and participation in public life."

Porn was the cattle prod, the attack dog, the high-pressure hose, the burning cross that kept women in place. MacKinnon and Dworkin offered this definition of demon porn: "Pornography is the sexually explicit subordination of women, graphically depicted whether in pictures or in words."

The statute banned women presented as "sexual objects, things or commodities" who "enjoy pain or humiliation," who "experience sexual pleasure

in being raped." The world could not present women "tied up or cut up or mutilated or bruised or physically hurt" or in "postures of sexual submission."

MacKinnon and Dworkin wanted the city to outlaw images that reduced women to "body parts—including but not limited to vaginas, breasts and buttocks," that showed them as "whores by nature," that showed them being "penetrated by objects or animals." Finally, the ordinance declared as toxic "scenarios of degradation, injury, abasement or torture, [with women being] shown as filthy or inferior, bleeding, bruised or hurt in a context that makes these conditions sexual."

Anyone who produced, sold, exhibited, or distributed porn was guilty of discrimination. Any woman could file suit on behalf of all women.

Any person who claimed to have been coerced into performing for pornography could sue, whether or not she had appeared in other porn, had appeared to cooperate in the production, had signed a contract, or otherwise showed a willingness to perform.

Any woman, man, child, or transsexual who had pornography "forced on him/her" could sue.

Any woman, man, child, or transsexual who was assaulted, physically attacked, or injured as the result of a specific piece of pornography could file a claim for damages against the person who assaulted him/her/it as well as the maker, distributor, seller, or exhibitor of the porn.

The Minneapolis city council still had to be persuaded. The hallucination began. Dworkin and MacKinnon re-created in public the traveling horror show that had mesmerized women's studies groups.

At public hearings on the ordinance, MacKinnon spoke of porn being used to season children, prostitutes, wives, and girlfriends to make them more compliant sexually. She spoke of men consuming porn, forcing it on their partners, demanding that they perform sexual acts they had no desire to perform.

Dworkin followed with the boilerplate. Porn was a "$7 billion industry that buys and sells women's bodies." She read into the record a magazine article that stated that "at least 25 percent of all heterosexual material sold in Washington's adult bookstores, for example, depicts explicit violence against women, torture of all kinds, whipping, beating, mutilation, rape and murder."

Then came the parade of witnesses. First was Professor Ed Donnerstein, who spoke about his research into the effects of sex and violence. Donnerstein

said that violence, not sex, begets violence. MacKinnon and Dworkin, however, seized on the interrelation between images and action.

Speaking over images of the Rolling Stones billboard, a *Hustler* layout, scenes from *Texas Chainsaw Massacre* and *The Toolbox Murders,* Donnerstein informed the politicians about lab findings. To him, R-rated films posed a greater threat than X-rated films, which contained almost no violence. He read from the cassette of one film: "See bloodthirsty butchers, killer thrillers, crazed cannibals, zonked zombies, mutilating maniacs, hemoglobin horrors, plasmatic perverts and sadistic slayers slash, strangle, mangle and mutilate bare-breasted beauties in bondage." Dr. Fredric Wertham would have been proud.

Donnerstein talked about desensitization, which allowed people who watched enough of this stuff to actually find humor in it. Donnerstein was a dupe of the feminists; neither group saw that slasher films were repeating a cultural message as old as Cotton Mather. America had always linked sex and punishment. The sex hadn't changed, just the means and degree of punishment, which had escalated from stocks and public dunkings to death by chain saw and nail gun. Donnerstein's slasher films weren't antifemale; they were antisex. But the hearings were obviously not the place for fine distinctions.

Next up was Linda Marchiano, a.k.a. Linda Lovelace. The former porn star had rewritten her life story in a 1980 biography titled *Ordeal.* The book recounted her path from porn star to born-again prude. Overnight she became the darling of Gloria Steinem, who had passed her along to MacKinnon and Dworkin.

Marchiano told the commissioners that for two and a half years she had been held captive and forced to perform as Linda Lovelace, "the sex freak of the seventies." The happily married housewife now blamed Chuck Traynor for her previous excesses. Her first husband and manager had dragged her from "prostitution to porn films to celebrity satisfier." She told of being forced to have sex with five strangers in a motel room and of her ultimate degradation, having sex with a "D-O-G."

She said Traynor had hypnotized her and taught her to perform deep throat, that he had beaten her after the first day of filming. "So many people say that in *Deep Throat,* I have a smile on my face, and I look as though I am really enjoying myself. No one ever asked me how those bruises got on my body. Virtually every time someone watches that film, they are watching me being raped."

Traynor had created the Linda Lovelace doll, but the hands manipulating the Linda Marchiano doll belonged to MacKinnon and Dworkin.

The celebrity porn victim was followed by feminist experts, who entered into the record Diana Russell's sexual assault research. Russell had asked, "Have you ever been upset by anyone trying to get you to do what they have seen in pornographic pictures, movies or books?" Ten percent of the women answered "yes" to the question.

One might wonder about the 90 percent who had not been upset, and being upset is not exactly being raped. Another witness itemized in alphabetical order some of the supposed victims of porn: Miss B was upset by group sex. Miss F drew the line at spanking. Miss G protested oral sex. Miss K resisted a lout who wanted to pour champagne on her vagina. Miss M was upset by anal sex.

Tim Campbell, a gay activist, challenged the Minneapolis ordinance, saying it would allow people to bring suit against the Bible. "Cinderella is a myth that would not pass the test. In fact, I defy the city council members to sit down now and write a three-sentence story involving a woman and sex that would pass the test of this ordinance. . . . Basically, the missionary position is no longer acceptable storytelling. The only thing you can do is Jack met Jill, maybe, and neither one pursued the other and they lived happily ever after."

MacKinnon and Dworkin paraded witnesses who claimed to have been harmed in the making of porn. One told of being photographed naked by an art-student boyfriend, of being cast in plaster with her arms tied over her head (which had caused some other models to faint). After that, she said, he switched to watercolors.

MacKinnon read into the record a letter from actress Valerie Harper, star of *Rhoda,* who had been mortified to find that a company called Shock Tops was selling T-shirts with the images "of seven famous women pictured in the nude," that a porn magazine had run a likeness with her head on a full-length figure, naked except for high-heeled shoes and stockings, taking off a shirt.

"I felt upset, ripped off, diminished, insulted, abused, hurt, furious and powerless," wrote the actress. She spoke of casting-couch horrors and the fear of the ultimate audition for a snuff movie.

The parade continued. A county attorney told of a stepfather or boyfriend who had a young girl hold up nude photographs while he masturbated. A

woman from a battered-women's shelter spoke of a husband who had "two suitcases full of Barbie dolls with ropes tied on their arms and legs and with tape across their mouths."

The testimony was unrelenting. One of the last to speak gave her name and address and said, almost apologetically, "I have not yet been raped."

Dick Marple, a member of the audience, grew tired of the litany of abuse. Approaching the microphone, he had the courage to complain about the unremitting slander. "If we have a civil rights ordinance trying to discourage presenting women as whores by nature," he said, "then I believe that men have a civil right not to be presented as rapists by nature."

On December 30, 1983, the city council passed the ordinance by a vote of seven to six. Almost immediately, Mayor Donald Fraser vetoed the bill, saying it was "probably" unconstitutional.

On July 10, 1984, Ruth Christenson, a witness in the hearings and a devoted follower of Dworkin's, walked into Shinder's, a bookstore in downtown Minneapolis. Dousing herself with gasoline, she set herself afire, then ran through the store. Her backpack was filled with antipornography brochures.

William Hudnut, the mayor of Indianapolis, had followed the Minneapolis hearings with great interest. Self-described as "just a dumb preacher who fell from grace and went into politics," Hudnut saw the appeal of the MacKinnon-Dworkin argument. He invited MacKinnon to introduce similar legislation in Indianapolis.

MacKinnon staged a streamlined sideshow of vice cops, incest victims, prostitutes, and pontificators. Although she billed the ordinance as a necessary step in women's rights, she did not enlist the aid of local feminists. Indeed, some accounts hinted that MacKinnon had made an unholy alliance with fundamentalists and right-wing politicians. Beulah Coughenour, a political conservative who had fought to defeat the Equal Rights Amendment, sponsored the bill in Indianapolis.

On May 1, 1984, the bill passed by a vote of 24 to 5. Within two hours of its passage, the American Booksellers Association and the Media Coalition filed suit. The constitutionality of the antiporn statute would at last be tested in courts.

The American Civil Liberties Union and the Feminist Anti-Censorship Taskforce filed amici curiae briefs opposing the ordinance. Nan Hunter and Sylvia Law argued that "the ordinance vests in individual women a power to impose their views of politically or morally correct sexuality upon other women by calling for repression of images consistent with those views."

They said that the ordinance ignored the rights of prosex women: "It makes socially invisible women who find sexually explicit images of women in positions of display or 'penetrated by objects' to be erotic, liberating or educational. These women are told that their perceptions are a product of false consciousness and that such images are so inherently degrading that they may be suppressed by the state. At the same time, it stamps the imprimatur of state approval on the belief that men are attack dogs triggered to violence by the sight of a sexually explicit image of a woman. It makes socially invisible those men who experience themselves as gentle, respectful of women or inhibited about expressing their sexuality."

Judge Frank Easterbrook, in overturning the statute, agreed. "This is thought control. It establishes an approved view of women, of how they may react to sexual encounters, of how the sexes may relate to each other. Those who espouse the approved view may use sexual images; those who do not may not."

The MacKinnon-Dworkin road show was terrible law, but great politics. And it was the answer to Republican prayers.

The religious right began to pressure President Reagan for more dramatic action. In March 1983 he had told representatives of the Moral Majority that porn was a form of pollution. His administration had "identified the worst hazardous-waste sites in America. We have to do the same with the worst sources of pornography."

In May 1984 the president outlined his war on sex. The enemy, he declared, was the 1970 President's Commission on Obscenity and Pornography, the landmark research that said pornography had no significant effect on crime or delinquency. Nixon had rejected the report, but America had gone on to enjoy the seventies anyway. Now something more was needed.

"I think the evidence that has come out since that time, plus the tendency of pornography to become increasingly more extreme, shows that it is time to take a new look at this conclusion," said Reagan, "and it's time to stop pretending that extreme pornography is a victimless crime. And so I want to announce that the Attorney General is setting up a new national commission to study the effects of pornography on our society. We consider pornography to be a public problem."

The previous President's Commission had spent nearly $3 million on original research. Reagan could soothe the religious right for a mere $500,000. He would create a national hearing on porn, similar to that conducted by the feminists. Eleven handpicked commissioners would travel the country like war correspondents touring a battlefield. One glance at the lineup and you knew there could be only one possible verdict.

Henry Hudson, a smut-busting county attorney from Arlington County, Virginia, was chosen to head the commission. Father Bruce Ritter, a Franciscan who ran Covenant House, a shelter for runaway kids on Times Square, revealed his bias: "I would say pornography is immoral, and the source of my statement is God, not social science." James Dobson, described by one reporter as a "professional Christian," was an author, radio commentator, and founder of the ultraconservative Focus on the Family. He viewed the sexual revolution in apocalyptic terms, as a struggle between ultimate good and evil. At one point he would announce that Satan, in retaliation for Dobson's role on the commission, had pursued members of his family in a black Porsche. Frederick Schauer, a professor of law, believed the First Amendment was irrelevant. Porn was more like a sex toy than a sonnet. If something aided arousal, it was simply sex. Dr. Park Dietz was a psychiatrist and criminologist who believed that detective magazines were more harmful than Centerfolds. A judge, a speechwriter for Richard Nixon, a child-abuse expert, a women's-magazine editor, a psychologist who worked with sex offenders, and a community activist rounded out the panel.

Novelist Kurt Vonnegut labeled the commission "sewer astronauts." They would go where no man had gone before, or, rather, where enough men and women had gone to create a multibillion-dollar industry. Like the vice investigators of the 1910s, who chronicled licentious behavior in dance halls and red-light districts, the team of handpicked citizens visited peep shows, adult

bookstores, and mom-and-pop video stores, and heard about warehouses filled with dildos. They sat through slide shows, listened to so-called victims of porn speak from behind curtains. Just as Anthony Comstock had weighed confiscated porn, the commission tabulated titles of 2,325 magazines (from *Big Tit Dildo Bondage* to *Wham Bam Window Washers*), 725 books (*Bound, Whipped and Raped Schoolgirls, Daughter Loves Doggy Fun, Mom's Golden Shower Nights*), and 2,370 X-rated films (from *Adam Foreskin Fantasy #1 and #2* to *Wet Shorts* and *Wrestling Meat*).

Asked to define a porn-related injury, Dr. Judith Becker, a psychologist tapped to serve as a commissioner, looked back on weeks of leafing through erotica. One harm came to mind: "a paper cut from turning porn magazine pages."

The hearings presented a stacked deck of antisex witnesses. Barry Lynn, an observer from the ACLU, gave this tally: "Of the 208 witnesses before the Commission, at least 160 were urging tighter controls over sexually explicit material. These included 68 law enforcement officers, eight elected officials, 30 alleged victims of pornography, 14 representatives of antipornography groups, eight representatives of local or national organizations whose policies include opposing pornography, ten individuals who are prominent antipornography activists, and 22 clinicians or social science researchers who have seen patients or collected scientific data that they conclude would support suppression of some or all pornography."

Philip Nobile and Eric Nadler, authors of *United States of America vs. Sex: How the Meese Commission Lied About Pornography,* noted a more crucial bias. Only one witness out of 208 spoke positively about porn as an aid to masturbation.

Moving from Washington to Chicago, Houston, Los Angeles, Miami, and New York, the commission provided a platform for the weird. Recruiters sought witnesses who would make their presupposed point that there was a causal relation between porn and social ills. An agent of the commission approached Dr. Lois Lee, head of Children of the Night (a Los Angeles–based organization devoted to rescuing teenagers from street life and prostitution). The agent wanted Lee's kids to testify that pornography had been used as a tool when their parents molested them and that this experience had led them into prostitution. Lee replied, "None of our kids got started turning tricks because their fathers started using pornography. None. Even if you got rid

of all the pornography in the world, you couldn't get rid of abusive or drunk fathers."

The agent said, "I don't think we're going to need your kids."

Surgeon General C. Everett Koop released a statement warning, "Pornography may be dangerous to your health." The world contemplated warning stickers on erections.

Koop, an outspoken foe of abortion, spoke from the heart, unsupported by any research. "Pornography is a destructive phenomenon. It does not contribute anything to society, but rather takes away from and diminishes what we regard as socially good." For Koop, pornography "intervenes in normal sexual relationships and alters them." When asked if he had scientific studies to support such conclusions, Koop admitted it was just his hunch. He promptly convened a body of social scientists to produce *The Report of the Surgeon General's Workshop on Pornography and Public Health.* It would conclude that the evidence still showed no direct harm.

The commission buried itself in the grotesque. It listened while a born-again Christian claimed that seeing a deck of pornographic playing cards at the age of twelve warped him for life. Soon he was shoplifting *Playboy*s from the local grocery store. "From the pictures, I was stimulated to practice oral and finger stimulation on my parents' dogs."

FBI agent Kenneth Lanning gave a presentation of child porn and fetish magazines. The commission looked at pictures of nails driven through foreskins, pins driven through scrotums, nipples pierced by rings, men and women having sex with dogs, a young girl disemboweled by fist-fucking.

The closest thing to normal porn was a close-up of "a vagina surrounded by a woman."

Judith Reisman gave a slide show and warned about the danger of shaved genitalia. Linda Lovelace repeated her testimony from Minneapolis. Andrea Dworkin told the commission about snuff films in which "a woman is killed and the orifices in her head are penetrated with a man's penis—her eyes, her mouth and so on." Of course, she could not produce a sample. "This information comes from women who have seen the films and escaped," she said.

The panelists toyed with definitions, trying to distinguish between the brutal images they had uncovered in their tour of the sewer, and mainstream erotica. One bystander of the debate, a vice cop, suggested this difference

between porn and erotica: "It is erotic when you stroke a woman's naked body with a feather. And it is kinky when you rub her with the whole chicken."

Dr. Victor Cline, an outspoken critic of the 1970 President's Commission, claimed that sexual expression was a slippery slope. Porn, he said, was physically addictive: After getting hooked, porn users moved to harder stuff. Soon, he said, they began acting out their fantasies. Seduction, sexual aggression against women, group sex and partner-switching, voyeurism, exhibitionism, fetishism, and necrophilia—all were inevitable outcomes.

The commission played a shell game. Although it seemed to focus on the extreme world of fetishes and child porn, its real target became clear.

The Reverend Donald Wildmon pulled the trigger. The head of the NFD and crusader for clean television had a new cause. With Jerry Falwell he organized pickets outside 7-Eleven stores and retail outlets that sold *Playboy* and *Penthouse*. A legion of old ladies sent postcards emblazoned with charges such as "Why do Revco drugstores sell pornography?" to chief executives. On the backs of the postcards was the statement "Pornography is a cancer that warps minds, corrupts morals and destroys souls." The truly zealous phoned retailers and advertisers in the magazines and sent them postcards calling them Pornographer of the Month. Some harangued advertisers at home, terrorizing whoever answered the phone, including children.

Now Wildmon told the commission, "The general public usually associates pornography with sleazy bookstores and theaters. However, many of the major players in the game of pornography are well-known household names. Few people realize that 7-Eleven convenience stores are the leading retailers of porn magazines in America. Indeed, 7-Eleven is perhaps the most important key to successful marketing of pornography in the family marketplace."

He gave the commission his enemies list. Alan Sears, executive director of the commission, acted on Wildmon's testimony, sending an ominous letter on Justice Department stationery to the heads of the named companies in February 1986. "During the hearing in Los Angeles in October 1985, the Commission received testimony alleging that your company is involved in the sale or distribution of pornography. The Commission has determined that it would be appropriate to allow the company to respond to the allegations prior to drafting its final report section on identified distributors."

Sears included Wildmon's testimony without naming the source. The commission never considered *Playboy* to be pornography, and Attorney General Edwin Meese would later explain that the magazine was not what the commission had been established to investigate. But the damage was done.

Lawyers from Southland Corp. (parent corporation for 7-Eleven) had probably heard that the commissioners were planning to recommend applying racketeering charges to the porn industry.

A company identified as a distributor stood to forfeit all its assets. On April 10, Southland's president, Jere Thompson, announced that 7-Eleven would no longer sell *Playboy*. More than 10,000 stores across the country cleared their shelves of the most popular men's magazine in America.

Hugh Hefner attacked the commission's tactic, calling it sexual McCarthyism. Playboy Enterprises filed a lawsuit against Meese, Sears, Henry Hudson, and the members of the commission and won a small victory: Sears wrote a second letter affirming that *Playboy* was not obscene, and the companies targeted by Wildmon's testimony would not be listed as pornographers in the final report. To show that Jere Thompson was not in touch with even his own employees, *Playboy*'s editors put together a nude pictorial celebrating "The Women of 7-Eleven."

The commission released a 1,900-page report, initially printing 2,000 copies and offering them to the public at $35 apiece. In one of the clumsiest photo ops of the century, Attorney General Ed Meese stood before a barebreasted statue of the Spirit of Justice when he met the press. In 1970 William Hamling had published an illustrated version of the Report of the Commission on Obscenity and Pornography and went to jail for his troubles. In 1986 Michael McManus, a syndicated columnist on religion and ethics, released his own version of the Meese Commission Report, selling more than 30,000 copies to conservative ministers and antiporn groups.

Barry Lynn, the ACLU lawyer who had dogged the commission, issued a 188-page rebuttal, noting that the report clearly tried to tar sex with the brush of the grotesque. *Time* called the commission "a kind of surrealist mystery tour of sexual perversity, peeping at the most recondite forms of sexual behavior known—though mostly unknown—to society."

The commission's report was easily the steamiest document of the decade. Susie Bright, the resident sexpert of *On Our Backs* (the magazine billed

as entertainment for adventurous lesbians), announced proudly that she had masturbated to the Meese Report. Most readers were baffled by the endless list of movie, book, and magazine titles. But the tome serves as a time capsule. In it are recorded some of the first erotic chats on computers:

> SLICK: Do you wanna come all over my titties and my pretty face? Maybe I should get out my instant camera so I can take a picture of your come shooting out.
>
> LUST: Do you really have a camera? I think the keyboard would look great covered with your come.

The report contained a description of sixty-three photographs in the magazine *Tri-Sexual Lust* and a pictorial in *Pregnant Lesbians,* scene-by-scene descriptions of *Deep Throat, The Devil in Miss Jones, Debbie Does Dallas,* and lengthy transcriptions of a novel called *Tying Up Rebecca.*

The report also stapled together personal statements from different commissioners. Father Bruce Ritter admitted that "one man's nudity is another man's erotica is another man's soft-core pornography is another man's hard-core obscenity is another man's boredom." He was saddened that the commission had not been tougher on sex. "I think it fair to say that by its refusal to take an ethical or moral position on premarital or extramarital sex, either heterosexual or homosexual, the Commission literally ran for the hills."

Ritter found that pornography "degrades sex itself and dehumanizes and debases a profoundly sacred relationship." Other commissioners saw porn as propaganda for the sexual revolution, a banner for promiscuity. Porn depicted sex "outside of marriage, love, commitment or affection. There are undoubtedly many causes for what used to be called the sexual revolution," the commission reported, "but it is absurd to suppose that depictions or descriptions of uncommitted sexuality were not among them. Although there are many members of this society who can and have made affirmative cases for uncommitted sexuality, none of us believes it to be a good thing."

The report attempted to draw distinctions between erotic material. The commission asserted that sexually violent material was harmful. Images that were nonviolent but degrading were condemned. Explicit material that was

neither violent nor degrading, was, well—damn the evidence—not "in every instance harmless."

The commission made ninety-two recommendations. It called for an all-out war on porn, including appointing a national porn czar. It encouraged boycotts, pickets, and letter-writing campaigns by citizens' action groups.

It seems that while on their cross-country circus, the commissioners must have watched MTV in their hotel rooms. The report suggested monitoring rock lyrics. "Many popular idols of the young commonly sing about rape, masturbation, incest, drug usage, bondage, violence, homosexuality and intercourse."

Following the release of the report, the nation saw a wave of censorship. Store owners pulled from their shelves copies of *Vogue, American Photographer, Ms.*—at the mere sight of a nipple.

Ed Donnerstein, one of the social scientists quoted by the commission, publicly declared that the report was "bizarre," that it had misrepresented their research, but, once again, it was too late. The lie was taken as truth.

Eventually, more objective scholars exposed the ghosts in the machine, the flaws that guaranteed headlines. Diana Russell's study—which claimed the real rape rate was thirteen times higher than the official FBI estimate—included in her definition of rape such acts as "unwanted sexual experience, including kissing, petting or intercourse" or attempts at such behaviors. Augustine Brannigan, a professor of sociology at the University of Calgary, and his colleague, Andros Kapardis, called the flaw overinclusion and asked simply, "How meaningful is it to collapse intercourse, kissing and petting, as well as attempts at these things? There appears to be an interest in letting virtually anything count as rape for the purposes of establishing an epidemic, while at the same time treating it all as the same, grave, undifferentiated harm. Surely this mystifies the very thing we are trying to understand."

Similarly, the *Ms.* study on college sex had an overinclusive definition of rape. Included in the survey were questions that asked if a woman had had sexual intercourse when she didn't want to after a man had served her alcohol or drugs, and if she had "given in to sexplay (fondling, kissing or petting but not intercourse) when you didn't want to, because you were overwhelmed by a man's continual arguments and pressure." Whining is not rape. Only 27 percent of the women *Ms.* said had been raped labeled themselves as rape victims. If three quarters do not believe what happened to them was rape, it wasn't.

Some 42 percent of the so-called rape victims continued to have sex with the so-called rapist.

Neil Malamuth was another researcher who would not take no for an answer. College-aged males who answered the hypothetical "Would you rape?" question did so on a scale that ranged from one (not at all likely) to five (very likely). The vast majority who circled one were not exempt—they were classified as having a low likelihood of rape. Anyone who scored two or higher was said to have a high likelihood of rape. Malamuth overincluded. Only three to five percent circled the five option. That figure (three to five percent of males say they are very likely to rape) just doesn't have headline appeal.

Similarly, the headlines that suggested the violent content of porn was on the increase were clutching at straws. Malamuth's study claimed the increase was fivefold—from one percent to five percent. A more exhaustive study by Joseph Scott and Steve Cuvelier at Ohio State University examined the so-called violence in *Playboy* from 1954 to 1983. They found there was no increase; indeed, there was something of a decrease—if you could find images to begin with. Overall, they noted, sexual violence occurred in about one page out of every 3,000 and in less than four out of every 1,000 pictures.

Ed Donnerstein's lab experiments at the University of Wisconsin were tempting to liberals and conservatives alike. At last there was science that seemed to support their politics. Feminists used the "shock the attractive lab assistant" model to crow that these sexually violent materials increased violence toward women. Liberals seized upon the finding that it was violence, not sex, that increased aggression.

Both of these assertions were nonsense. Watching violent material increased overall agitation or arousal, and that found its way into increased aggression. But other things produced the same effect. Loud noise "caused" the same increase in "violence toward women." Watching a movie of eye surgery had the same effect as watching a movie about bestiality.

Working out on an exercise bicycle increased aggressive behavior. Humor increased aggressive behavior. In the lab, Brannigan pointed out the folly of trying to base laws on such flawed research: "Would we prevent jogging and issue noise bans on the pretext that this would make the world safer for women?"

And, of course, the government overlooked the evidence that certain factors (tropical heat, marijuana, and mild erotica) reduced aggression against

women. Should the government make it mandatory to smoke weed and look at girlie calendars?

The government had its own agenda.

Within a week of the release of the Meese Report, the Supreme Court betrayed the sexual revolution. In a series of landmark decisions throughout the sixties and seventies, the Court had upheld a right to privacy, defined succinctly as "the right to be let alone." Under that fundamental liberty, a man had the right to enjoy erotica in the home, men and women had the right to birth control, women had the right to determine when and whether to reproduce. "The makers of our Constitution undertook to secure conditions favorable to the pursuit of happiness," the Court had said. "They sought to protect Americans in their beliefs, their thoughts, their emotions and their sensations."

If a man was not free in his bedroom, in his most intimate affairs, then freedom was meaningless. Unfortunately, lawbooks were filled with statutes dating from the colonial era, blue laws that intruded into intimate relationships. The classic argument against reform was simple: The laws were symbolic and never enforced. Through the late seventies and early eighties a number of cases had come to light, indicating that the sex police were still active. *Playboy* chronicled the exploits of "Officer Green Knees," a cop in Wauwatosa, Wisconsin, who liked to crawl up to couples in parked cars. (The resulting stains on his uniform prompted the nickname.) In one summer, he had made sixteen arrests for "lewd and lascivious" conduct. When challenged over a verdict that threatened to send a couple to jail for having sex in a vacant house they had been hired to paint, the circuit court judge said he was drawing on the "law of Moses." The defense attorney tried to point out that "going to hell was one thing. Going to prison is quite another."

The constitutional guarantee of the right to privacy was meaningless if it didn't protect behavior between consenting adults. Lower-court judges had ruled in a consensual sodomy case that "the right of two individuals to choose what type of sexual conduct they will enjoy in private is just as personal, just as important, just as sensitive" as the decision "to engage in sex using a contraceptive to prevent unwanted pregnancy."

By 1989 twenty-five states had overturned laws forbidding sodomy, that infamous crime against nature. Some thought it was time to free the remaining states.

On July 5, 1982, Atlanta police officer Keith Torrick saw Michael Hardwick leave a gay bar with a bottle of beer in his hand. He cited Hardwick for drinking in public. When Hardwick missed his court date (there was a mistake on the ticket), Torrick went hunting.

On August 3, Torrick entered Hardwick's house and, peering through a bedroom door, observed Hardwick engaged in "mutual oral sex" with another man. He arrested them for sodomy and, after allowing them to dress, handcuffed them and dragged them off to jail. The ACLU contacted Hardwick and asked if he would join a suit challenging the Georgia statute, which forbade both heterosexual and homosexual sodomy.

After hearing arguments, the Supreme Court straw-polled and tallied five to four to overturn the statute. The majority included the champions of privacy—Justices William Brennan, Harry Blackmun, Thurgood Marshall, John Paul Stevens, and Lewis Powell. Opposed were Justices Warren Burger, Byron White, William Rehnquist, and Sandra Day O'Connor. But Lewis Powell, who said he had "never met a homosexual" and was quoted by a colleague as saying "I hate homos," changed his mind.

The confusion of the Court was evident in the number of separate opinions. Burger declared, "In Constitutional terms there is no such thing as a fundamental right to commit homosexual sodomy." In words that belonged more on Jerry Falwell's *Old-Time Gospel Hour* than in the nation's highest court, Burger thundered on: "Condemnation of those practices is firmly rooted in Judeo-Christian moral and ethical standards. Homosexual sodomy was a capital crime under Roman law." His loathing oozed through the brief. He cited those who called homosexuality "the infamous crime against nature" and "an offense of deeper malignity than rape."

For Burger, the crime "not fit to be named" was an act "the very mention of which is a disgrace to human nature." To uphold the practice of homosexual sodomy would "cast aside millennia of moral teaching."

Harry Blackmun issued a passionate dissent: "Depriving individuals of the right to choose for themselves how to conduct their intimate relationships

poses a far greater threat to the values most deeply rooted in our nation's history than tolerance of nonconformity could ever do."

Justice White dismissed the right to privacy championed by the Court of the sixties and seventies: "None of the rights announced in those cases bear any resemblance to the claimed Constitutional right of homosexuals to engage in sodomy. No connection between family, marriage or procreation on the one hand and homosexual activity on the other has been demonstrated," and "to claim that a right to engage in such conduct is 'deeply rooted in this nation's history and tradition' or 'implicit in the concept of ordered liberty' is, at best, facetious."

Critics of the logic pointed out that the nation's tradition had tolerated slavery, that the past was not a prison. The issue was not that the Constitution granted a special right to homosexuals, but rather that they deserved the same rights as all Americans. Laurence Tribe, the law professor from Harvard who had argued the case, said the Court had missed the point. The question before the Court was "not what respondent Michael Hardwick was doing in the privacy of his own bedroom, but what the State of Georgia was doing there."

The *New York Times* called the decision "a gratuitous and petty ruling, an offense to American society's maturing standards of individual dignity."

Time produced "Sex Busters," a cover story linking the Meese Commission and the Supreme Court decision as the "new moral militancy. If Jerry Falwell had a divine plan for America, then the Supreme Court's sodomy decision and the Meese Report would both be on his drawing board. Falwell views these two events as the trophies of the New Right's gradual rise to power."

Falwell himself announced that the Court decision was "a clarion call that enough is enough."

The Meese Commission had encouraged vigilante action by private citizens' groups. The call for direct action was an implicit support for anarchy. The new moral militancy would turn ugly.

In 1974, one year after *Roe vs. Wade,* some 7,000 right-to-lifers marched on Washington, D.C. In 1981, 60,000 came, carrying signs that stated: WANTED FOR MURDER: FIVE MILLION MOTHERS AND THEIR DOCTORS. The pro-lifers' crusade had moved in halting, frustrating waves. The courts had whittled down a woman's

right to abortion, ruling first that federal funds could not be used for the procedure. Religious zealots were offended that their tax money was going to the slaughter of innocents.

In June 1982 The Playboy Forum reported on a bizarre case in which an eighteen-year-old pregnant woman tried to obtain an abortion. The cost ($1,000) was beyond her means. No public funds would cover the operation. Distraught, she took a loaded .22 pistol and shot herself in the stomach. The court found her guilty, not of attempted suicide, but of illegal abortion. Abortion by bullet.

At the federal level, conservative politicians drafted laws declaring that life began at conception. In Congress, Representative Bob Dornan (R-Cal.) invoked the Holocaust: "American citizens dying in their mothers' wombs have gone beyond the Herodian slaughter of the Hitler regime. And that's a conservative estimate. Only 30,000 were killed at Dachau. We kill 30,000 innocent citizens in their mothers' wombs every month!"

In April 1981 Representative Henry Hyde and Senator Jesse Helms proposed a congressional statute asserting that the fetus is a person. The Senate vote (47 to 46) was shy of the two thirds needed. An amendment proposed by Orrin Hatch, which would return control of abortion laws to the states (undercutting *Roe vs. Wade*), got 50 votes to 49, again short of the two thirds needed.

The religious right took its crusade outside the law. In 1982, three birth-control clinics were targets of bomb or arson attacks. A group calling itself the Army of God took credit for a Washington, D.C., clinic bombing. The violence escalated. A man who had torched four clinics in the Pacific Northwest claimed he acted "for the glory of God." Bombings struck more than twenty-four clinics in 1984. A lay minister, Michael Bray, and two confederates were charged with planting bombs at seven Washington, D.C., clinics in 1985.

When police arrested four people who bombed clinics in Pensacola, Florida, on Christmas day, Kaye Wiggins said the bombings were "a gift to Jesus on his birthday."

Time reported Falwell's response to the bombings. He called for a "national day of mourning" on the twelfth anniversary of *Roe vs. Wade* and a right-to-life march in which followers would wear black armbands "in remembrance" of all aborted babies.

The child was the centerpiece of the decade's sexual hysteria. One can trace the roots of this panic to the end of the seventies. In 1977 Dr. Judianne

Densen-Gerber, the founder of Odyssey House, had pulled a trunkful of child porn into a congressional hearing. Having scoured adult bookstores, she claimed there were 264 kid-porn magazines produced each month. She said as many as 1.2 million children were victims of kid porn and prostitution. Some, she claimed, were sold to produce snuff movies.

By 1980, she had "arbitrarily doubled" that number to 2.4 million. Sergeant Lloyd Martin testified that 30,000 children were victims of sexual exploitation in Los Angeles alone. He alerted the nation to the Rene Guyon Society, part of a "vast network of pedophiles" whose motto was "Sex Before Eight, or Then It's Too Late." The press fanned the hysteria. *Ladies' Home Journal,* for example, titled its exposé "Innocence for Sale" and said the kiddie-porn industry was "estimated at" between $500 million and $1 billion annually. Father Bruce Ritter told the *Journal:* "This sickness exists because a small segment of society wants it, another segment profits by it and the rest aren't doing anything about it. Maybe we don't know enough—or care enough."

There were real monsters out there. In 1981 Adam Walsh, a six-year-old in Florida, disappeared. His body was found in a field, the head severed. Concerned citizens launched a campaign that put the pictures of missing children on milk cartons and posters in tollbooths. The new experts claimed that 50,000 children were kidnapped every year. If the figure had been true, our schools soon would have been empty.

The religious right seized upon the statistics. Donald Wildmon sent out newsletters claiming, "Each year, 50,000 missing children are victims of pornography. Most are kidnapped, raped, abused, photographed and filmed for porno magazines and movies and finally, more often than not, murdered." In another fund-raising letter the figure had soared. "The latest craze in filth is now child pornography. Each year some 600,000 youngsters—some just babies—are kidnapped or seduced for pornographic magazine photos."

Halfway through the decade, journalists began to question the inflammatory figures on kiddie porn. The FBI reported that it investigated a total of sixty-eight abductions by strangers in 1985 and sixty-nine the year before. Most of the 30,000 (not 1.5 million) children reported missing every year were runaways who returned home within twenty-four hours. Most of the rest were taken by a parent during a custody dispute. FBI spokesman Bill Carter put it this way: "The high figures are impossible. More than 50,000 soldiers died

in the Vietnam War. Almost everyone in America knows someone who was killed there. Do you know a child who has been abducted? That should tell you something."

The FBI conducted a thirty-month investigation into child pornography. Agents simultaneously raided sixty warehouses where child porn was supposedly stored. There was none found. An independent three-year investigation by the Illinois Legislative Investigating Committee reached the same conclusion: "Neither child pornography nor child prostitution has ever represented a significant portion of the porn industry."

A study of federal arrest records revealed this: "Between January 1, 1978, and May 21, 1984, only 67 defendants were indicted under all the Federal statutes covering the creation, importation, mailing, production, receipt and exchange of child pornography. Many of those 67 were guilty only of buying one or two child pornography magazines or films from Europe for personal viewing. Since May 1984, around 600 defendants nationwide have been indicted on child-porn related crimes. It must be stressed that the increase in child pornography indictments—61 in 1984, 126 in 1985, 147 in 1986 and 247 in 1987—was not a result of better law enforcement or a rise in child pornography crimes. Instead, it is wholly attributable to the mass marketing of child pornography by U.S. Customs and the U.S. Postal Service. Anyone looking for a child-porn underground will find only a vast network of postal inspectors and police agents."

The legions of missing children haunted and twisted the American psyche. In 1980 Michelle Smith and her psychiatrist, Dr. Lawrence Pazder, coauthored *Michelle Remembers,* a supposedly true account of satanic ritual abuse. The popular book pitted an innocent Christian girl against a satanic cult, whose members abused her, raping and sodomizing her with candles. They also sacrificed babies and butchered adults. The experience had been so traumatic that Smith had repressed the memories for more than twenty years. The horror was exposed during therapy, in the form of "recovered memories."

The FBI investigated the evidence in more than three hundred alleged crimes by organized cults and found no satanic cults. Michelle may have glimpsed hell, but it could not be found on earth.

In 1988 Ellen Bass and Laura Davis created *The Courage to Heal,* which became known as the bible of the recovered-memory movement. The authors

claimed that one third of American women had been abused as children. According to Bass and Davis, some girls forgot the experience in order to survive, others created multiple personalities. Within a decade, an estimated 40,000 patients would be diagnosed with multiple personality disorder.

Survivors of abuse turned up on *Donahue, The Larry King Show,* and *The Oprah Winfrey Show.* Celebrities such as Roseanne and LaToya Jackson came forward to chronicle past abuse. Gloria Steinem rallied around the movement. (Not only were women victims of inequality, they had been abused! Trauma dragged through a woman's life like an evil anchor.)

No one pointed out that the recovered memories all seemed to stem from a distant past—the very time when the sexual revolution took off. The symptoms were likely those of mass hysteria, not isolated trauma. If you doubted such claims you were the enemy and possibly an abuser yourself.

It was only a matter of time before the hysteria claimed new victims. The call to arms was simple: Believe.

The story broke on February 2, 1984. A TV reporter in California sat in front of a large graphic of a mangled teddy bear and said that more than sixty children, "some of them as young as two years of age, who were enrolled in the McMartin Preschool in Manhattan Beach, have now each told authorities that he or she had been keeping a grotesque secret of being sexually abused and made to appear in pornographic films while in the preschool's care—and of having been forced to witness the mutilation and killing of animals to scare the kids into staying silent."

Less than a year earlier, a distraught mother called the Manhattan Beach police. She'd noticed blood on her two-and-a-half-year-old son's anus, she said. Her son had said something about a man named Ray at his nursery school. When police investigated, they could not get the boy to talk to them at all. But the mother, an alcoholic and paranoid schizophrenic, continued to talk. She told the police that Ray Buckey, an employee at McMartin, had sodomized her son while he stuck the boy's head in a toilet, that he had worn a mask and a cape, that he had made her son ride naked on a horse, and had molested him while dressed as a cop, a fireman, a clown, and Santa Claus. She claimed that McMartin teachers had jabbed scissors into her son's eyes and staples

into his ears, nipples, and tongue, and that Buckey "pricked [her son's] right finger and put it in a goat's anus and [that Buckey's mother] killed a baby and made the boy drink the blood." She charged that the three women at McMartin were witches who had buried her son in a coffin, that her son had watched a ritual in which one of the teachers had killed a real baby.

The police arrested Ray Buckey on September 7, 1983. Searching his house, they found two issues of *Playboy,* a camera, and a graduation robe. No video cameras, no porn films, no pictures of children.

The police sent a letter to two hundred parents of McMartin preschoolers, indicating that Buckey was a suspect. "Please question your child to see if he or she has been a witness to any crime or if he or she had been a victim. Our investigation indicates possible criminal acts include oral sex, fondling of genitals, buttocks or chest area, and sodomy, possibly under the pretense of taking the child's temperature. Any information from your child is important."

In "McMartin: Anatomy of a Witch-Hunt," *Playboy* reported: "Not one parent reported abuse. Not one child disclosed anything suspicious."

Prosecutors referred parents to the Children's Institute International, an agency that cares for abused and neglected children. The McMartin parents who took their children to the institute initially did not believe they had been abused, and none of the children had indicated they had been abused. But suspicion flowed into concern, then panic. By mid-1984 the CII had questioned 400 children. It filed reports indicating that 369 had been abused. The parents began to believe.

Rewarded for inventing stories, the children talked of underground tunnels, digging up coffins, of having sex at a car wash. "The children identified community leaders, gas station attendants and store clerks as molesters," noted *Playboy.* "They picked the pictures of the chief councilman of Los Angeles and actor Chuck Norris out of a stack of pictures as being abusers."

District Attorney Robert Philibosian brought charges against seven adults who worked at the school. Basing his case solely on the CII interviews, he filed 208 charges involving forty-two children. He jailed Ray Buckey and his mother.

The pretrial maneuvering generated a media frenzy. Philibosian claimed that the "primary purpose of the McMartin Preschool was to solicit young children to commit lewd conduct with the proprietors of the school and also

to procure young children for pornographic purposes." The D.A.'s office claimed "millions of child pornography photographs and films" existed.

Despite an extensive investigation by the FBI, the U.S. Customs Service, and Interpol, and despite the parents' offer of a reward of $25,000 for a photo, no picture of a McMartin child was ever found. No videotape or film turned up. Nothing.

The trial lasted twenty-eight months—the longest such proceeding in American history. It cost an estimated $16 million.

A juror who watched the taped interviews saw immediately that the horror existed in the minds of the interviewers, not in the children. Social workers had brainwashed the supposed victims, planting ideas, rewarding fantasies. In the end Peggy Buckey was acquitted. Ray Buckey was found not guilty on 52 of 65 counts (the jury was hung on the rest of the charges).

America had believed and innocents had suffered. The McMartin tragedy was repeated at school after school across the country. Papers continued to fan the flames through the decade, with headlines such as MOMMY, DON'T LEAVE ME HERE!, THE DAY CARE THAT PARENTS DON'T SEE, and WHEN CHILD CARE BECOMES CHILD MOLESTING: IT HAPPENS MORE OFTEN THAN PARENTS LIKE TO THINK.

In *Backlash: The Undeclared War Against American Women,* Susan Faludi argues that the hysteria seemed to burn along party lines, centering on the favorite targets of the New Right. The witch-hunt obscured the true abuse. "In 1985," she writes, "there were nearly 100,000 reported cases of children sexually abused by family members (mostly fathers, stepfathers or older brothers), compared with about 1,300 cases in day care."

Those who fanned the flames soon became engulfed in scandals of their own. A box in The Playboy Forum pointed out the hypocrisy of Donald Wildmon's newsletter: "Average number of soft-porn readers who commit violent crimes and are reported in the AFA Journal each month: 3. Number of ministers currently facing sexual child abuse charges in America: 200. Number of ministers accused of sexual child abuse who are reported in the AFA Journal each month: 0."

Jim Bakker, televangelist superstar and head of the Praise the Lord ministry, confessed to "one afternoon of sin in 1980" with Jessica Hahn, a twenty-one-year-old church secretary. He had been caught using church collections to pay her hush money. The Reverend Jimmy Swaggart, another televangelist

who railed frequently against sex, claimed the Bakker scandal was a "cancer that needed to be excised from the body of Christ." Swaggart would soon find himself in disgrace, when he was caught visiting prostitutes in Louisiana.

Father Bruce Ritter, a moral conscience of the Meese Commission, was forced to resign when four former residents came forward to say he had molested them when they were in his care at Covenant House. Ritter traded sex for favors, they said, paying his favorite kids out of church funds. Ritter denied the charges, but the discovery of financial irregularities sealed his downfall.

Charles Keating, the self-appointed protector of decency, tottered toward self-destruction. At the annual Children's Ball that he staged at his Phoenician Resort in Arizona, he told "sad stories about depravity against children" and raised money for moral mercenaries like Alan Sears (hired fresh from the Meese Commission) and Bruce Taylor. He used other people's money (from the teetering Lincoln Savings and Loan) to help the soon-to-be-disgraced Ritter buy a Times Square hotel for runaway children. Keating surrounded himself with attractive, large-breasted women, handing out bonuses that would pay for breast implants, dresses, and jewelry, and prepared to fight the government lawyers who accused him of stealing millions.

Those most opposed to the sexual revolution would themselves reap the whirlwind.

TIME CAPSULE

Raw Data From the 1980s

FIRST APPEARANCES

CNN. *USA Today.* Post-it notepads. RU-486 abortion pill. AIDS. AZT. Vietnam Memorial. Martin Luther King, Jr. Holiday. IBM-PC. Pac-Man. Liposuction. Female VP candidate. The thong. Compact disc. Camcorders. Nintendo. Computer mouse. Time-Warner Inc. *American Psycho.* Gangsta Rap. Crack. Condom commercials on TV. The G-spot. Hackers. MTV. *Porky's. Fast Times at Ridgemont High.* Prozac. Leveraged buyout. Poison pill. Golden Parachute. Junk bonds. Reaganomics. Star Wars defense. Iran-Contra. Stonewashed jeans. Jack-and-Jill-Offs. PMRC (Parents Music Resource Center). Date rape. Sex addiction. Operation Rescue.

WHO'S HOT

Ronald Reagan. Jerry Falwell. Pat Robertson. Jim and Tammy Bakker. Jimmy Swaggart. Madonna. Princess Di. Prince. Harrison Ford. Arnold Schwarzenegger. Tom Selleck. Tom Cruise. Tom Hanks. Kevin Costner. Bruce Willis. Cybill Shepherd. Al Pacino. Robert De Niro. Jack Nicholson. William Hurt. Kathleen Turner. Michael Douglas. Michelle Pfeiffer. Jane Fonda. Bo Derek. Kim Bassinger. Meryl Streep. Linda Evans. Joan Collins. The Brat Pack. George Lucas. Steven Spielberg. Martin Scorsese. Oliver Stone. Michael Jackson. Janet Jackson. Brooke Shields. Dr. Ruth. Oprah Winfrey. Ted Turner. Donald Trump. Michael Milken. Vanessa Williams. Jessica Hahn. Donna Rice. Eddie Murphy. Robin Williams. Whoopi Goldberg. Christie Brinkley. Vanna White. Don King. Mike Tyson. Magic Johnson. Wayne Gretzky. Michael Jordan.

WE THE PEOPLE

Population of the United States in 1980: 226 million. Population of the United States in 1990: 249 million.

Percentage of college students in 1966 survey who thought their parents were too promiscuous: 1. Percentage of college students in 1986 survey who thought their parents were too promiscuous: 31. Percentage of Americans under thirty-five who reported having premarital sex: 65; percentage who say they regret having premarital sex: 8.

Percentage of sexually active women (between the ages of eighteen and forty-four) using contraception: 93. Number of abortions per 1,000 live births in 1985: 354. Number of pro-lifers who marched on Washington in 1981: 60,000. Number of pro-choice women who marched on Washington in 1989: 300,000.

Oft-repeated quote of 1986: "Women over the age of forty are more likely to be killed by terrorists than to marry." Actual odds that a woman of thirty would marry: 2 in 3; that a woman of forty would marry: 1 in 5. According to census, actual number of single men between twenty-four and thirty-four for every 100 single women: 119.

MONEY MATTERS

Gross National Product in 1980: $2.7 trillion. Gross National Product in 1990: $5.6 trillion. National debt in 1980: $9,09 million. National debt in 1990: $3.2 trillion. Percentage the stock market dropped on Monday, October 19, 1987: 22 percent; in points: 508.

The decline in standard of living in percentage experienced by divorced women: 30. The improvement in standard of living in percentage experienced by divorced men: 10 to 15.

VD BLUES

Number of American AIDS cases reported in 1981: 189; number of cases reported in 1990: 43,339. Total number of AIDS cases reported between 1981 and 1990: 161,073; number who had died by 1990: 100,777. Estimated number of Americans infected with HIV in 1991: 1 million. Estimated number of infections reported by the World Health Organization: 8 million to 10 million adults, 1 million children. In 1991, number of infections predicted for the year 2000: 40 million. In 1989, rank of AIDs as cause of death among men between the ages of twenty-five and forty-four: second. The four next leading causes of death: heart disease, cancer, suicide, and homicide. In 1988, rank of AIDS as cause of death among women between the ages of twenty-five and forty-four: fifth.

SAFE-SEX SLOGANS

Just Say No. Control your urgin', be a virgin. Don't be a louse, wait for your spouse. Do the right thing, wait for the ring. Sleep around and you could wind up with more than a good time.

NO NEWS LIKE BAD NEWS

In a Nexis search of newspapers, magazines, wire services, and newsletters between 1980 and 1990, number of stories that mention casual sex: 1,071; number of stories that mention rape: 91,425; number of stories that mention pornography: 21,769; number of stories that mention Acquired Immune Deficiency Syndrome: 43,105.

Number of stories that mention sex within ten words of "pleasure": 896. Number of stories that mention sex within ten words of "death": 3,976.

DRUGSTORE COWBOYS

Percentage of teenagers in 1978 who thought marijuana was dangerous: 25. Percentage of teenagers in 1986 who thought marijuana was dangerous: 75. Number of Americans who had tried cocaine in 1986: 22 million; number who had done so within preceding thirty days: 4.3 million.

LESBIAN CHIC

Problem encountered by *Ms.* editor Florence King upon discovering that lesbian love had become mainstream: "No matter how good the sex was, I could not shake the feeling that I was part of some hideous trend; my tongue had taken up jogging."

FINAL APPEARANCES

1980: John Lennon, Dorothy Stratten, Mae West, Alfred Hitchcock, Steve McQueen, Henry Miller, Marshall McLuhan, William O. Douglas. 1981: Joe Louis, Bill Haley, Natalie Wood. 1982: John Belushi, Henry Fonda, Grace Kelly, Ingrid Bergman, Ayn Rand, the Equal Rights Amendment. 1983: Tennessee Williams, Gloria Swanson. 1984: Johnny Weissmuller, Count Basie, Richard Burton, Indira Gandhi, Truman Capote, Marvin Gaye, Francois Truffaut. 1985: Rock Hudson, Orson Welles, leaded gas. 1986: The Chal-

lenger, Chernobyl, Cary Grant, Benny Goodman, Desi Arnaz, Roy Cohn. 1987: Fred Astaire, Bob Fosse, Jackie Gleason, Rita Hayworth, John Huston, Liberace, Andy Warhol. 1989: Lucille Ball, Irving Berlin, Laurence Olivier, Hirohito, Ayatollah Khomeini.

Chapter Ten

REAL SEX: 1990—1999

With Virtual Valerie, the star of the 1000 interactive CD ROM game, sex was just a click away.

re we having sex now or what? The question seemed to float on the tongue. Greta Christina, a columnist for *On Our Backs,* first raised it in an essay in a volume called *The Erotic Impulse: Honoring the Sensual Self.* What, she asked, counts as having sex with someone?

When she slept only with men the criterion was simple. Sex began when the man entered a woman's body. One could keep count.

"Len was number one," she wrote. "Chris was number two, that slimy awful little heavy metal barbiturate addict whose name I can't remember was number three . . ."

But what about the fondling, groping, rubbing, grabbing, smooching, pushing, and pressing with other men. Sex? Not Sex?

And since the author has a classic San Francisco résumé, what about the women? "With women, well, first of all there's no penis, so right from the start the tracking system is defective," she wrote, "and then there are so many ways women can have sex with each other, touching and licking and grinding and fingering and fisting—with dildos or vibrators or vegetables or whatever happens to be lying around the house or with nothing at all except human bodies. Between women, no one method has a centuries old-tradition of being the one that counts."

She struggled with definitions, trying to find the line. Is sex what happens when you are feeling sexual?

"I know when I'm feeling sexual," she decided. "I'm feeling sexual if my pussy's wet, my nipples are hard, my palms are clammy, my brain is fogged, my skin is tingly and supersensitive, my butt muscles clench, my heartbeat speeds up, I have an orgasm (that's the real giveaway) and so on."

A friend suggested a simple rule: "If you thought of it as sex when you were doing it, then it was."

Christina confronted the array of sexual options open to a resident of San Francisco. She'd attended an all-girl orgy with twelve other women. "The experience, which was hot and sweet and silly and very, very special, had been created by all of us, and although I only really got down with a few, I felt that I'd been sexual with all of the women there. Now when I meet one of the women from the party, I always ask myself: have we had sex?"

She had once worked as a nude dancer in a peep show. When a customer watched her and masturbated, and she had masturbated right back, was that sex?

In 1992 Nicholson Baker, another West Coast resident, published *Vox,* a 168-page novel about phone sex. Two strangers, one lying on a chenille bedspread, the other in a darkened room, tease each other's imagination, finding things in common. Both share a voyeur's delight in a lingerie catalog from Deliques Intimates. The woman tells of becoming so aroused, she'd stained a silk chemise. But a private act can have more participants than intended (in this case, an employee of a dry-cleaning service). "When [the chemise] came back from the cleaners there were these five dot stains on it," she says, "little ovals, not down where I'd been wet, but higher up, on the front."

Excitement is a shared experience. The phone lovers fantasize about shipping boys at Deliques wrapping a pair of tights around flagstaff-size erections, indulging themselves before putting the apparel into a mailing carton. Phone sex is as seductive as the confessional. She shares sexual details with her unseen lover, telling him that when she masturbates she pulls her bra down so that it catches under her nipples. He talks about strumming orgasms, of watching X-rated videos, "fast-forwarding through the numbing parts, trying to find some image that was good or at least good enough to come to." There are just times, he says, when you want a fixed image. "I felt at that moment that I wanted to talk to a real woman, no more images of any kind, no fast forward, no pause, no magazine pictures." After a night of shared sexual history, they describe in detail what they would do in person.

They climax.

Forget that *Vox* was fiction. Was what the two lovers attained real sex?

Sexual energy had a tendency to leak across boundaries. Dean Kuipers, a writer for *Playboy,* recalled watching two people having sex in an apartment across the way from his own room in the Chelsea Hotel: "I sat in the dark, a short but uncrossable distance from the couple working on each other in their own well-lit erotic theater. It was clear they wished to be watched: The entire back of the hotel was their grandstand. And yet, they didn't acknowledge the lights or look out the window. Their reward was my response. I did what they wanted me to do: have sex with them, without ever meeting them, without touching them, without intruding into their lives in any messy way and without being able to recapture the moment except in memory."

Would he count them on his list of lovers? Was it real sex?

Kuipers's anecdote set up an article on the world of amateur pornography. The journalist found that, in the nineties, sex could exist beyond the moment. Lovers recorded and played back their own sexual encounters to prolong arousal, or to create layers of ecstasy. They time-shifted orgasms. Were they having sex with themselves?

Some traded videos in a new sexual black market. How many Americans shared the wedding night of Olympic skater Tonya Harding and Jeff Gillooly? To whom was she offering that open palm?

An artist named Sunshine described the role of the camera: "It's like an interesting sort of robotic voyeur. You are aware of its presence. It's just this gentle statue of excitement, right over there. This weird kind of eye. It's sort of like your own eye. It's wonderful."

Americans discovered that in cyberspace there are no boundaries. They logged onto an Internet Relay chat or a Multi User Dungeon for what some called "speed writing interactive erotica."

Fingers flashed across a keyboard, describing a scene in a hot tub to a crowd of silent watchers, whose names appear across the bottom of the screen: "Furry Clam, Babyface, Madcap and Falc are here."

Furry Clam? The person on the other end of the connection claims that she is twenty-one and built like Venus. She wants your body. She creates a character, who climbs into a hot tub and performs outrageous acts on your noncorporeal body. Is she a she? Does it matter? Concepts of male and female are so old-fashioned, so analog. On the Internet everyone is beautiful. Never mind that it's quite likely that Furry Clam is a fourteen-year-old guy.

Is it sex? How can it be sex if lovers don't exchange bodily fluids? If they can't taste the sweat or feel the slippery sensations of arousal?

The desire to create a border between sex and not-sex, to contain the great god lust in a cage without consequence, cropped up everywhere. America seemed to be looking for loopholes. Where once young girls looked at promiscuity as "building a police blotter" against themselves, girls now found permission in subtle distinctions. In the 1994 film *Clerks* a young couple discusses past lovers. The boy is relieved to hear that his girlfriend has had only three lovers. But she destroys his equanimity when she admits that she has given blow jobs to thirty-seven guys. Her defense: Oral sex isn't real sex.

Such confusion swirled through the world of consensual sex. When the debate moved to the question of unwanted sex, the whole nation would watch.

On October 11, 1991, America attended a national teach-in on sexual harassment.

Anita Hill, a quiet-spoken woman, conservatively dressed, faced the Senate Judiciary Committee.

"Mr. Chairman, Senator Thurmond, members of the committee, my name is Anita F. Hill, and I am a professor of law at the University of Oklahoma."

She told of being born on a farm, the youngest of thirteen children, of going from Oklahoma State University, to Yale Law School, to a job with Clarence Thomas, first when he was assistant Secretary of Education for Civil Rights, then as Chairman of the Equal Employment Opportunity Commission. She wrote an article for Thomas, she said, that went out under his signature. They had a positive working relationship.

"After approximately three months of working there, he asked me to go out socially with him. What happened next and telling the world about it are the two most difficult things, experiences of my life. It is only after a great deal of agonizing consideration and a number of sleepless nights that I am able to talk of these unpleasant matters to anyone but my close friends."

She told the senators that she had declined Thomas's invitation, saying it would jeopardize a very good working relationship, that it was ill-advised to date one's supervisor.

He continued to ask her out, pressing her to justify her refusal. Then, she said, the talk turned sexual.

"He spoke about acts that he had seen in pornographic films involving such matters as women having sex with animals, and films showing group sex or rape scenes. He talked about pornographic materials depicting individuals with large penises, or large breasts, individuals in various sex acts. On several occasions Thomas told me graphically of his own sexual prowess. Because I was extremely uncomfortable talking about sex with him at all, and particularly in such a graphic way, I told him that I did not want to talk about these subjects."

She offered an example of their discussions. "One of the oddest episodes I remember was an occasion in which Thomas was drinking a Coke in his office; he got up from the table at which we were working, went over to his desk to get the Coke, looked at the can and asked, 'Who has put a pubic hair on my Coke?'

"On other occasions he referred to the size of his own penis as being larger than normal and he also spoke on some occasions of the pleasures he had given to women with oral sex."

She had suffered harm, she said. In late 1982, she began to feel severe stress on the job. "I began to be concerned that Clarence Thomas might take out his anger with me by degrading me or by not giving me impor-

tant assignments. I also thought that he might find an excuse for dismissing me."

She said that when she finally left, Thomas asked her to dinner one last time. She accepted. He admitted that what he had done could ruin his career.

The circus was under way. When George Bush nominated Clarence Thomas to replace Thurgood Marshall on the Supreme Court, liberals became alarmed. Thomas, like Hill, a farm-born, bootstrap-raised product of the Yale Law School, was a conservative black, who was opposed to affirmative action and a cipher on the issue of abortion rights. Republican supporters had ushered him through the confirmation hearings. They were ill-prepared for the media frenzy that followed the allegation that their candidate for the Supreme Court had, ten years earlier, sexually harassed a subordinate. The same subordinate had followed her alleged harasser when he changed jobs, had said nothing when Thomas was appointed to a circuit court judgeship. Now, she had come forward, reluctantly perhaps, to challenge the character of the nominee.

For three days, Americans watched on television the events in the Senate Caucus Room. Apparently outraged politicians pushed for details. Hill said that during one exchange Thomas had alluded to a well-endowed porn actor, calling him by name. "Long Dong Silver" became part of the congressional record and penis size part of dinner conversation across America.

Senators made asses of themselves, first posturing about the monstrous nature of Thomas's remarks. Said Utah Senator Orrin Hatch: "These are gross, awful, sexually harassing things which, if you take them in combination, would have to gag anyone." He continued, "That anybody could be that perverted—I'm sure there are people like that, but they are generally in insane asylums."

Others saw a different kind of monster. Senator Arlen Specter (R-Pa.) sensed a liberal conspiracy. "It is my legal judgment that the testimony of Professor Hill was flat-out perjury."

Senators accused Hill of concocting her story, borrowing the detail of the pubic hair from a scene in *The Exorcist,* the comment about Long Dong Silver from a 1988 10th Circuit Court of Appeals case where a woman charged her employer with flashing a picture of the man with a nineteen-inch penis. They brought forward a former classmate who said Hill built elaborate fantasies around people she barely knew. Hill, the senators suggested, suffered from erotomania.

Thomas claimed the charges were untrue. He had never asked Hill out. He had never discussed sex with her. He called the hearing a high-tech lynching. He was confirmed by a 52 to 48 vote of the full Senate.

Polls showed that almost twice as many people believed Thomas (40 percent) as Hill (24 percent). One year later, the credibility of the participants had changed, with 34 percent believing Thomas and 44 percent believing Hill. Americans seemed to believe that something had happened, but not the way either had described it.

What was this thing called sexual harassment? Lin Farley, a professor at Cornell University, invented the term "sexual harassment" in 1975. She was teaching a course called Women and Work and, as a feminist and labor, was looking for a universal issue. At a speak-out, women complained about male coworkers who wouldn't let them alone. "We have to have a name for it," Farley realized. The group considered labeling such behavior "sexual coercion," then "sexual blackmail," before settling on the more ephemeral "sexual harassment." It would take decades to fully define the term.

Catharine MacKinnon wrote the definitive text, *Sexual Harassment of Working Women,* in 1979. In it she argued that sexual harassment was a form of intimate violation that included coerced sex, unwanted sexual advances, and retaliation. Building on the definition hammered out in the Ithaca workshop, she claimed the behavior extended along a continuum of severity and unwantedness, from "verbal sexual suggestions or jokes, constant leering or ogling, brushing against your body 'accidentally,' a friendly pat, squeeze or pinch or arm against you, catching you alone for a quick kiss, the indecent proposition backed by the threat of losing your job and forced sexual relations."

A study by the Center for Women Policy Studies reported that as many as 18 million American females were harassed sexually while at work during 1979 and 1980. Antifeminist Phyllis Schlafly, head of the conservative Eagle Forum, told a Senate committee that the 18 million were asking for it. "Sexual harassment on the job is not a problem for virtuous women," she said, "except in the rarest of cases. Men hardly ever ask sexual favors of women from whom the certain answer is no. Virtuous women are seldom accosted."

Throughout the 1980s the crusade had languished, as MacKinnon spent her energy trying to turn pornography into a civil rights action. In 1980, the

EEOC issued guidelines on sexual harassment, making it part of Title VII of the Civil Rights Act of 1964. It forbade outright coercion—the quid pro quo of a supervisor saying, "Sleep with me or you lose your job."

Clarence Thomas inherited those guidelines when he moved to the EEOC in 1982. Anita Hill left Washington for a job at Oral Roberts University the following year. In 1986 the Supreme Court ruled that sexual harassment was illegal. Mechelle Vinson, an assistant branch manager of the Meritor Savings Bank in Washington, D.C., had filed suit against her employer, charging that her manager had made sexual demands. She had submitted to him forty or fifty times, on his desk, in the bank vault, in the ladies' room, at motels. Lower courts had looked at the case and declared that Vinson's actions were voluntary. The Supreme Court agreed, but held that her boss's sexual demands created a hostile environment, that the workplace should be free from "discrimination, ridicule and insult."

In 1988 the EEOC fine-tuned its guidelines, stating that harassment could occur when "unwelcome sexual conduct unreasonably interferes with an individual's job performance or creates an intimidating, hostile or offensive working environment."

In the eighties magazines still ran articles on how to run an office affair. Michael Korda told *Playboy* readers, "Two things will happen as more women join the executive ranks—the politics will get tougher and the sex will get terrific."

The EEOC granted that sex was alive and well in the workplace, carefully crafting the following: "Because sexual attraction may often play a role in the day-to-day social exchange between employees, the distinction between invited, uninvited but welcome, offensive but tolerated and flatly rejected sexual advances may well be difficult to discern. But this distinction is essential because sexual conduct becomes unlawful only when it is unwelcome in the sense that the employee did not solicit or incite it, and in the sense that the employee regarded the conduct as undesirable or offensive."

Perhaps sensing the danger of allowing Mrs. Grundy or an equivalent bluenose to dictate what was offensive, the EEOC advised that harassment should be judged from the standpoint of a reasonable person: "Title VII does not serve as a vehicle for vindicating the petty slights suffered by the hypersensitive."

From 1980 to 1990, the EEOC received 38,500 sex-harassment complaints. Some were clear-cut examples of coercion, women fired because they would not submit to a boss's advances. Some were clear-cut examples of hostility, bosses who would say women had "shit for brains" and belonged not in the workplace but "barefoot and pregnant."

But other cases were not as clear. Lois Robinson, a welder at the Jacksonville Shipyards, filed suit in 1986, claiming that her workplace was a virtual obstacle course of pornography, sexually demeaning cartoons, and graffiti. (After conferring with the New York–based Women Against Pornography, she had kept a detailed diary of every pin-up and lewd remark she encountered. When her coworkers became aware of her crusade they retaliated, putting pin-ups in her tool box. Whether their hostility was directed toward Robinson as a woman or as a prude provocateur is hard to say.) A judge ordered the locker rooms cleaned out. He fined the shipyard $1.

In another case, five women employees sued the Stroh Brewery Company, claiming the company's television commercials (featuring the Swedish Bikini Team) contributed to a hostile work environment. The commercials depicted manly men out fishing or hiking, drinking beer, and commenting, "It doesn't get any better than this." At which point a cascade of blondes arrives by parachute or raft.

In January 1991 Kerry Ellison, a female agent for the Internal Revenue Service, received unwanted attention and love letters from Sterling Gray, a colleague (not a supervisor). The letters were not what most people would call hostile: "I know that you are worth knowing with or without sex. I have enjoyed you so much, watching you. Experiencing you. Don't you think it odd that two people who have never even talked together alone are striking such intense sparks? Some people seek the woman, I seek the child inside. With gentleness and deepest respect. Sterling." She complained. Gray was transferred, for six months but that wasn't enough. Ellison filed suit.

The first judge who heard the case dismissed it as trivial, but appeals judge Robert Beezer had a different opinion. While a man might look at Gray's conduct and see him as a modern-day Cyrano de Bergerac wishing only to woo Ellison with his words, "conduct that many men consider unobjectionable may offend many women."

He concluded that the case should be decided from the viewpoint of "a reasonable woman." His rationale was right out of a radical feminist Take Back the Night rally. "Because women are disproportionately victims of rape and sexual assault, women have a stronger incentive to be concerned with sexual behavior," Beezer wrote. "Women who are victims of mild forms of sexual harassment may understandably worry whether a harasser's conduct is merely prelude to a violent sexual assault."

John Leo, in *U.S. News and World Report,* saw the dangerous shift toward Big Sister sex police. "Driven by feminist ideology, we have constantly extended the definition of what constitutes illicit male behavior," he wrote. "Very ambiguous incidents are now routinely flattened out into male predation."

The new code of etiquette "is a rich compost of antisex messages: males are predatory; sex is so dangerous that chitchat about it can get you brought up on charges; hormone-driven gazing at girls will bring the adult world down on your neck. The most harmful message, perhaps, is that women are victims, incapable of dismissing creeps with a simple 'Buzz off, Bozo.'"

The feminist chorus chanted "Men just don't get it." Anita Hill's story struck a chord. Between October 1990 and September 1991 the EEOC received 6,883 complaints but pursued only 66 cases. Following the hearing, suits filed with the EEOC jumped to a record 9,920 in 1992.

A few weeks after the Anita and Clarence show, the *New York Times* interviewed Michelle Paludi, a psychologist at Hunter College who coordinated a campus committee on sexual harassment. She told about a hypothetical scenario that she presented to men and women, before asking when sexual harassment had occurred.

"In one scenario, a woman gets a job teaching at a university and her department chairman, a man, invites her to lunch to discuss her research. At lunch he never mentions her research, but instead delves into her personal life. After a few such lunches, he invites her to dinner and then for drinks. While they are having drinks, he tries to fondle her.

"Most of the women said that sexual harassment started at the first lunch when he talked about her private life instead of her work," said Paludi. "Most of the men said that sexual harassment began at the point he fondled her."

A *Playboy* editorial challenged the account: "There is a gulf here, but not between men and women: It is between the bold and the brainwashed. The rush to judgment is as suspect as it is incendiary. Legally, sexual harassment

has not occurred. There is no quid pro quo (she already has her job) and no hostile sexual environment (nothing in the scenario indicates that the attention is unwanted). What you have here is the standard American mating ritual. Lunches lead to dinner. Dinner leads to drinks. At some point, the participants move from talking to touching (or in this case, attempted touching). The man expresses interest. In the absence of a clearly expressed lack of interest, he proceeds. In the absence of a clearly stated rejection, what happens is not harassment. It is, quite simply, none of our business."

Writing in the *New York Times,* Lloyd Cohen saw sexual harassment as the final, chaotic campaign in the sexual revolution: "In our open, dynamic and multicultural society, there is no discreet set of accepted ways in which men and women make known their availability, to say nothing of their attraction to a particular person. And one can no longer read people's sexual standards from their dress, occupation, the places they frequent or their activities. The prudish and the promiscuous are forced to rub shoulders, but often fail to recognize each other's sexual values."

Surveys found that huge percentages of women had experienced sexual harassment, but a *Playboy* writer questioned the term. "Substitute 'sexual interest' for 'sexual harassment' and the hysteria dissipates. Consider the following rewritten headlines:

• Anywhere from 40 to 80 percent of all working women will find themselves subjected to sexual interest at some point in their careers.

• Although nearly half said they had been the object of sexual interest, none had sought legal recourse and only 22 percent said that they had told anyone else about the incident.

• Sexual interest is the single most widespread occupational hazard."

Somehow, flirting did not rise to the seriousness of black lung disease. That would soon change. Congress tried to demonstrate a new sensitivity to women's issues. Lawmakers passed a bill that put a price tag on harassment. Where once an aggrieved woman could only sue for lost wages, now her lawyers could seek punitive damages. Peggy Kimzey, a clerk at Wal-Mart whose supervisor snickered when she bent over to pick up a package, sued. The oaf had muttered something to the effect that "I just found someplace to put my screwdriver." A jury awarded Kimzey $50 million, which was later cut to $5 million.

Sexual harassment promised big bucks, a huge redistribution of wealth. In 1997 the EEOC fielded 15,889 cases. Monetary settlements went from $7.7 million in 1990 to nearly $50 million in 1997. Men were getting it, and getting it big.

As they had in the 1920s and the 1960s, college campuses led the culture in sexual change, only this time the trend was toward repression.

Administrators formed committees to review issues of harassment and sex. Groups with titles such as The Committee on Women's Concerns applied power politics to sex, drafting codes that proclaimed "A faculty member may not make romantic or sexual overtures to, or engage in sexual relations with, any undergraduate student."

Doug Hornig, in a *Playboy* article called "The Big Chill on Campus Sex," reported that Harvard's code included a spy system. "Whoever witnesses an illicit liaison is required to report it. If you aid and abet one, you share liability with the guilty parties. If you merely fail to turn in miscreants you may be subject to sanctions."

When the University of Virginia moved to consider a code, the whole nation watched. Student Council president Anne Bailey told CNN, "It's an invasion of the private lives of consenting adults. It reeks of paternalism. We're old enough to go to war and to have abortions, so I think we're old enough to decide who to go to bed with."

Ann Lane, the director of Virginia's women's studies program and one of the proponents of the code, had a different view. "We're trying to create a set of guidelines for ethical behavior in the university faculty," she explained. "We're not trying to curtail students' sexual freedom. Ultimately they have that authority. What we are saying is, 'Don't fuck your students.'" Further, she said, "Free sex is not a right. Society is an agreement on the part of people to give up some of their privileges in exchange for community control. In any case, there are certain cultural benchmarks of maturity and 18 isn't one of them."

Tom Hutchinson, a professor who opposed the code, married a woman he met when she was an undergraduate and he was a faculty member. "A tawdry little affair," he told *Playboy,* "that's lasted, oh, about 35 years now."

He pointed out that the hysteria exceeded the problem. In 1992 the school had received forty-seven complaints: twenty-six from students, fifteen from

faculty, and six from non-university personnel. Out of a community of 18,000, said Hutchinson, "this seems to me an extraordinarily small number."

At a debate on the code, a man received a standing ovation for remarking, "We cannot consider any proposal that has the potential to limit, restrict or preclude quality intercourse at this university."

Where the woman's face would be, a blue dot hovered. Her hand played with a string of pearls as she answered questions from the prosecutor. More than 3 million Americans watched as the thirty-year-old single mother accused William Kennedy Smith of rape.

On Good Friday in 1991, the woman had met Smith at the Au Bar in Palm Beach. He accepted her offer of a ride home. She said he seemed a nice man, a medical student she trusted because he could talk about the problems she had experienced with her prematurely born daughter.

In the car they kissed and fondled. They took a walk along the beach at 3:30 A.M. Then, she said, he threw her to the ground, pulled up her skirt, pulled aside her panties, and raped her. She struggled and tried to protest. He told her, "Stop it, bitch." "I thought he was going to kill me," she said to the court.

When she'd confronted him, told him that what had just happened was rape, he said, "No one will believe you." But police and prosecutors did. Wrote *Time*, "Perhaps it was the bruises on her leg, or the instincts of the investigators who found her, panicked and shaking, curled up in the fetal position on a couch; or the lie-detector tests she passed."

J'Accuse. In her last minutes on the stand, the woman pointed at Smith: "What he did to me was wrong." She told Smith's lawyer, "Sir. Your client raped me."

The attorney for William Kennedy Smith did not deny that sexual intercourse had taken place on the lawn. They had met, kissed in her car, where she had removed her pantyhose and shoes. They had had sex twice. When he ejaculated, her mood had changed, as she suddenly feared pregnancy. She had asked if she could come in the house. Smith related, "I said it was late. I'm tired, I'm going to bed."

Rebuffed, she confronted him in the house. They argued over the meaning of the sexual encounter that had taken place.

She said, "Michael, you raped me."

He said, "I didn't rape you and my name's not Michael."

The prosecutor scoffed at Smith's description. "Well, Mr. Smith, what are you? Some kind of sex machine?"

The prosecutor lined up three of Smith's female acquaintances who had survived similar experiences, moments of trust that turned into wrestling matches. Smith had forced himself on them, holding them down with his full weight, releasing them only after they struggled and protested. Out of fairness, since the jury would not hear the victim's past (which included three abortions and a history of sexual abuse), the judge ruled that the testimony was not admissible.

The jury took 77 minutes. William Kennedy Smith, they said, was not guilty of rape.

Harry Stein, writing in *Playboy,* noted, "The central question was not whether the sex on the Kennedy lawn had been strictly consensual, but what the hell was the woman doing there at 3:30 in the morning if she *didn't* expect something to happen."

A *Time* story asked "When Is It Rape?" and offered a portrait of confusion: "Women charge that date rape is the hidden crime; men complain it is hard to prevent a crime they can't define. Women say it isn't taken seriously; men say it is a concept invented by women who like to tease but not take the consequences. Women say the date rape debate is the first time the nation has talked frankly about sex; men say it is women's unconscious reaction to the excess of the sexual revolution. Meanwhile, men and women argue among themselves about the gray area that surrounds the whole murky arena of sexual relations and there is no consensus in sight."

At colleges across America posters covered walls: DATE RAPE IS VIOLENCE, NOT A DIFFERENCE OF OPINION.

WHEN DOES A DATE BECOME A CRIME? asked a poster put out by the Santa Monica Hospital Rape Treatment Center. "It happens when a man forces a woman to have sex against her will. And even when it involves college students, it's still considered a criminal offense. A felony. Punishable by prison. So if you want to keep a good time from turning into a bad one, try to keep this in mind. When does a date become a crime? When she says 'No' and he refuses to listen. Against her will is Against The Law."

In 1985 *Ms.* magazine had funded the Project on Campus Sexual Assault. Researcher Mary Koss found that one in four women had reported having been the victim of rape or attempted rape, usually by acquaintances. "One in Four" became a rallying cry for Take Back the Night marches. The statistic for actual rape (15.4 percent) became a poster: "Think of the six women closest to you. Now guess which one will be raped this year."

Men were predators; women victims. At Brown and Northwestern, guerrilla graffiti squads created castration hit lists—students deemed too aggressive on dates. If Susan Brownmiller had said in her 1975 book *Against Our Will,* "Rape is nothing more or less than a conscious process of intimidation, by which all men keep all women in a state of fear," then the date-rape propaganda was the reverse, the attempt to intimidate all men.

Schools created rape crisis centers, conducted date-rape awareness seminars for incoming students. Stephanie Gutmann, writing in *Reason* and *Playboy,* was one of the first journalists to question the wave of hysteria. Noting that in the previous decade there had been seventy mentions of date or acquaintance rape in the *New York Times* alone, she charted how the most toxic word in the language had been stretched to cover all male behavior.

The training guide for Swarthmore College's Acquaintance Rape Prevention Workshop stated, "Acquaintance rape spans a spectrum of incidents and behaviors, ranging from crimes legally defined as rape to verbal harassment and inappropriate innuendo."

Dr. Andrea Parrot of Cornell University had an equally broad definition, "Any sexual intercourse without mutual desire is a form of rape."

A sheaf of headlines reprinted the slander. *Newsweek* wrote of colleges working "to solve—and stop—a shockingly frequent, often hidden outrage." The *Chicago Tribune* announced: FEAR MAKES WOMEN CAMPUS PRISONERS. A rape counselor told *Newsweek* in 1986 that acquaintance rape "is the single largest problem on college campuses today."

Gutmann, investigating these claims, did some basic sleuthing and found that over the five years prior to 1990, Columbia University's security department reported zero rapes. A year later, Peter Hellman, a writer for *New York* magazine, updated the figures. At Barnard College of Columbia University, not one of the school's 2,200 students had reported a rape in 1991. At Columbia, there were just two rape accusations for a student body of almost 20,000.

Neither of these charges held up under investigation. One of the victims said her attacker had just pushed her on a bed. The rape crisis centers stood empty. Hellman found one center that had treated just seventy-nine clients, only ten of whom were the victims of recent assaults.

And yet the rallies continued, with date-rape martyrs breathlessly recounting abuse. One victim claimed, "I counted the times I had a penis in me that I haven't wanted and had to stop at 594."

The date-rape pamphlets painted a grim and absurd picture of fractured courtship. "Remember," warned the sex-ed pamphlet from the Santa Monica rape crisis center, "that some men think that drinking heavily, dressing provocatively and going to a man's room indicates a willingness to have sex."

Well, yes. And the advice to men was equally befuddling: "Don't assume that just because a woman has had sex with you previously she is willing to have sex with you again. Also don't assume that just because a woman consents to kissing or other sexual intimacies she is willing to have sexual intercourse."

The codes seemed bent on breaking the momentum of courtship, on hobbling desire. When Antioch University created a code that required students to have explicit verbal permission for each "escalating sexual act," the howls of laughter could be heard as far as Washington. "If you want to take her blouse off, you have to ask. If you want to touch her breasts, you have to ask." Columnist George Will described it as the legislation of sexual style by committee.

The code sounded like a cross between the adolescent game Mother May I and the script for a dominance and submission fantasy: Mistress, May I. It assumed that the man always makes the first move, that a woman never reached a hand down the front of a man's jeans or tied him to a bed and read him poems by Emily Dickinson.

Besides, there was plenty of evidence that the so-called victims of date rape didn't view themselves that way. Some 43 percent of the women classified as rape victims in the *Ms.* study did not realize they had been raped. A similar study by Sarah Murnen, Annette Perot, and Donn Byrne questioned 130 women about "their most recent encounter with unwanted sexual activity." The researchers said that 55.3 percent of the women felt they had had unwanted sex. Although the researchers had a bias (they called males "coercers," any sexual initiative an "attack," and any act of unwanted intercourse "rape"), the

students themselves had a different view. The vast majority said they had had moderate to total control of the situation. Half had subsequent contact with the so-called attacker, some of it sexual. None had reported the "attack," said the authors, "due to a belief that the event was not important."

Katie Roiphe, a Princeton student, looked at the controversy and concluded, in an editorial for the *New York Times,* "These pamphlets are clearly intended to protect innocent college women from the insatiable force of male desire. We have been hearing about this for centuries. He is still nearly uncontrollable; she is still the one drawing the line. This so-called feminist movement peddles an image of gender relations that denies female desire and infantilizes women. Once again, our bodies seem to be sacred vessels. We've come a long way, and now, it seems, we are going back." She compared date-rape pamphlets to Victorian guides to conduct. For example, the American College Health Association advised coeds to "communicate your limits clearly. If someone starts to offend you, tell him firmly and early."

Roiphe pointed out the similarity to an 1853 manners guide that advised young women, "Do not suffer you body to be held or squeezed without showing that it displeases you by instantly withdrawing it. . . . These and many other little points of refinement will operate as an almost invisible though a very impenetrable fence, keeping off vulgar familiarity, and that desecration of the person which has so often led to vice." A corset by any other name is still a corset. Our ideal of female virtue had come full circle.

Rush Limbaugh, a conservative talk radio host, began to call the radical sisterhood "feminazis." The antimale politics of activists on campus and in the workplace drove a wedge between men and women, and between feminists themselves. The philosophy that all men are rapists justified increasingly bizarre dramas.

In the early hours of June 23, 1993, Lorena Bobbitt took an eight-inch carving knife and cut off her sleeping husband's penis. As she drove off, she tossed the severed organ into a field. She told police that her husband had raped her and that he was insensitive. "He always has an orgasm and he doesn't wait for me. He's selfish. I don't think its fair, so I pulled back the sheets then and I did it."

Police launched a search for the missing organ, found it in a vacant lot, dropped it into a Ziploc bag, and, nine hours of surgery later, John Wayne Bobbitt was almost whole again.

The story made the *New York Times,* initially as a medical miracle. The article detailed how surgeons had successfully reattached a severed penis, tagging each individual blood vessel with tiny sutures, rerouting this and that with tubes.

But the real story soon became a rallying cry for radical feminists. Lorena was photographed waiflike in a swimming pool in the November 1993 *Vanity Fair.* A new heroine? A role model? Lorena was a woman pushed to the edge. "I remember many things," she told *Vanity Fair.* "I was thinking many things. I was thinking the first time he hit me. I was thinking he raped me. I just wanted him to disappear. I just wanted him to leave me alone, to leave my life alone. I don't want to see him anymore." Some feminists were upset that Lorena had not tossed the male organ down the garbage disposal.

Lorena was eventually acquitted of the charge of "malicious wounding."

John Wayne Bobbitt took his story on the road, appearing as a guest on Howard Stern's 1994 New Year's Eve pay-per-view special selling T-shirts depicting a knife-wielding woman and the words "Love Hurts," marketing a line of penis protectors, and starring in a porn film, *John Wayne Bobbitt: Uncut—* which has all the morbid appeal of a driver's-ed film showing accident victims.

Hollywood capitalized on the antimale attitude with a series of films, including *Sleeping With the Enemy* (1991) and *La Femme Nikita* (1991), all suggesting that women would find equality in the Second Amendment through the judicious use of weaponry. Women were armed and dangerous.

In 1991, the movie *Thelma & Louise* debuted and America was introduced to the ultimate male bashers. When Geena Davis and Susan Sarandon decide to take a weekend away from an oafish husband and a noncommital boyfriend, a girls' night out turns into a murderous escapade. The pivotal scene occurs early in the film. A cowboy follows an intoxicated Thelma into a parking lot and forces himself on her. Louise pulls a gun from her purse. When he suggests, "Suck my dick," she shoots him.

Later, a redneck trucker ogles the dynamic duo. The male gaze, it seems, is grounds for immediate retaliation. The assertive femmes blow up his gasoline tanker. Facing arrest, the two choose death, sending their car over the

edge of a cliff. The movie sparked a firestorm of debate. Columnist Ellen Goodman called it a "PMS movie, plain and simple."

By 1993, the braggadocio of the antimale feminists would surface at a University of Chicago Law School conference featuring Catherine MacKinnon and Andrea Dworkin. Buttons declaimed: DEAD MEN DON'T USE PORN or THE BEST WAY TO A MAN'S HEART IS THROUGH HIS CHEST. Another button: SO MANY MEN, SO LITTLE AMMUNITION. Over a drawing of a bloodstained .45 automatic, the words: FEMININE PROTECTION.

An anxious media went looking for women who liked men. A February 1994 *Esquire* article titled simply "Yes" presented a lineup of young ladies who embraced lust.

Patricia Ireland, president of the National Organization for Women, told the writer, "What's going on is not your mother's feminism. The young women who grew up in *Ms.* households feel the need to assert that they're *not* antimale, *not* antisex, that they don't believe all sex is rape. But they're also nobody's victim. There are two parts to these young women's view: One, they're going to enjoy sex; two, on their terms." *Esquire* dubbed the new political stance "do me feminism," an odd term for women who advocated sexual independence. These were women just as willing to strap on dildos and do you.

Lisa Palac, the editor of *Future Sex*, a San Francisco–based magazine, explained her politics after discovering she liked porn. "Even though I got liberated, it's still very complicated. I say to men, 'Okay, pretend you're a burglar and you've broken in here and you throw me down on the bed and make me suck your cock!' And they're horrified. It goes against all they've recently been taught. 'No, no it would degrade you!' Exactly. Degrade me when I ask you to."

bell hooks, then a professor of women's studies at Oberlin College, gave her guidelines for the new male. "If all we have to choose from is the limp dick or the superhard dick, we're in trouble. We need a versatile dick who admits that intercourse isn't all there is to sexuality, who can negotiate rough sex on Monday, eating pussy on Tuesday and cuddling on Wednesday."

In the same issue, the editors of *Esquire* threw in the towel. In an article listed under the category "Savoir Faire," Susie Bright told men "How to Make Love to a Woman: Hands On Advice From a Woman Who Does."

Bright, a.k.a. Susie Sexpert, wrote the advice column for *On Our Backs: Entertainment for the Adventurous Lesbian.* Now, she proposed a quickie book on *How To Pick Up Girls Using the Real-Live Dyke Method.* Among her suggestions was The Look. "Because, for humans, it all begins with seeing," she explained. "Look at her. All over. Linger anywhere you like. When she notices (and she will if you're really looking), hold her eyes with yours. Hold them close. Every second will feel like a minute. You'll be tempted to avert your gaze, but don't. This is the essence of cruising, the experience that all the virtual reality and phone sex in the world will never replace. It is also the moment of truth. You'll know then and there whether she wants you or not.

"If she doesn't, she'll complain to her friends about how you 'objectified' and 'degraded her,' but ignore all that crap. Calling a man a sexist interloper is just a trendy way of expressing an old-fashioned sentiment: 'He's not my type.'" She warned men not to confuse girl-watching (checking out every passing chick) with looking ("to exercise the power of vision.")

Bright also revealed the secret of The Touch: "Lesbians too have probing, yearning, insistent sex organs. We call them hands. And if you have not had the pleasure of taking a woman in your hands—your thumb parting her mouth, your fingers tracing her ears, your hand curled up inside her—you are missing some of the finer points of ecstasy." At the turn of the century, Ida Craddock had insisted, in a suppressed sex manual, that the proper finger of love was the male organ. Now we learned that the proper finger of love was, well, the finger, if not the whole hand.

Bright edited a series of feminist porn stories called *Herotica* and *Herotica II.* Male authors such as Norman Mailer, Philip Roth, and John Updike had liberated sexual language in the sixties; now it was time for female writers to develop a sexual voice. The factor that distinguished feminist porn from male erotica was simple, Bright said. "The woman comes." In male-centered stories, "We read about how he sees her responding to him, but we don't see inside her explosion."

Ms. feminists would have us believe that women needed protection from sex. Women authors suggested otherwise. A *Playboy* review of Clit Lit 101 gave this assessment: "The heroines make love in oceans, lakes, rivers and swimming pools, in the back of pickups, on trains, in buses, bent over tires in gas stations, handcuffed to beds, on top of tables and desks, on beaches,

in cliffside tents, in back country stores, on living room couches and, oh yes, occasionally in bed. They have out-of-body sexual experiences with the ghosts of dead lovers and enjoy the attention of extraterrestrials in off-planet brothels. They mate with beams of sunshine and with shapes of glowing light that rise from the depths of summer ponds. They use feathers and night sticks, lotions and leather. They fuck potters, cowboys, motorcycle cops, young boys, ocean waves, strangers, dildoes, dykes, vibrators and their own fingers." Many women in the nineties delighted in transgressing boundaries, real and imagined.

Women charted their own arousal. A character in Susanna Moore's novel *In the Cut* complained, "I can remember every man I ever fucked by the way he liked to do it, not the way I liked to do it."

If reading is thinking with another man's brain, reading feminist porn was feeling with another gender's body.

The riot grrls fascinated America. We watched Madonna grab her crotch in concerts, listened to Liz Phair sing about things unpure, unchaste, about wanting to fuck her boyfriend like a dog, to fuck him till his dick turned blue, to be his blow job queen. Alanis Morissette topped the charts by challenging a lover about his new flame, "Is she perverted like me? Will she go down on you in a theater?"

In 1992 Madonna published her own collection of erotica, a portfolio of nudes and S&M fetish shots stitched together with short fantasies, bound in aluminum and sealed in Mylar. Called *Sex,* it was a worldwide event—mocked in monologues on late-night television, but a major success. At the Chicago conference of radical feminists, antiporn activist Nikki Craft led a mob action, tearing to shreds the pages from a copy of *Sex.*

Two decades of propaganda had tarred and feathered male sexuality and, indeed, most heterosexuality. The only sexual minority that was not villainous was lesbian love.

Looking for something to celebrate, the national media focused on fabulous femmes. Madonna and Sandra Bernhard had flaunted their friendship at the end of the eighties. Singer k.d. lang appeared on the cover of the August 1993 *Vanity Fair*—shown getting a close shave from supermodel Cindy Crawford.

Lesbians had their own clubs, and their own conferences. Some five hundred lesbians turned out for LUST (Lesbians Undoing Sexual Taboos) at the NYU law school for workshops that included "Toys R. Us: Ropes, Whips and Dicks."

Gay characters appeared in movies (*Go Fish* and *Boys on the Side*) and on television—*Roseanne, Married with Children,* and *Friends.* When Ellen DeGeneres, star of *Ellen,* told the world that she was gay, the Reverend Jerry Falwell called her "Ellen DeGenerate." Singer Melissa Etheridge and Julie Cypher appeared on the cover of *Newsweek* to announce to the world that "We're Having a Baby."

The boundaries between sex roles continued to dissolve. In 1995, a Harvard professor released a 600-page celebration of gender confusion, *Vice Versa: Bisexuality and the Eroticism of Everyday Life.* Marjorie Garber argued that most people would be bisexual if not for "repression, religion, repugnance, denial . . . [and] premature specialization."

Heterosexuality, monogamy—reduced to the "premature specialization." What's your sexual major? I haven't decided yet. Garber wondered if bisexuality was merely the badge of the nonconformist: "Is sexuality a fashion—like platform shoes, bell-bottomed trousers, or double breasted suits—that appears and then disappears, goes underground only to be 'revived' with a difference? Do we need to keep forgetting bisexuality in order to remember and rediscover it?"

She resurrected the century's sexual celebrities (Jagger, Bowie, Marlene Dietrich, Oscar Wilde, James Dean, Madonna) and concluded that sex was a performance art. "Celebrities do constantly reinvent themselves," she wrote. "One of the ways in which they have done this . . . is by renegotiating and reconfiguring not only their clothes, their bodies and their hair, but also their sexualities." She spoke of a sex star's ability "to shock and give pleasure" as an art.

Newsweek described bisexuality as "the wild card of our erotic life" and profiled young couples who proclaimed, "Sexuality is fluid. There is no such thing as normal." Michael Stipe, lead singer for the rock group REM, confessed, "I've always been sexually ambiguous in terms of my proclivities. I think labels are for food." Another source said simply, "I don't desire a gender. I desire a person."

In 1998, a former porn star named Annie Sprinkle toured the country with an evening of performance art called *Annie Sprinkle's Herstory of Porn: From Reel to Real.* The veteran of twenty-five years of x-rated self-expression, she played a visual record of her past, of her skill in the art of shock and pleasure. In the seventies she had been a child of the counterculture, performing fellatio and group sex in film after film. She had become famous as the woman who would do anything—she had sex with vegetables, sex with amputees, golden showers, bondage, S&M, sex with post-op transsexuals. In 1976 she was arrested for sodomy, the infamous crime against nature, but explained Annie, "Nature didn't mind."

Eventually she abandoned heterosexual porn for films that celebrated sluts and goddesses. One clip showed an arm buried almost to the wrist, one woman giving another a G-spot orgasm. She had moved into New Age sex, finding the goddess within through extended vibrator-assisted orgasms. In one era she had turned to live shows in which she inserted a speculum and invited audience members to look at her cervix. By 1998 she had discovered the Internet. "Those of you who missed it, don't despair," she said, "you can still see my cervix on my website."

Now, Sprinkle produces her own films, and concludes her show with a clip devoted to mermaid sex. Attired in fins, she and a young woman have a ménage à trois with a male. The scene, which seems to suggest a return to heterosexuality, climaxes with the removal of the male's penis, revealing it to be a stunt dildo.

In the question-and-answer session following the performance, an audience member asked Annie, "Of all the faces we've seen, which was your true self?"

It is a question that, as we approach the end of the century, many Americans could ask of themselves.

The generation that came of age in the nineties received mixed messages about pleasure. For them, sex education was AIDS education. They learned not about the birds and the bees but instead a stark message: Sex could kill you. When basketball star Magic Johnson announced that he had contracted HIV, the message seemed to be: It can happen to anyone. Katie Roiphe, in *Last Night in*

Paradise, recounted growing up with the object lesson of Alison Gertz, the girl next door who had contracted AIDS from a one-night stand with a bartender from Studio 54. (He had been a bisexual.) Gertz became the poster child for heterosexual transmission, wrote Roiphe, proof that "It takes only one night with the wrong man."

The religious right advocated abstinence ed, and condemned safe-sex campaigns that stressed condom use. When the Free Congress Foundation declared that condoms did not protect one from AIDS, Dr. Ronald Carey at the FDA pointed out that even the worst-quality condom is 10,000 times better in terms of reducing exposure to HIV than unprotected sex. Ira Reiss, co-author of *An End to Shame: Shaping Our Next Sexual Revolution,* put it bluntly: "We can no more assume that every believer in abstinence invariably abstains from sex any more than we can assume that every condom user will have perfect condoms and be a perfect user. When one makes an unbiased comparison of promoting abstinence versus promoting condom use the results are obvious. Vows of abstinence break far more easily than do condoms."

When a psychologist asked Surgeon General Joycelyn Elders if she would consider promoting masturbation to discourage children from trying all-out sex, she replied, "With regard to masturbation, I think that is something that is a part of human sexuality and a part of something that perhaps should be taught."

An outspoken woman, she had favored giving condoms to public school students. ("Well, I'm not going to put them on their lunch trays, but yes.") In earlier years as a state health official, she had kept condoms as a desk ornament labeled "Ozark rubber plant." Conservative radio host Rush Limbaugh labeled her the condom queen. And the Traditional Values Coalition, claiming to represent 31,000 churches, condemned her for "malicious attacks on heterosexuals and Christians" and demanded her resignation. On December 9, 1994, Elders stepped down.

The generation that watched its leaders bicker about sex had also grown up watching Madonna. Girls bought the lingerie they wore under or over their prom dress at Victoria's Secret. They'd grown up in a world where sex was not a mystery, but was visible, explicit, and sophisticated.

In 1996 *Playboy* commissioned a survey of a dozen colleges. Two years later, the magazine went back for a second look. The two surveys present a snap-

shot of a generation that had grown up in the shadow of AIDS and in the dim blue light of MTV. The surveys found that students had incorporated both caution and creativity. In 1996 almost half the men and women had masturbated in front of their partners—sometimes because they didn't have condoms, sometimes as a stand-in for intercourse, sometimes as a hot form of hooking up. Some two thirds had performed phone sex.

The learning curve was immediate. Approximately a third of the students had tried bondage and spanking, one in five had used a blindfold during sex or posed nude for a lover. More than half of the males and four out of ten girls had had sex in the presence of other people. The vast majority had watched X-rated videos, many with a partner.

Students had created a new permission, a kind of double-entry bookkeeping. Approximately half said that oral sex was not real sex, three quarters said they did not include in their list of lovers those partners with whom they had just had oral sex.

The survey uncovered a haphazard approach to sex. Almost half of the students had not—on the night they'd lost their virginity—expected to have sex. Sex, sometimes, just happened.

The lesson they had learned was that intercourse was okay, as long as you used a condom. In the first survey more than a third of students had taken an AIDS test. A few years later the figure dropped to about one out of four. The test was a way of admitting they had made a sexual mistake or to assuage panic, or as a ritual of purification with a new partner, one that would allow them to enjoy naked sex (no condom).

The 1998 survey also found that 15 percent of college students chose to remain virgins. Admittedly, the definition of virgin meant only that you had not had intercourse. Even technical virgins experimented with touching, kissing, and extreme fondling. But sexual autonomy—defined by the right to say no—became a central issue.

The cult of virginity recruited its ranks from high school. True Love Waits, a church-sponsored movement, asked teenagers to take a pledge: "Believing that true love waits, I make a commitment to God, myself, my family, my friends, my future mate and my future children to be sexually abstinent from this day until the day I enter a biblical marriage relationship."

In 1996, the movement held rallies where teens took the chastity oath and strung 350,000 pledge cards from the ceiling. Virgins carried picket signs

that declared "Do Your Homework Not Your Girlfriend." "Save Sex not Safe Sex."

In 1997, in an event organized by the Pure Love Allliance, five hundred virgins actually marched on Washington, staking their pledges on the mall and urging motorists to "Honk For Purity." The media created the concept of virginity chic, rolling out celebrity virgins singer Juliana Hatfield, actresses Tori Spelling and Cassidy Rae, and MTV veejay Kennedy. In 1999, Wendy Shalit published *A Return to Modesty,* an intellectual defense of sexual restraint. She wanted the return of "feminine mystique and with it male honor."

How to protect all these virgins, that was the question. The answer was over a century old. The religious right resurrected its crusade against indecency.

Their first target was *As Nasty As They Wanna Be,* a rap album by 2LiveCrew. James Dobson's Focus On The Family alerted followers that, "There has never been an album recorded in our nation's history for sale to the public with this level of explicit sex and degradation. . . . There are 87 descriptions of oral sex, 116 mentions of male and female genitalia and other lyrical passages referring to make ejaculation."

In Florida, a born-again lawyer named Jack Thompson copied the lyrics to *As Nasty As They Wanna Be* and sent them to lawmakers and sheriffs' departments around the state. Parroting radical feminist rhetoric, he claimed, "These guys are out promoting the idea that women are there for nothing but to satisfy men's desires. This stuff makes it more likely that women will be abused."

U.S. District Judge Jose Gonzalez listened to the album and declared the opus obscene. Songs like "Me So Horny" appealed "to dirty thoughts and the loins, not to the intellect and the mind."

Sheriff's deputies in Broward County tape-recorded a 2LiveCrew concert at a nightclub in Hollywood, Florida, and arrested rappers Luther Campbell, Mark "Brother Marquis" Ross, and Chris "Fresh Kid Ice" Wongwon for obscenity. Moving on a second front, police arrested Charles Freeman, a record-store owner, for selling *Nasty.*

The nightclub trial was a farce; the jury laughed out loud at the tapes of the performance and acquitted the rappers. A second jury found Freeman guilty of selling obscenity. Facing a sentence of up to five years in jail and a $5,000 fine, Freeman appealed. The album ended up selling about two million copies. (The cleaned up version, *As Nice As They Wanna Be* fared less well.)

State legislators introduced labeling bills that would require record companies to issue parental advisories for explicit lyrics that described or advocated "suicide, incest, bestiality, sadomasochism, sexual activity in a violent context, murder, morbid violence or illegal use of drugs or alcohol."

Fundamentalists and feminists launched attacks against shock jock Howard Stern. Stern had long been the bad boy of radio, whose shows include segments called "The Adventures of Fartman," "Lesbian-Dial-A-Date," "Bestiality Dial-A-Date," and "Sexual Innuendo Wednesday."

Stern had a menagerie of guests, from a guy named Vinnie who volunteered to put his penis in a mousetrap, to a man who played piano with his penis (this last bit earned Stern a $6,000 FCC fine). He talked about diminutive testicles and having sex with Lamb Chop the puppet. In 1991 skits involving gerbils, Pee-wee Herman's legal problems, and Aunt Jemima resulted in a record $600,000 FCC fine. A sample of the offending remarks: "The closest I ever came to making love to a black woman was masturbating to a picture of Aunt Jemima on a pancake box." Stern called the FCC "thought police" and continued with his routines. Bits on television celebrity Kathie Lee Gifford, toilet habits, and church-scandal heroine Jessica Hahn earned a $500,000 fine. An on-air analysis of lubricants, buttocks, sexual aids, panties, and his prepubescent daughter's attractiveness brought another $400,000 fine.

Reverend Donald Wildmon, head of the American Family Association, launched a crusade against Stern. The National Organization for Women threatened a boycott when Stern moved to cable television.

By 1995 Stern faced almost $2 million in fines. It was not until Wildmon pressured the FCC to deny Infinity Broadcasting's right to acquire new stations that his employers paid the fine, making a "voluntary contribution" to the Treasury Department of $1.7 million. It was simply the cost of doing business. Stern generated $15 million a year for Infinity, half of which covered his $7 million salary.

The most disturbing antisex crusade erupted in Cincinnati, the home of Charles Keating's Citizens for Decency through Law. Sheriff Simon Leis had conducted an all-out attack on pornography, closing eleven adult bookstores, five adult movie houses, and a massage parlor over a six-year period. Leis had hounded not only peep shows and nude-dancing bars, but also kept *Vixen, Last Tango*

in Paris, and Martin Scorsese's *The Last Temptation of Christ* from corrupting the citizens of Cincinnati.

The religious right saw the opportunity to lay siege to the hallowed ground of high culture. Al Goldstein, *Screw*'s publisher, used to defend the newsstand as art museums for the blue-collar crowd. Cleaning up newsstands was not enough; they wanted to eliminate sex from the fine arts as well.

On April 7, 1990, Cincinnati's Contemporary Arts Center put on an exhibit of 175 photographs by Robert Mapplethorpe. Mapplethorpe, who had died of AIDS in 1989, had documented his sexual subculture. The exhibit included floral still lifes, portraits, male nudes, and shots with sadomasochistic and homoerotic themes. One part of the exhibit asked viewers to compare the sex organs of flowers with those of gay males. The exhibit, sponsored in part by an NEA grant, had toured Chicago, Berkeley, and Hartford without incident.

Senator Jesse Helms condemned the photos on the floor of Congress. In an act of political cowardice, Washington's Corcoran Gallery of Art canceled the exhibition.

On opening day, Cincinnati police barricaded the doors of the Contemporary Arts Center, videotaped the photographs, and indicted museum director Dennis Barrie and the CAC for "pandering obscenity" and for "using minors in nudity related material."

The museum remained open. Some 81,000 citizens lined up to see the now infamous "XYZ photos"—including five shots that detailed fisting, golden showers, and anal insertion of different objects, as well as two shots that showed a nude boy on a chair and a little girl whose lifted skirt exposed her genitals.

The prosecution brought in Judith Reisman, the former songwriter for *Captain Kangaroo* turned antiporn expert. She told the jury to look at how the child's legs come together in a triangle, calling attention to the genitals in a lewd and lascivious manner. She invoked the specter of child molesters. "By placing images of children that are focused on the genitals, that have been sexualized, whose sex organs are clearly visible on the walls of our museums, what we are doing is legitimizing the public display of the photograph. And I think you are then putting at risk additional children."

Lou Sirkin, lawyer for the CAC and Barrie, challenged the jury. "If you think those pictures are frightening or that they are a lewd exhibition that concentrates on the genitals of those children, that they are anything more than

the display of moral innocence . . . I don't believe the people of this city have that kind of evil eye. If you take things and try to turn them the way the state wants you to do, the way Judith Reisman wants you to do, to turn something human into something dirty and ugly . . . The human body is not ugly. It is ugly only if you try to make it that way."

On October 5, 1990, a jury took less than two hours to find Barrie and the Contemporary Arts Center not guilty of all charges. On the same day, the Cincinnati Reds were playing game two of the National League Championship. The radio station broadcasting the game interrupted its coverage to announce the verdict. Fans gave a standing ovation.

Conservatives thought they had found a political hot button; in Congress lawmakers tried to impose sanctions on art grants that funded "indecent art." The strategy to purify existing technologies—radio, recording, and film—was nothing to what greeted the newest form of communication.

Boundaries disappeared via technology. Throughout the century, technology had created new avenues for lust. Mr. Bell's telephone had allowed lovers to create a sexual space in intimate conversation. A boyfriend's voice could enter the house on currents of electricity, could be heard on the pillow next to one's ear, without violating community propriety.

Sex drives technology. Ask the swingers who bought the early Polaroid cameras, who turned videocassette recorders into home porn theaters, who turned their own videocams into time-shifting sex toys. And it was sex that sold the Internet.

Cyberspace was an invisible, intimate realm that allowed free expression and, even more important, the right of free association. Net heads flocked to chat rooms and newsgroups devoted to every aspect of sex. Like blondes? Try alt.sex.blonde. Reading literary lust? Try alt.sex.erotica. Do you have a taste for whips and chains? Try alt.sex.bondage. The list was endless, from basics such as alt.sex.backrubs and alt.sex.masturbation to fringe activities on alt.sex.fetish.diapers and alt.sex.hello-kitty.

Matthew Childs investigated "Lust Online" for *Playboy* in 1994 and found the nineties version of the zipless fuck, posted by a woman who called herself Sara: "Just as the train is about to pull out of the station, a young woman boards

the car you're on. The train moves along the tracks and you can feel the vibrations of the rails. As you begin to feel hot, you feel your cock getting harder and you squirm in your seat trying to get comfortable. You imagine yourself touching the silky fabric of her dress, realizing that it has fallen apart at your touch and you are touching bare skin—everywhere. Your fingers move down her body, absorbing the wonderful sensations. You hear a slight moan in your ear as you near that part of her that is getting hot and wet."

Was sharing fantasies a sex act? Chat groups debated the question. Were people online exchanging virtual bodily fluids? Childs concluded that modem sex "allows users to test drive their fantasies with other people while still preserving their anonymity. With that facelessness comes the freedom to try different sexual personas." Putting your fantasies on public display was never safer. Imaginary whips don't leave marks.

Two individuals half a continent apart meet in cyberspace:

PRIAPUS: My tongue lashes out at your clit, licking furiously.

NIKKI: Lick me! Hard, long, from front to back.

PRIAPUS: I taste your mingled juices and my hand runs up and down my cock. Long swipes of my tongue from your clit back over the lips of your pussy.

NIKKI: My lips graze your cock, lick its tip, taste the salt.

PRIAPUS: I thrust up my hips seeking to enter your mouth.

And so forth. A few rounds of this, and maybe, just maybe, the woman who typed "Goddess, give me more" will give you a telephone number.

Chat groups debated whether a participant in one of these fantasies was male or female, as though the imagined male or the imagined female was like a Platonic ideal of masculine and feminine. Without physical clues, what determines sexuality. There were no sexual characteristics in cyberspace, no five-o'clock shadow or high-pitched voice to give one away. The vision of too much freedom, of sex without limits, summoned the monsters.

There was no topic too obscene or boring that a million geeks couldn't find time to discuss it. The Internet provided support groups for the weird, like basement 12-Step programs. Stephen Bates, in an editorial for the *Wall*

Street Journal, worried that the cyberright of free association might empower pedophiles.

Instead, the anonymity of the Internet proved a boon to police. The tactics employed by the government were as old as the postal stings conducted by Anthony Comstock. Agents posed as young girls and boys. When potential pedophiles sent pornography to their new friends, they were arrested. When they made dates and flew halfway across the country to do the things they had talked about via e-mail, they were arrested.

Newspapers ran accounts of teens lured to S&M sessions by online stalkers. Henry Hudson, the former Meese Commission star, oversaw a huge investigation that netted two men who were into gay S&M fantasies, one of whom was an "ineffective pedophile." Agents, posing as mobsters interested in making snuff films and kiddie porn, met with two men in a motel. The group speculated about kidnapping and killing a boy. An army of agents then placed the two under surveillance. Although no victim was targeted and no kidnapping attempt made, the two men were each sentenced to more than 30 years in prison. The stories were lurid—and rare. The media made the most of ten or so high-profile cases.

Those with access to computers went directly for the sexual. The *Harvard Crimson* looked at activity on the school's computer network and reported that twenty-eight students had downloaded some five hundred pornographic pictures in one week. Patrick Groeneveld, the sysop who ran a Digital Picture Archive at the University of Delft in the Netherlands, kept a record of the fifty top consumers of erotica. The list included AT&T, Citicorp, and Ford.

Every new technology creates its own moral panic. Senator James Exon (D-Neb.) introduced legislation to control the Internet, saying, "I want to keep the information superhighway from resembling a red-light district." The Communications Decency Act of 1995 was intended to punish anyone who "makes, transmits or otherwise makes available any comment, request, proposal, image or communication" that is "obscene, lewd, lascivious, filthy or indecent" using a "telecommunications device." Modem morality.

But was what happened on the Internet real sex? A University of Michigan student named Jake Baker posted a bunch of sordid torture fantasies on alt.sex.stories. Baker used his real name and, like an idiot, gave the victim in

a story the name of a woman in one of his classes. Authorities at the university ordered a psychiatric exam, then suspended Baker. The feds arrested the student and had him held without bond "to prevent rape and murder."

"Target: Cyberspace," an editorial in the July 1995 *Playboy,* revealed the irony of the charge. "Jake Baker is the author of a grubby little chronicle in which he and a friend hold a woman captive (tying her by her hair to a ceiling fan), then abuse her with clamps, glue, a big spiky hairbrush, a hot curling iron, a spreader bar, a knife and finally fire. He lands in jail. Bret Easton Ellis comes up with a novel, *American Pyscho,* in which the protagonist holds a woman captive, sprays her with Mace, decapitates her to have sex with her severed head, nails a dildo to her genitals and drills holes in various parts of her body, all while capturing the events on film. Ellis has a table at Elaine's [a fashionable New York watering hole frequented by writers]."

The Internet had its own way of punishing bad behavior: flaming and scorn. The editorial went on. "Within days of Baker's arrest, stories began to appear on the Net with characters named Jake Baker. Drag queens in prison rape the fantasy Jake and cut out his tongue. A woman meets the fantasy Jake on the street, tortures and shoots him. The devil asks the fantasy Jake to torture a woman, then masturbate, and when the fantasy Jake is unable to obtain an erection, the devil shoves a curling iron up fantasy Jake's ass."

Senator Exon held a stag party on the floor of Congress, wielding a little blue book with images he said were available "at the click of a button." His Communications Decency Act passed 84 to 16.

Time devoted a cover story to "Cyberporn," illustrating the article with the face of a terrified child and a picture of a man having sex with his computer. The story presented the findings of a study conducted by a Carnegie Mellon undergraduate with the daunting title *Marketing Pornography on the Information Superhighway: A study of 917,410 Images, Descriptions, Short Stories and Animations Downloaded 8.5. Million Times by Consumers in over 2,000 Cities in 40 Countries, Provinces and Territories.* It was pure propaganda, a college prank, a bit of political science that recalled Judith Reisman's inept study of images of children and violence in men's magazines. And most magazines fell for the ruse. Philip Elmer-DeWitt, the reporter for *Time,* boiled it down: "There's an awful lot of porn online."

Meaning 917,410 is an awfully big number.

"It is not just naked women. The adult BBS [bulletin board system] market seems to be driven largely by a demand for images that can't be found in the average magazine rack—a grab bag of deviant material that includes images of bondage, sadomasochism, urination, defecation and sex acts with a barnyard full of animals."

Meaning his cyber address book is better than yours.

"The appearance of material like this on a public network accessible to men, women and children around the world raises issues too important to ignore—or to oversimplify."

But oversimplify they did. Ralph Reed, executive director of the Christian Coalition, appeared on *Nightline* to sound the clarion call: "This is bestiality, pedophilia, child molestation. According to the Carnegie Mellon survey, one quarter of all the images involve the torture of women."

Never mind that these statistics weren't in the Carnegie Mellon report; neither were they on the Internet. Politicians batted around a McCarthyesque figure: "Of the images reviewed, 83.5 percent—all on the Internet—are pornographic."

Marty Rimm, the student who concocted the survey, had looked at offerings on dozens of private adult bulletin board sites. He cataloged how images were described, not the images themselves.

Professor Carlin Meyer, an NYU professor who actually read the study, noted, "Interestingly the Carnegie Mellon study never found such descriptions as snuff, kill or murder, and rarely found such others as pain, torture, agony, hurts, suffocates and the like. The term rape appeared fewer than a dozen times in descriptions of more than 900,000 images."

People who didn't know how to program their VCR could not discern the difference between a Usenet group and a private bulletin board, and yet they made public policy.

Rimm had sought out the bizarre, actually counseling adult-oriented bulletin board operators on how to spice up the language in listings. Then, he studied the world he had helped create. Mike Godwin, a lawyer for the Electronic Frontier Foundation, saw the bias. Rimm's study was "as if you did a study of bookstores in Times Square and used it to generalize about what was in Barnes & Noble stores nationwide."

Of course there were bulletin boards devoted to sex, but the latter were not a click away. To get onto Pleasure Dome, ThrobNet, SwingNet, StudNet, or KinkNet usually involved access codes, passwords, a driver's license, and credit cards, not exactly the tools of childhood. Rimm when pressed, admitted that pornographic content represented a mere .35 percent of traffic on the Net.

Parents sought out so-called George Carlin software, which could block out not only the original seven dirty words (shit, piss, cunt, fuck, cocksucker, motherfucker, tits) but also words like genitalia, prick, and asexual.

The ACLU successfully challenged the Communications Decency Act. In 1996 the Supreme Court voted unanimously to overturn the law. Justice John Paul Stevens noted a lower-court ruling that found "Content on the Internet is as diverse as human thought." Overzealous policing of the Net would eliminate information on AIDS, safe sex, birth control, homosexuality—all topics of vital interest in the nineties. Justice Sandra Day O'Connor wrote that trying to restrict the Internet was "akin to a law that makes it a crime for a bookstore owner to sell pornographic magazines to anyone once a minor enters his store."

As America struggled to impose codes of sexual behavior on campuses and in workplaces, one arena repeatedly commanded attention. Washington had always used the military to conduct experiments in social engineering, from the introducing of sex ed to soldiers in World War I to racial integration of troops to allowing women in combat. The Pentagon evidently believed that lust could be tamed by military discipline.

In 1991, a group of Navy and Marine Corps aviators attended the "Tailhook Symposium" at the Las Vegas Hilton Hotel. During the event, drunken officers took over the third-floor corridor for a ritual called "running the gauntlet." Women who traversed the gauntlet were fondled, touched, pushed, and treated to conduct unbecoming. A drunken aviator forced his hands down a female officer's shirt, grabbing at her breasts. She had to bite his hand to escape. Another aviator reached under her skirt and tried to remove her panties. Another woman officer told of being repeatedly bitten on the buttocks by a naval officer. She kicked her assailant, who then departed. When women complained, they were told, "That's what you get when you go to a hotel party with a bunch of drunk aviators."

Lt. Paula Coughlin, one of the twenty-six women attacked at Tailhook, went public with her charges. The Navy launched an investigation, as did the Pentagon Inspector General and the House Armed Services Committee.

Admiral Frank Kelso declared, "It's not boys will be boys. The times have changed." Acting Navy Secretary Dan Howard told *U.S. News & World Report,* "There's a subculture here . . . the macho man idea, the hard drinking, skirt chasing that goes with the image of the Navy and Marines. That crap's got to go."

The Navy ordered all units to stand down for sensitivity-training classes. In the wake of Tailhook, the Navy received more than a thousand sexual harassment charges, and 3,500 charges of indecent assault.

The toll of this new battlefield was staggering. In 1996, *Newsweek* pointed out that no admiral had been lost in combat since 1944, but that within the past year the Navy "had lost five admirals to sex—to disgrace for sexual harassment or inappropriate sexual behavior."

The crisis moved through the armed forces. A 1995 Pentagon survey of 90,000 active-duty service members found that between a half and two thirds of military women had experienced some form of harassment—from teasing and jokes (44 percent) to looks or gestures (37 percent) to pressure for sexual favors (11 percent) to actual or attempted rape (4 percent).

At Aberdeen Proving Ground, Maryland, nineteen female soldiers charged that they had been raped or sexually assaulted by drill sergeants, instructors, male trainees or company commanders. The Army set up a telephone hot line to process rape and sexual-harassment complaints: It received 4,000 calls in the first week alone. Investigators thought about five hundred were serious. The Veterans Administration concluded that one in four women veterans had been raped or sexually assaulted while on duty.

The military announced a policy of zero tolerance and launched a series of court-martials that produced mixed results. Juries found some charges to be clear-cut assault, others to be consensual.

The armed forces proved as politically correct as college campuses. In January 1995, Captain Ernie Blanchard addressed the cadets at the Coast Guard academy. He told a joke about a cadet's fiancée wearing a brooch featuring maritime signal flags. "She said the flags meant 'I love you.' They really said, 'Permission granted to lay alongside.'"

When the commandant of cadets complained, Blanchard apologized. But a dozen Coast Guard women demanded officers launch a criminal probe into the jokes. Blanchard offered to resign, but was turned down. On March 14, 1996, he committed suicide.

The crusade to reestablish moral authority in the ranks spread to other acts. Lt. Commander Kelly Flinn was tossed out of the Air Force for having an affair with the husband of another enlisted female soldier. The hierarchy tried to explain that Flinn was ousted because she had disobeyed a direct order not to see the man, and that she had lied about continuing the affair.

The notion that sex was something that was subject to direct orders made for intriguing water-cooler conversations, but at the heart of the controversy was America's puritan mean streak.

Sex would not do as it was told. In the wake of Flinn, 67 officers and enlisted personnel were discharged for adultery. Air Force General Joseph Ralston had to turn down a top post when it was revealed that he had had an affair thirteen years earlier. The blade of zero tolerance reached deep into the past.

The desire to use the military as the proving ground for moral ideas appealed to presidential candidate William Jefferson Clinton. In his 1992 campaign he promised to ban sexual discrimination from the armed forces. On taking office, he promised, his first act as commander in chief would be to allow gays to serve in the military.

Since Von Steuben trained Washington's troops in Valley Forge, gays had served America, sometimes with distinction. Clinton would end the witch-hunts, the persecutions, the cause for dishonorable discharge. Just as Truman had ended racial discrimination in the military with the stroke of a pen following World War II, so Clinton would end sexual discrimination.

No single act would incite such hatred or invite so much retaliation from the religious right. Jerry Falwell had stepped down as leader of the Moral Majority in 1989, saying he was going back to saving souls. But the issue of gays in the military had Falwell pleading for funds to fight the "new, radical homosexual rights agenda." Viewers could phone a 900 number (at 90 cents a minute) to add their names to a petition urging Clinton not to lift the military ban. Some 24,000 viewers responded within hours. Falwell began churning out fund-raising letters that asked, "Are we about to become a hedonistic nation of unrestrained homosexuality, abortion, immorality and lawlessness?"

Televangelist Pat Robertson asked viewers of the *700 Club* to telephone Capitol Hill. More than 434,000 calls flooded the congressional switchboards.

D. James Kennedy of Coral Ridge Ministries in Florida beseeched supporters, "I'm writing today to ask your support in fighting this depravity. I'm deeply saddened that Clinton believes it's okay to go against the laws of God."

Reverend Lou Sheldon of the California based Traditional Values Coalition labeled Clinton "the homosexual president with his homosexual initiatives."

Americans were split on the issue. A poll in the February 8, 1993, *Newsweek* found that 53 percent of Americans favored allowing gays to serve, 42 percent opposed.

The arguments reflected the depth of the bias. Senator Sam Nunn from Georgia thought allowing gays to remain in the military might violate the privacy rights of heterosexual soldiers, and that "it would pose a risk to the high standards of morale, good order and discipline." In other words, being the object of another man's gaze would unnerve America's finest and might incite violence. Gays scoffed that they already shared showers with heterosexuals—in college dorms, in steam rooms, at health clubs—without chaos.

By 1993, Nunn and the Joint Chiefs of Staff had hammered out a policy of "Don't ask, don't tell, don't pursue." Recruits did not have to testify to their heterosexuality or homosexuality on enlistment. The military would no longer conduct queer-hunts. But the line wavered. Open homosexuality would still be grounds for discharge. Gays who went public, e.g., marching in a gay rights parade or making public statements, would face discharge.

What constituted going public? Was cyberspace the same as a parade ground? In one widely publicized case, sailor Timothy R. McVeigh was discharged after he described himself as gay in a chat room on America Online. Investigators demanded and received the identity of the man calling himself "Tim" and discharged him.

The policy, designed to shield gays, actually increased the number of discharges—from 597 in 1994 to 997 in 1997.

The right to privacy was central to the sexual revolution. Conservatives castigated the notion, saying that the Supreme Court had concocted it out of thin air, that the word was nowhere in the Constitution.

The right to privacy was first articulated in an 1890 *Harvard Law Review* article by Louis Brandeis and Samuel Warren. The two were concerned about the rising practice of yellow journalism, in which reporters paraded personal gossip, tales of suicide, accidents, engagement, elopements, and divorces. According to scholar Rochelle Gurstein, author of *The Repeal of Reticence,* Brandeis and Warren were alarmed by the scandal-hungry mob and the newspapers that served them. "The unprecedented reporting of subjects previously believed to fall beneath public notice led to a rancorous debate concerning the proper role of the press in a democracy."

Brandeis and Warren championed the concept of a right to privacy, "the right to be let alone." Although men who became public figures "renounced their right to live their lives screened from public observation . . . there were some things all men alike are entitled to keep from popular curiosity, whether in public life or not."

In the sixties and seventies, the Court used Brandeis's formulation to support the sexual revolution, finding in the right of privacy the right to practice birth control, to read erotica, to possess pornography, to choose when and whether to have a child. It had stopped short of kicking the state out of the bedroom in a 1986 ruling that upheld a Georgia sodomy statute.

With a few notable exceptions, the press had respected the privacy of public figures. And public figures had practiced reticence. In 1976, when a *Playboy* reporter asked Jimmy Carter his views on sex, the candidate responded that he was human, that he had lusted in his heart for women other than his wife. That disclosure made Carter the first politician to talk openly about his sex life. It humanized his campaign.

In 1987 the press questioned Gary Hart about his private life. The presidential candidate challenged reporters to "follow me around. I don't care." They did and produced a photograph of young Donna Rice sitting on Hart's lap aboard a boat called *Monkey Business.*

Sex became a character issue. Hart's blatant escapade—not to mention his cavalier taunting of the press—was proof, it was said, that he did not have the discretion and judgment necessary for high office.

The Anita Hill/Clarence Thomas confrontation scorched the boundary between public and private behavior. People who backed Hill, charged that Thomas's sexual character disqualified him for the nation's highest court.

If there were skeletons in a candidate's closet, they'd better not be wearing lingerie.

On October 3, 1991, William Jefferson Clinton, governor of Arkansas, declared his intention to run for the presidency of the United States. He was the first candidate to have come of age with the sexual revolution of the sixties, and the first to put his sex life to a vote. The rumors started early.

According to a lawsuit filed by a disgruntled state employee, Clinton had had an affair with a lounge singer named Gennifer Flowers. She denied the story. Others whispered that Clinton had a black love child, that he had slept with Miss America, that he hit on anything wearing a skirt. Clinton admitted that his marriage had not been perfect and took his campaign to New Hampshire. *New York* called it the "Bimbo Primary." *Time* called it Clinton's "Moment of Truth."

Gennifer Flowers changed her story and sold it to a supermarket tabloid for a reported $100,000. MY 12-YEAR AFFAIR WITH BILL CLINTON, screamed the headlines in the *Star,* PLUS THE SECRET LOVE TAPES THAT PROVE IT.

On the evening of the 1992 Super Bowl, the Clintons went on *60 Minutes.* Clinton admitted knowing Flowers, saying that she was "a friendly acquaintance." He said the allegation of a twelve-year affair was false. Correspondent Steve Kroft asked the candidate, "You've said that your marriage has had problems, that you've had difficulties. . . . Does that mean you were separated? Does that mean you contemplated divorce? Does it mean adultery?"

Clinton replied, "I'm not prepared tonight to say that any married couple should ever discuss that with anyone but themselves. . . . I have acknowledged wrongdoing. I have acknowledged causing pain in my marriage. . . . I think most Americans who are watching tonight—they'll know what we're saying, they'll get it and they'll feel we've been more than candid." It was up to the nation and the press, said Clinton, "to agree that 'this guy has told us about all we need to know.'"

Mrs. Clinton, after denying that she was doing a Tammy Wynette "Stand By Your Man," put it this way: "I'm sitting here because I love him and I respect him and I honor what he's been through and what we've been through together. And you know, if that's not enough for people, then heck, don't vote for him."

Time spoke of Clinton's "zipper control" problem and the threat posed by the "bimbo du jour" (at least three other women he had explicitly denied

sleeping with were making Flowers-like charges). Clinton's own staff worked to contain "bimbo eruptions."

The story was huge in New York and Washington. *Newsday* and the *Daily News* ran the same headline: SEX, LIES AND AUDIOTAPE.

The mainstream press recoiled from the tabloid stench. But the crisis seemed to provoke a dick-measuring contest. The *New York Times,* for example, buried its story in an unsigned "8 inches in length" story in the back pages, while the *Washington Post* devoted 43 inches.

In an eerie moment of voyeuristic self-loathing, or of delusions of grandeur, the press inserted itself into the story. Edwin Diamond, in a *New York* article called "Crash Course: Campaign Journalism 101," confessed that the press had dozed through the Kennedy years, "missing three years of phone calls, around the clock FBI stakeouts, coast to coast liaisons and an organized crime connection," but that "eight presidential campaigns later, the sex lives of presidential candidates are a more open field of inquiry."

"The press," he lamented, "is thoroughly confused, and at times both confused and sanctimonious, about its role in such matters. Currently the media are drowning in a sea of self-recriminations about their coverage of Clinton and Flowers."

"Pornographers are trying to hijack democracy," wrote a *Boston Globe* columnist. *Time* titled a story on the New Hampshire primary "The Vulture Watch."

Robert Scheer, the *Playboy* reporter who had been present when Jimmy Carter brought up lust, suggested that Clinton should have said, "I've lived a full-blooded life. So far as I know, no one got hurt and I was always careful to use a condom and I urge others, when the need calls, to do the same."

It would not be the last time America played "What he should have said."

The religious right had pitted family values against the excesses of the sexual revolution. The Clinton moment was soon overshadowed by what journalist Lance Morrow called "one of those vivid, strange electronic moral pageants."

Vice President Dan Quayle, who had himself survived a charge that he had dallied with a lobbyist when his wife came to his defense, saying, "My husband likes golf more than sex," crossed the boundary between the real

world and fantasy. In a speech before the Commonwealth Club in Los Angeles, Quayle invoked the traditional law-and-order themes of the Republican Party. He castigated "indulgence and self-gratification" and an entertainment industry that "glamorized casual sex and drug use."

Warming to the topic, he launched into familiar territory. "The failure of our families is hurting America deeply. . . . Children need love and discipline. They need mothers and fathers. A welfare check is not a husband. The state is not a father. . . . Bearing babies irresponsibly is, simply, wrong."

"It doesn't help matters," continued Quayle, "when prime-time TV has Murphy Brown—a character who supposedly epitomizes today's intelligent, highly paid professional woman—mocking the importance of fathers by bearing a child alone and calling it just another 'lifestyle' choice."

Quayle shot himself in the remote. The nation did not want a TV critic one heartbeat from the presidency. Single mothers and women who wanted to protect their reproductive rights voted Bill Clinton into office.

In 1991, in the wake of the William Kennedy Smith trial, Republican Congresswoman Susan Molinari proposed the Sexual Assault Prevention Act. The bill was a feminist wish list, a catalog of victims' rights that sought to change the rules of justice.

The bill established a new double standard. Women had won protection in rape trials—shield laws kept their names (but not that of the accused rapist) out of the press. A woman's past sexual history could not be introduced by the defense to establish promiscuity. The SAPA embedded into law feminist theories about men as sexual predators. Not only were men rapists and abusers, they were rapists and abusers all the time. Sexual harassers, it was said, exhibited a "pattern and practice of abuse."

The press had turned up a second woman who claimed that Clarence Thomas had harassed her. In the William Kennedy Smith trial, women came forward to say that they too had experienced rough sex at the hands of the defendant. The stories were not heard by the jury.

Molinari's bill gave victims of sexual crime the right of "discovery." A man's past was prologue; prior misconduct would be admissible in court. In 1994 President Clinton signed the bill into law, and, in doing so, laid the foundation of his own ordeal.

Long before it affected courts of law, the new double standard made itself felt in the court of public opinion. The press took the character issue as a permit to probe public figures. A woman who had once worked for Senator Bob Packwood (but had turned up in his opponent's campaign) charged that, years earlier, he had made an unwanted sexual advance. The press uncovered two dozen or more women who said the same thing, that the senator was a serial fondler. Packwood resigned from office.

The American public had forgiven Clinton's past by voting him into office. His political enemies, knowing that scandal has no statute of limitation, that confessions can and will be used against the unwary, saw an opportunity. Conservative Richard Scairfe created a fund for anti-Clinton journalism. It rapidly bore poisonous fruit.

The American Spectator story hit the stands in late December 1993. David Brock reported that several Arkansas state troopers claimed to have provided then Governor Clinton with women on various occasions. At the Excelsior Hotel, on May 8, 1991—five months before announcing his candidacy for president—Clinton had entertained a woman named "Paula" in his hotel room. She had left smiling, and had reportedly told the trooper that she was willing to be Clinton's "regular girlfriend" if he wanted.

On February 11, 1994, the Conservative Political Action Conference introduced Paula Corbin Jones at a press conference. Claiming to be the "Paula" in Brock's story, she said that a trooper had escorted her to Clinton's hotel room. After several minutes of small talk, Clinton had suggested "a type of sex" that would not require her to remove her clothes. The *New York Times* mentioned the press conference in a 250-word story buried on page 8.

Jones began to supply details. She told a reporter for the *Washington Post* that Clinton had dropped his trousers and underwear and asked her to perform oral sex. She'd headed for the door. She had told two women of the encounter when it first happened. The *Spectator* story, she said, had humiliated her.

Although it was too late to file a sexual-harassment claim with the EEOC, her lawyers drafted a "tort of outrage" and filed suit on May 6, 1994. She sought $700,000 from Clinton (she also sued the state trooper for defaming her by suggesting she'd had sex with Clinton). Her new lawyers added to the story. Their client could identify "distinguishing characteristics" in Clinton's "genital area."

Clinton's lawyer called the charge "tabloid trash with a legal caption." James Carville, Clinton's campaign adviser, said simply, "Drag a hundred dollars through a trailer park and there's no telling what you'll find."

Jones's own family depicted her as something of a slut. Her sister told the press that Paula had told her, "Whichever way it went, it smelled of money."

The case of *Jones v. Clinton* moved through the courts. Initially, the mainstream press continued its reticence, or rather, its bend-over-backwards practice of reporting the story about the story. Thomas Plate of the *Los Angeles Times* said, "What the American press is asking is whether Clinton is a serial bonker and if he is, whether that is related to some basic element of character." William A. Henry III pondered, "How to Report the Lewd and Unproven."

Joe Klein, a reporter who had covered the Clinton campaign, realized that the way to cover presidential sex was through fiction. The novel *Primary Colors* by "Anonymous" was a brilliant depiction of the Stantons—a womanizing politician and his wife—that was so thinly veiled, it might as well have been the naked truth. The story ends with the narrator facing a moral choice—can he separate the public man from the private, and work for a sexually impulsive/compulsive candidate out "to make history."

The stories were there for those who were looking.

In 1996 Anne Manning confessed in a *Vanity Fair* article that as a young campaign worker almost twenty years earlier, she had performed oral sex on Newt Gingrich (R-Ga.) when they were both married to other people. According to Manning, Gingrich insisted on oral sex so that, if questioned, he could say "I never slept with her."

The Washington Post explored "the new lust loophole" in an article that revealed how former governor, now Senator Charles Robb of Virginia defended himself against charges that he had committed adultery. In a memo to his staff Robb had explained, "I've always drawn the line on certain conduct. I haven't done anything that I regard as being unfaithful to my wife, and she is the only woman I've loved, slept with or had coital relations with in the 20 years we've been married—I'm still crazy about her." He too could answer a reporter's question with the coy denial, "I haven't slept with anyone, haven't had an affair." But Robb had reportedly accepted nude massages and oral sex from young beauties.

Are we having sex now or what?

The oral-sex loophole was shared by Clinton. One of the troopers involved in the Paula Jones case came forward to say that Clinton had found proof in the Bible that oral sex is not adultery.

Politics had made fellatio a national topic. "Is oral sex adultery?" pondered Ted Koppel on *Nightline.* Experts on the Bible and Talmudic texts opined that the answer wasn't clear.

In May 1997 the Supreme Court voted 9–0 that the president was not above the laws of the land, that Paula Corbin Jones could pursue her lawsuit against Clinton while he was still in office. The Justices believed that his lawyers could handle a sexual-harassment suit in such a way that it would not diminish or distract him from his duties as the president.

Never had the Court been so wrong.

The Jones team, now supplemented by private investigators, pro bono hairdressers, plastic surgeons, and fashion consultants, moved forward. They exercised their rights of discovery, tracking down women (an estimated one hundred victims) alleged to have been propositioned by the president. And they set a date on which to grill Clinton about past indiscretions that might fit the pattern of a sexual predator.

Journalists began to look at the legal merits of the Jones case. Trying to explain why feminists were not outraged by the charges of sexual harassment, as they had been over Anita Hill, Gloria Steinem pointed out that, unlike Thomas, Clinton took no for an answer.

Playboy noted that even if you believed Paula Jones's account, no sexual harassment had occurred. There was no quid quo pro. Even if the invitation was unwanted (about which there was some doubt), it was not repeated. Jones was free to leave and she did. "You can't outlaw sexual interest. If you love a person who doesn't love you, that is unrequited love." The foundation for country-and-western music.

Jones recruited a new legal team, funded by the conservative Rutherford Institute. Interrogatories filed in October 1997 asked Clinton whether he had had or had proposed having sexual relations with any woman other

than his wife during the time he was Attorney General of Arkansas, Governor of Arkansas, and President of the United States. Clinton refused to answer.

In December, the lawyers amended their lawsuit to charge that Clinton had discriminated against Paula Jones by treating favorably women who had accepted his sexual advances. On the list of possible witnesses was a White House intern named Monica Lewinsky.

On January 17, 1998, lawyers interrogated Clinton for six hours.

Judge Susan Webber Wright placed a gag order on the deposition, but within days the nation knew the major details of the inquiry. The president had been asked about Kathleen Willey, a former flight attendant and Clinton fund-raiser, who claimed that he had fondled her when she came to him for a job. The president denied the charge. Then the lawyers asked if he had had sexual relations with Monica Lewinsky.

The most bizarre aspect of the deposition was the definition of sexual relations crafted by Paula Jones's lawyers and Judge Webber Wright: "For the purposes of this deposition, a person engages in sexual relations when the person knowingly engages in or causes: 1) contact with the genitalia, anus, groin, breast, inner thigh, or buttocks of any person with an intent to arouse or gratify the sexual desire of any person."

What kind of definition of sexual relations leaves out the lips and mouth? Tossed out by the judge were definitions that specified "contact between any part of the person's body or an object and the genitals or anus of another person" and "contact between the genitals or anus of the person and any part of another person's body." Contact meant "intentional touching, either directly or through clothing."

Circling the first definition, the president denied having sexual relations with Monica Lewinsky.

Matt Drudge, an Internet gossipmonger, challenged the president's account. *Newsweek* magazine, he said, had known of an affair between Clinton and Lewinsky, but had chosen not to run with it. *Newsweek* editors responded on February 2, 1998, with a cover story by Michael Isikoff and Evan Thomas. Isikoff had been in contact with Linda Tripp, a former White House employee who had taped conversations with Monica Lewinsky, in which the two dis-

cussed Lewinsky's affair with "the big creep." In one tape, the two discussed how many men Monica had slept with. "What about the big creep?" asked Tripp. "No," replied Monica. "There was no penetration."

The dialogue was right out of *Clerks,* except that one of the friends had a tape recorder. Lewinsky told Tripp that she and the president had engaged in phone sex, talking dirty at 2 or 3 A.M. She had performed oral sex on the president. Lewinsky said she was keeping a navy blue dress stained with Clinton's semen. "I'll never wash it again," she'd said. And there were rumors about sex with a cigar.

It seemed that everyone was willing to comment on the allegations. Andrea Dworkin declared that Clinton's "fixation on oral sex—nonreciprocal oral sex—consistently puts women in states of submission to him." Camille Paglia said that Clinton used oral sex "to silence women."

There was no shortage of stereotypes. Lewinsky was the exploited intern, the victim—except that friends told the press she had gone to Washington with her "presidential knee pads." She was an innocent debauched by a powerful man—exept that she was a Beverly Hills girl who grew up in a culture where blow jobs were as casual as handshakes.

The producer/director of *Wag the Dog,* a movie about a president who molests a "Firefly Girl" and tries to cover up the scandal by launching a war against Albania, apologized to the nation. "Hey," wrote Barry Levinson. "We were just kidding."

On January 12, 1998, Tripp played the tapes for Ken Starr, the independent investigator who had inherited the stalled Whitewater probe. Starr had spent four years and $30 million trying to establish that the Clintons had profited from an illegal land deal in their Little Rock days.

Starr asked for and received permission to expand his investigation. The witch-hunt was on. It was not the sex, the nation was told, it was the lying, the obstruction of justice.

It was about the sex.

The president angrily denied the affair, as he had with Gennifer Flowers and every other alleged sex partner. Wagging his finger, he declared, "I did not have sexual relations with that woman—Monica Lewinsky."

Hillary Clinton said the affair reeked of a right-wing conspiracy. Linda Tripp had tried to sell a book on the White House to Lucianne Goldberg, a literary agent who had previously published anti-Clinton trash. Alfred Regnery, whose conservative publishing house had looked at the manuscript, was the Reagan-era Republican who had commissioned Judith Reisman's absurd study of cartoons in men's magazines, and whose political career had ended when the press disclosed that police once found a cache of porn under his bed while investigating a false rape charge filed by his wife. A lawyer for the Rutherford Institute had represented Reisman in an outlandish lawsuit against the Kinsey Institute. (Reisman had charged that Kinsey was a child molester, with a homosexual agenda; that the sexual revolution was a lie.) A group of conservative lawyers known as the Federalist Society worked in the shadows, drafting legal motions, exchanging leads.

Starr was a one-man national inquisition. He papered Washington with subpoenas. We watched the parade of shell-shocked witnesses, grew used to the leaks and abuse of power. When Starr seized the records of the bookstore where Lewinsky had bought a copy of Nicholson Baker's *Vox*—the novel about phone sex—only a few cried outrage. Starr stripped away executive privilege, lawyer-client privilege, mother-daughter privilege, the bond between president and Secret Service bodyguards, between president and friends.

Almost unnoticed, on April 2, 1998, Judge Webber Wright dismissed the Paula Jones lawsuit. While the then governor's behavior may have been "boorish and offensive," she wrote, "the plaintiff has failed to demonstrate that she has a case worthy of submitting to the jury." There was no quid pro quo. Jones had not suffered setbacks at work (indeed she had been given satisfactory job reviews, a cost-of-living increase, and a merit raise). That she had not received flowers on secretary's day in 1992, one of her claims of harm, "does not give rise to a federal cause of action."

It was too little too late.

Through it all, the president's popularity rating remained high. Most Americans, it seemed, thought that the president's sex life was none of our business. When a cartoonist drew a presidential seal with the Playboy Rabbit Head, Hugh Hefner dubbed Clinton "The Playboy President." Here was a politician who

embodied lust, whose libido refused to wilt under the pressures of the office, who was vital, sexual, and competent. But that very insight—that Clinton was the first politician to have come of age in the sexual revolution, to have dabbled with sex, drugs, rock 'n' roll—played to the passions of conservatives fighting a culture war.

It is said that television brought the Vietnam War into our homes. Now, the country witnessed the final chapter of the sexual revolution. According to the Center for Media and Public Affairs, the major networks had given just nineteen stories to the original Gennifer Flowers allegations of adultery. They had given just one story to Paula Jones's first press conference, and nine stories to the filing of her lawsuit. In the week of January 21, 1998, the networks devoted 124 stories to the White House intern. By August 15, they had run more than 596 stories. Oddly, it was a silent movie. Americans saw clips of Monica Lewinsky and Linda Tripp walking to their cars, of White House aides and battalions of lawyers emerging from grand jury interrogations—but it was almost a year into the scandal before the nation heard Monica's voice.

The scandal forced America to confront the often contradictory views it held about sex. News commentators found themselves mouthing words they had never used (reporting that when the president played golf with Vernon Jordan, they had discussed "pussy").

An editorial in *The Washington Post* asked, "What is sex?" The author, Deborah Roffman, an associate editor of the *Journal of Sex Education,* saw the Clinton scandal as a wonderful opportunity to redefine sex. She pointed out that most Americans think only of intercourse when asked such questions as "Is it all right for teenagers to have sex?" Get rid of the foreplay-intercourse-orgasm model and "sex would become characterized not as a single act, but as a wide, open-ended and fluid range of physical intimacies." A more succinct statement of the goal of the sexual revolution cannot be found.

"The real beneficiaries," she said, "would be our children. All sexual behaviors between people, we could explain, are to be considered real, meaningful and significant. All involve real feelings, real decisions and real accountability. There are no ethical 'free spaces' when it comes to being sexually active, whether that activity happens to include sexual intercourse or not."

Jay Leno, host of *The Tonight Show,* had the most honest public reaction to the scandal. The sex was above all ludicrous, Clinton a laughingstock. Hardly a night passed without a shot at the president:

"Al Gore is now just an orgasm away from the presidency."

"I don't want to imply President Clinton is getting a lot of sex on the side, but today Pamela and Tommy Lee asked to see his movie."

"This was the first State of the Union speech that was simulcast on the Spice Channel."

"Mike McCurry said today the president denies ever having an affair with this woman and he is going about his normal daily routine. Denying having an affair with a woman pretty much is Clinton's normal daily routine."

"If Clinton had followed Joycelyn Elder's advice he wouldn't be in trouble now."

"Hillary has hired her own White House intern—Lorena Bobbitt."

"Clinton says he wants to tell the truth, the whole truth and nothing but the truth. The problem is, to Clinton, those are three different things."

Leno's monologue helped the president. It humanized sex, and pulled the rug out from under the stern moralists. Humor is a form of tolerance, a recognition that love and lust regularly include ridiculous behavior.

Compared to the official Inquiry, Leno's nightly monologue was lighthearted and free of prudery. He was everyman, and the laughs shared with six million viewers a night the best indicator of our fin de siècle sophistication. Without it, Clinton and America might not have survived.

On August 17, 1998, Starr's staff set up video cameras in the White House and interrogated President Clinton for four hours. That evening the president told the nation, "I had an inappropriate relationship with Monica Lewinsky."

On September 10, 1998, Starr sent his report to the House Judiciary Committee. Cameras showed agents hauling dozens of sealed boxes into the Capitol. The independent prosecutor charged Clinton with perjury (he had lied about having sexual relations with Monica in his deposition and to the grand jury), with witness tampering (discussing his testimony with Betty Currie), obstructing justice (for having an understanding with Lewinsky to jointly con-

ceal the truth about their relationship), and abusing his authority (misleading staffers; frustrating lawyers by claiming executive privilege). The Starr report was grimly attentive to sexual details, a puritan document worthy of inclusion in a Nathaniel Hawthorne novel.

For more than a century, the sexual revolution had been about the control of sex. Who should judge—the church, the state, the individual? On the morning of September 11, Clinton played the religion card, telling a breakfast prayer meeting, "I don't think there is a fancy way to say that I have sinned. It is important to me that everybody who has been hurt know that the sorrow I feel is genuine—first and most important my family, also my friends, my staff, my cabinet, Monica Lewinsky and her family and the American people. I have asked all for their forgiveness."

Most networks carried the extraordinary speech live. On CNBC Clinton's face was surrounded by the stock market tickers, Dow Jones, and Nasdaq indexes, which twitched like the scrolling lines of a polygraph. The Dow moved upward more than a hundred points within an hour of the talk. God was silent, but the market had forgiven Clinton.

On that same Friday the House Judiciary Committee voted to release the 445-page Starr report on the Internet. Newspapers and magazines reprinted the report, or carefully edited portions. The feeding frenzy continued. The reaction came in two waves. Talking heads in Washington discussed, in sober tones, recklessly destructive behavior, impeachable offenses, the death of outrage, and, oh yes, sex.

The Starr report was about sex—oral sex without climax, oral sex with climax, the stained blue dress, sex with cigars, phone sex, and footnote sex. A level of sexual detail that once landed works by artists such as Theodore Dreiser, Edmund Wilson, and D. H. Lawrence in court now was part of the Congressional Record. America knew the numbers: He had touched her bare breast nine times, stimulated her genitals four times, brought her to orgasm three times, once to multiple orgasm. Footnote 209 alleged oral/anal sex. The president had masturbated during phone sex. Talk about a wake-up call.

Some read the report and saw a touching portrait of a man whose sexual world had been reduced to a space no larger than a doorway, who found erotic refuge in the electronic whisper of phone sex, who found himself in a world where it was impossible to consummate passion with real sex. His denial was the stuff of the adulterer discovered, not perjury. Whatever the feminists could say about the imbalance of power, this was a man who was captivated by a glimpse of thong underwear. The leader of the Western world was a fool for love.

There were some who called the report pornographic, that the very Congress that had voted to cleanse the Internet of porn had itself despoiled cyberspace. But porn is meant to arouse. The style of the Starr report was more conducive to loathing. "The explicit, but coldly clinical report" of a "furtive sex drama" was *Time*'s appraisal. "Sanctimonyfest," said columnist Molly Ivins. The Starr report was an airless room. The formula was as old as Anthony Comstock; you were allowed to share the salacious details of sexual scandal and be aroused—as long as the emotion aroused was prudish, not prurient; punitive, not pleasure-bent.

For George Will, a *Newsweek* columnist who evidently has never masturbated, the question for the country was, "Should this man, who is seen in Starr's report masturbating in the West Wing after an episode with the intern, be seen for 28 more months in the presidency?"

And there it was. The Starr report had obliterated the walls that make good neighbors. In the classic Puritan worldview, the moral agenda of the community imposed itself completely on the individual. Every detail of lust was subject to scrutiny and loathing.

For more than a hundred years, America had evolved away from that invasive, totalitarian code, creating and protecting a space for individual pleasure, individual freedom. The Starr report presumed that privacy was an illusion, or worse—that it was a breeding ground for conspiracy. It exhumed e-mail, recorded private conversations, and forced Monica Lewinsky to divulge the most intimate details of her life. It was an act of public shaming unprecedented in America.

Ken Starr was Cotton Mather reincarnate, a Christian champion in the grand tradition of Comstock and Keating. "Who better to bring Bill Clinton to justice," the *Wall Street Journal* wrote, "than a hymn-singing son of a fundamentalist minister?"

Monicagate was a culmination of something—the bloodletting that follows any revolution, the final conflict, a sexual Armageddon. Margaret Carlson, resident scold for *Time,* had written months earlier, "We've been building to this sexual peak for decades, through scandals concerning bold-type names from stage, screen and sports, Congressmen, Senators and presidential candidates. And now, live from the capital, it's the President. As the ultimate celebrity trial goes forward, there's little hope of truth and every chance we'll all be diminished."

René Girard, literature and religion scholar at Stanford, told Joe Klein that Clinton was a classic scapegoat. "In Greek mythology, the scapegoat is never wrongfully accused. But he is always magical. He has the capacity to relieve the burden of guilt from a society. This seems to be a basic human impulse. There is a need to consume scapegoats. It is the way tension is relieved and change takes place."

Clinton, wrote Klein, "is all that his accusers loathe most about themselves . . . the guilt about the sexual excesses of the past quarter century, the self-hatred of a generation reared in prosperity and never tested by adversity."

Republican Congressman Bob Barr, an enemy of Clinton, known for ranting about the "flames of hedonism, the flames of narcissism, the flames of self-centered morality" of the permissive society, now called for impeachment.

Ronald Brownstein, in the *Los Angeles Times,* declared, "With its unmistakable tone of disgust, Starr's manifesto is not only the opening bell in a battle over impeachment but a resounding salvo in the culture wars that have raged for a quarter century about the impact of the baby boom generation on American morals."

The House Judiciary voted to release the tape of Clinton's deposition. The nation watched four hours of legal jousting. Clinton steadfastly defended his admission of inappropriate conduct as sufficient. The definition concocted by Paula Jones's legal team was bizarre, and his denial was legally true, if absurd. It was not his job to do the work for the opposing counsel. His anger became our anger. His approval rating rose to extraordinary heights.

Salon magazine, an Internet publication, revealed that Henry Hyde, the Republican who had taken over the impeachment inquiry, had himself had an adulterous affair—and, indeed, had broken up his lover's marriage. Hyde dismissed it as a youthful indiscretion. He was forty-one at the time. Dan Burton (R-Indiana) and Helen Chenoweth (R-Idaho), both Clinton opponents, con-

fessed that they had had extramarital affairs. Columnists began to question what we required of a public figure, where the inquisition might lead. *USA Today* reported that an "air of Sexual McCarthyism chills the nation's capital."

Hustler publisher Larry Flynt offered a million-dollar bounty for anyone who could prove adultery in high places. If Ken Starr could squander the taxpayer's money on a sexual witch-hunt, why couldn't a private citizen squander as well?

Voters in the November election expressed their dissatisfaction with Republican moralizers. When the GOP lost five seats, Newt Gingrich stepped down as Speaker of the House and strategist for the party.

A hearing would only reveal the true sin of America—the hypocrisy of self-appointed moral guardians. Still the Republicans moved forward. When they voted, they would vote with stones. The House Judiciary Committee split 21–19 along party lines to move the articles of impeachment to the entire House. It's not the sex, they said, it's the lying.

The nation watched Republicans who had themselves cheated on wives and broken marital oaths make speeches about sacred honor, the rule of law, about what to tell the children, about the meaning of oaths, about truth and lies and the ability to lead. We listened to Democrats discuss the triviality of the charges, the Founding Fathers' intent when they first drafted the words "High crimes and misdemeanors."

It was moral karaoke, practiced indignation, the inspired reading of a Starr-scripted score. It was the great American art of hypocrisy played large. On the day of the vote, Robert Livingston, a Louisiana Republican slated to fill the Speaker of the House slot, stunned his peers. Livingston admitted to a series of marital infidelities. He urged impeachment, then offered his resignation as a model for the president. Larry Flynt's million-dollar bounty had claimed its first victim.

Along strict party lines, the House voted 228 to 206 to impeach Clinton for perjury in his grand jury testimony, 221 to 212 for obstruction of justice. The air inside the beltway was bitter, brittle, and bipartisan. Clinton's response to the vote (and to Livingston's resignation) was a simple statement: "We must stop the politics of personal destruction."

On February 9, 1999, Henry Hyde, acting as manager of the House prosecution team, made his closing argument before the Senate. "I wonder if after

this culture war is over," he warned, "an America will survive that's worth fighting to defend."

The Senate acquitted Clinton of perjury (55–45) and obstruction of justice (50–50). That vote, more than any other measure, became the lasting battlefield statistic of the sexual revolution. Are we having sex yet? It was almost too close to call.

The sexual revolution had begun as a clash of personalities. Self-appointed champions grappled to control the sex lives of millions. Anthony Comstock vs. Margaret Sanger. Will Hays and the Legion of Decency vs. Hollywood. Charles Keating and the CDL vs. Lenny Bruce. The Meese Commission vs. *Playboy*. Reverend Donald Wildmon and the National Federation for Decency vs. television. Ken Starr and the religious right vs. Bill Clinton. Like two actors fighting atop a speeding train, the conflict was fascinating. But the train moved on and we returned to everyday life.

In the wake of the vote, Paul Weyrich, president of the conservative Free Congress Foundation, threw in the towel. "I no longer believe that there is a moral majority," Weyrich told followers. "I do not believe that a majority of Americans actually shares our values. The culture we are living in becomes an ever wider sewer. In truth, I think we are caught up in a cultural collapse of historic proportions, a collapse so great that it simply overwhelms politics."

The future of sex had arrived, would continue to arrive, propelled by forces outside the political arena. Each attempted puritan coup was defeated by the city electric, by technology that entertained and educated Americans, providing free and open discussions of sex. No longer could a prosecutor rise and condemn an act, with the accusation that good citizens don't do such things. From Edison's kinetoscope, which had given us the nickel image of the *Kiss,* to today's seemingly unlimited Internet potential, Americans have increasingly made sex visible. The electric lights that had taken sex out of the shadows now provided not a sewer, but a pulsing, sensuous, sane environment, a carnal consensus for the millennium.

TIME CAPSULE

Raw Data From the 1990s

FIRST APPEARANCES

Norplant. NC-17. Iron John. Same-sex marriage. *Men Are From Mars, Women Are From Venus.* World Wide Web. Netscape. Yahoo. Amazon.com. www. Playboy.com. Hubble Telescope. Tai Bo. Harvesting sperm. Dream Team. First female Attorney General. First female Secretary of State. DVD. Female condom. Morning-after pill. Protease inhibitor cocktails. Hepatitis C. Viagra. Women in combat. *The Vagina Monologues.* Generation X.

WHO'S HOT

Bill Clinton. Monica Lewinsky. Bill Gates. Helen Hunt. Jack Nicholson. Harrison Ford. Bruce Willis. Madonna. Demi Moore. Tom Hanks. Tom Cruise. Nicole Kidman. Cindy Crawford. Katarina Witt. Pamela Anderson. Jenny McCarthy. Neve Campbell. Jay Leno. Hef. Xena. Calista Flockhart. Jennifer Lopez. Liv Tyler. Steven Spielberg. George Lucas. Drew Barrymore. Cameron Diaz. Jim Carrey. Matt Damon. Ben Affleck. The Beastie Boys. The Spice Girls. Jerry Seinfeld. Will Smith. Adam Sandler. Mel Gibson. Janet Jackson. Alanis Morissette. Courtney Love. Leonardo DiCaprio. George Clooney. Kevin Costner. Lauryn Hill. Camille Paglia. Princess Di. Evander Holyfield. Oscar De La Hoya. Michael Jordan. Dennis Rodman. Mark McGwire. Sammy Sosa.

WHO'S CAUGHT

Pee-wee Herman. Hugh Grant. Eddie Murphy. George Michaels. Frank Gifford. Marv Albert. Charlie Sheen. Robert Livingston. Dan Burton. Helen Chenoweth. Henry Hyde. Bill Clinton.

CANDID CAMERA

Rob Lowe. Pamela Anderson. Tommy Lee. Tonya Harding.

WE, THE PEOPLE

Population of the United States in 1990: 249 million. Population of the United States in 1999: 271 million.

Percent of M.B.A. degrees received by women in 1970: 4; percent received by women in 1999: 40. Percent of law degrees received by women in 1970: 5; percent received in 1999: 40. In 1995 percent of senior managers at Fortune 1000 industrial and Fortune 500 service companies who are women: 5.

In 1998 amount paid by Mitsubishi Motors to women on assembly line to settle sexual-harassment suit: $34 million.

FAMILY VALUES

In 1970 percentage of American households occupied by traditional family (i.e., married couple with kids): 40. In 1998, percentage of American households occupied by traditional family: 25. In 1970 percentage of American households occupied by unrelated roommates (gay couples and unmarried heterosexuals living together): 2. In 1998 percentage of households occupied by unrelated roommates: 5.

VIAGRA

Estimated number of Viagra prescriptions filled in first year (1998): 4 million. Number of men who died while using Viagra during first four months it was on market: 69. Amount sought by Pentagon to provide Viagra to military personnel: $50 million. How many F-15 Air Force fighters $50 million would buy: 3; how many Army Blackhawk helicopters: 15. Slang term for Viagra: poke.

LEATHER

Number of organizations devoted to S&M in 1971: 1. According to the National Leather Association, the number of S&M support groups and social clubs in 1997: more than 400. Number of hits per month logged on website devoted to gay male S&M activists: 200,000. Cost of a custom- made whip made of bull, moose, or elk hide by Janette Heartwood: $300. Name of the nation's first S&M theme restaurant: La Nouvelle Justine; clever review: "Dinner and a dominatrix"; cost for one serving of Verbal Abuse and Spanking: $20.

QUEER STUDIES

Date of first American academic conference on gay and lesbian studies: 1987; number of participants: 200; number of participants in 1992: 2,000; number of papers presented in 1992: 200.

THE STARR REPORT

Number of pages in the Starr report: 445. Number of words: 119,059. Number of times "oral sex" is mentioned: 92. Number of times "breasts" are mentioned: 62. Number of times the word "genitalia" is used: 39. Number of references to phone sex: 29. Number of times "cigar" is mentioned: 27. Number of times "semen" is mentioned: 19. Number of times "bra" is mentioned: 8. Number of times "thong" is mentioned: 1.

MONEY MATTERS

Gross National Product in 1980: $5.6 trillion. Gross National Product in 1998: $8.5 trillion. National debt in 1990: $3.2 trillion. National surplus for fiscal year ending Sept. 30, 1998: $69.246 billion.

THAT'S ENTERTAINMENT

Amount of money grossed in the United States by the film *Titanic*: $580 million.

Number of hits on *Playboy*'s free website per day: 5 million.

Number of hard-core videos produced in 1996: 8,000; number of new titles per week: 150. Number of X-rated rentals in 1985: 75 million; in 1996: 665 million.

Number of Americans who engage in phone sex each night: 250,000; length of average call in minutes: 6 to 8. Amount Americans spent on phone sex in 1996: $750 million to $1 billion.

Total Americans spent on hard-core videos, peep shows, live sex acts, adult cable programing, sexual devices, computer porn, and sex magazines in 1998: $8 billion.

IS IT SEX?

How Webster's defines "sex act": *sexual intercourse.* How Webster's defines "sexual relations": *coitus.* How Webster's defines "coitus": *physical union of*

male and female genitalia accompanied by rhythmic movements leading to the ejaculation of semen from the penis into the female reproductive tract; also intercourse. How Webster's defines "orgasm": *an intense or paroxysmal emotional excitement. The climax of sexual excitment typically occurring toward the end of coitus; specifically: the sudden release of tensions developed during coitus, usually accompanied in the male by ejaculation.*

FINAL APPEARANCES

1990: Greta Garbo. Paulette Goddard. Ava Gardner. Keith Haring. Leonard Bernstein. Sammy Davis, Jr. 1991: Frank Capra. Miles Davis. Dr. Seuss. 1992: Marlene Dietrich. Alex Haley. Benny Hill. Sam Kinison. 1993: Thurgood Marshall. Myrna Loy. Lillian Gish. Rudolf Nureyev. Federico Fellini. Arthur Ashe. 1994: Richard Nixon, Jackie Kennedy Onassis. Cab Calloway. John Candy. 1996: Timothy Leary. 1997: Allen Ginsberg. William Brennan. 1998: Frank Sinatra. Princess Di. Dr. Mary Calderone. 1999: Stanley Kubrick. Harry A. Blackmun. Mel Torme. Shel Silverstein.

EPILOGUE

For the past three years I have experienced erotic time travel, surrounding myself with words, photographs and film. I told friends that I was writing a history of the sexual revolution, that I couldn't wait to see how it turned out.

The project changed the way I looked at the world. Ours is not a culture that commemorates the battles of the sexual revolution. At several points during the project I volunteered to conduct walking tours of New York, Washington, San Francisco—looking for sites that deserved bronze plaques or statues.

America's sexual history is embedded in the landscape. In New York I could stand on a street corner near Union Square and look from the building that once housed the office of the ACLU (where lawyer Morris Ernst fought the battles that allowed Americans to import both James Joyce's *Ulysses* and the latest in Japanese pessaries) to the studio where Irving Klaw photographed Betty Page. In Greenwich Village I could walk from the home of Edna St. Vincent Millay ("Lust was there and nights not spent alone") past labor halls where Emma Goldman preached free love and anarchy to the courthouse where America watched the first trial of the century. On Times Square I saw a billboard promoting *Ragtime,* a musical based on the Stanford White-Evelyn Nesbit-Harry K. Thaw triangle. The story still fascinates America. I also savored an exhibit that showed the evolution of a single building. The New Amsterdam theater had been home to the Ziegfeld Follies, a temple devoted to the glorification of the American girl. The Depression had bankrupted the great showman, and the New Amsterdam had been reduced to a burlesque house. It followed the decline of 42nd Street into a row of grind-house movie theaters, then X-rated triple-bill porn parlors. Now the building was the Times Square den of Disney's *Lion King.*

Mayor Rudolph Giuliani had launched a major clean-up of New York City with an ordinance that forbid adult enterprises operating within 500 yards of a church or school. As I walked past Cooper Union, where Victoria Woodhull had lectured on free love, I passed a street vendor selling pornography out of a push-cart. The slow-paced version of the information highway.

In Washington, the tour started at Union Station, built at the turn of the century when Americans traveled to the capital by rail. The building is guarded by statues of Roman centurions standing behind shields. The sculptor had originally created naked warriors, but city fathers demanded modesty panels. Apparently, the public had to be protected from the notion that their leaders had private parts.

The city had crushed sexuality under vast marble buildings. The Ronald Reagan Building stands where once flourished a red-light district, and where, in the seventies, you could get a burger and a massage on your lunch hour. A guest on the tour pointed out that J. Edgar Hoover's old office had looked out on the city's leading gay bar. I toyed with the idea of creating public monuments—a fiberglass Fanny Fatal splashing through the reflecting pool. A giant Bob Packwood standing beside a marble Xerox machine. A DO NOT DISTURB sign in front of the Bill of Rights. A can of Coke with a barbed-wire pubic hair in front of the EEOC. That tour was one week before William Jefferson Clinton gave his deposition in the Paula Jones lawsuit, a media minute before Monica Lewinsky's name surfaced on the *Drudge Report*.

In San Francisco, the city does commemorate landmarks of the sexual revolution. The nightclub where Sally Rand danced naked in the thirties has been lovingly restored. It is the Great American Music Hall, just down the street from the Mitchell brothers' O'Farrell Theater, where crowds flock to see X-rated films and X-rated stars perform in private booths. The Behind the Green Door massage parlor, just off Union Square, still operates, although it shares its lease with a shoe-repair shop. Outside the Condor, a bronze plaque tells passersby that this was where it all started, where the world watched Carol Doda's breasts swell from a 34- to a 44-inch monument. Once again, I could stand on a single corner and glance from the City Lights bookstore, where the Beats laid the seeds of the counterculture, to a block of nightclubs like the Hungry i, where hip subversives mocked the conformity of the fifties. The

Condor is now a sports bar, which may say more about the outcome of the sexual revolution than any other landmark.

In Los Angeles, the Pussycat Theater, where *Deep Throat* had played thirteen times a day for ten years, is now the Tomcat, devoted to all-gay fare. On the sidewalk outside, the foot- and handprints of John Holmes, Linda Lovelace, Marilyn Chambers, and Harry Reems are immortalized in concrete, although those are the parts of a porn star's anatomy the public is least interested in. The Pleasure Chest is still just across the street. Both survivors of the seventies are in decline, replaced by the world of X-rated videos and catalog erotica. Ciro's, where Paulette Goddard and Anatole Litvak grappled under a table during World War II, where Lili St. Cyr was paid $7,500 a week to bathe naked in a see-through bathtub filled with soap bubbles, is now the Comedy Store, breeding ground for stand-up sex historians.

Someone still places fresh flowers on the grave of Virginia Rappe, the actress who died after partying with Fatty Arbuckle in San Francisco in 1921. Near the tomb of Cecille B. DeMille, the filmmaker who made all those biblical orgy epics, is a grave reserved for two men. It says simply "Companions."

We are no closer to understanding sex now than we were a hundred years ago. Walter Lippmann suggested that lust has a thousand avenues. It is woven into the fabric of our lives, in ways that slide and slither, or rub us raw. Every new technology, from the telephone to the Internet, has added a thread to the weave. We will never go back. We have, in one way, become a single sexual culture—nothing is hidden. Both sides, the liberated and the censorious, react to the same Madonna video, one with arousal, one with loathing.

We have expanded forever the repertoire of private acts between consenting adults. There is no single way to be a man, no single way to be a woman. Sex has survived attempts to shackle it with adjectives like "degrading" or "dehumanizing." The sexual revolution was indeed a war of words, fought on newsstands and in television studios across the country. In its way, the Magazine Publishers Association recognized this when it gave lifetime achievement awards to both Hugh Hefner and Gloria Steinem in 1998, inducting them into the MPA Hall of Fame.

The battle to control sex careens into the next century. Moving from the bully pulpit to the threat of boycotts, the religious right resists research in birth control and abortion drugs. Right to Life groups call RU-486 "the French death pill." The Vatican calls it "the pill of Cain: the monster that cynically kills its brother." That debate has moved beyond words. The more zealous have fired bullets into the homes of abortion providers and placed bombs in clinics. They have resisted extending common, everyday rights to sexual minorities, trying to protect the institution of marriage by eliminating all other alternatives. They have beaten, burned, and hung from fences those who disagree.

As they have for more than a hundred years, different factions seize the tools of government and try to create a lasting canon of sex in their own likeness. Blue laws against sodomy nestle next to codes that criminalize flirtation as sexual harassment, laws that prohibit indecency stand next to the First Amendment.

As they have for more than a hundred years, special-interest groups from the Society for the Suppression of Vice to Charles Keating's CDL to Jerry Falwell's Moral Majority and the Rutherford Institute have targeted individuals. They have used panic and the blunt instrument of fear to shape public ideas of sexual propriety. Scandal, the freeze-frame of the information age, nearly toppled a presidency.

There have been those who moralized about sex and those who treated it as a medical problem. There are those who let disease run rampant as the wages of sin, and those who fight to find cures, to keep sex free of crippling consequence.

Pinned to my bulletin board is a headline from the August 15, 1998, *Bay Area Reporter* : NO OBITS.

For the first time in seventeen years, the gay weekly, based in San Francisco, contained no death notices for AIDS victims. At the height of the epidemic the paper had run a dozen obituaries a week.

The news was repeated in official form in October 1998 when the Centers for Disease Control reported that AIDS deaths had plummeted by more than half. While no cure for HIV is in sight, doctors have found that a cocktail of protease inhibitors could block reproduction of the virus. In America, the epidemic is slowing down: In the mid-eighties San Francisco doctors had re-

corded 8,000 new infections a year; the figure is now down to 600. This is good news to carry into the next century.

In 1998 Pfizer introduced Viagra, a pill initially offered as a cure for impotence and erection difficulties. The pill affects the tide of blood that accompanies arousal: It makes for firmer, longer-lasting erections. It was immediately perceived as a recreational drug, D. H. Lawrence in a bottle.

"The penis is back," proclaimed an editorial in *Playboy*. "The sixties put the clitoris stage center. The penis had been symbolic of male oppression. After 30 years of clitoral tyranny, millions of hours of cunnilingus and battery assisted orgasm, Viagra offered a return to phallic-centered sex, the great god Cock."

There was surprisingly little controversy surrounding Viagra. Bob Dole, who had recently run for president, became a spokesperson for erectile dysfunction.

Viagra is the first of a series of quality-of-life drugs. In the pipeline are laboratory concoctions that purport to increase female response, gels that aid arousal. There are scientists who think increased pleasure is a worthy goal, not an ethical failure. This, too, is good news.

America will forever be divided into two warring camps. There are those who say, "If you do not control sex, sex controls you." They see in the glimpse of an ankle or an exposed breast the entire universe of sex, the chaos, the risk, the temptation, the loss of self. They look at the world through a keyhole, and what lies beyond terrifies. It is adult. It is demonic. It is not the safety of the untempted, the unaware. For a hundred years and more the censors have tried to eliminate the sexual from the environment in the name of protecting women and children. Anthony Comstock plucking *September Morn* from a store window was moral father of the woman who demanded that a *Where's Waldo* puzzle be removed because you could see part of a woman's breast on a beach scene. Wrath has a way of being undermined by the ridiculous. Witness the current controversy surrounding Jerry Falwell's charge that a certain purple Teletubby clutching a purse is gay and to be avoided.

Conservatives despise the sexual revolution, viewing it as the assault on a single sacred model of sex: that of intercourse within marriage, an act bound by consequence and responsibility. An act done—à la the animals on the ark— by couples.

We have witnessed a hundred years of alternatives, from commercial sex to premarital sex, from solo sex to sex with multiple partners to sex with toys and via technologies. Sex exists outside of the private, intimate coupling of husband and wife, in a thousand different forms, almost all of them fascinating. And not, if one reads the lesson of history, mutually exclusive.

There are those who embrace sex, who play with the danger, who pass through the keyhole into a universe of pleasure. They swim laps in the "sea of provocation" and consider "genital commotion" to be the most human of vital signs. For them, sex is a form of enthusiasm, a personal playground, a team sport, a wellspring of intimacy, chuckles, and ecstasy.

They are the victors in the sexual revolution.

ACKNOWLEDGMENTS

This book is a *Playboy* product, in the best sense of the word. Hugh Hefner conceived the project. Arthur Kretchmer, editorial director, asked me to find a writer. It was a short list of one.

Hefner edited the manuscript with a greed for understanding that made the final version clear to all. He also was the world's only seven-figure researcher, sending along everything from old issues of *Yank* to videotapes of interviews to film clips from documentaries.

Barbara Nellis offered sound guidance and a quick reality check on rough drafts. Carolyn Brown gave me a short course in organizing background material at the outset of the project. Carol Keeley read everything that I read and fact-checked everything I wrote. She made sure that every word was true (and provided the notes that are a record of the oft-chaotic scholarship). Lee Froehlich raked through the text, cleaning language that was careless or clichéd. Howard Shapiro vetted the manuscript and guarded contracts. Kerig Pope showcased the material when it ran in the magazine, and his sources provided the artwork that graces this edition. Peter Glasberg supervised the electronic dialogue between Los Angeles and Chicago. Adonis San Juan, Mary Yurkovic, and Jason Simons captured and preserved the images on computer; Elizabeth Georgiou granted access to *Playboy*'s photo library; Marcia Terrones and Diane Griffin supervised rights and permissions. Natalie Bortoli and Antonia Simigis, interns on loan from Northwestern University, walked point, bringing cartons of articles and books. (They also worked with Chip Rowe, Josh Green, and Terry Glover on what I came to view as my day job—putting out *The Playboy Forum* each month.)

I'm grateful for the sentries—the librarians at the Kinsey Institute, Planned Parenthood, SIECUS, the National Archive, the Morris Collection of Southern Illinois University at Carbondale, Northwestern University, the

Evanston Public Library—who guard the treasure of our sexual history. I'm proud to say that almost none of this manuscript was aided by the Internet. Rather, with the help of Mark Duran in *Playboy*'s library, I made use of an old technology, inter-library loans, that let me be overdue in fifty states instead of one.

Outside of *Playboy,* I would like to thank Ted Fishman for feedback over countless lunches; Bruce Cohen, Seth Kamil, and Eric Wakin for organizing the walking tours of New York, Washington, San Francisco, and Los Angeles.

Thanks to Sarah Lazin for selling the idea, Morgan Entrekin for publishing it, and Brendan Cahill for the editorial guidance that turned a magazine series into a book.

Finally, I am in debt to my wife, Susan, who kept our family intact while I filled the house with books and papers, and to my children, Sierra and Conor, for always bringing me back to the moment. Thanks.

SOURCES

Magazines don't usually publish footnotes. I tried to work my sources into the text of the articles. Here are additional notes.

Before starting on a given decade I would turn to the appropriate volume of Time-Life's *This Fabulous Century.* The combination of artifact and commentary was a true visual feast, akin to rummaging around a grandparent's attic. Turner Publishing's *Our Times: The Illustrated History of the 20th Century* (1995), James Trager's *The Women's Chronology* (1994), and Dorling Kindersley's *Chronicle of America* (1997) helped establish a timeline for each decade.

Next, I would read accounts of the period, books that had been written while events were still fresh in the mind. More often than not, these volumes were the work of journalists, not historians. Mark Sullivan's audacious *Our Times,* a six-volume attempt to capture the first twenty-five years of the century, was one such time machine.

Isolating the sexual was the real challenge. Historians have only just started to examine sex. *Intimate Matters: A History of Sexuality in America* (1988) by John D'Emilio and Estelle Freedman proved that it could be done. Their bibliography provided an excellent map of the territory.

CHAPTER ONE: THE CITY ELECTRIC

For the city electric I turned to Lewis A. Erenberg's *Stepping Out: New York Nightlife and the Transformation of American Culture 1890–1930* (1981) and David Nasaw's *Going Out: The Rise and Fall of Public Amusements* (1993). They proved history could be fun. Theordore Dreiser's *Sister Carrie* (1900) offered social realism as a counterpoint to the likes of Mrs. Burton Kingsland, whose column on "Good Manners and Good Form" in the January 1908 *Ladies' Home Journal* attempted to instill propriety in young women.

Each decade had its own vigilant guard. Kathy Peiss's essay "Charity Girls and City Pleasures" in *Powers of Desire: The Politics of Sexuality* (1983), edited by Ann Snitow, Christine Stansell, and Sharon Thompson, alerted me to the odd creature known as the vice investigator. When women change, someone pays attention. The Committee of Fifteen's *Report on the Social Evil of 1910* was an earnest look at the sporting life in New York and the rise of a philosophy of hedonism. Joanne Meyerowitz's *Women Adrift: Independent Wage Earners in Chicago: 1880–1930* (1988) provided background for the period.

Anthony Comstock: Roundsman of the Lord (1927) by Heywood Broun and Margaret Leech is a thorough biography of America's own Grand Inquisitor. D. M. Bennett's *Anthony Comstock: His Career of Cruelty and Crime* (1878) and John Money's *The Destroying Angel* (1985) yielded additional details. Comstock's own words were as riveting as they were delusional, whether in *Traps for the Young* (1883/1967) or his annual reports to the New York Society for the Suppression of Vice. The Northwestern University library has a volume of Comstock's collected reports, from 1875–1915. I found examples of turn-of-the-century erotica in Paul Aratow's *100 Years of Erotica: A Photographic Portfolio of Mainstream American Subculture from 1845–1945* (1973) and G .G. Stoctay's *America's Erotic Past: 1868–1940.* (1973). The Kinsey Institute yielded a copy of the privately printed 1904 volume, *The Modern Eveline: Or The Adventures of a Young Lady of Quality Who Was Never Found Out.*

Piecing together the story of Ida Craddock was the first pleasure of this project. Edward de Grazia's *Girls Lean Back Everywhere* (1992) quoted fragments of her marriage manual, *Advice to a Bridegroom.* The Morris Library Special Collections at Southern Illinois University at Carbondale had a complete copy her *The Wedding Night.* Taylor Stoehr's excellent *Free Love in America: A Documentary History* (1979) preserved Craddock's *Right Marital Living* as well as the correspondence between Craddock and Comstock. That section is called, quite rightly, "Letters of a Martyr." Both de Grazia's and Stoehr's works belong in the core curriculum for any study of sex in America, as a story is best told in the words of its participants.

For background on the first sex trial of the century I turned to Michael MacDonald Mooney's *Evelyn Nesbit and Stanford White: Love and Death in the Gilded Age* (1976) and Frederick Lewis's *Glamorous Sinners* (1932). Paula

Uruburu generously provided details from her forthcoming biography of Nesbit. In addition, the *American Experience* series of documentaries on PBS had an excellent segment devoted to Stanford White.

For the background on white slavery, I relied almost completely on David J. Langum's *Crossing Over the Line: Legislating Morality and the Mann Act* (1994). Langum follows the evolution of a single law through the century, chronicling the creation of a national sex police (what eventually became the FBI) and its subsequent abuses. If your only tool is a hammer, every problem looks like a nail. If your only tool is the Mann Act, every dissent looks like a sex crime. This is another book that belongs in the core curriculum.

For background on turn-of-the-century prostitution I walked the pages of *City of Eros: New York City, Prostitution and the Commercialization of Sex, 1790–1920* (1992) by Timothy J. Gilfoyle; *Storyville, New Orleans: Being an Authentic, Illustrated Account of the Notorious Red-Light District* (1974) by Al Rose; *The Lost Sisterhood: Prostitution in America, 1900–1918* (1982) by Ruth Rosen; *Come Into My Parlor: A Biography of the Aristocratic Everleigh Sisters* (1934) by Charles Washburn; and *The American Way of Sex* (1978) by Bradley Smith. Also, of use was a facsimile of a tourist souvenirs dating from 1936 called *The Blue Book: A Bibliographical Attempt to Describe the Guide Books to the Houses of Ill Fame in New Orleans as they were Published There. Together with some pertinent and illuminating remarks pertaining to the establishments and courtesans as well as to Harlotry in general in New Orleans.* Gilfoyle recounted a story about Anthony Comstock that still fascinates me. Comstock, in 1878, visited a Greene Street brothel to watch a show called *Busy Fleas.* He watched naked women perform on a stage, pouring beer over each other, licking and sucking each other's genitals, inserting cigars into unexpected orifices, feigning intercourse. Comstock arrested the performers, but Gilfoyle suggests the event was isolated. Comstock gave up on policing real behavior, perhaps because it was a turf war—other vice societies existed that wanted to police prostitution. There's a sense that he thought prostitutes represented the terminal conditon of vice and were beyond salvation, were subhuman compared to the innocent. Whatever the motivation, Comstock provided the blueprint for a century of censors. The formula: Attack the image, not the behavior.

D'Emilio and Freedman provided guidance on the crusades against prostitution and venereal disease. *Social Diseases and Marriage: Social Prophylaxis*

(1904) by Prince A. Morrow was an early voice of sanity. An even better example of courage was the contribution of Edward Bok, a magazine editor who defied his audience. The story is retold in his autobiography, *The Americanization of Edward Bok*. "The Editor's Personal Page" in the September 1908 *Ladies' Home Journal* was the fulcrum by which he sought to move America. See also "Why Didn't My Parents Tell Me?," an *LHJ* article by Dr. William Lee.

What we told our children about sex was the theme of Patricia J. Campbell's *Sex Education Books for Young Adults 1892–1979* (1979). Finding surviving examples of such fare was a daunting task—libraries either never stocked sex manuals or discarded such when the advice became outmoded or embarrassing. Campbell's frank descriptions of antimasturbation sermons, her discerning eye for what was not included in anatomy diagrams (America misplaced the clitoris for fifty years) put her, too, in the core curriculum. Similarly, Hoag Levins's *American Sex Machines* (1996) and Rachel Maines's *The Technology of Orgasm: Hysteria, the Vibrator and Women's Sexual Satisfaction* (1999) give a glimpse of artifacts long neglected by history. A friend sent a copy of Maines's original 1989 article, titled "Socially Camouflaged Technologies: The Case of the Electromechanical Vibrator," published in *Technology and Society*. That research cost Maines her job at Clarkson University. She persevered and expanded the paper into a delightful book.

Edward Brecher called Havelock Ellis "The First of the Yea-Sayers." Brecher's *The Sex Researchers* (1969) framed my account of Ellis's contribution. I also relied on Paul Robinson's *The Modernization of Sex: Havelock Ellis, Alfred Kinsey, William Masters and Virginia Johnson* (1976) and Nathan G. Hale's contrarian *Freud and the Americans: The Beginnings of Psychoanalysis in the United States, 1876–1917* (1971), as well as the discussion in *Intimate Matters*. The Deering Collection at Northwestern allowed access to Ellis's *Studies in the Psychology of Sex* (published as seven volumes between 1897 and 1928, collected and revised in four volumes in 1936).

CHAPTER TWO: THE END OF INNOCENCE

F. Scott Fitzgerald published *This Side of Paradise* in 1920, but the coming of age he described occurred in the teens. Similarly, Malcolm Cowley's literary odyssey of the twenties, *Exile's Return,* was published in 1934, and covered his boyhood dreams of mistresses in New York. It was a time for first impres-

sions. The background on Alberto Vargas was taken from his autobiography *Vargas* (1978), from the Taschen collection of his art, *Vargas* (1993), and a profile in *Cigar Aficionado.*

Stepping Out and *Going Out* had prepared me for the dance craze, quoting newspaper articles celebrating "The Revolt of Decency" and describing admonitory posters from dance halls. The Kinsey Institute yielded a volume that combined Tom Faulkner's *From the Ball Room to Hell* (1894) with *The Lure of the Dance* (1916). It also had a copy of Polly Adler's *A House Is Not a Home* (1953) personally autographed and dedicated to Dr. Kinsey "from one research worker to another." The *Report of the Senate Vice Committee* (1916) on the dangers of the tango showed that Illinois politicians have not changed over the years. Vice investigators recorded dance-hall decadence in *The Social Evil in Chicago* (1911) and in Walter Reckless's *Vice in Chicago* (1932). Walter Lippmann's *A Preface to Politics* (1914) provided a lucid critique of moral guardians, as valid today as it was then. Langum's *Crossing Over the Line* tallied the red-light abatement laws.

Intimate Matters provided background on the "maternal authority" of the WCTU, as did Ruth Burdin's *Women and Temperance: The Quest for Power and Liberty* (1981), Alan P. Grimes's *Puritan Ethic and Woman's Suffrage* (1967), Jane Larson's "Even a Worm Will Turn at Last" (undated manuscript), and Herbert Asbury's biography *Carry Nation* (1929).

This project could easily have become the history of sex in cinema. *Screening Out the Past* (1980) by Lary May and *A Pictorial History of Sex in the Movies* (1975) by Jeremy Pascal and Clyde Jeavons provided the framework for the section on the flickers. Eve Golden's *Vamp: The Rise and Fall of Theda Bara* (1996) supplied the details on the screen's first sex symbol. Gerald Rabkin described *Dirty Movies: An Illustrated History of Stag Film, 1915–1970* (1973). We also found a live source for the past. Filmfare Video Labs in Seattle sells a series called "Blue Vanities," featuring vintage porn.

I drew on Langum for the story of fighter Jack Johnson and the Caminetti escapade. The Supreme Court decision in *Caminetti v. United States* (1917) was compelling reading, in that it gave the federal government a legal standing in the war on sex. H. Wayne Morgan's *Drugs in America: A Social History, 1800–1980* (1981) and David Musto's *The American Disease: Origins of Narcotic Control* (1973) revealed the early association of drugs and sex.

For the section on the women of Greenwich Village I drew on Candace Falk's *Love, Anarchy and Emma Goldman* (1984) (especially the details of Emma's love letters). Madeline Gray's *Margaret Sanger: A Biography of the Champion of Birth Control* (1981), David Kennedy's *Birth Control in America: The Career of Margaret Sanger* (1970), and Ellen Chesler's *Woman of Valor: Margaret Sanger and the Birth Control Movement in America* (1992) were excellent sources on Sanger, who was a somewhat less reliable source about herself. She wrote autobiographies the way some people write fund-raising letters, most notably *My Fight for Birth Control* (1931) and *Margaret Sanger: An Autobiography* (1938). I spent a day at Planned Parenthood xeroxing copies of Sanger's *What Every Girl Should Know* and her classic pamphlet, *Family Limitation.* (Excerpts can be found in Campbell's *Sex Education Books for Young Adults* and Stoehr's *Free Love in America.*)

The section on World War I draws on Allan Brandt's *No Magic Bullet: A Social History of Venereal Disease in the U.S. Since 1880* (1985), another volume in our core curriculum. The description of boys about to ship out spending the night in a brothel comes from *Nell Kimball: Her Life as an American Madam* (1970), edited by Stephen Longstreet. There's some debate as to whether the words are hers or her editor's, but they remain compelling, as does Malcolm Cowley's assessment of the puritan crisis, taken from *Exile's Return* (1934).

CHAPTER THREE: THE JAZZ AGE

For general background I relied on *This Fabulous Century* and *Our Times*, but added Lois and Alan Gordon's *1920–1980: American Chronicle* (1987). The Playboy library has a shelf of books devoted to the 1920s (reflecting one of Hefner's personal passions), including George Mowry's *The Twenties: Fords, Flappers and Fanatics* (1963), Alan Jenkins's *The Twenties* (1974), *The American Heritage History of the 1920s and 1930s* (1970), and Paul Sann's *The Lawless Decade* (1957).

Middletown: A Study in Modern American Culture (1929) by Helen and Robert Lynd remains an honest, objective look at a small town. The authors did not exclude sex. Similarly, Frederick Lewis Allen, the editor of *Harper's,* gave sex its due in his informal history, *Only Yesterday* (1931).

It was a pleasure to reread Fitzgerald's *The Beautiful and the Damned* (1922) and *The Great Gatsby* (1925). Matthew J. Bruccoli's biography *Some Sort of Epic Grandeur: The Life of F. Scott Fitzgerald* (1981) clarified the fiction.

That a fundamental shift in dating and courtship was happening was evident to all. I drew on Beth Bailey's wonderfully titled *From Front Porch to Back Seat* (1988), E. S. Turner's *A History of Courting* (1955), Ellen K. Rothman's *Hands and Hearts: A History of Courtship in America* (1984), and Paula Fass's *The Damned and Beautiful: American Youth in the 1920s* (1977). Kevin White tackled the question of the flapper's boyfriend, the New Man that emerged to accompany the New Woman, in *The First Sexual Revolution: The Emergence of Male Heterosexuality in Modern America* (1993). Peter Ling's article "Sex and the Automobile in the Jazz Age" from the November 1989 *History Today* correctly identified one of the responsible technologies.

As a former giver of advice, I was drawn to *Dorothy Dix—Her Book: Everyday Help for Everyday People* (1926), and to Anna Steese Richardson's *Standard Etiquette* (1925). Prompted by a remark in *Intimate Matters,* I read several editions of Emily Post's *Etiquette: The Blue Book of Social Usage* (1922, 1936, 1938) to see one woman's attempt to deal with such change.

For coverage of the Scopes trial I relied on Frederick Lewis Allen and the reportage of H. L. Mencken, collected in *The Impossible Mencken* (1991), edited by Marion Elizabeth Rodgers. Bronislaw Malinowski's *The Sexual Life of Savages* (1929) and Margaret Mead's *Coming of Age in Samoa* (1928) are as seductive now as they were then.

At the Kinsey Institute I xeroxed page after page of W. F. Robie's *Rational Sex Ethics* (1918), *Sex Histories, Sex and Life* (1924), and *The Art of Love* (1925). Somewhat easier to find were copies of Samuel Schmalhausen's *Why We Misbehave* (1928). I'm told that a first edition of *Is Sex Necessary?,* James Thurber and E. B. White's 1929 send-up of the genre, is valued at $2,000— whether because it is Thurber's first book or for the sentiments on sex is hard to determine.

Edmund Wilson's journals *The Twenties* provided details of life and love in Greenwich Village, as did Jean Gould's *The Poet and Her Book: The Work of Edna St. Vincent Millay* (1969). Malcolm Cowley and Frederick Lewis Allen provided the details of Prohibition. The discussion on literary lust drew from

Charles Glicksberg's *The Sexual Revolution in Modern American Literature* (1971) and Mark Boyer's *Purity in Print: The Vice Society Movement and Book Censorship in America* (1968). Edward de Grazia's *Girls Lean Back* provided courtroom details. Mencken's essay "Puritanism as a Literary Force" appears in his *Book of Prefaces* (1928/1977). He continued his attack on puritans and prudes in "The Bashful Mystery, Prejudices," reprinted in his *Crestomathy* (1949).

Patricia Campbell devoted a chapter of her book to the trials of Margaret Sanger and Mary Ware Dennett. Constance Chen's *The Sex Side of Life: Mary Ware Dennett's Pioneering Battle for Birth Control and Sex Education* (1996) filled out the life of the other great crusader.

The trial of Fatty Arbuckle is recounted in David Yallop's *The Day the Laughter Stopped* (1976) and Stuart Oderman's *Rosco "Fatty" Arbuckle* (1994). Details on other scandals and Chaplin's divorce come from Kenneth Anger's *Hollywood Babylon* (1975). Charlie Chaplin's *My Autobiography* (1964) provided the brief account of his first marriage, while Lita Grey Chaplin told her side in *My Life With Chaplin: An Intimate Memoir* (1966).

Marjorie Farnsworth's *Ziegfeld Follies* (1956) was the source of the diamond anecdote; Zelda Fitzgerald gave her summary of riding on the tops of taxis in *Save Me the Waltz* (1932). The suicide story comes from Polly Adler's *A House Is Not a Home* (1953).

CHAPTER FOUR: HARD TIMES

For general background: *The Desperate Years* (1962) by James Horan and Cabell Phillips's *From the Crash to the Blitz* (1969). Once again I relied on the informal eye of Frederick Lewis Allen, whose *Since Yesterday* (1939) is as honest as its precurser, and the dedicated curiosity of Robert and Helen Lynd's *Middletown in Transition* (1937).

The Scottsboro events were described by Edmund Wilson in *The American Earthquake* (1958/1996), as well as in *Intimate Matters* and *Crossing Over the Line*. Articles in *The Nation* (June 3, 1931, and February 12, 1936) provided additional details.

The section on book burning is drawn from Paul Boyer's *Purity in Print*, Vern Bullough's *Science in the Bedroom* (1994), *Banned Books Resource Guide*, and Robert Haney's *Comstockery in America* (1974). The account of censor-

ship in Hollywood is indebted to *Sin and Censorship: The Catholic Church and the Motion Picture Industry* (1996) by Frank Walsh; *Hollywood Censored: Morality Codes, Catholics and the Movies* (1994) by Gregory D. Black; *The Dame in the Kimono: Hollywood, Censorship and the Production Code from the 1920s to the 1960s* (1990) by Leonard J. Leff and Jerold L. Simmons; *Censored Hollywood: Sex, Sin and Violence on Screen* (1994) by Frank Miller; *The Cutting Room Floor* (1994) by Laurent Bouzereau; and *See No Evil: Life Inside a Hollywood Censor* (1970) by Jack Vizzard. Additional details on Catholic censors came from Paul Facey's *Legion of Decency* (1974).

Critics Choice in Itasca, Illinois, sent me videos of Mae West's films. For background I relied on Parker Tyler's introduction to *The Films of Mae West* (1973). Readers seeking more Mae should consult Marybeth Hamilton's excellent *When I'm Bad, I'm Better: Mae West, Sex, and American Entertainment* (1997).

Hedy Lamarr's account, *Ecstasy and Me: My Life as a Woman* (1966), is a fascinating behind-the-scenes bio. I found *Grindhouse: The Forbidden World of 'Adults Only' Cinema* (1996) by Eddie Muller and Daniel Faris to be a quirky celebration of sexploitation films and a thoroughly useful resource. The details about La Guardia's closing burlesque houses came from William R. Taylor's *Inventing Times Square* (1991).

The section on sex and the newsstands owes much to *The American Magazine* (1991) by Amy Janello and Brennon Jones; *The Great American Pin-up* (1996) by Charles Martignette and Louis K. Meisel; *Advertising in America: The First 200 Years* (1990) by Charles Goodrum and Helen Dalrymple; *The Great American Comic Strip* by Judith O'Sullivan; and *Tijuana Bibles: Art and Wit in America's Forbidden Funnies, 1930s–1950s* (1997) by Bob Adelman.

Nathanael West's novels *Miss Lonelyhearts* (1933) and *Day of the Locust* (1939) substantiated the idea that movies and magazines were a distraction from the horror of the Depression.

The short section on radio draws from John Dunning's *Tune In Yesterday* (1976) and Frank Buxton's *The Big Broadcast: 1920–1950* (1972).

Grace Palladino's *Teenagers: An American History* (1996) prompted the section on Andy Hardy High. Anecdotes were drawn from Mickey Rooney's *I.E., An Autobiography* (1965), and from Arthur Marx's *The Nine Lives of Mickey Rooney* (1986). The Lynds provided the on-site details of teenage life in *Middle-*

town in Transition. Patricia Campbell dissects Roy Dickerson's *So Youth May Know—New Viewpoints on Sex and Love* (1930).

I first learned about Lewis Terman and Catherine Miles in Michael Kimmel's *Manhood in America* (1996). Kimmel reproduces sections of the male/female test in his appendix. The Hemingway/Fitzgerald anecdote came from Edmund Wilson's *The Thirties.* Terman described his groundbreaking sex research in *Psychological Factors in Marital Happiness* (1938).

The section on dating and mating revisited E. S. Turner's *A History of Courting,* Kevin White's *First Sexual Revolution,* and Beth Bailey's *From Front Porch to Back Seat.* In addition, I drew on *Youth and Sex: A Study of 1300 College Students* (1938) by Dorothy Dunbar Bromley and Florence Flaxton Britten, as well as a June 6, 1938, *Life* article about the survey.

The newsstand was not always devoted to glamour. The April 1937 *American Mercury* carried Anthony Turano's article on "Syphilis: Mrs. Grundy's Disease." (It had published his article on the Mann Act, "Adultery On Wheels," in December 1936.) The August 1937 *Reader's Digest* reprinted Margaret Banning's "The Case for Chastity." *Ladies' Home Journal* called for a crusade against VD in August 1937 with "We Can End This Sorrow" and again in November 1937 with "Can We Now fight Syphilis?" The August 29, 1937, *New York Times* carried stories of Hoover's raids on brothels.

My Hoover file consisted of *J. Edgar Hoover: The Man and His Secrets* (1992) by Curt Gentry; *Secrecy and Power: The Life of J. Edgar Hoover* (1987) by Richard Powers; *The Boss: J. Edgar Hoover and the Great American Inquisition* (1988) by Athan Theoharis and John Stuart Cox; *J. Edgar Hoover, Sex and Crime* (1988) by Athan Theoharis; and Langum's *Crossing Over the Line.*

The continuing story of birth control drew from Francis Packard's *History of Medicine in the U.S.A.* (1931), Max Hodann's *History of Modern Morals* (1976), Norman Himes's *Medical History of Contraception* (1936), and Gray's biography of Sanger. Another volume from the core curriculum, Marvin Olasky's *The Press and Abortion: 1833–1988* (1988), provided background. The discussion of eugenics was prompted by Allen Garland's article "Science Misapplied: The Eugenics Age Revisited" in the August 1966 *Technology Review.*

On a more frivolous note, the descriptions of the nude pavilions ad at the 1939 World's Fair came from Peter Galernter's *1939: The Lost World of the Fair* (1995).

CHAPTER FIVE: MALE CALL

My father wrote my mother almost every day of the war. He designed a dream house and planned his and my future. He was also the officer who censored letters aboard the USS *Vincennes. Since You Went Away* (1995), a collection of wartime love letters edited by Judy Burrell Litoff, added texture to this section. Hefner, too, recalled the importance of mail call, unearthing copies of *Yank;* the shopping service was described in the May 4, 1945, issue. The woman who married a dozen soldiers popped up in the July 1944 *Reader's Digest.*

John Costello's *Virtue Under Fire: How WWII Changed Our Social and Sexual Attitudes* (1985) was an exceptional source that created the blueprint for this chapter. The challenge was to find ground he had not covered. Following a single footnote (National Archives, RG 247 Decimal Class 250.1) I was led to Washington, which resulted in the section on the Chaplain General.

The section on the home front relied on Bailey's *From Front Porch to Back Seat* plus *Women at War With America* (1984) by D'Ann Campbell, *Wartime Women* (1981) by Karen Andersen, and *Wartime America* (1996) by John Jeffries. *Ladies' Home Journal* proved a valuable source for details on the domestic side of war, from articles asking "What Is Your Dream Girl Like?" and "Marriages at War" (March 1942) to "Life Without Father" (March 1944) and Mona Gardner's warning on "Chastity and Syphilis" (January 1945). Margaret Mead's article "A GI View of Britain" appeared in the March 10, 1944, *New York Times Magazine.*

Novelists articulated the urgency of the times. Norman Mailer's *Naked and The Dead* (1948) conveyed the grunt's fantasy world. James Jones's *From Here to Eternity* (1951) and *The Thin Red Line* (1962) were unexpectedly sexual, discussing both heterosexuality and homosexuality in ways that disquieted America. But Jones's nonfiction account, *WWII* (1975), was also useful, in part because he described how the war played out in hotel rooms and bars. Additional details were drawn from *Dirty Little Secrets* (1994) by James F. Dunnigan and Albert A. Nofi.

Not surprisingly, the section on the pin-up benefited from Hefner's expertise, as well as from Ralph Stein's *The Pin-up: From 1852 to Now* (1974). The Litvak-Goddard anecdote appears in both Jones's *WWII* and Allan Sherman's *The Rape of the A*P*E* [*American Puritan Ethic*] in slightly different form. Gary Valant's *Vintage Aircraft Nose Art* (1987) preserves more than a

thousand examples of the form. Details of the battle of the Varga Girl come from Hugh Merrill's *Esky: The Early Years at Esquire* (1995) and Arnold Gingrich's *Nothing but People* (1971).

The chaplain's battle with the USO prompted me to read Bob Hope's often moving *Don't Shoot, It's Only Me* (1990). Jokes, of course, are an accurate lens on history.

I relied on *Virtue* and *No Magic Bullet* for the section on venereal disease, as well as on Gene Tunney's article "The Bright Shield of Continence" in the August 1942 *Reader's Digest* and Albert Deutsch's piece in the September 22, 1945, *Nation.* The sources for the discovery of penicillin were Andre Maurois's *Life of Sir Alex Fleming* (1959), John Rowland's *The Penicillin Man: The Story of Sir Alexander Fleming* (1959), David Wilson's *In Search of Penicillin* (1976), and David Adams's *The Greatest Good to the Greatest Number: Penicillin Rationing on the American Home Front, 1940–1945* (1991).

Many different magazine articles described the homecoming, but the most succinct account was found in Betty Friedan's *It Changed My Life* (1976).

The controversy surrounding *The Outlaw* is covered in *Dame in the Kimono, Hollywood Censored,* and *Sin and Censorship.* Frank Krutnik's *In a Lonely Street* (1991) made the connections between pin-ups and film noir. For real-life Hollywood scandals, I turned to Errol Flynn's *My Wicked, Wicked Ways* (1960), Charlie Chaplin's *My Autobiography,* Donald Spoto's *Notorious: The Life of Ingrid Bergman* (1997), and Kenneth Anger's *Hollywood Babylon,* as well as articles in *Time, Newsweek, The Nation,* and the *New York Times.*

Edward de Grazia's *Girls Lean Back* first alerted me to Edmund Wilson's journals and provided the details for the trial of Wilson's *Memoirs of Hecate County.*

One of the pleasures of this project was to come upon books from the other side, seeing them as they first appeared. Such was the case for Alfred Kinsey's *Sexual Behavior in the Human Male* (1948). Background came from Wardell Pomeroy's *Dr. Kinsey and the Institue for Sex Research* (1972), Edward Brecher's *The Sex Researchers,* Paul Robinson's *The Modernization of Sex,* and magazine articles from *Reader's Digest* (June and September 1948). I had finished the sections on Kinsey when James H. Jones's controversial biography *Alfred C. Kinsey: A Public/Private Life* (1997) appeared. Part of a wave of revisionist histories, the book held that Kinsey was both a homosexual and a mas-

ochist, and that his secret life may have biased his statistics. The bias was in society, not the science. A more subtle critique of the Kinsey Report was offered by sociologist John Gagnon, who thinks the surveys are a snapshot of sex during time of war.

Morris Ernst's remarks appeared in the May 1950 *Scientific Monthly*. Hefner was kind enough to supply me with a copy of his term paper "Sex Behavior and the U.S. Law." A copy is now available at the Kinsey Institute.

CHAPTER SIX: COLD WAR COOL

The general background drew from *The Fifties* by David Halberstam (1997), *Grand Expectations: The United States, 1945–1974* (1996) by James Patterson, and *The Way We Never Were: American Families and the Nostalgia Trap* (1992) by Stephanie Coontz, a wonderfully contrarian view of the good old days. Myron Sharaf's biography of Wilhelm Reich, *Fury on Earth (1983)*, provided details of the orgone box and persecution of Reich.

I discovered the phenomenon of poison-pen letters in John Makris's *The Silent Investigators: The Great Untold Story of the United States Postal Inspection Service* (1959).

Hefner sent me copies of *Confidential*. I drew additional details from Kenneth Anger's *Hollywood Babylon* and an *Esquire* article on Robert Harrison by Tom Wolfe. Gay Talese described the ambience of the magazine in *Thy Neighbor's Wife* (1980). Eric Kroll's appreciation of John Willie as the "Leonardo da Vinci of Fetish" appeared in the introduction to the two-volume Taschen reprint of the complete *Bizarre* (1995).

Details about the great homosexual panic–red scare came from various Hoover biographies, Nicholas Von Hoffman's biography *Citizen Cohn* (1988), and Colin Spencer's *Homosexuality in History* (1995). Ralph Major's article "The New Moral Menace to Our Youth" in the September 1950 *Coronet*, and stories in *Time* (December 25, 1950; "Sex Pychopaths" March 9, 1953; "The Abnormal" April 17, 1950) provided additional details, as did George Chancey's essay "The Postwar Sex Crime Panic" in *True Stories From the American Past* (1993).

Mike Benton's *Illustrated History of Horror Comics* (1993) and Lee Daniels's *Comix: A History of Comic Books in America* (1971) provided information on the wave of comic censorship. Fredric Wertham made his views known in the

May 29, 1948, *Saturday Review,* the November 1953 *Ladies' Home Journal,* and the May 8, 1954, *New Yorker,* as well as in his best-seller *Seduction of the Innocent* (1954). Kenneth Davis's *Two-Bit Culture: The Paperbacking of America* (1984) provided a wonderful tour of the pulps. When this series ran in the magazine I added a sidebar of "The Good Parts" from such steamy books as Mickey Spillane's *I, The Jury,* Grace Metalious's *Peyton Place,* and Evan Hunter's *The Blackboard Jungle*—all of which involved women disrobing or being disrobed, and all of which stopped this side of sex.

By far the most important book of the decade was Kinsey's *Sexual Behavior in the Human Female* (1953). For background I consulted David Allyn's "Private Acts/Public Policy" in the December 1996 *Journal of American Studies;* Ernest Havemann's article in the August 24, 1953, *Life;* Wardell Pomeroy's *Dr. Kinsey and the Institute;* Ashley Montagu's *The Natural Superiority of Women;* and *An Analysis of the Kinsey Reports* (1954), edited by Donald Geddes.

The section on Hefner is a model of restraint, in part because Hefner felt the real *Playboy* story happened in the sixties. I agreed that the most insightful descriptions of the magazine came from outsiders, particularly Barbara Ehrenreich's *The Hearts of Men: American Dreams and the Flight From Commitment* (1983), Gay Talese's *Thy Neighbor's Wife* (1980), and David Halberstam's *The Fifties* (1993).

For the section on suburban life, I utilized Herbert Gans's *Levittowners: Ways of Life and Politics in a New Suburban Community* (1967), John Keats's *Crack in the Picture Window* (1956), David Riesman's *The Lonely Crowd* (1950), and Betty Friedan's *The Feminine Mystique* (1963). Friedan's book was a watershed event in the sixties, but it was also excellent journalism about the fifties.

Patricia Campbell and Grace Palladino, again, framed the discussion on teenage sex. J. D. Salinger's *Catcher in the Rye* (1951) has appealed to adolescent angst for almost half a century. Albert Goldman's *Elvis* (1981) provided much of the detail for the section on rebels without a cause.

I relied on Patterson's *Grand Expectations* and Halberstam's *The Fifties* for the account of the murder of Emmett Till. I was unable to resolve the exact wording of Eisenhower's remark: Did Southerners not want their daughters sitting next to "big black bucks" or "big overgrown Negroes"?

Dame in the Kimono, Sex in the Movies, Sin and Censorship, and *Grindhouse* described the search for sophistication in cinema. The section on hip

subversives drew from Tony Hendra's excellent *Going Too Far* (1987), Lenny Bruce's *How to Talk Dirty and Influence People* (1966), and profiles of Mort Sahl and Bruce that appeared in *Playboy*. The section on Kefauver and Klaw included information from the *Interim Report of the Committee on the Judiciary Subcommittee to Investigate Juvenile Delinquency* (1956). In contrast, *Betty Page: The Life of a Pin-up Legend* (1996) by Karen Essex and James L. Swanson gave a slightly healthier account, certainly one that was visually delightful. Edward de Grazia's *Girls Lean Back Everywhere* provided the framework for the trial of the last of the old-time pornographers. Additional details came from Makris's *The Silent Investigators,* Gay Talese's *Thy Neighbor's Wife,* and a government publication titled *Obscene Matter Sent Through the Mail, part 1, April 23, 1959*. Alfred Kazin's review of the suddenly legal *Lady Chatterley* appeared in *The Atlantic Monthly* (July 1959). The account of the Princeton, New Jersey, family's fallout shelter appeared in the August 16, 1959, *New York Times*.

Jack Kerouac's explanation of the Beats appeared in the June 1959 *Playboy;* his vision of the future in *On the Road* (1957).

CHAPTER SEVEN: MAKE LOVE, NOT WAR

Most of the general anthologies on the 1960s focus on the politics of the left, the antiwar movement, the civil rights movement—and miss the sexual tumult. *The Sixties: The Art, Attitudes, Politics and Media of Our Most Explosive Decade* (1995), edited by Gerald Howard, directed my attention toward Marshall McLuhan, whose *The Medium Is the Massage* (1967) and *Understanding Media* (1964) describe "participation mystique," a term that tied together everything from Beatlemania to the Playboy Clubs. The overview drew on *Re-Making Love: The Feminization of Sex* (1986) by Barbara Ehrenreich, Elizabeth Hess, and Gloria Jacobs as well as Grace Palladino's *Teenagers,* Theodore Roszak's *The Making of the Counterculture* (1969), and Tom Wolfe's *Pump House Gang* (1968).

If one wants to chart the repeal of reticence, one has only to count the paucity of articles on sexual matters listed in the *Reader's Guide to Periodical Literature*. At the outset of the century relevant articles filled a file folder; by the seventies, articles on sex filled several boxes. There are some who insist that the sexual revolution was an invention of the media. Judging from the coverage I read (and sometimes wrote), behavior always came first.

Norman Mailer's description of the Playboy Clubs appeared in *The Presidential Papers* (1963); Gloria Steinem's account of her Bunnyhood was reprinted in *Outrageous Acts and Everyday Rebellions* (1983). I treated The Playboy Philosophy as I did the Kinsey Report, pointing out what Hefner said, then measuring the public reaction. The sexual revolution was a war of words, fought on the newsstand. I collected articles from sources as diverse as *Christian Century, The Catholic World, Time, Mademoiselle,* and *Redbook.*

Abe Maslow's *Toward a Psychology of Being* (1962), Rollo May's *Love and Will* (1969), and Ira Reiss's *Premarital Sexual Standards in America* (1960) provided the theoretical framework for the new morality.

Betty Friedan's *Feminine Mystique* (1963) and Helen Gurley Brown's *Sex and the Single girl* (1962) supplied the women's response.

My discussion of the Pill was shaped by three books that belong in the core curriculum: Loretta McLaughlin's *The Pill, John Rock and the Church: The Biography of a Revolution* (1982); Bernard Asbell's *The Pill: A Biography of the Drug That Changed the World* (1995); and John Rock's *The Time Has Come: A Catholic Doctor's Proposals to End the Battle Over Birth Control* (1963). Additional details surfaced in Vern Bullough's *Science in the Bedroom* (1994), Charles Westoff's *Contraceptive Revolution* (1977), and John Guillebaud's *The Pill* (1984). The dialogue between Andrew Hacker in the *New York Times Magazine* (November 21, 1965) and the editors of *Mademoiselle* (April 1966) captured the changing etiquette; as did articles in *Ladies' Home Journal* (November 1965), *U.S. News and World Report* (July 11, 1966), and *Newsweek* (July 6, 1964).

John Heidenry begins *What Wild Ecstasy: The Rise and Fall of the Sexual Revolution* (1997) with an account of "The Orgasm That Changed the World." Can a woman's orgasm be called seminal? *Human Sexual Response* (1966) by William Masters and Virginia Johnson changed the way we thought about sex. For background I referred to "I'm Sorry, Dear" by Leslie Farber in the November 1964 *Commentary;* "Down With Sex" by Malcolm Muggeridge in the February 1965 *Esquire;* Colette Dowling and Patricia Fahey's "The Calculus of Sex" in the May 1966 *Esquire;* and two Playboy Interviews with Masters and Johnson (May 1968 and November 1979).

Gael Greene's *Sex and the College Girl* (1964) provided many of the details for the section on campus sex. Hefner recounted the plight of Professor Leo Koch in The Playboy Philosophy. Margaret Mead's take on Vassar ap-

peared in the October 1962 *Redbook;* Russell Kirk's in the February 11, 1963, *National Review;* Gloria Steinem's in the September 1962 *Esquire.* As they had throughout the century, novelists caught the mood. Robert Heinlein's *Stranger in a Strange Land* (1961) and Robert Rimmer's *The Harrad Experiment* (1966) were as fun to read now as they were then.

Charles Perry's *The Haight-Ashbury: A History* (1984) and Abe Peck's *Uncovering the Sixties: The Life and Times of the Underground Press* (1985) were the primary sources for the section on the counterculture. Stanley Booth recounts the Mick Jagger story in *Dance With the Devil* (1984). Timothy Leary's discovery of the effect of LSD on sex appears in his autobiography, *Flashbacks* (1983); the September 1966 Playboy Interview broke the news to the world. "Sex, Ecstasy and the Psychedelic Drugs" by R.E.L. Masters followed in the November 1967 *Playboy.* Background on the yippies came from Jonah Raskin's *For the Hell of It: The Life and Times of Abbie Hoffman* (1996).

The FBI file on Martin Luther King, Jr., has been the subject of several books. I utilized David J. Garrow's *The FBI and Martin Luther King, Jr.* (1983). Curt Gentry alluded to FBI wiretaps of King in *J. Edgar Hoover: The Man and His Secrets.* Taylor Branch printed details in *Pillar of Fire* (1998).

I found the information on Washington polygraph interrogations in Tristram Coffin's *The Sex Kick: Eroticism in Modern America* (1966). David Allyn's article "Private Acts/Public Policy" in the December 1996 *Journal of American Studies* outlined the story of the American Law Institute; as did articles in the May 30, 1955, and August 8, 1969, *Time. Playboy* wrote about the Donn Caldwell case in June 1965 and July 1968.

The Supreme Court decisions in *Griswold vs. Connecticut* and *Stanley vs. Georgia* are beautiful. David J. Garrow's *Liberty and Sexuality: The Right to Privacy and the Making of Roe v. Wade* (1994) tells the story brilliantly. *Life*'s odd thoughts on the right to privacy appeared in July 2, 1965. The section on the liberation of language comes from de Grazia's *Girls Lean Back* and Charles Rembar's charming and erudite *The End of Obscenity: The Trials of Lady Chatterley, Tropic of Cancer and Fanny Hill* (1968). Those decisions paved the way for Norman Mailer's *American Dream* (1965), John Updike's *Couples* (1968), and Philip Roth's *Portnoy's Complaint* (1969).

Details on Keating and the CDL came from de Grazia, as well as from *Trust Me* (1993) by Charles Bowden and Michael Binstein (1993); Lenny

Bruce's arrest, and that of Hefner, were covered in The Playboy Philosophy from December 1962 through May 1965.

The section on the pornography of violence came out of Muller and Faris's *Grindhouse* as well as a July 1967 *Esquire* article by Tom Wolfe.

The rise of gay power was sparked by visibility; I drew on magazine articles in *The Christian Century* (September 11, 1963), *Newsweek* (December 30, 1963, and October 27, 1969), *Life* (June 26, 1964), *Look* (January 10, 1967), and the *New York Times Magazine* (November 12, 1967). Details about Stonewall came from *Intimate Matters*, *What Wild Ecstasy,* and various media coverage. The emergence of radical feminists is documented in Robin Morgan's *Sisterhood Is Powerful* (1970) and *Going Too Far: The Personal Chronicle of a Feminist* (1977) and Anne Koedt's *Radical Feminism* (1973).

The "Butterfly Flick" can be found in J's *The Sensuous Woman* (1963).

CHAPTER EIGHT: THE JOY OF SEX

When I got to my seventies chapter, for research I played my office. One of my first projects at *Playboy* was editing excerpts of Morton Hunt's *Sexual Behavior in the 1970s* (1974). His introduction provided the story of Philip Bailey's "lifestyle defense." Tom Wolfe provided an overview of "The Sexed-Up, Doped-Up, Hedonistic Heaven of the Boom-Boom Seventies" in a 1979 article for *Life.*

It was a pleasure to revisit Alex Comfort's *The Joy of Sex* (1972)—I still have the edition with the hairy counterculture couple, far more resonant that the reissue that featured Yuppies. *Remaking-Love: The Feminization of Sex* (1986) by Barbara Ehrenreich, Elizabeth Hess, and Gloria Jacobs first noted that the seventies saw the development of a woman's voice about sex, but Dr. Comfort taught the band to play. Still the sirens of sex were impressive sources, from Germaine Greer's *The Female Eunuch* (1971) and *The Madwoman's Underclothes* (1986), to Nancy Friday's *My Secret Garden* (1973; the introduction to the twenty-fifth anniversary edition, published in 1998, was illuminating). Erica Jong's memoir *Fear of Fifty* (1994) supplied the origins of *Fear of Flying* (1973). The Playboy Interview with Jong appeared in September 1975. Ehrenreich et al. was the primary source for my discussion of Marabel Morgan's *Total Woman* (1973); I also drew on an article by Joyce Maynard in

the September 28, 1975, *New York Times Magazine. McCall's* probed Helen Andelin's Fascinating Womanhood in June 1973.

Hefner provided a tape of the *Dick Cavett Show* that first aired in March 1970.

The section on sex clinics came from several sources, most notably Linda Wolfe's June 1974 *Playboy* article, "Take Two Aspirin and Masturbate," the *Playboy* interviews with Masters and Johnson, articles in *Newsweek* (November 27, 1972, and November 29, 1979), and *Ladies' Home Journal* (July 1970), plus pertinent sections in Heidenry.

The section on women's demand for equal orgasm followed a rereading of Shere Hite's *The Hite Report: A Nationwide Study on Female Sexuality* (1976) and *Women as Revolutionary Agents of Change* (1994), Hite's anthology of her work. Lonnie Barbach's *For Yourself: The Fulfillment of Female Sexuality* (1976) gave me Thea Lowry's remark that sex is perfectly natural, but almost never naturally perfect.

For information on sex toys I turned to Jack Boulware's *Sex American Style* (1998), D. Keith Mano's "Tom Swift Is Alive and Well and Making Dildos," from the March 1978 *Playboy,* and "Plain Talk About the New Approach to Sexual Pleasure," from the March 1976 *Redbook.*

Richard Smith's *Getting Into Deep Throat* (1973) provided background details on the film and subsequent trial. Linda Lovelace generated four purported autobiographies. I read *The Intimate Diary of Linda Lovelace* (1974), with a cover blurb from Hefner, the born-again best-seller *Ordeal* (1980), and the postfeminist conversion *Out of Bondage* (1986), with remarks by Gloria Steinem. Gerard Damiano told his side of the story in *High Society.* The Vincent Canby essay on the meaning of porn appeared in the January 21, 1973, *New York Times.*

Gay Talese's *Thy Neighbor's Wife* framed the discussion on commercial sex. Gilbert Bartell's *Group Sex: A Scientist's Eyewitness Report on the American Way of Swinging* (1971) and George and Nena O'Neill's *Open Marriage* (1973) also contributed. My article on Plato's Retreat, "The Public Sex Explosion," ran in the May 1978 *Playboy.* For details on Studio 54 I turned to Anthony Haden-Guest's *The Last Party: Studio 54, Disco and the Culture of the Night* (1997). Josh Alan Friedman's *Tales of Times Square* (1986) supplied the reportage on the Spermathon.

Critic's Choice sent me a boxful of films from the seventies. I read both Lacey Fosburg's *Closing Time: The True Story of the Goodbar Murder* (1977) and Judith Rossner's *Looking for Mr. Goodbar* (1975), which provided different takes on the same event.

For the section on the pubic wars I utilized Laura Kipnis's *Bound and Gagged* (1996), the November 1976 *Esquire* article that asked "What Have They Done to the Girl Next Door?," and personal recollections of the staff of *Playboy.*

Alain Robbe-Grillet's article on porn appeared in the May 20, 1972, *Saturday Review,* Peter Prescott's description in the March 15, 1971, *Newsweek,* and Margaret Mead's in the February 1976 *Redbook.* The rumors about snuff films cropped up in the October 1, 1975, and February 28, 1978, *New York Post.* Boulware chronicles the put-on in *Sex American Style.*

Susan Brownmiller's *Against Our Will: Men, Women and Rape* (1975) and Robin Morgan's *Going Too Far* provided ammunition for the porn debate. Gloria Steinem's "Erotica and Pornography: A Clear and Present Difference" appeared in the November 1978 *Ms.* and was reprinted in *Outrageous Acts and Everyday Rebellions. Esquire* ran "302 Women Who Are Cute When They're Mad" in July 1973. *Newsweek* asked "Is Gloria Steinem Dead?" on September 2, 1974.

For the section on the President's Commission on Obscenity I relied on Talese and the report itself; for details on the subsequent trials I turned to de Grazia, Heidenry, and articles in *Commonweal, Newsweek, U.S News and World Report,* and *Reader's Digest. Playboy* covered the *Deep Throat* trial in Memphis; *Newsweek* and the *New York Times* the trials of Al Goldstein and Jim Buckley in Kansas.

The long road to *Roe vs. Wade* benefited from David J. Garrow's *Liberty and Sexuality,* Leslie Reagan's *When Abortion Was a Crime: Women, Medicine and Law in the United States, 1867–1973* (1973), and Sarah Weddington's *A Question of Choice* (1992).

For the section on gay rights I drew from Charles Kaiser's *Gay Metropolis* and the Playboy Interview with Anita Bryant (May 1978), plus articles from various magazines and newspapers and personal interviews with participants.

CHAPTER NINE: THE GREAT REPRESSION

Both the March 2, 1981, *Newsweek* and the March 1981 *Esquire* article "An Unmentionable Occasion" by Bob Greene described the sex Tupperware par-

tics. Again, I played my office for background, rereading *Ladies' Home Erotica: Tales, Recipes and Other Mischief by Older Women* (1984) by the Kensington Ladies' Erotica Society, Alan and Donna Brauer's *ESO: How You and Your Lover Can Give Each Other Hours of Extended Sexual Orgasm* (1983), and *The G Spot and Other Recent Discoveries About Human Sexuality* (1982) by John Perry, Alice Ladas Kahn, and Beverly Whipple. Background on public response came from Linda Wolfe's "The Next Sexual Hype: The G Spot" (July 19, 1982, *New York*); see also "In Search of the Perfect G" (September 13, 1987, *Time*). The "Venus Butterfly" episode of *L.A. Law* was first broadcast on November 21, 1986. Winning entries in The Playboy Advisor's Venus Butterfly contest can be found in *365 Ways to Improve Your Sex Life* (1996) by the author. Details and quotes on cable, VCR sex, and X-rated videos came from various *Time* articles, particularly "Romantic Porn in the Boudoir" by John Leo on March 30, 1987. The December 22, 1983, *Rolling Stone* provided the example of "Giving Good Phone." For the end-of-the-revolution scare, I drew on Leo's article in the April 9, 1984, *Time,* George Leonard's gloomy piece in the December 1982 *Esquire,* and Peter Marin's "A Revolution's Broken Promises" in the July 1983 *Psychology Today.*

Covering the revolution became an accepted beat. Leo and Maureen Dowd covered herpes in the August 2, 1982, *Time* article "The New Scarlet Letter." The tip about putting lingerie in the microwave came from the November 1988 *Harper's Bazaar.*

My article on the S&M scene, "A Walk on the Wild Side," appeared in the August 1983 *Playboy.*

Randy Shilts's exceptional *And the Band Played On: Politics, People and the AIDS Epidemic* provided the framework for the AIDS section, supplemented by Kaiser's *The Gay Metropolis,* Craig Vetter's "The Desexing of America" in the December 1983 *Playboy,* and unfolding coverage in the *New York Times.* Pat Buchanan's loathsome remark appeared in the May 24, 1983, *New York Post.*

Details about the safe-sex crusade were found in "Fear of Sex" (November 24, 1986, *Newsweek*); "The Big Chill: Fear of AIDS" (February 16, 1987, *Time*); "Does Miami Vice's Sonny Crockett Carry Condoms?" (March 1987 *Glamour*); "And How Do Men Feel Now About Monogamy" (July 1988 *Glamour*); "The World's First Safe-Sex Orgy" (April 1989 *Playboy*); "Abstinence Ed"

(April 1992 *Playboy*); and "Sex From Now On?" (July 1988 *Glamour*). Katie Roiphe's *Last Night in Paradise* (1998) describes coming of age in the dark days of the AIDS epidemic.

"The Astonishing Wrongs of the New Moral Right" by Johnny Greene in the January 1981 *Playboy* provided the details of Reagan's early years. The section on the Reverend Donald Wildmon came from various *Playboy* articles, from the November 3, 1978, *Wall Street Journal,* copies of the *NFD Informer, The AFA Journal,* and George Higgins's "TV Puritans: Who Killed J.R.'s Sex Life (*Harper's,* October 1985).

Neil Malamuth and Edward Donnerstein summarized their own research in *Pornography and Sexual Aggression* (1984). The best assessment of the flaws in porn research came from Augustine Brannigan and Andros Kapardis, "Controversy Over Pornography and Sex Crimes: The Criminological Evidence and Beyond." Brannigan and F. M. Christensen, another Canadian and author of *Pornography: The Other Side* (1990), acted as a truth squad throughout the eighties.

America needed one. The section on Al Regnery and Judith Reisman drew on *Take Back the Night,* edited by Laura Lederer, my article in the October 1988 *Playboy,* Murray Waas's "Al Regnery's Secret Life" (*The New Republic,* June 20, 1986), and Howard Kurtz's "Serious Flaws Shelve $734,371 Study" (*Washington Post,* November 19, 1986), as well as relevant sections of Heidenry.

The earliest rebuttal of the antiporn fanatics came in John Gordon's *The Myth of the Monstrous Male—and Other Feminist Fables* (1982). I reported on the antiporn movement in "Pleasure and Danger" (*Playboy,* December 1985) and in "Politically Correct Sex" (*Playboy,* October 1986). Betty Friedan's sane remarks appear in *The Second Stage* (1981). Ehrenreich, Hess, and Jacobs filed "A Report on the Sex Crisis" in the March 1982 *Ms.*

Catharine MacKinnon and Andrea Dworkin often claim that they are misquoted. Dworkin's claim that the two hallucinated rights appears on page 250, *Letters From a War Zone* (1988). The account of the hearings comes from *In Harm's Way: The Pornography Civil Rights Hearings* (1997), edited by MacKinnon and Dworkin.

My coverage of the Meese Commission is based on Robert Sheer's "Inside the Meese Commission" (*Playboy,* August 1986); *United States of America vs. Sex: How the Meese Commission Lied About Pornography* (1986) by Philip Nobile and Eric Nadler; Barry Lynn's "ACLU Public Policy Report: Polluting

the Censorship Debate"; as well as Hugh Hefner's well-titled editorial "Sexual McCarthyism" in the January 1986 *Playboy*. I reread the Meese report and found it far more salacious than the Starr report.

Christina Hoff Sommers's *Who Stole Feminism?* offers a cogent rebuttal to various porn studies, as does Marcia Pally's *Sense and Sensibilities: Reflections on Forbidden Mirrors and the Will to Censor* (1994).

David Garrow's *Liberty and Sexuality: The Right to Privacy and the Making of Roe v. Wade* (1994) gives a good account of the Supreme Court's decision on sodomy. The July 21, 1986, *Time* article "Sex Busters" took notice of the betrayal of the revolution, as did Ramsey Clark's "Courting Disaster" in the December 1986 *Playboy*. The magazine also covered "Illegalizing Abortion" in July 1981 and "Abortion by Bullet" in June 1982. *Time* covered the abortion wars on January 14, 1985.

Lawrence Stanley reported on "The Child Pornography Myth" in the *Cardoza Law Review* and the September 1988 *Playboy*. Debbie Nathan and Michael Snedecker tracked the roots of the hysteria in *Satan's Silence: Ritual Abuse and the Making of a Modern American Witch Hunt* (1995). Articles such as "Innocence for Sale" (*Ladies' Home Journal,* April 1983) were typical of mainstream press coverage. "McMartin: Anatomy of a Witch Hunt" by the author, ran in the June 1990 *Playboy*. Susan Faludi's insight into the day-care controversy is in *Backlash: The Undeclared War Against Women* (1991).

Jessica Hahn told about the Bakker debacle in *Playboy*. Ritter's fall from grace was chronicled by Rick Anderson in "A Life in Ruins and Molestations Allegations Against a Priest" in the February 9, 1990, *Seattle Times*. Charles Keating's lifestyle was described in *Trust Me*.

CHAPTER TEN: REAL SEX

Greta Christina's "Are We Having Sex Now or What?" delighted me when I first encountered it in *Erotic Impulse: Honoring the Sensual Self* (1992), edited by David Steinberg. Similarly, I enjoyed Nicholson Baker's *Vox* (1992). Who would have guessed these two works foreshadowed the culminating event of the decade. Dean Kuipers's "Sex, Home and Video Tape" appeared in the November 1995 *Playboy*.

Anita Hill's testimony appears in *Speaking Truth to Power* (1997). It strikes me as odd that Hill neither changed nor added to the words that riveted the nation. Perhaps that is the trap of making a sworn statement, as others would

discover. I also utilized articles about the hearings, notably "Judging Thomas" in *U.S. News and World Report* (October 28, 1991); "Men on Trial II" in *New York* (December 16, 1991); "He Said, She Said" in *Time* (October 21, 1991); and "Anita Hill's Legacy" in *Time* (October 19, 1992).

The section on sexual harassment is drawn largely from Stephanie Gutmann's "Sexual Harassment: When Does Policy Become Propaganda?," which appeared in *Playboy,* February 1991. Peter Wyden chronicled the origin of the term in the July 1993 *Good Housekeeping.* Catharine MacKinnon laid claim to it in *Sexual Harassment of Working Women* (1979).

Phyllis Schlafly's virtuous-woman defense appeared in "Asking For It?," a May 4, 1981, *Time* article. Details of the Michelle Vinson case are in Phillip Weiss's "No Sex, Please. This Is a Workplace" (*New York Times Magazine,* May 3, 1998). I wrote about sexual harassment for *Playboy,* covering the Jacksonville shipyard case in "The War on Nudity: The Great Pin-up Controversy" (July 1991) and in "Mixed Company: Some Women Just Don't Get It" in February 1992.

The section on politically correct sex was drawn almost entirely from Doug Hornig's "The Big Chill on Campus Sex" (*Playboy,* November 1993).

For material on William Kennedy Smith I relied on Cathy Booth's "Behind the Blue Dot" (*Time,* December 16, 1991) and "The Case That Was Not Heard" (*Time,* December 23, 1991); Harry Stein's "It Happened One Night" (*Playboy,* April 1992); John Taylor's "Men on Trial I" (*New York,* December 16, 1991); and Nancy Gibbs's "When Is It Rape?"(*Time,* June 3, 1991).

The section on date rape is based on a two-part series in *Playboy:* Stephanie Gutmann's October 1990 piece, "Date Rape: Does Anyone Really Know What it Is?" and the November 1990 "Date Rape, Pt. II: The Making of a Crisis." The Katie Roiphe editorial appeared in the *New York Times;* also *Playboy* May 1992.

For the Lorena Bobbitt saga I drew on Jill Smolowe's "Swift Sword of Justice" (*Time,* November 22, 1993), Kim Masters's "Sex, Lies and an 8 inch Carving Knife" (*Vanity Fair,* November 1993), and Lawrence Altman's "The Doctor World: Artful Surgery: Reattaching a Penis" (*New York Times*, July 13, 1993). The antimale buttons are described in Ted Fishman's "Hatefest" (*Playboy,* August 1993).

The section on do-me feminists was culled from Tad Friend's "Yes" and Susie Bright's "How to Pick Up Girls Using the Real Live Dyke Method" (*Es-

quire, February 1994), plus the author's "Clit Lit 101: Feminists Discover a Sexuality That Feels Good—to Them" (*Playboy,* October 1993) and "Sex and Danger" (*Playboy,* August 1996).

An article on bisexual chic in *Harper's Bazaar* led me to Lynn Darling's *Vice Versa: Bisexuality and the Eroticism of Everyday Life* (1995); John Leland's "Bisexuality" (*Newsweek,* July 17, 1995) was the source of celebrity quotes. I caught Annie Sprinkle's show in San Francisco in May 1998, with Susie Bright and the students in her UC-Santa Cruz porn class. An indication of how far we've traveled in a single decade is that pornography is now a recognized academic subject.

The section on campus life in the age of AIDS followed readings of Kate Roiphe, and of Ira Reiss's *An End to Shame: Shaping our Next Sexual Revolution* (1990). Details on the Joycelyn Elders story came from "A Case of Too Much Candor" (*U.S. News and World Report,* December 19, 1994) and "Goodbye to the Condom Queen" (*Newseek,* December 19, 1994). The author and Marty Klein conducted "*Playboy*'s College Sex Survey" in October 1996 and again in November 1998. Material on the born-again virgins came from Erica Werner's "The Cult of Virginity" (*Ms.,* March/April 1997) and Michele Ingrassia's "Virgin Cool" (*Newsweek,* October 17, 1994), and from various newspaper stories.

I followed the 2LiveCrew case in the *New York Times.* For material on Howard Stern I turned to the *Playboy* Interview (April 1994), Richard Zoglin's "Shock Jock" (*Time,* November 30, 1992), David Wild's "Who Is Howard Stern?" (*Rolling Stone,* June 14, 1990), and Jeanie Kasindorf's "Bad Mouth" (*New York,* November 23, 1992). I covered the Dennis Barrie/Mapplethorpe trial in "Showdown in Cincinnati" (*Playboy,* March 1991).

Matthew Childs's "Lust Online" (*Playboy* April 1994) was a useful source. The author has reported on the Internet for The Playboy Forum, in such articles as "Target: Cyberspace" (July 1995), "On-line Pedophiles" (March 1995), "The Postman Always Stings Twice" (December 1994), and "Internet Sex: It's Not All Bestiality, Torture and Alt.sex.pervert" (September 1996). At least, it wasn't then. Mike Godwin has a fine section on the Marty Rimm–Carnegie Mellon study in *CyberRights: Defending Free Speech in the Digital Age* (1998). For a less fine account (i.e., totally gullible), read Phillip Elmer-Dewitt's "Cyberporn" (*Time,* July 3, 1995).

The section on sex in the miltary drew on many sources, including coverage in *Time, Newsweek, U.S. News and World Report, The Washington Post, The Boston Globe,* and the *Times Picayune.*

How do you source the last years of the century? The Clinton story was everywhere. Did I first learn detail X from the Internet? From the television monitor in the airport? From the stack of newsweeklies? As the author of this series, I found myself the center of press conferences and radio talk shows. I tried to apply the same lens to the Clinton story that I had to other events of the century; I looked at events through the other end of the telescope. What will be important fifty years from now? What caught my eye were stories that etched the media's changing role: Michael Kinsley's "Private Lives: How Relevant" (*Time,* January 27, 1992); Edwin Diamond's "Crash Course: Campaign Journalism 101" (*New York,* February 17, 1992); and William A. Henry III's "How to Report the Lewd and Unproven." Dealing with the lewd and proven was another matter. In the end, the nation that set out to liberate sex instead became its prisoner.

SOURCES FOR PHOTOGRAPHY, ART, AND ARTIFACTS

One of the great joys of this project was meeting collectors and archivists. We sorted through thousands of images and chose to include those that conveyed the sexual flavor of each decade, waves in the sea of provocation. Kerig Pope, the art director for the series, and I favored what archivist Carol Wald calls "Paper Americana"—artifacts such as ads, magazine art, book covers, and pin-up calendars that have made sex visible. I also included movie stills and posters, because of the important role that icons have played in the past one hundred years, as have the real heroes and villains whose portraits are featured here. If the images seem weighted to the feminine, it is because in the twentieth century when women changed, sex changed.

In the following credits, the numbers in parentheses refer to the page of the insert. Paula Uruburu: color postcard of Evelyn Nesbit (2). The Morris Collection at Southern Illinois University: Ida Craddock (3). The New York Historical Society: Anthony Comstock (3). Carol Wald: corset ad (1); postcards and cigar band (3); Woodbury's ad (6) and sheet-music cover (7); cover of

Smart Set (9); fruit-crate art (11); cigarette and mattress ads and matchbook cover (17); suffragette postcard at the beginning of Chapter Two. George Hagenauer: Tijuana Bible Buck Rogers parody (11); Sad Sack panel (15); art from *Swing Shift Cinderella* (16); the Spillance paperback, *Crime & Suspense*, and *Archie* covers (20); "Go Naked" ad (22); cover of *Snatch* (24). MBI Publishing Company: bomber art from the book *Vintage Aircraft Nose Art* by Gary Valant (14). Reid Austin: Petty Girl (13). Bill Paige: *Two Virgins* album cover (24). Jack Boulware: *Hustler* cover (27). Ben Stevens: Rolf Armstrong pin-up (10). Daniel Faris: *Forbidden Desires* film poster (13). The Library of Congress: war posters (5 and 15). The American Registry of Pathology: VD posters (15). The U.S. Patent Office: the blue print of Albert Todd's anti-masturbation device (1). Archive Photos: Mae West (12); Gloria Steinem (27); the gay pride and abortion protests (28); Prince (30); Anita Hill and Ken Starr (31); shot of the coed with birth control pills at the opening of Chapter Seven. Photofest: J. Edgar Hoover and James Cagney (12); the Rolling Stones promo still (27). Corbis Bettman: Margaret Mead (9); the Ziegfeld Girl (10); Alfred Charles Kinsey (17); Timothy Leary (21) shot of Ed Meese at the beginning of Chapter Nine. The Kobal Collection Ltd.: Theda Bara (4); the magazine cover featuring Betty Grable (16); still from *Last Tango in Paris* (26). The Everett Collection: Roscoe "Fatty" Arbuckle (9); Elvis Presley (21); Masters and Johnson (24); Marilyn Chambers (27). Culver Pictures: girl on bike (3). All the other images are from the *Playboy* archives.

INDEX